75 YEARS OF HOLLYWOOD PARTIES

OSCAR®
NIGHT

FROM THE EDITORS OF

VANITY
FAIR

BY GRAYDON CARTER AND DAVID FRIEND

WITH AN AFTERWORD BY DOMINICK DUNNE

ALFRED A. KNOPF NEW YORK 2004

VANITY FAIR WOULD LIKE TO GRATEFULLY ACKNOWLEDGE GIORGIO ARMANI FOR HIS SUPPORT OF OSCAR NIGHT.

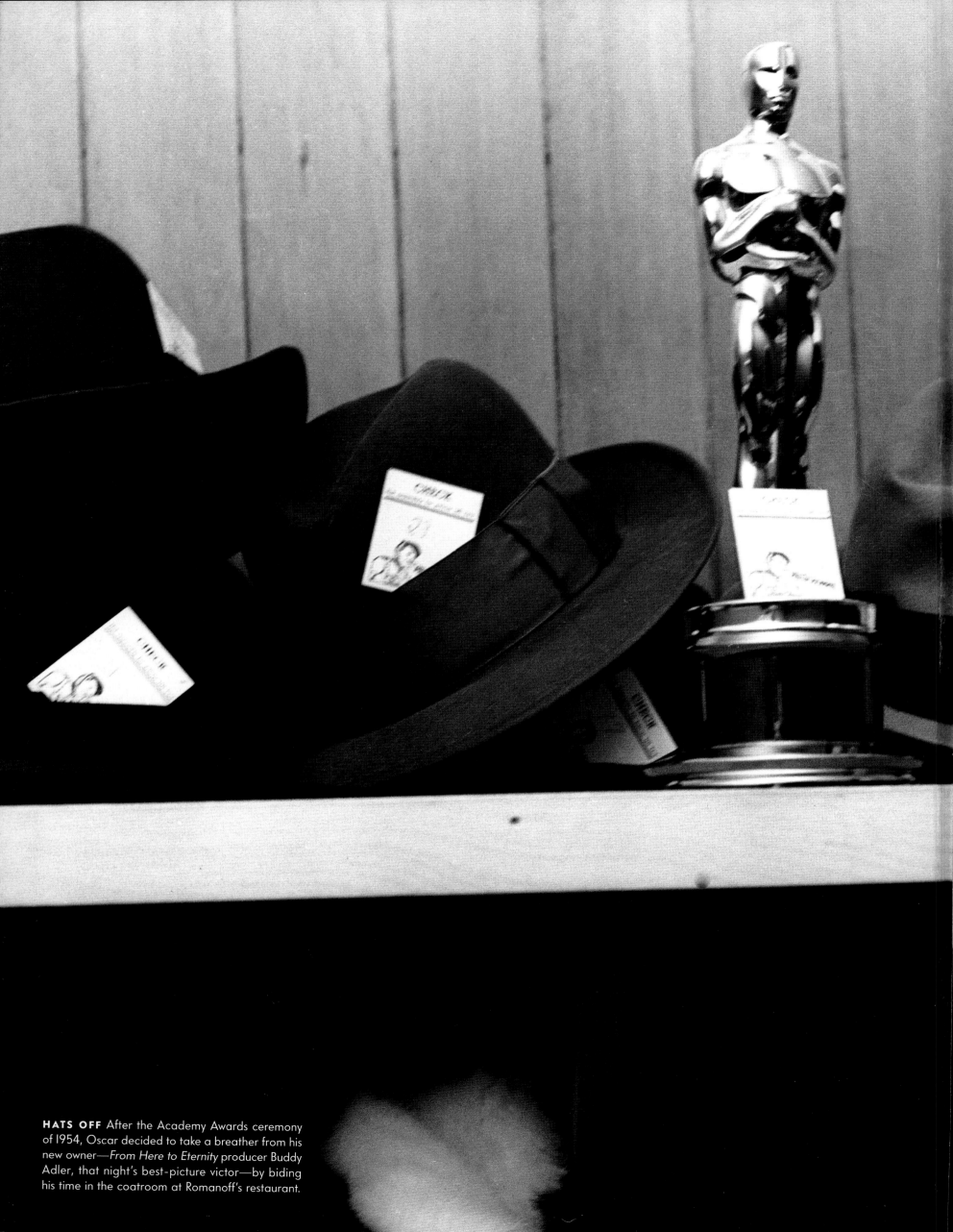

HATS OFF After the Academy Awards ceremony of 1954, Oscar decided to take a breather from his new owner—*From Here to Eternity* producer Buddy Adler, that night's best-picture victor—by biding his time in the coatroom at Romanoff's restaurant.

BY **GRAYDON CARTER** AND **DAVID FRIEND**

DESIGNER MIMI PARK
PHOTOGRAPHY EDITOR MELISSA GOLDSTEIN
PRODUCTION DIRECTOR MARTHA HURLEY
TEXT DAVID FRIEND, BRUCE HANDY,
STEPHEN LEVEY, JENNIFER MASSONI,
EVGENIA PERETZ, JIM WINDOLF
AFTERWORD DOMINICK DUNNE
ASSOCIATE EDITOR JENNIFER MASSONI
INTERVIEWS AND FIELD RESEARCH SARA SWITZER
COVER DAVID HARRIS, CHRIS MUELLER
REPORTING-RESEARCH NAT MOSS (CHIEF), JAMES BUSS,
JOHN FANNING, MICHELLE MEMRAN, ELIZABETH FEIFER,
SUE TERRY AND ROBERT C. COHEN (LOS ANGELES)
COPY PETER DEVINE (CHIEF), JOHN BRANCH,
JIM CHOLAKIS, DAVID FENNER, SCOTT FERGUSON,
FLORENCE FLETCHER, MARY LYN MAISCOTT,
ROBERT MORROW, ADAM NADLER,
S. P. NIX, SYLVIA TOPP
PRODUCTION ASSISTANCE BETH BARTHOLOMEW
PRODUCTION LAURA BELL, KACEY CHUILLI,
MARSHA COTTRELL, JEAN FOOS, CARL GERMANN,
SARAH HAYNES, LESLIE HERTZOG, MEGHAN HOWARD,
JOEL KATZ, LYNDALL KAZMARZYK-BAILEY, SUSAN M. RASCO,
TRINA ROBINSON, PATRICIA RUSH, NANCY C. SAMPSON
CONSULTING EDITOR WENDY STARK MORRISSEY
SPECIAL CONSULTANT PATRICIA BOSWORTH
PHOTO ASSOCIATE BETSY HORAN
PHOTO ASSISTANCE KATHRYNE HALL,
ROBIN RIZZUTO, JANE YEOMANS
DESIGN ASSISTANCE LORNA CLARK, MELANIE deFOREST,
SHARON OKAMOTO
EDITORIAL ASSISTANCE DAISY HO, KAREN IMBERT,
PAUL LAWRENCE, JT LYONS
LEGAL JERRY BIRENZ, PATRICIA CLARK,
RICHARD CONSTANTINE, ROBERT WALSH
RIGHTS AND PERMISSIONS REBECCA HEISMAN,
ANTHONY PETRILLOSE, MICHAEL STIER

EXPERTISE AND IMAGERY GRACIOUSLY PROVIDED BY
Barry Avrich, Henry and Jane Berger, Jennifer Bikel
(Fairchild Publications), Barbara Baker Burrows,
Bronwyn Cosgrave, Gwen Davis, Janet de Cordova,
Rosa DiSalvo (Getty Images), Lisa Dubisz (The Motion Picture
and Television Archive), Todd Eberle, John Frook,
Mike Gallagher, Anjelica Huston, Erik Hyman, Linda LeRoy
Janklow, Sam Jones, Karen Lerner, Martha Luttrell,
Mary Panzer, Michelle Phillips, Julian and Judith Plowden,
George and Jolene Schlatter, Arnold Schwartzman,
Daniel Selznick, Ben Silverman, Annette Tapert, Michael Toth,
Connie Wald, Ray Whelan Jr. (Globe Photos),
Audrey Wilder, Gregory Williams, Joan Rathvon Wilson

SPECIAL THANKS TO THE VANITY FAIR **EDITORIAL TEAM**
John Banta, Chris Garrett, Punch Hutton, Ellen Kiell,
Beth Kseniak, Wayne Lawson, Jeannie Rhodes, Jane Sarkin,
Krista Smith, Susan White
and
Dori Amarito, Dina Amarito-DeShan,
Aimée Bell, Lisa Berman, Carolyn Bielfeldt, Patrick Christell,
Bob Colacello, Anne Fulenwider, SunHee C. Grinnell,
Reinaldo Herrera, Michael Hogan, Anne McNally,
Eilish Morley, Meg Nolan, Maureen Orth,
Elise O'Shaughnessy, Lisa Robinson, Douglas Stumpf,
Matt Tyrnauer, Elizabeth Saltzman Walker, Julie Weiss

AND VANITY FAIR **PUBLISHING**
Louis Cona (Vice President and Publisher),
Hope Hening, Janine Silvera

FOR MAKING THIS BOOK POSSIBLE, VERY SPECIAL THANKS TO
Sonny Mehta
Pat Johnson
Shelley Wanger
Andy Hughes
Lydia Buechler
Victoria Pearson

The teams at ALFRED A. KNOPF and RANDOM HOUSE

Andrew Wylie

S. I. Newhouse, Jr.
Charles H. Townsend
James Truman

THIS IS A BORZOI BOOK
PUBLISHED BY ALFRED A. KNOPF

1 3 5 7 9 10 8 6 4 2

This book was printed by Amilcare Pizzi, Milan, Italy.

Copyright © 2004 by The Condé Nast Publications

LIBRARY OF CONGRESS CONTROL NUMBER: 2004108340
ISBN 1-4000-4248-8

PHOTOGRAPHERS
Photographs courtesy of
the Academy of Motion Picture Arts and Sciences,
copyright © Academy of Motion Picture Arts and Sciences,
and from the archives of *Vanity Fair*,
with additional images by:

Ken Abbinante, Bernie Abramson, Evan Agostini, Jack Albin,
Ernest A. Bachrach, Peter Beard, Jonathan Becker,
Bob Beerman, Alan Berliner, Alex Berliner, Dana Brown,
Michael Caulfield, Eric Charbonneau, Ed Clark, Nate Cutler,
Loomis Dean, Kevork Djansezian, Ralph Dominguez,
Scott Downie, Dominick Dunne, Todd Eberle, Frank Edwards,
J. R. Eyerman, Larry Fink, Ron Galella, Ewing Galloway,
Allan Grant, Bud Gray, Curt Gunther, Rex Hardy Jr.,
David Harris, Erik Hyman, Aloma Ichinose, Michael Jacobs,
Dafydd Jones, Sam Jones, Jeff Kravitz, Gene Lester,
Kevin Mazur, David McGough, Patrick McMullan, Max Miller,
Harry Morrison, Bill Nation, Sophie Olmsted, Terry O'Neill,
John Peodincuk, Michelle Phillips, Dustin Pittman,
Herb Ritts, Marissa Roth, Roman Salicki, Lawrence Schiller,
Sheedy & Long, George Silk, Peter Stackpole, Phil Stern,
Dennis Stock, David Sutton, John Swope,
Mario Testino, Michael Toth, Jeff Vespa, Pierre-Gilles Vidoli,
Cliff Wesselman, Kevin Winter, Richard Young

ILLUSTRATORS
Leo Politi, Risko, Basil Walter

STILL-LIFE PHOTOGRAPHY
Jim McHugh

DIGITAL COLORIZATION
Nucleus Imaging Inc., N.Y.C.

(Due to limitations of space,
permission to reprint previously published material
can be found on the credits page.)

VANITY FAIR **WOULD LIKE TO GRATEFULLY ACKNOWLEDGE**
Giorgio Armani

SPECIAL ASSISTANCE PROVIDED BY
THE ACADEMY OF MOTION PICTURE ARTS AND SCIENCES
Bruce Davis
Frank Pierson
Ric Robertson

THE MARGARET HERRICK LIBRARY OF
THE ACADEMY OF MOTION PICTURE ARTS AND SCIENCES
Barbara Hall, Janet Lorenz, Linda Harris Mehr
and
Robert Cushman, Kristine Krueger,
Frans Offermans, Jennifer Romero,
Matt Severson, Libby Wertin

FOR THEIR ASSISTANCE WITH THE VANITY FAIR **PARTY**
Sara Marks
Jane Sarkin
Krista Smith
Pam Morton
Peter Morton
Hamilton South
Steve Tisch

WITH SPECIAL THANKS TO
Pete Barford
Basil Walter and all at Basil Walter Architects
Patrick Woodroffe
Victoria Swift
Jeremy Thom
Hugo Beaver
Brenda Bello
Adam Bassett
and
Don Luciano, Charlie Frankel, Crystal Fisher,
Emily Poenisch, Jane Hill,
Matt Ullian, Melissa Gonzalez
along with
Beth Altschull, Sarah Briuer, Dana Brown,
Audrey Campigotto-Ellar, Sarah Czeladnicki, Punch Hutton,
Siobhan McDevitt, Tim McHenry, Thomas Piechura,
Sharon Schieffer, Sara Switzer, Lauren Tabach-Bank,
Matt Trainor
as well as
Bob Currie and Marla Weinhoff,
Stephen Rivers, The Beverly Hills Hotel, Festival Artists
(Craig Bugajski), George & Goldberg, Kelly Hommon,
Videocam, Inc., and all the show crew,
Light & Sound Design/Fourth Phase, McQueens Unlimited,
Steeldeck, Theatrical Rags,
Vari-Lite, Inc./The Automated Lighting Company, PMK,
Bragman Nyman Cafarelli

IN ADDITION, VANITY FAIR **WOULD LIKE TO THANK**
ALL THOSE AT THE OFFICES OF
The City of West Hollywood
The West Hollywood Sheriff's Station
Fire Station 7—Fire Prevention Unit

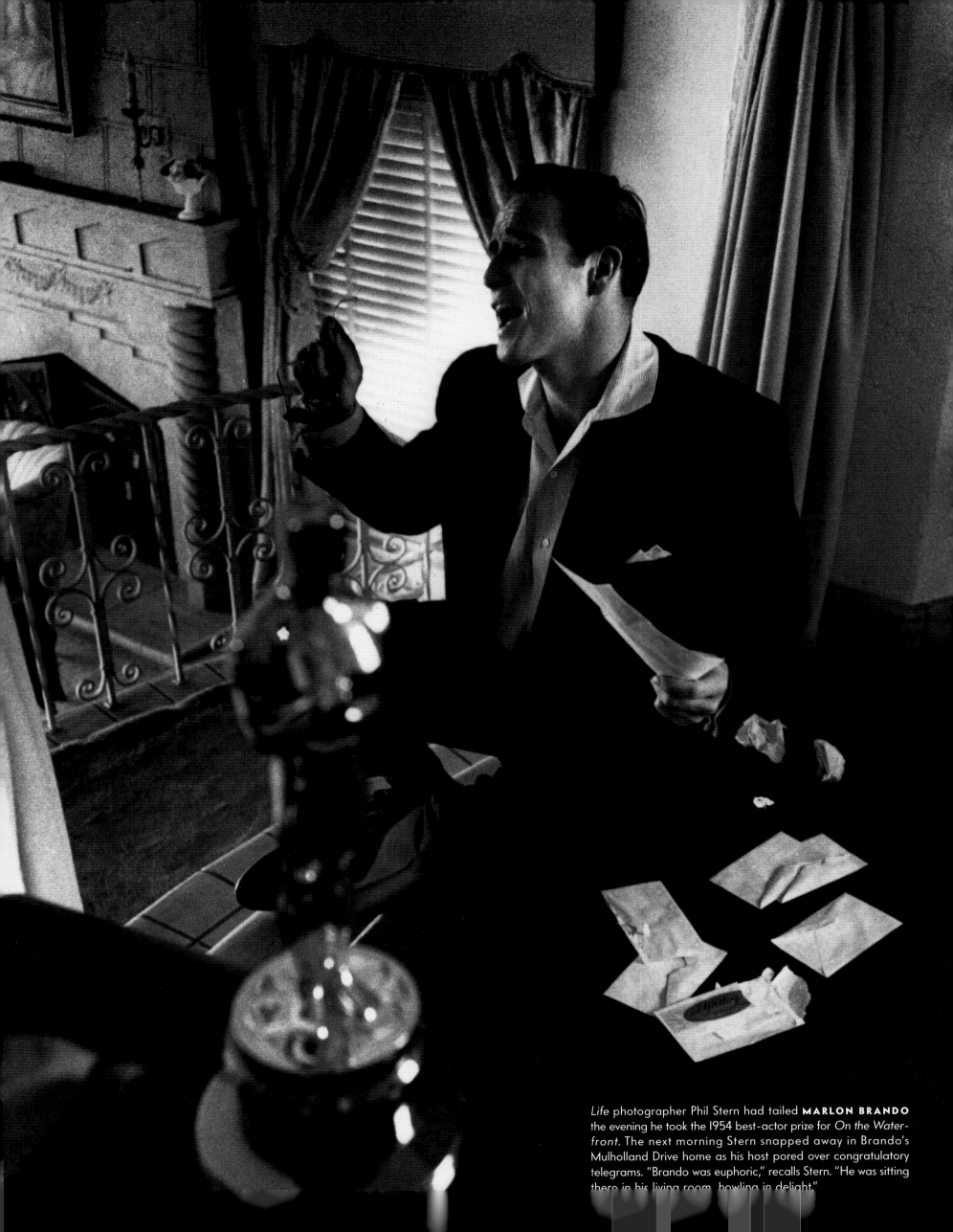

Life photographer Phil Stern had tailed **MARLON BRANDO** the evening he took the 1954 best-actor prize for *On the Waterfront*. The next morning Stern snapped away in Brando's Mulholland Drive home as his host pored over congratulatory telegrams. "Brando was euphoric," recalls Stern. "He was sitting there in his living room, howling in delight."

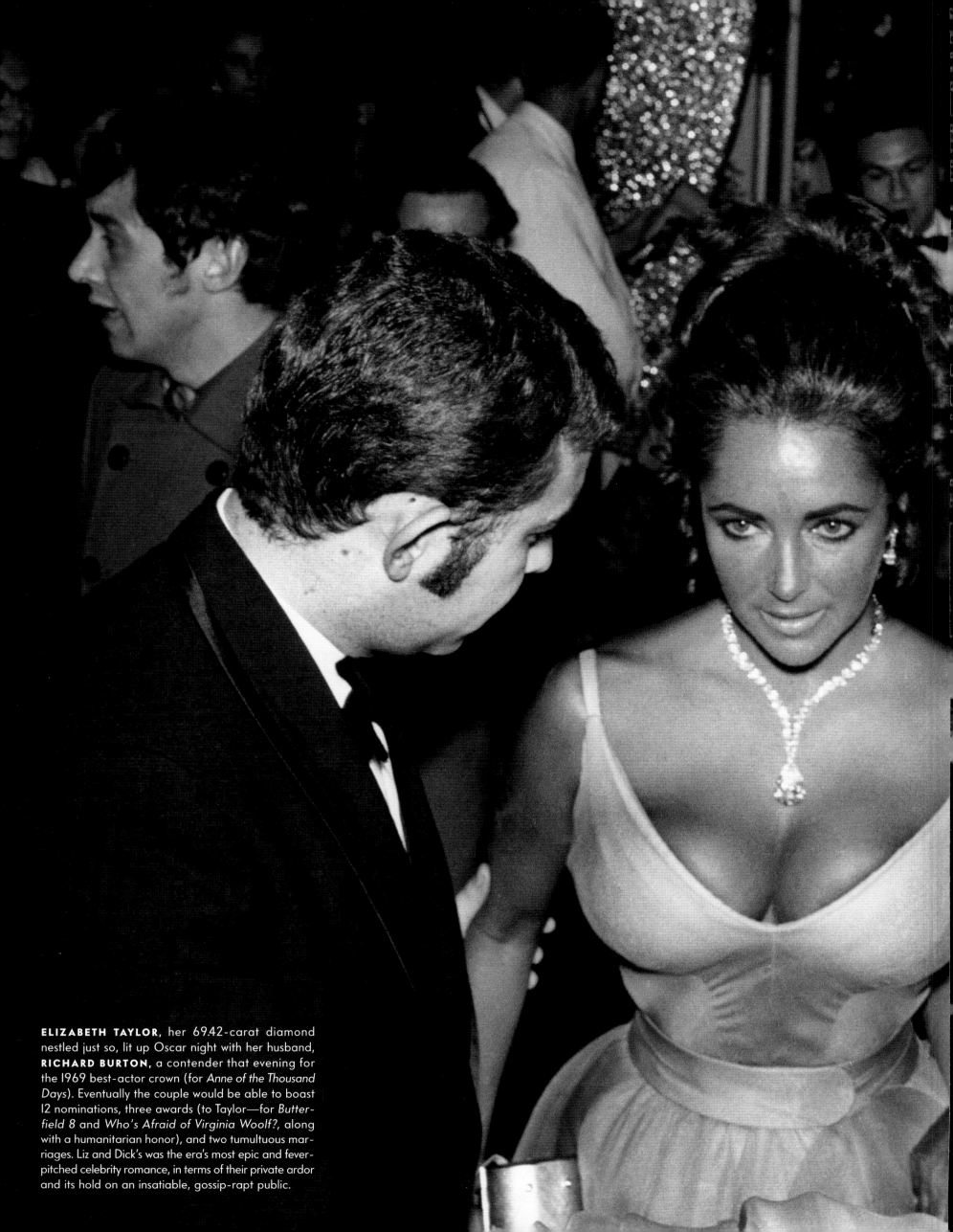

ELIZABETH TAYLOR, her 69.42-carat diamond nestled just so, lit up Oscar night with her husband, **RICHARD BURTON,** a contender that evening for the 1969 best-actor crown (for *Anne of the Thousand Days*). Eventually the couple would be able to boast 12 nominations, three awards (to Taylor—for *Butterfield 8* and *Who's Afraid of Virginia Woolf?*, along with a humanitarian honor), and two tumultuous marriages. Liz and Dick's was the era's most epic and fever-pitched celebrity romance, in terms of their private ardor and its hold on an insatiable, gossip-rapt public.

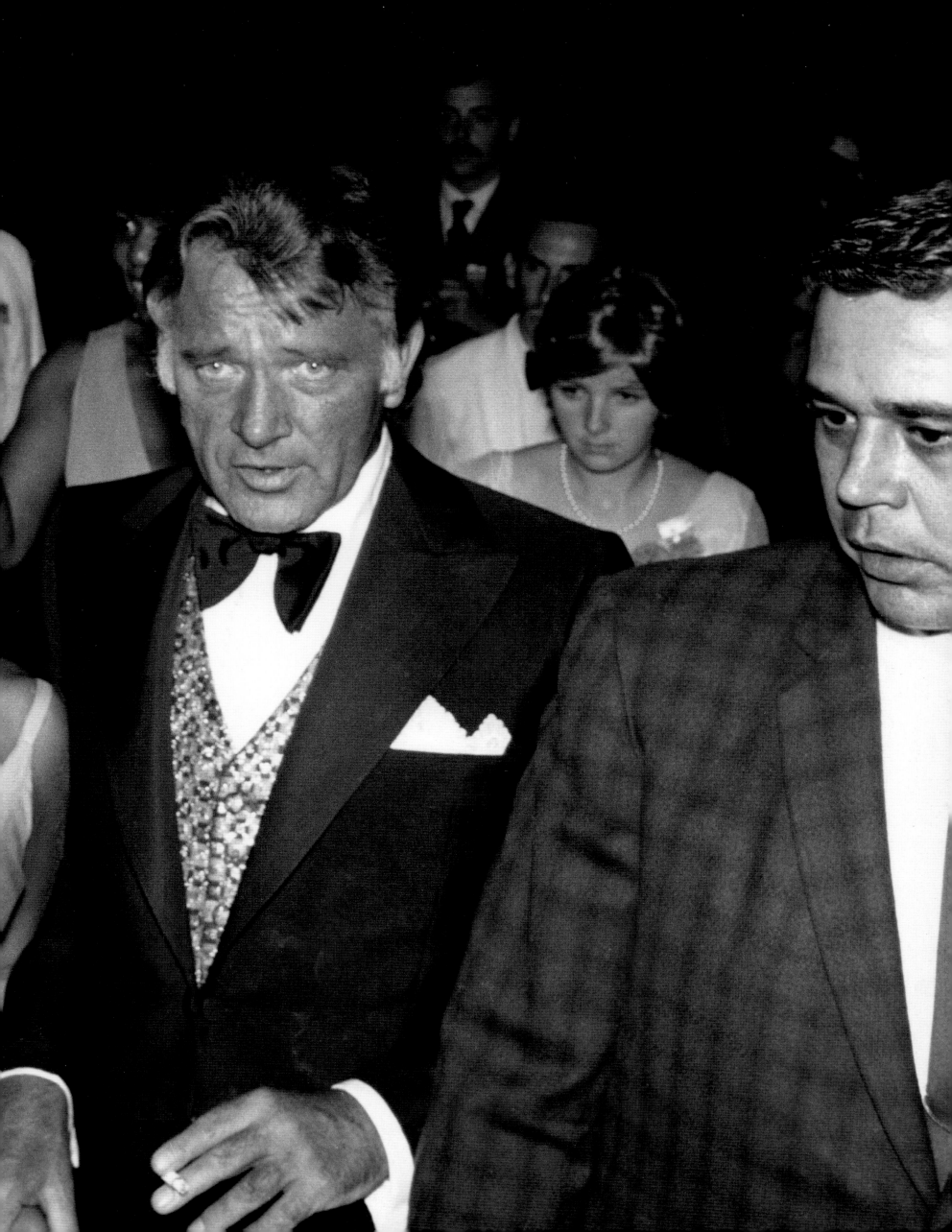

GRAYDON CARTER

INVITES

Mrs. Olivia De Havilland

FOR DINNER

TO CELEBRATE THE

SEVENTY-SIXTH ACADEMY AWARDS ®

SUNDAY, FEBRUARY 29, 2004

MORTONS

5:00 P.M. PROMPT

BLACK TIE

R.S.V.P.

CONTENTS

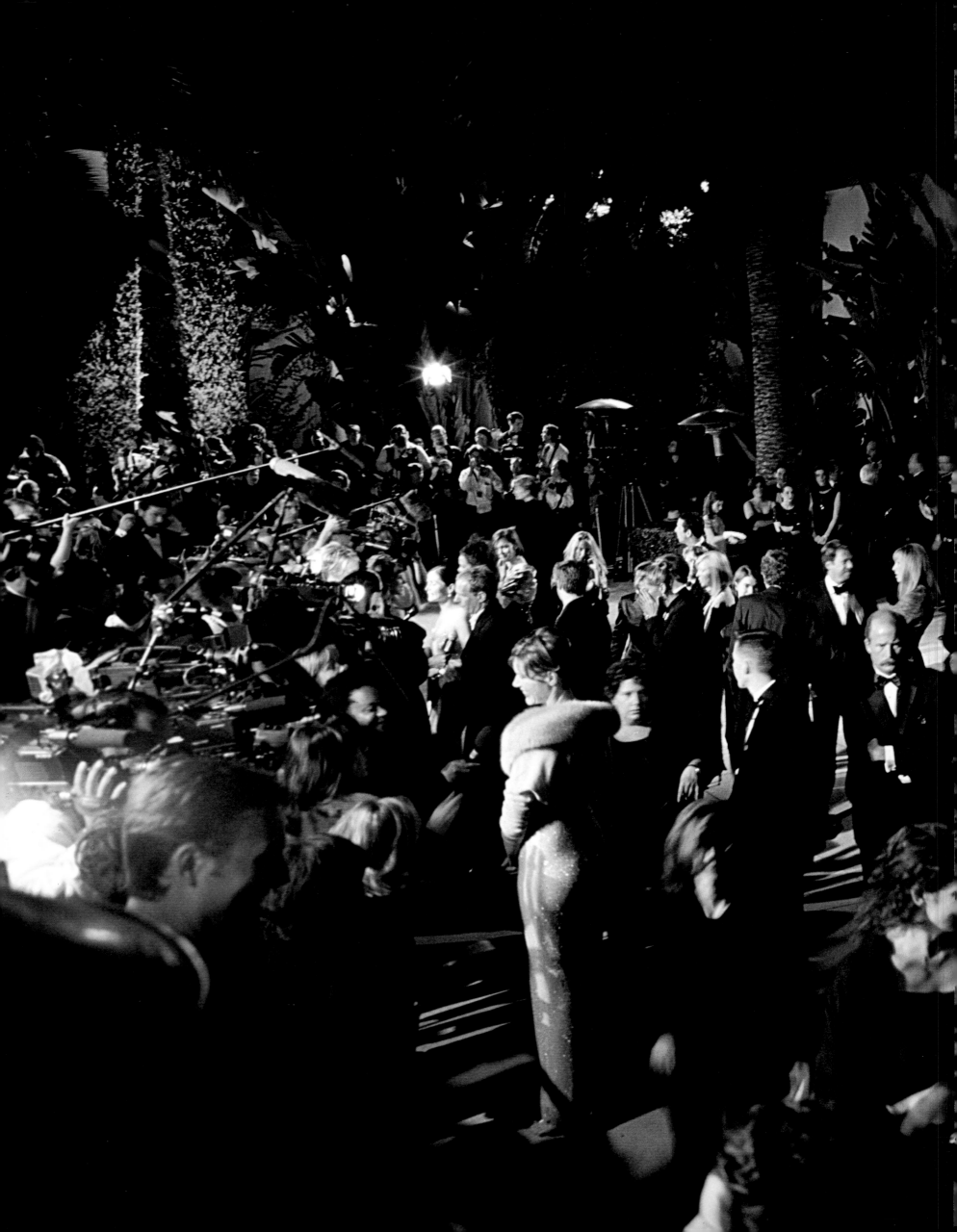

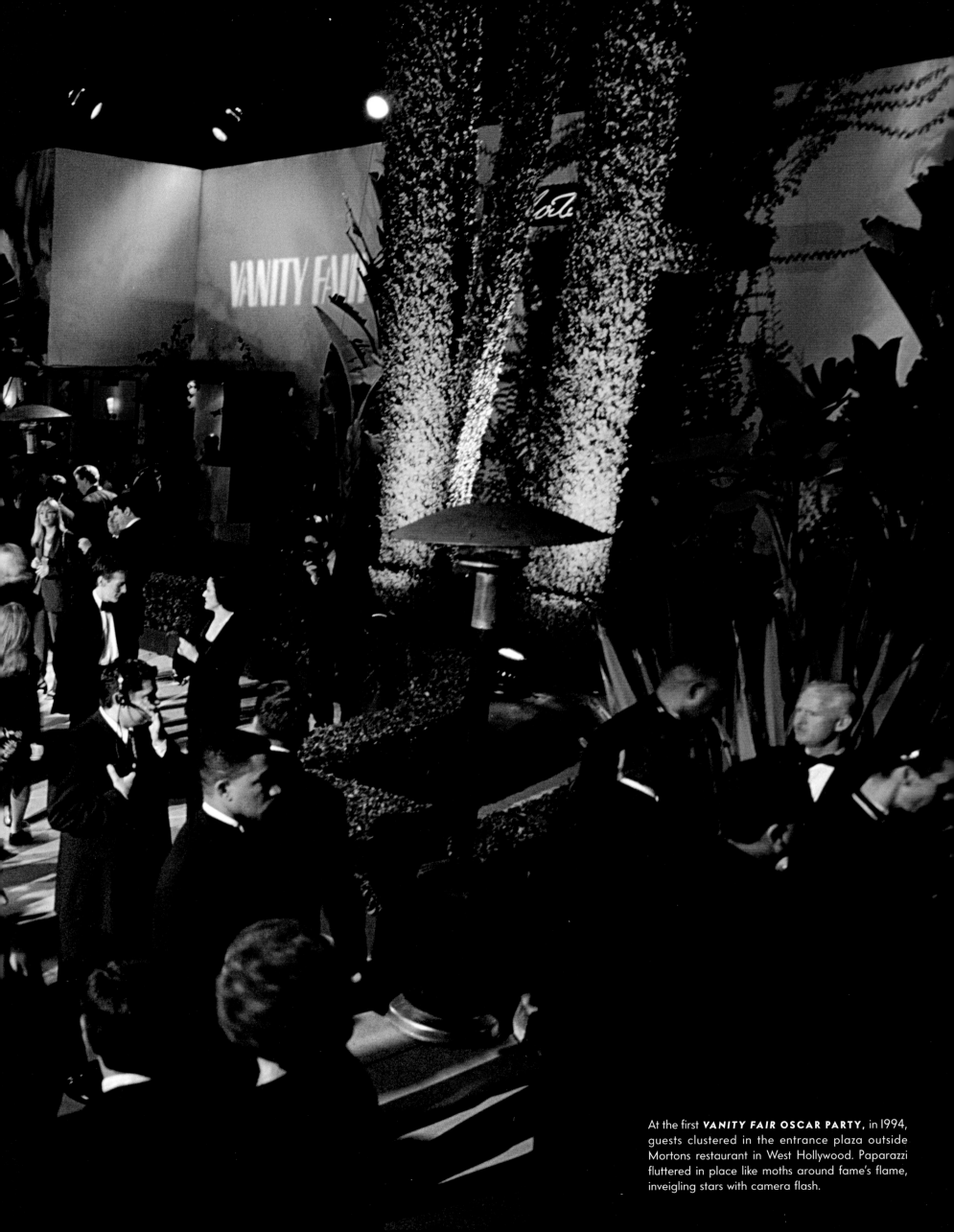

At the first **VANITY FAIR OSCAR PARTY,** in 1994, guests clustered in the entrance plaza outside Mortons restaurant in West Hollywood. Paparazzi fluttered in place like moths around fame's flame, inveigling stars with camera flash.

By Graydon Carter

O scar-night parties, for 30 years, were the purview of one diminutive, unforgettable gent—Irving "Swifty" Lazar. He began the tradition at the Bistro restaurant in 1964, the night *Tom Jones* won the best-picture award, and eventually moved the whole shebang in 1985 to Spago, which was then perched above Sunset Boulevard. They were glamorous affairs, but they certainly weren't the most relaxing. Swifty patrolled the perimeter of his domain like a prison guard. The dinner was divided into two rooms, more or less—an A-room for the swells of Old Hollywood and big-league stars, and a B-room for up-and-comers and below-the-line talent. The point was to sit in your garden chair for four hours and watch the show on an array of television sets. Interplay between the two rooms—between two *people* for that matter—was discouraged. If you weren't wearing a brakeman's cup and had to get up to go to the bathroom, Swifty would kindly pat you on the shoulder and make sure you sat back down and held it in. I was fortunate enough to attend his last such dinner, in 1993, and I can tell you that Swifty's gatherings were militaristic affairs, but in a warm, cozy kind of way.

Swifty died later that year, and a lot of people sprang up to fill the void—most significantly Elton John, who every year since 1993 has hosted a sparkling party that raises international awareness and resources for those affected by H.I.V./AIDS. For some misguided reason—and having not a clue about party hosting, or even much in the way of party going—I decided to throw *Vanity Fair's* hat into the ring. At the time, I had in mind a modest affair. At *Spy* magazine, in the 1980s, we had a Hollywood columnist named Celia Brady, who'd sign off her copy with a breezy "See you Monday night at Mortons"—Mortons then being the power restaurant, and Monday being the evening when the powerful most often assembled there. Oscar night in those days was held on Mondays, so Mortons seemed a serendipitous choice.

I called Peter Morton to see if his place was available. I'd gotten to him too late; Peter told me he had already promised the restaurant to his friend producer Steve Tisch. I called Steve, in turn, to inquire if he might be interested in co-hosting the party, and Steve, being the fellow he is, was agreeable to the idea. It was a relatively small group back then: 100 to 125 for dinner, and 300 to 400 invited to attend after the awards. The next year, Steve won the best-picture Oscar for *Forrest Gump* and couldn't even make the dinner. By year three, he had decided that it was perhaps best for *Vanity Fair* to go it alone; I would host the evening myself, and Steve would have his own table every Oscar night thereafter.

S o began the *Vanity Fair* Oscar party. From the beginning, I laid out a couple of ground rules. For one, I've always hated the idea of roped-off V.I.P. areas at events. This party was going to be more democratic: once you got in—not the easiest thing to do—you would be treated the same as everybody else. Second, S. I. Newhouse, Jr., *Vanity Fair's* proprietor, and I decided that we would stand outside Mortons and greet people arriving for the dinner portion of the evening. I'm always nervous upon entering a party, and anytime a host or hostess comes over to welcome me, I'm hugely relieved. I don't think I'm alone in this. Only morons charge into a room full of people feeling superconfident. I'll admit that for the first couple of years my

duties at the door were nerve-racking, sometimes excruciatingly so. The fact is, I'm the sort of person who gets anxious when I'm having *two* people over for dinner. And, truth be told, by the time the evening arrives I'd just as soon be home in bed watching the ceremony on television. So I'd have a stiff drink, make sure a staff member with a clipboard was standing nearby (should I forget the name of someone heading toward me), and do my best to look like I was having a great time. My feeling was that if the host appeared to be enjoying himself, others would, too.

I imagine I wasn't the only one secretly panicking. The fact is that movie stars are as insecure as the rest of us—if not more so. Many live in a luxurious bubble in which their best friends are their trainer, their hairdresser, their publicist, and their Kabbalah instructor. Because of this, they may not understand when normal people, too intimidated to talk to them, pretend they don't see them. And because the actors who are actually *working* often have to be on movie sets before dawn, they generally tuck in around 7:30.

Now, suddenly, we couldn't get rid of them. They were lingering until three A.M.—well after even I had left. For a couple of years we had this phenomenal dance band from Havana, and pretty much the only fool cutting the rug was me. So it wasn't the dancing they stayed late for. Hollywood people being Hollywood people, all they wanted to do was meet one another. They couldn't stop hatching deals, exchanging business cards, flirting, lying about how they loved the other person's last movie, and just . . . talking.

The guest list, the product of two months of deliberation among Sara Marks, *Vanity Fair's* director of special projects, Jane Sarkin, the magazine's features editor, and me, yields on some nights the most extraordinary collection of people since the J.F.K. inaugural. From the very beginning, we made sure to include a big contingent of Old Hollywood. Over the years, we've had everyone from Artie Shaw and Nancy Reagan to Connie Wald, Kirk Douglas, Ernest Lehman, and just about every key figure from that era who's still alive. Tony Curtis and his wife, Jill Vanden Berg, are wonderful company and have almost become mascots, in the best sense of the word. The Old Hollywood people make perfect guests. They come on time, dress up nicely, and have great manners. The same doesn't necessarily hold true for Young Hollywood. Some of them read an invitation—dinner at six P.M., black-tie—and translate it as: nine P.M., jeans and a T-shirt. Nevertheless, the *Vanity Fair* party makes for one of the few evenings of the year when Hollywood, young and old, can meet—and try to figure out what their respective audiences see, or saw, in the other. Throw into that mix several helpings of rock stars, literary legends, politicians, athletes, artists, soldiers, moguls, and the newsmaker or two of the year, and you end up with some odd but wonderful pairings. Where else would Monica Lewinsky and Sir Ian McKellen meet and become chums?

Not everyone gets along so rosily. We've had fights—usually involving agents—and, on at least one night, the tossing of a drink in a guest's face. We've seen our share of spectacles we'd like to forget, such as the time Pamela Anderson, looking like she had just come from a job at the car wash, spent the evening glued at the hip to Elizabeth Hurley. There's been some truly bad behavior. Consider Courtney Love in 2001. She came up to me and complained that her manager was stuck at the door. "Graydon, Graydon, you've got to let him in," she said. "He's got my money, my car keys, my cell

phone, and my drugs." I told her to take it up with Sara. When she learned that Sara was not about to accommodate her, Ms. Love went outside, stood before a wall of video cameras, and said, "I've got an important announcement to make. Sara Marks is a c- - -!" Certainly a creative use of the medium, I thought.

Courtney Love made Sara something of a legend. I remember going to see *Minority Report* and being amused that the woman the "pre-cogs" were trying to tag as a would-be murder victim was named "Sarah Marks." I couldn't help but feel that there was some screenwriter or associate producer who, years before, had been turned away at 11:30 P.M. (Sara, for the record, has a heaven-sent sense of taste and knack for detail; when it comes to creating perfect social gatherings, she is beyond compare.) Suffice it to say that by now most people understand that Sara is the gatekeeper. People have actually asked me whether I have any pull with her. (In 1994, Martin Landau showed up at the door uninvited. Somebody came over to me and asked what to do. At that point, Landau had probably been forgotten by much of Hollywood, and so I told them to let him in. They did, and the next year he arrived with his best-supporting-actor Oscar for his part in Tim Burton's *Ed Wood.*)

The lengths to which people go to get in are so absurd sometimes that they can be quite touching. One year, a mystery woman was discovered seated between John Cleese and Faye Dunaway. Lou Palumbo, the head of security at the time, approached the problem like the cool operator he is. He went over and quietly explained the situation to Faye Dunaway. She got up, and Lou took her seat beside the unidentified woman. "My name's Lou Palumbo, and I'm head of security," he said softly. "What we're going to do is this: We're going to sit here and talk for a few minutes and then we're going to quietly get up and leave." I discovered that, in the gap between the preparations for the party and the party itself, she had pretended to be a staff person and had gone into the bathroom, stood up on a toilet, and cooled her heels for three or four hours. She then put on a fancy dress and started mingling.

Alas, not all attendees invite themselves with such panache. A reality-show star recently called to say that he'd bought his wife a dress and jewelry and was ready to come to the party. I had to tell him, Sorry, but no reality television. The rule of thumb for something like this is simple: it's not just about those you invite, it's about those you *don't* invite. (There's a list of about a dozen or so people who will never be asked back. And at the top of that list are a number of prominent Hollywood names who have been genuinely rude to our staff.)

In the same way that the wrong element can throw a party off, seating the wrong two people next to each other for the dinner can be unbearably uncomfortable. (We've learned the hard way.) So in the week before the party, a few contributors and members of the staff—Sara, Jane, Dominick Dunne, Bob Colacello, Reinaldo Herrera, Fran Lebowitz, Krista Smith, Wendy Stark, and me—sit around, quite often by the pool at the Beverly Hills Hotel, trying to anticipate disasters. Didn't so-and-so screw so-and-so's wife? Didn't this one just fire this other one's husband? It takes a considerable

amount of diplomacy and care to get it right. My kids have witnessed a couple of these meetings, and I'm convinced that they learn more about the human condition from these sessions than they would from sitting in a classroom that week.

It's all about the details, and the *Vanity Fair* team usually gets them right. Basil Walter and Pete Barford are the principal engineers of the party, with Basil designing the setup and Pete building it. Patrick Woodroffe handles the lighting inside and out. Over the years we've had old-fashioned cigarette girls, engraved Zippo lighters, lollipops with movie stars' faces on them, cookies glazed with *Vanity Fair* covers, and In-N-Out burgers for folks arriving late and famished. The guests seem to love these little novelties. They also seem to love the various room accessories. The pewter ashtrays, which were inspired by one I saw in a Terence Conran restaurant, and which weigh as much as bowling balls, disappear by the dozens each year. Once we had lamps with shades featuring stills from Oscar-nominated movies. They vanished, too. (In coming years we may even have strategically placed copies of this volume, *Oscar Night*—created courtesy of our friends at Alfred A. Knopf, and Giorgio Armani, who provided generous support for the book. Those may go with the guests, too—and so be it.)

Reporters get swept up in the frenzy of the night as well. In addition to almost 50 camera crews and dozens of photographers outside, there are a number of newspaper columnists invited inside by Beth Kseniak, our director of publicity. If I stick a cigarette in my mouth, filter facing out, chances are columnist Liz Smith, or Frank DiGiacomo of *The New York Observer,* will be there to catch it and write about it later. And you'd better look out for the paparazzi circling the door. I remember Stephen Rivers, a former consultant for the magazine, sidling over and saying, "Graydon, Monica Lewinsky's about to come in. I think this is a photo op you don't want to be a part of." The rush to get in can be so frenetic that the fire warden stands near the entrance with a clicker, allowing only a certain number of people in the room at any one time. One night, when he hit his limit, we had about six Oscar winners waiting outside, *The Day of the Locust*–style, statuettes in hand. We learned to be careful, after having been shut down once, early on. But in a curious way the disasters only make the evening more memorable. The night that we had three blackouts was interesting. Our generator and backup blew, one after the other. It made it seem like more of a happening, as we used to say in the 70s.

One thing that makes the party especially enjoyable for me is bringing my kids along. I know that decades from now, when the early *Vanity Fair* Oscar parties are history, my children will have some indelible memories. They're not particularly wowed by movie stars, but, let's face it, in a theater the stars are 40 feet high, and, well, kids *aren't.* I've been stuck carrying around my daughter's fluffy mauve-and-pink purse for two hours when she decided she didn't want to hold it anymore. I've also been able to see the expression on their faces when I introduce them to people they admire, such as Cleese, John Cusack, Brad Pitt, and Ali G. The look is one of nervous excitement, the kind we learn to hide when we become old and more controlled. Still, it's nice to realize you can see that look on so many faces on Oscar night. When the stars come out.

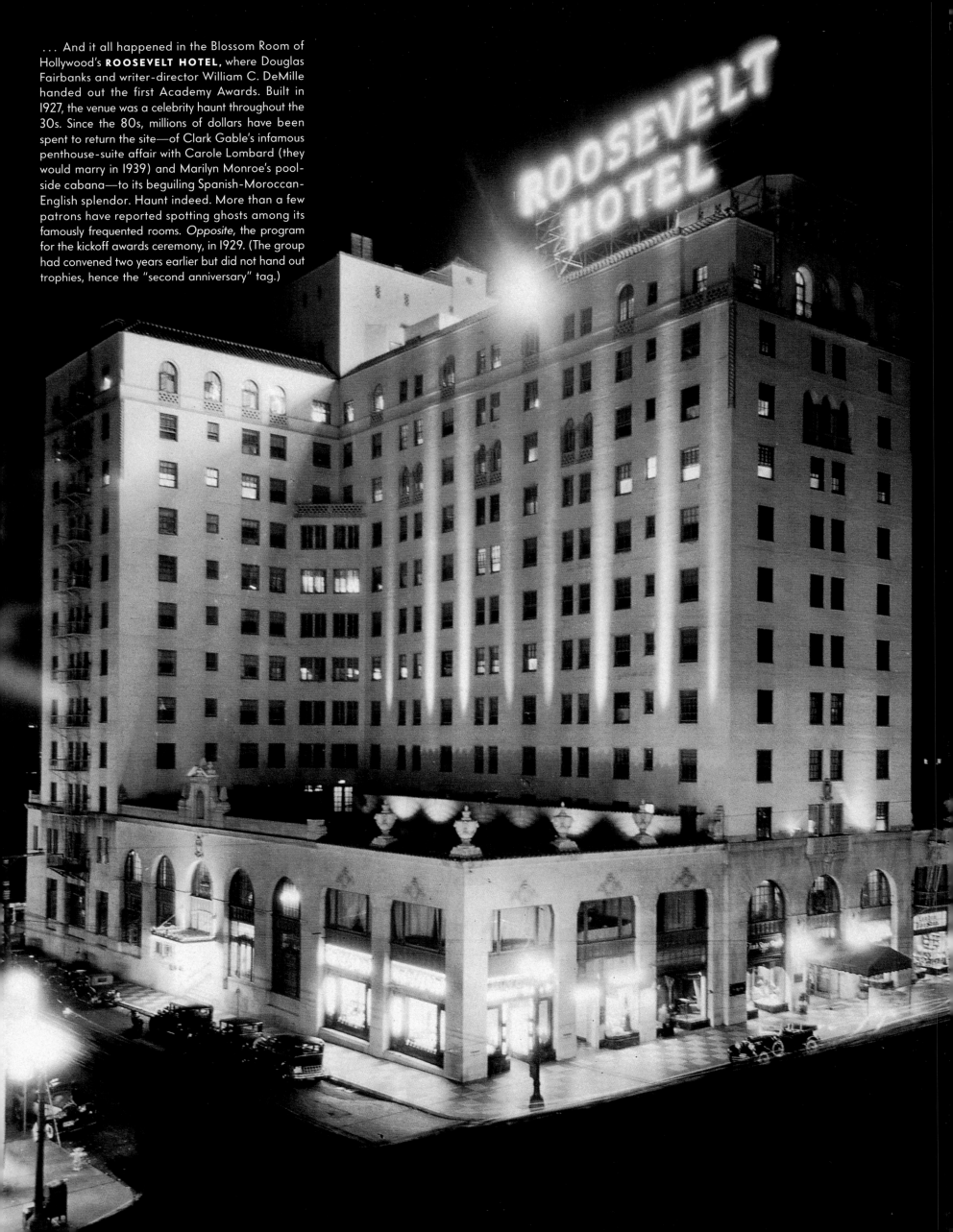

... And it all happened in the Blossom Room of Hollywood's **ROOSEVELT HOTEL,** where Douglas Fairbanks and writer-director William C. DeMille handed out the first Academy Awards. Built in 1927, the venue was a celebrity haunt throughout the 30s. Since the 80s, millions of dollars have been spent to return the site—of Clark Gable's infamous penthouse-suite affair with Carole Lombard (they would marry in 1939) and Marilyn Monroe's pool-side cabana—to its beguiling Spanish-Moroccan-English splendor. Haunt indeed. More than a few patrons have reported spotting ghosts among its famously frequented rooms. *Opposite,* the program for the kickoff awards ceremony, in 1929. (The group had convened two years earlier but did not hand out trophies, hence the "second anniversary" tag.)

By David Friend

On a quiet Sunday evening in January 1927, producer Louis B. Mayer went prospecting for daydreams and, inadvertently, struck Oscar gold. That night, so the story goes, Mayer was playing an idle game of solitaire at his home in Santa Monica and half listening to an exchange between two of his guests, actor Conrad Nagel and director Fred Niblo. Suddenly, Mayer—the emphatic second *M* in MGM—stopped his game and cut in. Enough talk. What if they were to actually form a fraternity of their peers, as the two men were suggesting? A fellowship of filmmakers, composed of the movie colony's movers and shakers? Such a society could engender studio unity and promote the motion-picture business. And, quite conveniently, it might just help give them leverage in anticipated labor negotiations. (In other accounts, there was no game of solitaire, plenty of brandy and cigars—and it was *Mayer* who first broached the idea.)

Whatever the initial scenario, their flight of fancy—and what some might call anti-union maneuvering—swiftly took wing. The following week three dozen studio stalwarts attended a brainstorming dinner at L.A.'s Ambassador Hotel. By May, Mayer, Douglas Fairbanks, and eight others were addressing several hundred in black-tie and ball gowns at Hollywood's Biltmore Hotel. Fairbanks presented the big picture, Mayer hit them up for $100 a head, and, lo and behold, they had forged an academy (Nagel's term) of cinema's elite. Little did L. B. Mayer suspect that two years later his simple notion would spawn a splendid offshoot: the first Academy Awards dinner dance, held on May 16, 1929, in the Blossom Room of the Roosevelt Hotel. (Early on, Mayer had supposedly regarded both the banquet and the trophies as extravagant, and urged his colleagues not to waste funds on a showy ceremony—to no avail.)

At that historic party, the Academy's founders issued special "awards of merit"—statuettes of a naked swordsman cast in gold-plated bronze (now electroplated Britannia metal with a touch of gold), designed in a sleek, modernist style by MGM's art director, Cedric Gibbons. That evening, those first dozen trophies were dispensed with remarkable celerity, in mere minutes; recipients were dissuaded from offering more than perfunctory speeches. In time, the awards became known as Oscars, a nickname coined—depending on which swath of hooey one abides—by actress Bette Davis *or* columnist Sidney Skolsky *or* Academy executive director Margaret Herrick, who was said to have remarked, "It looks like my Uncle Oscar!"

The ceremonies were formal and elegant, the mood sometimes spirited when it came to liquor flow. Tables were graced, on occasion, with Oscar centerpieces, champagne glasses (during non-Prohibition years), and cigarettes. (Plenteous Chesterfields were supplied gratis by the Liggett & Myers Tobacco Company.) From 1929 until 1944, in fact, the Academy Awards dinner *was* the party. Amid speeches and song and dance (to the strains of Duke Ellington and others), honorees were summoned to collect their baubles from eminent M.C.'s in white-tie (George Jessel, Bob Hope). For a time the voting results were massaged by Mayer and an inner circle of judges; for a dozen years the winners were pre-announced to accommodate press deadlines. (The famously close-lipped accounting firm of Price Waterhouse & Co. first tallied the ballots in 1936. Four years later came "The envelope, please.")

Official histories portray those gatherings as dignified and congenial. "It was more like a private party ... than a big public ceremony," said Janet Gaynor, winner of the first best-actress honor, for *7th Heaven,* a sentiment which the press would soon inflate with gusts of hype. Alta Durant, for example, would write in her 1940 "Gab" column in *Daily Variety* that the "entrance of Vivien Leigh on the arm of David O. Selznick into the lobby of the Ambassador last night was a signal for near riot."

Some of the most stylish female stars, however, began to shun the event as stuffy and clubbish. "It's the fashion among many actors and reporters out here," confessed Hollywood correspondent John Chapman in 1942, "to regard the dinner as a bore and to avoid it. Me, I love it." In the view of fashion historian Bronwyn Cosgrave, "It wasn't cool—it was an obligation. Louis B. Mayer and Adolph Zukor had to twist arms. The chic women didn't go. Hollywood bred rebels in the 20s and 30s who didn't want to

hang out with V.I.P.'s in penguin suits. The moguls had been chasing them around the desk since Hollywood began." Indeed, neither Greta Garbo nor Louise Brooks, two of the screen's trendsetting renegades, ever attended. A few winners (Claudette Colbert and Luise Rainer, for example) had to be corralled at the eleventh hour and brought in to pick up their presents. Marlene Dietrich showed up only once, to confer an award, as did Katharine Hepburn, despite a lifetime haul of 12 nominations and four wins. (Hepburn took the podium at the Dorothy Chandler Pavilion in 1974 wearing a schleppy pantsuit and clogs.)

The tony banquets of the 30s turned less festive once the Second World War began. By 1944 the ceremony, then hosted by Jack Benny, had been relocated to a theater (Grauman's Chinese), and the parties, held after the main event, became private matters, hosted by studio chiefs or Academy officials at posh nightclubs and restaurants—Ciro's and Romanoff's, Mocambo and Chasen's.

Come 1958, in a bid to accommodate more partygoers, the Academy instituted its Board of Governors Ball, a sumptuous dinner dance for nominees and motion-picture brass that helped revive some of the pre-war glitz. At the same time, in a curious parallel universe, Oscar "viewing parties" became the rage in Beverly Hills and across the country (the awards were first telecast in 1953), where neighbors, famous and otherwise, would come together in front of their smart new cathode-ray tubes. Such gatherings, and post-Oscar parties, took place at the homes of Milton and Ruth Berle, Charles and Doris Vidor, Billy and Audrey Wilder, and other Hollywood hosts.

And then, along came Swifty. The Napoleonic agent-impresario, as bald and incandescent as a newly buffed Oscar, Swifty Lazar muscled his way onto the scene in 1964. He convened the first of his storied Academy Awards–night bashes at L.A.'s Bistro, later moving the venue to the Bistro Garden, and finally settling in at Wolfgang Puck's balloon-festooned Spago. The party went on through the Summer of Love, through the decadent 70s, through the go-go 80s.

Upon Lazar's death at age 86, in 1993, there was a disturbing stillness in the Hollywood night, and *Vanity Fair* swept in as Swifty's natural heir. The magazine of the 20s and 30s had been a cultural bellwether of the Jazz Age. Its editor, Frank Crowninshield, and publisher, Condé Nast, had helped create Manhattan's "café society" via the parties they threw for their acquaintances in the newly intersecting spheres of literature, the arts, sports, politics, cinema, and so-called high society. The current *Vanity Fair,* revived in 1983, maintained a comparable mandate as a chronicler and arbiter of the modern age. So the magazine chose to expand upon the decades-old tradition with its own event, which would become the evening's capstone—"the Royal enclosure of Oscar night," in the words of *The Daily Telegraph* of London.

A reader, in an odd way, can glean the history of American elegance and ego by browsing through the photographs taken at Oscar parties—a wonderfully arcane subspecies of Hollywood images, all shot on a scant 75 evenings, from 1929 to now. (To explain the math: no formal parties were held on Oscar night 1968, six days after the assassination of civil-rights leader Martin Luther King Jr.) In this collection of largely candid pictures, one can chart the shifting tides of politics and war, of pop culture and popular fashion—from flapper-era dresses to 40s frocks, from postwar sophistication to modern glam. One can also gauge the buffeting fortunes of celebrities (for one evening in 1955, Ernest Borgnine *ruled*) and the absurd escalation of Celebrity itself. "Oscar night is a prism," observes producer George Schlatter, who has enlivened Academy Awards bashes for half a century. "It's all of movie history distilled into one evening."

"Hollywood," he says wistfully, "was a town at one time. Then it became an industry. Now it's a friggin' philosophy."

On these pages, an Academy Award is designated by the year in which its corresponding film was released. A date for an awards ceremony or party denotes the year that event was held. For example, the 1939 best-picture award, won by Gone with the Wind, *was handed out at the 1940 banquet.*

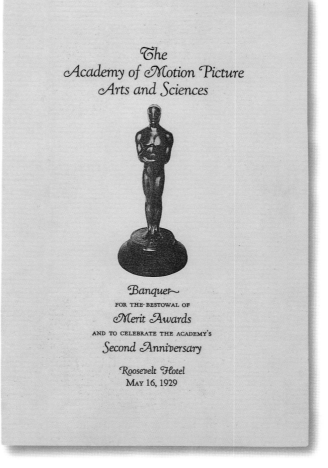

The
*Academy of Motion Picture
Arts and Sciences*

Banquet
FOR THE BESTOWAL OF
Merit Awards
AND TO CELEBRATE THE ACADEMY'S
Second Anniversary

Roosevelt Hotel
MAY 16, 1929

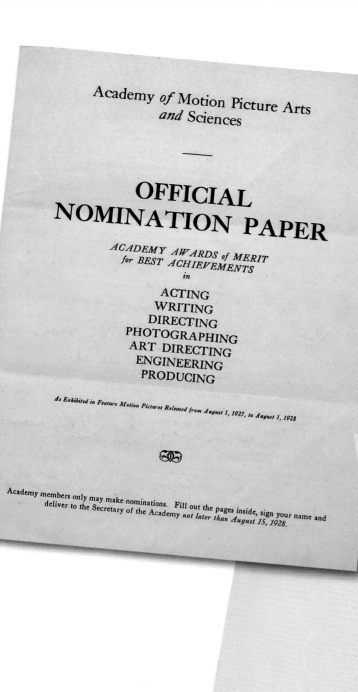

Academy of Motion Picture Arts and Sciences

OFFICIAL NOMINATION PAPER

ACADEMY AWARDS of MERIT for BEST ACHIEVEMENTS in

ACTING
WRITING
DIRECTING
PHOTOGRAPHING
ART DIRECTING
ENGINEERING
PRODUCING

As Exhibited in Feature Motion Pictures Released from August 1, 1927, to August 1, 1928.

Academy members only may make nominations. Fill out the pages inside, sign your name and deliver to the Secretary of the Academy *not later than August 15, 1928.*

1929 That first Oscar night—May 16, 1929—was a modest, almost down-home gathering. As some 300 guests enjoyed fillet of sole *sauté au beurre* or chicken on toast, Al Jolson cracked jokes, mogul Adolph Zukor appeared in a short film clip (with *sound,* of all things), and Janet Gaynor scooped up the first-ever best-actress Oscar, for *7th Heaven.* "I was sort of in a daze," she recalled, intimidated by having to "make a speech [without] the director telling me what to do."

Every movie to receive a citation that spring night was a silent film. (*Wings,* a World War I epic, nabbed the best-picture prize.) Nonetheless, according to one press account, the "outstanding feature [of the] distinctly formal affair [was] the premiere demonstration of Western Electric's portable talkie projection equipment." Warner Bros. also earned an award for *The Jazz Singer,* featuring Jolson, which the Academy dubbed "the pioneer outstanding talking picture which has revolutionized the industry." On this enchanted evening, cinema's infancy was clearly over. Hollywood had boldly entered the age of sound—and the era of Oscar.

May 14 1929.

To the Academy of Motion Picture Arts and Sciences, 7010 Hollywood Boulevard, Hollywood, California. *3 members (Miss Gaynor Guest) 2 complimentary*
Please reserve *9* places for me at the Academy Awards and Anniversary Banquet the night of May 16, 1929, at the Roosevelt Hotel, Hollywood, and enclosed find check for $*20.00* in payment.

Frank Borzage
Address *3974 Wilshire Blvd.*
Telephone *Wash 9285*

No charge for Academy Members
$5.00 per Cover for Guests
Reservations on or before Wednesday, May 15

Menu

HORS D'OEUVRE VARIE
CELERY OLIVES NUTS ROLLS
CONSOMME CELESTINE
FILET OF SOLE SAUTE AU BEURRE
HALF BROILED CHICKEN ON TOAST
NEW STRING BEANS LONG BRANCH POTATOES
LETTUCE AND TOMATOES WITH FRENCH DRESSING
VANILLA AND CHOCOLATE ICE CREAM
CAKES
DEMI TASSE

PROGRAM

DOUGLAS FAIRBANKS
President

WILLIAM C. DeMILLE
Vice-President and Chairman

BESTOWAL OF AWARDS

IMPROMPTU REMARKS
By Guests and Members

OPENING NIGHT *Opposite,* the actual seating chart and table listing for the inaugural Academy Awards banquet. *From top,* various 1929 items: Jack Warner's ballot for the first Oscars (upon which he wrote his nominee for best actor, Rin Tin Tin); an R.S.V.P. card; the evening's program, including the menu and roster of events; silent-film star Blanche Sweet's dinner ticket (she canceled).

ACADEMY DINNER TICKET

TABLE NO. *25*

The typed list:

```
TABLE 28            8        2
   Geraghty   Tom          2
   Sidney  Lazarus         1
   Al Cohn                 1
   Chas Logue
                           6
TABLE 29
   ...

TABLE 1        6
   Douglas Fairbanks       1
   Mary Pickford           1
   Wm de Mille             1

   Sir Gilbert Parker      1
   Fannie  Hurst           1
   Prof. W R Miles         1

TABLE #2    No Table 2

TABLE 3    8
   Glazer and Party        9

TABLE 4    8
   L B Mayer               2
   Irving Thalberg         2
   Harry Rapf              2
   Cecil de Mille          2

TABLE 5         12  Lois Wilson
   Mr & Mrs Nagel          2
   Leatrice Joy            1
   Mrs Harry Curzon        1
   Margaret Ettinger       2
   Mr & Mrs Shallert       2
   Fred Niblo              1

TABLE 6    8
   Clara Beranger          5
   Mr. Danielson           1
   Prof. Tickell           1

TABLE 7    8
   Alec Francis            4
   Louis Tolhurst          2
   Mrs. Louise Duffy       1
   Prof. Smith             1

TABLE 8    8
   M C Levee               4
   Grauman                 1

TABLE 9         9
   Peter Mole              6
   Slaughter Nugent        3

TABLE 10   8
   Bern   Paul             2
   Stromberg  Hunt         2
   Lewin  Albert           2
   Hyman  Bernard          2

TABLE 11   9
   Borzage, Frank          9

TABLE 12
```

"The Academy dinner … had a corner on the star market…. The Blossom Room [of the Roosevelt Hotel] was a gorgeous sight, with its soft lantern lights shedding rays and shadows on the brilliant gowns and gay blooms. Thirty-six tables, with their scintillating glassware and long tapers, each table bearing a replica in waxed candy of the bronze and gold statuette award, filled the entire floor space of the room."

—*THE ROOSEVELT* NEWSLETTER, MAY 1929

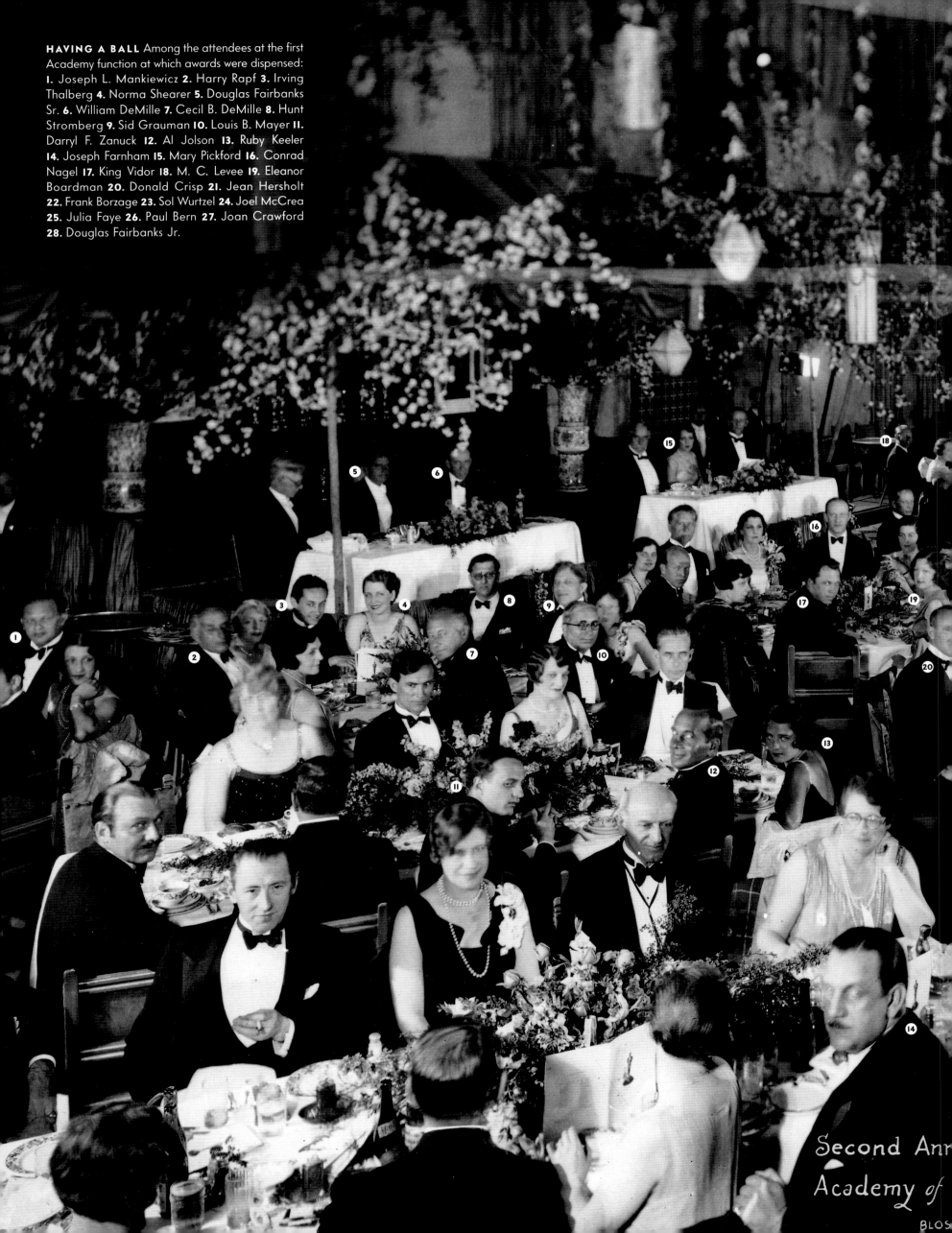

HAVING A BALL Among the attendees at the first Academy function at which awards were dispensed: **1.** Joseph L. Mankiewicz **2.** Harry Rapf **3.** Irving Thalberg **4.** Norma Shearer **5.** Douglas Fairbanks Sr. **6.** William DeMille **7.** Cecil B. DeMille **8.** Hunt Stromberg **9.** Sid Grauman **10.** Louis B. Mayer **11.** Darryl F. Zanuck **12.** Al Jolson **13.** Ruby Keeler **14.** Joseph Farnham **15.** Mary Pickford **16.** Conrad Nagel **17.** King Vidor **18.** M. C. Levee **19.** Eleanor Boardman **20.** Donald Crisp **21.** Jean Hersholt **22.** Frank Borzage **23.** Sol Wurtzel **24.** Joel McCrea **25.** Julia Faye **26.** Paul Bern **27.** Joan Crawford **28.** Douglas Fairbanks Jr.

Second Annual
Academy of
BLOS

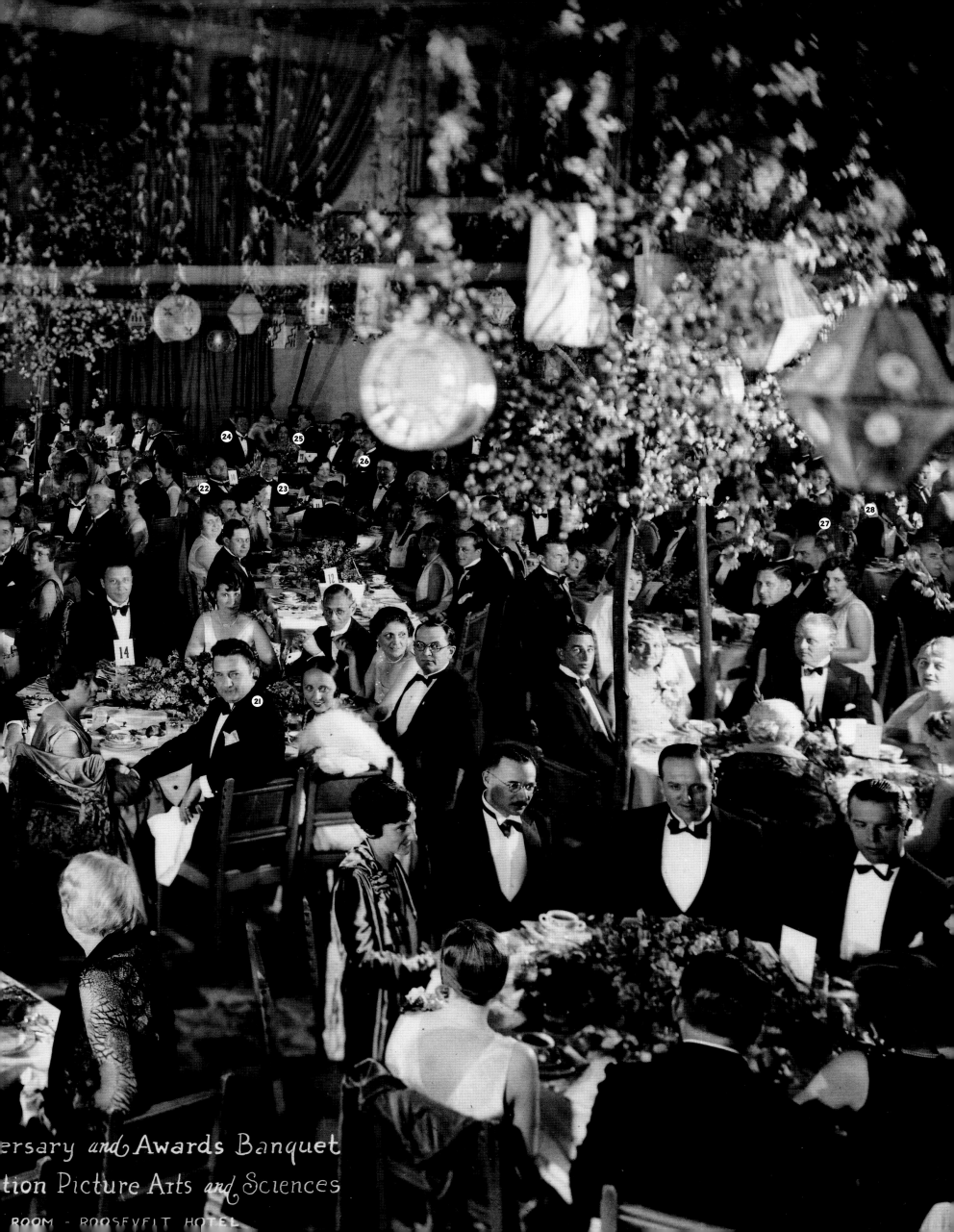

ersary and Awards Banquet
tion Picture Arts and Sciences
ROOM - ROOSEVELT HOTEL

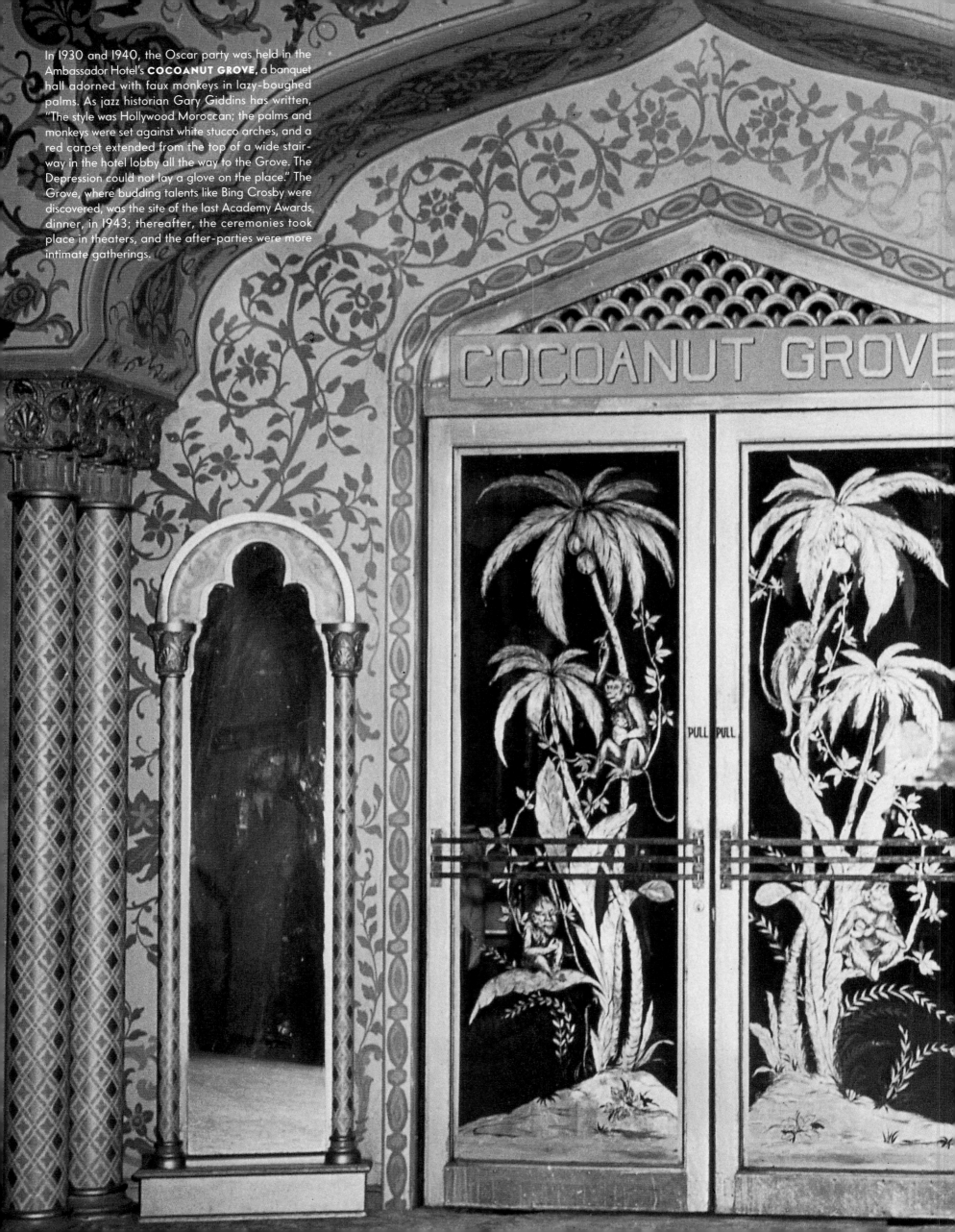

In 1930 and 1940, the Oscar party was held in the Ambassador Hotel's **COCOANUT GROVE**, a banquet hall adorned with faux monkeys in lazy-boughed palms. As jazz historian Gary Giddins has written, "The style was Hollywood Moroccan; the palms and monkeys were set against white stucco arches, and a red carpet extended from the top of a wide stairway in the hotel lobby all the way to the Grove. The Depression could not lay a glove on the place." The Grove, where budding talents like Bing Crosby were discovered, was the site of the last Academy Awards dinner, in 1943; thereafter, the ceremonies took place in theaters, and the after-parties were more intimate gatherings.

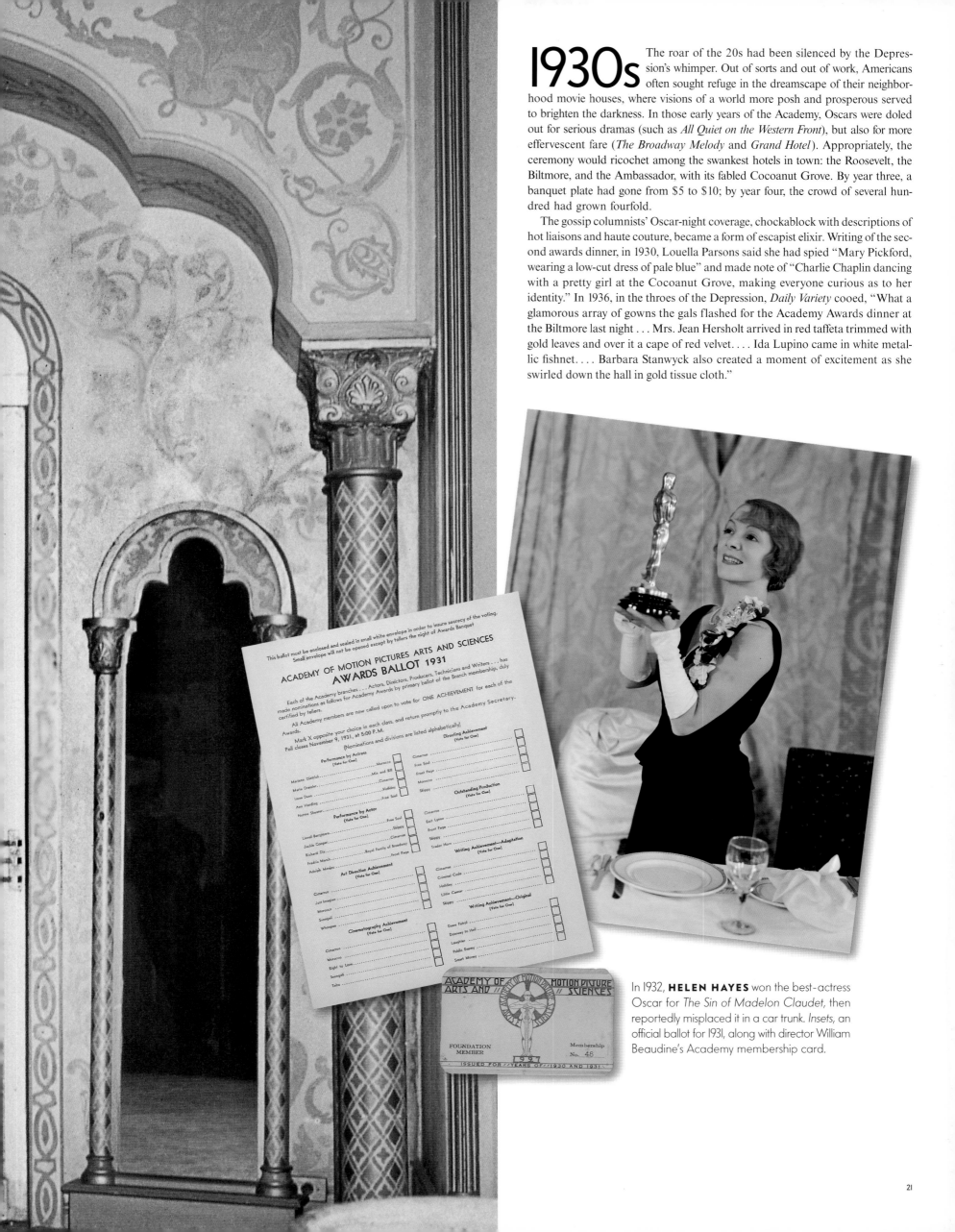

1930s

The roar of the 20s had been silenced by the Depression's whimper. Out of sorts and out of work, Americans often sought refuge in the dreamscape of their neighborhood movie houses, where visions of a world more posh and prosperous served to brighten the darkness. In those early years of the Academy, Oscars were doled out for serious dramas (such as *All Quiet on the Western Front*), but also for more effervescent fare (*The Broadway Melody* and *Grand Hotel*). Appropriately, the ceremony would ricochet among the swankest hotels in town: the Roosevelt, the Biltmore, and the Ambassador, with its fabled Cocoanut Grove. By year three, a banquet plate had gone from $5 to $10; by year four, the crowd of several hundred had grown fourfold.

The gossip columnists' Oscar-night coverage, chockablock with descriptions of hot liaisons and haute couture, became a form of escapist elixir. Writing of the second awards dinner, in 1930, Louella Parsons said she had spied "Mary Pickford, wearing a low-cut dress of pale blue" and made note of "Charlie Chaplin dancing with a pretty girl at the Cocoanut Grove, making everyone curious as to her identity." In 1936, in the throes of the Depression, *Daily Variety* cooed, "What a glamorous array of gowns the gals flashed for the Academy Awards dinner at the Biltmore last night . . . Mrs. Jean Hersholt arrived in red taffeta trimmed with gold leaves and over it a cape of red velvet. . . . Ida Lupino came in white metallic fishnet. . . . Barbara Stanwyck also created a moment of excitement as she swirled down the hall in gold tissue cloth."

In 1932, **HELEN HAYES** won the best-actress Oscar for *The Sin of Madelon Claudet*, then reportedly misplaced it in a car trunk. *Insets*, an official ballot for 1931, along with director William Beaudine's Academy membership card.

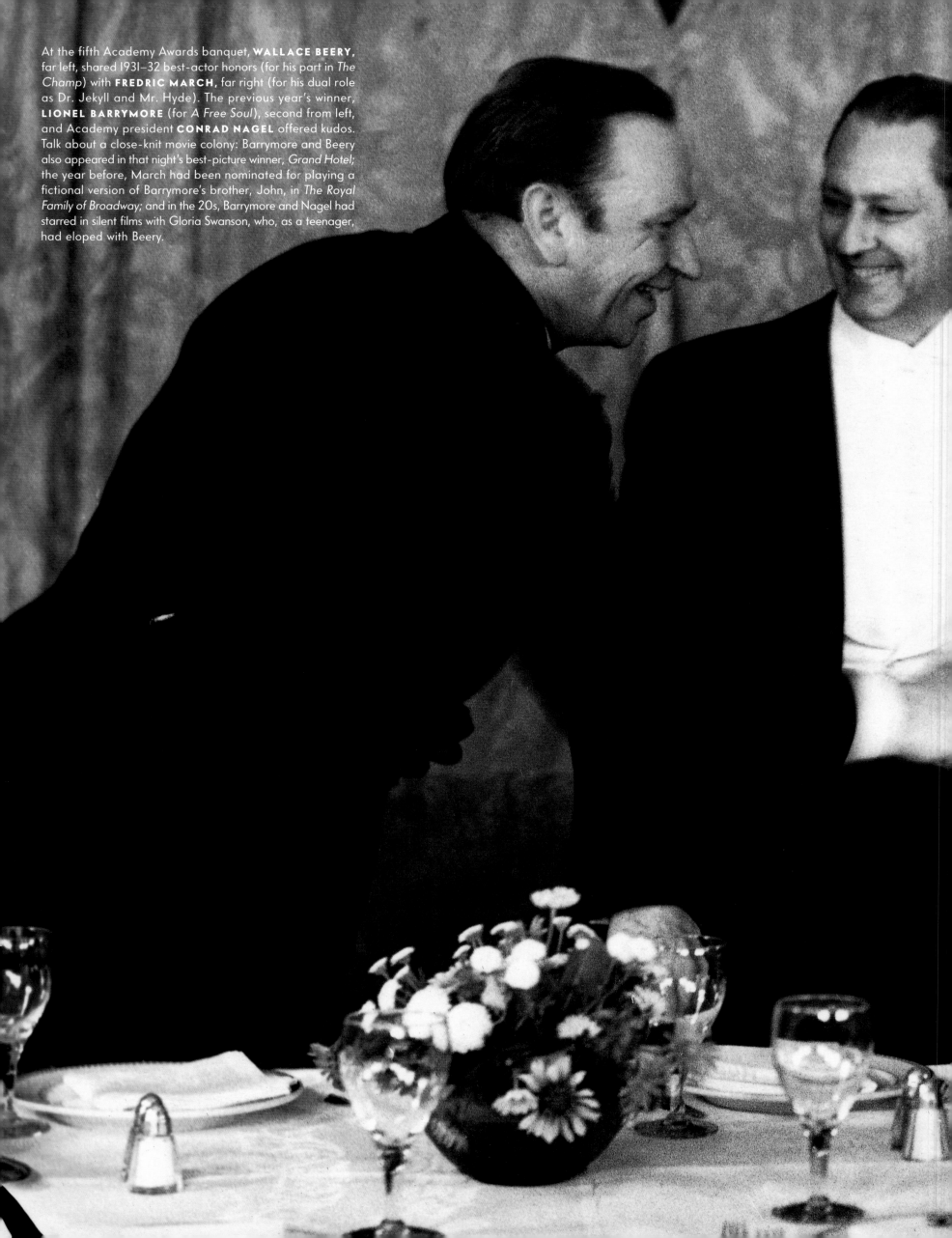

At the fifth Academy Awards banquet, **WALLACE BEERY**, far left, shared 1931–32 best-actor honors (for his part in *The Champ*) with **FREDRIC MARCH**, far right (for his dual role as Dr. Jekyll and Mr. Hyde). The previous year's winner, **LIONEL BARRYMORE** (for *A Free Soul*), second from left, and Academy president **CONRAD NAGEL** offered kudos. Talk about a close-knit movie colony: Barrymore and Beery also appeared in that night's best-picture winner, *Grand Hotel*; the year before, March had been nominated for playing a fictional version of Barrymore's brother, John, in *The Royal Family of Broadway*; and in the 20s, Barrymore and Nagel had starred in silent films with Gloria Swanson, who, as a teenager, had eloped with Beery.

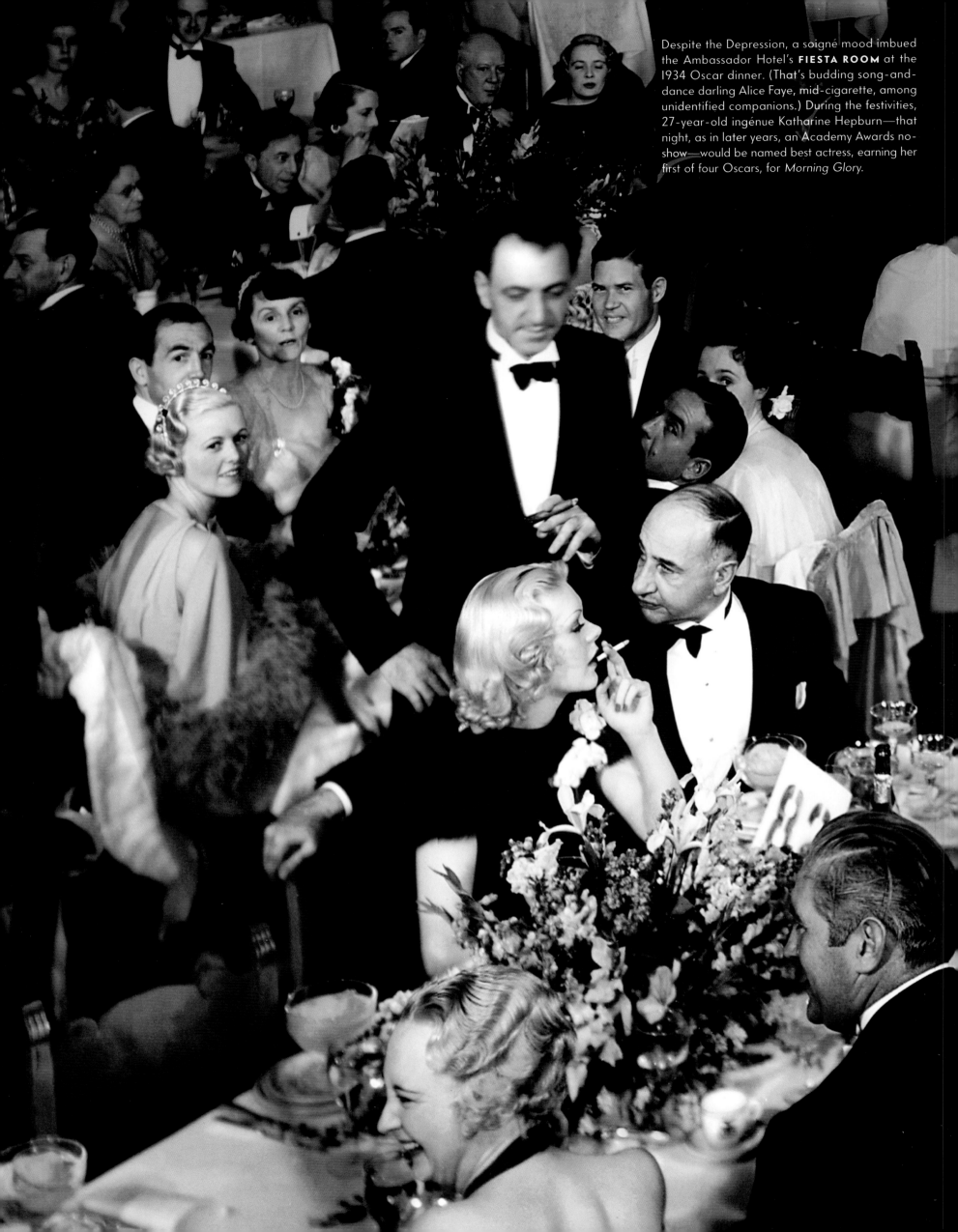

Despite the Depression, a soigné mood imbued the Ambassador Hotel's **FIESTA ROOM** at the 1934 Oscar dinner. (That's budding song-and-dance darling Alice Faye, mid-cigarette, among unidentified companions.) During the festivities, 27-year-old ingénue Katharine Hepburn—that night, as in later years, an Academy Awards no-show—would be named best actress, earning her first of four Oscars, for *Morning Glory*.

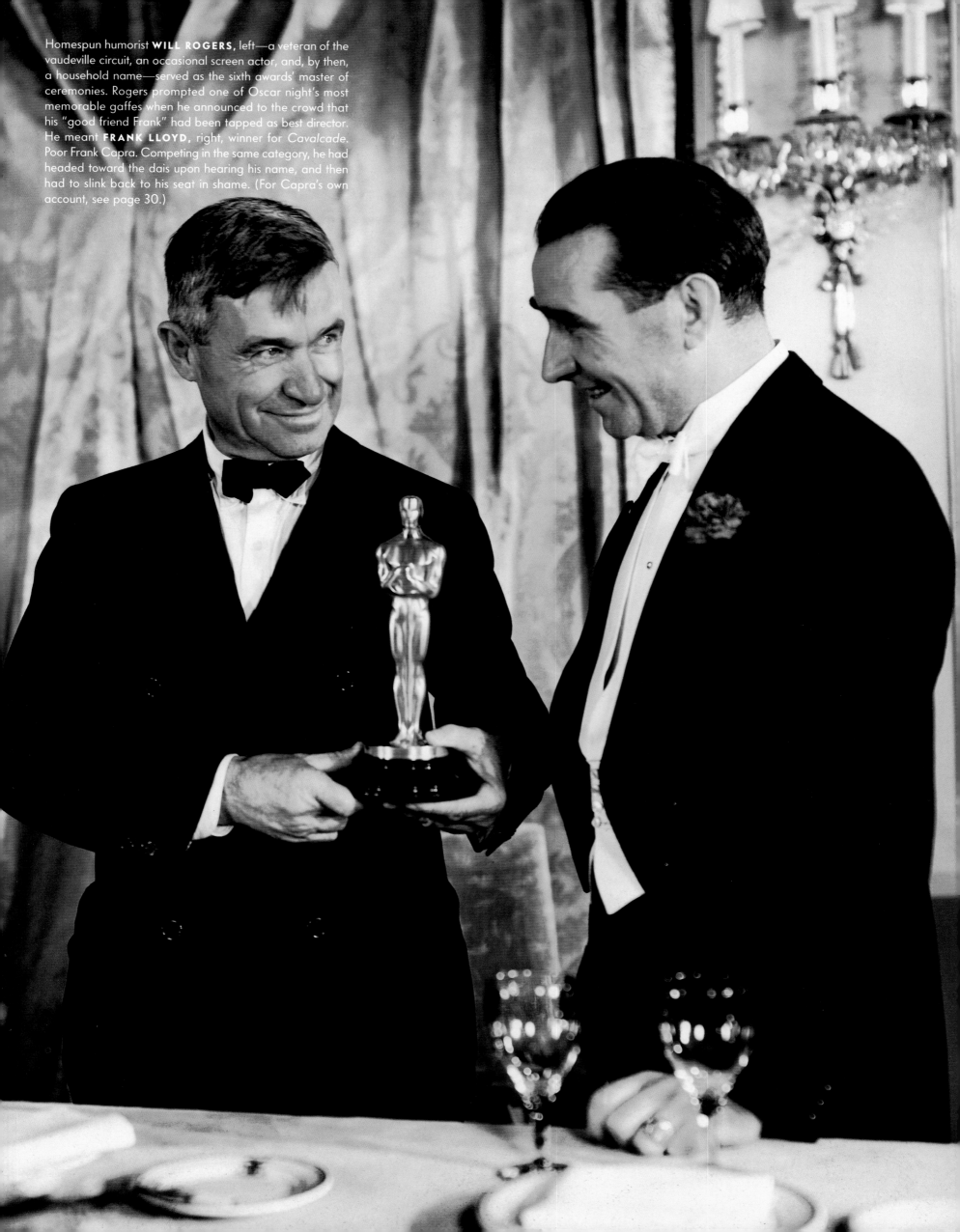

Homespun humorist **WILL ROGERS**, left—a veteran of the vaudeville circuit, an occasional screen actor, and, by then, a household name—served as the sixth awards' master of ceremonies. Rogers prompted one of Oscar night's most memorable gaffes when he announced to the crowd that his "good friend Frank" had been tapped as best director. He meant **FRANK LLOYD**, right, winner for *Cavalcade*. Poor Frank Capra. Competing in the same category, he had headed toward the dais upon hearing his name, and then had to slink back to his seat in shame. (For Capra's own account, see page 30.)

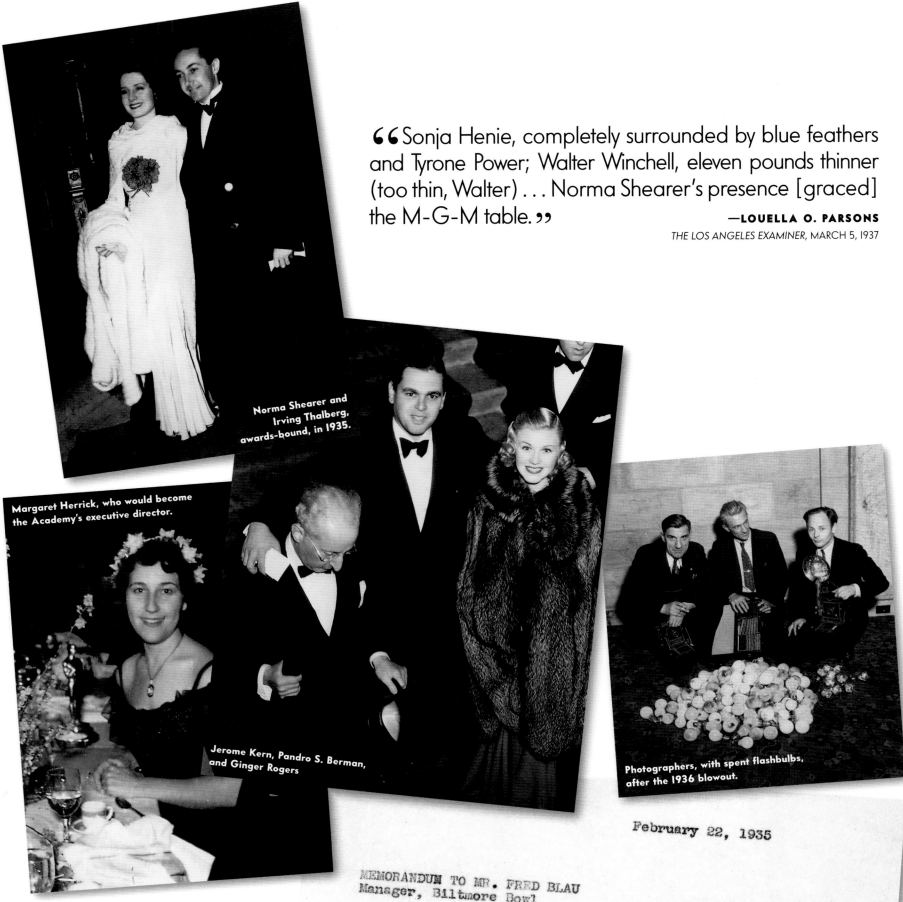

> "Sonja Henie, completely surrounded by blue feathers and Tyrone Power; Walter Winchell, eleven pounds thinner (too thin, Walter) . . . Norma Shearer's presence [graced] the M-G-M table."
>
> —LOUELLA O. PARSONS
> *THE LOS ANGELES EXAMINER, MARCH 5, 1937*

Norma Shearer and Irving Thalberg, awards-bound, in 1935.

Margaret Herrick, who would become the Academy's executive director.

Jerome Kern, Pandro S. Berman, and Ginger Rogers

Photographers, with spent flashbulbs, after the 1936 blowout.

NO DIM BULBS "We want to keep this under control," cautioned the Academy's executive secretary, Donald Gledhill, in this 1935 memorandum, *right*. Gledhill (married to Margaret Herrick, *above*) and other officials had decided to set alcohol strictures for the seventh awards banquet: "one drink apiece for the ten or fifteen photographers." How else to keep the lensmen from getting too lit up?

February 22, 1935

MEMORANDUM TO MR. FRED BLAU
Manager, Biltmore Bowl

Re: Academy Awards Banquet

Liquor arrangements for Press and Photographers

After thinking it over, we decided it would not be necessary to go as heavy on the liquor for the photographers as we tentatively discussed the other day.

Please figure on one drink apiece for the ten or fifteen photographers, and only a dozen or so for all the rest of the press.

STAN LAUREL was the slender schlemiel of the Laurel and Hardy comedy team. Melon-rind grin in place, he attended the awards proceedings in 1936, the year his and Hardy's *Tit for Tat* vied for best short subject. In 1932 an Oscar had been granted for what some consider the duo's finest effort, *The Music Box*, in which Stan and Ollie, representing a very star-crossed moving company ("Foundered 1931"), futilely attempt to deliver a player piano.

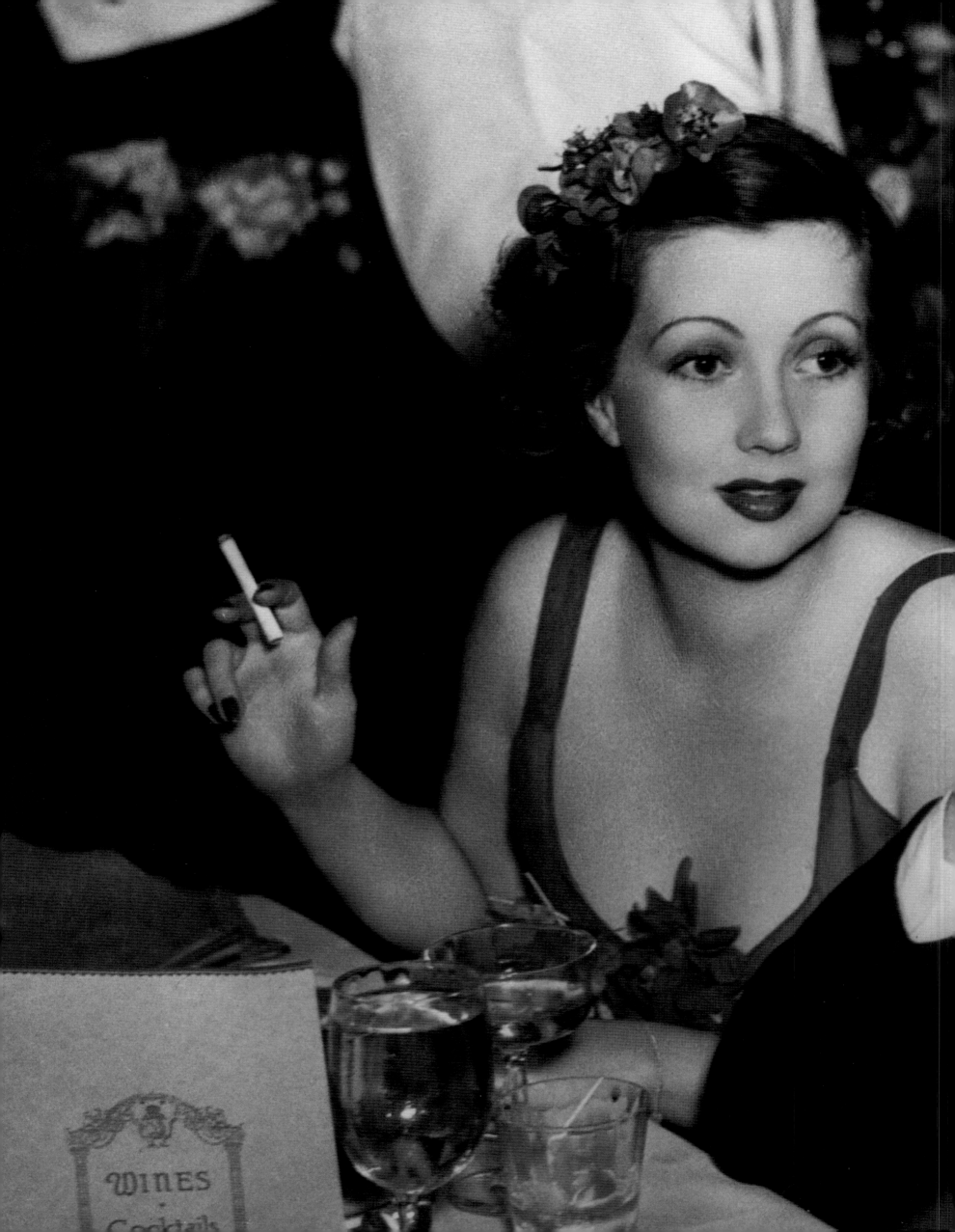

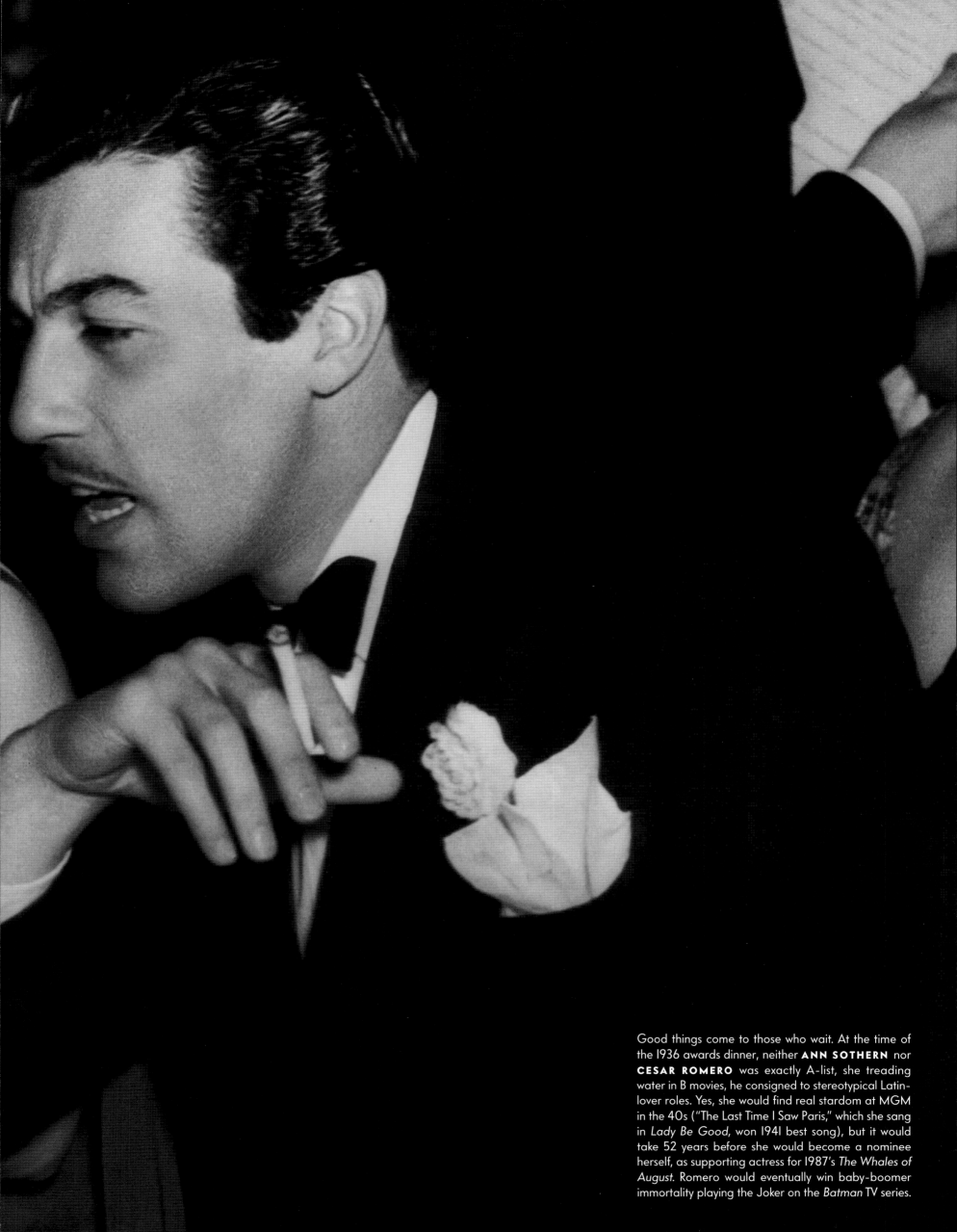

Good things come to those who wait. At the time of the 1936 awards dinner, neither **ANN SOTHERN** nor **CESAR ROMERO** was exactly A-list, she treading water in B movies, he consigned to stereotypical Latin-lover roles. Yes, she would find real stardom at MGM in the 40s ("The Last Time I Saw Paris," which she sang in *Lady Be Good*, won 1941 best song), but it would take 52 years before she would become a nominee herself, as supporting actress for 1987's *The Whales of August.* Romero would eventually win baby-boomer immortality playing the Joker on the *Batman* TV series.

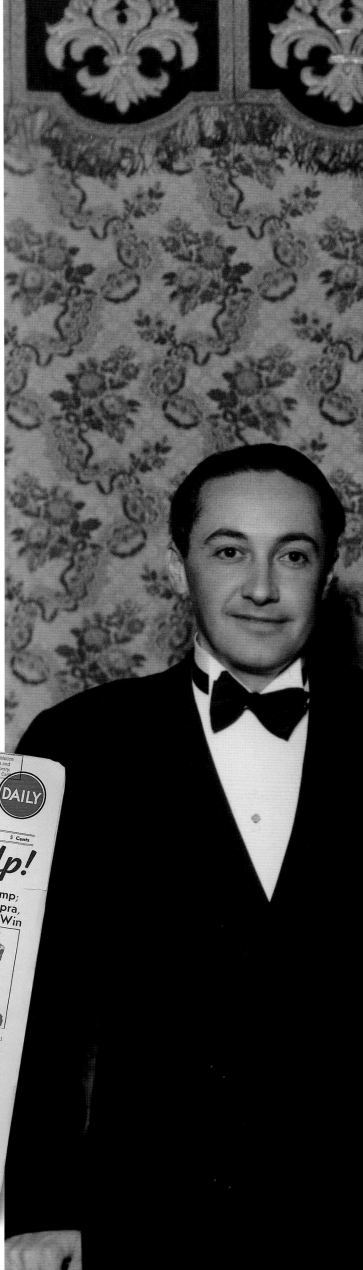

"The world's most publicized event—resplendent with white ties and the newest in cleavage gowns, reported by six hundred flacks—the Academy Awards banquet was held at the Biltmore Hotel. (Another good omen: My old friend Will Rogers would hand out the Oscars. I couldn't miss.) [Frank Capra had been nominated as best director, for *Lady for a Day*.] . . . [To] share my glory, I invited ten intimate friends: Mr. and Mrs. Myles Connolly, Dr. and Mrs. Stan Imerman, Mr. and Mrs. Jo Swerling, Mr. and Mrs. Al Lewin, and Dimitri Tiomkin and his wife, Albertina Rasch. [Robert] Riskin [nominated in the screenwriting-adaptation category for *Lady for a Day*] had his *own* table of nail biters.

During the technical awards given out by good old Will, my head swam through hot and cold flashes. I applauded like an idiot as each winner squeezed through celebrity-crowded tables to the small dance floor, where a spotlight picked him up, escorted him in glory to the dais where he clutched his coveted Oscar—and grinned like another idiot.

Then came the first of the major awards—Best Writing—the first of the *four* I expected to sweep. I looked over at Riskin's table. Bob *seemed* calm, but half of his cigarette disappeared with each puff. Will Rogers announced: ' . . . and the winner for Best Writing is . . . [opens envelope] . . . Victor Heerman and Sarah Y. Mason for *Little Women!* Come up and get it!'

I was stunned, but not overcome. 'Guess I'll have to settle for *three*,' I said inanely to my friends. A vague fear flitted over our table. It was immediately dissipated by Will Rogers. The next award was for Best Directing! While Rogers read the nominations, I sneaked a last quick look under the tablecloth at my wrinkled acceptance speech. But I couldn't even hold it, let alone read it.

Rogers said a few nice words about directors, then: ' . . . and the best director of the year is . . . the envelope, please . . . [he opened it, and laughed] Well, well, well, what do you know! I've watched this young man for a long time. . . . Saw him come up from the bottom, and I *mean* the bottom. It couldn't happen to a nicer guy. COME UP AND GET IT, FRANK!'

My table exploded into cheers and applause. It was a long way to the open dance floor, but I wedged through crowded tables, 'Excuse me . . . excuse me . . . sorry . . . thank you, thank you . . . ' until I reached the open dance floor. The spotlight searched around trying to find me. 'Over here!' I waved. Then it suddenly swept away from me—and picked up a flustered man standing on the *other* side of the dance floor—Frank Lloyd! The applause was deafening as the spotlight escorted Frank Lloyd [the director of *Cavalcade*] on to the dance floor and up to the dais, where Will Rogers greeted him with a big hug and a hearty handshake. I stood petrified in the dark, in utter disbelief, until an irate voice behind me shouted, 'Down in front!'

That walk back—through applauding V.I.P.'s yelling 'Sit down! Down in front! Sit down!' as I obstructed their view—was the longest, saddest, most shattering walk in my life. I wished I could have crawled under the rug like a miserable worm. When I slumped into my chair I felt like one. All my friends at the table were crying. . . .

Back at my house we all got drunk fast. Al Lewin fell in the goldfish pond; Myles Connolly socked Doc Imerman; Imerman socked Connolly; I passed out in a laughing jag."

—FRANK CAPRA

(SHOWN FAR RIGHT IN 1936), FROM HIS AUTOBIOGRAPHY,
THE NAME ABOVE THE TITLE, DESCRIBING A FAMOUS 1934 OSCAR-NIGHT INCIDENT

FINE PRINT In 1935, director Frank Capra sent in this response card, *below*, to cover his guests at the Biltmore—the Edward G. Robinsons and Jean Hersholts, among others. (The tab: $5 a plate.) The morning after the ceremony, *Daily Variety, near right,* heralded a sweep for Capra's *It Happened One Night.*

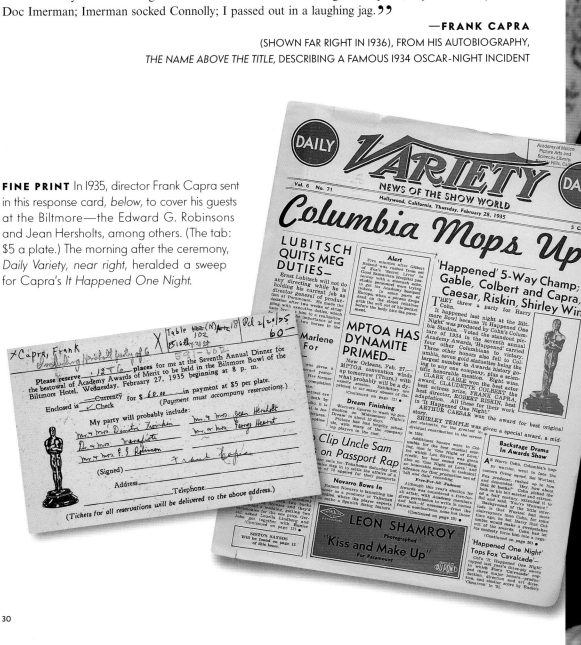

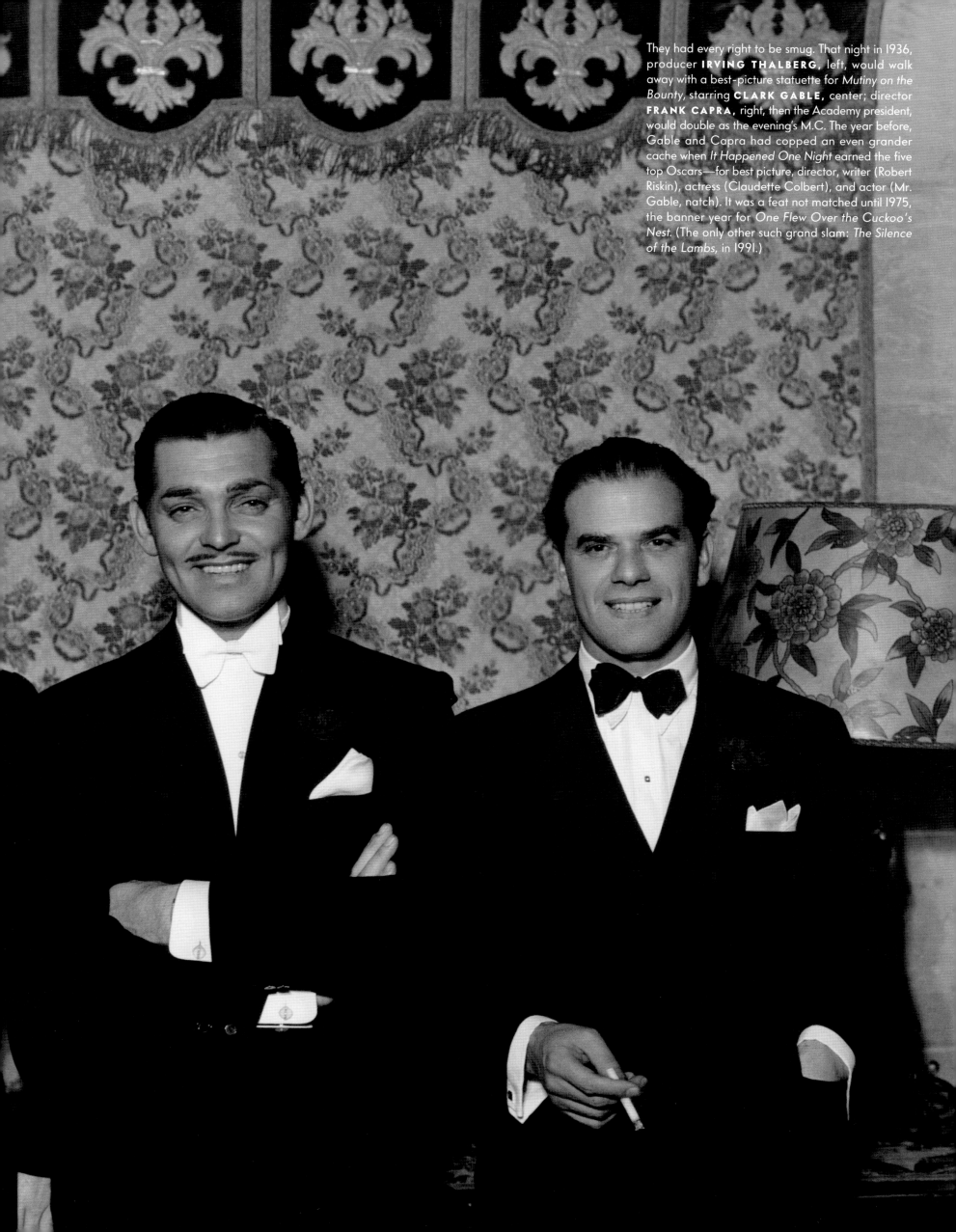

They had every right to be smug. That night in 1936, producer **IRVING THALBERG**, left, would walk away with a best-picture statuette for *Mutiny on the Bounty*, starring **CLARK GABLE**, center; director **FRANK CAPRA**, right, then the Academy president, would double as the evening's M.C. The year before, Gable and Capra had copped an even grander cache when *It Happened One Night* earned the five top Oscars—for best picture, director, writer (Robert Riskin), actress (Claudette Colbert), and actor (Mr. Gable, natch). It was a feat not matched until 1975, the banner year for *One Flew Over the Cuckoo's Nest*. (The only other such grand slam: *The Silence of the Lambs*, in 1991.)

ON WITH THE SHOW Some 1,500 convened for the ninth annual awards banquet, in March of 1937. The event was bittersweet for Norma Shearer, who was escorted by producer Louis B. Mayer. Though she was up for the fifth of her six Oscar nominations (for *Romeo and Juliet*), only six months before she had lost her husband, onetime boy-wonder producer Irving Thalberg, who had died of pneumonia at age 37.

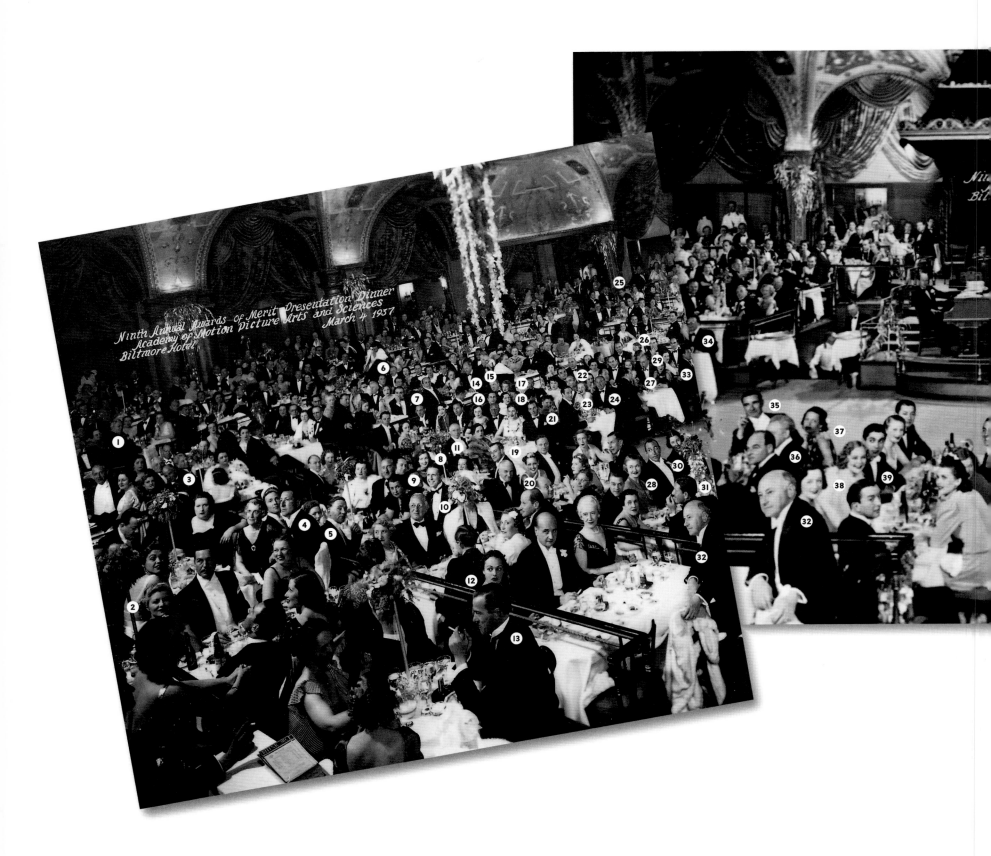

1. S. Z. "Cuddles" Sakall 2. Claire Trevor 3. Sid Grauman 4. Arthur Treacher 5. Walter Huston 6. Joan Crawford 7. Akim Tamiroff 8. Marsha Hunt 9. Robert Wyler 10. Sheridan Gibney 11. Adolph Zukor 12. Katherine DeMille 13. Walter Pidgeon 14. Harry Joe Brown 15. Dr. Harry Martin 16. Mervyn LeRoy 17. Bette Davis 18. Louella Parsons 19. William Wyler 20. Dorothy Lamour 21. Ann Warner 22. Charles Boyer 23. Jean Arthur 24. Jack Warner 25. Henry Armetta 26. Helen Hayes 27. Harry Cohn 28. Herbert Biberman 29. Jane Wyatt 30. Louise Treadwell Tracy 31. Spencer Tracy 32. Cecil B. DeMille 33. Frank Capra 34. Clifford Odets

THE BIG ACADEMY DINNER

The men were wearier and wearier
 The women thinner and thinner
The speeches drearier and drearier
 At the Big Academy Dinner.

Writers were more and more pensive
 Except for an occasional beginner
Women were horribly expensive
 At the Big Academy Dinner.

At the Metro-Goldwyn table
 Winner sat next to winner
And cheered as much as they were able
 At the Big Academy Dinner

Garbo the lovely barber
 Cooper the tall mule skinner
Had all sailed into the harbor
 At the Big Academy Dinner

But also the pimp and crook
 Also the pious sinner
And none of them got the hook
 At the Big Academy Dinner

May the peritone cause me pain
 May ulcers puncture my inner
Tubes if I go again
 To the Big Academy Dinner.

—F. SCOTT FITZGERALD
WRITTEN DURING THE ACADEMY AWARDS BANQUET
AT THE BILTMORE BOWL ON MARCH 10, 1938

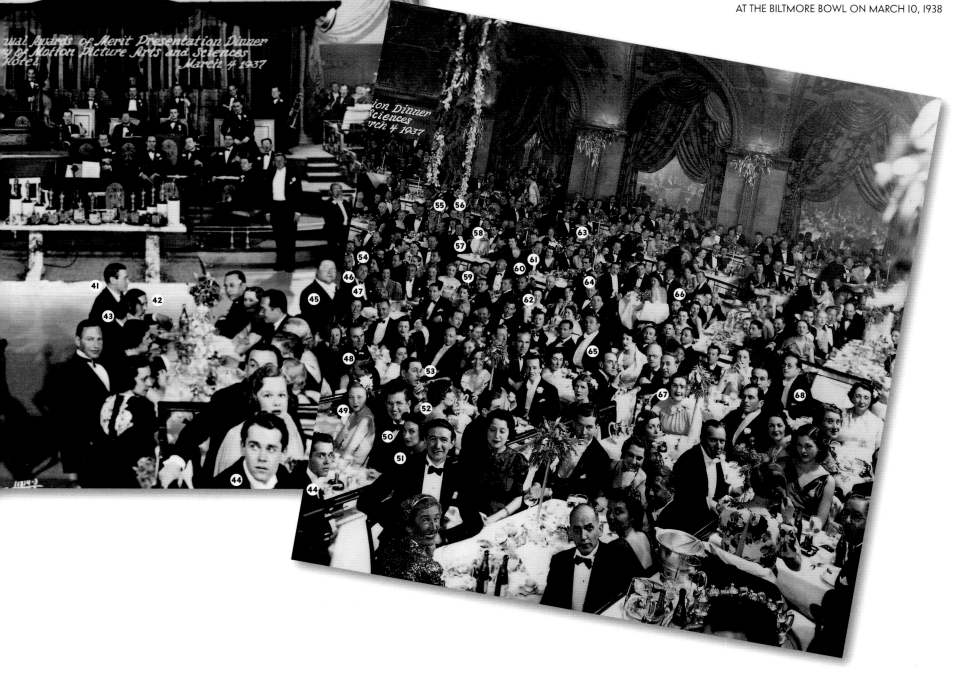

35. Frank Lloyd 36. Leopold Stokowski 37. Gale Sondergaard 38. Sonja Henie 39. Tyrone Power 40. Vic Orsatti 41. Herbert Marshall 42. Dorothy Fields 43. Jerome Kern 44. Henry Fonda 45. Jack Oakie 46. Louis B. Mayer 47. Eddie Mannix 48. Ben Piazza 49. Frances Seymour Brokaw (Mrs. Henry Fonda) 50. David O. Selznick 51. Irene Mayer Selznick 52. Lillian Disney 53. Walt Disney 54. Norma Shearer 55. Anita Louise 56. Leif Erickson 57. Maria Ouspenskaya 58. Frances Farmer 59. W. S. Van Dyke 60. J. J. Cohn 61. Robert Z. Leonard 62. Pete Smith 63. May Robson 64. Hunt Stromberg 65. Victor McLaglen 66. Walter Brennan 67. Joe Pasternak 68. Henry Koster

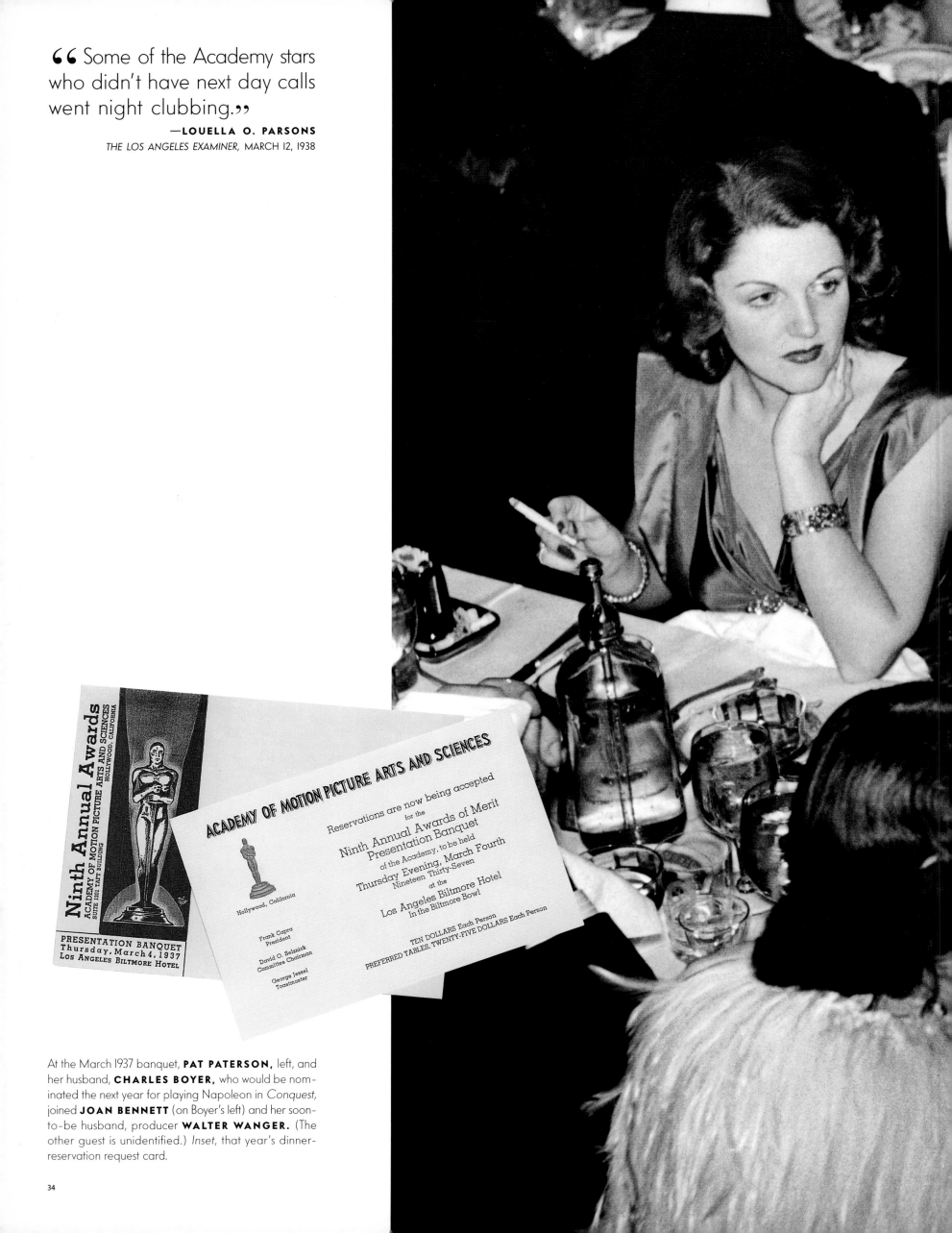

> **❝** Some of the Academy stars who didn't have next day calls went night clubbing. **❞**
> —**LOUELLA O. PARSONS**
> *THE LOS ANGELES EXAMINER,* MARCH 12, 1938

Ninth Annual Awards
ACADEMY OF MOTION PICTURE ARTS AND SCIENCES
SUITE 1201 TAFT BUILDING
HOLLYWOOD, CALIFORNIA

PRESENTATION BANQUET
Thursday, March 4, 1937
Los Angeles Biltmore Hotel

ACADEMY OF MOTION PICTURE ARTS AND SCIENCES

Reservations are now being accepted
for the
Ninth Annual Awards of Merit
Presentation Banquet
of the Academy, to be held
Thursday Evening, March Fourth
Nineteen Thirty-Seven
at the
Los Angeles Biltmore Hotel
In the Biltmore Bowl

Hollywood, California

Frank Capra
President

David O. Selznick
Committee Chairman

George Jessel
Toastmaster

TEN DOLLARS Each Person
PREFERRED TABLES, TWENTY-FIVE DOLLARS Each Person

At the March 1937 banquet, **PAT PATERSON**, left, and her husband, **CHARLES BOYER**, who would be nominated the next year for playing Napoleon in *Conquest*, joined **JOAN BENNETT** (on Boyer's left) and her soon-to-be husband, producer **WALTER WANGER**. (The other guest is unidentified.) *Inset*, that year's dinner-reservation request card.

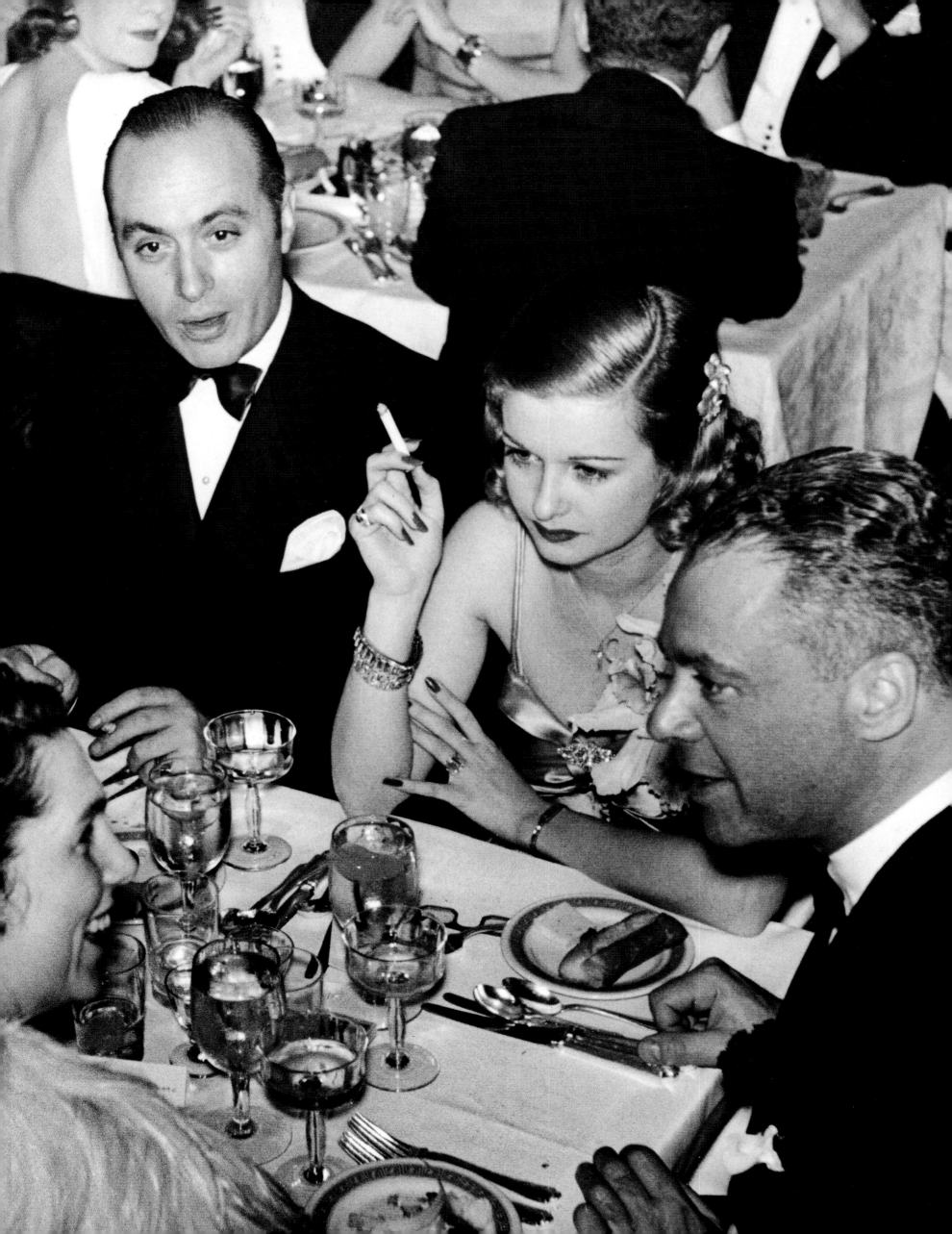

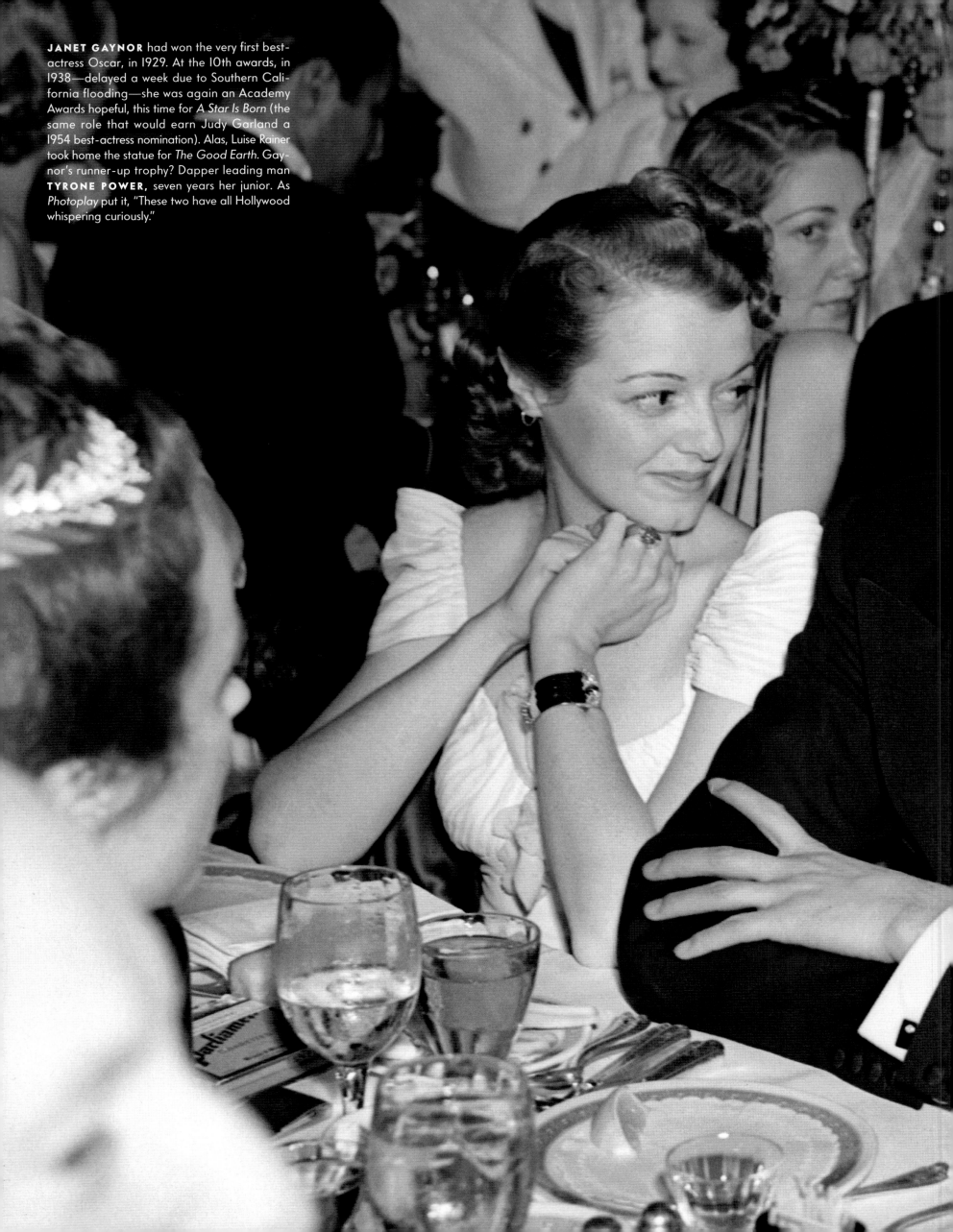

JANET GAYNOR had won the very first best-actress Oscar, in 1929. At the 10th awards, in 1938—delayed a week due to Southern California flooding—she was again an Academy Awards hopeful, this time for *A Star Is Born* (the same role that would earn Judy Garland a 1954 best-actress nomination). Alas, Luise Rainer took home the statue for *The Good Earth*. Gaynor's runner-up trophy? Dapper leading man **TYRONE POWER**, seven years her junior. As *Photoplay* put it, "These two have all Hollywood whispering curiously."

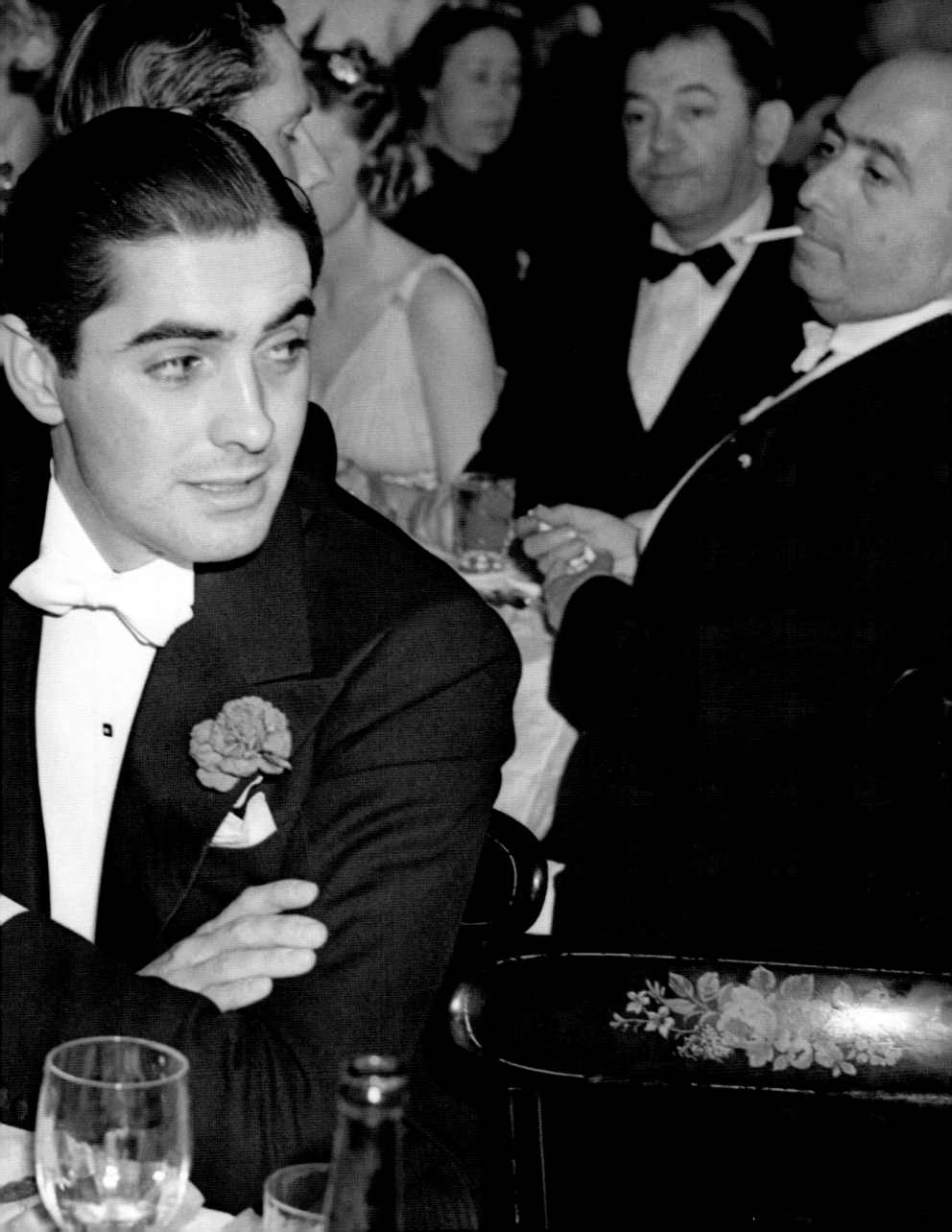

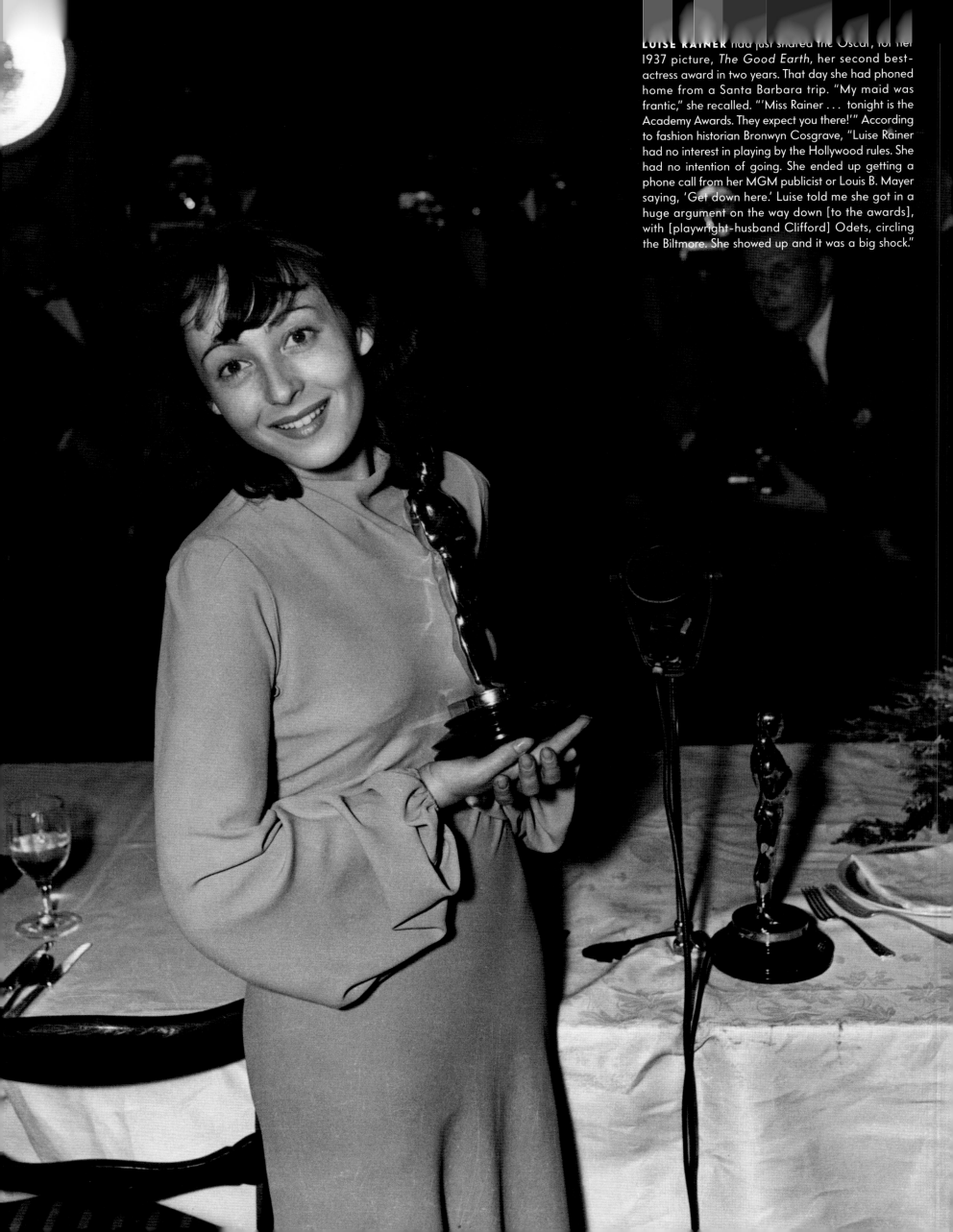

LUISE RAINER had just shared the Oscar, for her 1937 picture, *The Good Earth*, her second best-actress award in two years. That day she had phoned home from a Santa Barbara trip. "My maid was frantic," she recalled. "'Miss Rainer . . . tonight is the Academy Awards. They expect you there!'" According to fashion historian Bronwyn Cosgrave, "Luise Rainer had no interest in playing by the Hollywood rules. She had no intention of going. She ended up getting a phone call from her MGM publicist or Louis B. Mayer saying, 'Get down here.' Luise told me she got in a huge argument on the way down [to the awards], with [playwright-husband Clifford] Odets, circling the Biltmore. She showed up and it was a big shock."

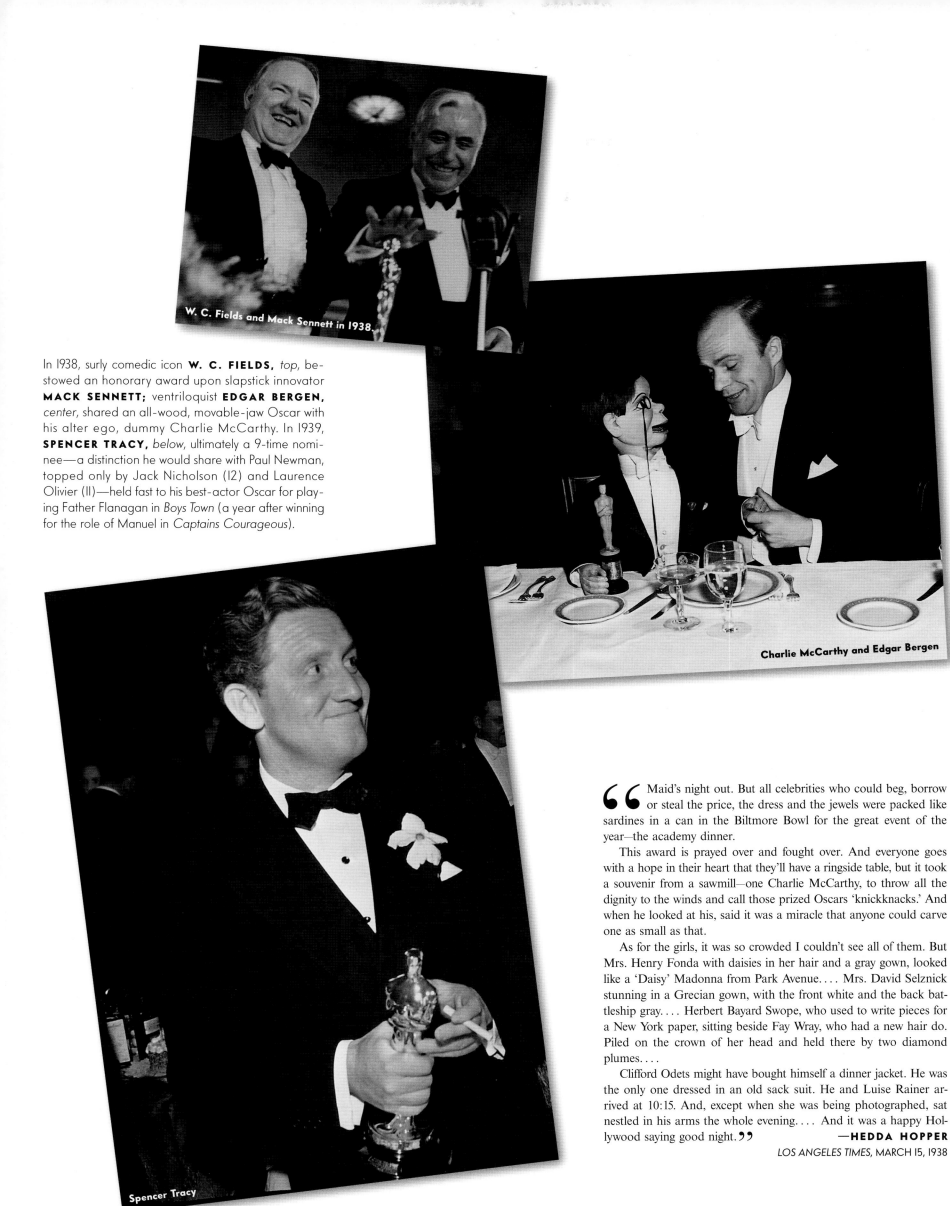

W. C. Fields and Mack Sennett in 1938.

In 1938, surly comedic icon **W. C. FIELDS,** *top,* bestowed an honorary award upon slapstick innovator **MACK SENNETT;** ventriloquist **EDGAR BERGEN,** *center,* shared an all-wood, movable-jaw Oscar with his alter ego, dummy Charlie McCarthy. In 1939, **SPENCER TRACY,** *below,* ultimately a 9-time nominee—a distinction he would share with Paul Newman, topped only by Jack Nicholson (12) and Laurence Olivier (11)—held fast to his best-actor Oscar for playing Father Flanagan in *Boys Town* (a year after winning for the role of Manuel in *Captains Courageous*).

Charlie McCarthy and Edgar Bergen

Spencer Tracy

" Maid's night out. But all celebrities who could beg, borrow or steal the price, the dress and the jewels were packed like sardines in a can in the Biltmore Bowl for the great event of the year—the academy dinner.

This award is prayed over and fought over. And everyone goes with a hope in their heart that they'll have a ringside table, but it took a souvenir from a sawmill—one Charlie McCarthy, to throw all the dignity to the winds and call those prized Oscars 'knickknacks.' And when he looked at his, said it was a miracle that anyone could carve one as small as that.

As for the girls, it was so crowded I couldn't see all of them. But Mrs. Henry Fonda with daisies in her hair and a gray gown, looked like a 'Daisy' Madonna from Park Avenue.... Mrs. David Selznick stunning in a Grecian gown, with the front white and the back battleship gray.... Herbert Bayard Swope, who used to write pieces for a New York paper, sitting beside Fay Wray, who had a new hair do. Piled on the crown of her head and held there by two diamond plumes....

Clifford Odets might have bought himself a dinner jacket. He was the only one dressed in an old sack suit. He and Luise Rainer arrived at 10:15. And, except when she was being photographed, sat nestled in his arms the whole evening.... And it was a happy Hollywood saying good night. " **—HEDDA HOPPER**
LOS ANGELES TIMES, MARCH 15, 1938

Into the night they strode. **FRANK McHUGH,** **PAT O'BRIEN,** and **JAMES CAGNEY**—the Sidekick, the Priest, and the Gangster, respectively—were all Irish-blooded lads who made their names on Broadway before becoming Warner Bros. staples. (O'Brien and Cagney shared the screen in 10 pictures.) Cagney, a nominee that February evening in 1939 for *Angels with Dirty Faces*, would take the gold for his tap-dancing turn in 1942's *Yankee Doodle Dandy.*

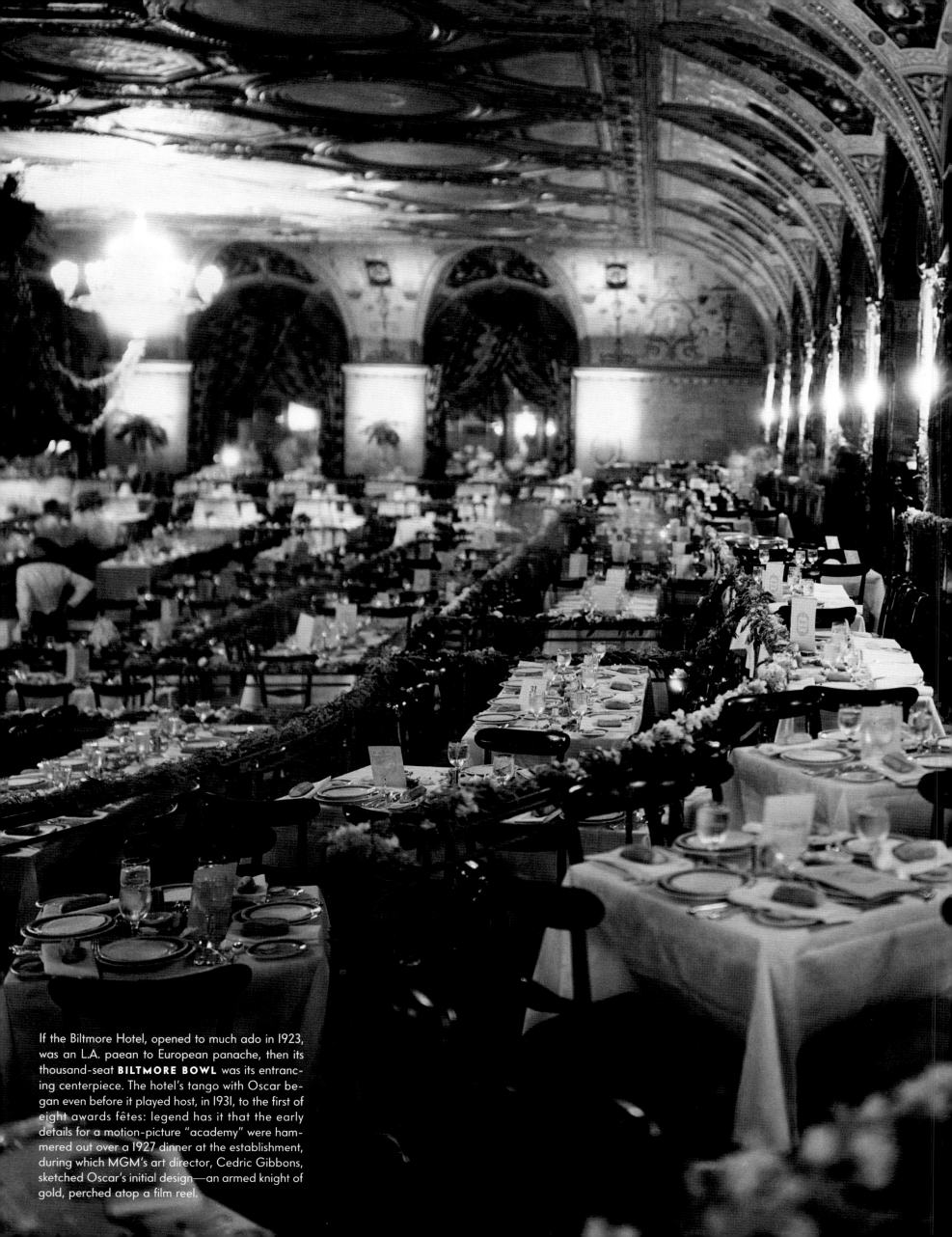

If the Biltmore Hotel, opened to much ado in 1923, was an L.A. paean to European panache, then its thousand-seat **BILTMORE BOWL** was its entrancing centerpiece. The hotel's tango with Oscar began even before it played host, in 1931, to the first of eight awards fêtes: legend has it that the early details for a motion-picture "academy" were hammered out over a 1927 dinner at the establishment, during which MGM's art director, Cedric Gibbons, sketched Oscar's initial design—an armed knight of gold, perched atop a film reel.

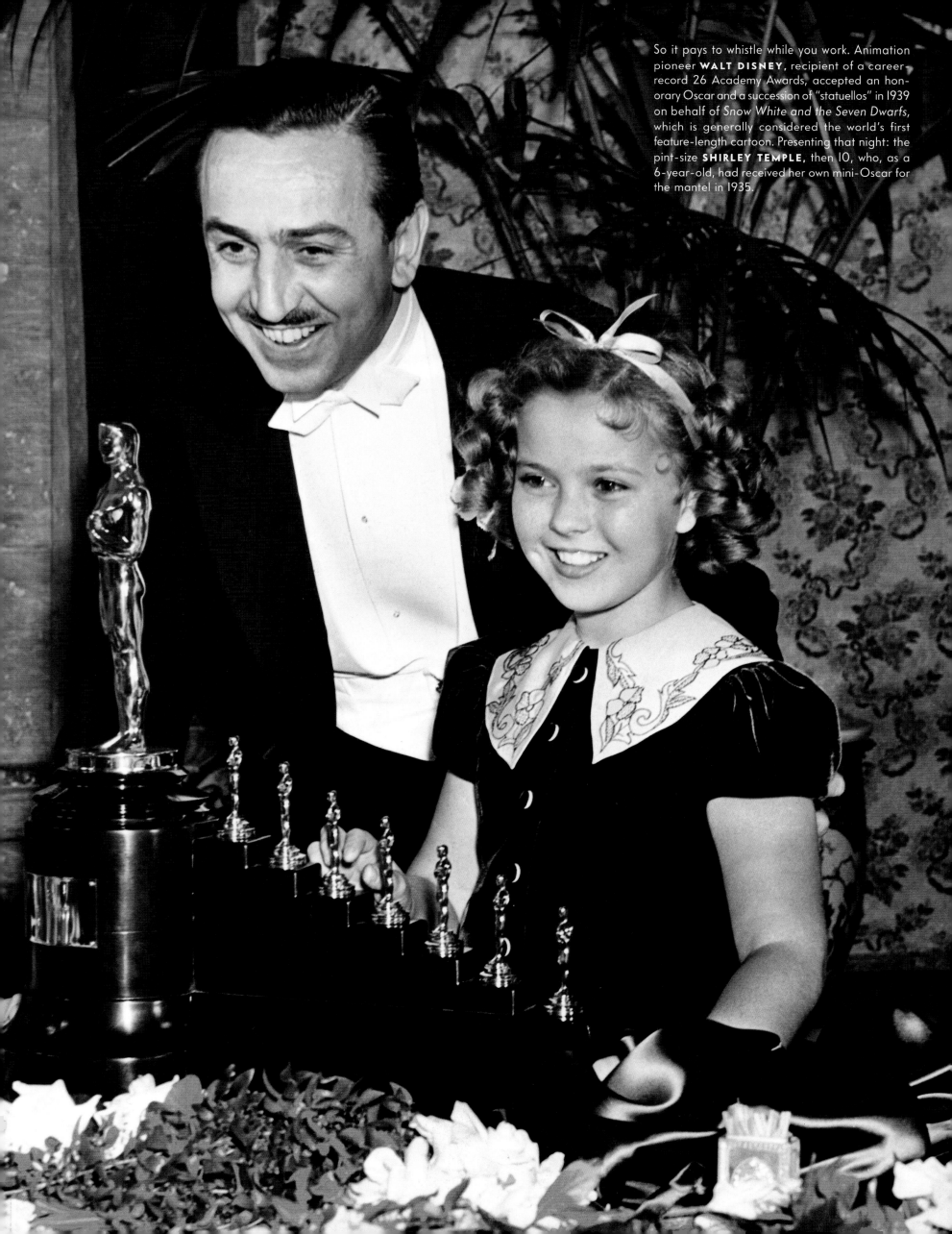

So it pays to whistle while you work. Animation pioneer **WALT DISNEY**, recipient of a career-record 26 Academy Awards, accepted an honorary Oscar and a succession of "statuellos" in 1939 on behalf of *Snow White and the Seven Dwarfs*, which is generally considered the world's first feature-length cartoon. Presenting that night: the pint-size **SHIRLEY TEMPLE**, then 10, who, as a 6-year-old, had received her own mini-Oscar for the mantel in 1935.

ALICE FAYE, left, at the 1939 banquet, was a chorus girl turned musical heartthrob. The star was part of the Twentieth Century Fox stable run by the mogul **DARRYL F. ZANUCK,** right (in time, a winner of three Irving G. Thalberg awards), known for his savvy grasp of the public pulse—and his way with the ladies. Quoth actor Don Ameche: "Zanuck never did anything but be nice to me. Oh, yeah, maybe he chased Alice Faye around, but a lot of people chased Alice Faye around."

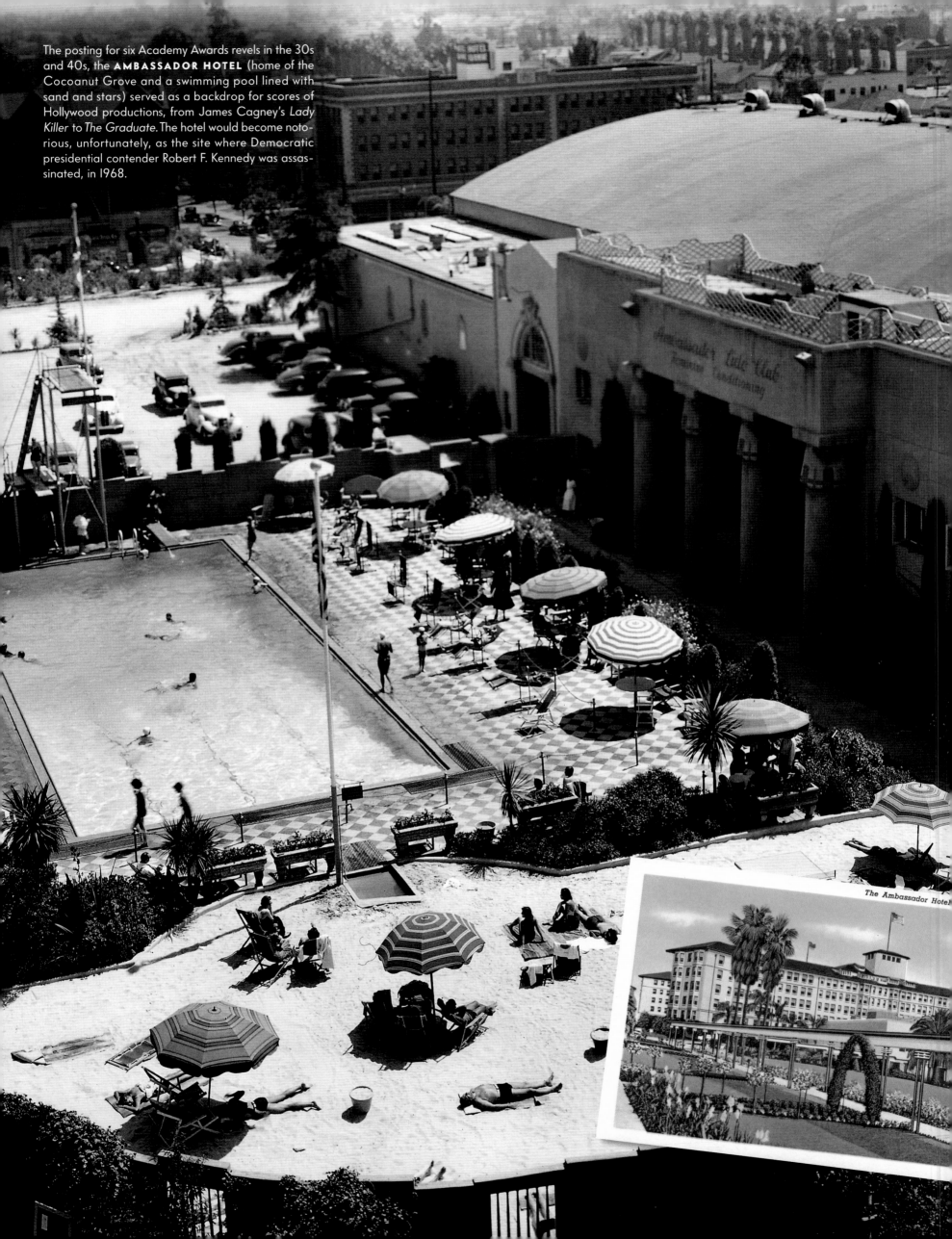

The posting for six Academy Awards revels in the 30s and 40s, the **AMBASSADOR HOTEL** (home of the Cocoanut Grove and a swimming pool lined with sand and stars) served as a backdrop for scores of Hollywood productions, from James Cagney's *Lady Killer* to *The Graduate*. The hotel would become notorious, unfortunately, as the site where Democratic presidential contender Robert F. Kennedy was assassinated, in 1968.

The Ambassador Hotel

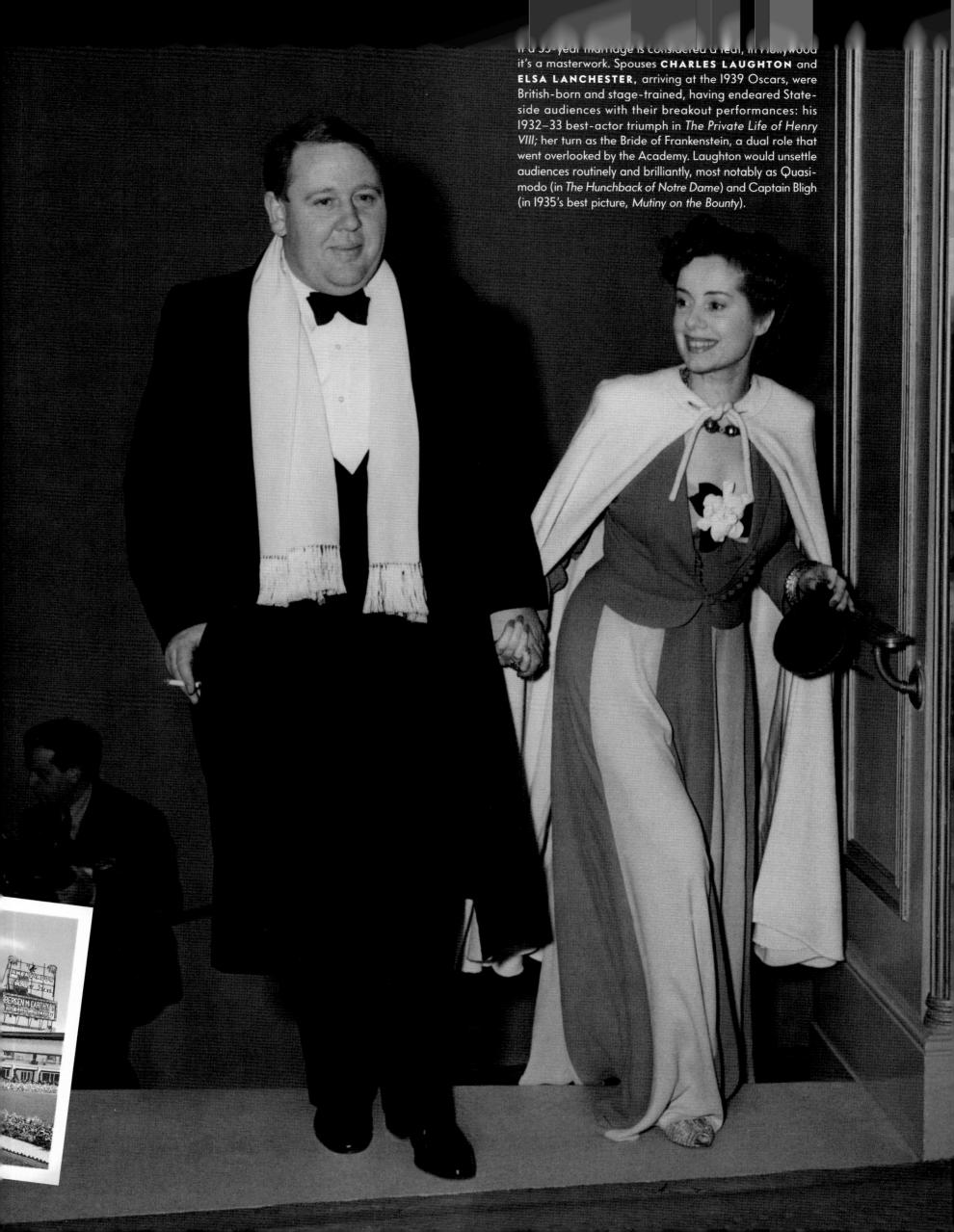

If a 35-year marriage is considered a feat, in Hollywood it's a masterwork. Spouses **CHARLES LAUGHTON** and **ELSA LANCHESTER**, arriving at the 1939 Oscars, were British-born and stage-trained, having endeared State-side audiences with their breakout performances: his 1932–33 best-actor triumph in *The Private Life of Henry VIII;* her turn as the Bride of Frankenstein, a dual role that went overlooked by the Academy. Laughton would unsettle audiences routinely and brilliantly, most notably as Quasimodo (in *The Hunchback of Notre Dame*) and Captain Bligh (in 1935's best picture, *Mutiny on the Bounty*).

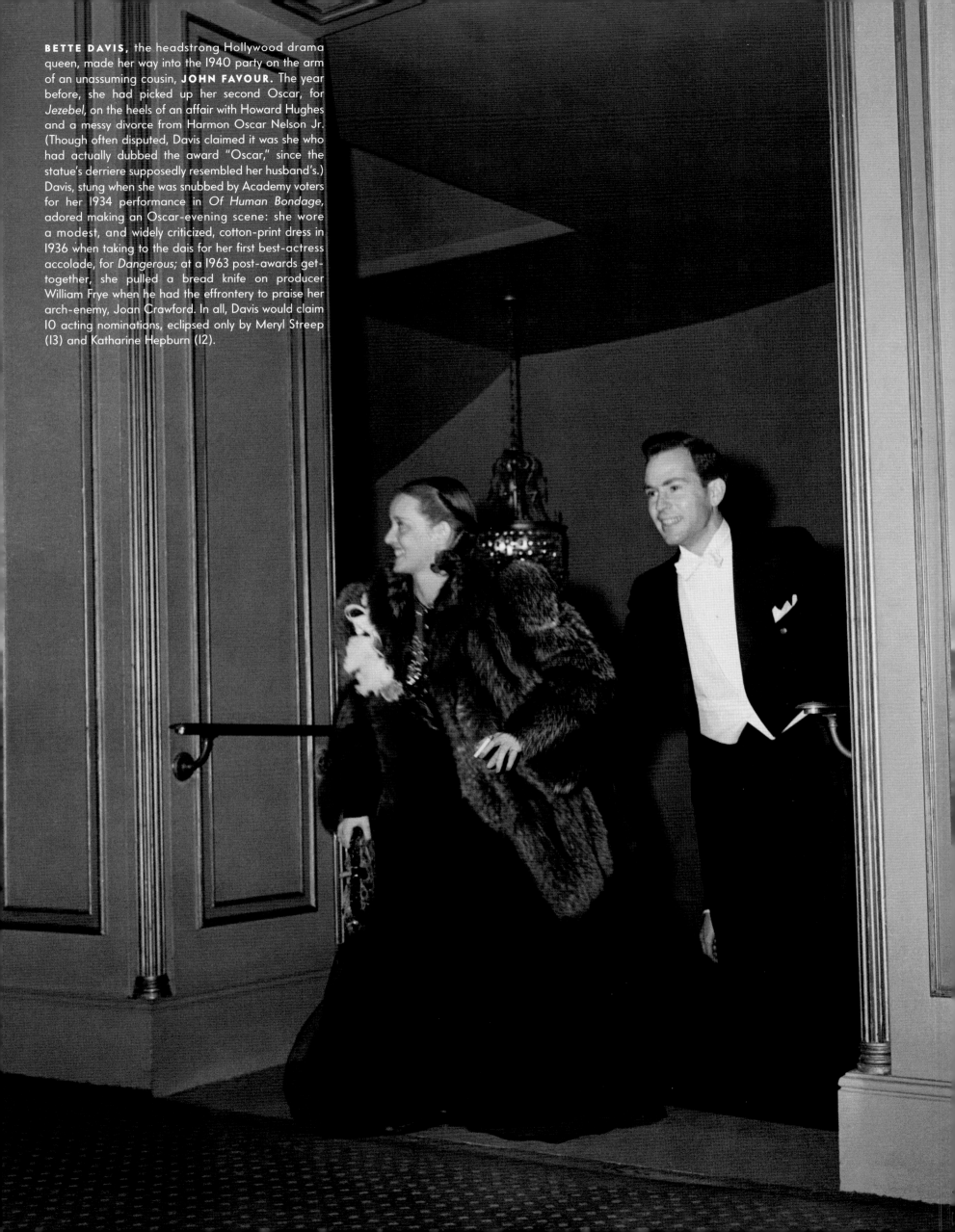

BETTE DAVIS, the headstrong Hollywood drama queen, made her way into the 1940 party on the arm of an unassuming cousin, **JOHN FAVOUR.** The year before, she had picked up her second Oscar, for *Jezebel,* on the heels of an affair with Howard Hughes and a messy divorce from Harmon Oscar Nelson Jr. (Though often disputed, Davis claimed it was she who had actually dubbed the award "Oscar," since the statue's derriere supposedly resembled her husband's.) Davis, stung when she was snubbed by Academy voters for her 1934 performance in *Of Human Bondage,* adored making an Oscar-evening scene: she wore a modest, and widely criticized, cotton-print dress in 1936 when taking to the dais for her first best-actress accolade, for *Dangerous;* at a 1963 post-awards get-together, she pulled a bread knife on producer William Frye when he had the effrontery to praise her arch-enemy, Joan Crawford. In all, Davis would claim 10 acting nominations, eclipsed only by Meryl Streep (13) and Katharine Hepburn (12).

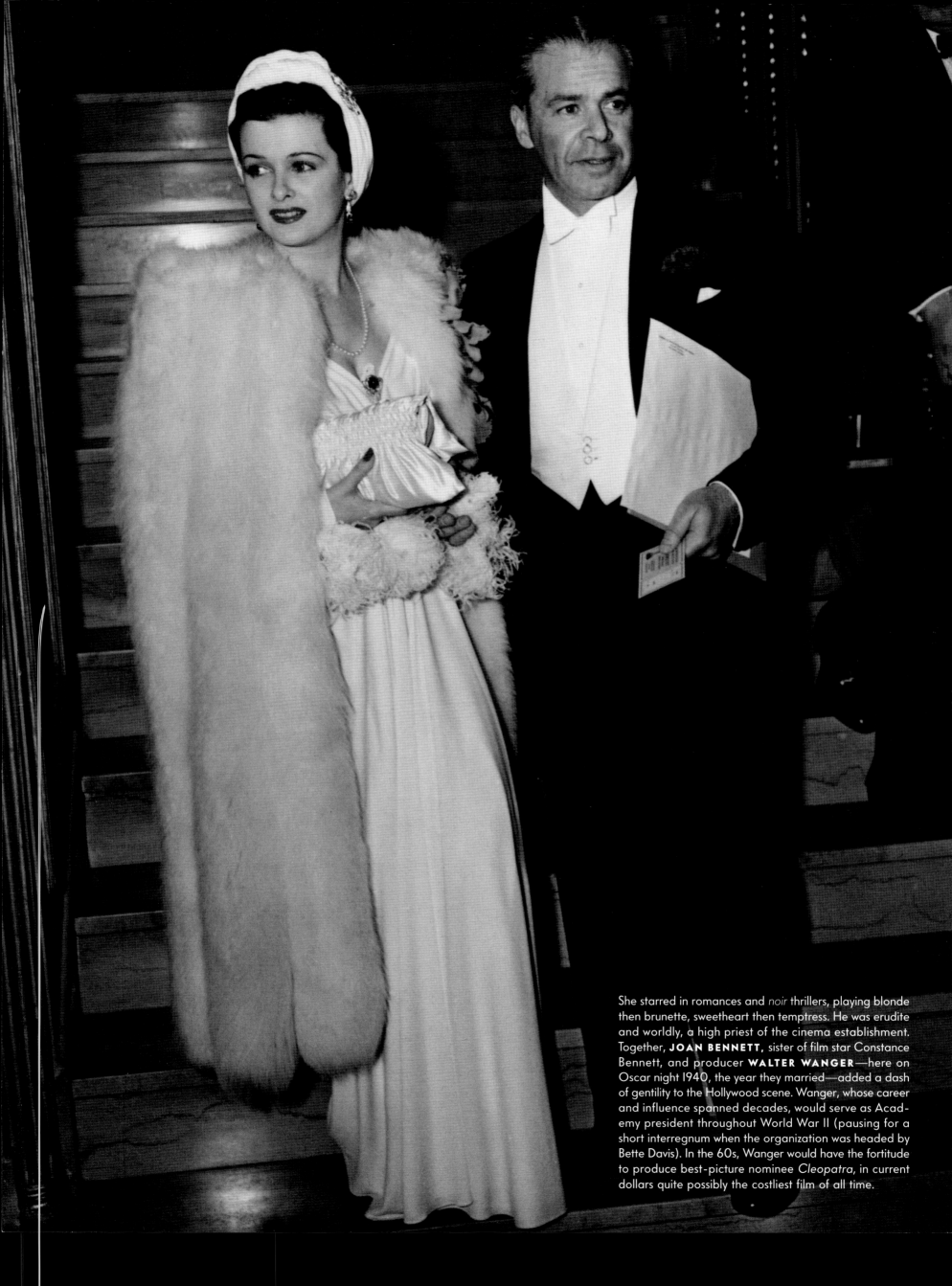

She starred in romances and *noir* thrillers, playing blonde then brunette, sweetheart then temptress. He was erudite and worldly, a high priest of the cinema establishment. Together, **JOAN BENNETT,** sister of film star Constance Bennett, and producer **WALTER WANGER**—here on Oscar night 1940, the year they married—added a dash of gentility to the Hollywood scene. Wanger, whose career and influence spanned decades, would serve as Academy president throughout World War II (pausing for a short interregnum when the organization was headed by Bette Davis). In the 60s, Wanger would have the fortitude to produce best-picture nominee *Cleopatra,* in current dollars quite possibly the costliest film of all time.

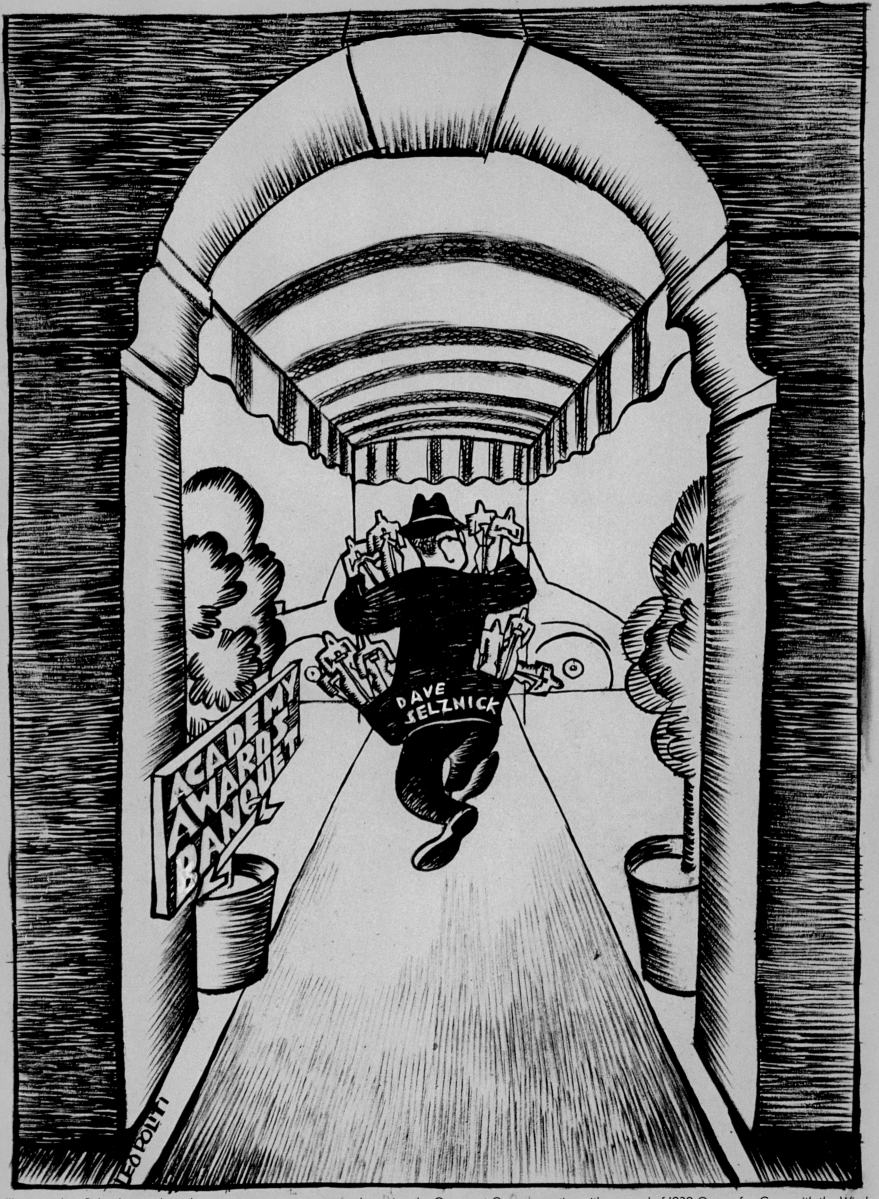

Illustrator Leo Politi depicted producer **DAVID O. SELZNICK** departing the Cocoanut Grove reception with a passel of 1939 Oscars for *Gone with the Wind.*

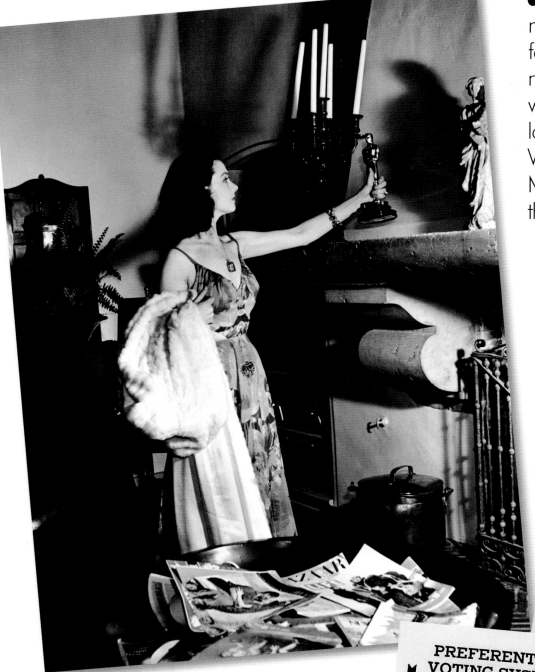

PREFERENTIAL VOTING SYSTEM FOR PRODUCTION AWARD

On the PRODUCTION BALLOT ONLY, please NUMBER YOUR CHOICES instead of marking with an X. You must vote for FIVE productions in the ORDER OF YOUR PREFERENCE; that is, mark the figure 1 opposite the title of your first choice, the figure 2 opposite the title of your second choice, etc. If you vote for less than five your ballot will be disqualified.

OUTSTANDING PRODUCTION
VOTE FOR FIVE CHOICES

	Choice Number
"Dark Victory"	☐
"Gone With the Wind"	☐
"Goodbye, Mr. Chips"	☐
"Love Affair"	☐
"Mr. Smith Goes to Washington"..	☐
"Ninotchka"	☐
"Of Mice and Men"	☐
"Stagecoach"	☐
"Wizard of Oz"	☐
"Wuthering Heights"	☐

[7]

The 1939 best-picture ballot, *left*, brimmed with titles destined to become classics. After the bash, *Gone with the Wind*'s Scarlett O'Hara, **VIVIEN LEIGH,** *top left*, placed her best-actress memento on her mantel as a *Life* lensman snapped away. *Above*, best supporting actress **HATTIE McDANIEL,** who had played the role of Mammy, became the first African-American to take home an Oscar.

1940

Never had there been such a bumper crop of exceptional motion pictures. The previous year, 1939, the studios had released some of the greatest features ever filmed: *Ninotchka* and *Stagecoach, The Wizard of Oz* and *Of Mice and Men, Dark Victory* and *Wuthering Heights, Mr. Smith Goes to Washington* and *Goodbye, Mr. Chips.* The pickings were so fine that other gems didn't even make it onto the best-picture ballot: *The Women, Intermezzo, Love Affair, Destry Rides Again, Gunga Din, Union Pacific, Drums Along the Mohawk, Only Angels Have Wings,* and *The Hunchback of Notre Dame.* And yet nothing could compare to that year's masterpiece, *Gone with the Wind,* producer David O. Selznick's big-screen adaptation of the Margaret Mitchell best-seller. The Civil War saga, possibly cinema's best epic ever, earned an astounding 13 nominations as Oscar night 1940 approached.

On the afternoon of the ceremony, the *Gone with the Wind* contingent descended on Selznick's home on Summit Drive for cocktails, then decamped in a caravan of limousines to the Ambassador Hotel. Selznick rode with the film's co-stars, Clark Gable and Vivien Leigh. By night's end, as the revelers left the dance floor of the Cocoanut Grove, many realized that they had been witness to Hollywood history: David O. and company had waltzed away with a then unprecedented eight gold tokens, including the best-picture prize—and an honorary Thalberg Award for Selznick.

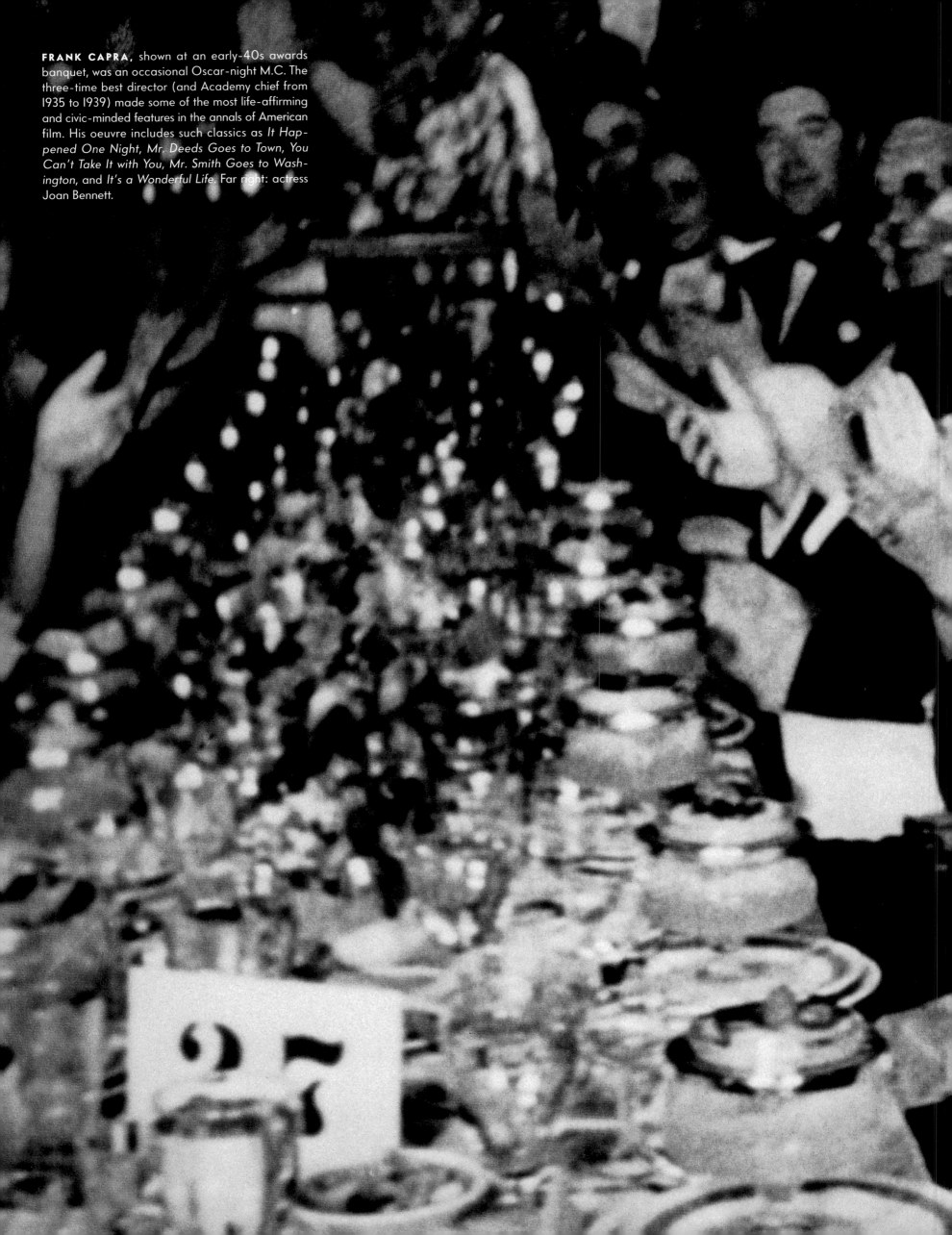

FRANK CAPRA, shown at an early-40s awards banquet, was an occasional Oscar-night M.C. The three-time best director (and Academy chief from 1935 to 1939) made some of the most life-affirming and civic-minded features in the annals of American film. His oeuvre includes such classics as *It Happened One Night*, *Mr. Deeds Goes to Town*, *You Can't Take It with You*, *Mr. Smith Goes to Washington*, and *It's a Wonderful Life*. Far right: actress Joan Bennett.

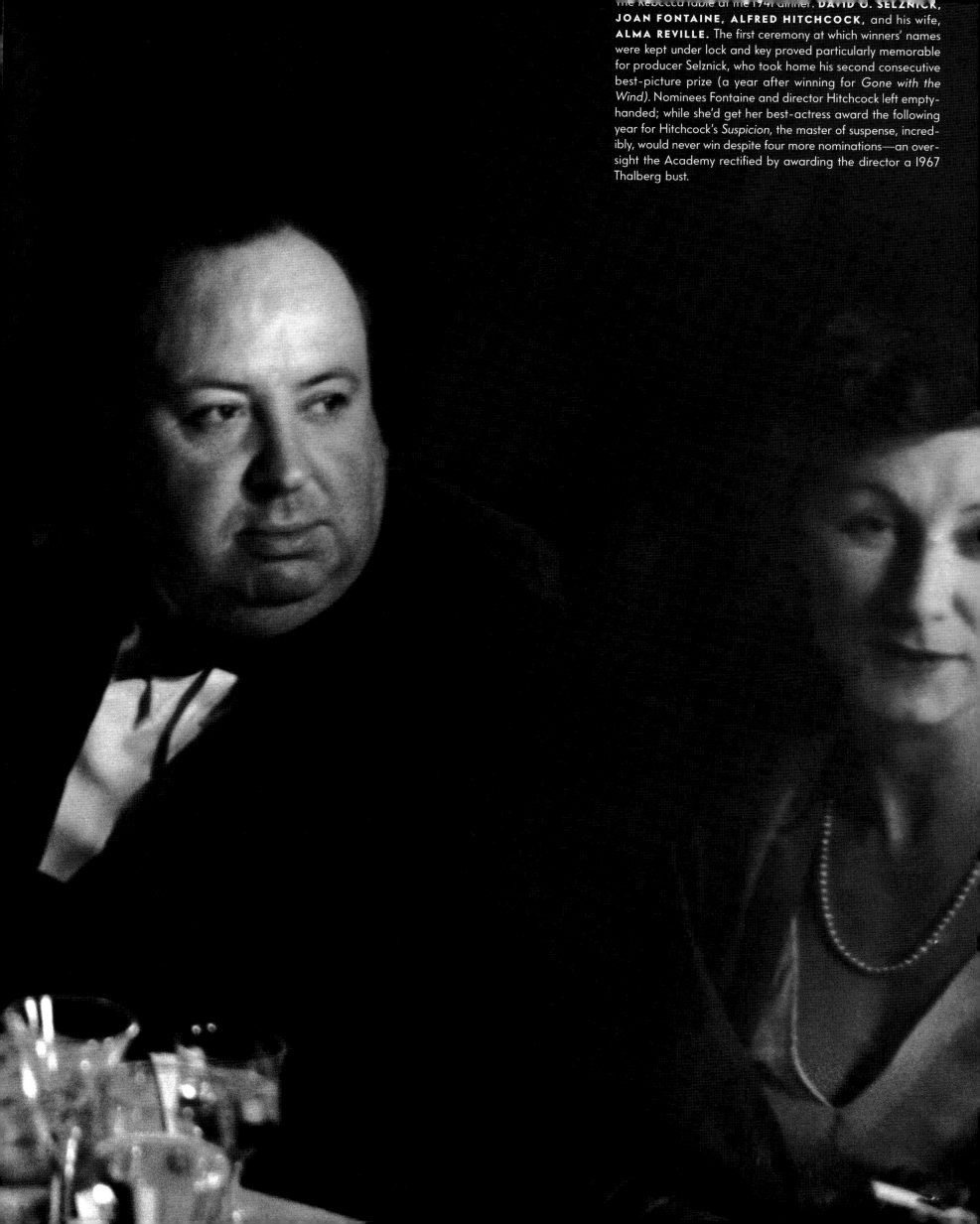

At the *Rebecca* table at the 1941 dinner: **DAVID O. SELZNICK, JOAN FONTAINE, ALFRED HITCHCOCK,** and his wife, **ALMA REVILLE.** The first ceremony at which winners' names were kept under lock and key proved particularly memorable for producer Selznick, who took home his second consecutive best-picture prize (a year after winning for *Gone with the Wind*). Nominees Fontaine and director Hitchcock left empty-handed; while she'd get her best-actress award the following year for Hitchcock's *Suspicion*, the master of suspense, incredibly, would never win despite four more nominations—an oversight the Academy rectified by awarding the director a 1967 Thalberg bust.

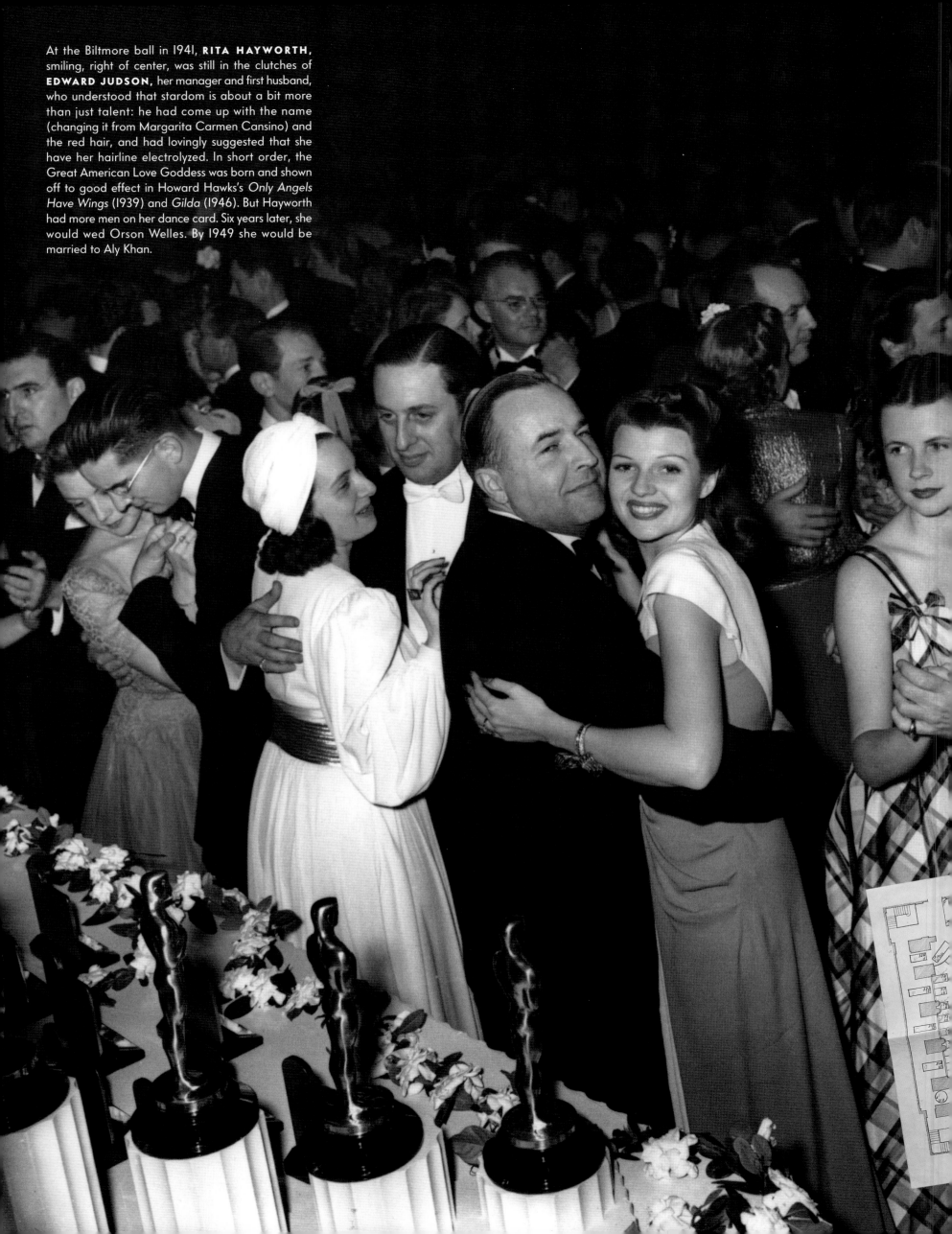

At the Biltmore ball in 1941, **RITA HAYWORTH,** smiling, right of center, was still in the clutches of **EDWARD JUDSON,** her manager and first husband, who understood that stardom is about a bit more than just talent: he had come up with the name (changing it from Margarita Carmen Cansino) and the red hair, and had lovingly suggested that she have her hairline electrolyzed. In short order, the Great American Love Goddess was born and shown off to good effect in Howard Hawks's *Only Angels Have Wings* (1939) and *Gilda* (1946). But Hayworth had more men on her dance card. Six years later, she would wed Orson Welles. By 1949 she would be married to Aly Khan.

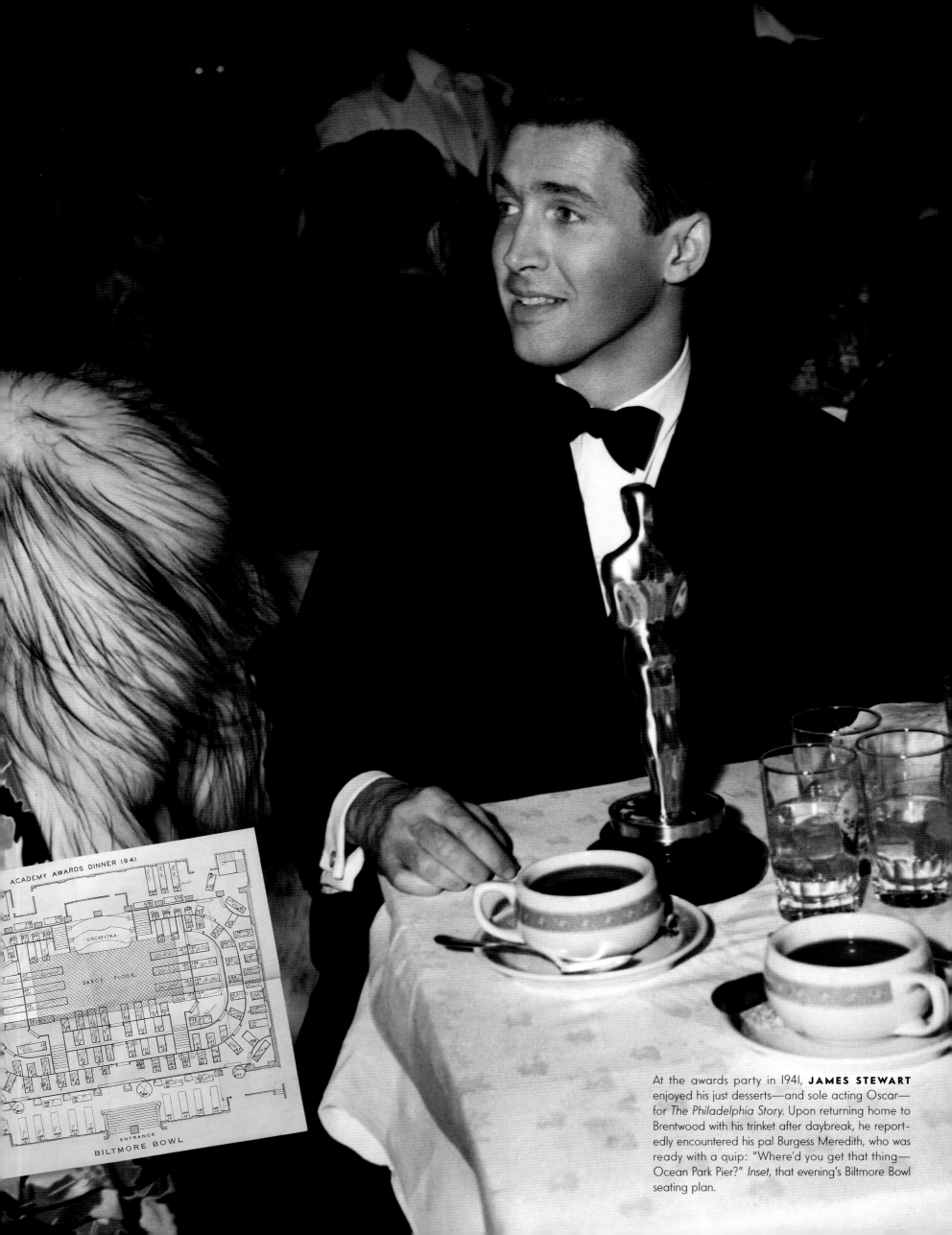

At the awards party in 1941, **JAMES STEWART** enjoyed his just desserts—and sole acting Oscar—for *The Philadelphia Story*. Upon returning home to Brentwood with his trinket after daybreak, he reportedly encountered his pal Burgess Meredith, who was ready with a quip: "Where'd you get that thing—Ocean Park Pier?" *Inset*, that evening's Biltmore Bowl seating plan.

ACADEMY AWARDS DINNER 1941

ORCHESTRA

DANCE FLOOR

ENTRANCE

BILTMORE BOWL

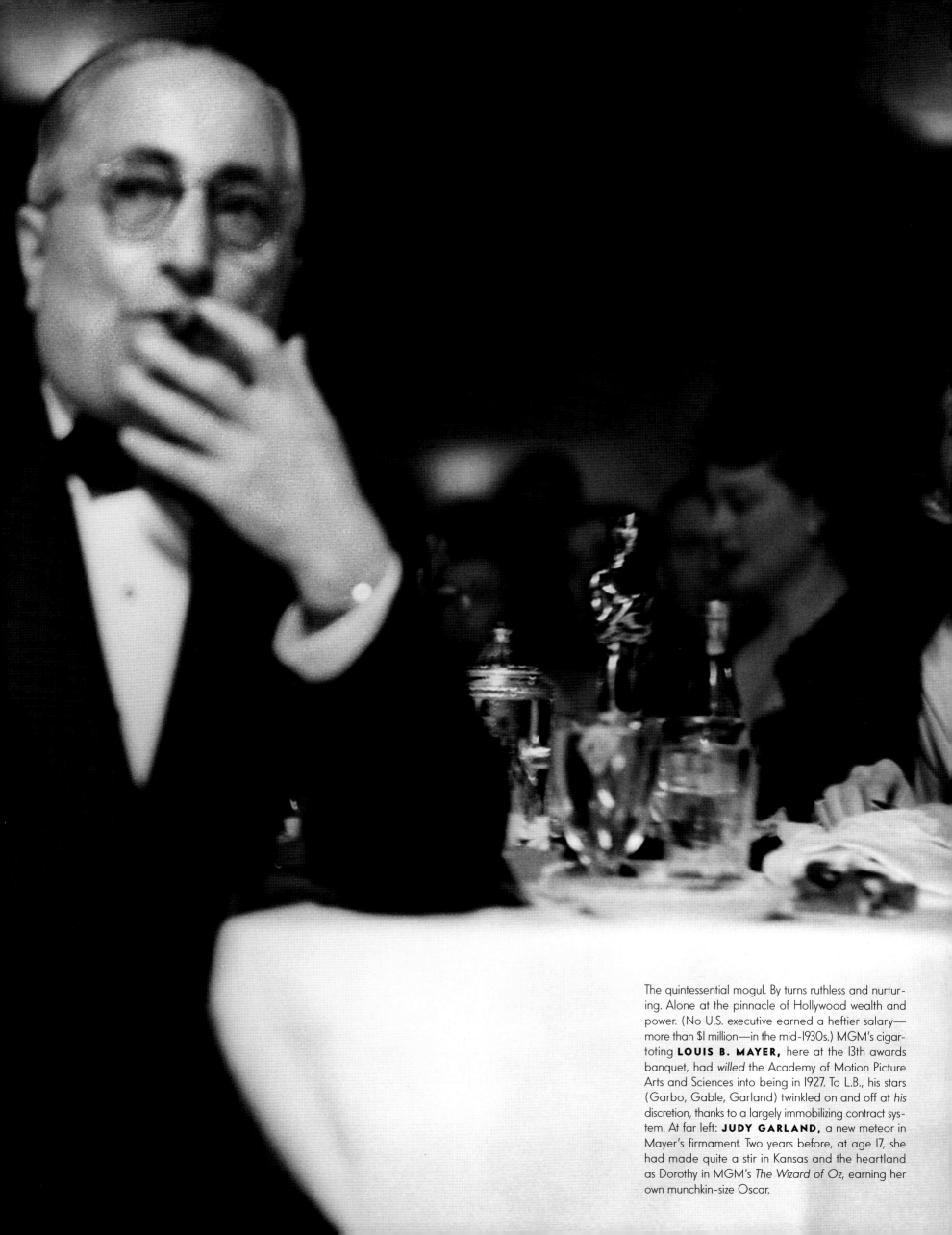

The quintessential mogul. By turns ruthless and nurturing. Alone at the pinnacle of Hollywood wealth and power. (No U.S. executive earned a heftier salary—more than $1 million—in the mid-1930s.) MGM's cigar-toting **LOUIS B. MAYER,** here at the 13th awards banquet, had *willed* the Academy of Motion Picture Arts and Sciences into being in 1927. To L.B., his stars (Garbo, Gable, Garland) twinkled on and off at *his* discretion, thanks to a largely immobilizing contract system. At far left: **JUDY GARLAND,** a new meteor in Mayer's firmament. Two years before, at age 17, she had made quite a stir in Kansas and the heartland as Dorothy in MGM's *The Wizard of Oz,* earning her own munchkin-size Oscar.

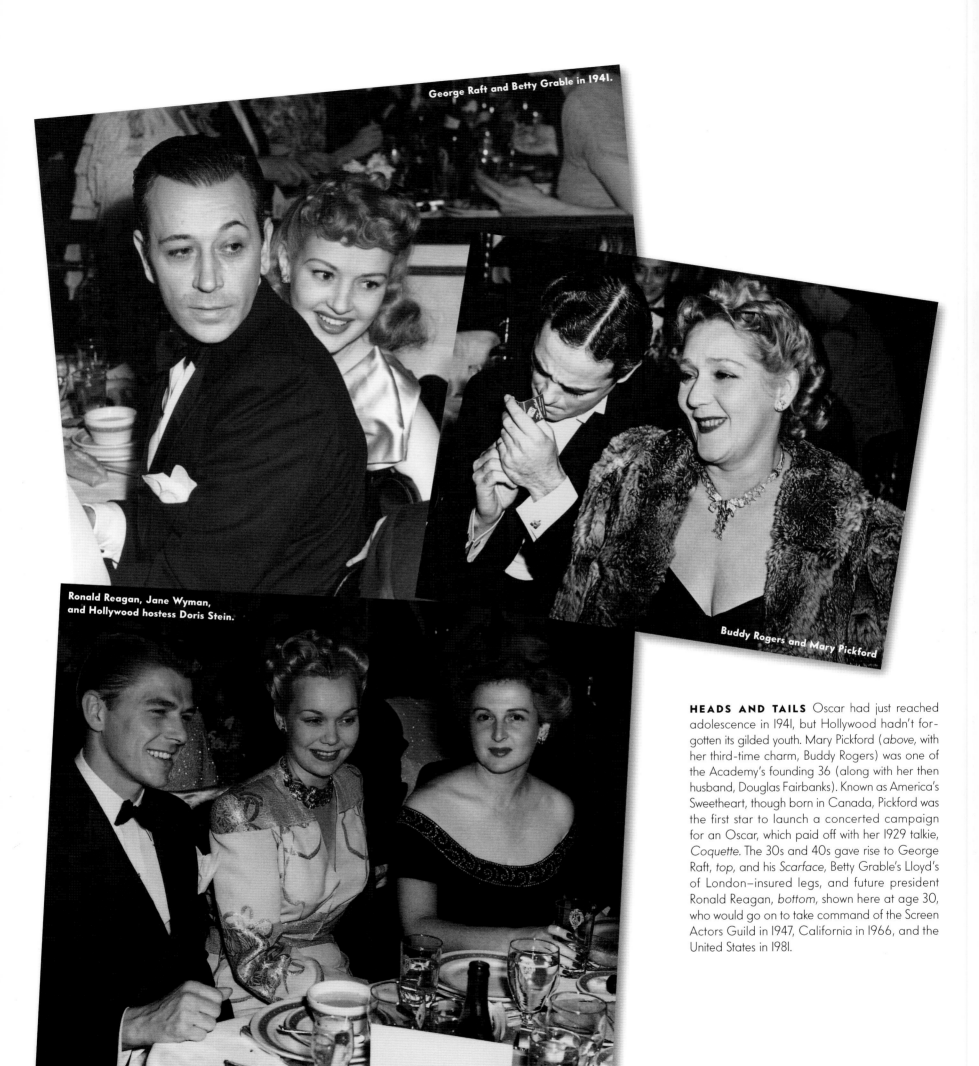

George Raft and Betty Grable in 1941.

Buddy Rogers and Mary Pickford

Ronald Reagan, Jane Wyman, and Hollywood hostess Doris Stein.

HEADS AND TAILS Oscar had just reached adolescence in 1941, but Hollywood hadn't forgotten its gilded youth. Mary Pickford (*above*, with her third-time charm, Buddy Rogers) was one of the Academy's founding 36 (along with her then husband, Douglas Fairbanks). Known as America's Sweetheart, though born in Canada, Pickford was the first star to launch a concerted campaign for an Oscar, which paid off with her 1929 talkie, *Coquette*. The 30s and 40s gave rise to George Raft, *top*, and his *Scarface*, Betty Grable's Lloyd's of London–insured legs, and future president Ronald Reagan, *bottom*, shown here at age 30, who would go on to take command of the Screen Actors Guild in 1947, California in 1966, and the United States in 1981.

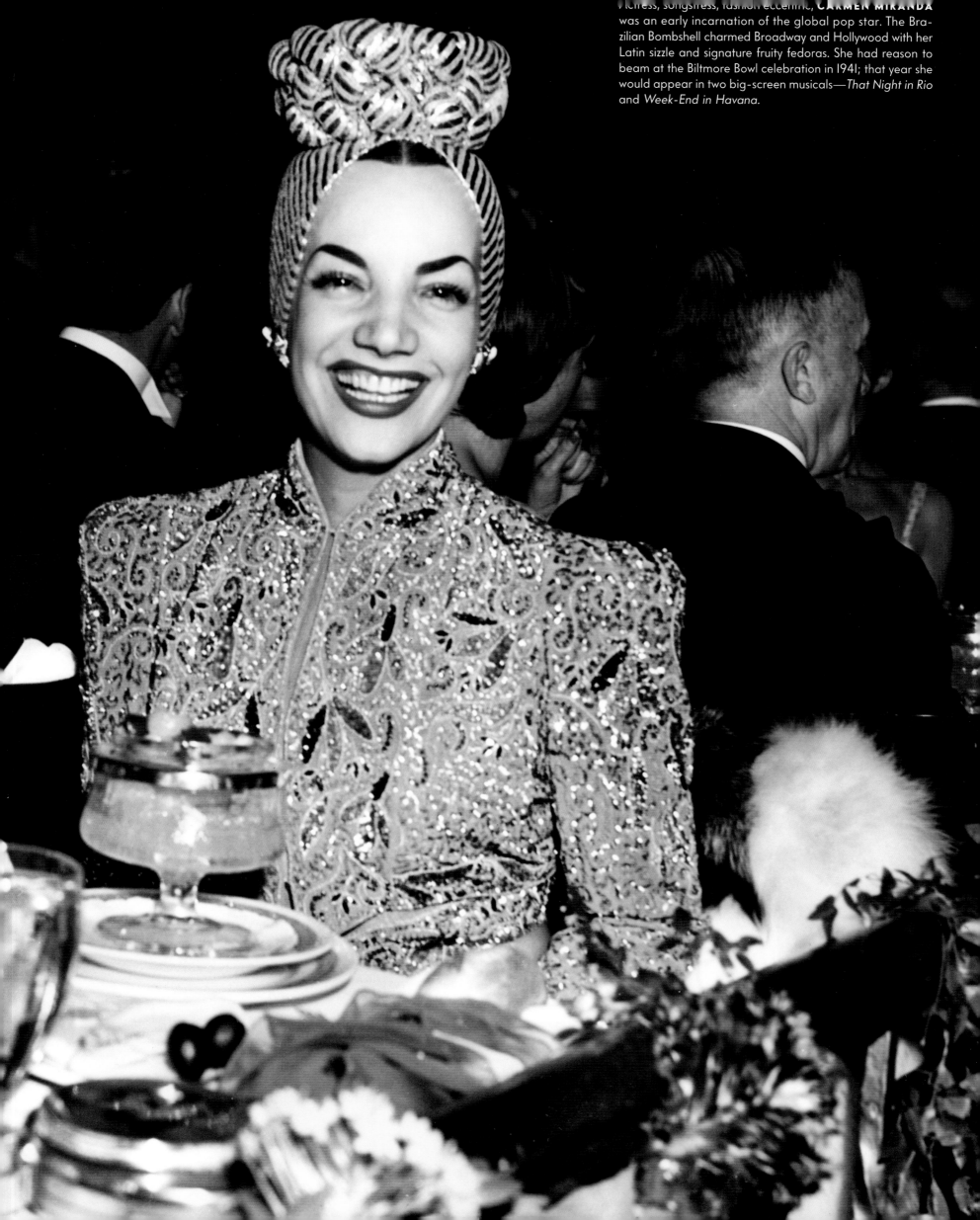

Actress, songstress, fashion eccentric, **CARMEN MIRANDA** was an early incarnation of the global pop star. The Brazilian Bombshell charmed Broadway and Hollywood with her Latin sizzle and signature fruity fedoras. She had reason to beam at the Biltmore Bowl celebration in 1941; that year she would appear in two big-screen musicals—*That Night in Rio* and *Week-End in Havana*.

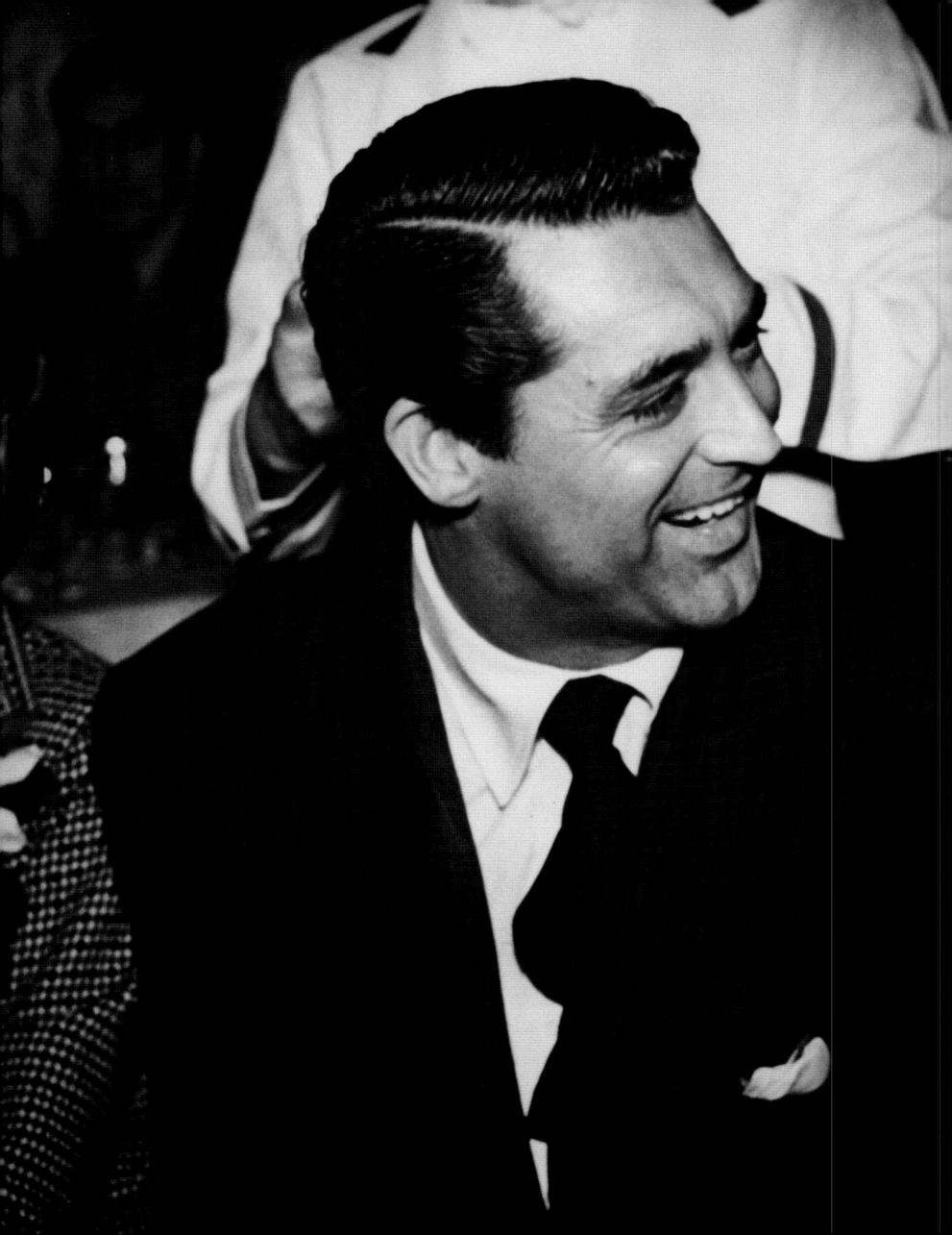

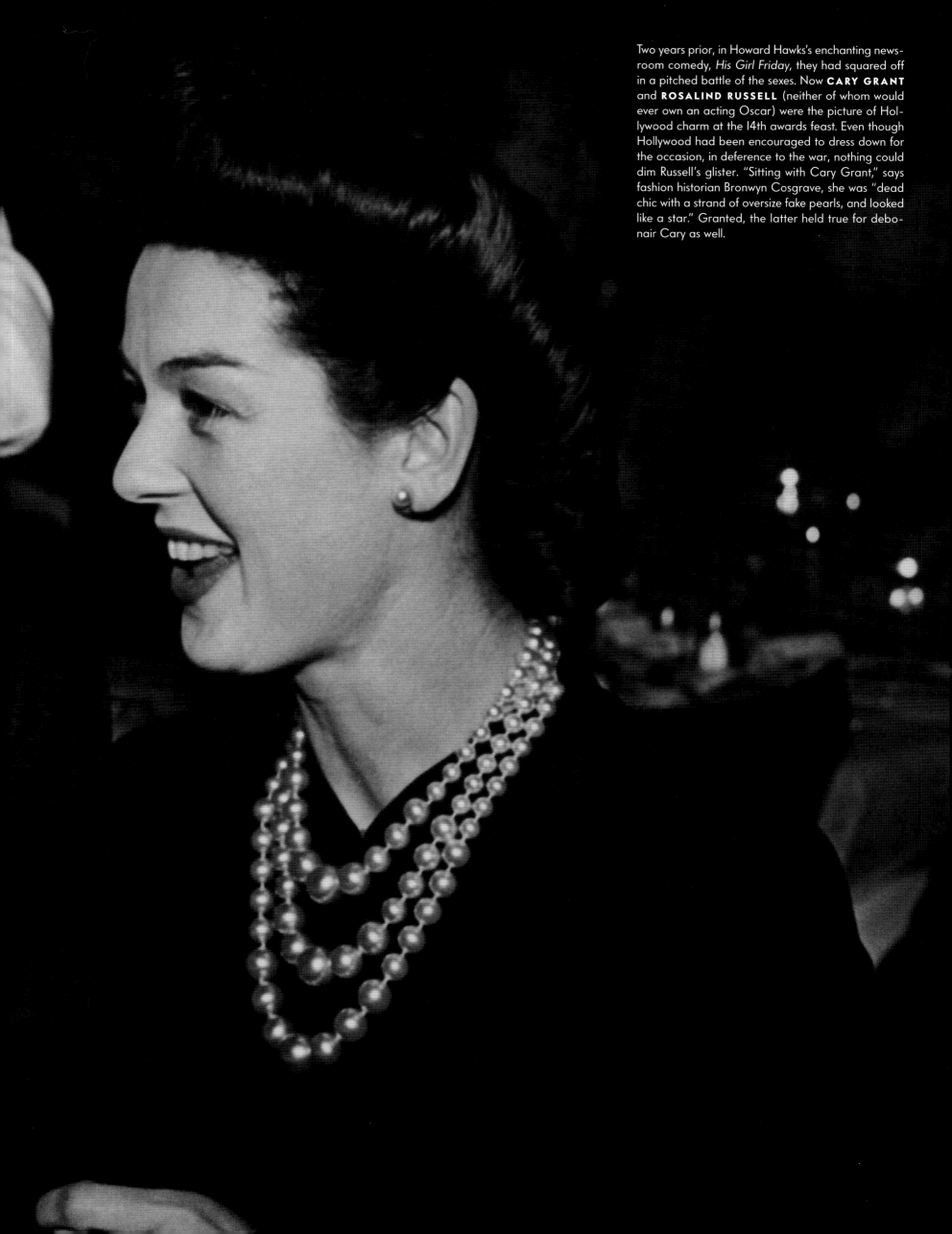

Two years prior, in Howard Hawks's enchanting news-room comedy, *His Girl Friday*, they had squared off in a pitched battle of the sexes. Now **CARY GRANT** and **ROSALIND RUSSELL** (neither of whom would ever own an acting Oscar) were the picture of Hollywood charm at the 14th awards feast. Even though Hollywood had been encouraged to dress down for the occasion, in deference to the war, nothing could dim Russell's glister. "Sitting with Cary Grant," says fashion historian Bronwyn Cosgrave, she was "dead chic with a strand of oversize fake pearls, and looked like a star." Granted, the latter held true for debonair Cary as well.

The 1942 ceremony, coming just two months after Pearl Harbor, was nearly canceled. But here was a choice wartime distraction: rivalrous sisters **JOAN FONTAINE,** left, and **OLIVIA DE HAVILLAND** were both up for best actress, Fontaine as the heroine in Alfred Hitchcock's *Suspicion,* De Havilland for playing a spinster in *Hold Back the Dawn.* Fontaine, younger by a year or so, would take home the trophy that night, with the blessing of her sister's tight smiles. ("Get up there," Olivia is said to have snapped when Joan became momentarily discombobulated after her name was read.) De Havilland had two best-actress wins in her near future, for 1946's *To Each His Own* and 1949's *The Heiress.* But in the wake of their 1942 head-to-head, the two became more estranged. (At left, **BURGESS MEREDITH,** who would be twice nominated in the 1970s, for roles in *The Day of the Locust* and *Rocky.*)

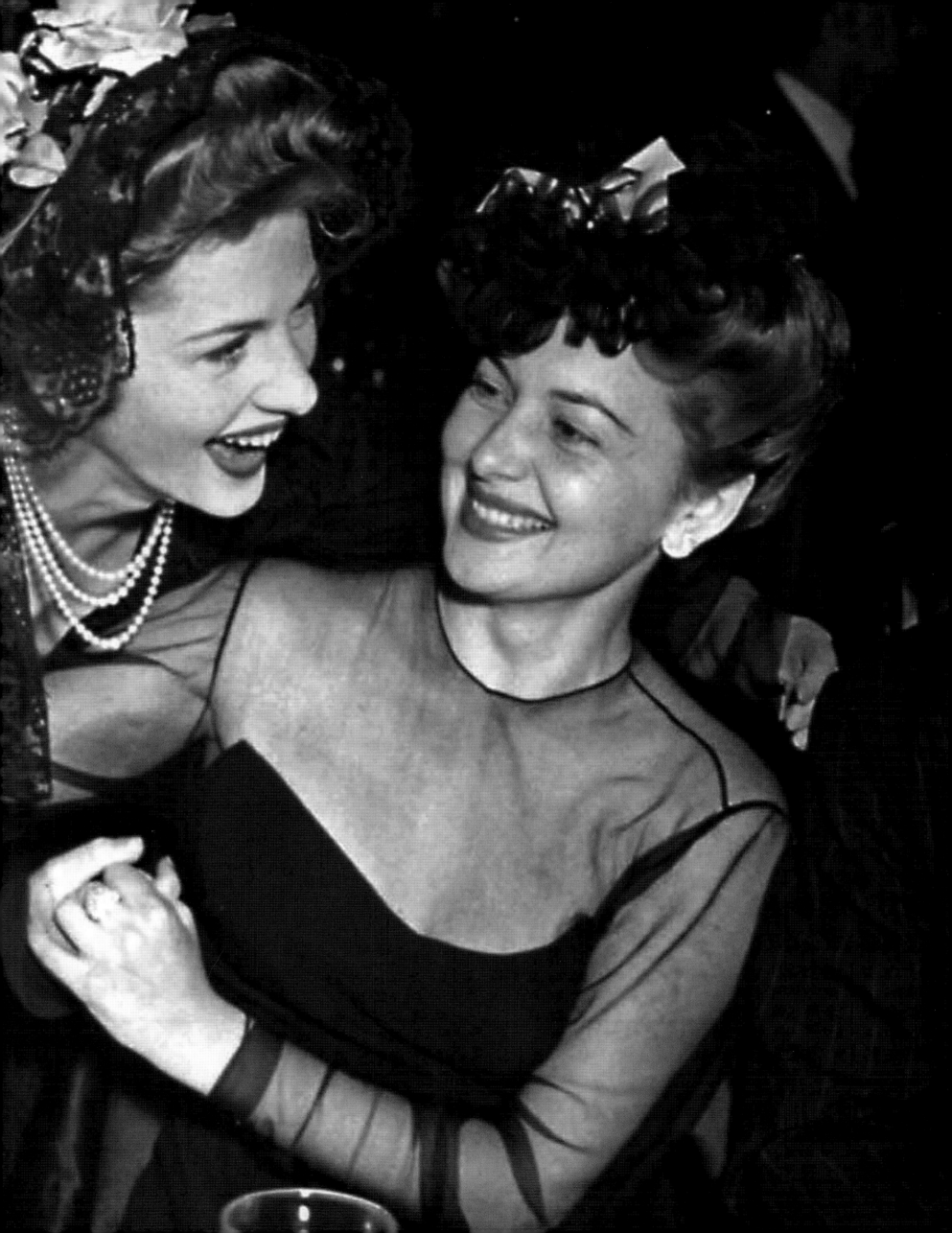

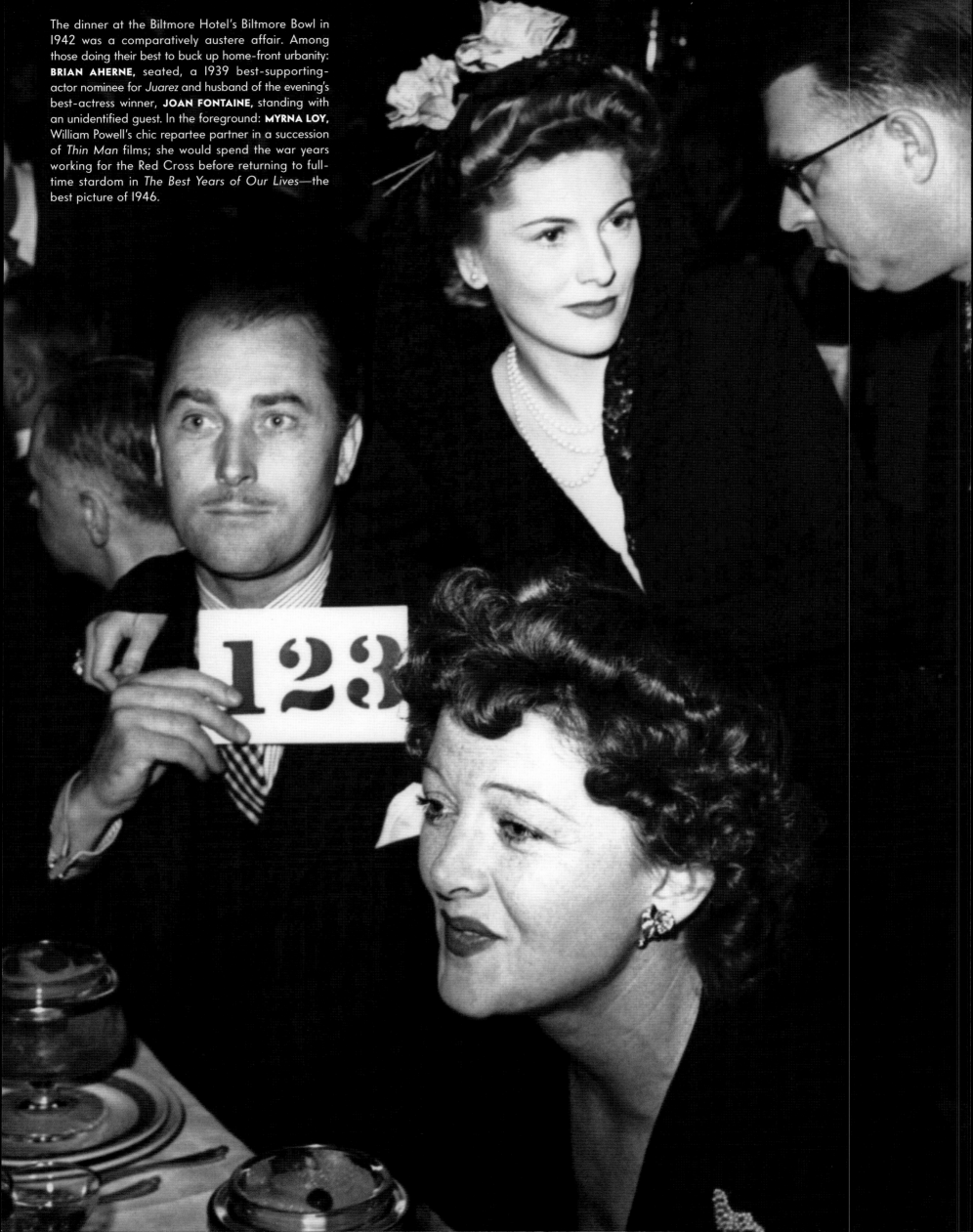

The dinner at the Biltmore Hotel's Biltmore Bowl in 1942 was a comparatively austere affair. Among those doing their best to buck up home-front urbanity: **BRIAN AHERNE**, seated, a 1939 best-supporting-actor nominee for *Juarez* and husband of the evening's best-actress winner, **JOAN FONTAINE**, standing with an unidentified guest. In the foreground: **MYRNA LOY**, William Powell's chic repartee partner in a succession of *Thin Man* films; she would spend the war years working for the Red Cross before returning to full-time stardom in *The Best Years of Our Lives*—the best picture of 1946.

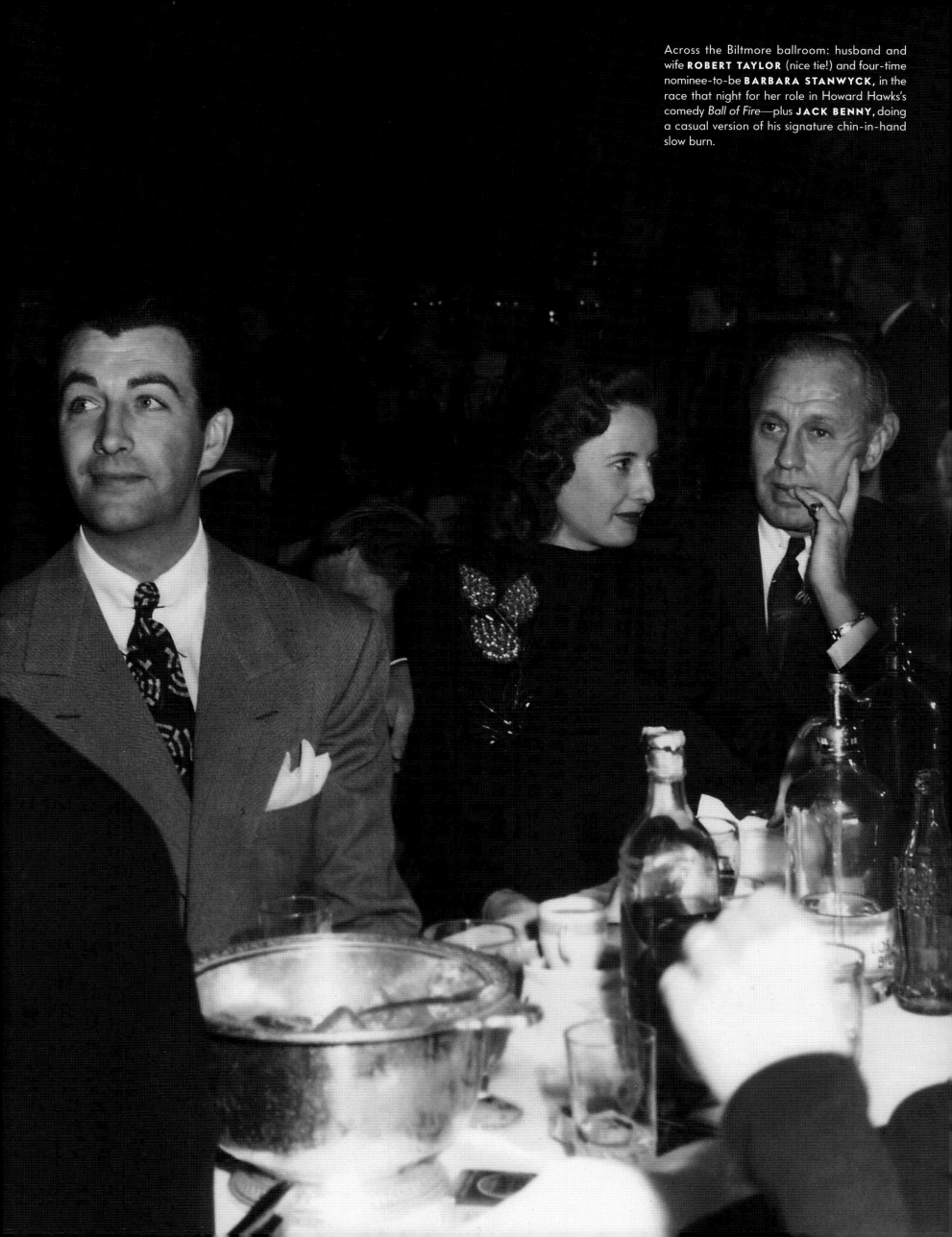

Across the Biltmore ballroom: husband and wife **ROBERT TAYLOR** (nice tie!) and four-time nominee-to-be **BARBARA STANWYCK,** in the race that night for her role in Howard Hawks's comedy *Ball of Fire*—plus **JACK BENNY,** doing a casual version of his signature chin-in-hand slow burn.

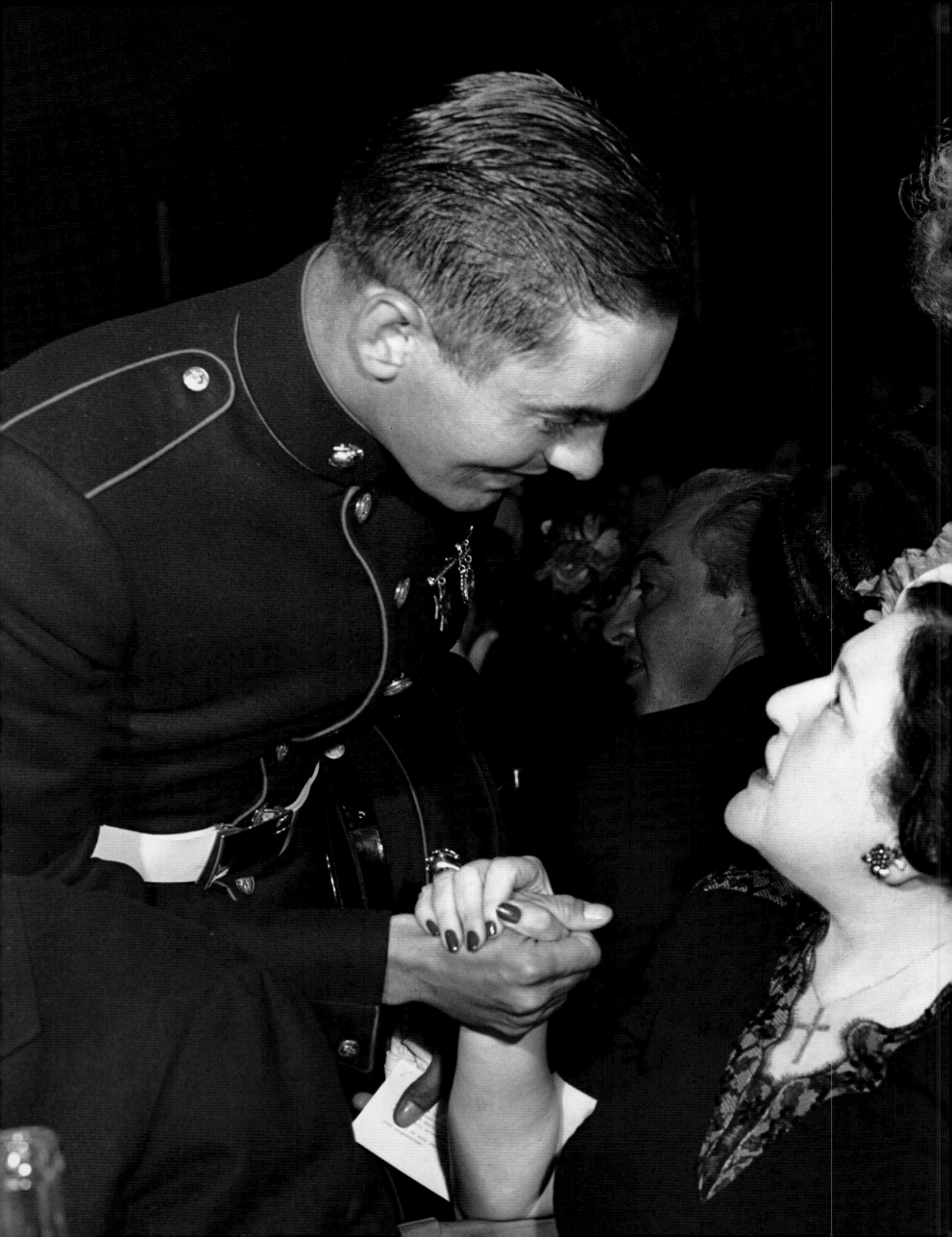

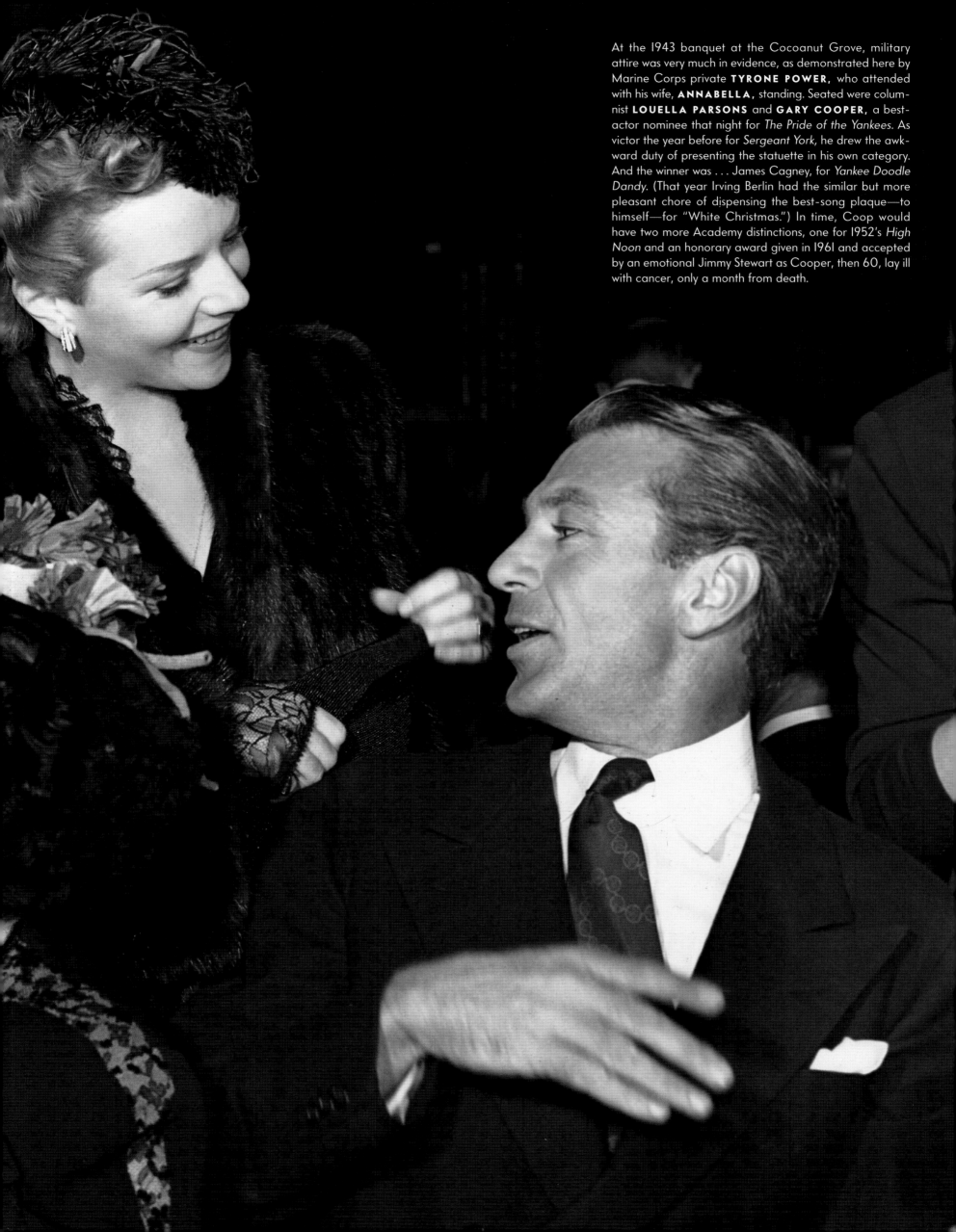

At the 1943 banquet at the Cocoanut Grove, military attire was very much in evidence, as demonstrated here by Marine Corps private **TYRONE POWER,** who attended with his wife, **ANNABELLA,** standing. Seated were columnist **LOUELLA PARSONS** and **GARY COOPER,** a best-actor nominee that night for *The Pride of the Yankees.* As victor the year before for *Sergeant York,* he drew the awkward duty of presenting the statuette in his own category. And the winner was . . . James Cagney, for *Yankee Doodle Dandy.* (That year Irving Berlin had the similar but more pleasant chore of dispensing the best-song plaque—to himself—for "White Christmas.") In time, Coop would have two more Academy distinctions, one for 1952's *High Noon* and an honorary award given in 1961 and accepted by an emotional Jimmy Stewart as Cooper, then 60, lay ill with cancer, only a month from death.

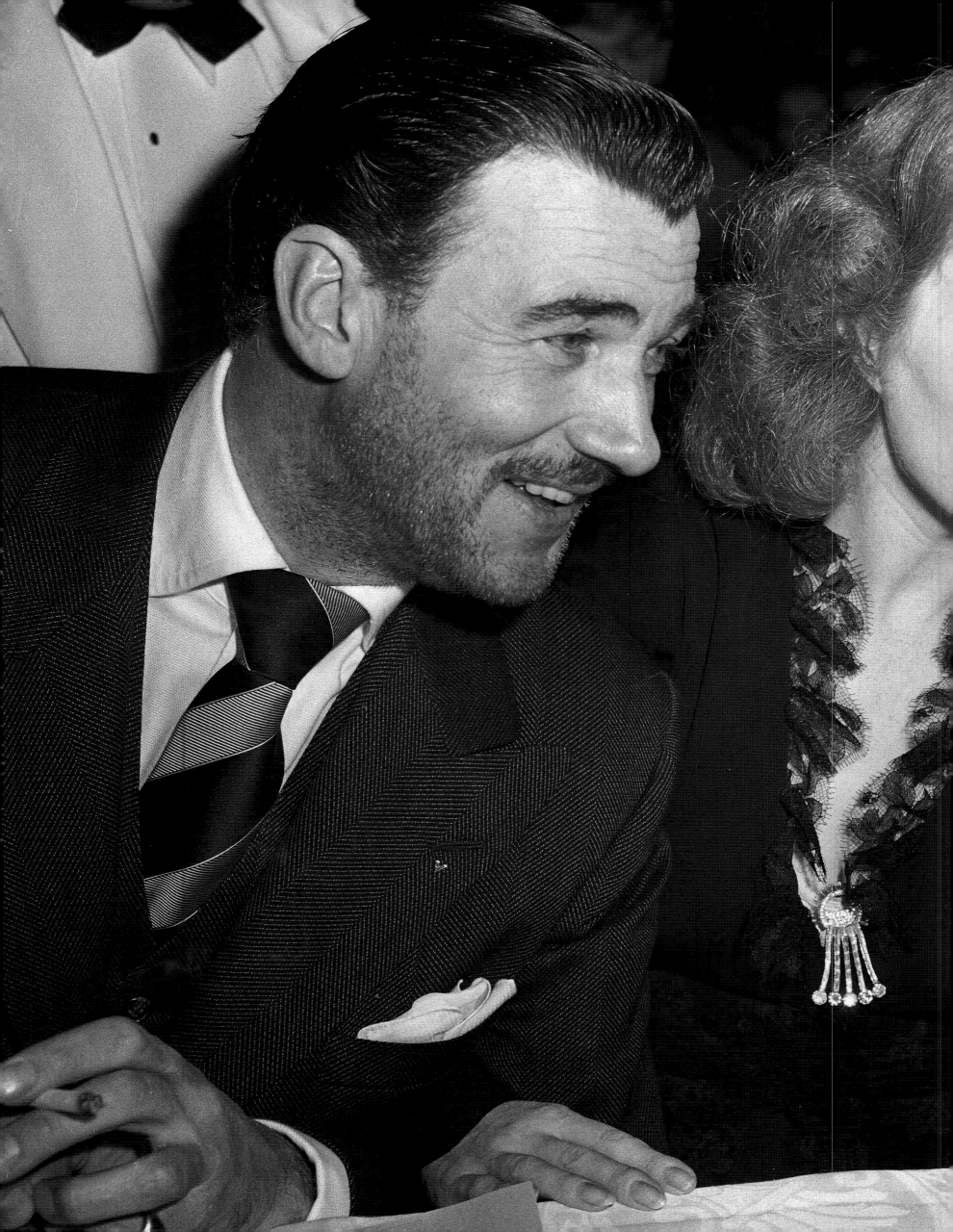

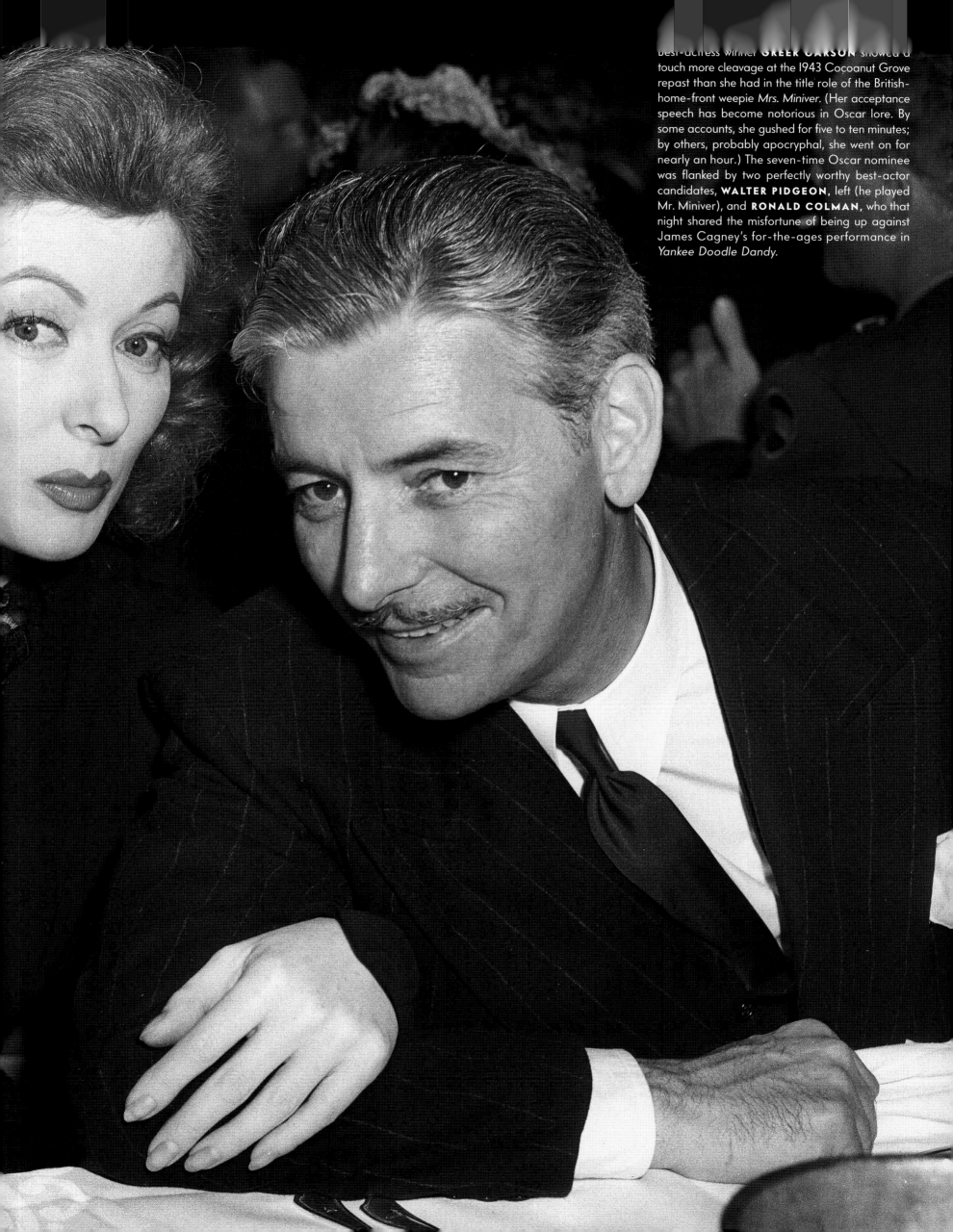

best-actress winner **GREER GARSON** showed a touch more cleavage at the 1943 Cocoanut Grove repast than she had in the title role of the British-home-front weepie *Mrs. Miniver*. (Her acceptance speech has become notorious in Oscar lore. By some accounts, she gushed for five to ten minutes; by others, probably apocryphal, she went on for nearly an hour.) The seven-time Oscar nominee was flanked by two perfectly worthy best-actor candidates, **WALTER PIDGEON**, left (he played Mr. Miniver), and **RONALD COLMAN**, who that night shared the misfortune of being up against James Cagney's for-the-ages performance in *Yankee Doodle Dandy*.

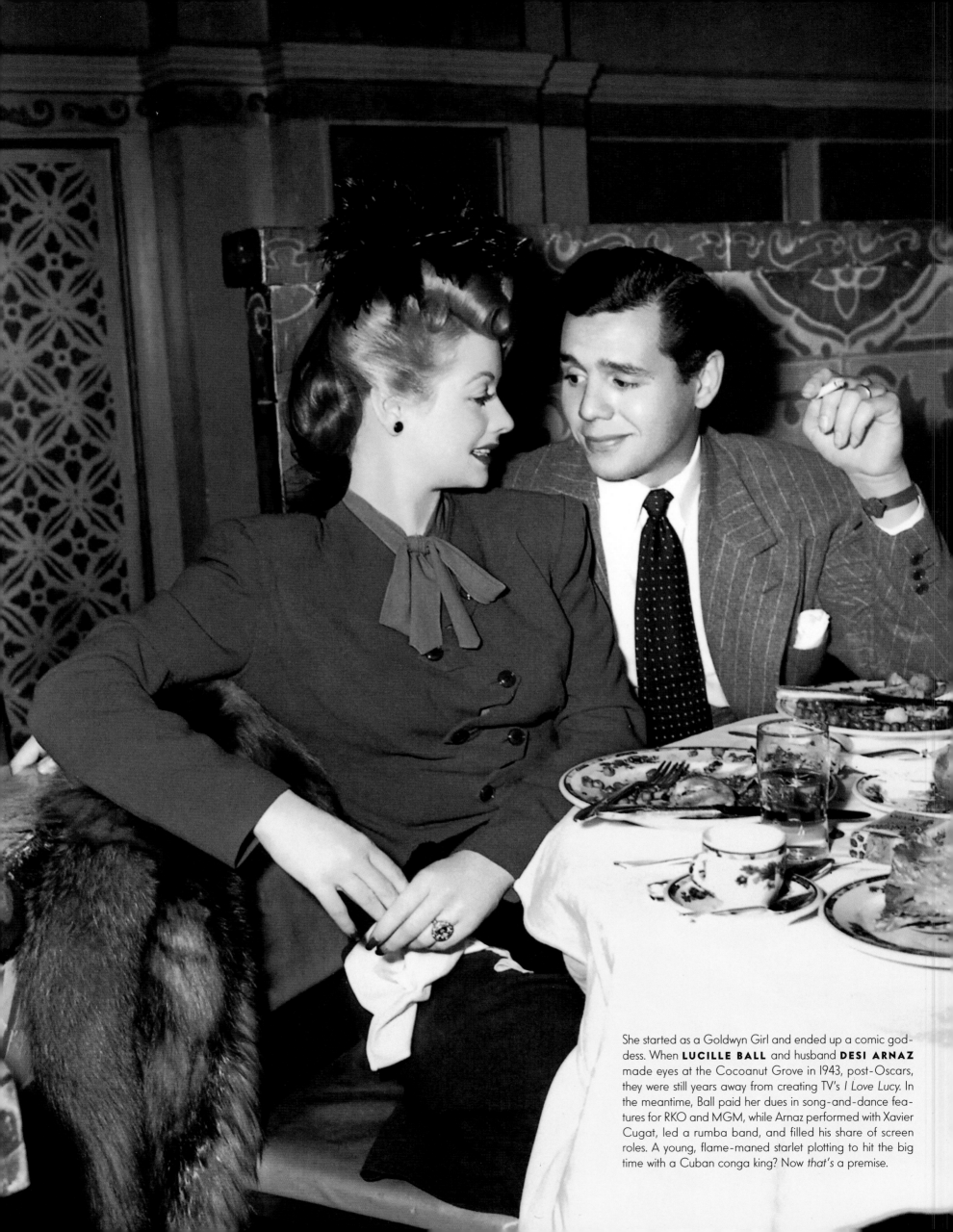

She started as a Goldwyn Girl and ended up a comic goddess. When **LUCILLE BALL** and husband **DESI ARNAZ** made eyes at the Cocoanut Grove in 1943, post-Oscars, they were still years away from creating TV's *I Love Lucy*. In the meantime, Ball paid her dues in song-and-dance features for RKO and MGM, while Arnaz performed with Xavier Cugat, led a rumba band, and filled his share of screen roles. A young, flame-maned starlet plotting to hit the big time with a Cuban conga king? Now *that's* a premise.

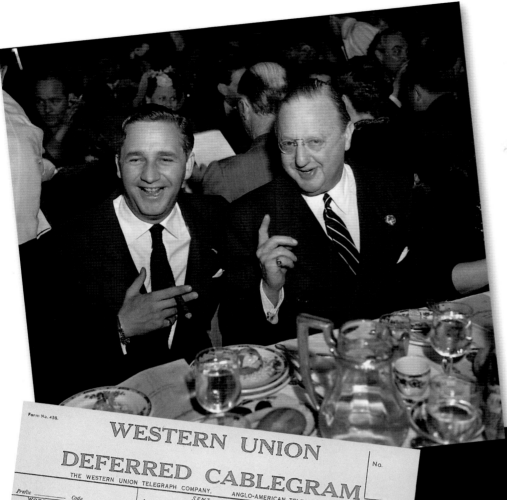

WESTERN UNION
DEFERRED CABLEGRAM

THE WESTERN UNION TELEGRAPH COMPANY. ANGLO-AMERICAN TELEGRAPH Co. Ld.

VIA WESTERN UNION

MRS. WILLIAM WYLER 125 COPA DE ORO ROAD

WEST LOS ANGELES (CALIFORNIA)

DARLING TERRIBLY THRILLED FAMILY ENLARGED BY OSCAR MUST MAKE

POSTWAR PLANS TO BUILD TROPHY ROOM

PLEASE CALL AND THANK FOR CABLES MAMAN BOB JOHN PAUL MACK

MERVYN TOLA LELAND AND ALL MY CONSTITUENTS

ALL MY LOVE DARLING AND DONT LET CATHY PLAY WITH MY NEW DOLL

WILLIAM WYLER

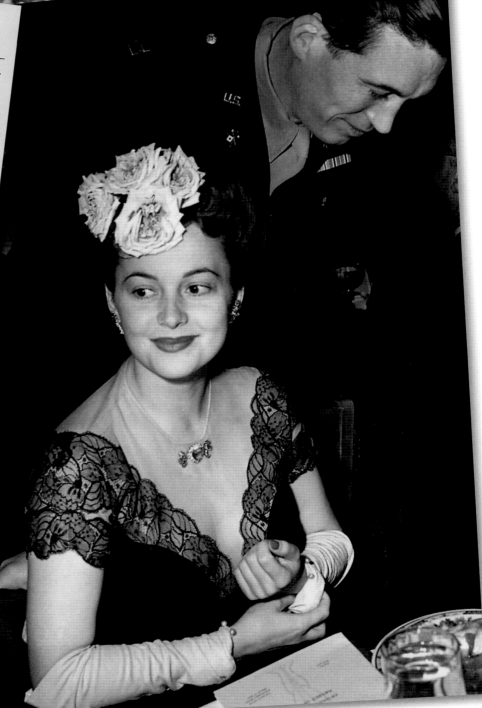

UNCLE OSCAR, MEET UNCLE SAM When his *Mrs. Miniver* was named the 1942 best picture, director William Wyler, named best director, was stationed in England with the 91st Bomb Group. Having come up short four straight years as best director, he sent a cable, *above*, upon learning he'd finally won: TERRIBLY THRILLED FAMILY ENLARGED BY OSCAR MUST MAKE POST-WAR PLANS TO BUILD TROPHY ROOM.... DON'T LET CATHY [daughter Catherine Wyler] PLAY WITH MY NEW DOLL. While *Random Harvest* director Mervyn LeRoy, *top*, at left (up against Wyler that evening), and producer Jesse L. Lasky emoted, Captain John Huston, *right*, stopped by Olivia De Havilland's table. The year before, though accompanied by his wife, Lesley, Huston had spent a fair stretch of the night blowing kisses at De Havilland. In 1949 her first husband, Marcus Goodrich, would come to the Oscars in a cape, supposedly intent on threatening his wife's former flame. "I was told he had a gun inside the cape," Huston later said. "He wanted to shoot me that night."

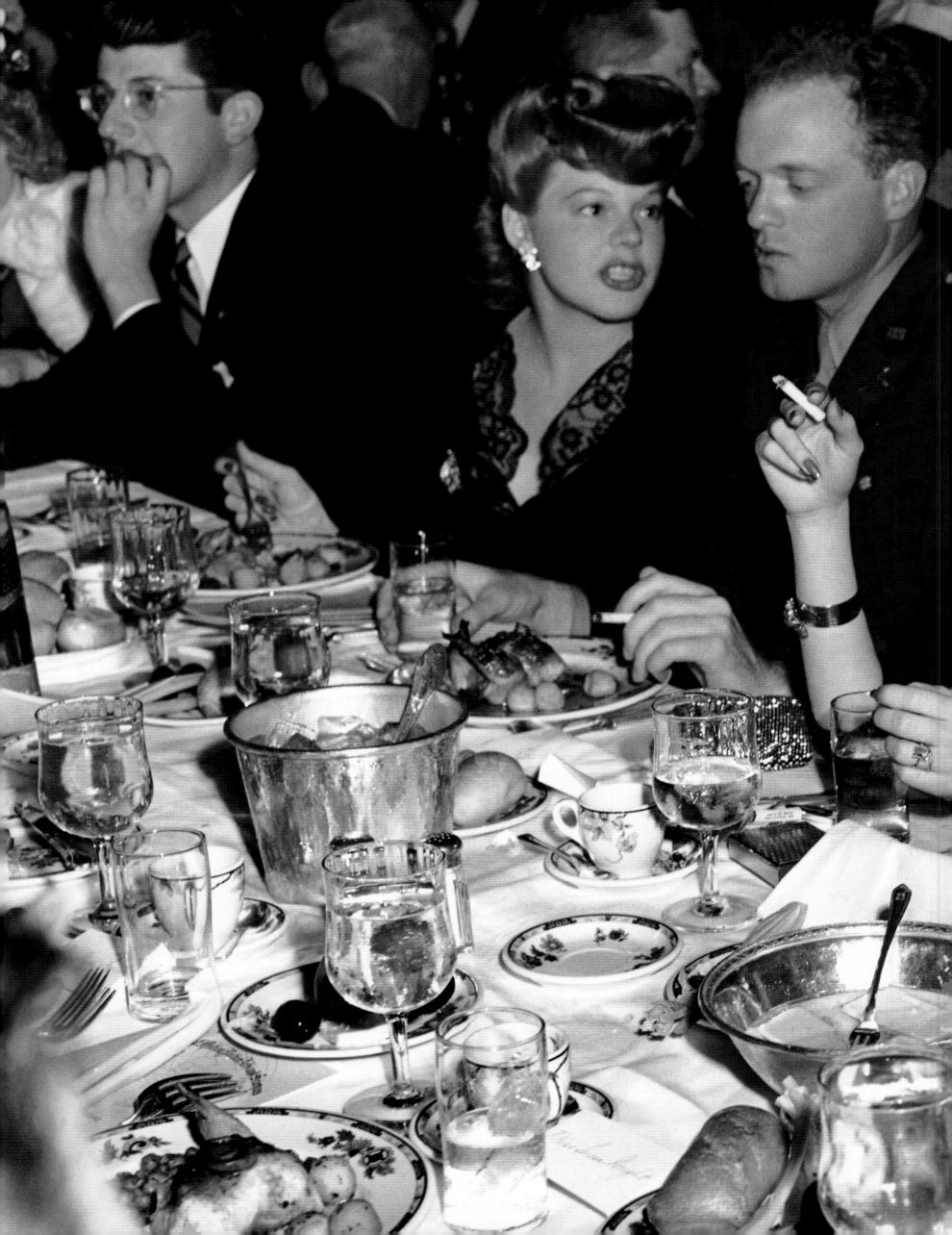

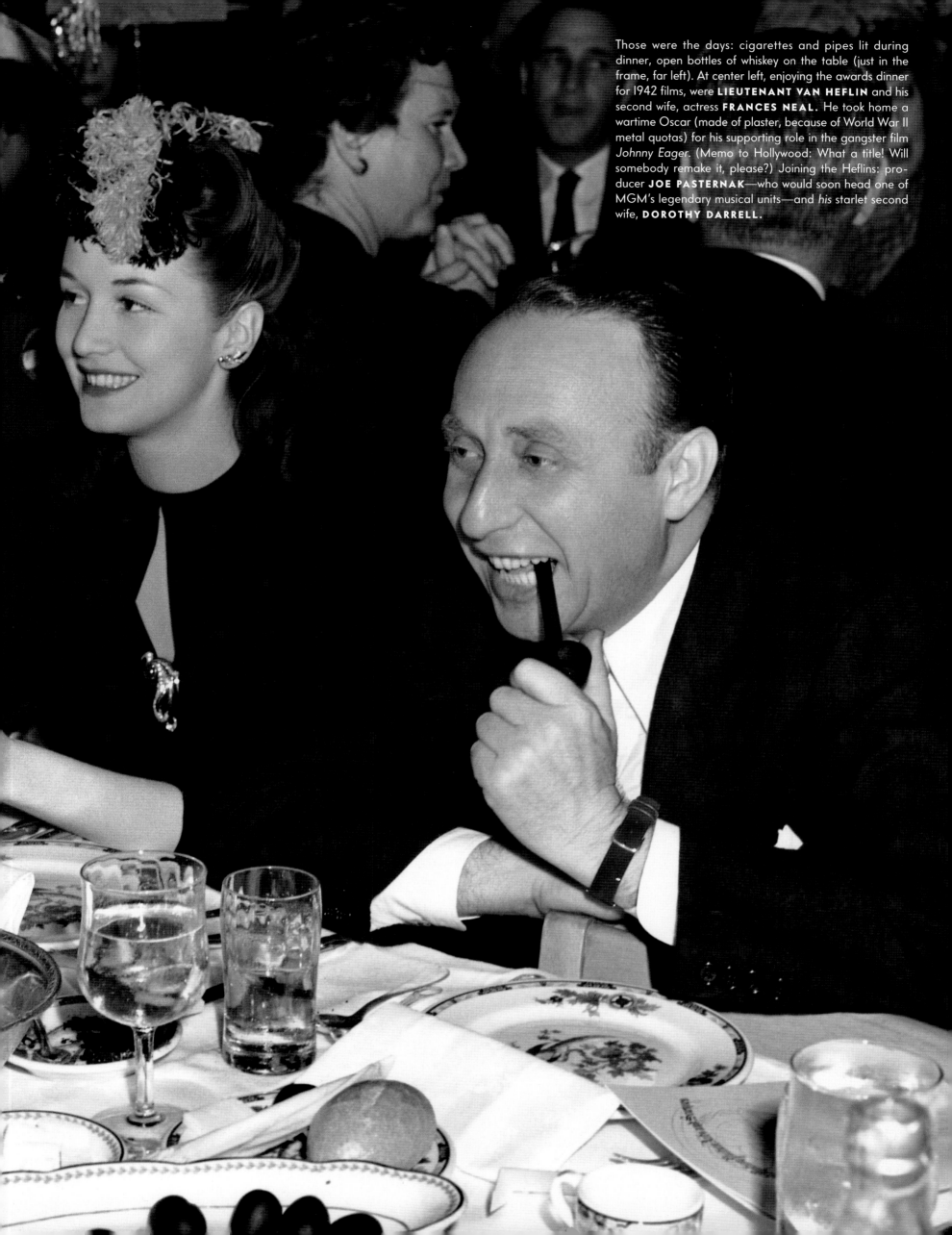

Those were the days: cigarettes and pipes lit during dinner, open bottles of whiskey on the table (just in the frame, far left). At center left, enjoying the awards dinner for 1942 films, were **LIEUTENANT VAN HEFLIN** and his second wife, actress **FRANCES NEAL.** He took home a wartime Oscar (made of plaster, because of World War II metal quotas) for his supporting role in the gangster film *Johnny Eager.* (Memo to Hollywood: What a title! Will somebody remake it, please?) Joining the Heflins: producer **JOE PASTERNAK**—who would soon head one of MGM's legendary musical units—and *his* starlet second wife, **DOROTHY DARRELL.**

GRAUMAN'S CHINESE THEATRE THURSDAY MARCH 2, 1944

SIXTEENTH ANNUAL AWARDS

ACADEMY OF MOTION PICTURE ARTS AND SCIENCES

SIXTEENTH ANNUAL AWARDS

1944

Oscar parties have always reflected the tenor of their times. In 1942, just three months after the assault on Pearl Harbor, guests mourned the loss of Carole Lombard, who, at 34, had perished in a bond-drive plane crash. In 1943, the stars wore an abundance of bars and brass as Air Corps private Alan Ladd and Marine Corps private Tyrone Power, according to Robert Osborne in *75 Years of the Oscar*, unfurled a flag with a design representing the "27,677 members of the motion picture industry . . . in uniform." Near the end of World War II, Louella Parsons's columns were punctuated with military flourishes: "There was a lot of gold braid at the [Walter] Wanger party. I had a talk with Colonel [Henry T. Myers] who flew the President back from Yalta."

With a world conflict raging (not to mention wartime fabric restrictions and shuttered couture houses in Paris), Academy chieftains issued an edict: Oscar galas would be informal, "with no tuxedos or full dress suits permitted"; one press release advised women to "wear dinner dresses either street or floor length with simplicity the keynote of the evening. Decolletage, however, is very definitely out." Lavish feasts seemed in poor taste as well, so in 1944 the awards ceremony was moved from a ballroom, for the first time, to an auditorium—a venue more theatrical than purely festive, and one which could accommodate plenty of men and women from the armed forces as spectators. Henceforth (until 1958, in fact, when a formal Oscar ball was re-introduced), the corresponding after-parties would be held at more discreet haunts—nightspots such as Mocambo, Ciro's, and Romanoff's. *Daily Variety,* in 1944, bemoaned the fact that the banquet had given way to the banquette: "All of the colorfulness of previous Academy Awards that took place in hotels was gone and the 16th annual award was just one of those things, so far as color, warmth and glamor are concerned."

FAR FROM THE THEATER OF WAR Bold times called for a boldly designed program (with Deco, Russian Constructivist, and Fascist touches), *opposite,* for the 1943 awards, held in 1944. The ceremony took place not in a ballroom but at Sid Grauman's ornate Chinese Theatre, *bottom,* which, as *The Hollywood Reporter* put it, made way for "three hundred soldiers, marines, gobs and WAVES." Fittingly, winners such as Charles Coburn (for *The More the Merrier*), *below,* at right, and Jennifer Jones (for *The Song of Bernadette,* celebrating her 25th birthday that evening) turned out in ties and understated gowns. Though Ingrid Bergman, *center,* right, having appeared in *For Whom the Bell Tolls,* had lost out to Jones that night, the next year she shared top acting honors (for *Gaslight*) with Bing Crosby (for *Going My Way*). Going *his* way, more like it. Crosby was said to have been summoned from a round of golf and had to be coaxed into making the trek to Grauman's. Bergman's Oscar record would prove remarkable: her three acting wins—on a par with Walter Brennan's and Jack Nicholson's—remain second only to Kate Hepburn's four.

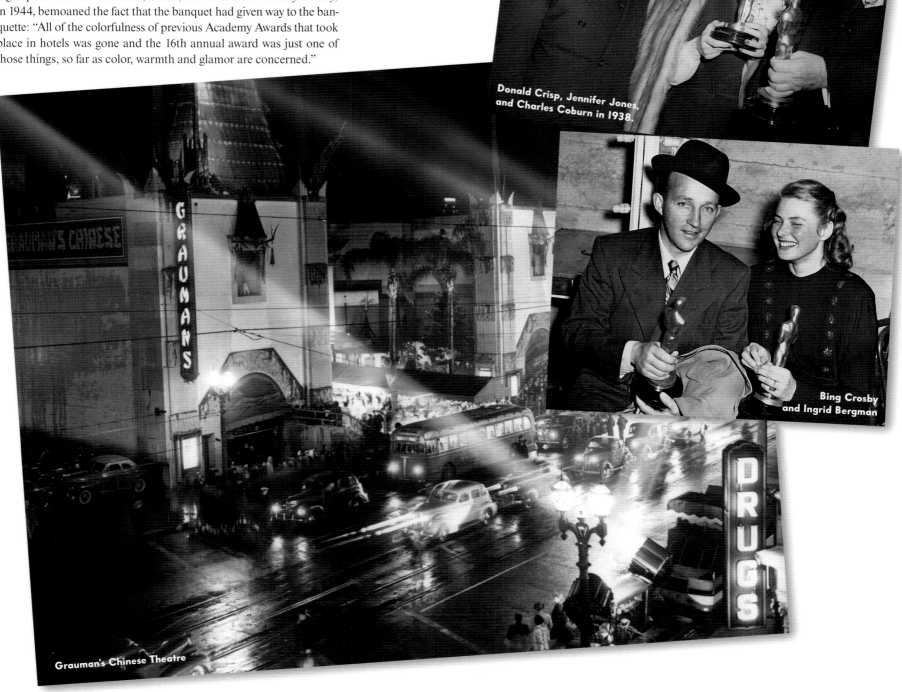

Donald Crisp, Jennifer Jones, and Charles Coburn in 1938.

Bing Crosby and Ingrid Bergman

Grauman's Chinese Theatre

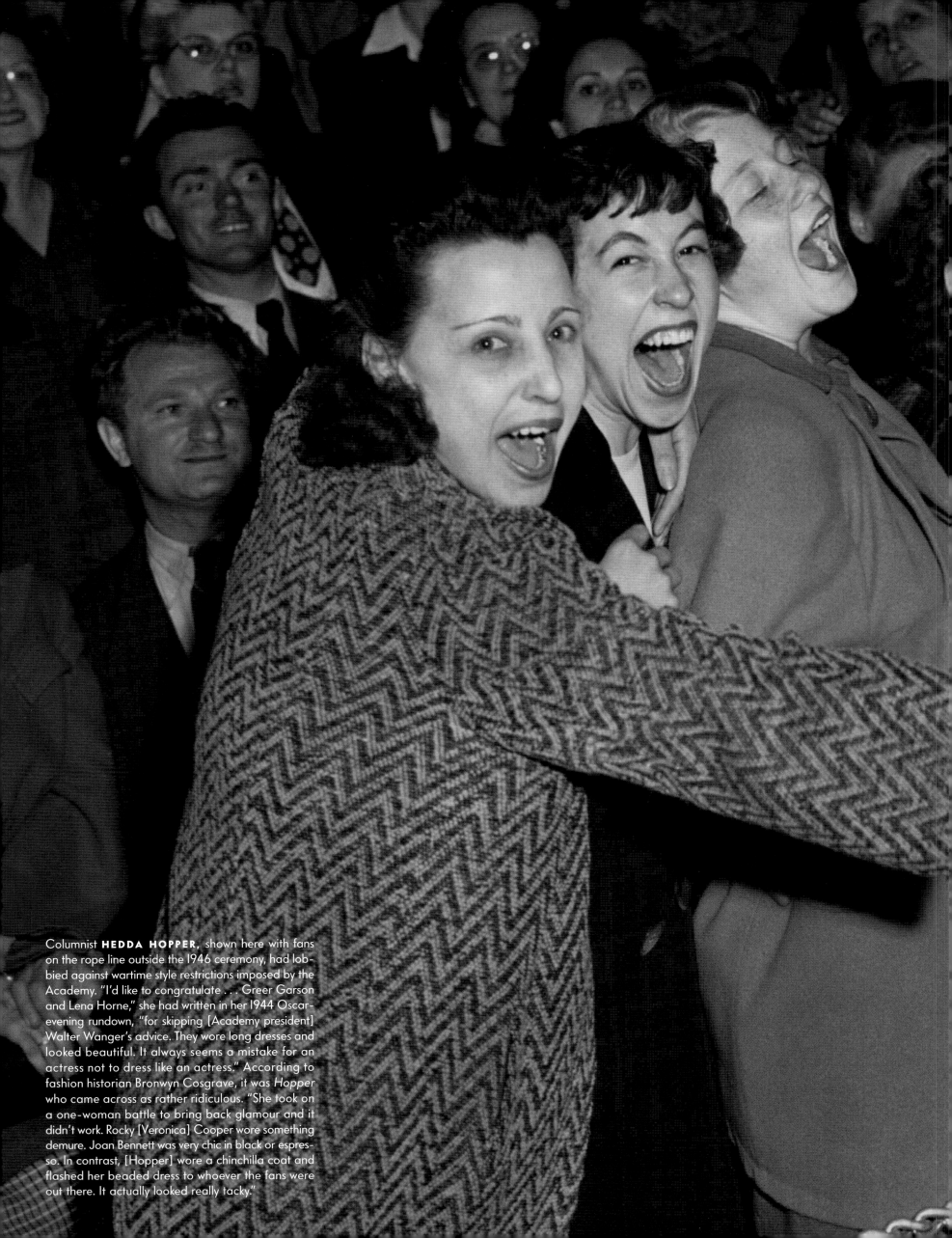

Columnist **HEDDA HOPPER**, shown here with fans on the rope line outside the 1946 ceremony, had lobbied against wartime style restrictions imposed by the Academy. "I'd like to congratulate . . . Greer Garson and Lena Horne," she had written in her 1944 Oscar-evening rundown, "for skipping [Academy president] Walter Wanger's advice. They wore long dresses and looked beautiful. It always seems a mistake for an actress not to dress like an actress." According to fashion historian Bronwyn Cosgrave, it was *Hopper* who came across as rather ridiculous. "She took on a one-woman battle to bring back glamour and it didn't work. Rocky [Veronica] Cooper wore something demure. Joan Bennett was very chic in black or espresso. In contrast, [Hopper] wore a chinchilla coat and flashed her beaded dress to whoever the fans were out there. It actually looked really tacky."

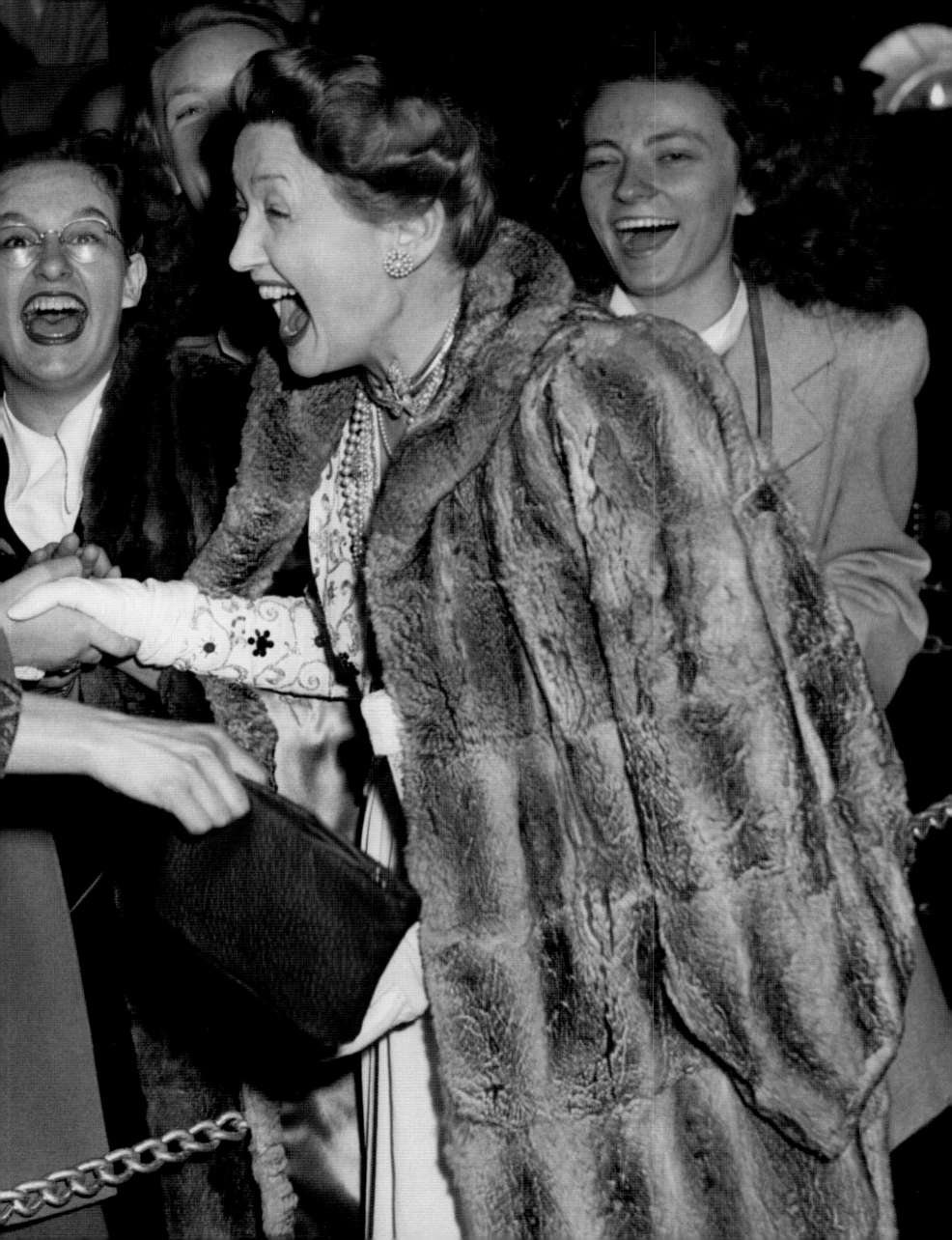

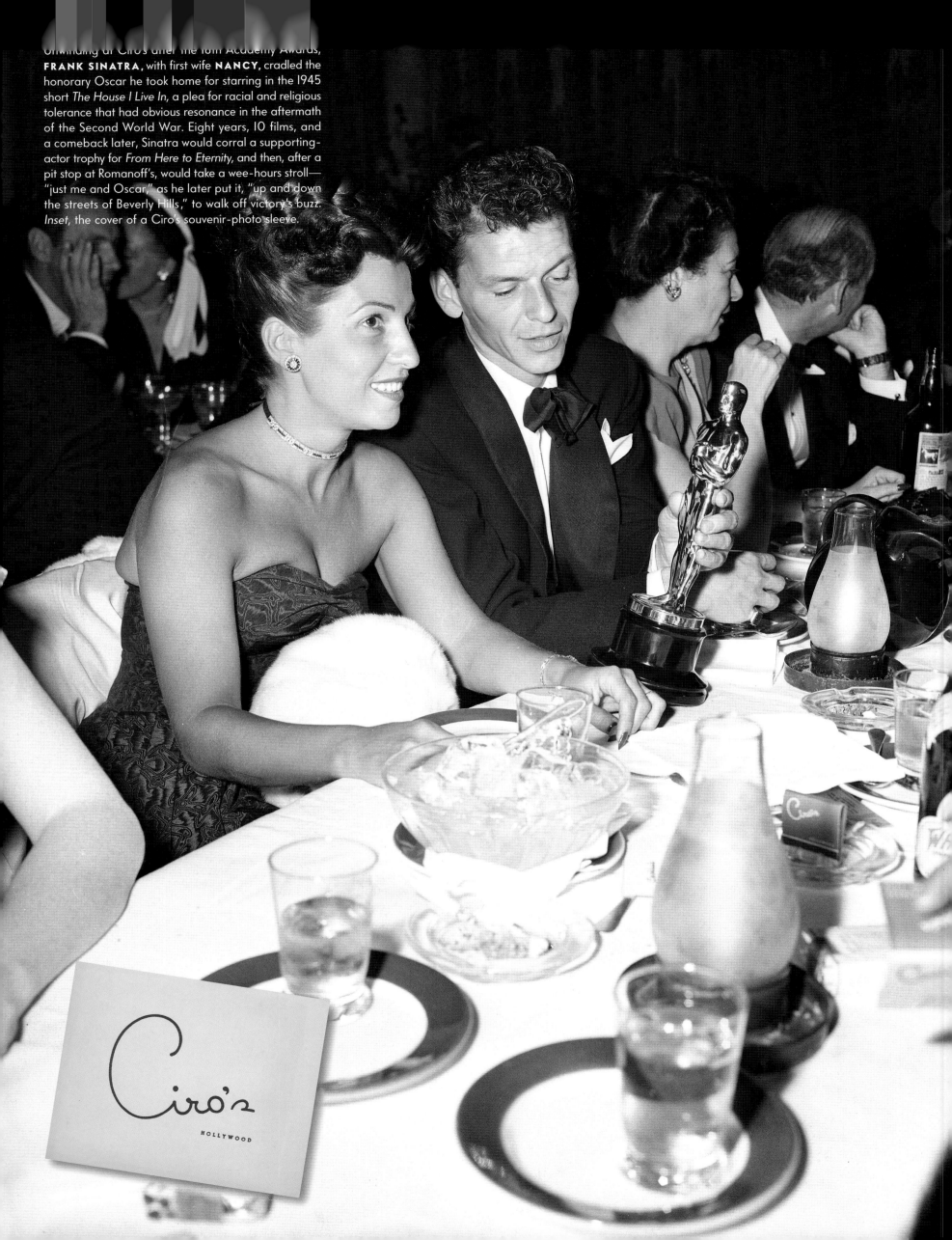

Unwinding at Ciro's after the 16th Academy Awards, **FRANK SINATRA**, with first wife **NANCY**, cradled the honorary Oscar he took home for starring in the 1945 short *The House I Live In*, a plea for racial and religious tolerance that had obvious resonance in the aftermath of the Second World War. Eight years, 10 films, and a comeback later, Sinatra would corral a supporting-actor trophy for *From Here to Eternity*, and then, after a pit stop at Romanoff's, would take a wee-hours stroll—"just me and Oscar," as he later put it, "up and down the streets of Beverly Hills," to walk off victory's buzz. *Inset*, the cover of a Ciro's souvenir-photo sleeve.

Ciro's

HOLLYWOOD

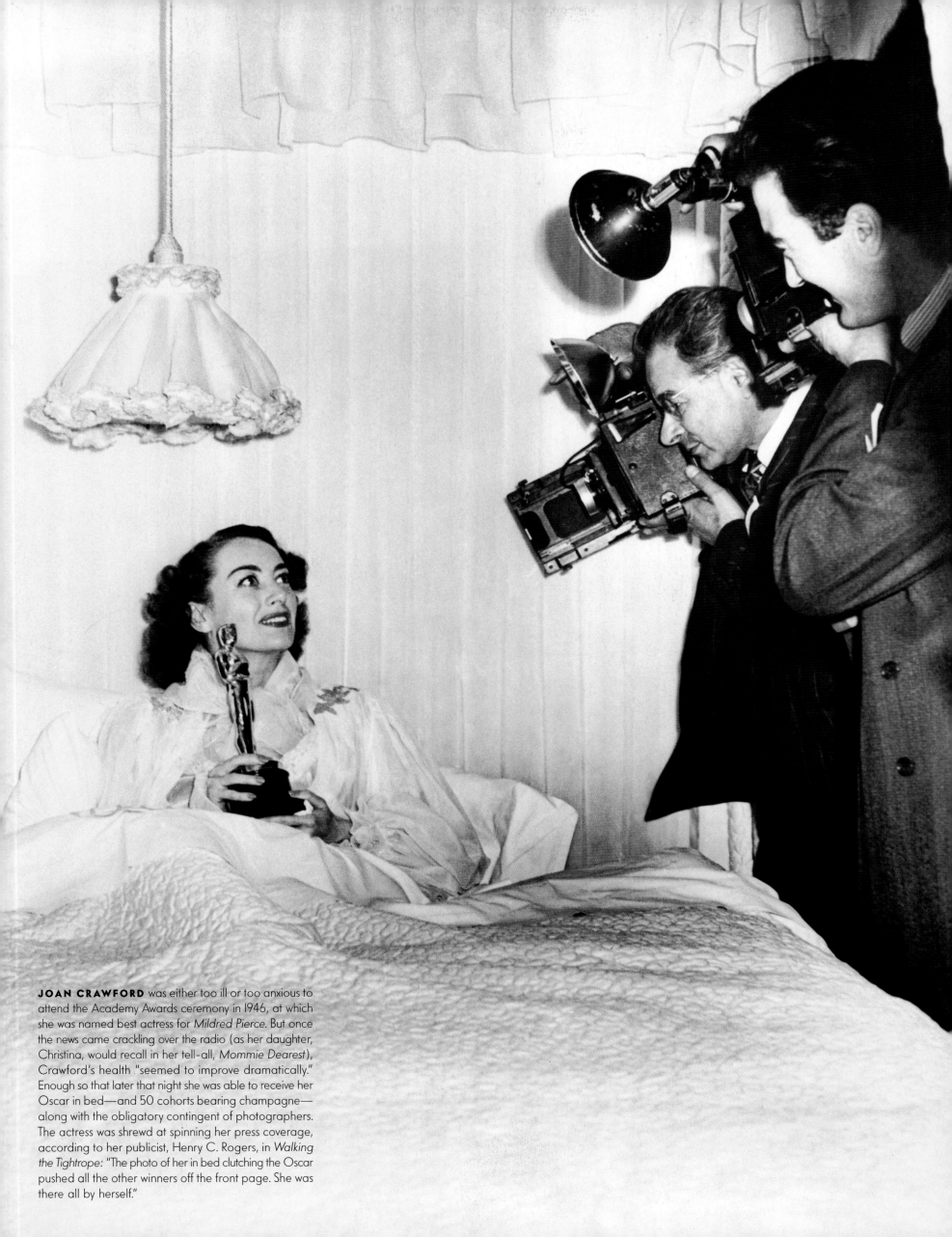

JOAN CRAWFORD was either too ill or too anxious to attend the Academy Awards ceremony in 1946, at which she was named best actress for *Mildred Pierce.* But once the news came crackling over the radio (as her daughter, Christina, would recall in her tell-all, *Mommie Dearest*), Crawford's health "seemed to improve dramatically." Enough so that later that night she was able to receive her Oscar in bed—and 50 cohorts bearing champagne— along with the obligatory contingent of photographers. The actress was shrewd at spinning her press coverage, according to her publicist, Henry C. Rogers, in *Walking the Tightrope:* "The photo of her in bed clutching the Oscar pushed all the other winners off the front page. She was there all by herself."

1947–48

"All the official histories are wrong," says Hollywood fashion expert Bronwyn Cosgrave. "Forget 1929. The first swank Oscar party was held in 1947. That was the year. The war was over. The ermine and sequins came out. It was a time for elegance. They'd been deprived for so long, they went into overdrive with glamour."

While the scene outside the Shrine Civic Auditorium that night hinted at a new level of dazzle and din (5,000 waiting fans, more than a dozen searchlights panning the heavens), the evening's true epicenter of pizzazz was 9955 Beverly Grove Drive, the estate of N. Peter Rathvon, then head of RKO (Radio-Keith-Orpheum). Rathvon and his wife, Helen, an East Coast socialite, decided to welcome 400 of cinema's brightest lights to their hilltop home—formerly owned by actor Charles Boyer—for dinner and dancing after the awards. The *Hollywood Citizen-News* called it "one of the most brilliant events of the social season."

Because of the steep climb to the Rathvons' house, guests were chauffeured there in a fleet of cars. Upon arrival, they encountered a rose garden, a pool, and, arching over the tennis court, "a tent so big," wrote Hedda Hopper, that "RKO workmen had spent a week erecting [it] and beautifying it with borders of blooming jonquils, roses and ferns." That evening Chez Rathvon shimmered with starlets: Joan Fontaine, Dorothy Lamour, Maureen O'Hara. Also on hand were power brokers Harry Cohn, Samuel Goldwyn, California governor Earl Warren, and a 36-year-old Ronald Reagan, the new leader of the Screen Actors Guild. ("He'll make a good president, too," observed Louella Parsons in that week's column.)

The following year, two actresses featured in RKO productions were up for the best-actress title—Rosalind Russell (the favorite, for *Mourning Becomes Electra*) and Loretta Young (*The Farmer's Daughter*)—setting the stage for a dramatic showdown. To mark the occasion, RKO's Rathvon played host again.

Both women attended the ceremony, at which Academy voters shocked the crowd by bestowing the Oscar upon underdog Loretta Young. (Russell actually rose in her seat to head for the stage—only to hear her rival's name announced—supposedly ripping the beads off her necklace in rejection's whiplash.) Next, they went separately to the Mocambo nightclub, to join best-picture winner Darryl Zanuck (for *Gentleman's Agreement*), and nominee Russell insisted on greeting winner Young with open arms.

Finally, the actresses put in command appearances at the Rathvon manse with its enormous tent, a band, and ice sculptures carved by employees of the RKO canteen. "It was exciting," remembers daughter Joan Rathvon Wilson, anticipating the arrival of "two great women. Roz Russell, being very humorous, and Loretta Young, being very serious and committed . . . quite religious—she had prayed that she would win." When they did approach each other, again, a cameraman was positioned to record the hug. "The emotional undercurrent of the evening was this encounter," says Rathvon's younger daughter, Judith Plowden, who recalls dancing with Peter Lawford that evening. "I was 14," she says. "I had a crush on him and I was trembling."

"My parents," her sister, Joan, remembers, "were like children in the forest, looking around at the magic that Hollywood was." That night in 1948, Rathvon actually seemed more Merlin than child, entertaining the film colony's most privileged members in fitting grandeur. And then, quite abruptly, the glitter was gone. Later that year Rathvon would hand in his resignation. Aviation magnate Howard Hughes had swooped in to wrest control of RKO.

With the poise of a consummate actress, **ROSALIND RUSSELL**, *opposite*, right, runner-up for *Mourning Becomes Electra*, graciously embraced **LORETTA YOUNG**, the surprise best-actress winner for *The Farmer's Daughter*. After this pas de deux at the Mocambo, they reconvened at the estate of Peter and Helen Rathvon, who are pictured, *below*, to the right of the two actresses. Rathvon, *bottom*, then dined betwixt the starlets.

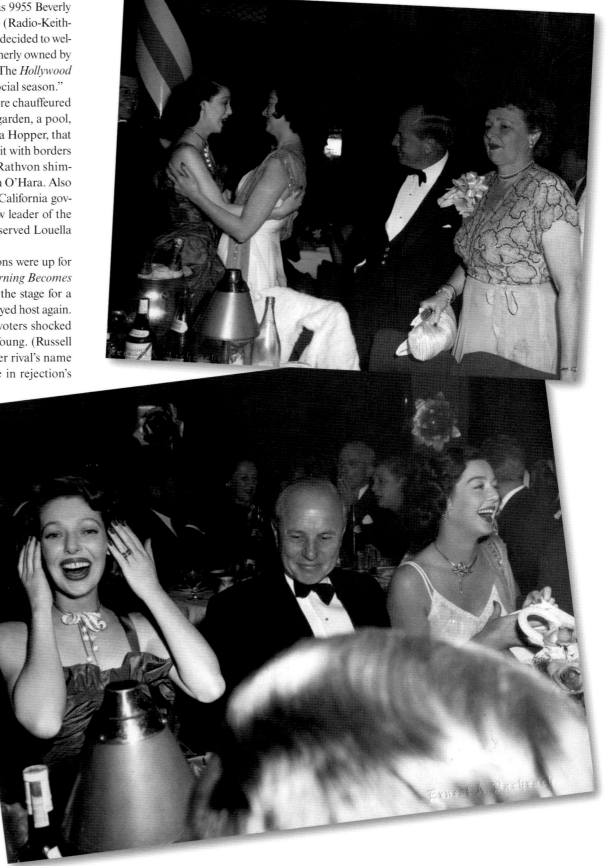

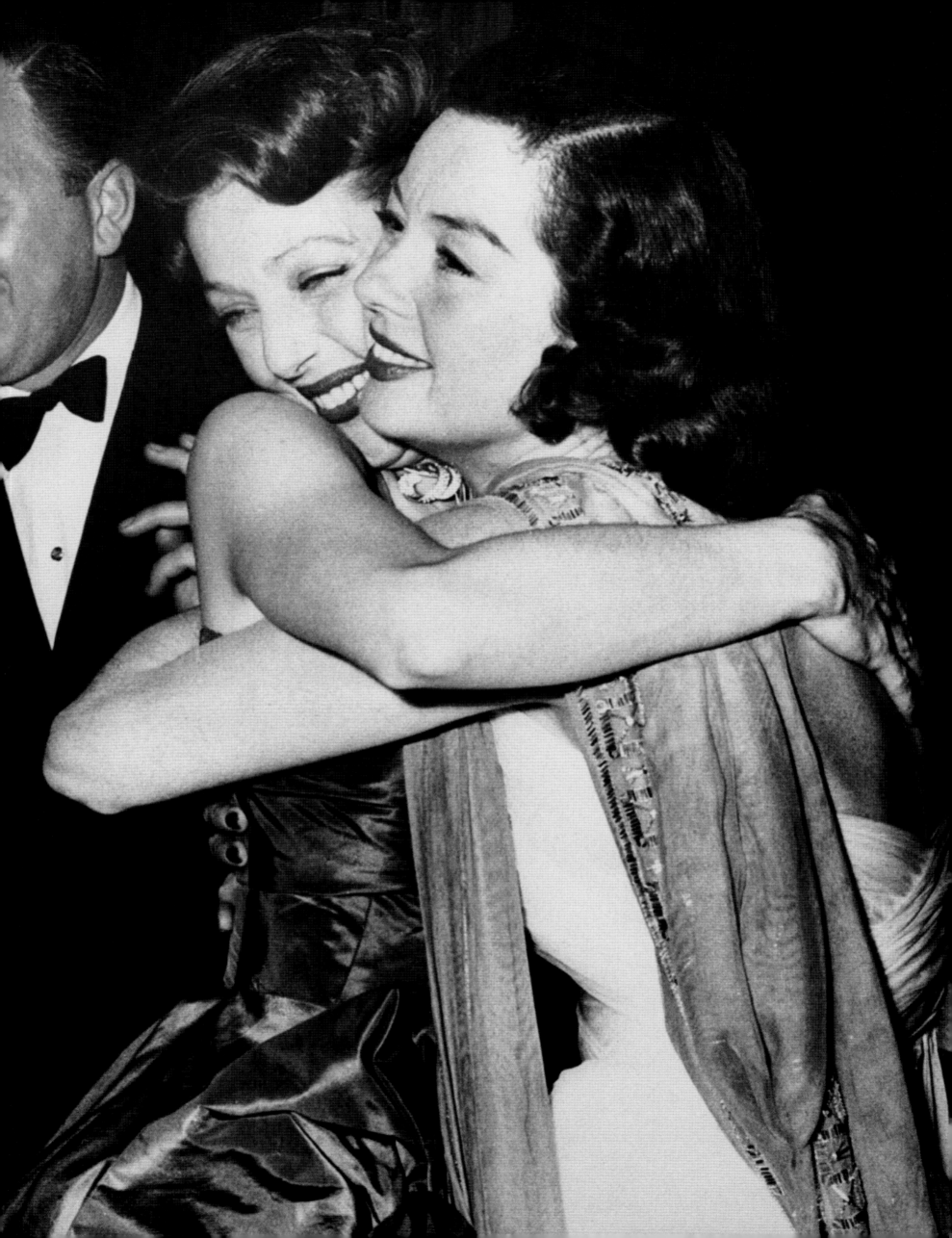

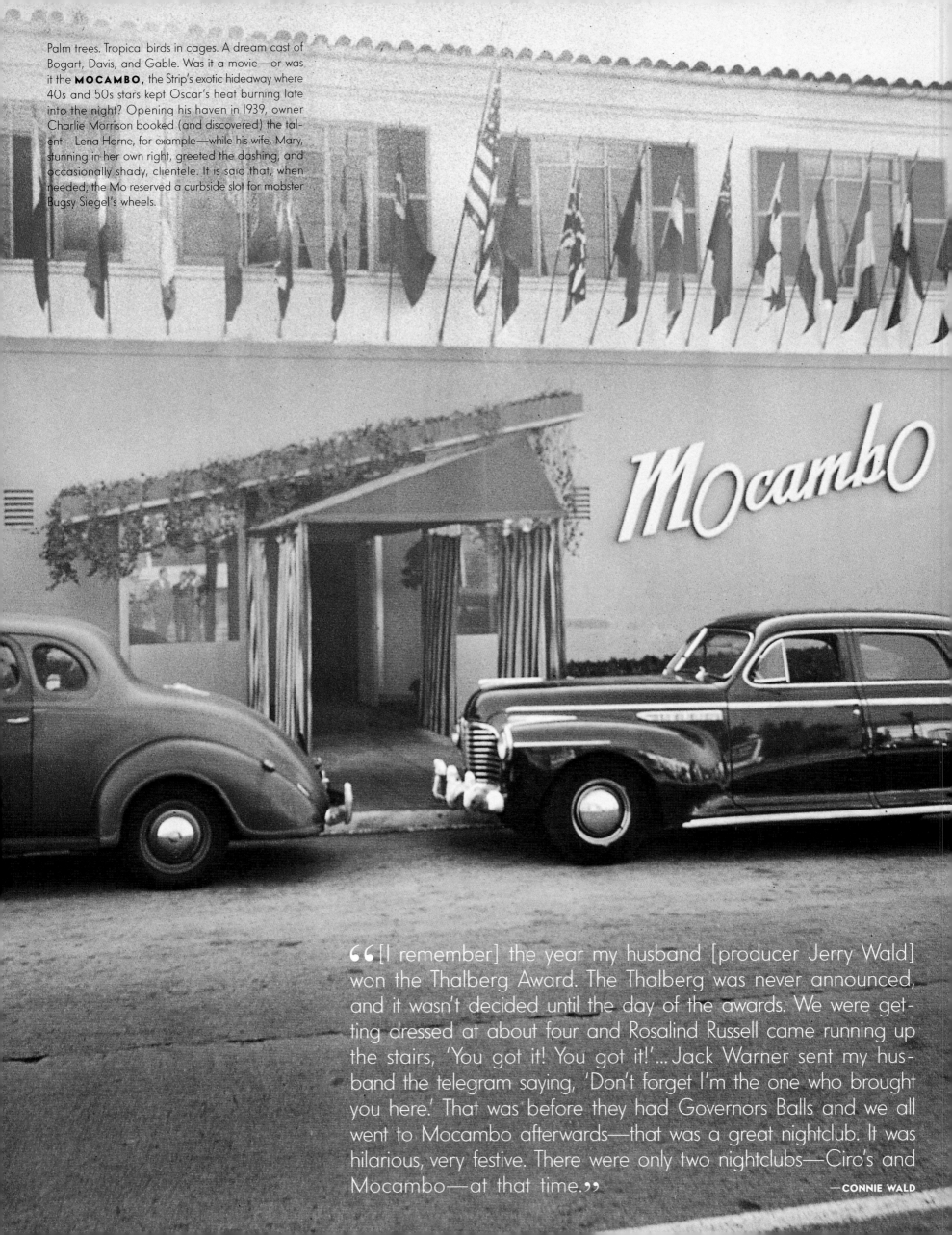

Palm trees. Tropical birds in cages. A dream cast of Bogart, Davis, and Gable. Was it a movie—or was it the **MOCAMBO,** the Strip's exotic hideaway where 40s and 50s stars kept Oscar's heat burning late into the night? Opening his haven in 1939, owner Charlie Morrison booked (and discovered) the talent—Lena Horne, for example—while his wife, Mary, stunning in her own right, greeted the dashing, and occasionally shady, clientele. It is said that, when needed, the Mo reserved a curbside slot for mobster Bugsy Siegel's wheels.

66 [I remember] the year my husband [producer Jerry Wald] won the Thalberg Award. The Thalberg was never announced, and it wasn't decided until the day of the awards. We were getting dressed at about four and Rosalind Russell came running up the stairs, 'You got it! You got it!'...Jack Warner sent my husband the telegram saying, 'Don't forget I'm the one who brought you here.' That was before they had Governors Balls and we all went to Mocambo afterwards—that was a great nightclub. It was hilarious, very festive. There were only two nightclubs—Ciro's and Mocambo—at that time. 99

—CONNIE WALD

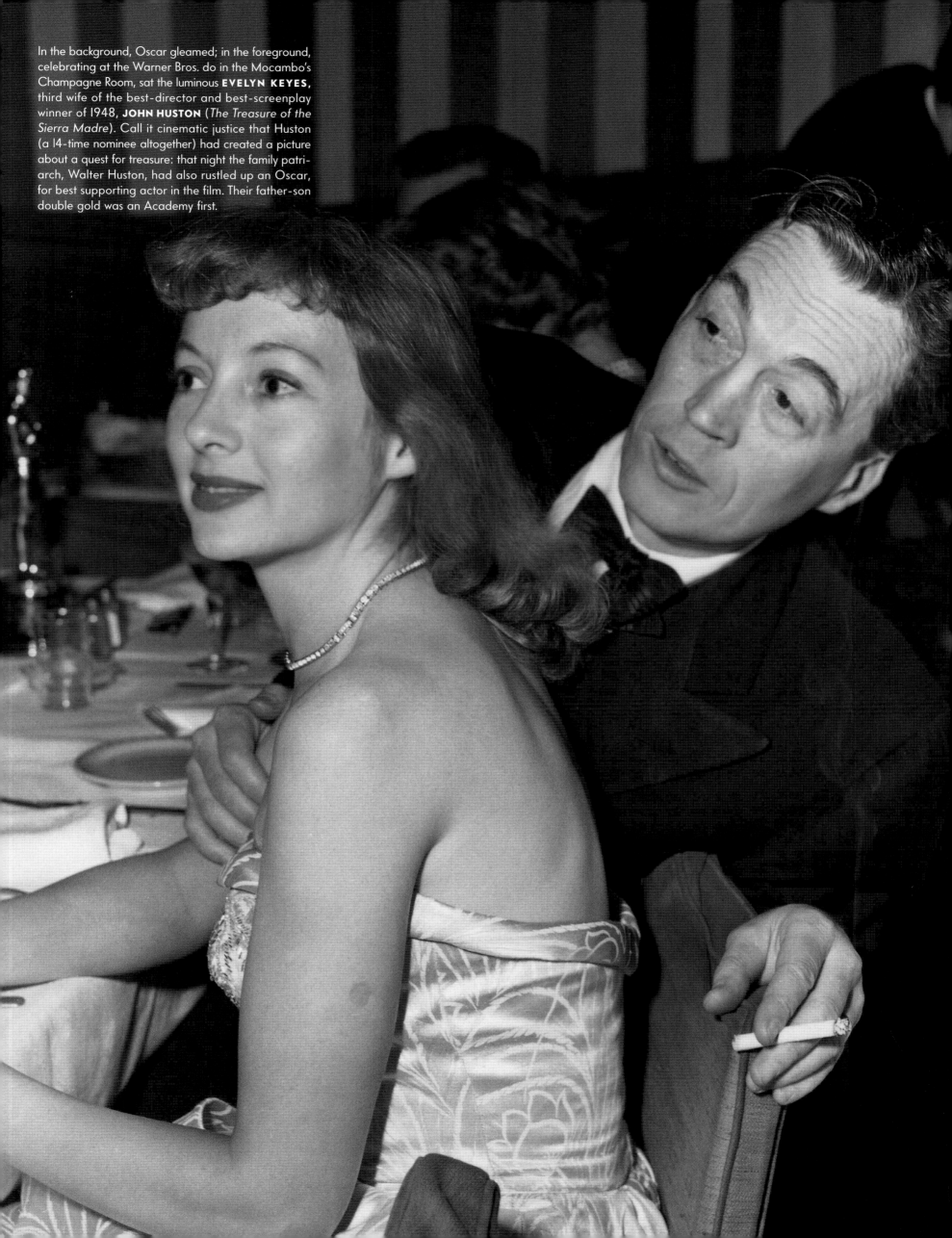

In the background, Oscar gleamed; in the foreground, celebrating at the Warner Bros. do in the Mocambo's Champagne Room, sat the luminous **EVELYN KEYES**, third wife of the best-director and best-screenplay winner of 1948, **JOHN HUSTON** (*The Treasure of the Sierra Madre*). Call it cinematic justice that Huston (a 14-time nominee altogether) had created a picture about a quest for treasure: that night the family patriarch, Walter Huston, had also rustled up an Oscar, for best supporting actor in the film. Their father-son double gold was an Academy first.

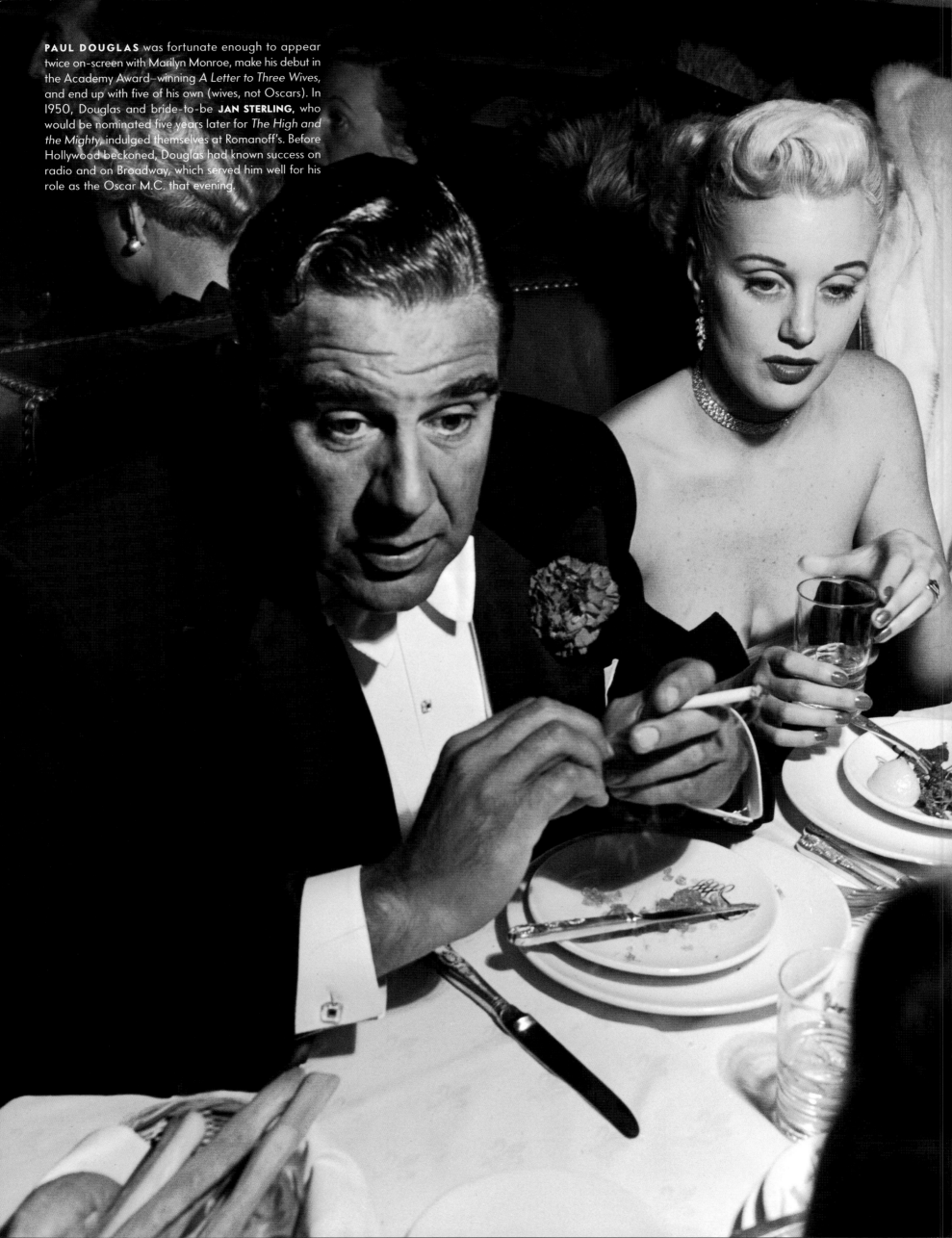

PAUL DOUGLAS was fortunate enough to appear twice on-screen with Marilyn Monroe, make his debut in the Academy Award–winning *A Letter to Three Wives*, and end up with five of his own (wives, not Oscars). In 1950, Douglas and bride-to-be **JAN STERLING**, who would be nominated five years later for *The High and the Mighty*, indulged themselves at Romanoff's. Before Hollywood beckoned, Douglas had known success on radio and on Broadway, which served him well for his role as the Oscar M.C. that evening.

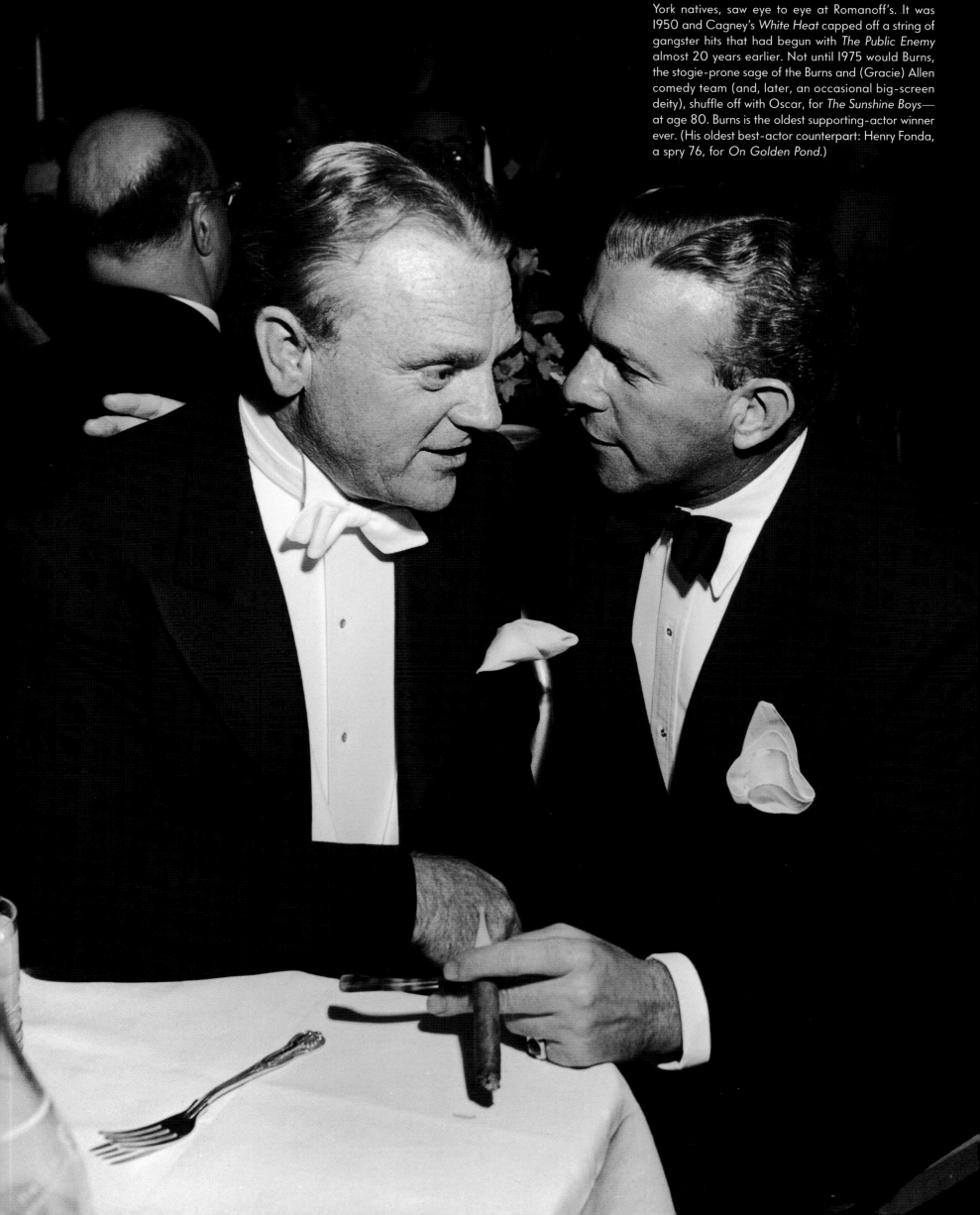

York natives, saw eye to eye at Romanoff's. It was 1950 and Cagney's *White Heat* capped off a string of gangster hits that had begun with *The Public Enemy* almost 20 years earlier. Not until 1975 would Burns, the stogie-prone sage of the Burns and (Gracie) Allen comedy team (and, later, an occasional big-screen deity), shuffle off with Oscar, for *The Sunshine Boys*— at age 80. Burns is the oldest supporting-actor winner ever. (His oldest best-actor counterpart: Henry Fonda, a spry 76, for *On Golden Pond*.)

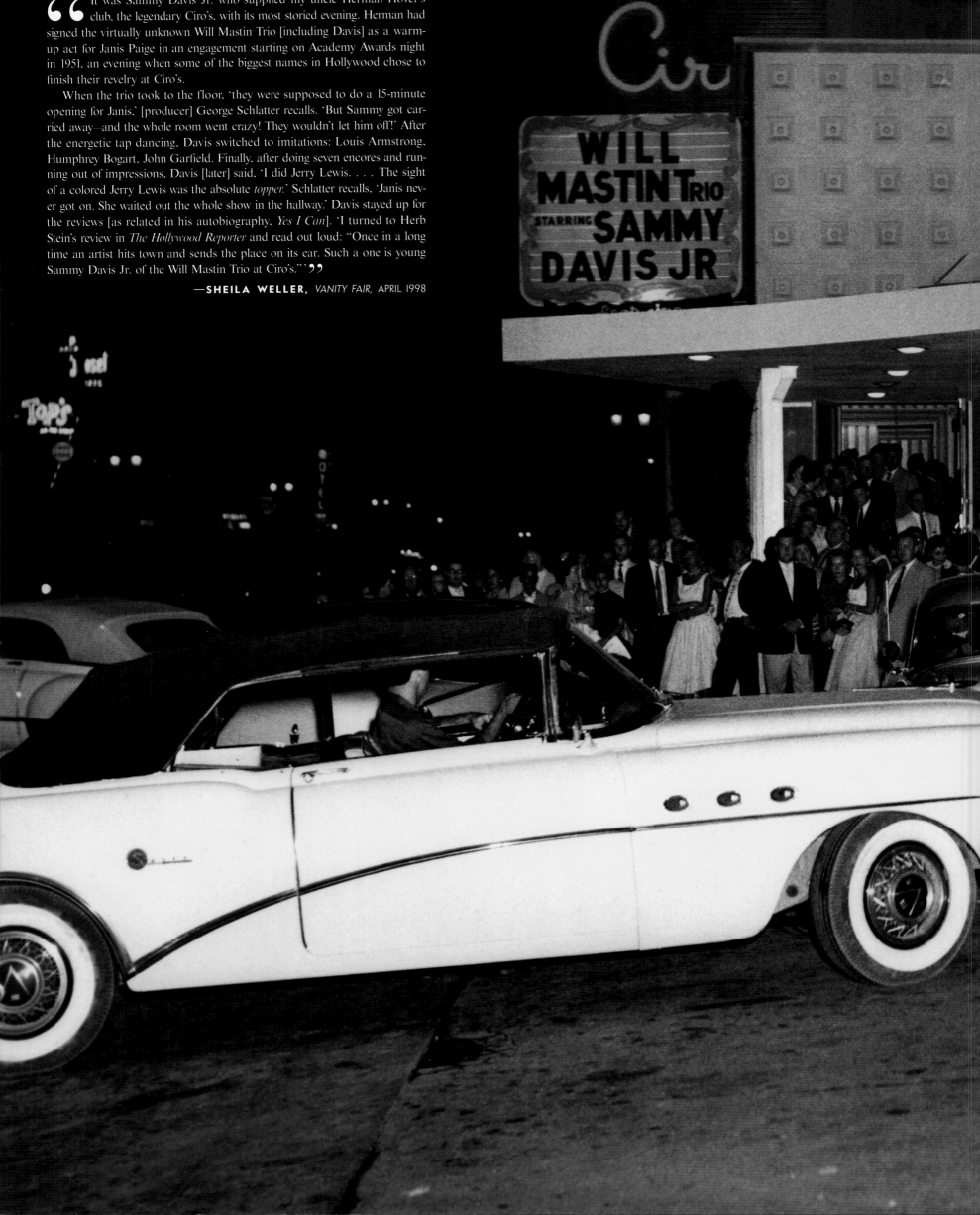

"It was Sammy Davis Jr. who supplied my uncle Herman Hover's club, the legendary Ciro's, with its most storied evening. Herman had signed the virtually unknown Will Mastin Trio [including Davis] as a warm-up act for Janis Paige in an engagement starting on Academy Awards night in 1951, an evening when some of the biggest names in Hollywood chose to finish their revelry at Ciro's.

When the trio took to the floor, 'they were supposed to do a 15-minute opening for Janis,' [producer] George Schlatter recalls. 'But Sammy got carried away—and the whole room went crazy! They wouldn't let him off!' After the energetic tap dancing, Davis switched to imitations: Louis Armstrong, Humphrey Bogart, John Garfield. Finally, after doing seven encores and running out of impressions, Davis [later] said, 'I did Jerry Lewis. . . . The sight of a colored Jerry Lewis was the absolute *topper.*' Schlatter recalls, 'Janis never got on. She waited out the whole show in the hallway.' Davis stayed up for the reviews [as related in his autobiography, *Yes I Can*]. 'I turned to Herb Stein's review in *The Hollywood Reporter* and read out loud: "Once in a long time an artist hits town and sends the place on its ear. Such a one is young Sammy Davis Jr. of the Will Mastin Trio at Ciro's."'"

—**SHEILA WELLER,** *VANITY FAIR, APRIL 1998*

"Featuring the most beautiful girls in the world"

Ciro's

↓ PARKING ENTER HERE

Café Trocadero owner Billy Wilkerson started his next Sunset Boulevard sensation, **CIRO'S**, in 1940, and soon Tinseltown's finest were holding court at its coveted tables. After Herman Hover took over as host (Mickey Rooney played headwaiter on reopening night in '42), the nightclub went stratospheric. The white-hot comedy team of Dean Martin and Jerry Lewis, aided by its Ciro's gigs, continued its rise to prominence. Stripper Lili St. Cyr would loll in a mammoth champagne glass (for guests such as Walter Winchell and Marilyn Monroe). One night director Anatole Litvak even dove under a table to service Paulette Goddard as onlookers leered. The club, shown here in the early 50s (Sammy Davis Jr. and the Will Mastin Trio took second billing on Oscar night 1951), would be auctioned off in November 1959. In its place would spring another marker of success on the Strip: the Comedy Store.

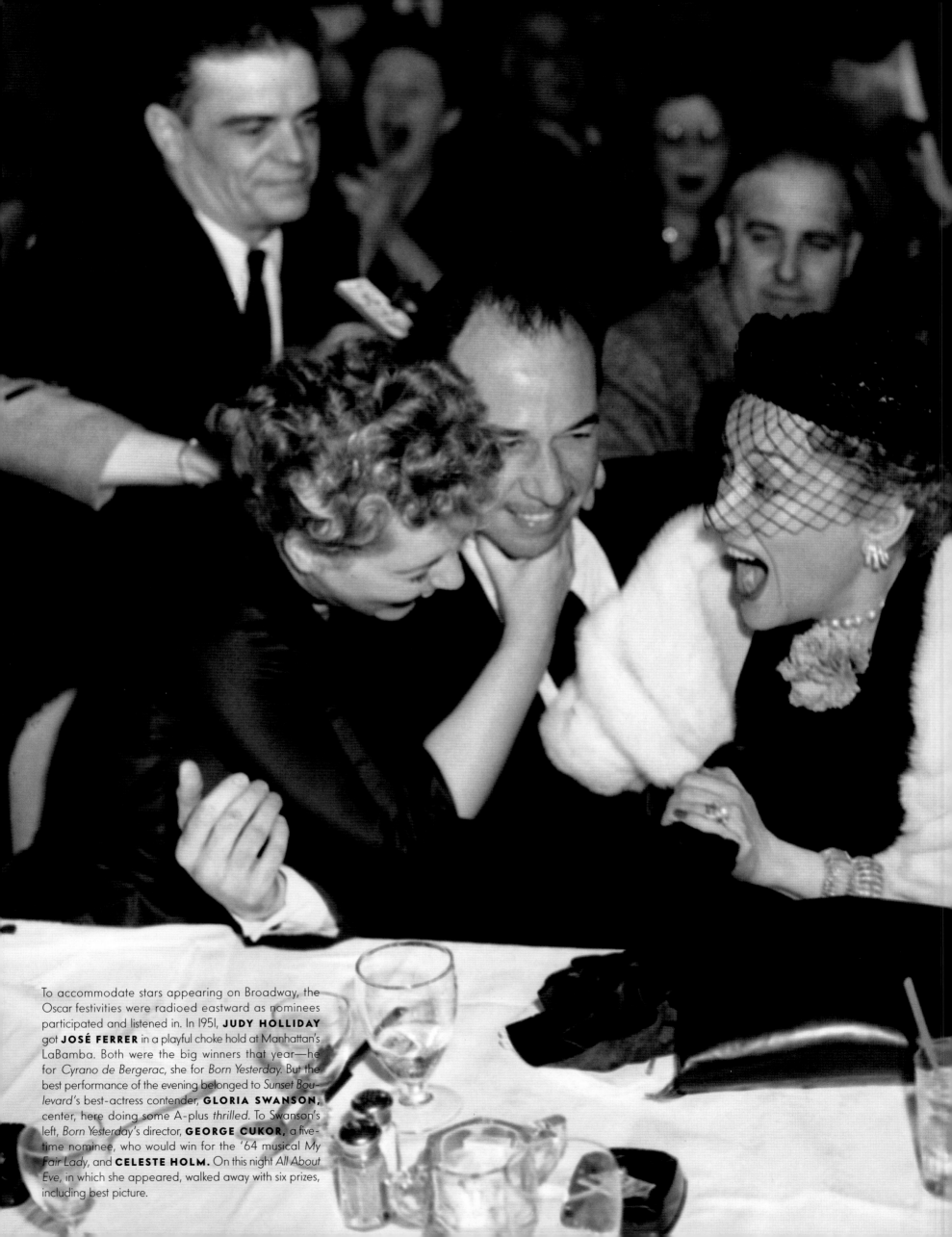

To accommodate stars appearing on Broadway, the Oscar festivities were radioed eastward as nominees participated and listened in. In 1951, **JUDY HOLLIDAY** got **JOSÉ FERRER** in a playful choke hold at Manhattan's LaBamba. Both were the big winners that year—he for *Cyrano de Bergerac*, she for *Born Yesterday*. But the best performance of the evening belonged to *Sunset Boulevard*'s best-actress contender, **GLORIA SWANSON,** center, here doing some A-plus *thrilled*. To Swanson's left, *Born Yesterday*'s director, **GEORGE CUKOR,** a five-time nominee, who would win for the '64 musical *My Fair Lady*, and **CELESTE HOLM.** On this night *All About Eve*, in which she appeared, walked away with six prizes, including best picture.

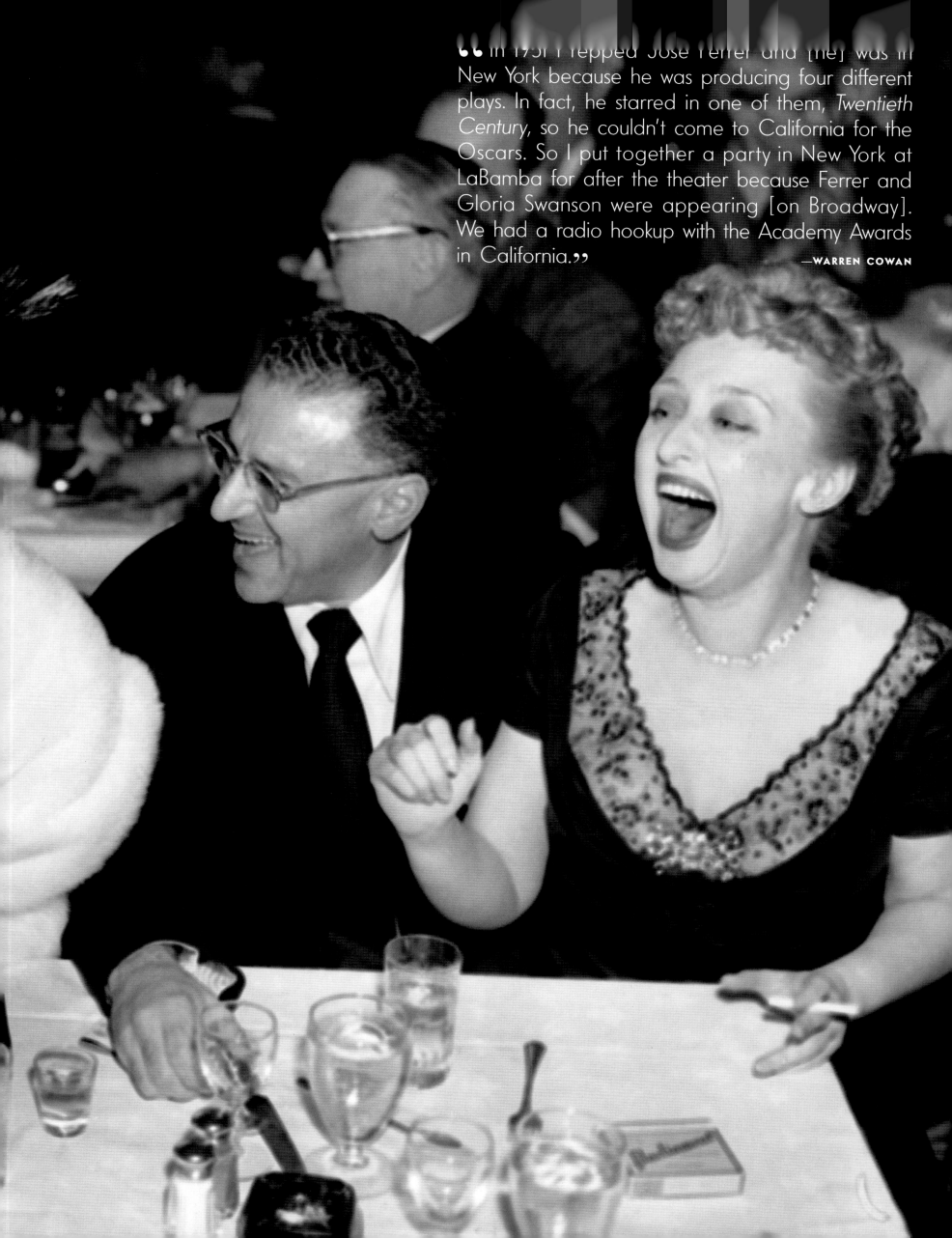

"In 1951 I repped Jose Ferrer and [he] was in New York because he was producing four different plays. In fact, he starred in one of them, *Twentieth Century*, so he couldn't come to California for the Oscars. So I put together a party in New York at LaBamba for after the theater because Ferrer and Gloria Swanson were appearing [on Broadway]. We had a radio hookup with the Academy Awards in California."

—WARREN COWAN

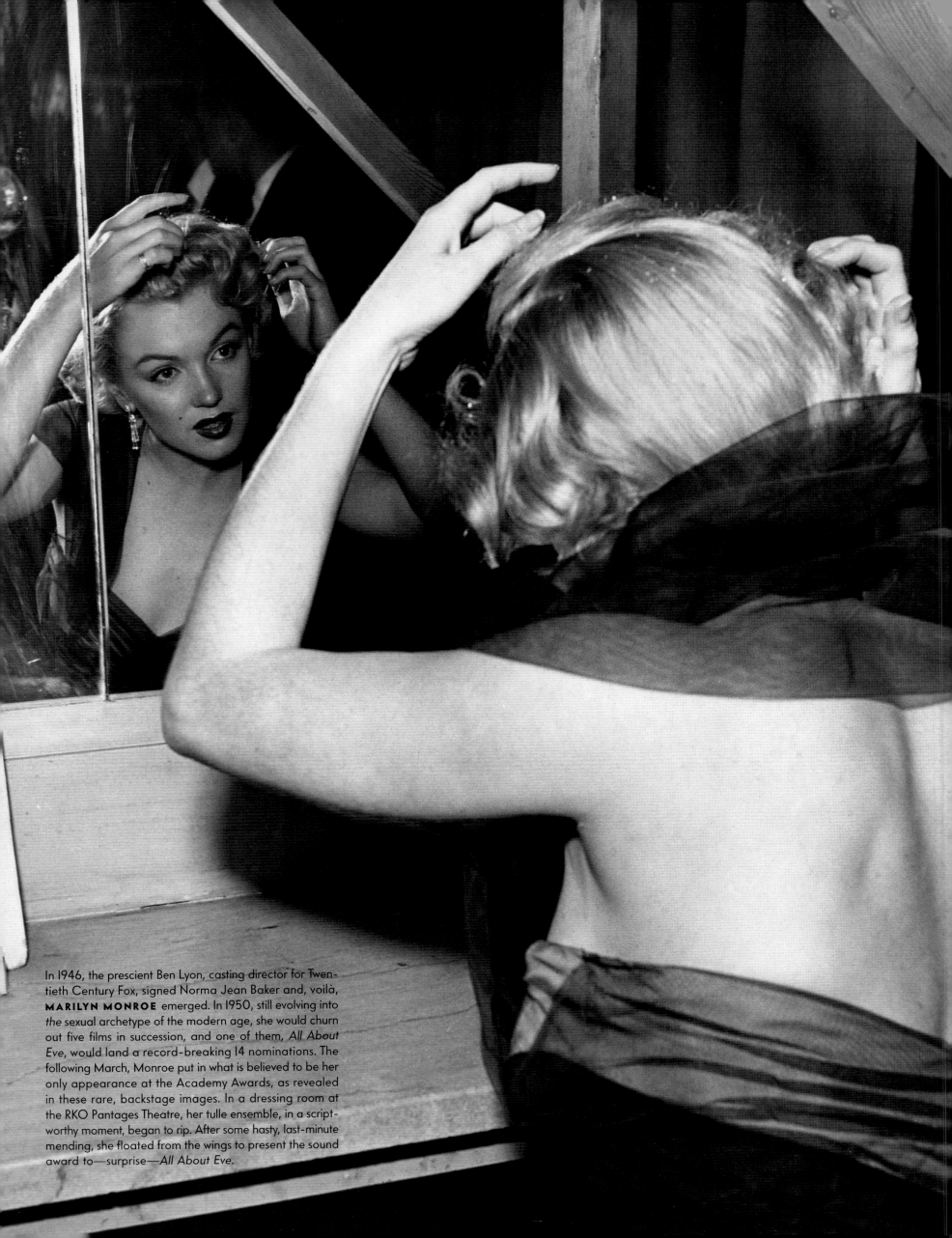

In 1946, the prescient Ben Lyon, casting director for Twentieth Century Fox, signed Norma Jean Baker and, voilà, **MARILYN MONROE** emerged. In 1950, still evolving into *the* sexual archetype of the modern age, she would churn out five films in succession, and one of them, *All About Eve*, would land a record-breaking 14 nominations. The following March, Monroe put in what is believed to be her only appearance at the Academy Awards, as revealed in these rare, backstage images. In a dressing room at the RKO Pantages Theatre, her tulle ensemble, in a script-worthy moment, began to rip. After some hasty, last-minute mending, she floated from the wings to present the sound award to—surprise—*All About Eve*.

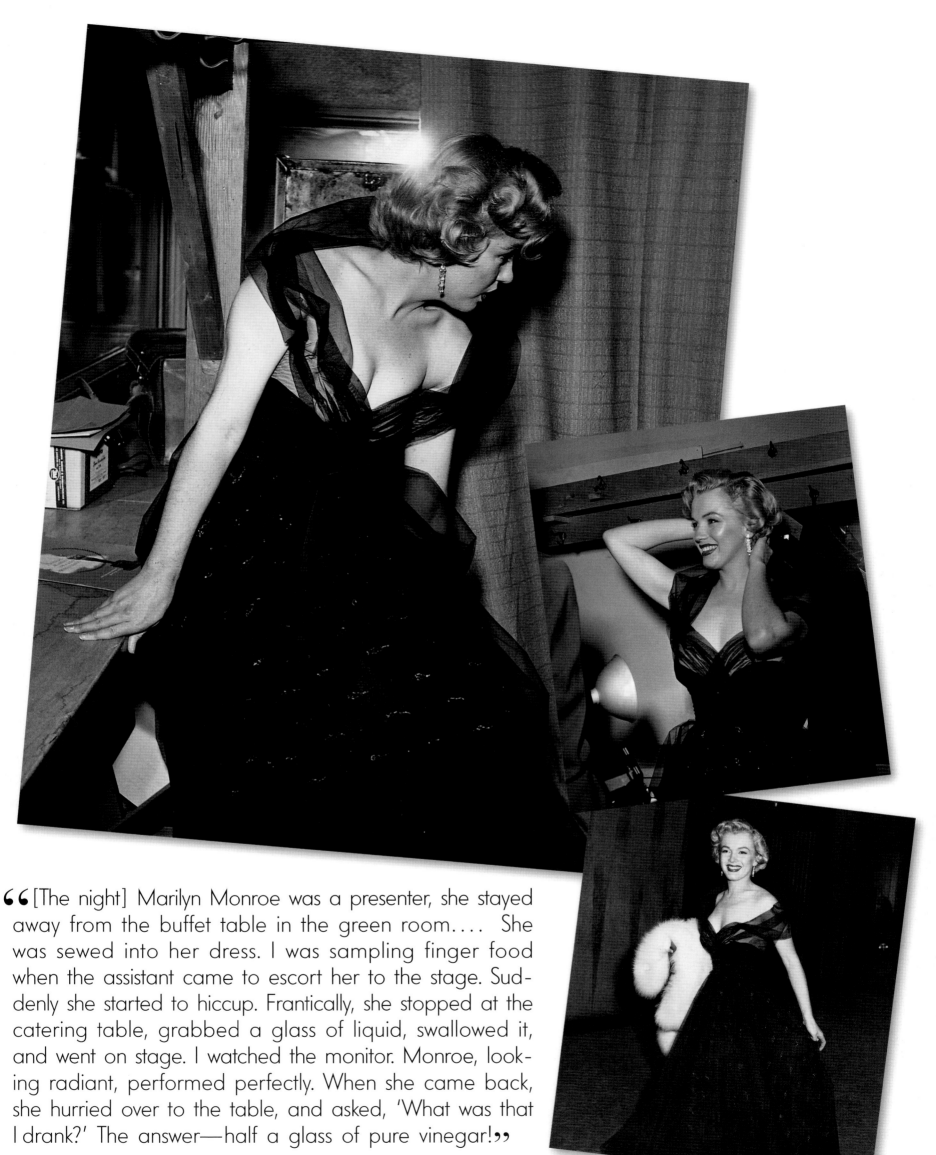

66 [The night] Marilyn Monroe was a presenter, she stayed away from the buffet table in the green room.... She was sewed into her dress. I was sampling finger food when the assistant came to escort her to the stage. Suddenly she started to hiccup. Frantically, she stopped at the catering table, grabbed a glass of liquid, swallowed it, and went on stage. I watched the monitor. Monroe, looking radiant, performed perfectly. When she came back, she hurried over to the table, and asked, 'What was that I drank?' The answer—half a glass of pure vinegar! 99

—COLUMNIST **BONNIE CHURCHILL**
THE CHRISTIAN SCIENCE MONITOR, MARCH 24, 2000

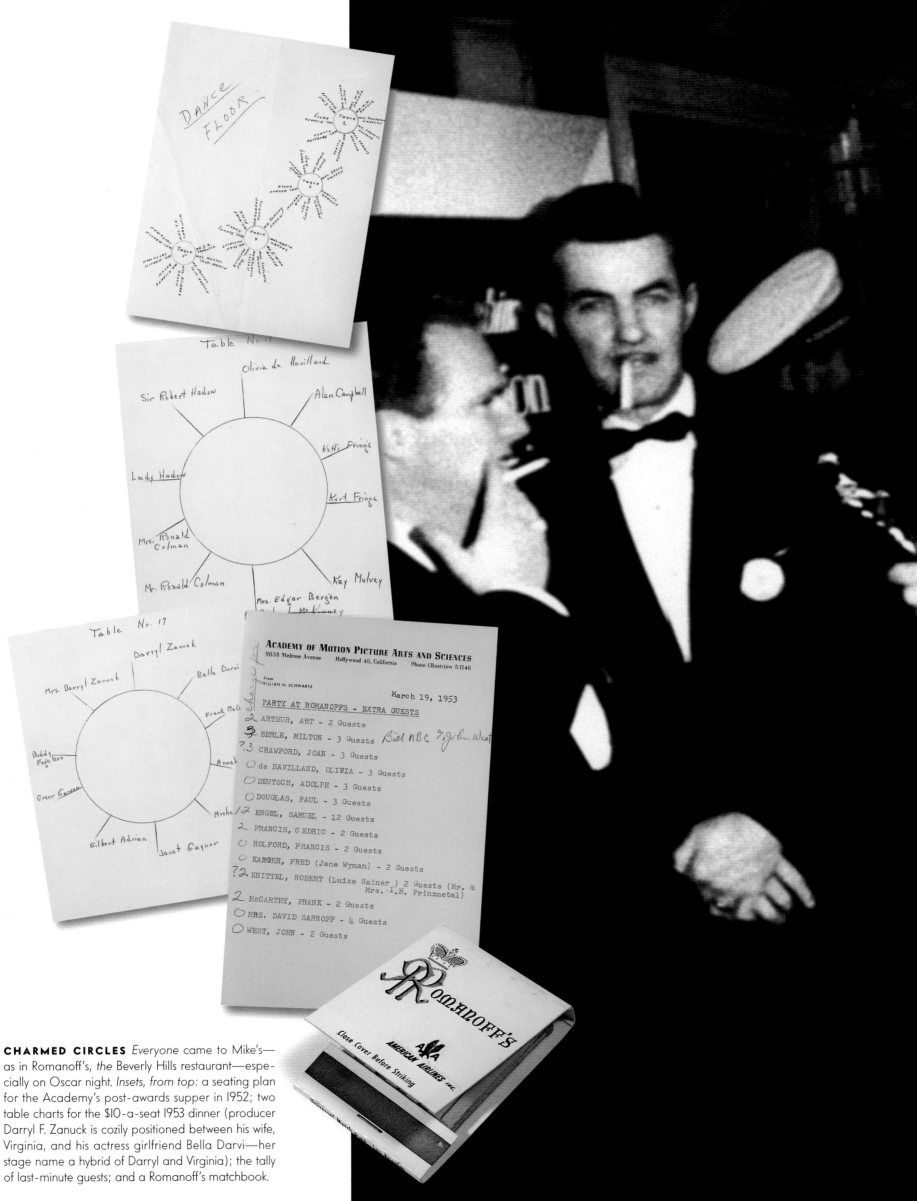

Table No. 17

Olivia de Havilland

Sir Robert Hadow Alan Campbell

 Ketti Frings

Lady Hadow

 Kurt Frings

Mrs. Ronald
Colman

Mr. Ronald Colman Kay Mulvey

 Mrs. Edgar Bergen
 ___ L. McKinney

Table No. 17

Darryl Zanuck

Mrs. Darryl Zanuck Bella Darvi

 Frank McC__

Buddy
Fogelson

Greer Garson Annak___

 Miche_

Gilbert Adrian Janet Gaynor

ACADEMY OF MOTION PICTURE ARTS AND SCIENCES
9038 Melrose Avenue Hollywood 46, California Phone CRestview 5-1146

from
LILLIAN N. SCHWARTZ
 March 19, 1953

PARTY AT ROMANOFFS - EXTRA GUESTS

2 ARTHUR, ART - 2 Guests
3 BERLE, MILTON - 3 Guests Bill NBC ?, John West
?3 CRAWFORD, JOAN - 3 Guests
○ de HAVILLAND, OLIVIA - 3 Guests
○ DEUTSCH, ADOLPH - 3 Guests
○ DOUGLAS, PAUL - 3 Guests
/2 ENGEL, SAMUEL - 12 Guests
2 FRANCIS, CEDRIC - 2 Guests
○ HOLFORD, FRANCIS - 2 Guests
○ KARGER, FRED (Jane Wyman) - 2 Guests
?2 KNITTEL, ROBERT (Luise Rainer) 2 Guests (Mr. &
 Mrs. I.H. Prinzmetal)
2 McCARTHY, FRANK - 2 Guests
○ MRS. DAVID SARNOFF - 4 Guests
○ WEST, JOHN - 2 Guests

CHARMED CIRCLES *Everyone* came to Mike's—as in Romanoff's, *the* Beverly Hills restaurant—especially on Oscar night. *Insets, from top:* a seating plan for the Academy's post-awards supper in 1952; two table charts for the $10-a-seat 1953 dinner (producer Darryl F. Zanuck is cozily positioned between his wife, Virginia, and his actress girlfriend Bella Darvi—her stage name a hybrid of Darryl and Virginia); the tally of last-minute guests; and a Romanoff's matchbook.

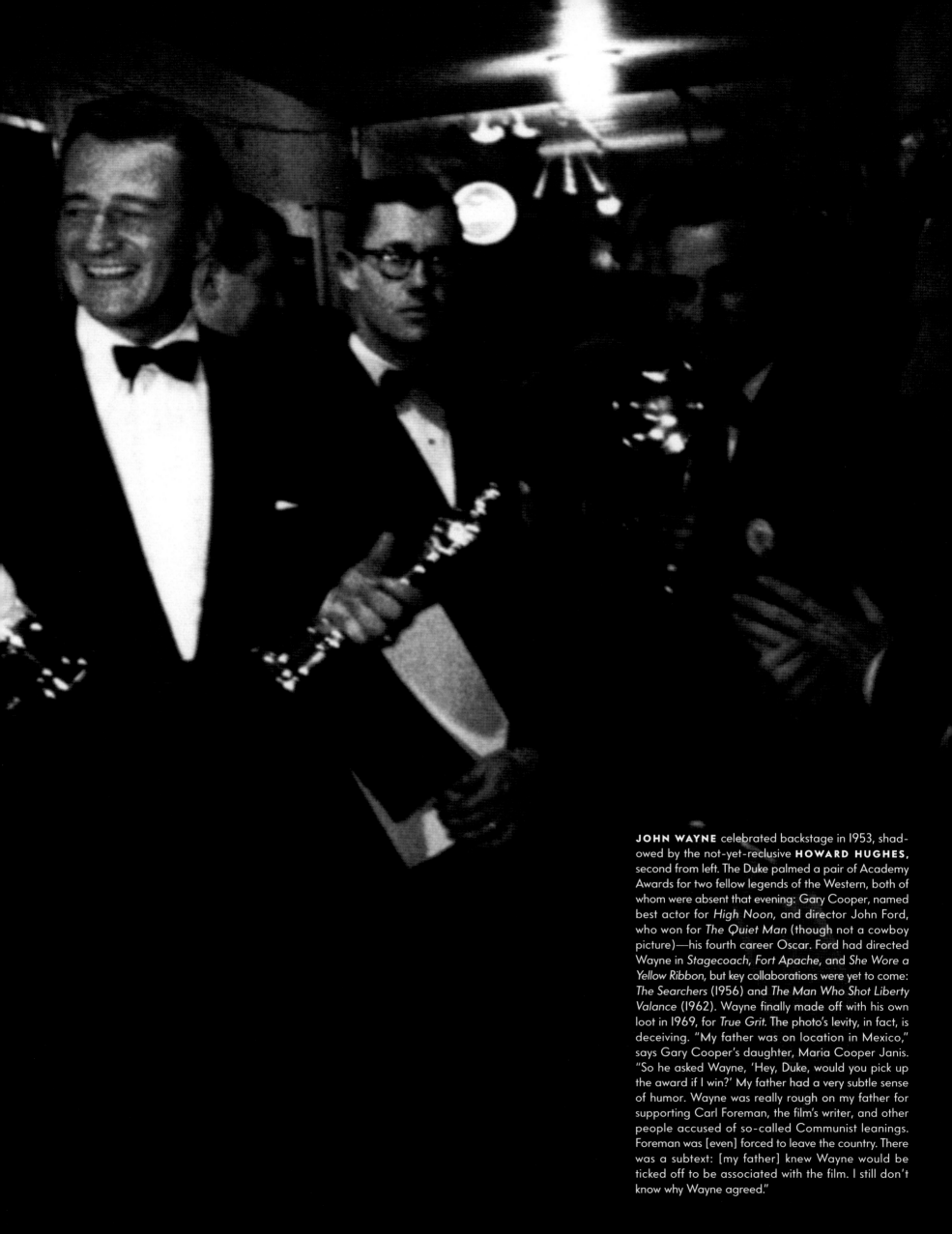

JOHN WAYNE celebrated backstage in 1953, shadowed by the not-yet-reclusive **HOWARD HUGHES,** second from left. The Duke palmed a pair of Academy Awards for two fellow legends of the Western, both of whom were absent that evening: Gary Cooper, named best actor for *High Noon,* and director John Ford, who won for *The Quiet Man* (though not a cowboy picture)—his fourth career Oscar. Ford had directed Wayne in *Stagecoach, Fort Apache,* and *She Wore a Yellow Ribbon,* but key collaborations were yet to come: *The Searchers* (1956) and *The Man Who Shot Liberty Valance* (1962). Wayne finally made off with his own loot in 1969, for *True Grit.* The photo's levity, in fact, is deceiving. "My father was on location in Mexico," says Gary Cooper's daughter, Maria Cooper Janis. "So he asked Wayne, 'Hey, Duke, would you pick up the award if I win?' My father had a very subtle sense of humor. Wayne was really rough on my father for supporting Carl Foreman, the film's writer, and other people accused of so-called Communist leanings. Foreman was [even] forced to leave the country. There was a subtext: [my father] knew Wayne would be ticked off to be associated with the film. I still don't know why Wayne agreed."

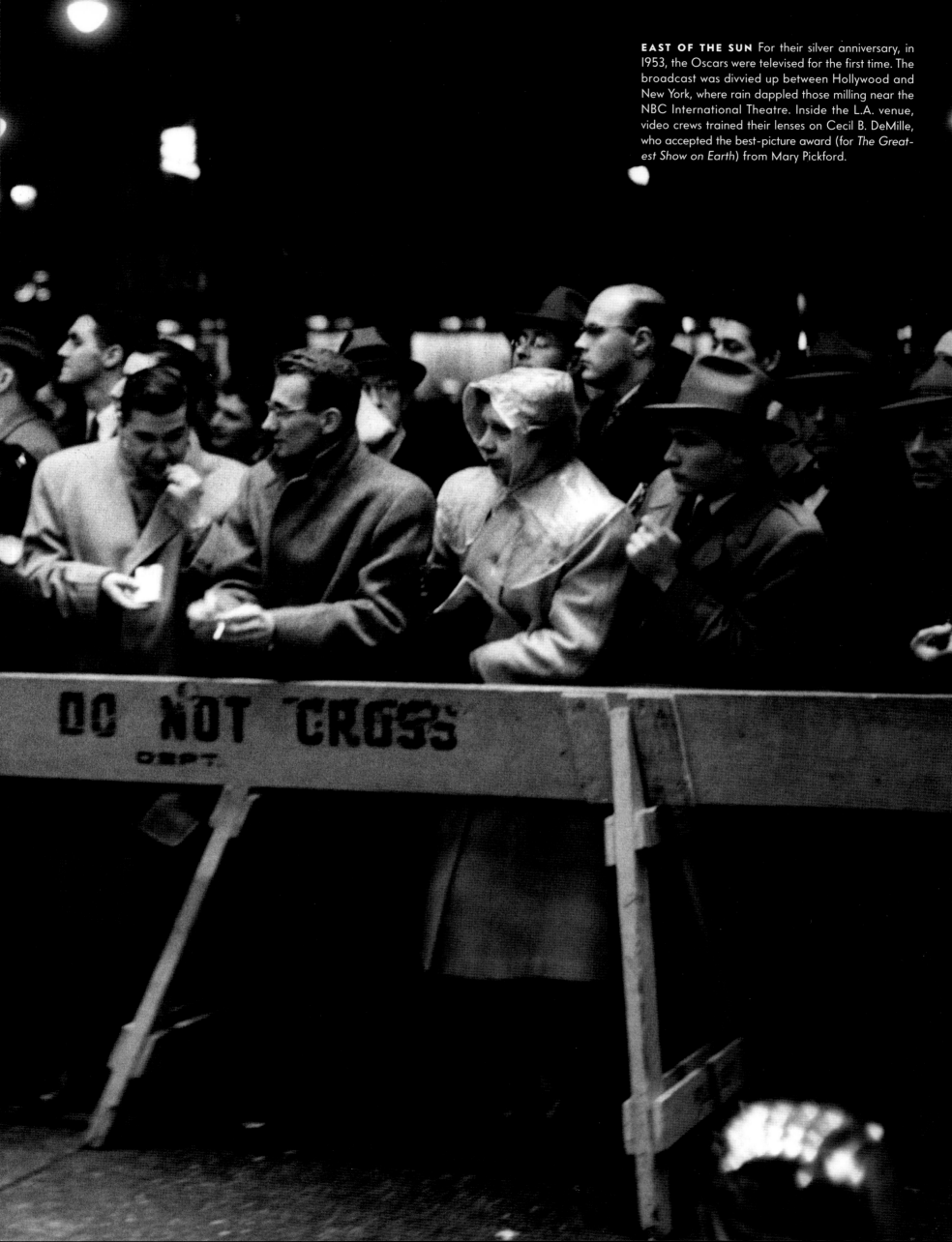

EAST OF THE SUN For their silver anniversary, in 1953, the Oscars were televised for the first time. The broadcast was divvied up between Hollywood and New York, where rain dappled those milling near the NBC International Theatre. Inside the L.A. venue, video crews trained their lenses on Cecil B. DeMille, who accepted the best-picture award (for *The Greatest Show on Earth*) from Mary Pickford.

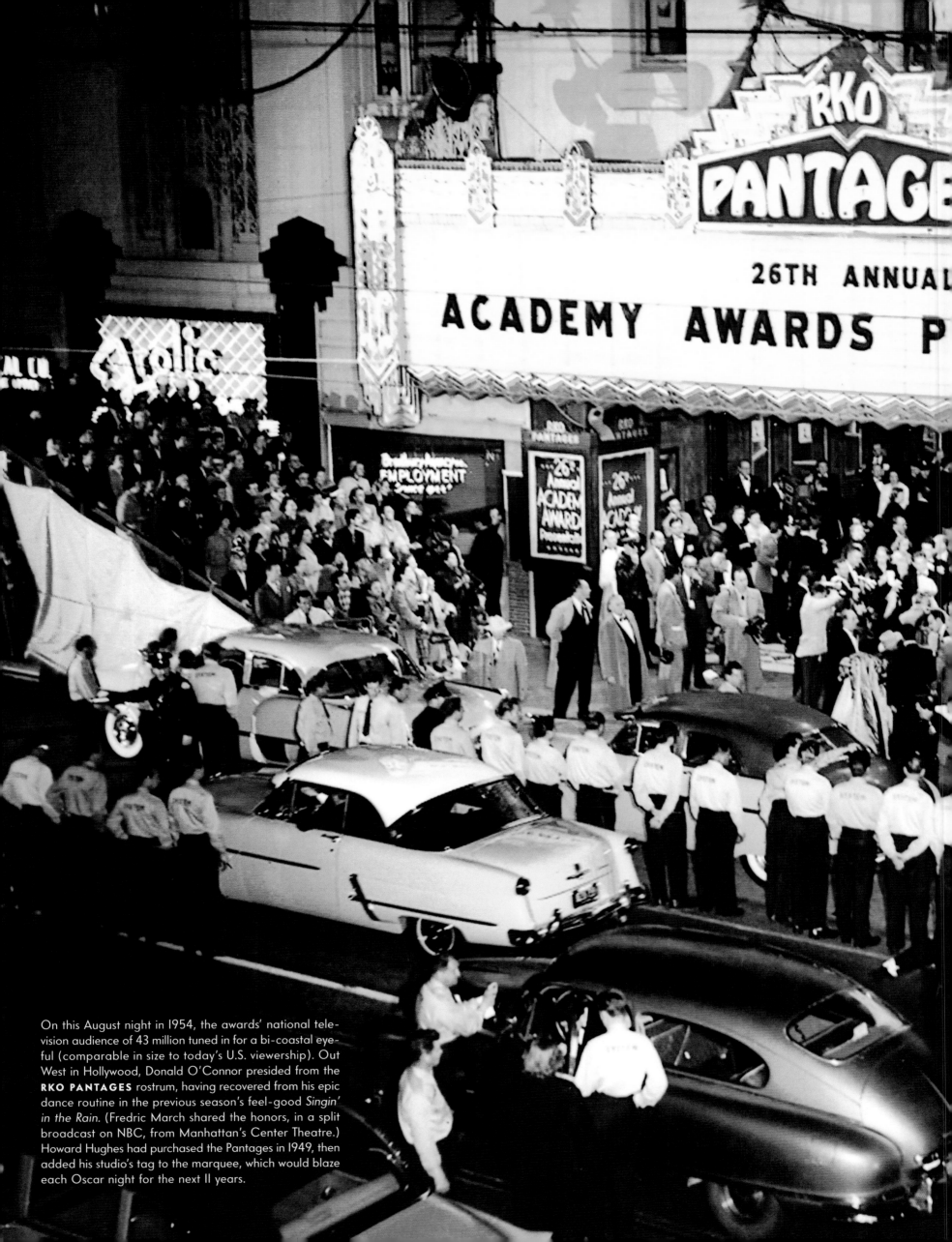

On this August night in 1954, the awards' national television audience of 43 million tuned in for a bi-coastal eyeful (comparable in size to today's U.S. viewership). Out West in Hollywood, Donald O'Connor presided from the **RKO PANTAGES** rostrum, having recovered from his epic dance routine in the previous season's feel-good *Singin' in the Rain*. (Fredric March shared the honors, in a split broadcast on NBC, from Manhattan's Center Theatre.) Howard Hughes had purchased the Pantages in 1949, then added his studio's tag to the marquee, which would blaze each Oscar night for the next 11 years.

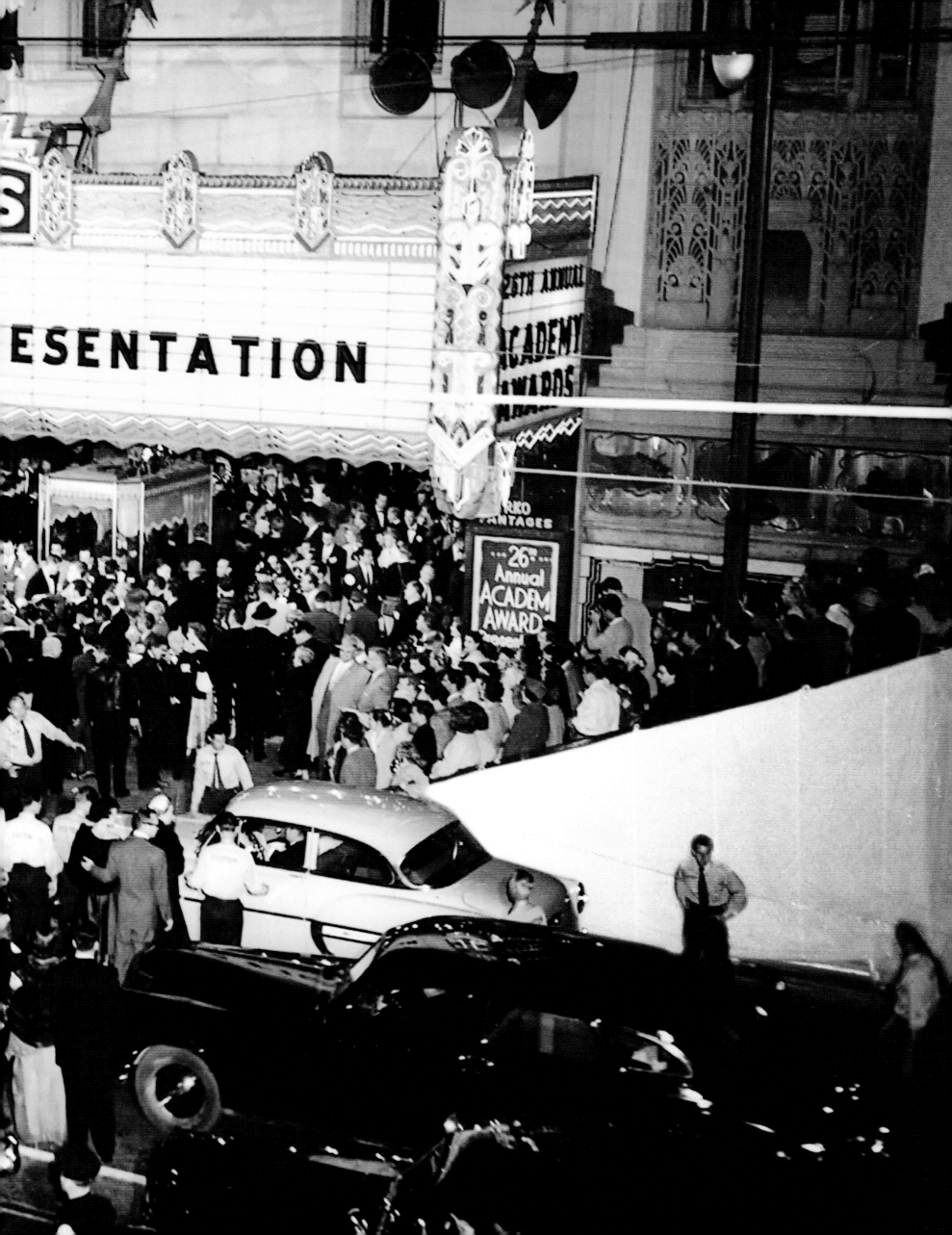

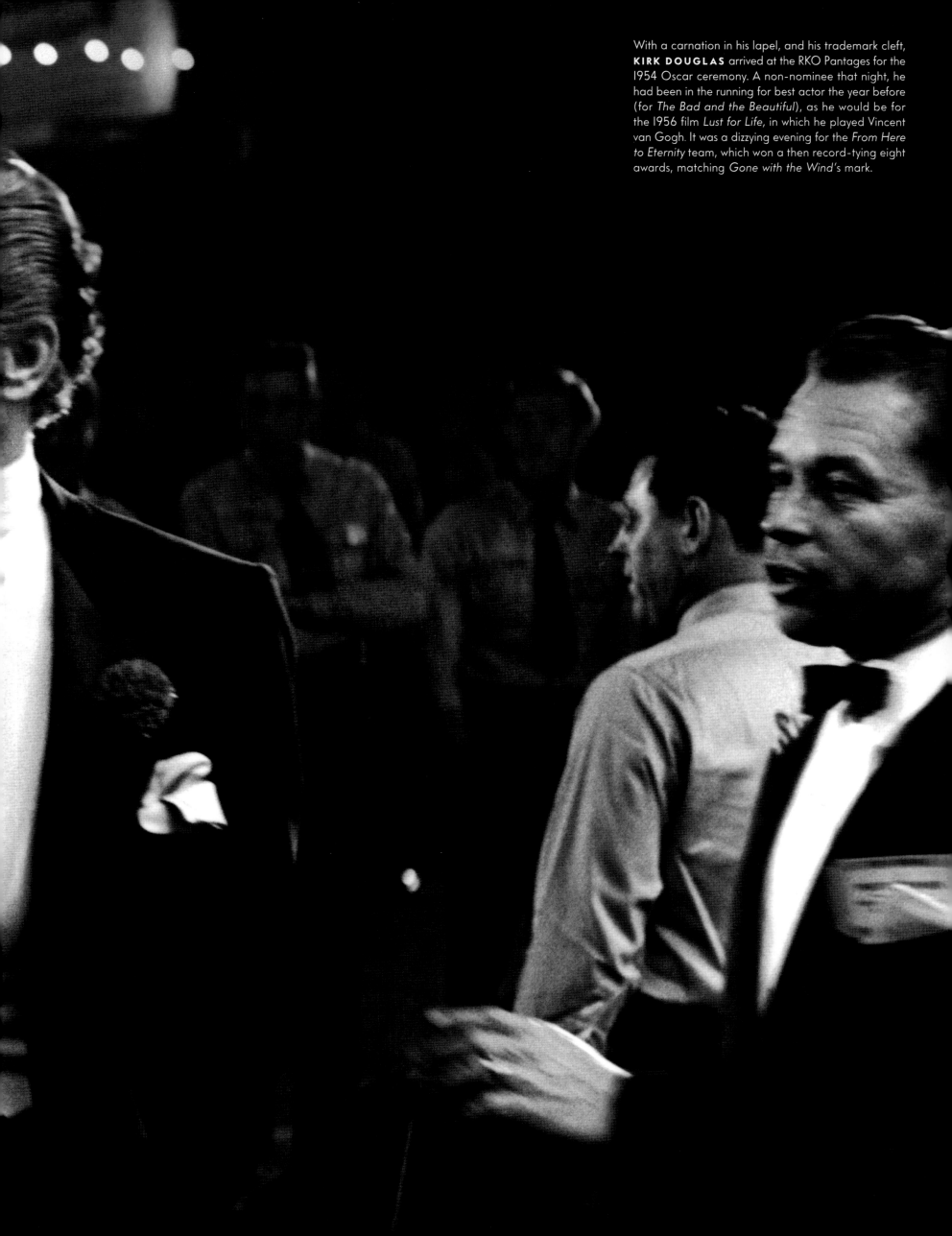

With a carnation in his lapel, and his trademark cleft, **KIRK DOUGLAS** arrived at the RKO Pantages for the 1954 Oscar ceremony. A non-nominee that night, he had been in the running for best actor the year before (for *The Bad and the Beautiful*), as he would be for the 1956 film *Lust for Life*, in which he played Vincent van Gogh. It was a dizzying evening for the *From Here to Eternity* team, which won a then record-tying eight awards, matching *Gone with the Wind*'s mark.

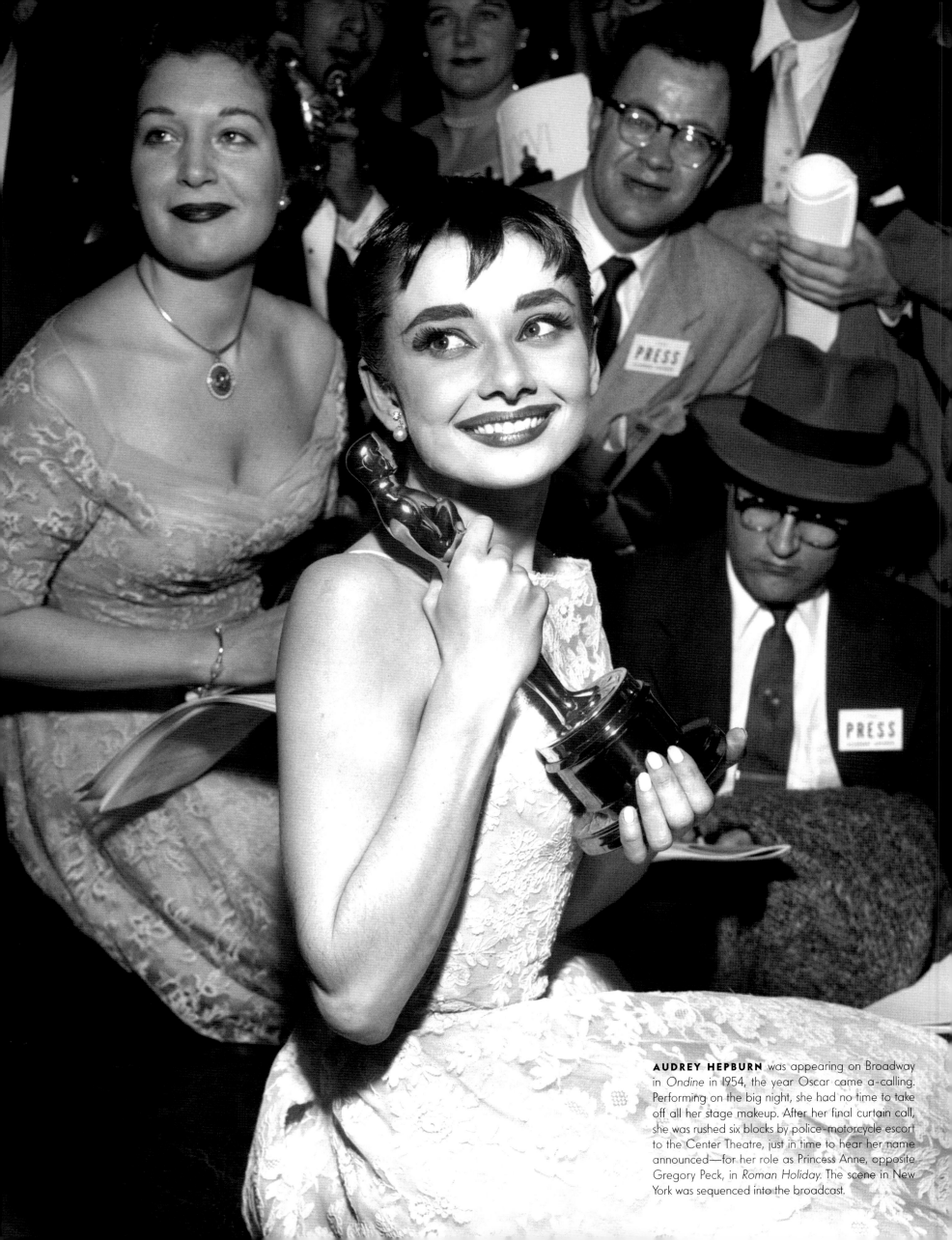

AUDREY HEPBURN was appearing on Broadway in *Ondine* in 1954, the year Oscar came a-calling. Performing on the big night, she had no time to take off all her stage makeup. After her final curtain call, she was rushed six blocks by police-motorcycle escort to the Center Theatre, just in time to hear her name announced—for her role as Princess Anne, opposite Gregory Peck, in *Roman Holiday*. The scene in New York was sequenced into the broadcast.

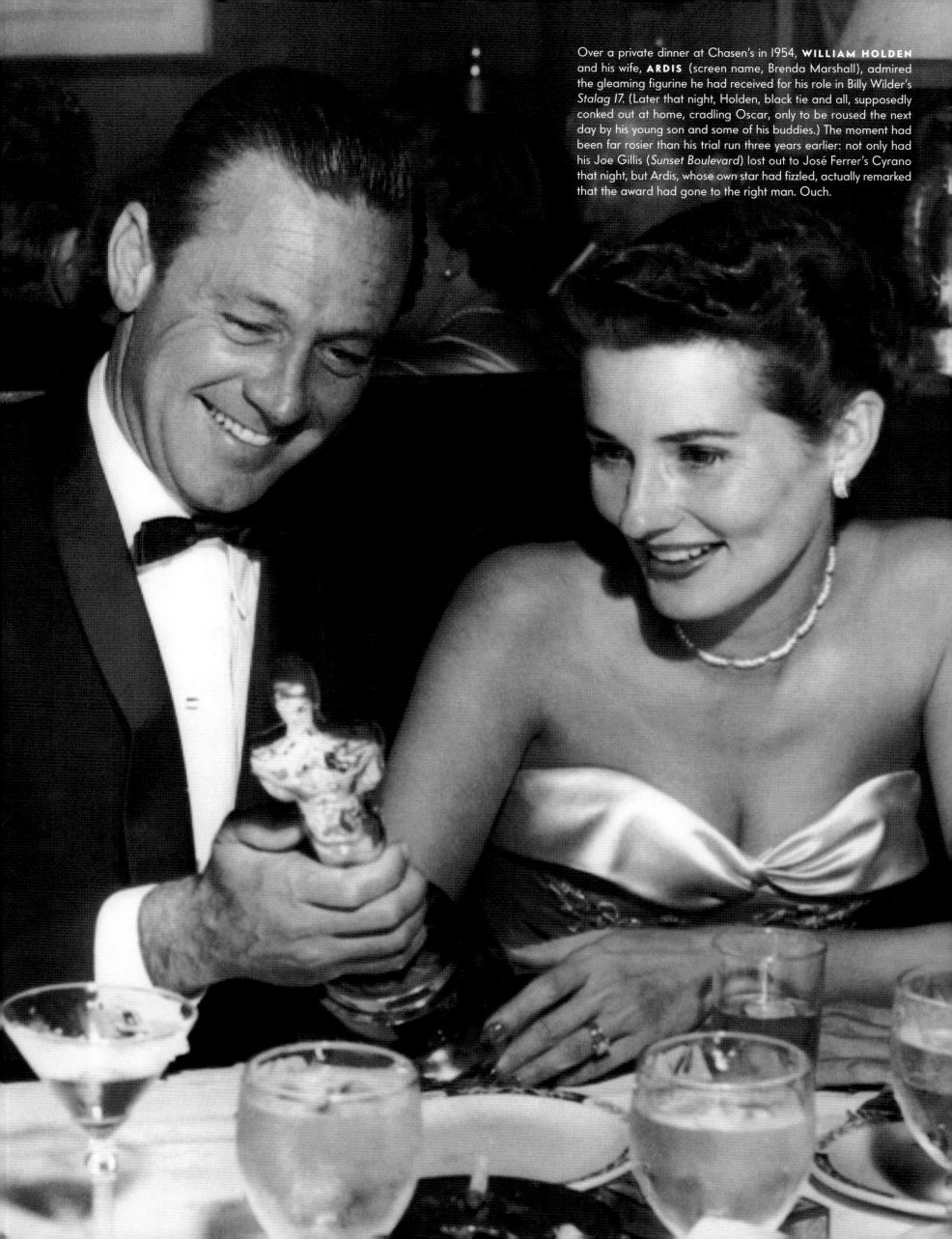

Over a private dinner at Chasen's in 1954, **WILLIAM HOLDEN** and his wife, **ARDIS** (screen name, Brenda Marshall), admired the gleaming figurine he had received for his role in Billy Wilder's *Stalag 17*. (Later that night, Holden, black tie and all, supposedly conked out at home, cradling Oscar, only to be roused the next day by his young son and some of his buddies.) The moment had been far rosier than his trial run three years earlier: not only had his Joe Gillis (*Sunset Boulevard*) lost out to José Ferrer's Cyrano that night, but Ardis, whose own star had fizzled, actually remarked that the award had gone to the right man. Ouch.

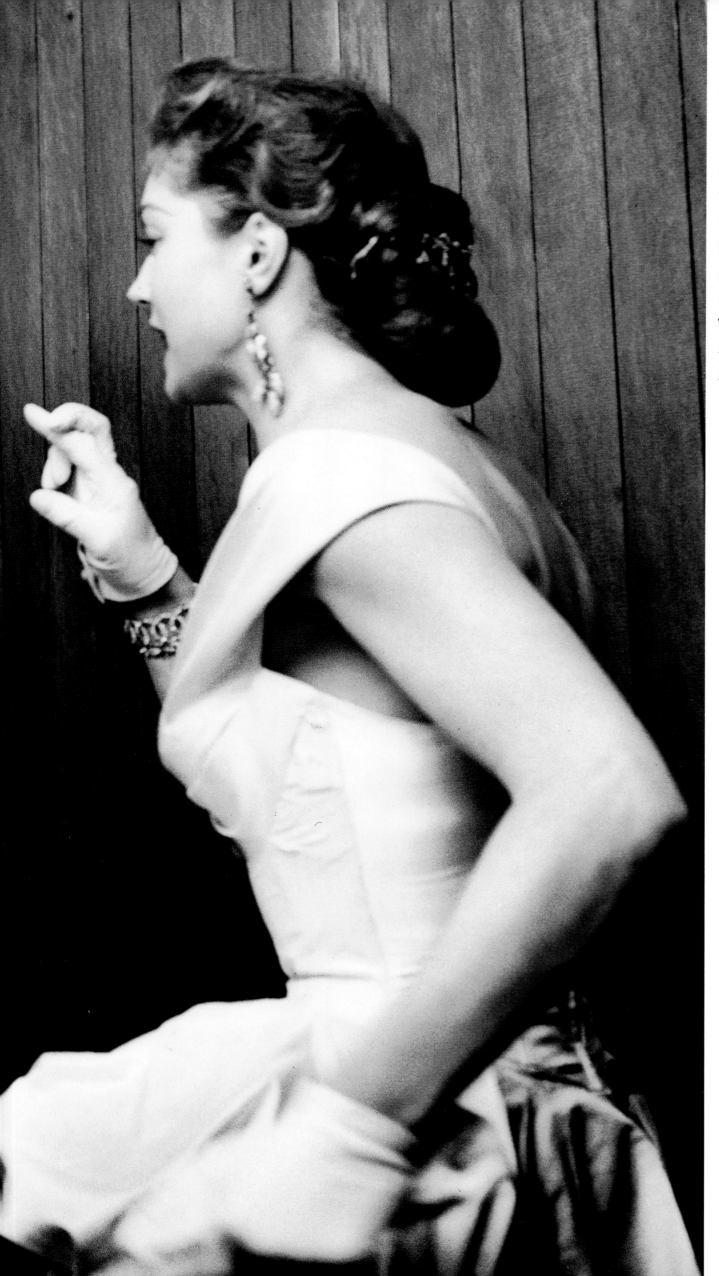

ESTHER WILLIAMS, right, the swimmer turned star, crossed her fingers for **DONNA REED** outside the powder room at Romanoff's in 1954. No need. Reed won best-supporting-actress honors that night for her portrayal of a prostitute in *From Here to Eternity*. Audiences were shocked to see her in such an edgy part, having become accustomed to her wholesome roles in features such as *It's a Wonderful Life* (1946).

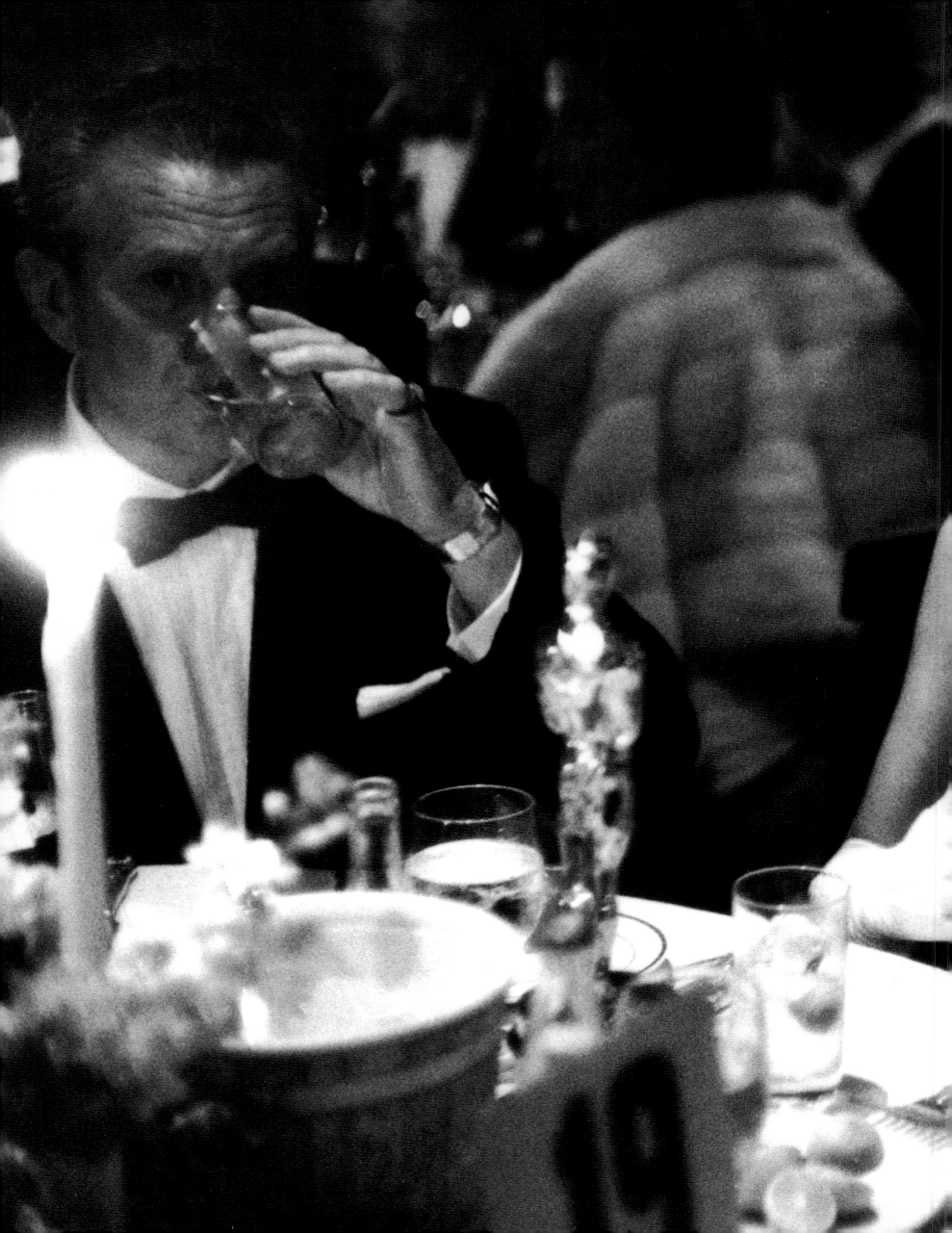

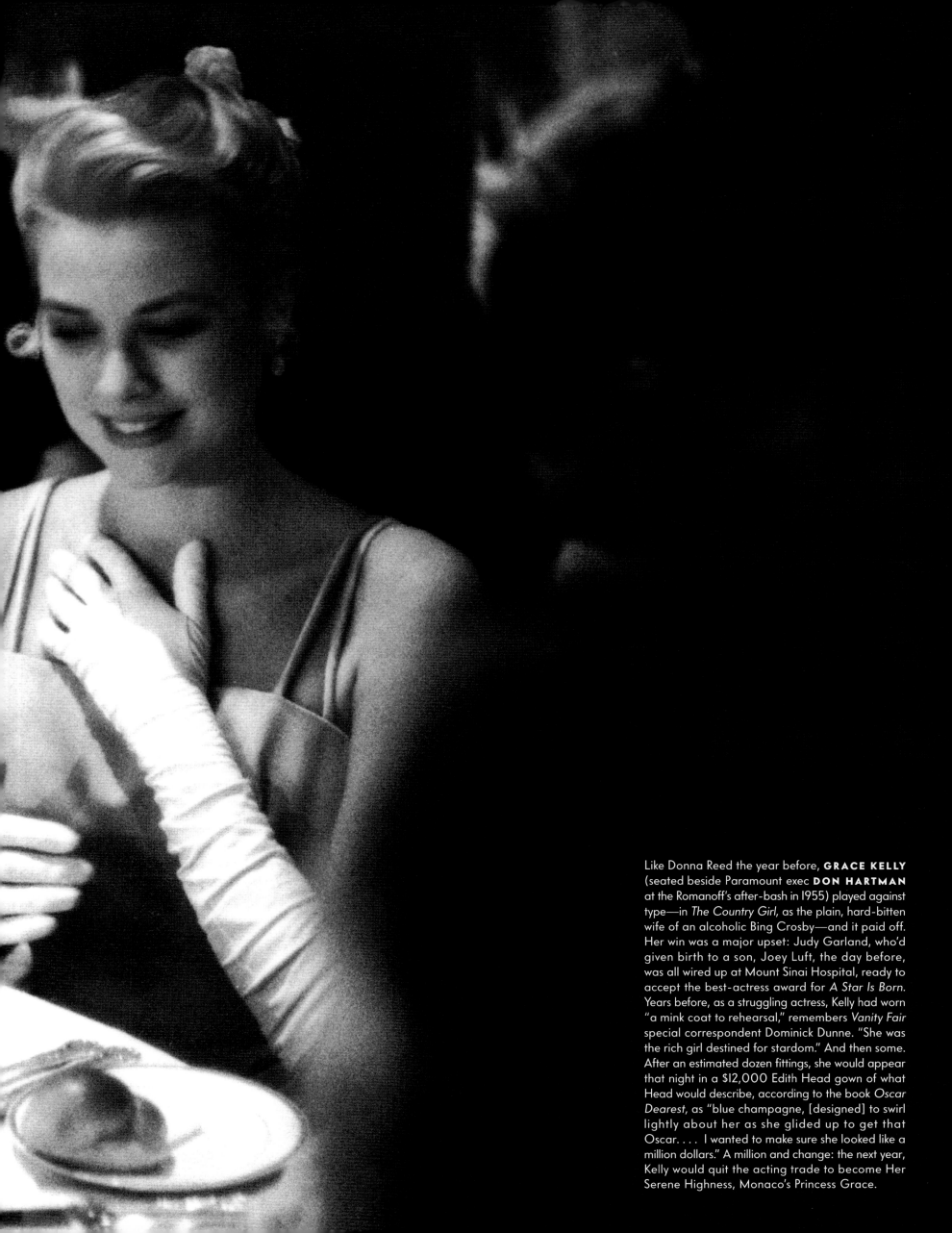

Like Donna Reed the year before, **GRACE KELLY** (seated beside Paramount exec **DON HARTMAN** at the Romanoff's after-bash in 1955) played against type—in *The Country Girl*, as the plain, hard-bitten wife of an alcoholic Bing Crosby—and it paid off. Her win was a major upset: Judy Garland, who'd given birth to a son, Joey Luft, the day before, was all wired up at Mount Sinai Hospital, ready to accept the best-actress award for *A Star Is Born*. Years before, as a struggling actress, Kelly had worn "a mink coat to rehearsal," remembers *Vanity Fair* special correspondent Dominick Dunne. "She was the rich girl destined for stardom." And then some. After an estimated dozen fittings, she would appear that night in a $12,000 Edith Head gown of what Head would describe, according to the book *Oscar Dearest*, as "blue champagne, [designed] to swirl lightly about her as she glided up to get that Oscar. . . . I wanted to make sure she looked like a million dollars." A million and change: the next year, Kelly would quit the acting trade to become Her Serene Highness, Monaco's Princess Grace.

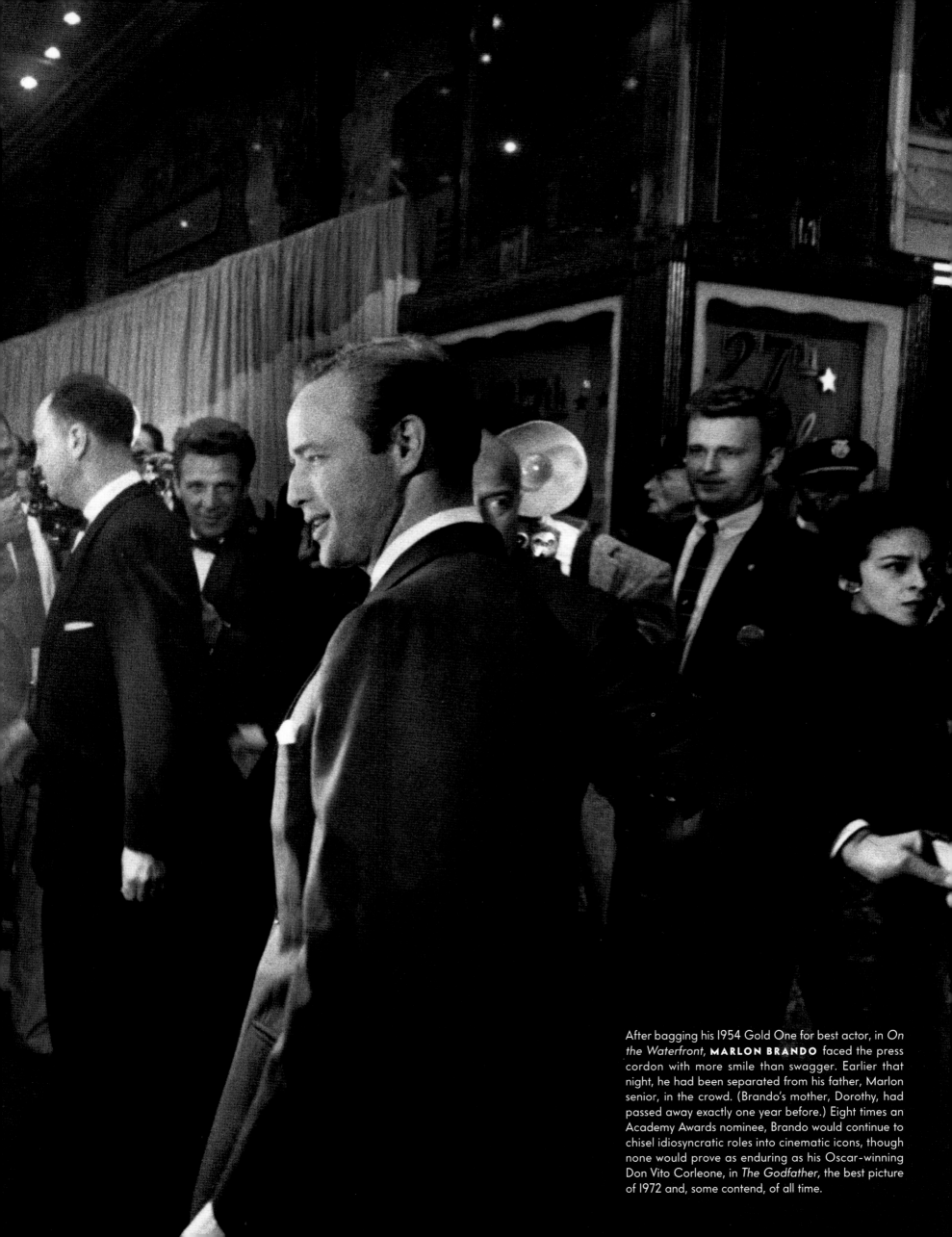

After bagging his 1954 Gold One for best actor, in *On the Waterfront*, **MARLON BRANDO** faced the press cordon with more smile than swagger. Earlier that night, he had been separated from his father, Marlon senior, in the crowd. (Brando's mother, Dorothy, had passed away exactly one year before.) Eight times an Academy Awards nominee, Brando would continue to chisel idiosyncratic roles into cinematic icons, though none would prove as enduring as his Oscar-winning Don Vito Corleone, in *The Godfather*, the best picture of 1972 and, some contend, of all time.

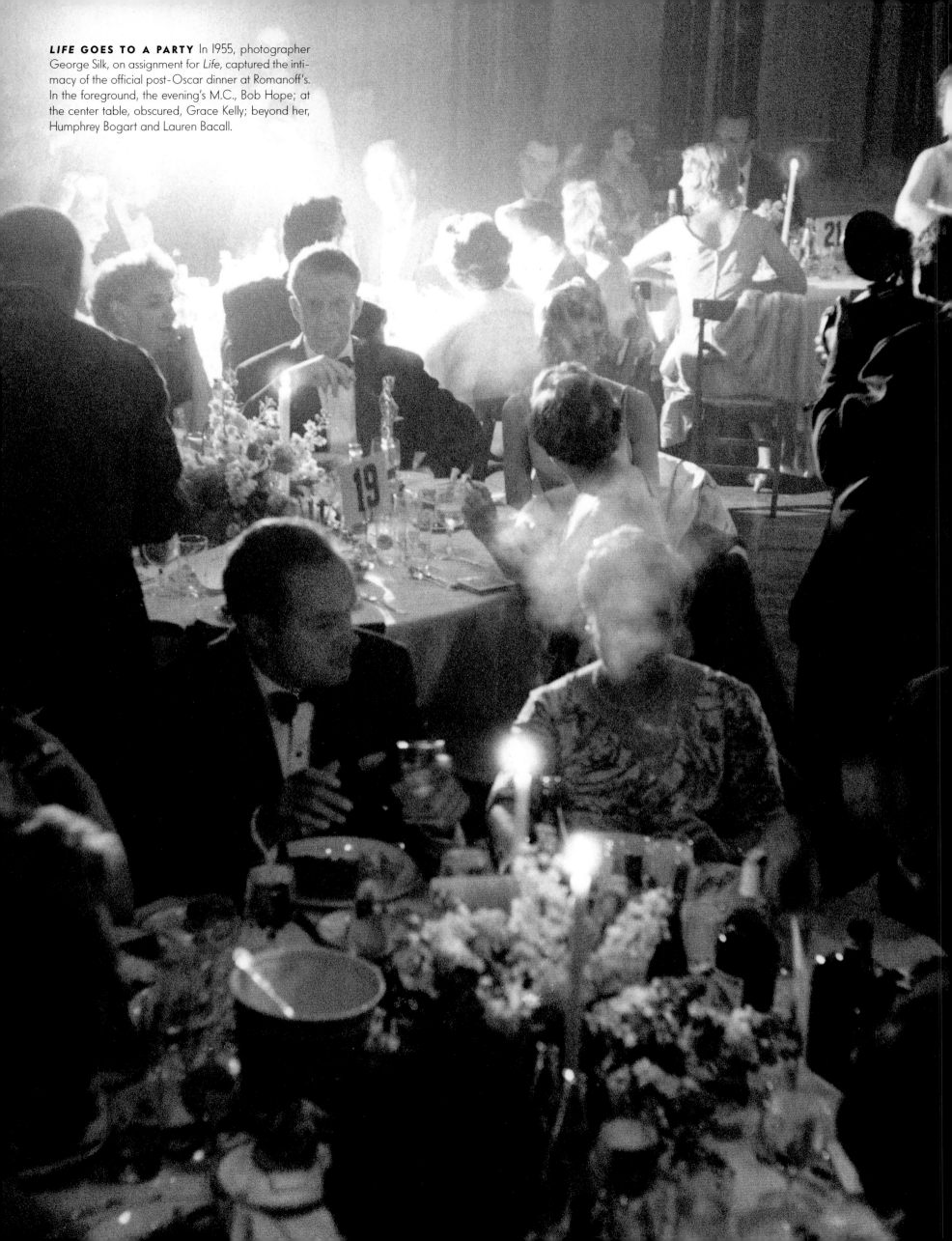

LIFE GOES TO A PARTY In 1955, photographer George Silk, on assignment for *Life*, captured the intimacy of the official post-Oscar dinner at Romanoff's. In the foreground, the evening's M.C., Bob Hope; at the center table, obscured, Grace Kelly; beyond her, Humphrey Bogart and Lauren Bacall.

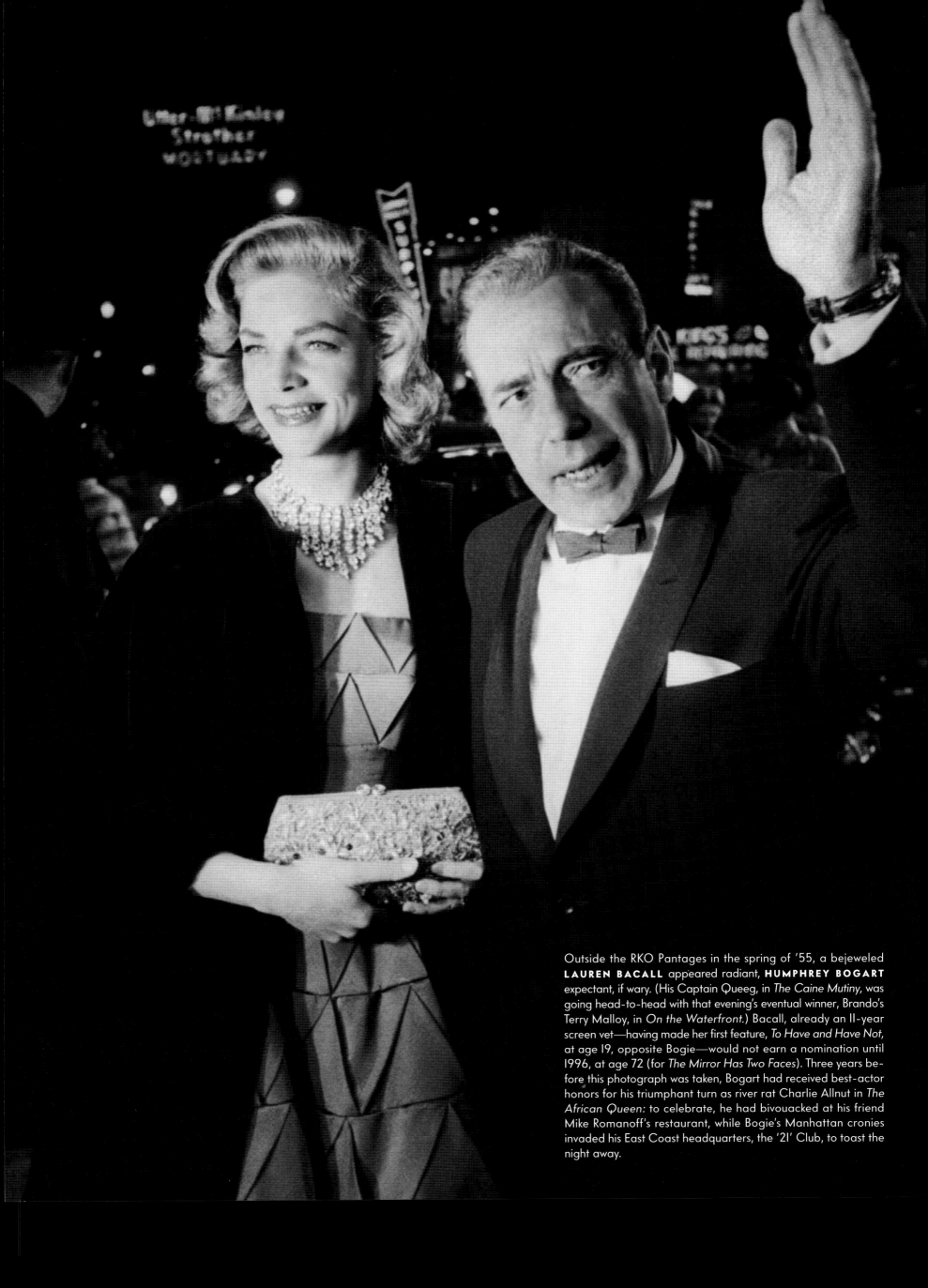

Outside the RKO Pantages in the spring of '55, a bejeweled **LAUREN BACALL** appeared radiant, **HUMPHREY BOGART** expectant, if wary. (His Captain Queeg, in *The Caine Mutiny*, was going head-to-head with that evening's eventual winner, Brando's Terry Malloy, in *On the Waterfront*.) Bacall, already an 11-year screen vet—having made her first feature, *To Have and Have Not*, at age 19, opposite Bogie—would not earn a nomination until 1996, at age 72 (for *The Mirror Has Two Faces*). Three years before this photograph was taken, Bogart had received best-actor honors for his triumphant turn as river rat Charlie Allnut in *The African Queen*: to celebrate, he had bivouacked at his friend Mike Romanoff's restaurant, while Bogie's Manhattan cronies invaded his East Coast headquarters, the '21' Club, to toast the night away.

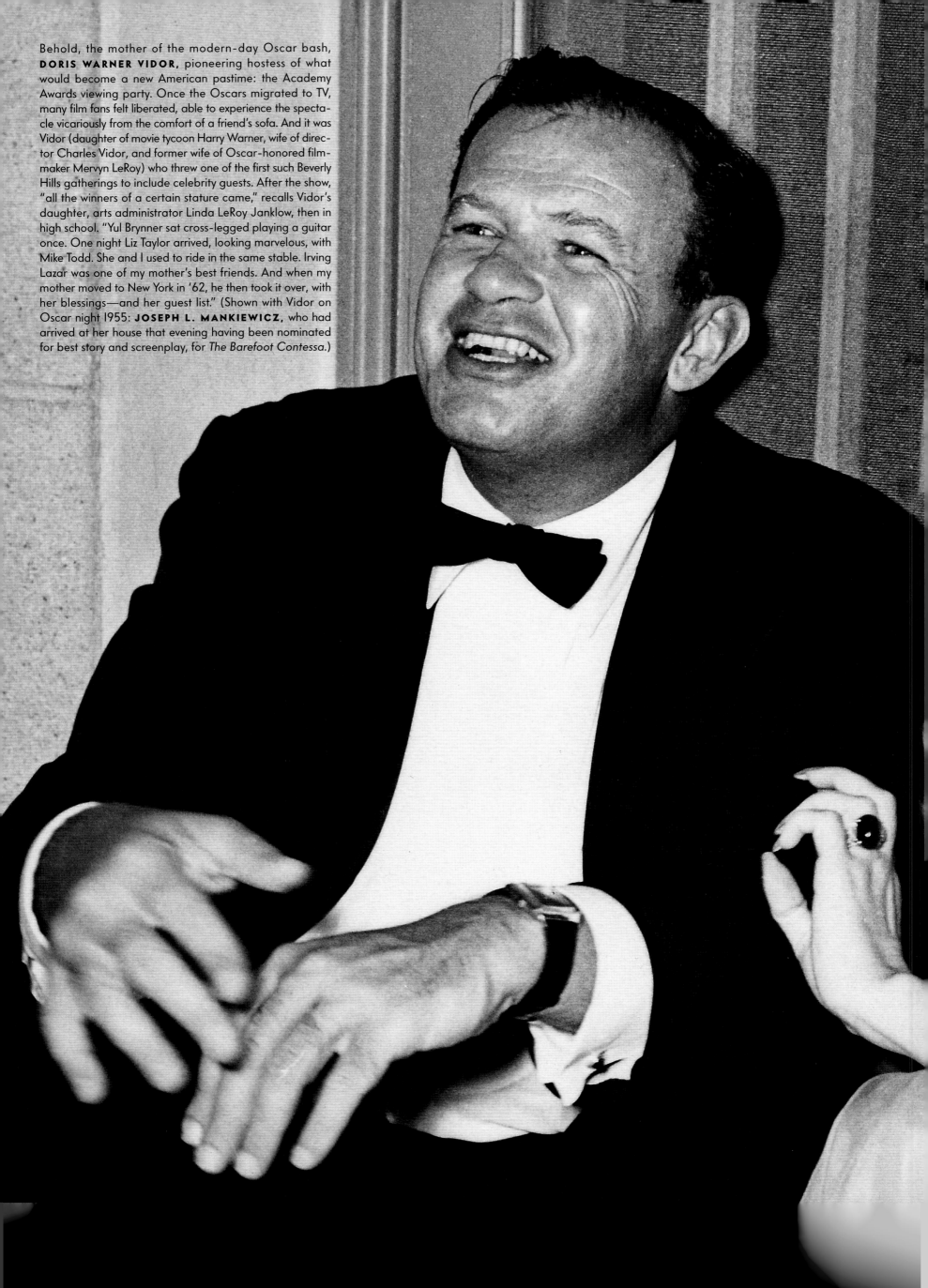

Behold, the mother of the modern-day Oscar bash, **DORIS WARNER VIDOR,** pioneering hostess of what would become a new American pastime: the Academy Awards viewing party. Once the Oscars migrated to TV, many film fans felt liberated, able to experience the spectacle vicariously from the comfort of a friend's sofa. And it was Vidor (daughter of movie tycoon Harry Warner, wife of director Charles Vidor, and former wife of Oscar-honored filmmaker Mervyn LeRoy) who threw one of the first such Beverly Hills gatherings to include celebrity guests. After the show, "all the winners of a certain stature came," recalls Vidor's daughter, arts administrator Linda LeRoy Janklow, then in high school. "Yul Brynner sat cross-legged playing a guitar once. One night Liz Taylor arrived, looking marvelous, with Mike Todd. She and I used to ride in the same stable. Irving Lazar was one of my mother's best friends. And when my mother moved to New York in '62, he then took it over, with her blessings—and her guest list." (Shown with Vidor on Oscar night 1955: **JOSEPH L. MANKIEWICZ,** who had arrived at her house that evening having been nominated for best story and screenplay, for *The Barefoot Contessa.*)

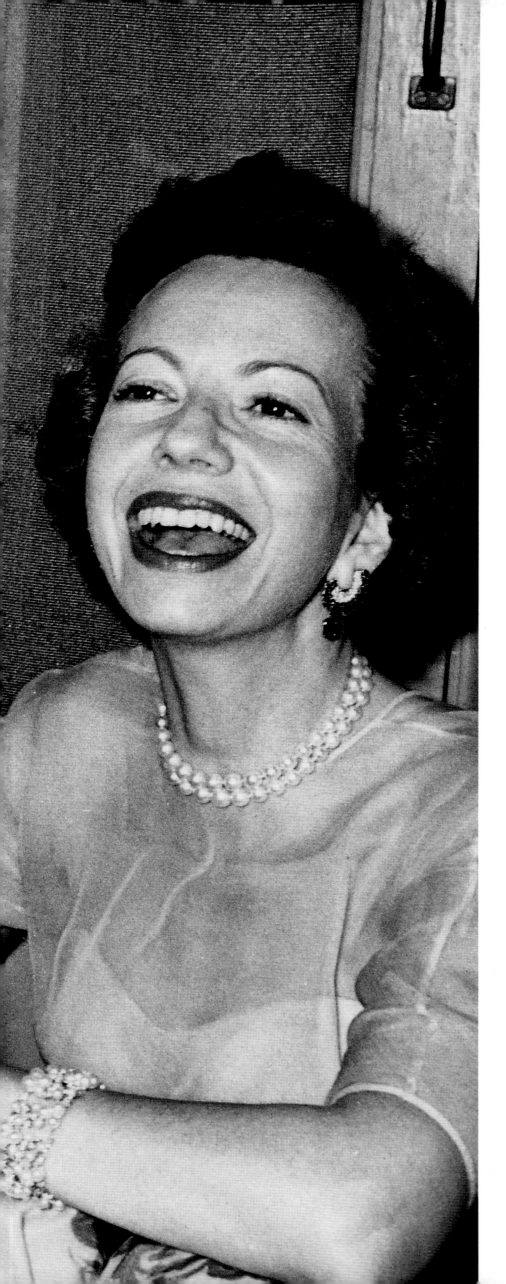

VIEWING PARTIES

Flickering in the Oscar mist was a beckoning aura called television. In 1953 the ceremonies became televised proceedings; five times during the 50s they were bi-coastal shows as well, with one host in L.A. and another in New York. With every passing year, the licensing of the broadcast rights to a network partner (first NBC, then ABC) increasingly proved to be the Academy's lifeblood. And soon the made-for-TV extravaganza was the life of the party.

In rec rooms and dens, in Manhattan town houses and L.A. mansions, Oscar "viewing" or "watching" parties became an awards-night routine. Within a few years, the stars themselves were being diverted from the auditoriums and the formal balls to receptions at private homes equipped with good (TV) reception. Among the first such venues: Milton and Ruth Berle's place on N. Crescent Drive, where they distributed ballots, says publicist Warren Cowan, and handed out "prizes, bottles of champagne, I think, to the ones who picked the most winners. I remember Lucille Ball coming."

Nearby, celebrities congregated at the home of director Charles Vidor and his wife, theatrical figure and philanthropist Doris Warner Vidor, pictured here. "TVs were set up all over the place," says son Brian Vidor, who recalls being awakened by his parents to meet the stars. "I would be in my pajamas. I remember Marilyn Monroe and Yves Montand. I remember seeing Efrem Zimbalist Jr.'s big Packard. They used to bring the Oscars over to the house." At producer Harold Mirisch's, Oscar replicas adorned the tables, and 10 TVs beamed. At set-and-costume maven Tony Duquette's, Chasen's did the catering. (On one memorable night, Gardner McKay showed up escorting a cheetah on a leash.)

Other stars preferred to just settle down in front of the TV at home. Producer William Frye recalls a viewing party in the 60s at which he, Van Johnson, Loretta Young, Connie Wald, and producer Jim Wharton gathered in Irene Dunne's library. "They got dressed up, in jewels," he says. "The men wore tuxes. We watched the whole awards on a rather corny set. The maid and [houseman] Melvin brought [dinner] in on a tray."

As Audrey Wilder remembers it, the Academy Awards parties she gave in the early 60s with her director husband, Billy Wilder (winner of six Oscars and one Thalberg), were freewheeling get-togethers. Participants bet on the awards race and imbibed copiously. ("There is no visual evidence," she insists. "No one took pictures. They were all getting drunk.") "We started out with about eight people," she says of their Wilshire Terrace place, with its vaulted ceilings; guests included Gene Kelly and Cary Grant, along with "the Pecks, the Lemmons, the Matthaus," remembers the Wilders' friend Janet de Cordova. "It eventually grew and grew to a before- and after-party," says Audrey. "I'd serve up a buffet. I had a Swiss-cheese salad. Then I'd make these German meatballs they used to serve in a nightclub in Berlin where I went with my husband, made with pork and veal, and you'd serve them cold and dip 'em in mustard. And cannelloni, which I'd buy at the deli." One year, recalls de Cordova, Audrey "asked the girls to wear hot pants instead of dresses. I got an Oscar de la Renta with a chiffon coat over the hot pant, with a gold satin boot. I wore my Oscar to the Oscar party."

"I had four TV sets," says Wilder, "and that wasn't enough, finally. . . . It just got too crowded." By 1964, agent *extraordinaire* Irving Lazar and his wife, Mary, intimates of the Wilders', had inherited the honor and the burden. (The Wilders were Oscar-party veterans, of sorts. Audrey also remembers a particularly long and liquid Academy Awards night back in 1960. "The year *Ben-Hur* won, Billy was up against it for best director with *Some Like It Hot,*" she says, describing how, instead of attending the ceremony, they had chosen to go to the Vidors' to follow the action on TV. "Billy had 14 martinis and couldn't walk." After barricading himself in the bathroom, he eventually emerged, thoroughly plastered, only to have Tony Curtis and Kirk Douglas carry him off to a waiting car.)

To this day, Hollywood hostess Dani Janssen, widow of actor David Janssen, invites a clutch of renowned friends (Clint and Whoopi and Quincy and Bruce, as in Springsteen) to her Century City penthouse for an Oscar-day spread that includes smothered chicken, sweet-and-sour meatballs, and her irresistible "monkey bread." "I had seven Oscars on the dining-room table that first year," she remembers. "The place was just breathing people [at] two or three A.M." ("Pound for pound," according to *W* magazine, Janssen "pulls in probably more stars than the Hubble telescope.")

In recent years, the parties have become more plentiful (ramping up the week before the event, with the standard-issue gauntlet of photographers poised outside and in), while the behavior, on occasion, has become more outrageous. At the 1998 pre-Oscar bash thrown by William Morris chief Arnold Rifkin, the suits and the stars mingled as one top exec and his female companion repaired to a backyard nook. Then, as if on cue, she knelt and commenced to satisfy him in plain view of the assembled. So much for store-bought cannelloni.

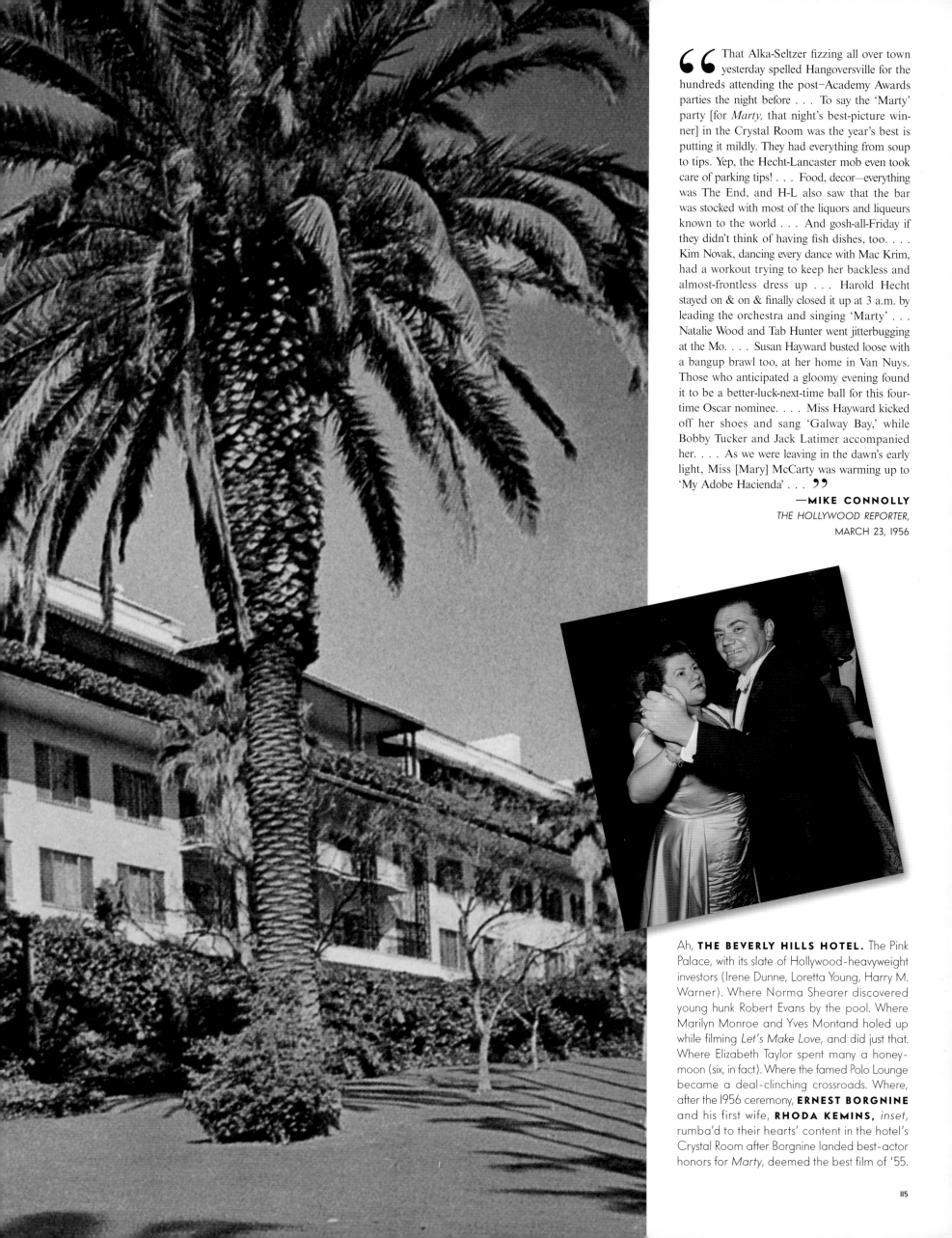

Ah, **THE BEVERLY HILLS HOTEL.** The Pink Palace, with its slate of Hollywood-heavyweight investors (Irene Dunne, Loretta Young, Harry M. Warner). Where Norma Shearer discovered young hunk Robert Evans by the pool. Where Marilyn Monroe and Yves Montand holed up while filming *Let's Make Love,* and did just that. Where Elizabeth Taylor spent many a honeymoon (six, in fact). Where the famed Polo Lounge became a deal-clinching crossroads. Where, after the 1956 ceremony, **ERNEST BORGNINE** and his first wife, **RHODA KEMINS,** *inset,* rumba'd to their hearts' content in the hotel's Crystal Room after Borgnine landed best-actor honors for *Marty,* deemed the best film of '55.

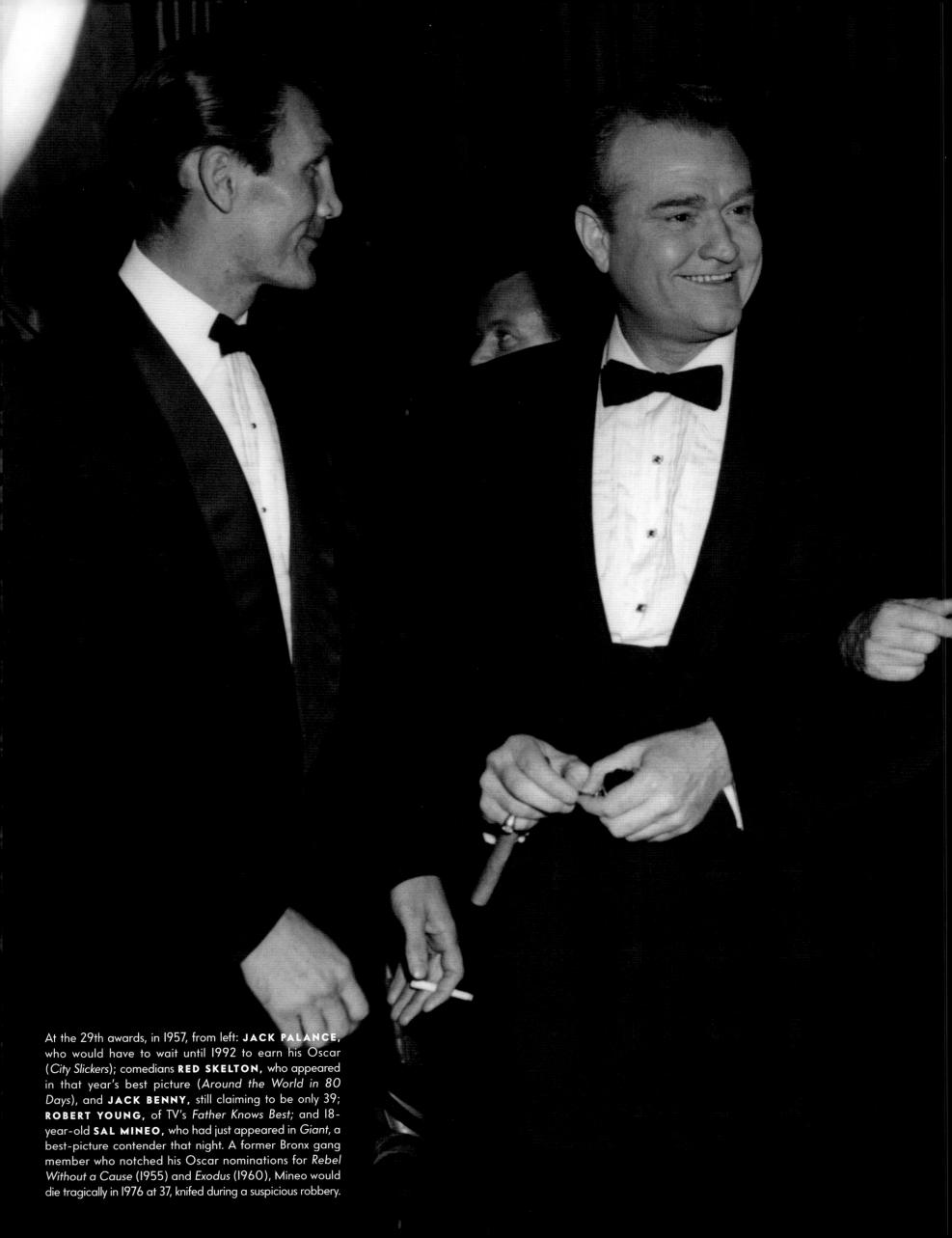

At the 29th awards, in 1957, from left: **JACK PALANCE**, who would have to wait until 1992 to earn his Oscar (*City Slickers*); comedians **RED SKELTON**, who appeared in that year's best picture (*Around the World in 80 Days*), and **JACK BENNY**, still claiming to be only 39; **ROBERT YOUNG**, of TV's *Father Knows Best*; and 18-year-old **SAL MINEO**, who had just appeared in *Giant*, a best-picture contender that night. A former Bronx gang member who notched his Oscar nominations for *Rebel Without a Cause* (1955) and *Exodus* (1960), Mineo would die tragically in 1976 at 37, knifed during a suspicious robbery.

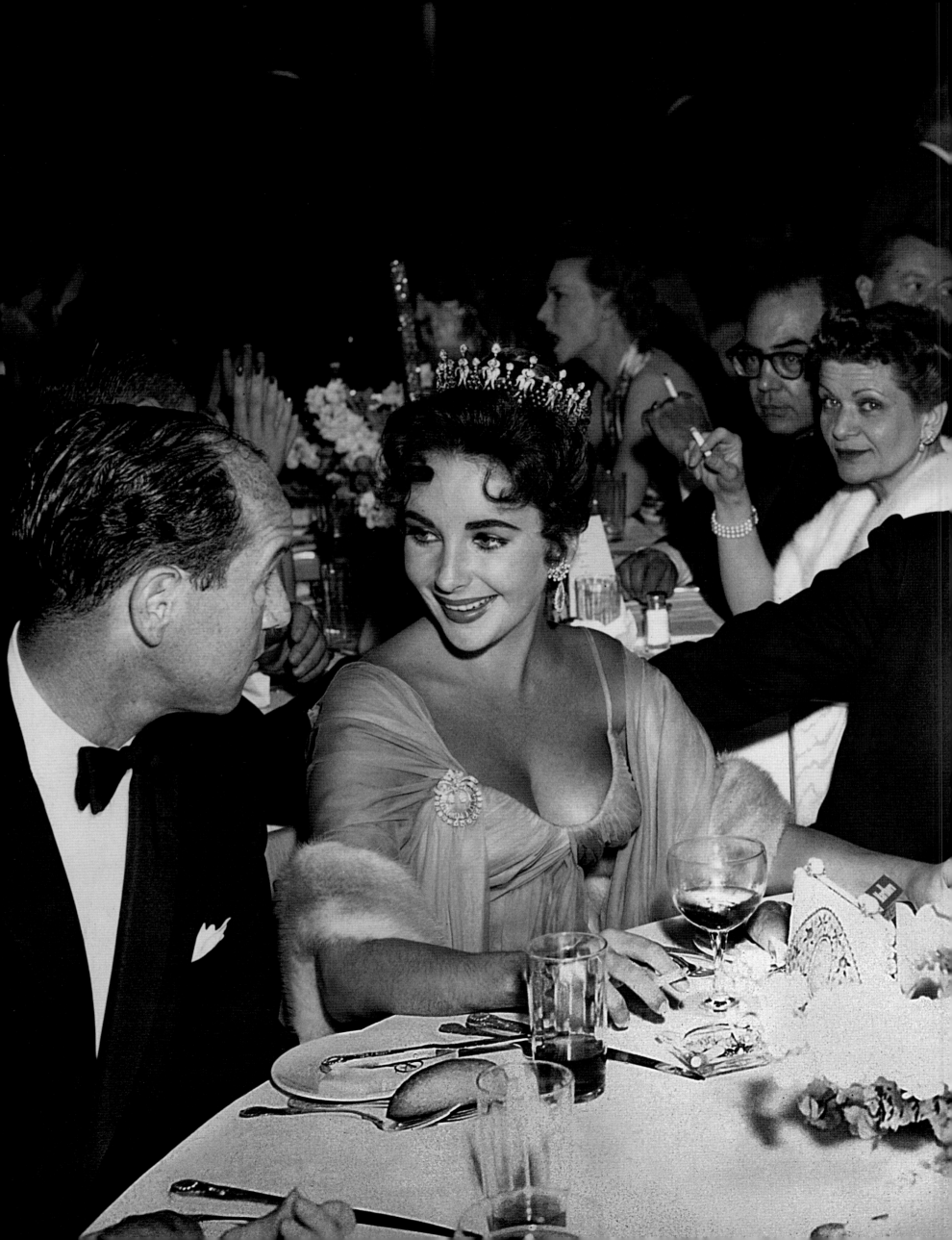

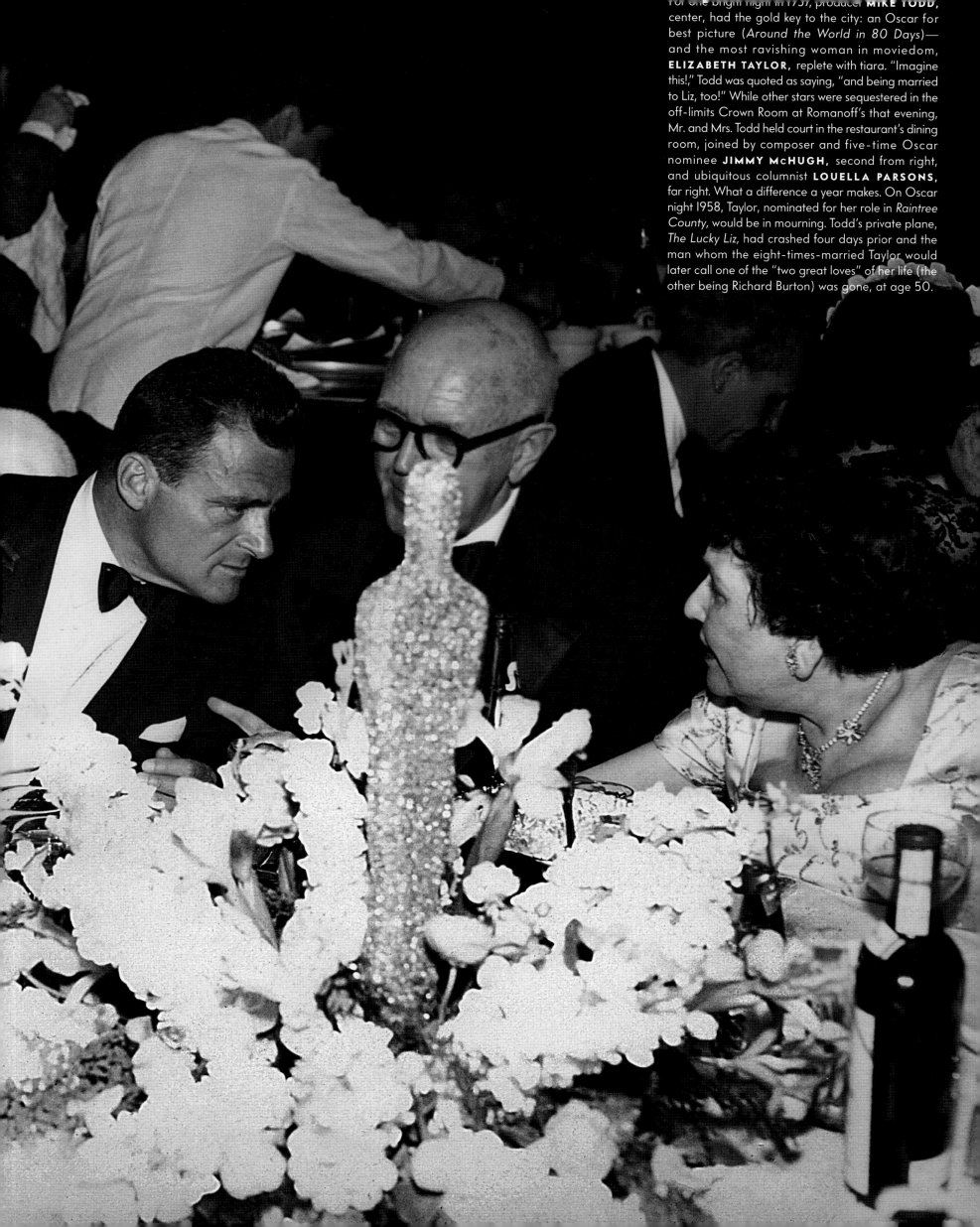

For one bright night in 1957, producer **MIKE TODD**, center, had the gold key to the city: an Oscar for best picture (*Around the World in 80 Days*)—and the most ravishing woman in moviedom, **ELIZABETH TAYLOR**, replete with tiara. "Imagine this!," Todd was quoted as saying, "and being married to Liz, too!" While other stars were sequestered in the off-limits Crown Room at Romanoff's that evening, Mr. and Mrs. Todd held court in the restaurant's dining room, joined by composer and five-time Oscar nominee **JIMMY McHUGH**, second from right, and ubiquitous columnist **LOUELLA PARSONS**, far right. What a difference a year makes. On Oscar night 1958, Taylor, nominated for her role in *Raintree County*, would be in mourning. Todd's private plane, *The Lucky Liz*, had crashed four days prior and the man whom the eight-times-married Taylor would later call one of the "two great loves" of her life (the other being Richard Burton) was gone, at age 50.

66 The ball at BevHilton Bali Room was a beaut: Clark Gable, with his beautiful bride [Kay Spreckels Gable], poised at the steps leading to the packed dance floor, said: 'I'm having a ball. We all stuck our chins out, tonight—and it paid off.' ... It was a beautiful night—right down to the dessert—ice cream decked with miniature Oscars ... Lana Turner's car broke down in front of the Pantages, she had to take a cab to the party.99

—ARMY ARCHERD, *DAILY VARIETY*, MARCH 28, 1958

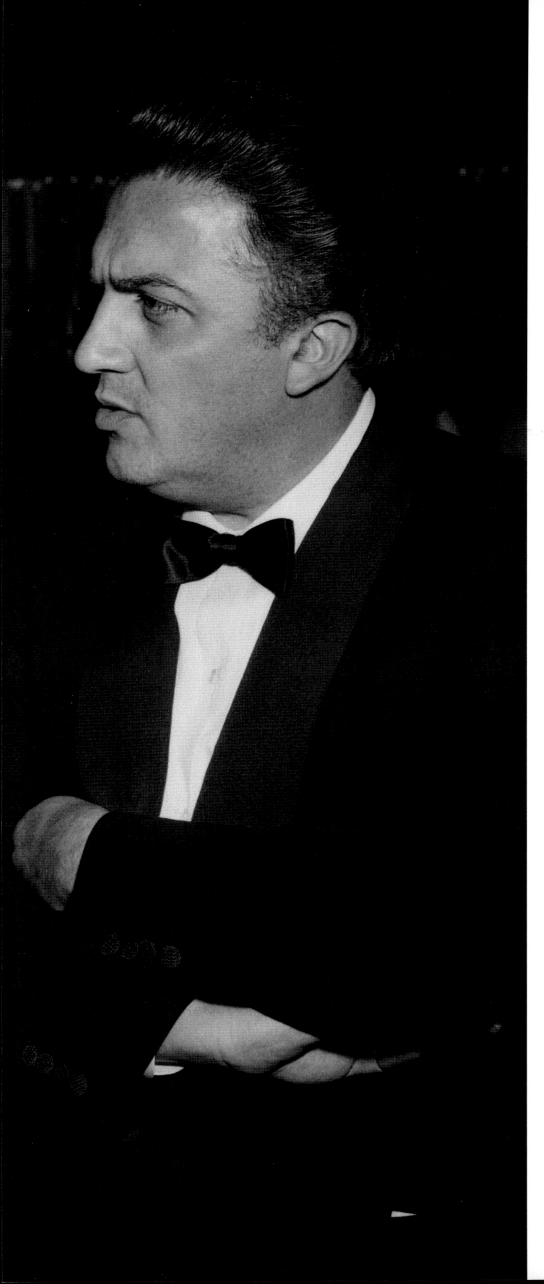

1958

Hollywood glamour thrived before and after the war. But in the 1950s and through the mid-60s, elegance was more evanescent, and the modern sense of style hardly seemed the exclusive province of the grand old studio stars. Instead, true cool was defined, more and more, by determinedly unconventional types: the jazzmen and the Beats and an edgy new breed of actor personified by James Dean and Marlon Brando. Meanwhile, innovative designers and image-makers were creating the new Modern Woman from their perches in Paris and Milan, and on the King's Road and Madison Avenue.

The Academy, of course, didn't do cool; Oscar wasn't about to grow a goatee. The ceremony and indeed the institution itself were strictly Establishment enterprises. And so Hollywood brass, in a move that amped up the glamour factor—and provided a larger venue for partygoers after the awards—decided to retrofit and have a ball, the first annual Board of Governors Ball. The evening's nominees, along with key studio and Academy figures—all 1,323 of them—were summoned to the ballroom of the new Beverly Hilton hotel (see following pages). In so doing, the Academy was burnishing Oscar's luster and reclaiming some of the verve that had distinguished those first banquets of the 30s.

Oscar night 1958 was a bona fide hit. Producer Jerry Wald set the evening's tone with a show of unprecedented razzmatazz at the RKO Pantages Theatre. The *pièce de résistance:* a Sammy Cahn–Jimmy Van Heusen number, "It's Great Not to Be Nominated," performed by Kirk Douglas and Burt Lancaster. Once the curtain closed, cinema's gentry regrouped at the Hilton's Bali Room, where they were treated to a dinner of filet mignon with fresh mushroom caps, and hearts of palm amandine, arranged by Fred Hayman, the hotel's resident banquet-and-catering manager (later a fashion Svengali to the stars, and owner of Giorgio, the Rodeo Drive mecca). A phalanx of more than 50 waiters, bearing tiny Oscars atop ice-cream mounds, filed into dinner to the theme from *The Bridge on the River Kwai.* "What a night!," Louella Parsons enthused. "The biggest and best Academy Awards in all its 30 years . . . with the biggest turnout of stars in our history. Rosalind Russell [in] tight trousers. . . . Rock Hudson, who came to our table, said he believes Mae West is due for a comeback." Songstress Pearl Bailey belted out a medley of favorites.

Still, one man's groove is another man's grouse. According to Army Archerd's column in *Daily Variety* that week, Marlon Brando would have none of it. The actor, said Archerd, "arrived at the Bali Room, took one look and fled" to his agent Jay Kanter's home, where he set to "munching fried chicken in the kitchen [until] 4:30 ayem!"

Though that initial, glittering Governors Ball was a smash, it was tinged with tragedy nonetheless. First, Elizabeth Taylor, a best-actress nominee for *Raintree County,* was in seclusion, devastated by the death of her husband, Mike Todd, whose private plane, *The Lucky Liz,* had crashed in New Mexico just days before the gala. Next came a sinister twist involving another best-actress hopeful, *Peyton Place*'s Lana Turner (who, along with Taylor, lost out that year to *The Three Faces of Eve* star Joanne Woodward). Turner, it so happened, had chosen to bring along her press agent, Glenn Rose, her mother, and her 14-year-old daughter, Cheryl Crane, as her escorts to the theater—snubbing her companion, mobster Johnny Stompanato. Slighted, Stompanato had made it plain that he wanted Turner to forgo the Hilton after-party and come back home. She defied him, returning late from the ball; that night Stompanato slugged her. "He roughed me up for the first time in front of my daughter, Cheryl," Turner would later recall. In a week's time, after yet another outburst and beating, Stompanato would lay in a pool of blood, purportedly stabbed to death with a kitchen knife by Cheryl, who claimed to have gone to the aid of her mother.

Is this the only photograph ever taken of **JERRY LEWIS,** left, with **FEDERICO FELLINI,** at right? Lewis, then recently separated from his film-and-performance partner, Dean Martin, hosted the 29th Academy Awards, where Fellini's *La Strada,* produced by **DINO DE LAURENTIIS,** center, and Carlo Ponti, was named the best foreign-language picture of 1956—the first competitive Oscar awarded in the category. Unfortunately, the Academy declined to recognize Martin and Lewis's work that year in *Pardners* and *Hollywood or Bust.* Many cinephiles have further lamented the fact that Lewis and Fellini never managed to collaborate.

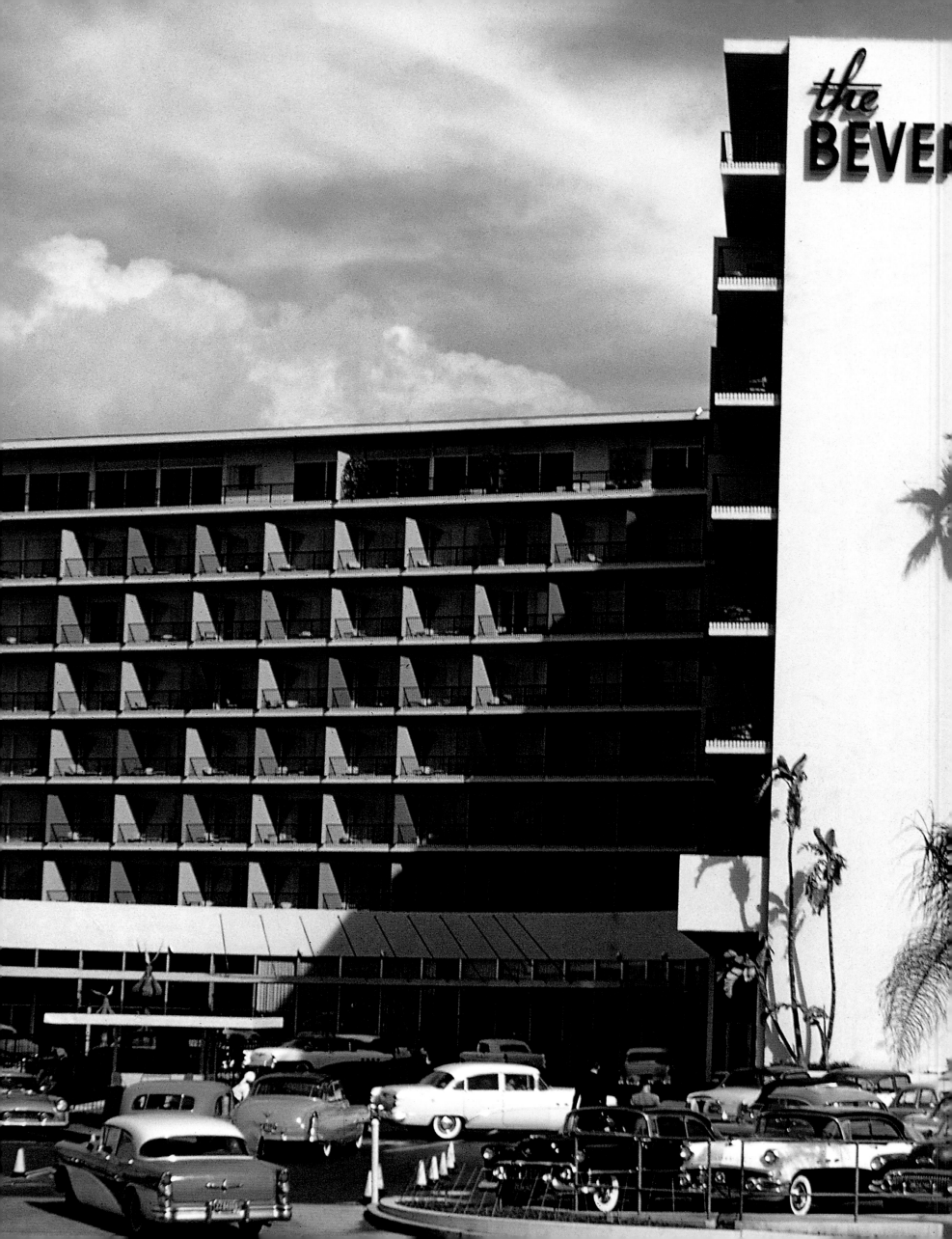

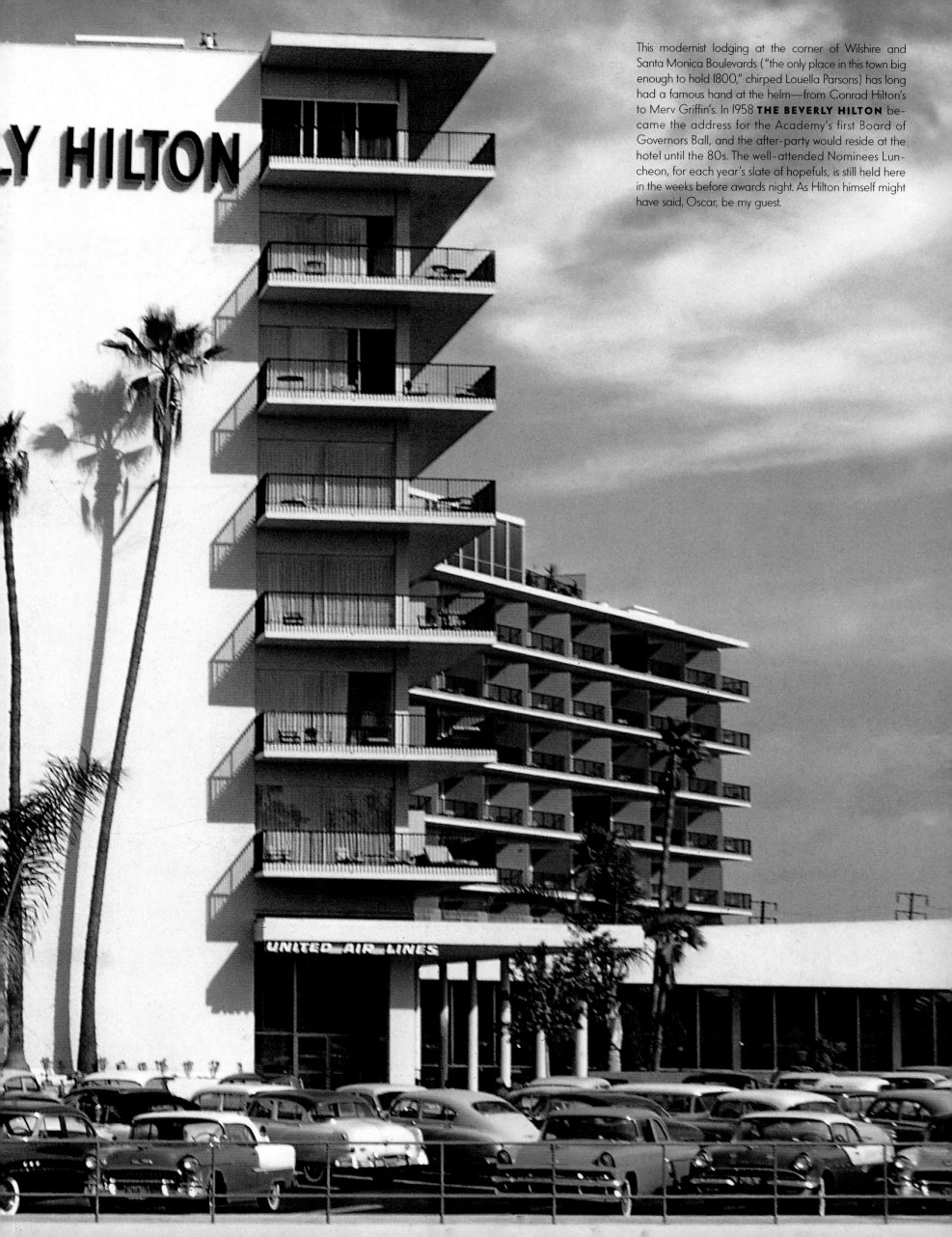

This modernist lodging at the corner of Wilshire and Santa Monica Boulevards ("the only place in this town big enough to hold 1800," chirped Louella Parsons) has long had a famous hand at the helm—from Conrad Hilton's to Merv Griffin's. In 1958 **THE BEVERLY HILTON** became the address for the Academy's first Board of Governors Ball, and the after-party would reside at the hotel until the 80s. The well-attended Nominees Luncheon, for each year's slate of hopefuls, is still held here in the weeks before awards night. As Hilton himself might have said, Oscar, be my guest.

LY HILTON

UNITED AIR LINES

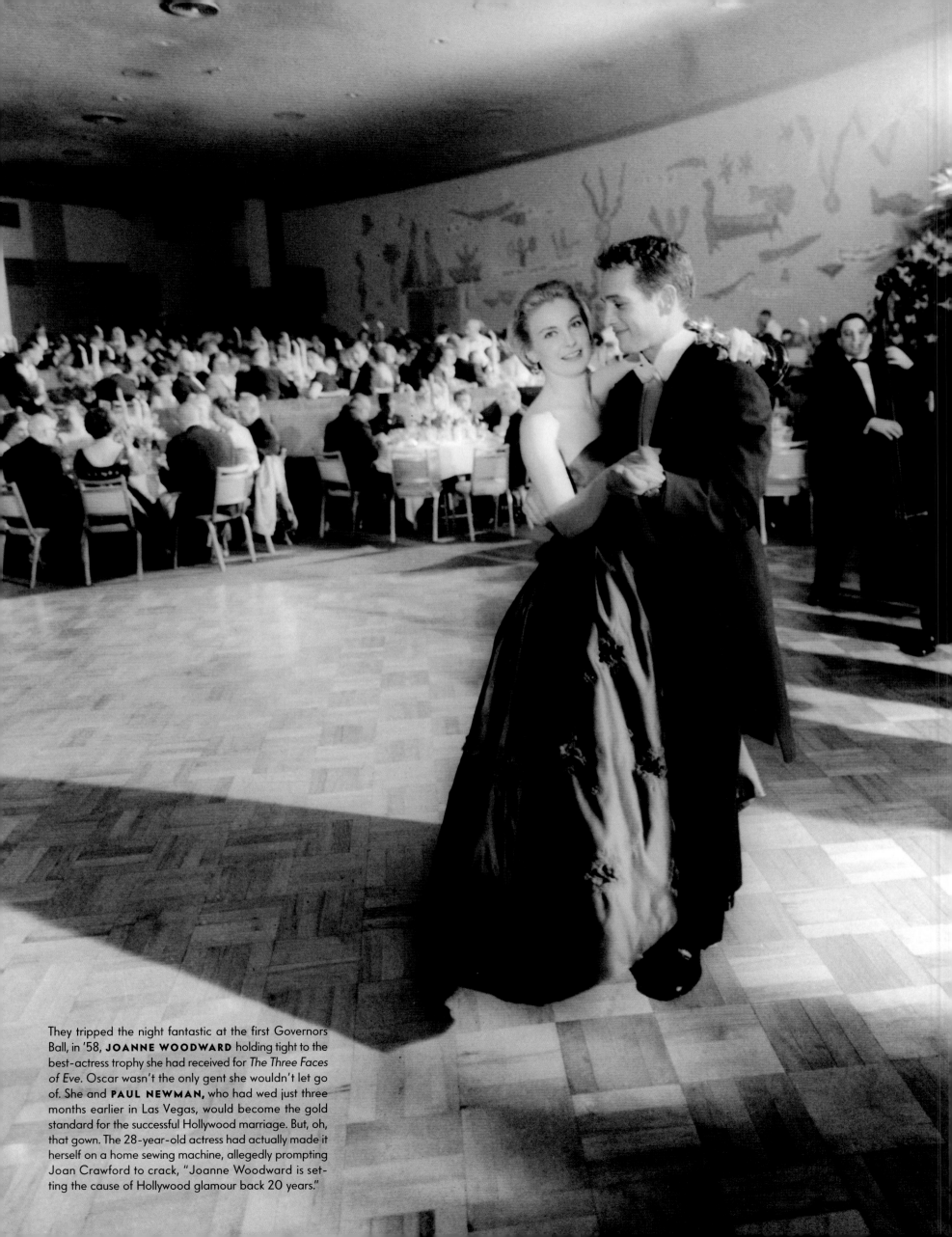

They tripped the night fantastic at the first Governors Ball, in '58, **JOANNE WOODWARD** holding tight to the best-actress trophy she had received for *The Three Faces of Eve.* Oscar wasn't the only gent she wouldn't let go of. She and **PAUL NEWMAN,** who had wed just three months earlier in Las Vegas, would become the gold standard for the successful Hollywood marriage. But, oh, that gown. The 28-year-old actress had actually made it herself on a home sewing machine, allegedly prompting Joan Crawford to crack, "Joanne Woodward is setting the cause of Hollywood glamour back 20 years."

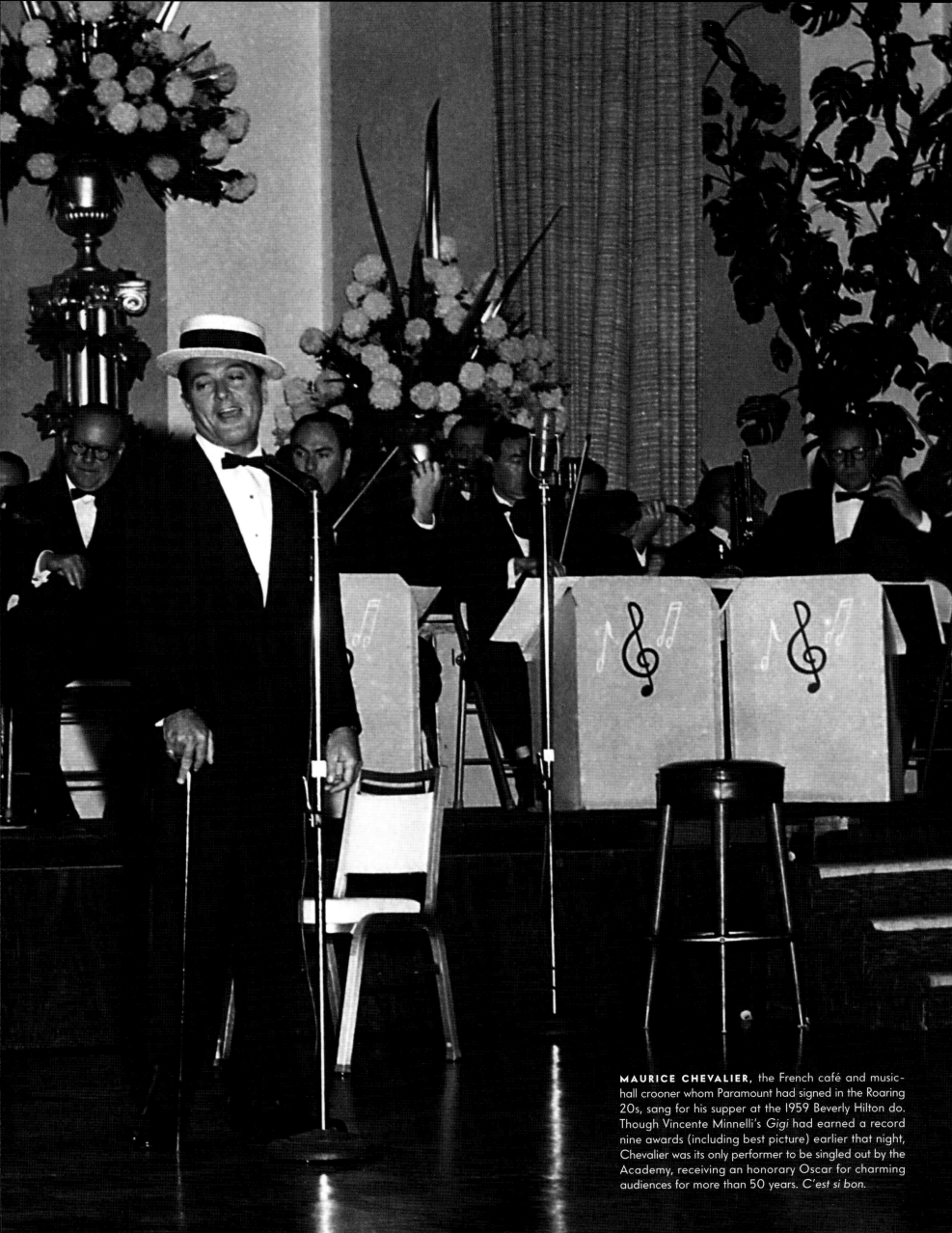

MAURICE CHEVALIER, the French café and music-hall crooner whom Paramount had signed in the Roaring 20s, sang for his supper at the 1959 Beverly Hilton do. Though Vincente Minnelli's *Gigi* had earned a record nine awards (including best picture) earlier that night, Chevalier was its only performer to be singled out by the Academy, receiving an honorary Oscar for charming audiences for more than 50 years. *C'est si bon.*

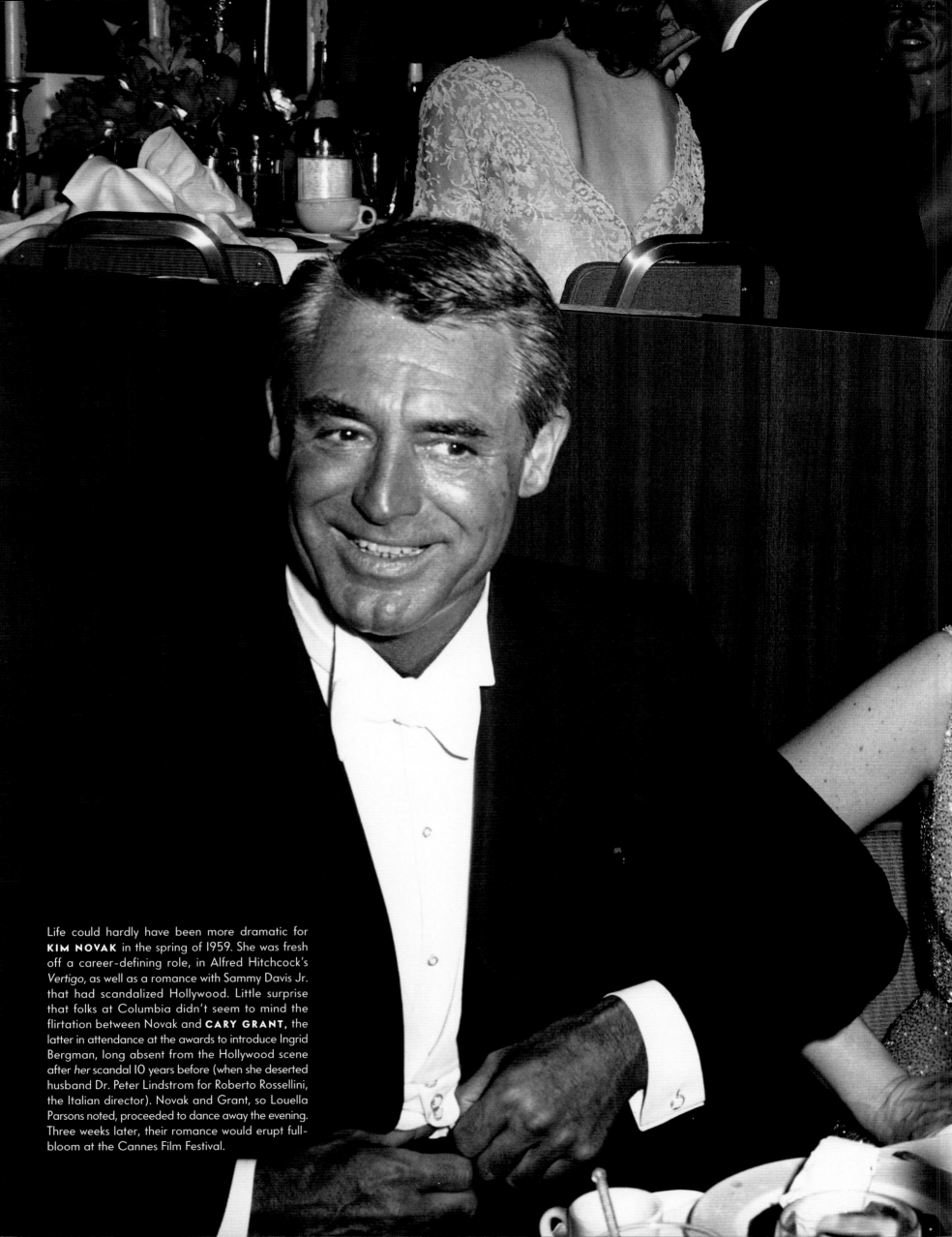

Life could hardly have been more dramatic for **KIM NOVAK** in the spring of 1959. She was fresh off a career-defining role, in Alfred Hitchcock's *Vertigo*, as well as a romance with Sammy Davis Jr. that had scandalized Hollywood. Little surprise that folks at Columbia didn't seem to mind the flirtation between Novak and **CARY GRANT**, the latter in attendance at the awards to introduce Ingrid Bergman, long absent from the Hollywood scene after *her* scandal 10 years before (when she deserted husband Dr. Peter Lindstrom for Roberto Rossellini, the Italian director). Novak and Grant, so Louella Parsons noted, proceeded to dance away the evening. Three weeks later, their romance would erupt full-bloom at the Cannes Film Festival.

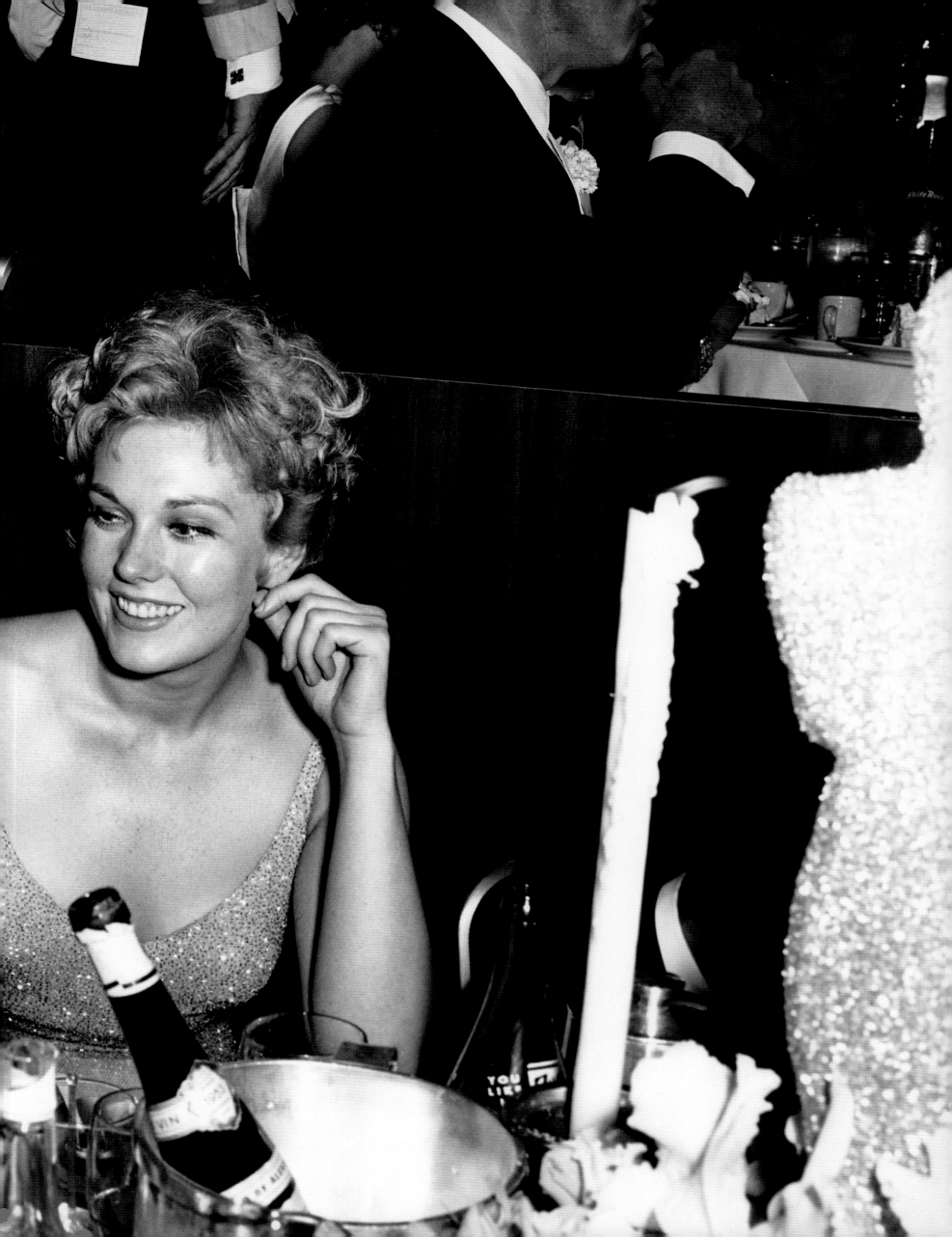

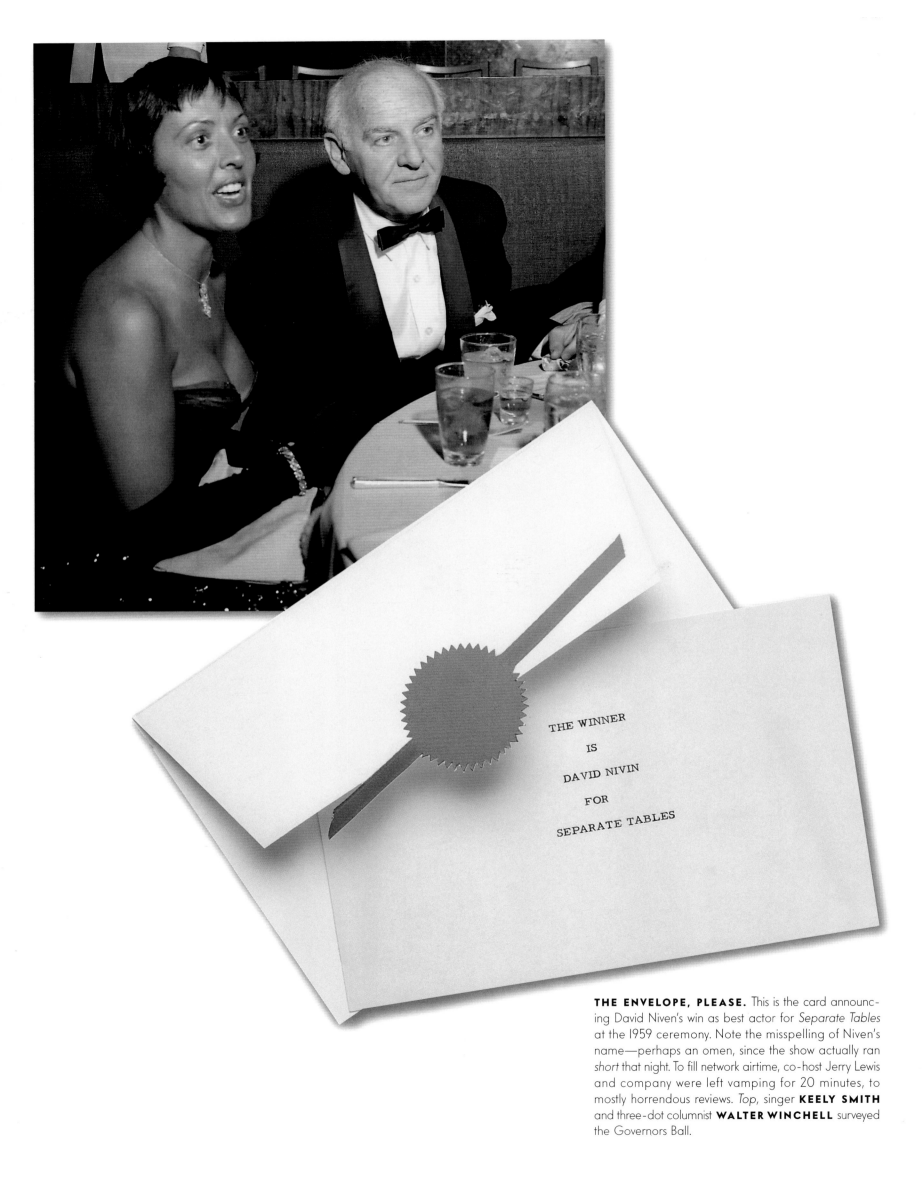

THE WINNER

IS

DAVID NIVIN

FOR

SEPARATE TABLES

THE ENVELOPE, PLEASE. This is the card announcing David Niven's win as best actor for *Separate Tables* at the 1959 ceremony. Note the misspelling of Niven's name—perhaps an omen, since the show actually ran *short* that night. To fill network airtime, co-host Jerry Lewis and company were left vamping for 20 minutes, to mostly horrendous reviews. *Top*, singer **KEELY SMITH** and three-dot columnist **WALTER WINCHELL** surveyed the Governors Ball.

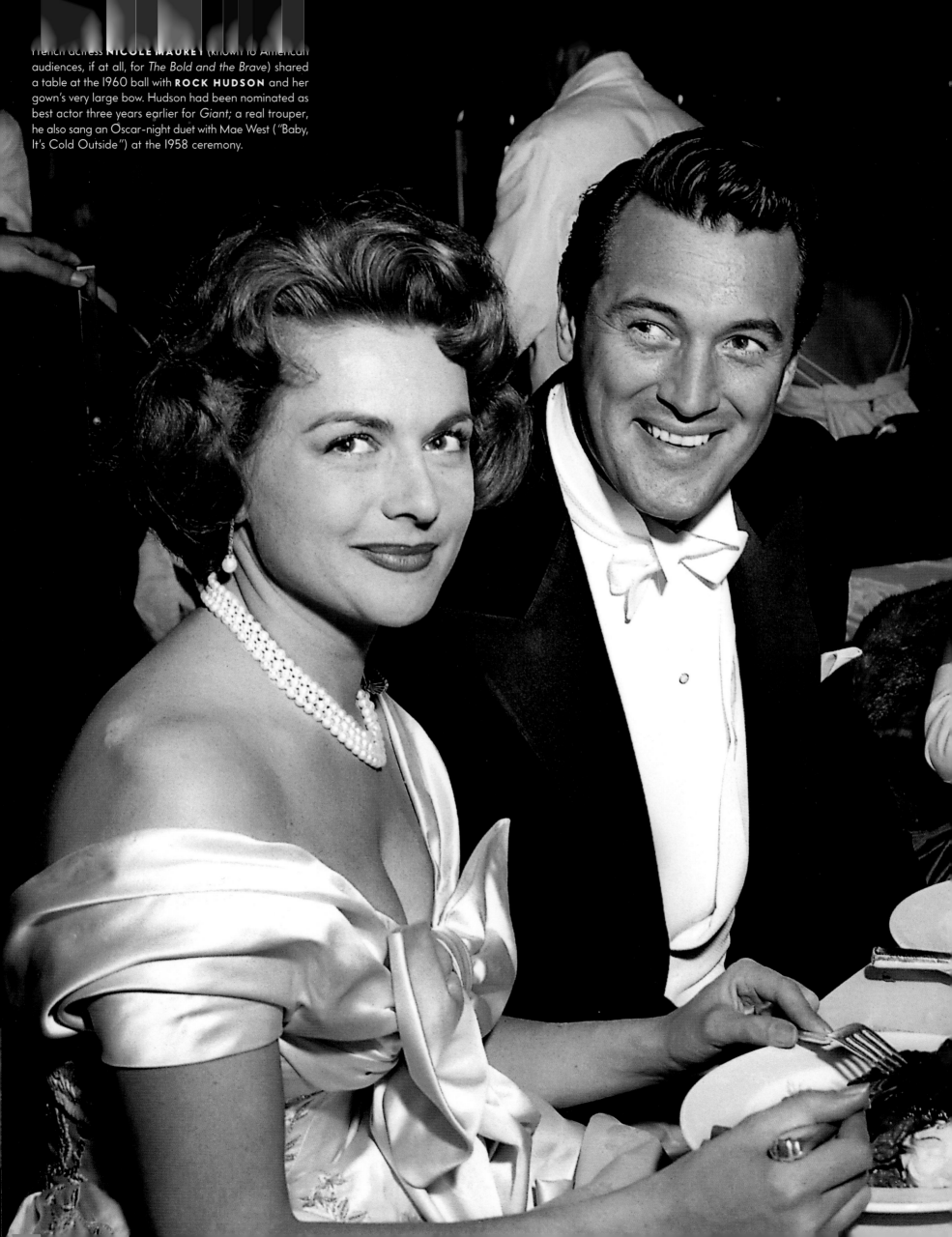

French actress **NICOLE MAUREY** (known to American audiences, if at all, for *The Bold and the Brave*) shared a table at the 1960 ball with **ROCK HUDSON** and her gown's very large bow. Hudson had been nominated as best actor three years earlier for *Giant;* a real trouper, he also sang an Oscar-night duet with Mae West ("Baby, It's Cold Outside") at the 1958 ceremony.

ANNUAL ACADEMY AWARDS

NEWSREEL

RKO PANTAGES THEATRE
APRIL 4, 1960

32nd

1120

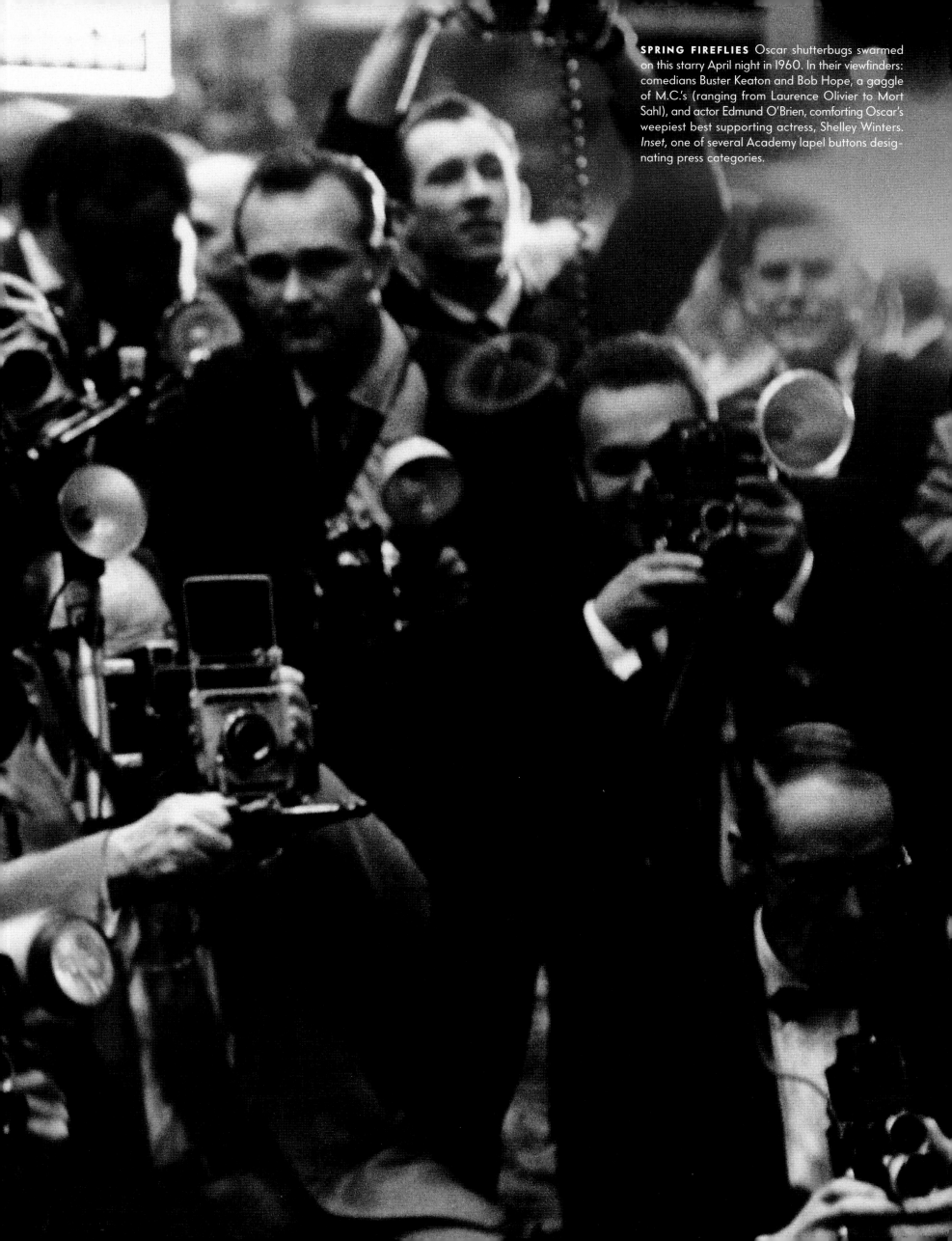

SPRING FIREFLIES Oscar shutterbugs swarmed on this starry April night in 1960. In their viewfinders: comedians Buster Keaton and Bob Hope, a gaggle of M.C.'s (ranging from Laurence Olivier to Mort Sahl), and actor Edmund O'Brien, comforting Oscar's weepiest best supporting actress, Shelley Winters. *Inset*, one of several Academy lapel buttons designating press categories.

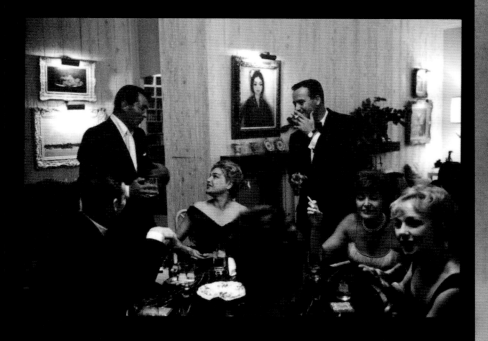

→7 →7A
KODAK SAFETY FILM 5063

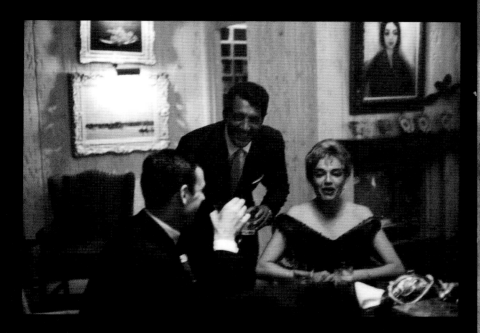

→13 →13A
M 5063 KODAK

SIMONE SIGNORET, center, luxuriated in her 1960 night at the Oscars, finessing best-actress kudos (the first for a foreign-made movie—Britain's *Room at the Top*) amid a formidable field: Doris Day, Liz Taylor, and *two* Hepburns. She then made the scene at the Governors Ball, "still shaking" from the shock of her victory, observed Louella Parsons. "She kept saying she was so grateful." And what would Oscar evening be without a stop at the Vidors' home in Beverly Hills? In the art-adorned living room, a van Dongen (over the TV set) peered down upon the celebrants: producer **SAM SPIEGEL** (kissing Signoret's hand); her husband, actor-singer **YVES MONTAND** (left, with cigarette); **DEAN MARTIN** (*top left*, far left, and *center*, laughing); and **JACK LEMMON** (*top left*, at right, and *bottom*, second from right).

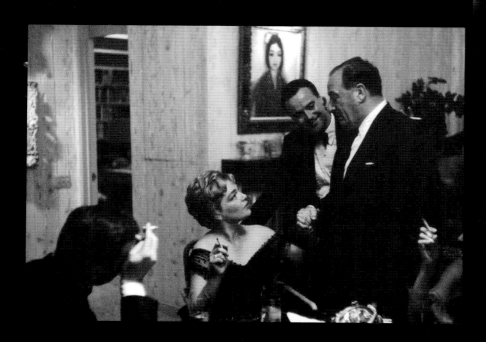

→19 →19A
KODAK SAFETY FILM 5063

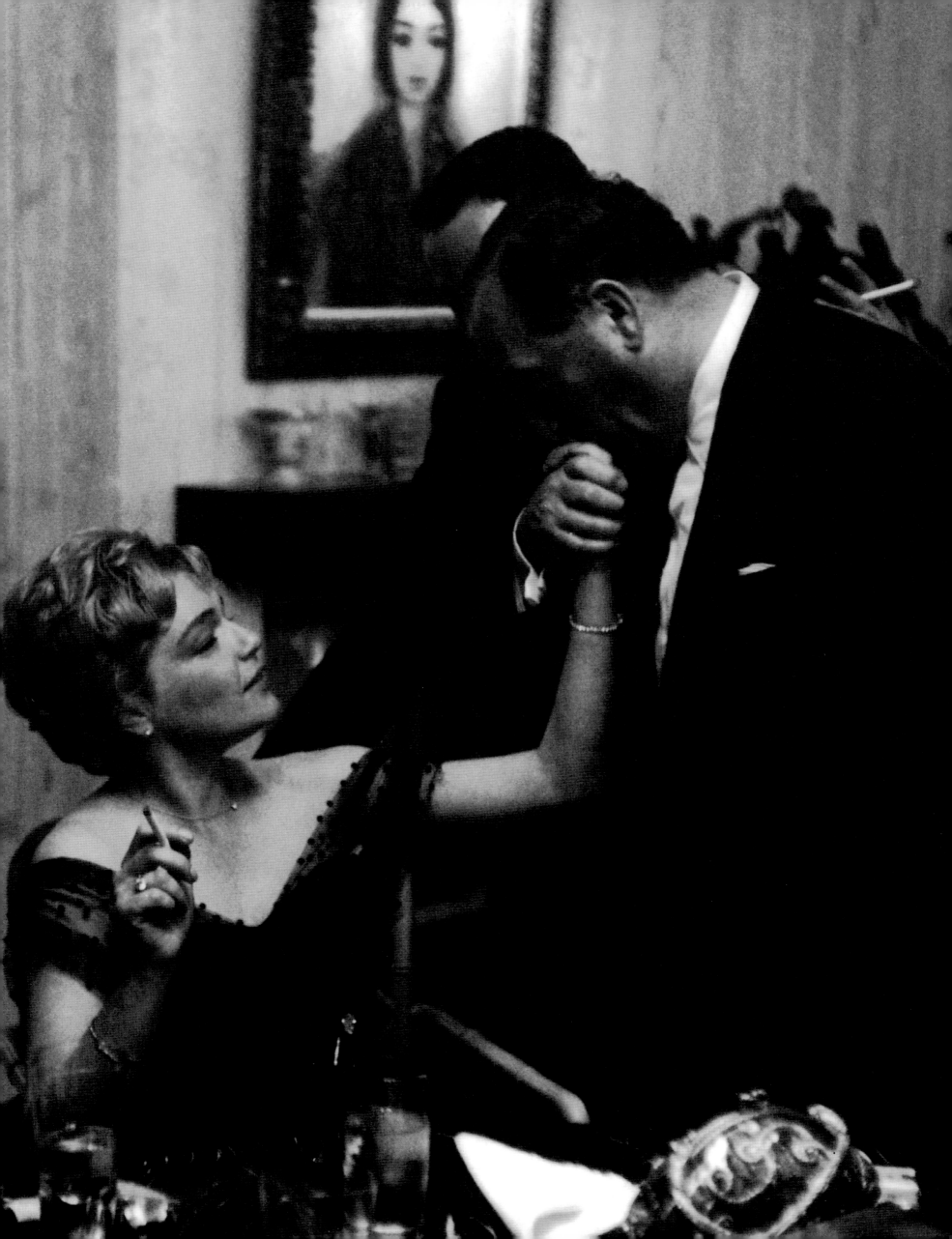

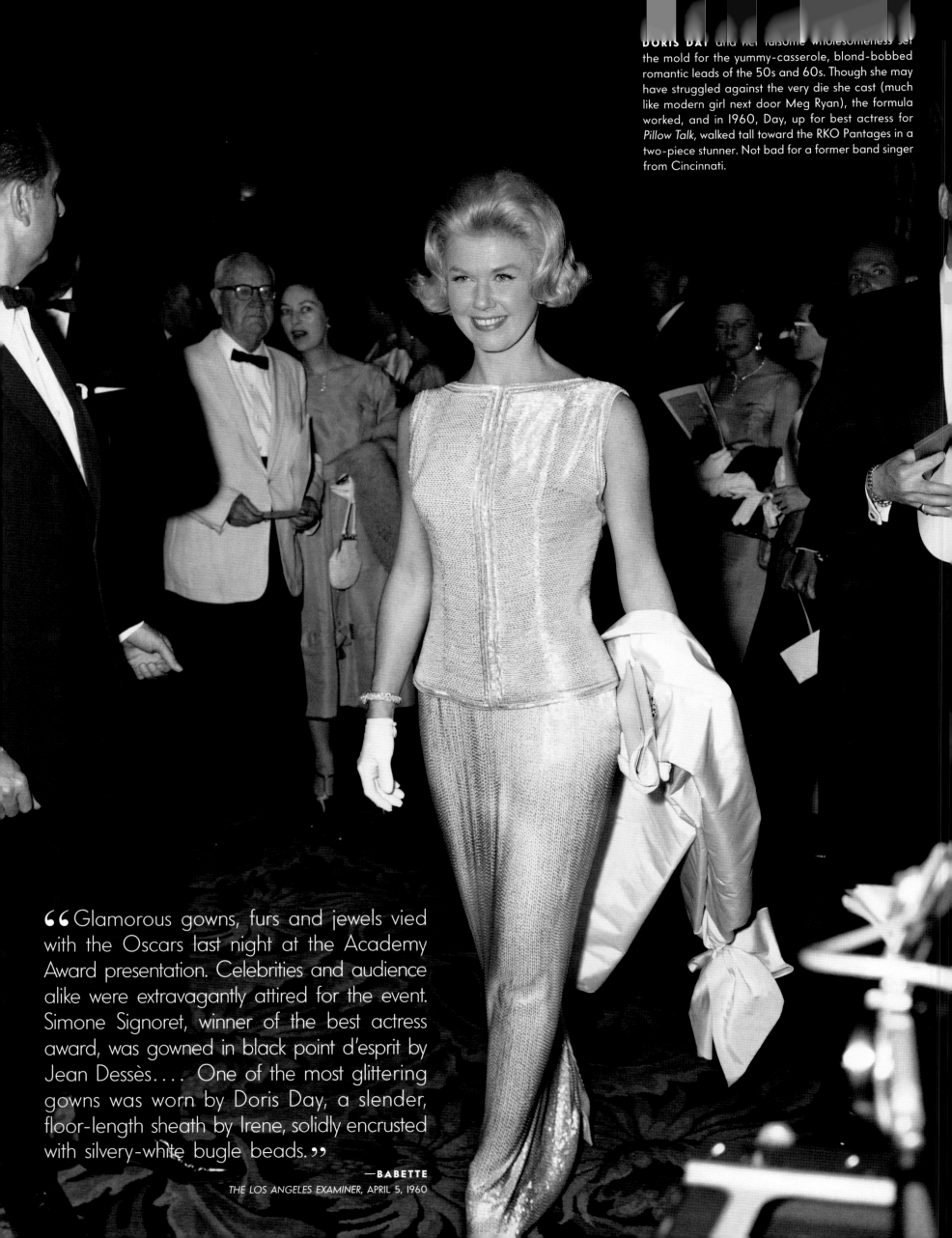

❝Glamorous gowns, furs and jewels vied with the Oscars last night at the Academy Award presentation. Celebrities and audience alike were extravagantly attired for the event. Simone Signoret, winner of the best actress award, was gowned in black point d'esprit by Jean Dessès.... One of the most glittering gowns was worn by Doris Day, a slender, floor-length sheath by Irene, solidly encrusted with silvery-white bugle beads.**❞**

—BABETTE
THE LOS ANGELES EXAMINER, APRIL 5, 1960

RED CARPETBAGGERS Across three generations, spectators like these, at the 32nd awards show, have clustered outside Oscar's many venues. Often, fans have camped overnight for a chance at a bleacher seat adjacent to a patch of starshine. Following the terrorist attacks of September 2001, however, a new protocol was instituted: henceforth, approximately 400 would be eligible to obtain reserved slots after submitting to a security screening.

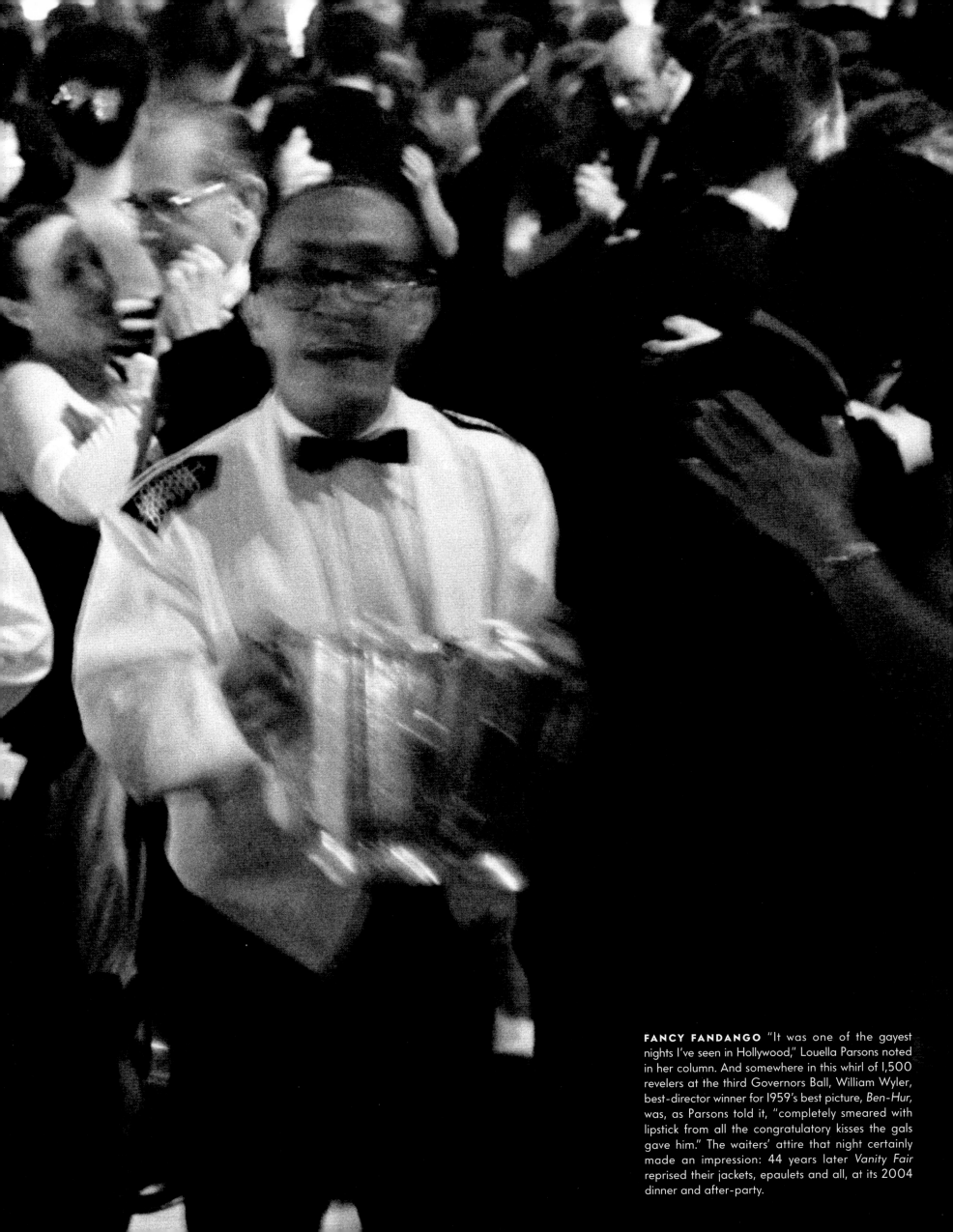

FANCY FANDANGO "It was one of the gayest nights I've seen in Hollywood," Louella Parsons noted in her column. And somewhere in this whirl of 1,500 revelers at the third Governors Ball, William Wyler, best-director winner for 1959's best picture, *Ben-Hur*, was, as Parsons told it, "completely smeared with lipstick from all the congratulatory kisses the gals gave him." The waiters' attire that night certainly made an impression: 44 years later *Vanity Fair* reprised their jackets, epaulets and all, at its 2004 dinner and after-party.

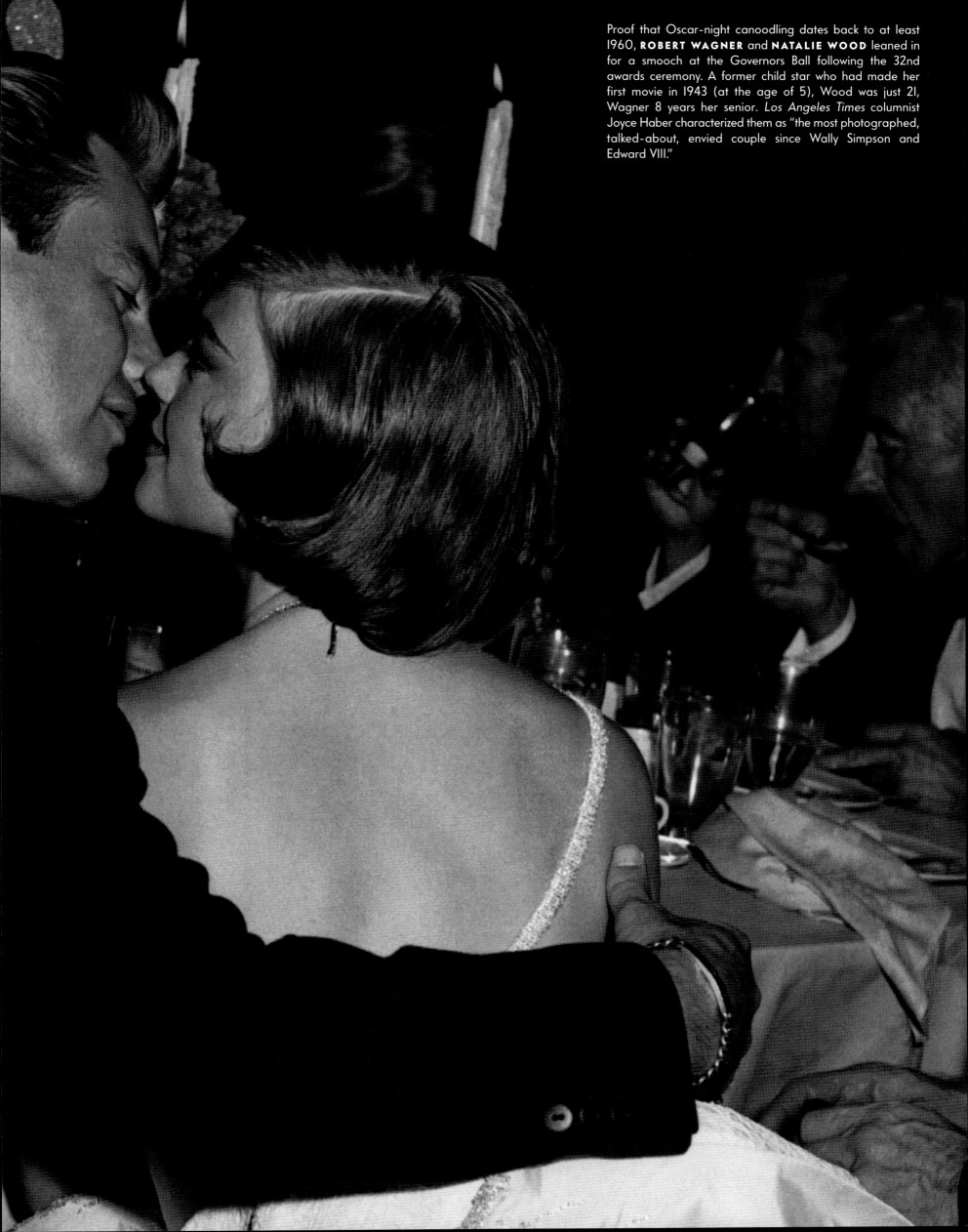

Proof that Oscar-night canoodling dates back to at least 1960, **ROBERT WAGNER** and **NATALIE WOOD** leaned in for a smooch at the Governors Ball following the 32nd awards ceremony. A former child star who had made her first movie in 1943 (at the age of 5), Wood was just 21, Wagner 8 years her senior. *Los Angeles Times* columnist Joyce Haber characterized them as "the most photographed, talked-about, envied couple since Wally Simpson and Edward VIII."

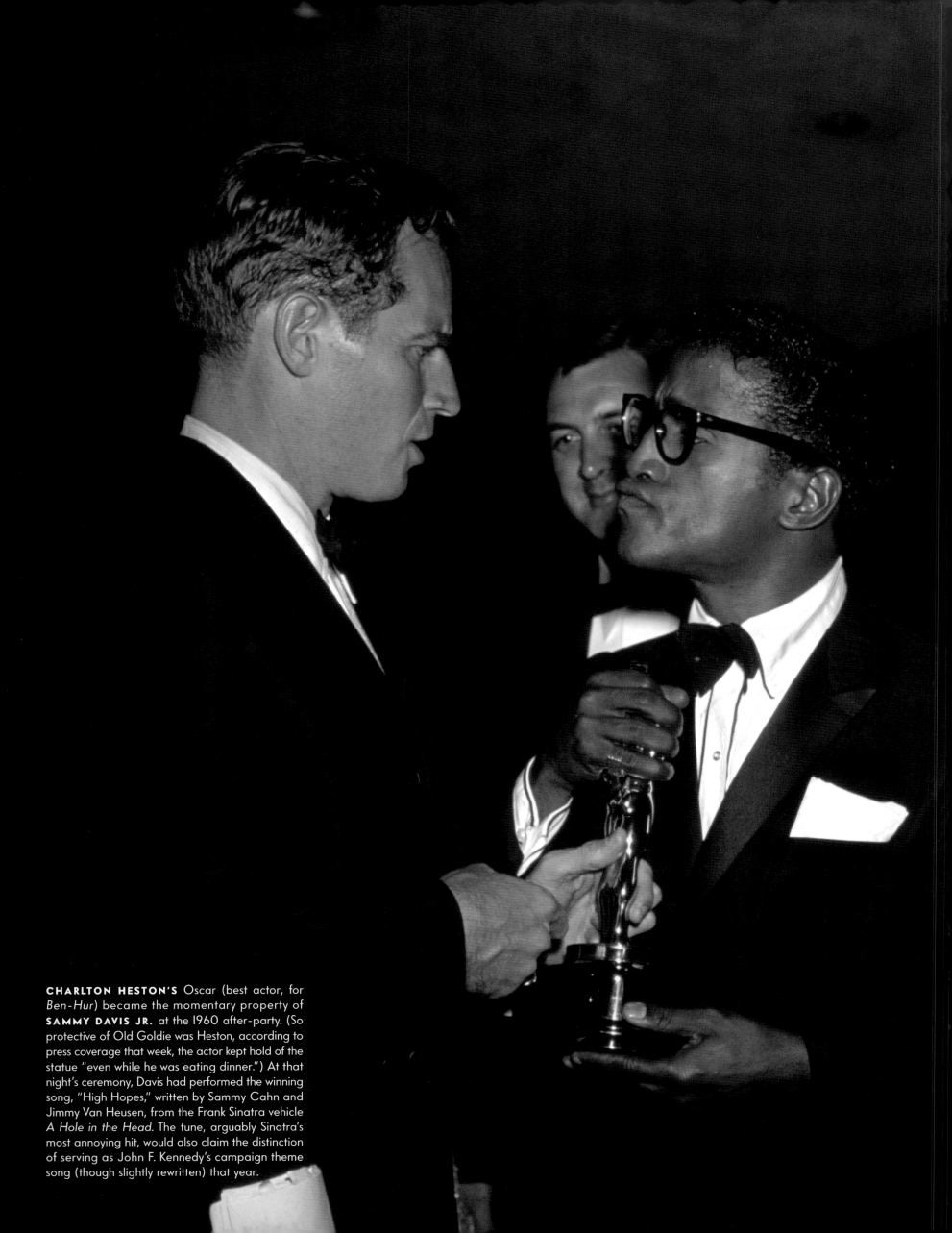

CHARLTON HESTON'S Oscar (best actor, for *Ben-Hur*) became the momentary property of **SAMMY DAVIS JR.** at the 1960 after-party. (So protective of Old Goldie was Heston, according to press coverage that week, the actor kept hold of the statue "even while he was eating dinner.") At that night's ceremony, Davis had performed the winning song, "High Hopes," written by Sammy Cahn and Jimmy Van Heusen, from the Frank Sinatra vehicle *A Hole in the Head*. The tune, arguably Sinatra's most annoying hit, would also claim the distinction of serving as John F. Kennedy's campaign theme song (though slightly rewritten) that year.

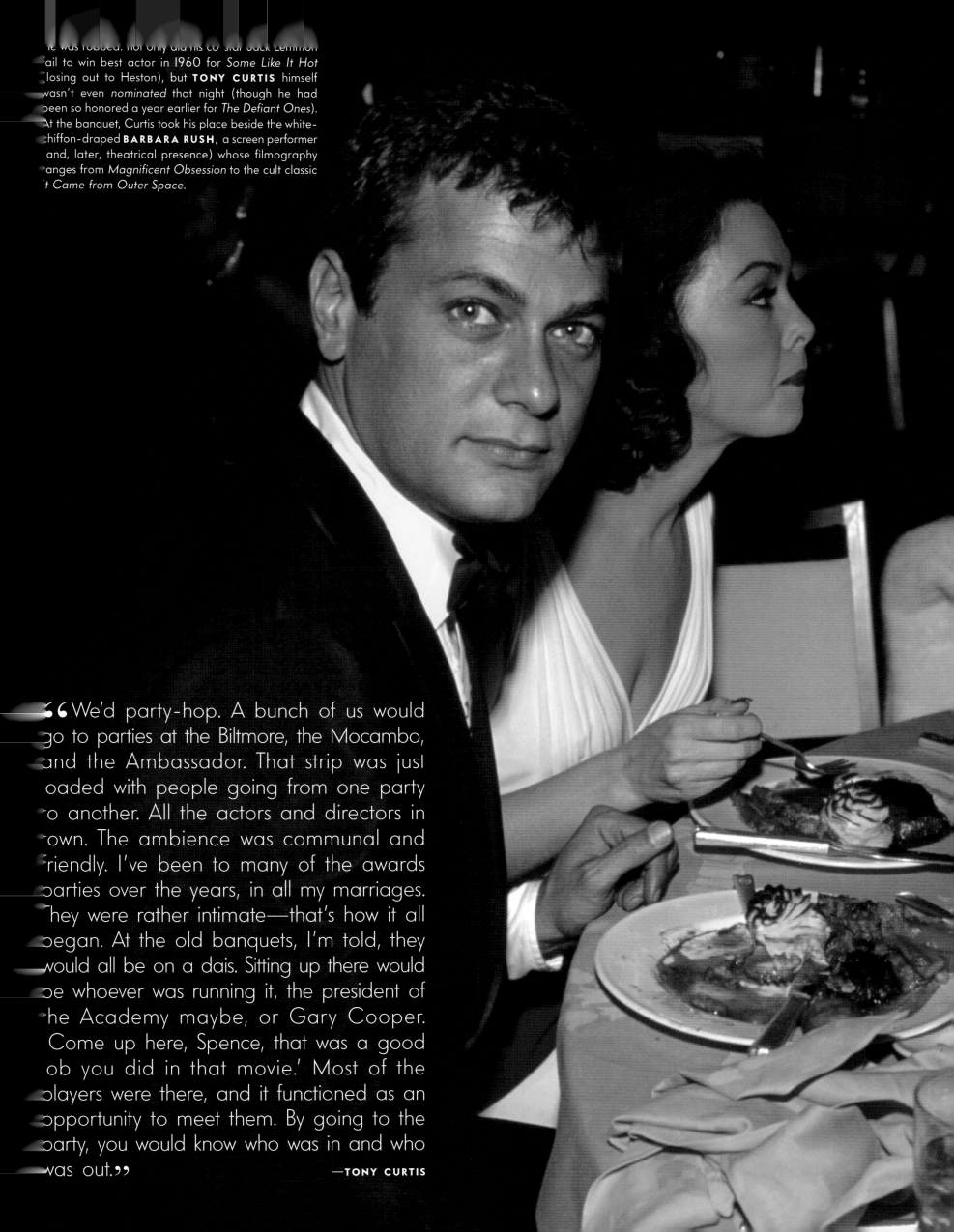

He was robbed. Not only did his co-star Jack Lemmon fail to win best actor in 1960 for *Some Like It Hot* (losing out to Heston), but **TONY CURTIS** himself wasn't even *nominated* that night (though he had been so honored a year earlier for *The Defiant Ones*). At the banquet, Curtis took his place beside the white-chiffon-draped **BARBARA RUSH,** a screen performer (and, later, theatrical presence) whose filmography ranges from *Magnificent Obsession* to the cult classic *It Came from Outer Space.*

❝We'd party-hop. A bunch of us would go to parties at the Biltmore, the Mocambo, and the Ambassador. That strip was just loaded with people going from one party to another. All the actors and directors in town. The ambience was communal and friendly. I've been to many of the awards parties over the years, in all my marriages. They were rather intimate—that's how it all began. At the old banquets, I'm told, they would all be on a dais. Sitting up there would be whoever was running it, the president of the Academy maybe, or Gary Cooper. 'Come up here, Spence, that was a good job you did in that movie.' Most of the players were there, and it functioned as an opportunity to meet them. By going to the party, you would know who was in and who was out.❞
—**TONY CURTIS**

THE AFTERCLAP The hoopla was over. (Perhaps "saturnalia" would be more apt, given *Ben-Hur's* 11-Oscar ransack that night—a record take, since tied by only two pictures: *Titanic* and *The Lord of the Rings: The Return of the King*.) Following the 1960 Governors Ball, as guests headed for the cloakroom, Magnum photographer Dennis Stock was clever enough to compose a midnight still life, complete with an endearing little gold guy. Take two Oscars and call me in the morning.

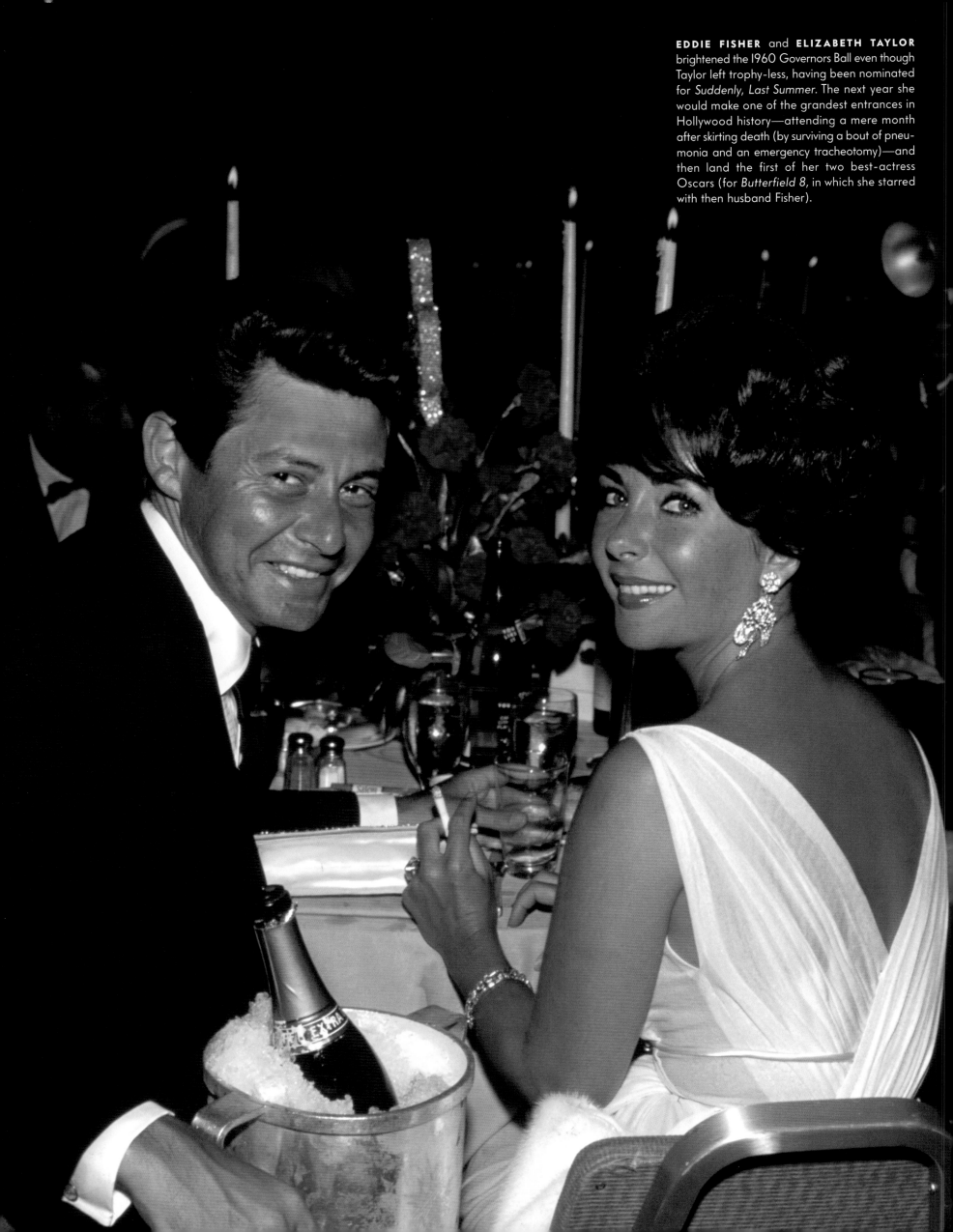

EDDIE FISHER and **ELIZABETH TAYLOR** brightened the 1960 Governors Ball even though Taylor left trophy-less, having been nominated for *Suddenly, Last Summer*. The next year she would make one of the grandest entrances in Hollywood history—attending a mere month after skirting death (by surviving a bout of pneumonia and an emergency tracheotomy)—and then land the first of her two best-actress Oscars (for *Butterfield 8,* in which she starred with then husband Fisher).

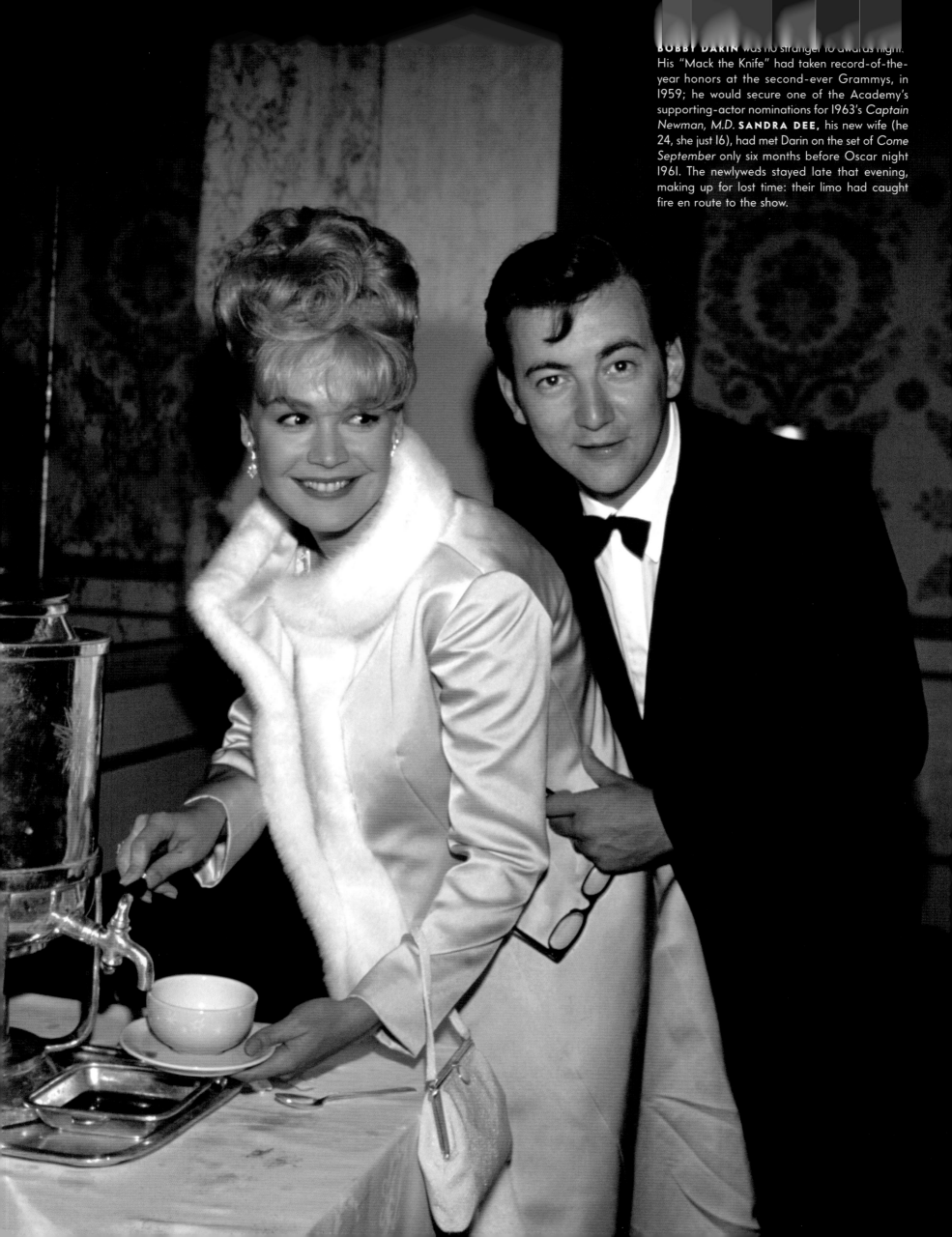

BOBBY DARIN was no stranger to awards night. His "Mack the Knife" had taken record-of-the-year honors at the second-ever Grammys, in 1959; he would secure one of the Academy's supporting-actor nominations for 1963's *Captain Newman, M.D.* SANDRA DEE, his new wife (he 24, she just 16), had met Darin on the set of *Come September* only six months before Oscar night 1961. The newlyweds stayed late that evening, making up for lost time: their limo had caught fire en route to the show.

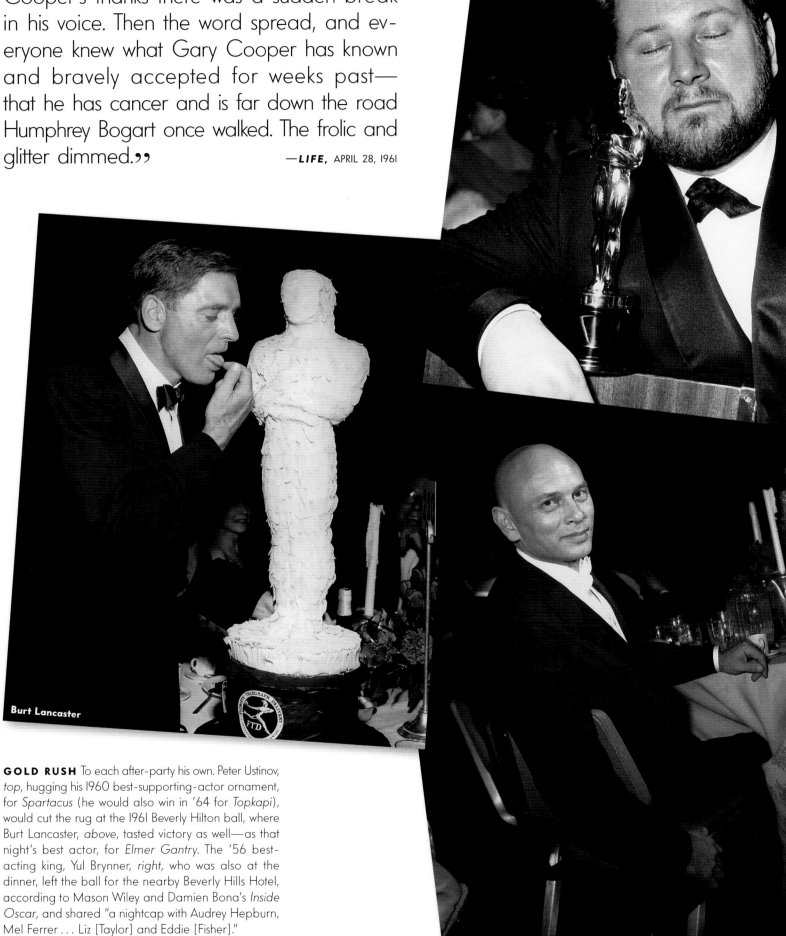

66 The secret was out on Academy Awards night. James Stewart went to the stage to accept an honorary award for his old and dear friend, Gary Cooper. As he voiced Cooper's thanks there was a sudden break in his voice. Then the word spread, and everyone knew what Gary Cooper has known and bravely accepted for weeks past—that he has cancer and is far down the road Humphrey Bogart once walked. The frolic and glitter dimmed. 99 —*LIFE*, APRIL 28, 1961

Peter Ustinov in 1961.

Burt Lancaster

Yul Brynner

GOLD RUSH To each after-party his own. Peter Ustinov, *top*, hugging his 1960 best-supporting-actor ornament, for *Spartacus* (he would also win in '64 for *Topkapi*), would cut the rug at the 1961 Beverly Hilton ball, where Burt Lancaster, *above*, tasted victory as well—as that night's best actor, for *Elmer Gantry*. The '56 best-acting king, Yul Brynner, *right*, who was also at the dinner, left the ball for the nearby Beverly Hills Hotel, according to Mason Wiley and Damien Bona's *Inside Oscar*, and shared "a nightcap with Audrey Hepburn, Mel Ferrer . . . Liz [Taylor] and Eddie [Fisher]."

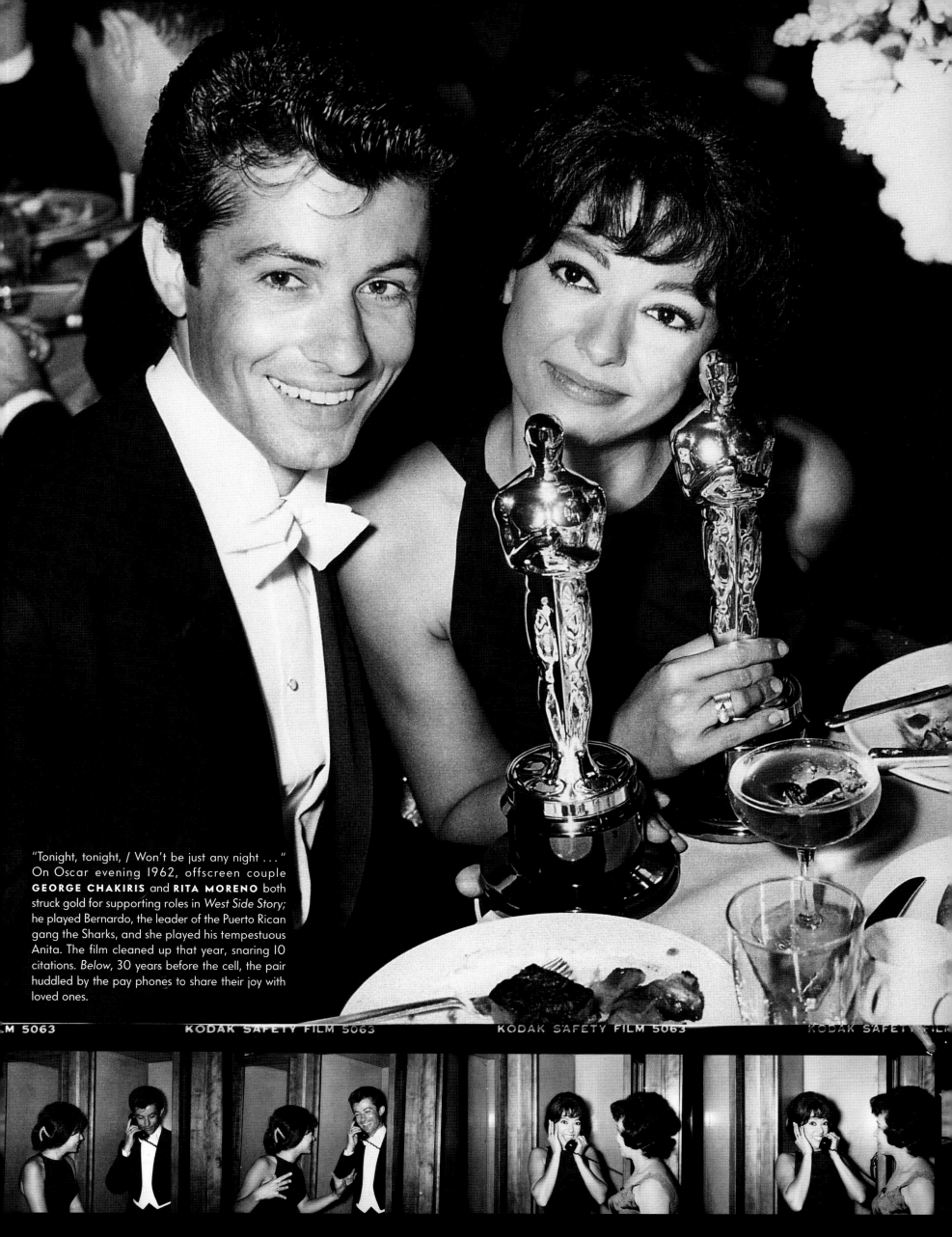

"Tonight, tonight, / Won't be just any night . . . "
On Oscar evening 1962, offscreen couple
GEORGE CHAKIRIS and **RITA MORENO** both
struck gold for supporting roles in *West Side Story*;
he played Bernardo, the leader of the Puerto Rican
gang the Sharks, and she played his tempestuous
Anita. The film cleaned up that year, snaring 10
citations. *Below*, 30 years before the cell, the pair
huddled by the pay phones to share their joy with
loved ones.

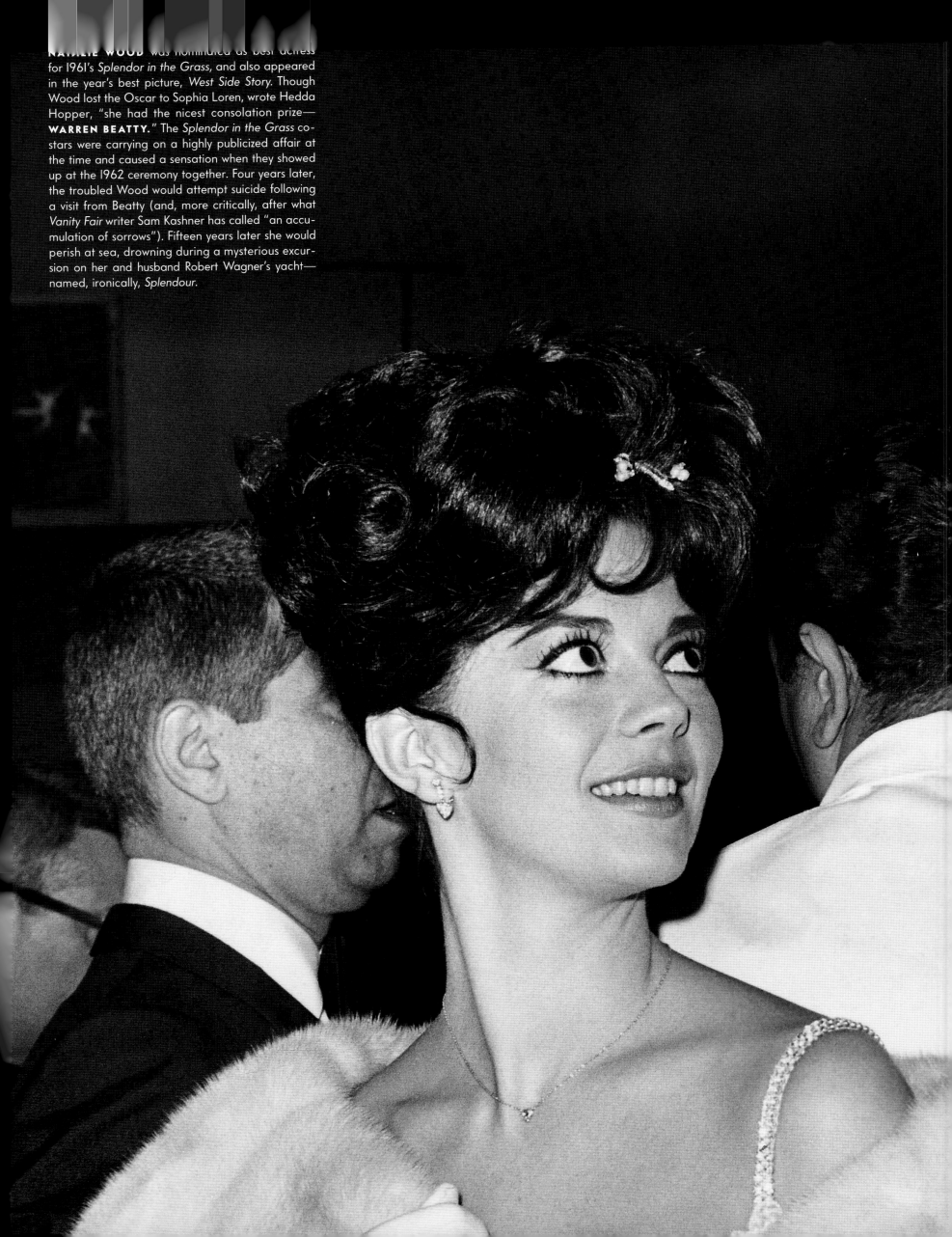

NATALIE WOOD was nominated as best actress for 1961's *Splendor in the Grass,* and also appeared in the year's best picture, *West Side Story.* Though Wood lost the Oscar to Sophia Loren, wrote Hedda Hopper, "she had the nicest consolation prize— **WARREN BEATTY.**" The *Splendor in the Grass* co-stars were carrying on a highly publicized affair at the time and caused a sensation when they showed up at the 1962 ceremony together. Four years later, the troubled Wood would attempt suicide following a visit from Beatty (and, more critically, after what *Vanity Fair* writer Sam Kashner has called "an accumulation of sorrows"). Fifteen years later she would perish at sea, drowning during a mysterious excursion on her and husband Robert Wagner's yacht— named, ironically, *Splendour.*

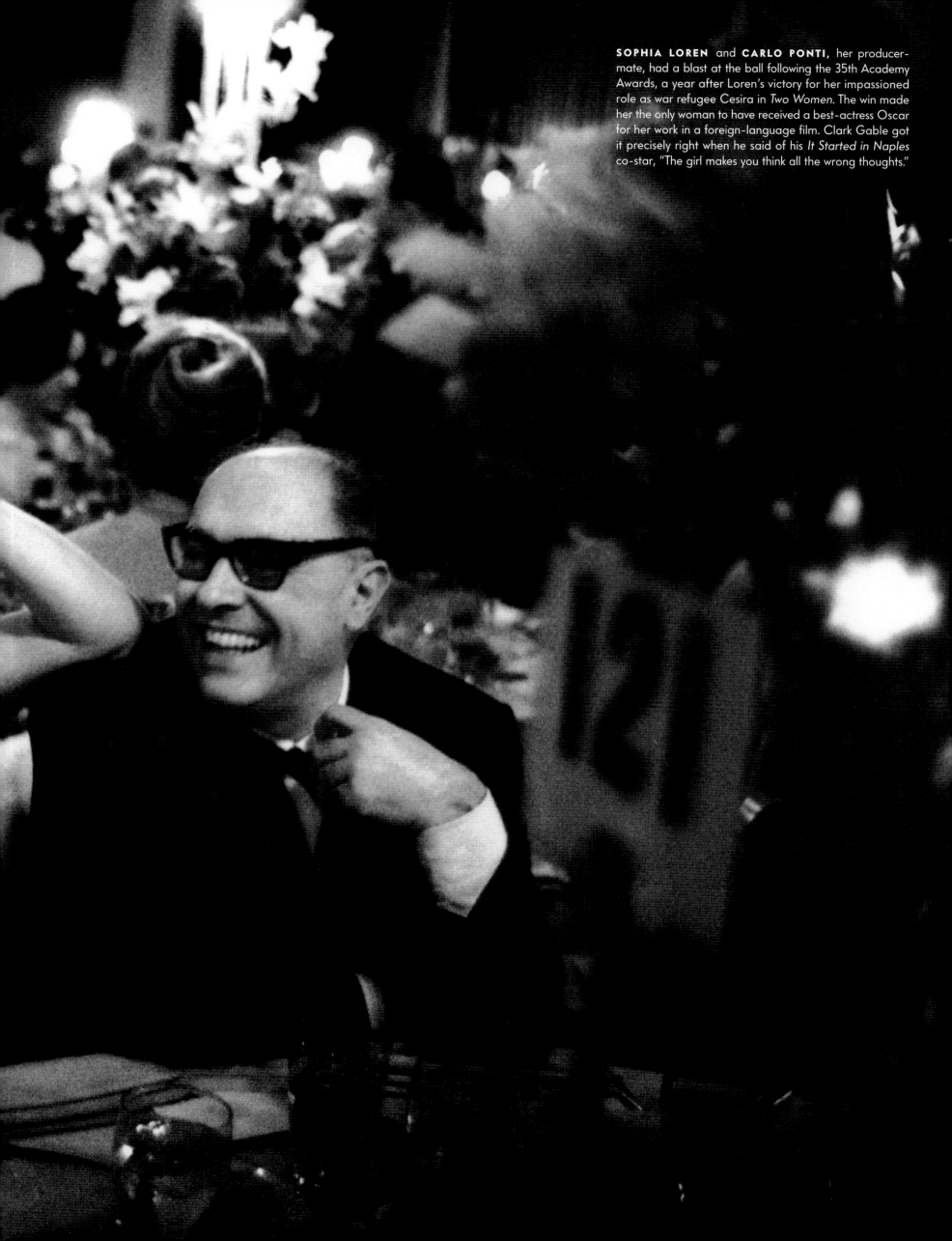

SOPHIA LOREN and **CARLO PONTI,** her producer-mate, had a blast at the ball following the 35th Academy Awards, a year after Loren's victory for her impassioned role as war refugee Cesira in *Two Women.* The win made her the only woman to have received a best-actress Oscar for her work in a foreign-language film. Clark Gable got it precisely right when he said of his *It Started in Naples* co-star, "The girl makes you think all the wrong thoughts."

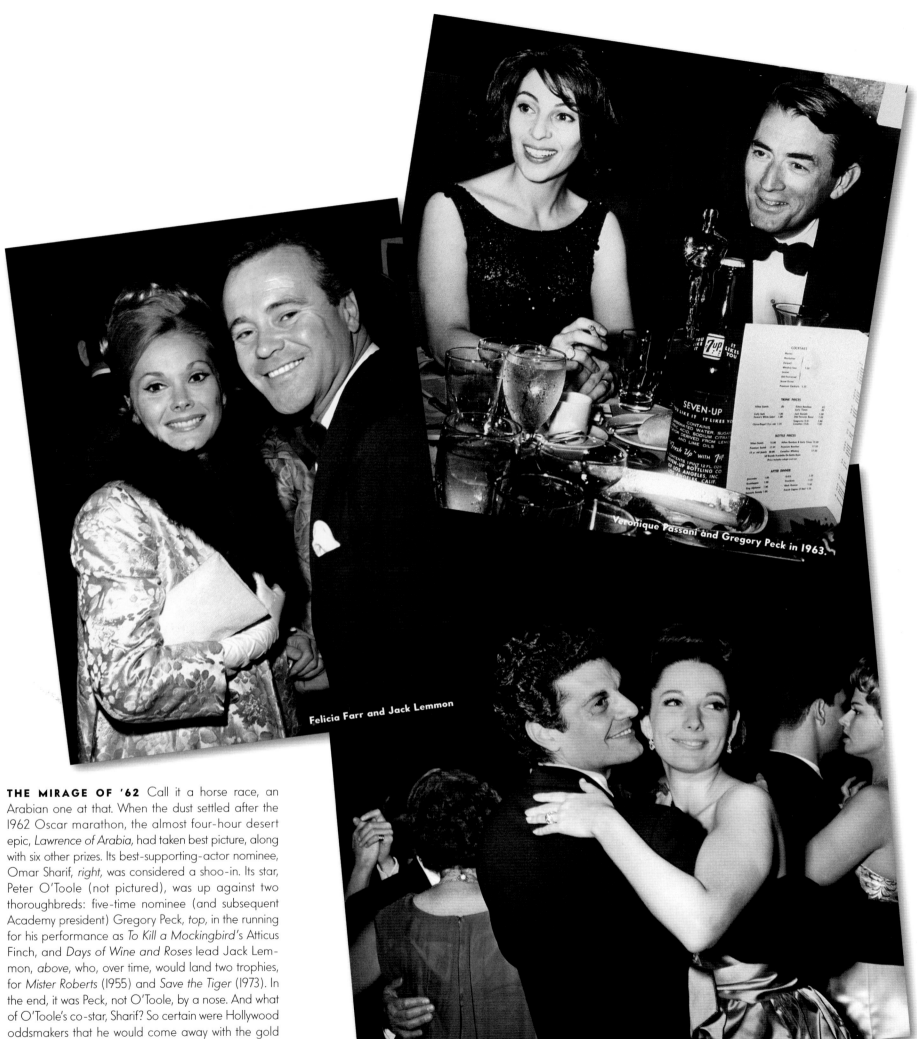

Veronique Passani and Gregory Peck in 1963.

Felicia Farr and Jack Lemmon

Omar Sharif and Sue Barton

THE MIRAGE OF '62 Call it a horse race, an Arabian one at that. When the dust settled after the 1962 Oscar marathon, the almost four-hour desert epic, *Lawrence of Arabia,* had taken best picture, along with six other prizes. Its best-supporting-actor nominee, Omar Sharif, *right,* was considered a shoo-in. Its star, Peter O'Toole (not pictured), was up against two thoroughbreds: five-time nominee (and subsequent Academy president) Gregory Peck, *top,* in the running for his performance as *To Kill a Mockingbird*'s Atticus Finch, and *Days of Wine and Roses* lead Jack Lemmon, *above,* who, over time, would land two trophies, for *Mister Roberts* (1955) and *Save the Tiger* (1973). In the end, it was Peck, not O'Toole, by a nose. And what of O'Toole's co-star, Sharif? So certain were Hollywood oddsmakers that he would come away with the gold that *Life*'s editors assigned photographer Zinn Arthur to spend the entire day with him, sneak a camera into the ceremony, and actually attend as Sharif's *date.* Then came the moment of truth: "For his role in *Sweet Bird of Youth* . . . Ed Begley." Now Sharif was stuck with a *Life* tagalong for the rest of the agonizing evening. Luckily, Sharif ditched him long enough to get in a dance or two with P.R. executive Sue Barton at the Governors Ball.

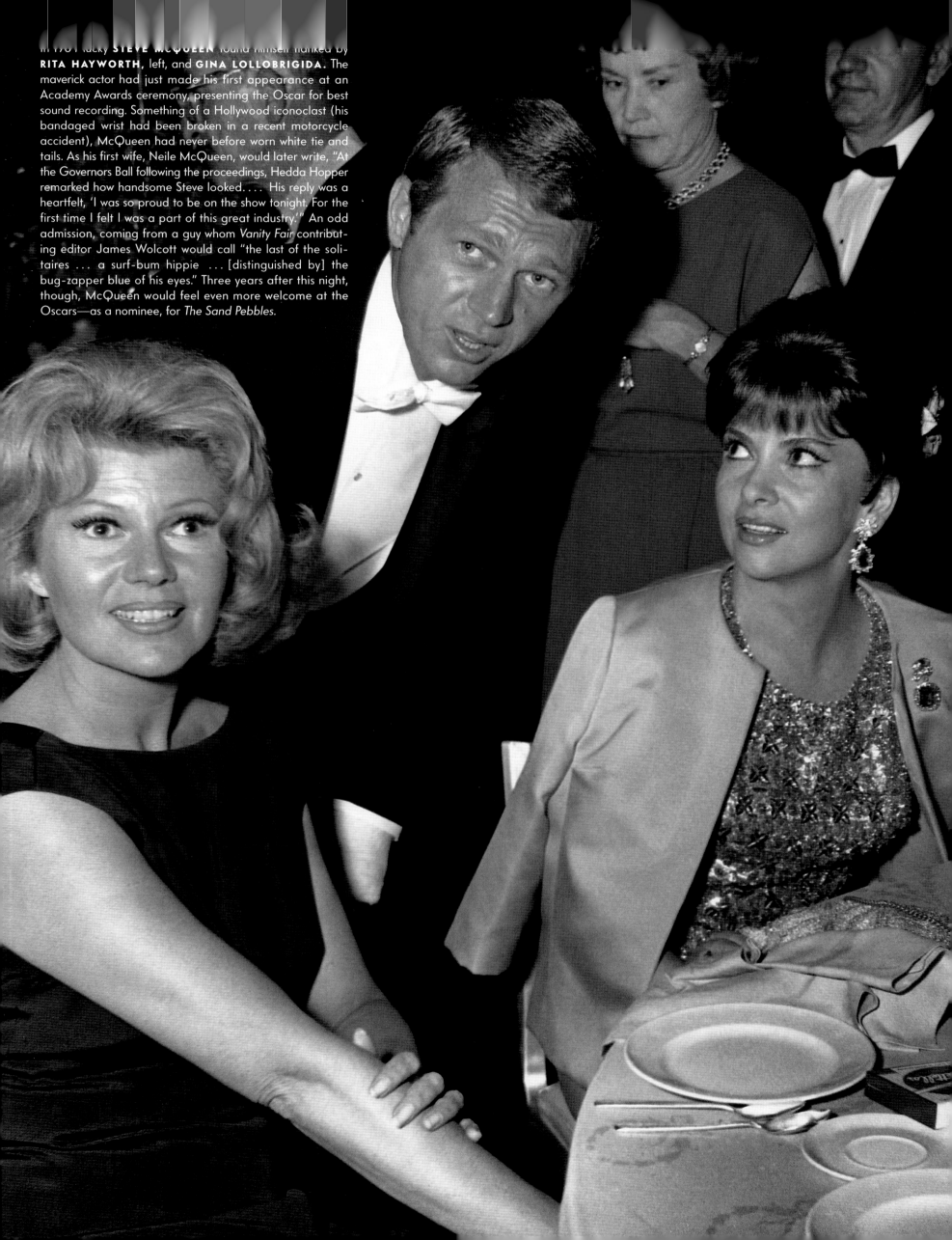

IN 1961 lucky **STEVE MCQUEEN** found himself flanked by **RITA HAYWORTH**, left, and **GINA LOLLOBRIGIDA**. The maverick actor had just made his first appearance at an Academy Awards ceremony, presenting the Oscar for best sound recording. Something of a Hollywood iconoclast (his bandaged wrist had been broken in a recent motorcycle accident), McQueen had never before worn white tie and tails. As his first wife, Neile McQueen, would later write, "At the Governors Ball following the proceedings, Hedda Hopper remarked how handsome Steve looked. . . . His reply was a heartfelt, 'I was so proud to be on the show tonight. For the first time I felt I was a part of this great industry.'" An odd admission, coming from a guy whom *Vanity Fair* contributing editor James Wolcott would call "the last of the solitaires . . . a surf-bum hippie . . . [distinguished by] the bug-zapper blue of his eyes." Three years after this night, though, McQueen would feel even more welcome at the Oscars—as a nominee, for *The Sand Pebbles.*

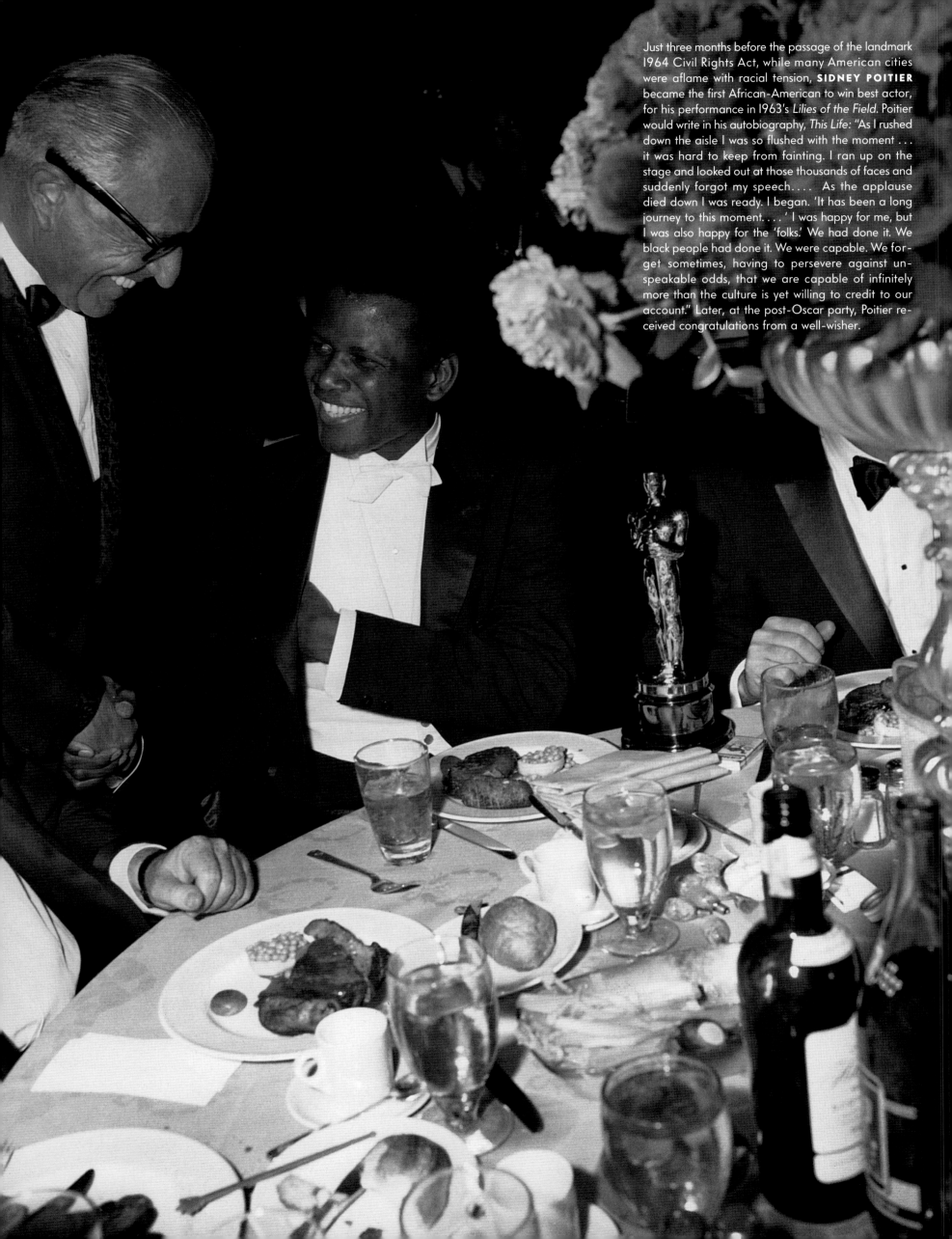

Just three months before the passage of the landmark 1964 Civil Rights Act, while many American cities were aflame with racial tension, **SIDNEY POITIER** became the first African-American to win best actor, for his performance in 1963's *Lilies of the Field*. Poitier would write in his autobiography, *This Life*: "As I rushed down the aisle I was so flushed with the moment . . . it was hard to keep from fainting. I ran up on the stage and looked out at those thousands of faces and suddenly forgot my speech. . . . As the applause died down I was ready. I began. 'It has been a long journey to this moment. . . .' I was happy for me, but I was also happy for the 'folks.' We had done it. We black people had done it. We were capable. We forget sometimes, having to persevere against unspeakable odds, that we are capable of infinitely more than the culture is yet willing to credit to our account." Later, at the post-Oscar party, Poitier received congratulations from a well-wisher.

In his *Los Angeles Herald-Examiner* column coven
Oscar night '64, Harrison Carroll noted, "As usu
the life of the party at the Beverly Hilton after t
awards was **SHIRLEY MacLAINE.** She danced
vigorously that her gown came unbuttoned in t
back and husband Steve Parker had to hastily pr
vent de-frocking." MacLaine—seen here in a m
stationary moment with **DEBBIE REYNOLDS**—h
missed out on an Oscar that night for her perfo
mance in *Irma la Douce*.

SKIE'S IN THE HOUSE Into the 1965 Governors Ball he bobbed, shoulder-borne by servants, like some [m]idas-touched pasha. Perhaps Oscar was just strutting [his] stuff for that year's heavy-metal mama: *Goldfinger's* [Sh]irley Eaton, who had gamely agreed to be coated in [go]ld paint for the third James Bond film.

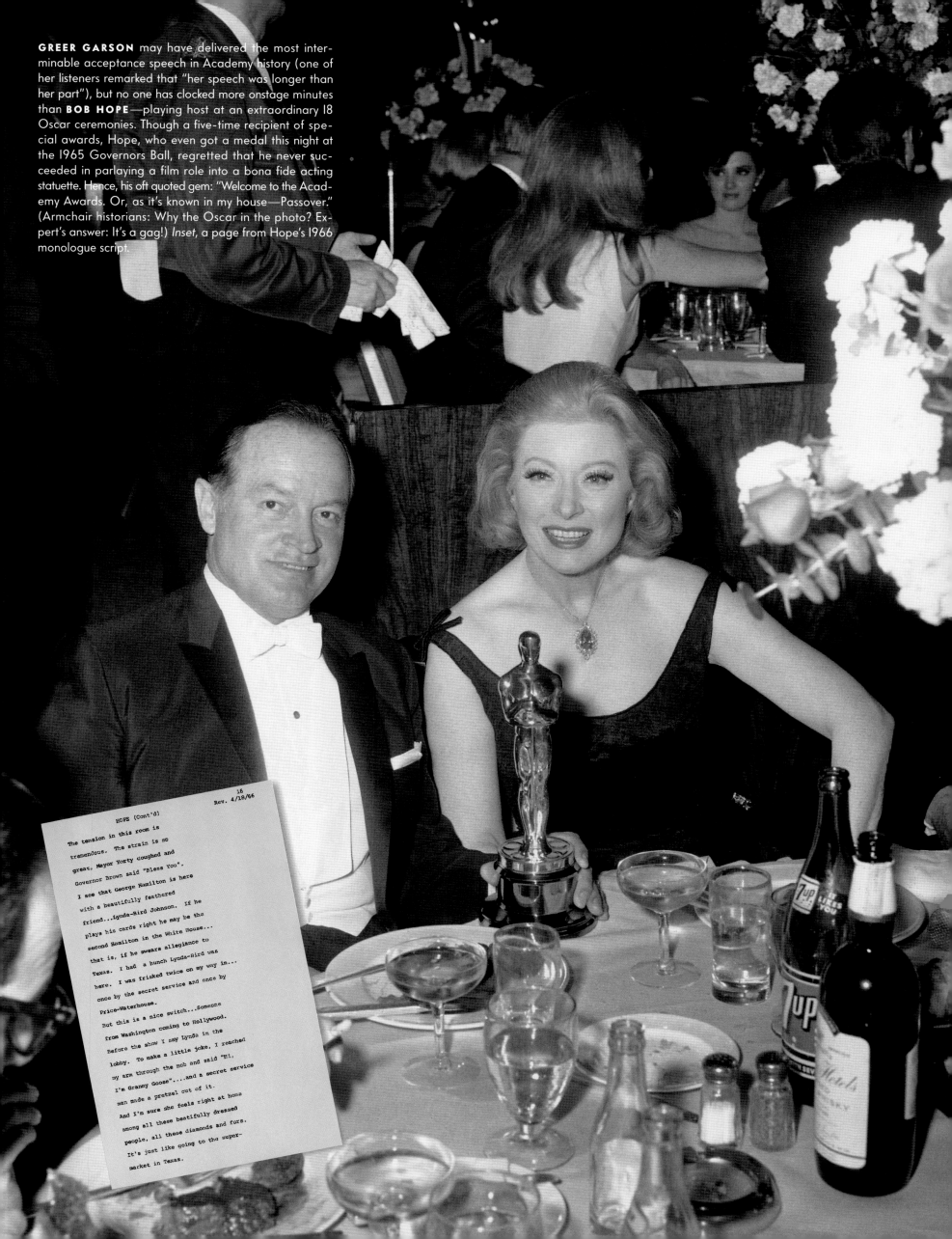

GREER GARSON may have delivered the most interminable acceptance speech in Academy history (one of her listeners remarked that "her speech was longer than her part"), but no one has clocked more onstage minutes than **BOB HOPE**—playing host at an extraordinary 18 Oscar ceremonies. Though a five-time recipient of special awards, Hope, who even got a medal this night at the 1965 Governors Ball, regretted that he never succeeded in parlaying a film role into a bona fide acting statuette. Hence, his oft quoted gem: "Welcome to the Academy Awards. Or, as it's known in my house—Passover." (Armchair historians: Why the Oscar in the photo? Expert's answer: It's a gag!) *Inset,* a page from Hope's 1966 monologue script.

16
Rev. 4/18/66

HOPE (Cont'd)

The tension in this room is tremendous. The strain is so great, Mayor Yorty coughed and Governor Brown said "Bless You".
I see that George Hamilton is here with a beautifully feathered friend...Lynda-Bird Johnson. If he plays his cards right he may be the second Hamilton in the White House... that is, if he swears allegiance to Texas. I had a hunch Lynda-Bird was here. I was frisked twice on my way in... once by the secret service and once by Price-Waterhouse.
But this is a nice switch...Someone from Washington coming to Hollywood.
Before the show I saw Lynda in the lobby. To make a little joke, I reached my arm through the mob and said "Hi, I'm Granny Goose"....and a secret service man made a pretzel out of it.
And I'm sure she feels right at home among all these beatifully dressed people, all these diamonds and furs. It's just like going to the super-market in Texas.

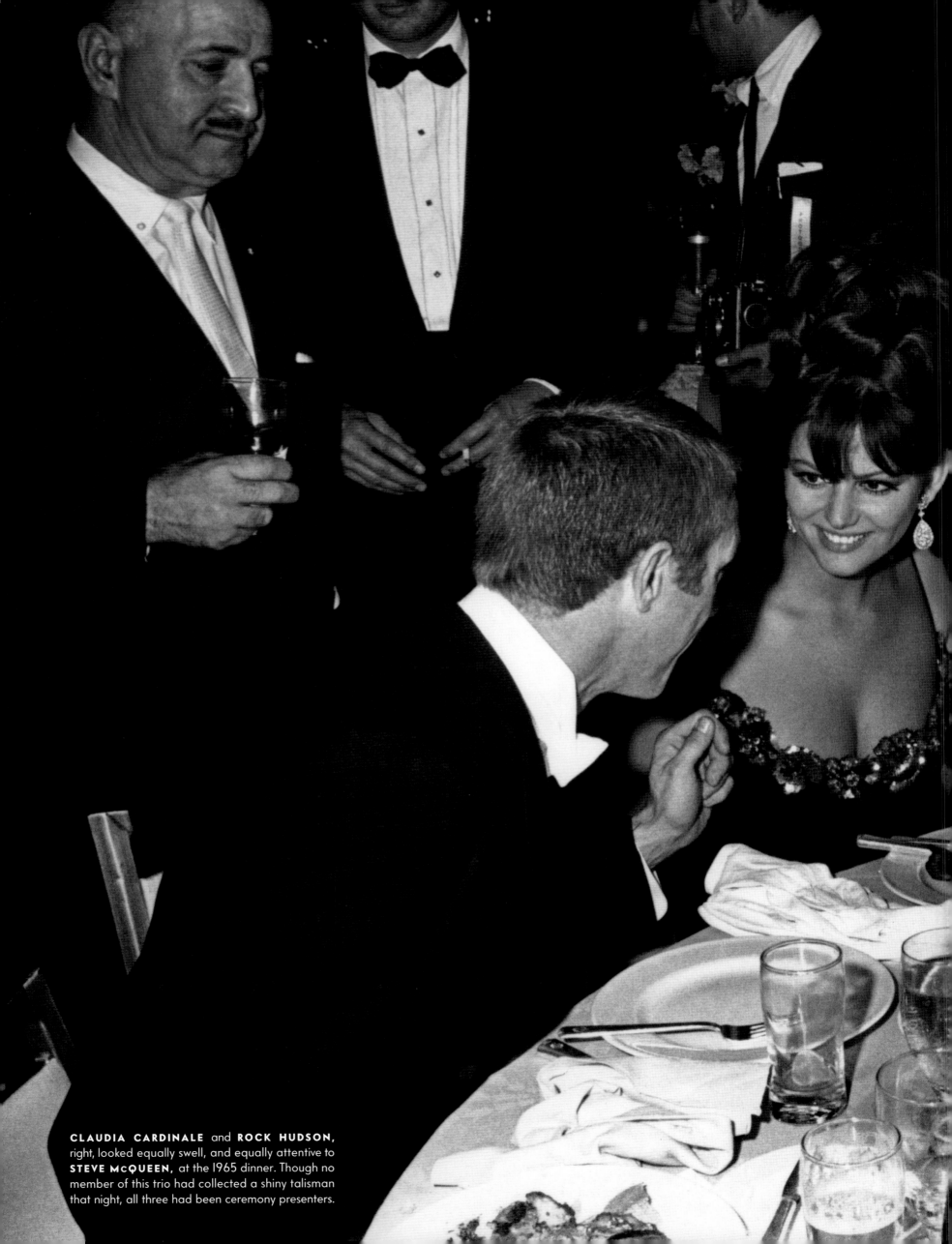

CLAUDIA CARDINALE and ROCK HUDSON, right, looked equally swell, and equally attentive to STEVE McQUEEN, at the 1965 dinner. Though no member of this trio had collected a shiny talisman that night, all three had been ceremony presenters.

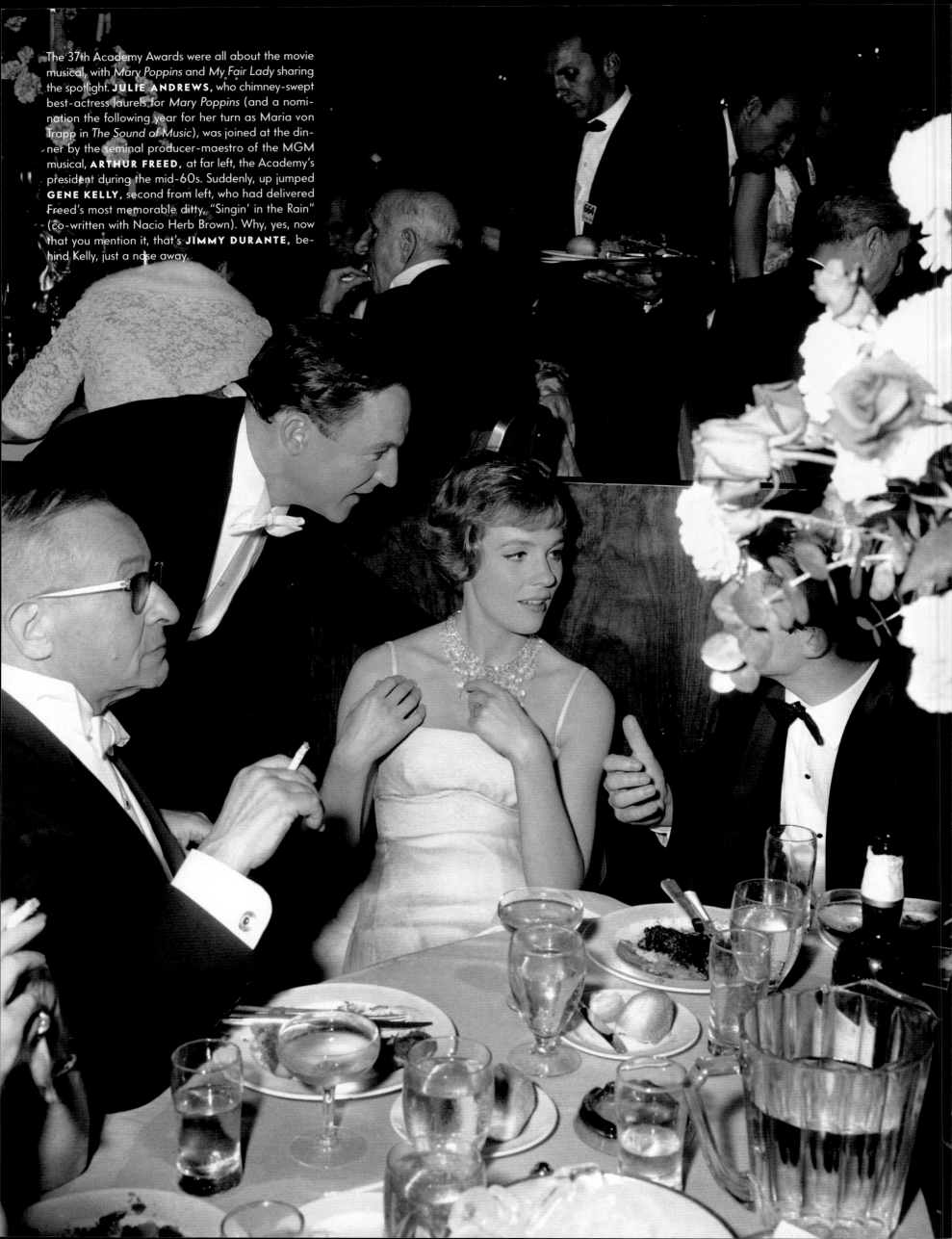

The 37th Academy Awards were all about the movie musical, with *Mary Poppins* and *My Fair Lady* sharing the spotlight. **JULIE ANDREWS,** who chimney-swept best-actress laurels for *Mary Poppins* (and a nomination the following year for her turn as Maria von Trapp in *The Sound of Music*), was joined at the dinner by the seminal producer-maestro of the MGM musical, **ARTHUR FREED,** at far left, the Academy's president during the mid-60s. Suddenly, up jumped **GENE KELLY,** second from left, who had delivered Freed's most memorable ditty, "Singin' in the Rain" (co-written with Nacio Herb Brown). Why, yes, now that you mention it, that's **JIMMY DURANTE,** behind Kelly, just a nose away.

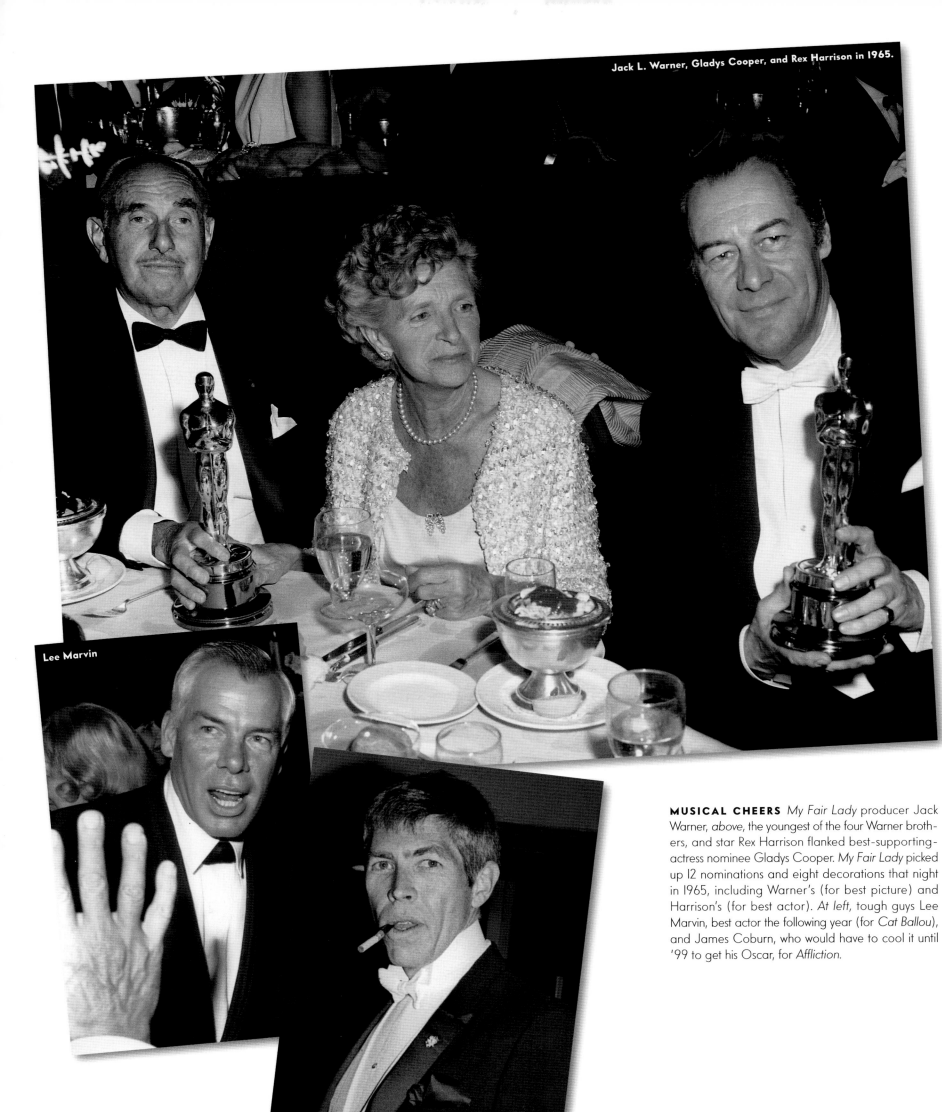

Jack L. Warner, Gladys Cooper, and Rex Harrison in 1965.

Lee Marvin

James Coburn

MUSICAL CHEERS *My Fair Lady* producer Jack Warner, *above*, the youngest of the four Warner brothers, and star Rex Harrison flanked best-supporting-actress nominee Gladys Cooper. *My Fair Lady* picked up 12 nominations and eight decorations that night in 1965, including Warner's (for best picture) and Harrison's (for best actor). *At left*, tough guys Lee Marvin, best actor the following year (for *Cat Ballou*), and James Coburn, who would have to cool it until '99 to get his Oscar, for *Affliction*.

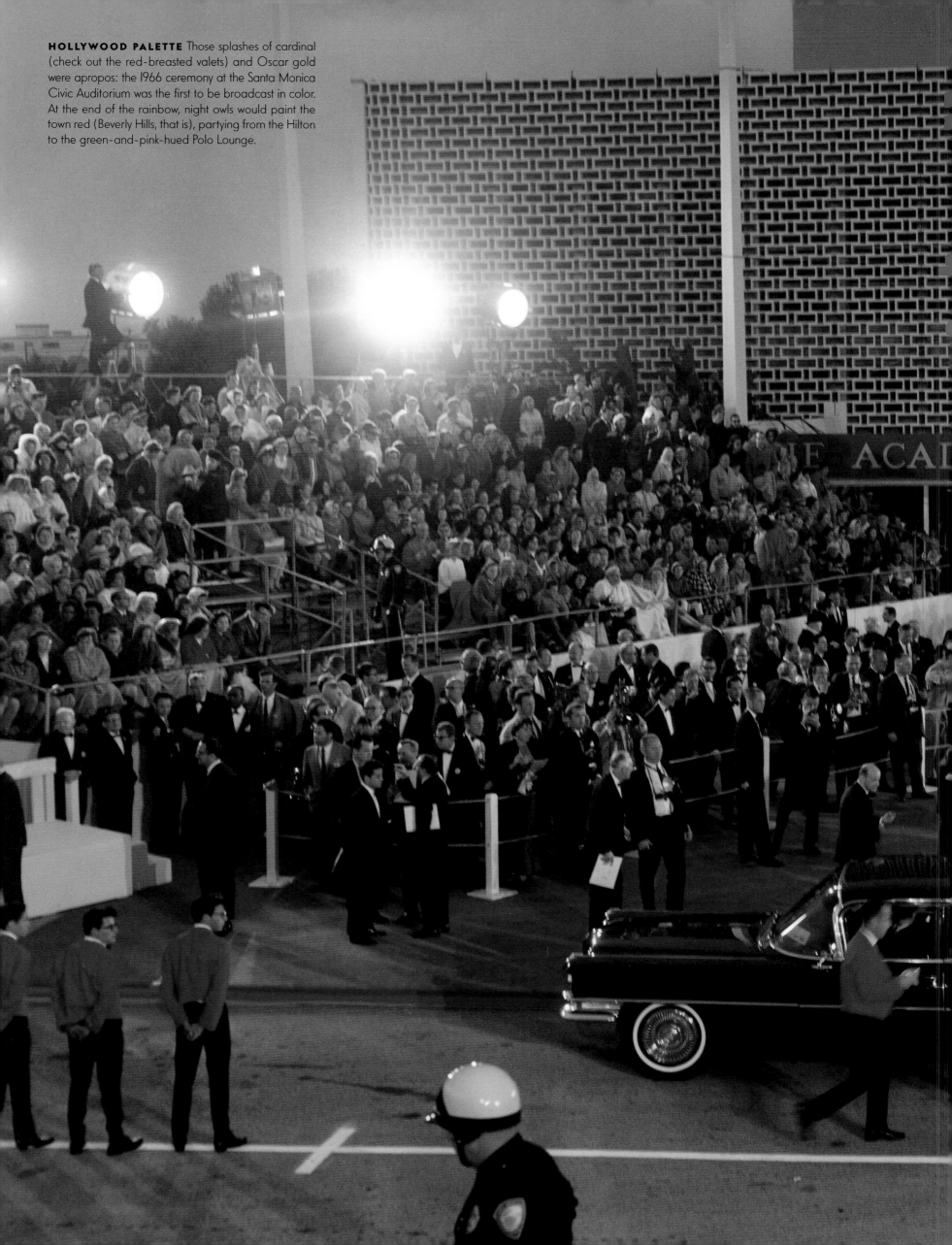

HOLLYWOOD PALETTE Those splashes of cardinal (check out the red-breasted valets) and Oscar gold were apropos: the 1966 ceremony at the Santa Monica Civic Auditorium was the first to be broadcast in color. At the end of the rainbow, night owls would paint the town red (Beverly Hills, that is), partying from the Hilton to the green-and-pink-hued Polo Lounge.

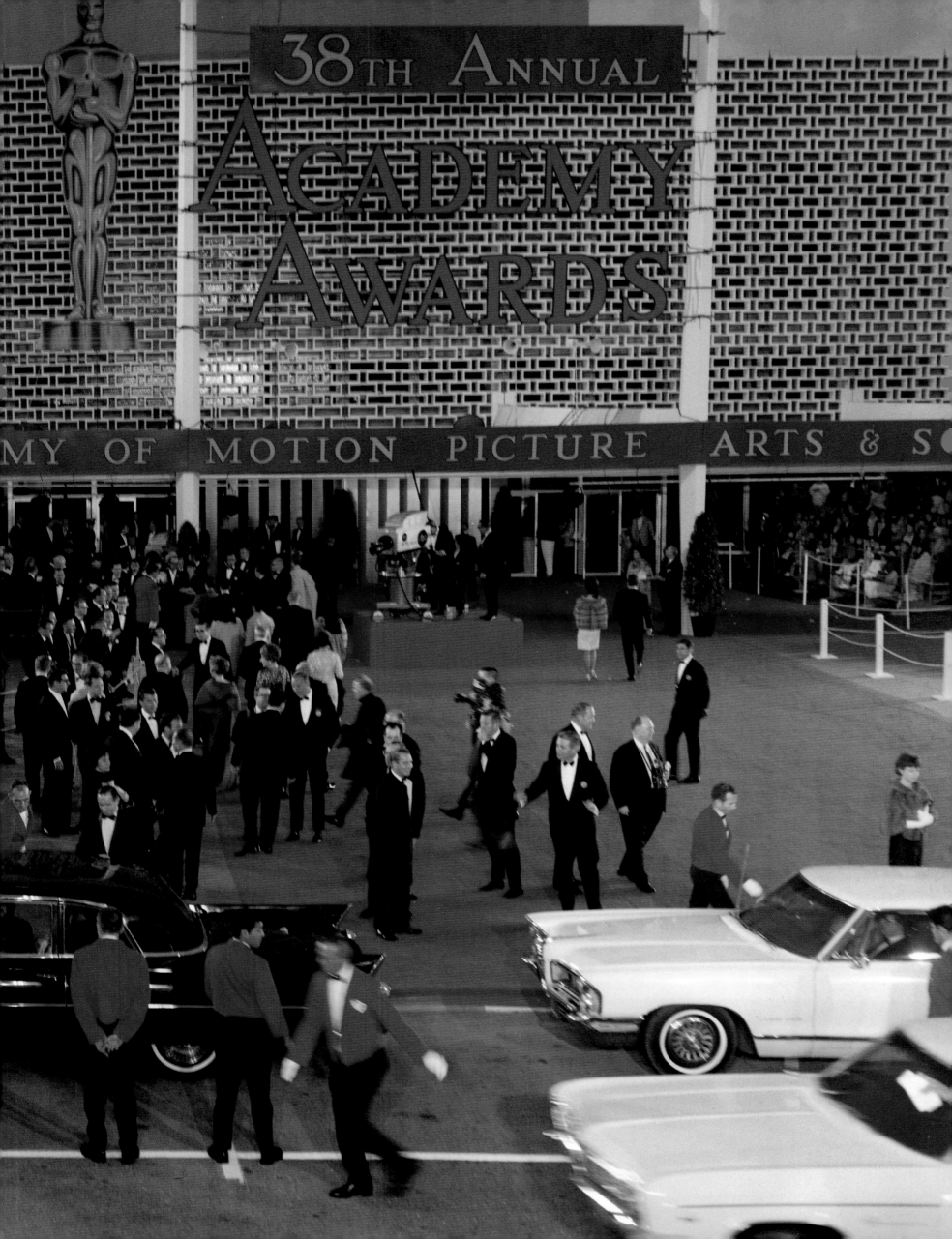

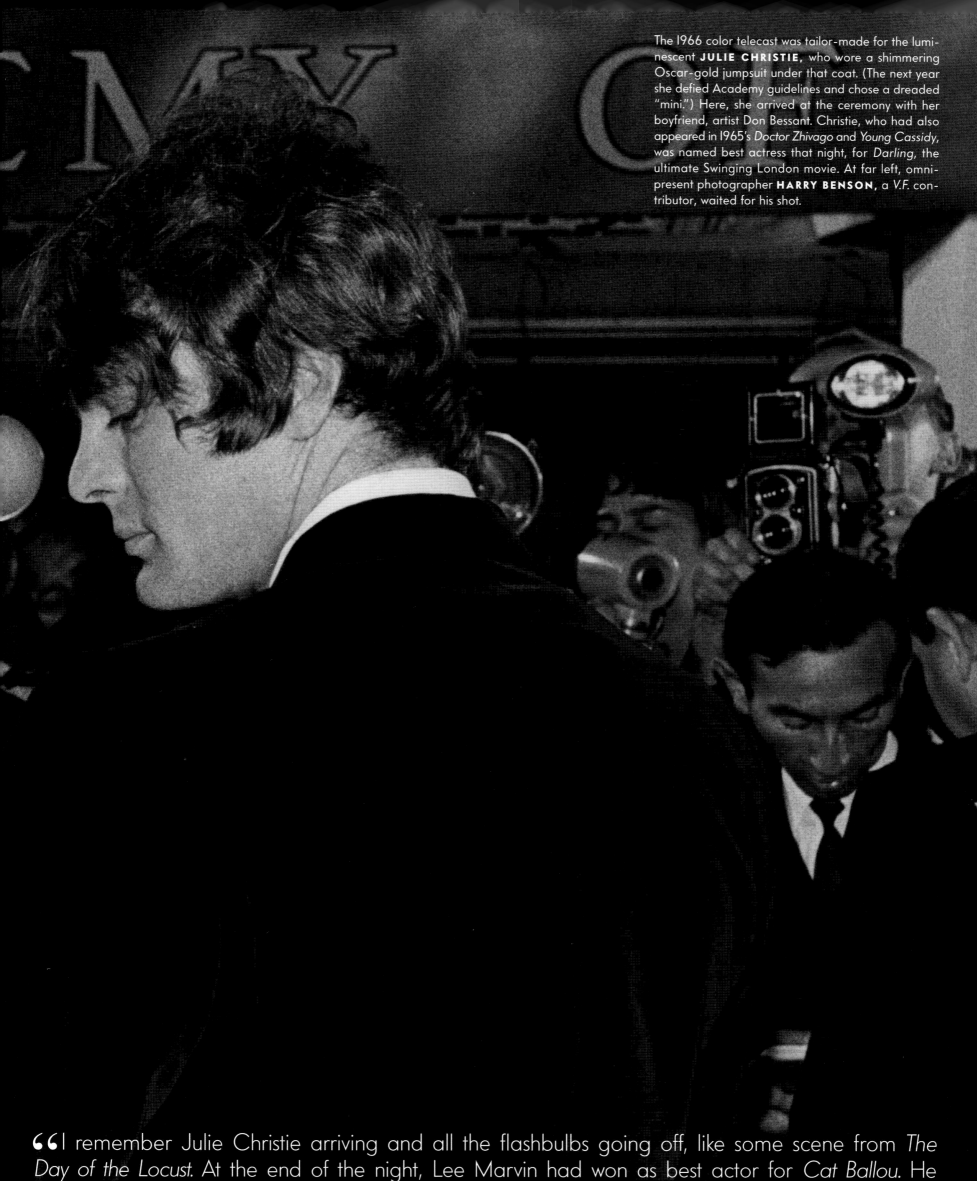

The 1966 color telecast was tailor-made for the luminescent **JULIE CHRISTIE**, who wore a shimmering Oscar-gold jumpsuit under that coat. (The next year she defied Academy guidelines and chose a dreaded "mini.") Here, she arrived at the ceremony with her boyfriend, artist Don Bessant. Christie, who had also appeared in 1965's *Doctor Zhivago* and *Young Cassidy*, was named best actress that night, for *Darling*, the ultimate Swinging London movie. At far left, omnipresent photographer **HARRY BENSON**, a *V.F.* contributor, waited for his shot.

"I remember Julie Christie arriving and all the flashbulbs going off, like some scene from *The Day of the Locust*. At the end of the night, Lee Marvin had won as best actor for *Cat Ballou*. He went to the Polo Lounge at the Beverly Hills Hotel and placed his Oscar right up there on the bar. He said he'd buy a drink for anyone who walked by. And he *did*."

HARRY BENSON

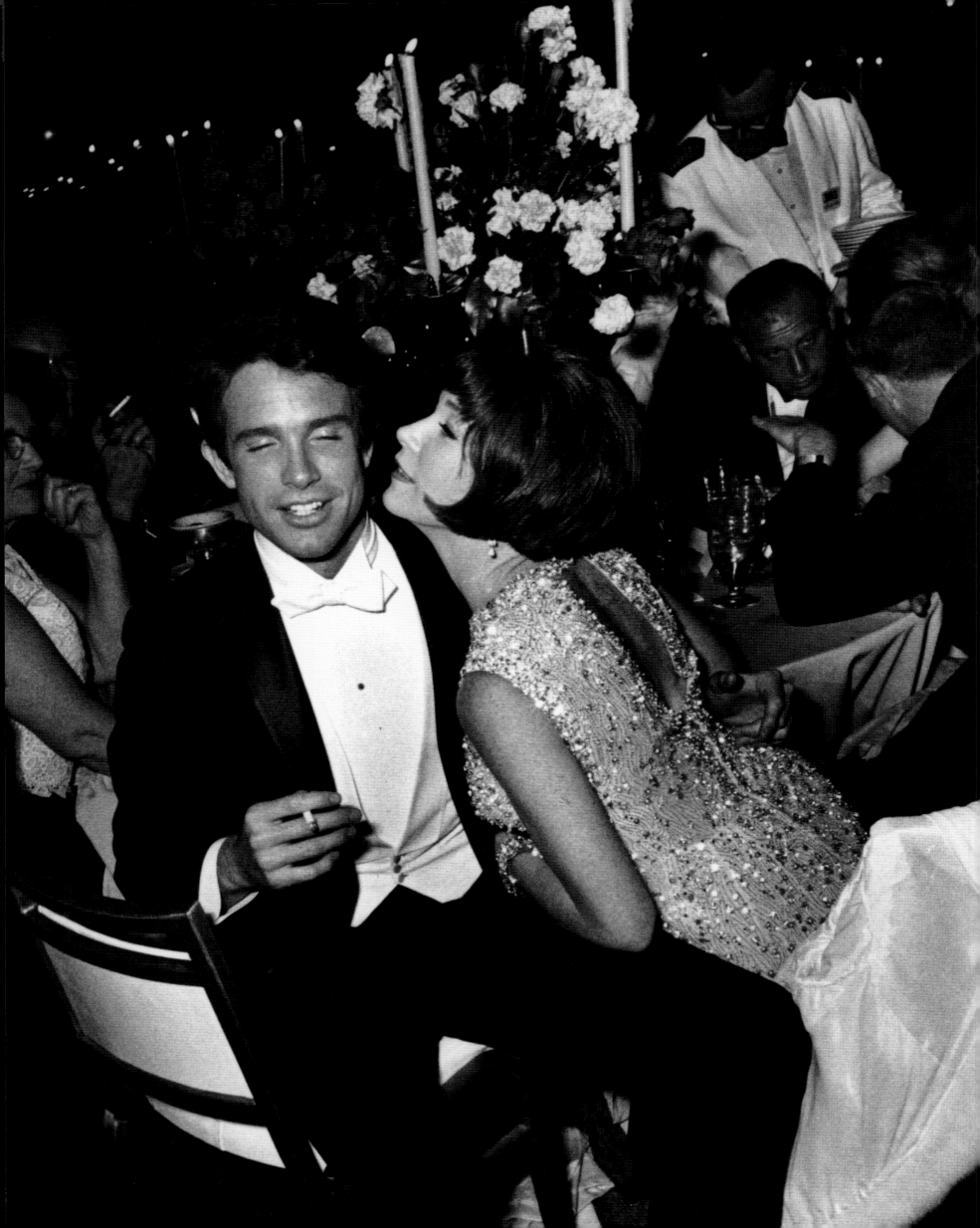

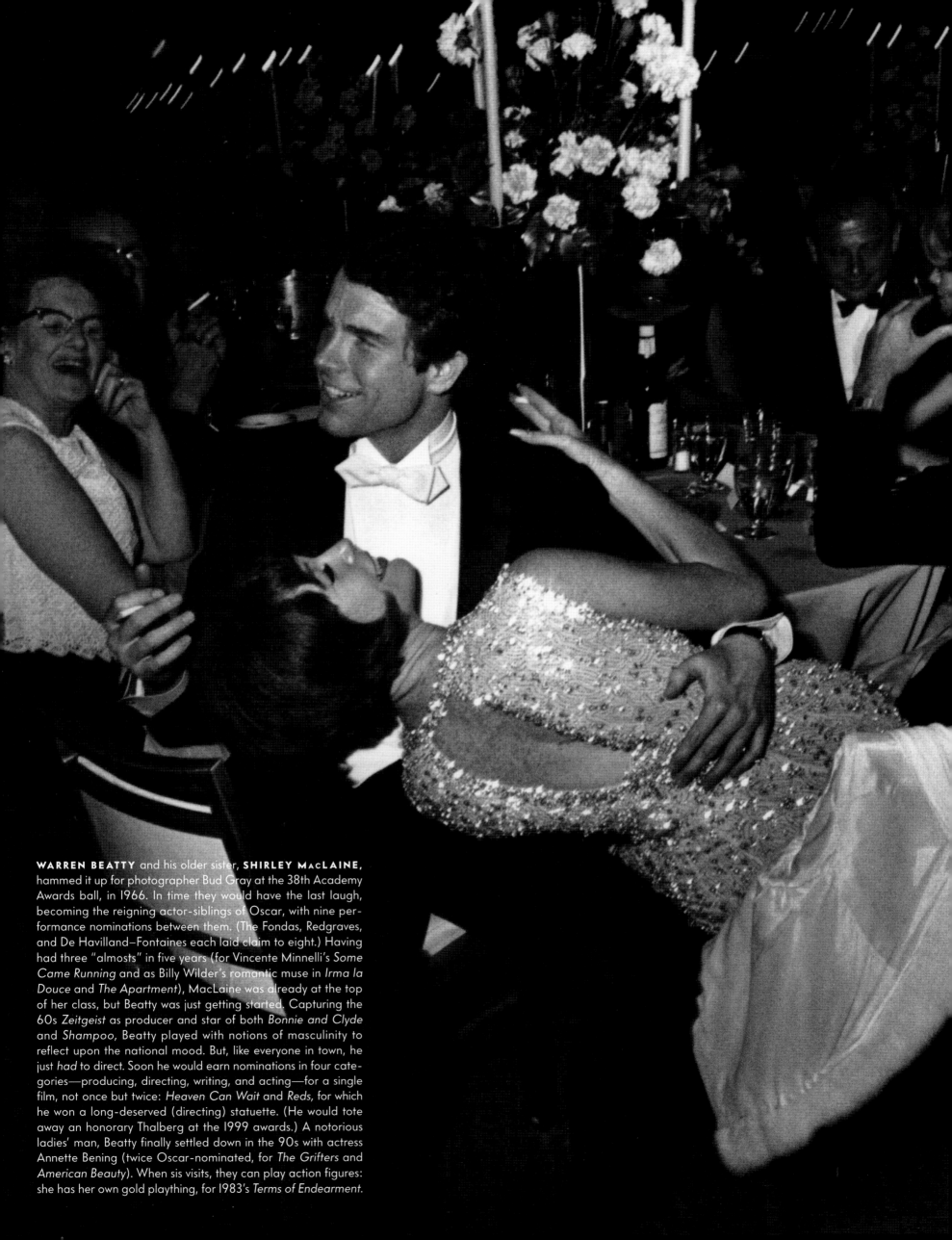

WARREN BEATTY and his older sister, **SHIRLEY MacLAINE,** hammed it up for photographer Bud Gray at the 38th Academy Awards ball, in 1966. In time they would have the last laugh, becoming the reigning actor-siblings of Oscar, with nine performance nominations between them. (The Fondas, Redgraves, and De Havilland–Fontaines each laid claim to eight.) Having had three "almosts" in five years (for Vincente Minnelli's *Some Came Running* and as Billy Wilder's romantic muse in *Irma la Douce* and *The Apartment*), MacLaine was already at the top of her class, but Beatty was just getting started. Capturing the 60s *Zeitgeist* as producer and star of both *Bonnie and Clyde* and *Shampoo,* Beatty played with notions of masculinity to reflect upon the national mood. But, like everyone in town, he just *had* to direct. Soon he would earn nominations in four categories—producing, directing, writing, and acting—for a single film, not once but twice: *Heaven Can Wait* and *Reds,* for which he won a long-deserved (directing) statuette. (He would tote away an honorary Thalberg at the 1999 awards.) A notorious ladies' man, Beatty finally settled down in the 90s with actress Annette Bening (twice Oscar-nominated, for *The Grifters* and *American Beauty*). When sis visits, they can play action figures: she has her own gold plaything, for 1983's *Terms of Endearment.*

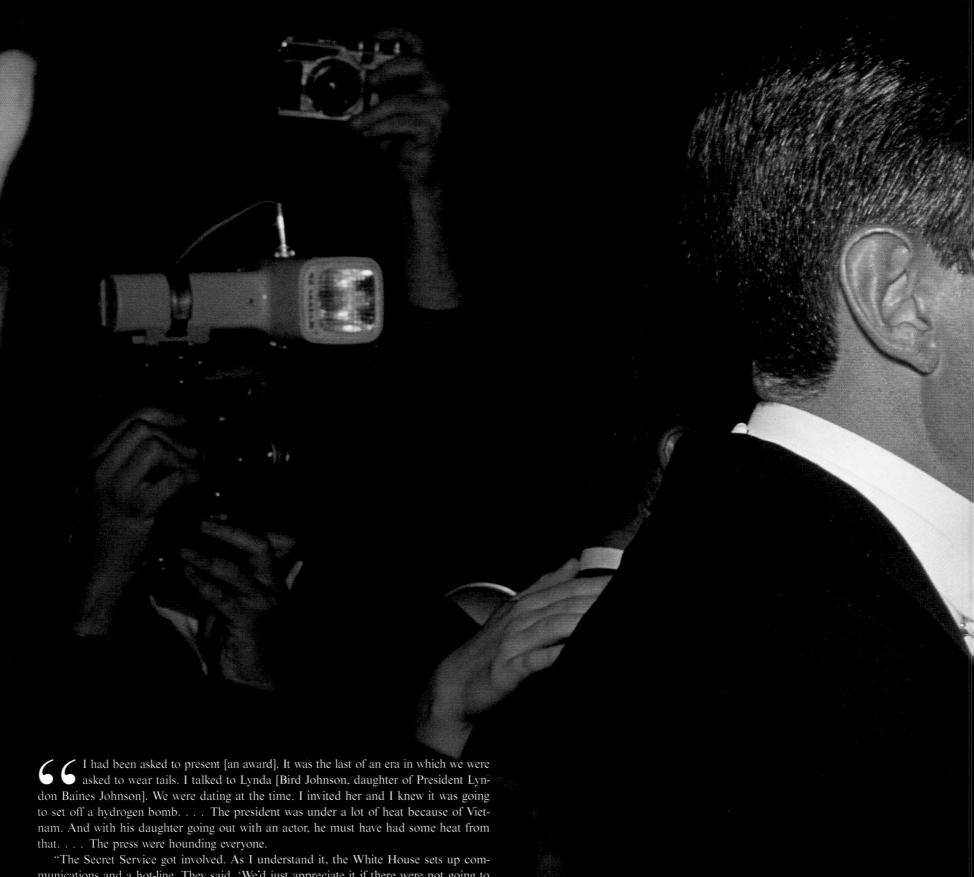

 I had been asked to present [an award]. It was the last of an era in which we were asked to wear tails. I talked to Lynda [Bird Johnson, daughter of President Lyndon Baines Johnson]. We were dating at the time. I invited her and I knew it was going to set off a hydrogen bomb. . . . The president was under a lot of heat because of Vietnam. And with his daughter going out with an actor, he must have had some heat from that. . . . The press were hounding everyone.

 "The Secret Service got involved. As I understand it, the White House sets up communications and a hot-line. They said, 'We'd just appreciate it if there were not going to be any surprises.' It was an era right after [Lee Harvey] Oswald [had shot President John F. Kennedy]. They came to [my] house, which Douglas Fairbanks had [once lived in] and wanted a place to set up, where they had control of the perimeter.

 "[On the day of the Oscars] I thought Lynda would want her hair done, so I called up George Masters. George Masters was the biggest hairdresser at the time. Huge. He had dozens of people to do [that day], but he said he'd try [to stop by]. He had a huge hair dryer in the back of his truck. It looked like a sail on an America's Cup [boat]. He came in shorts, a tank top, and combat boots. And he was stoned out of his head. And the Secret Service said, 'There's somebody downstairs with an instrument. And he says he's here to work on Miss Johnson.' They weren't too happy about it. He'd had a few too many. [But] he came up and completely re-did her hair. I called Luis Estevez. He was a leading guy in dress design. Luis came over with an incredible gown and gloves and wrap for her.

 "Then came the moment I didn't expect. Hollywood was going to be rivaled by the appearance of the daughter of the president of the United States. When we walked in, I tried to step back. I wanted her to have that night. I have always had a Professor [Henry] Higgins complex. I was simply the armpiece, the frame. She looked fantastic and she upstaged Hollywood and they didn't like it one bit. When we walked in, she looked better than any star. The next day she was in all the papers and had made her mark on history. . . . Power trumped glamour, [as] it always had. **"**

—GEORGE HAMILTON

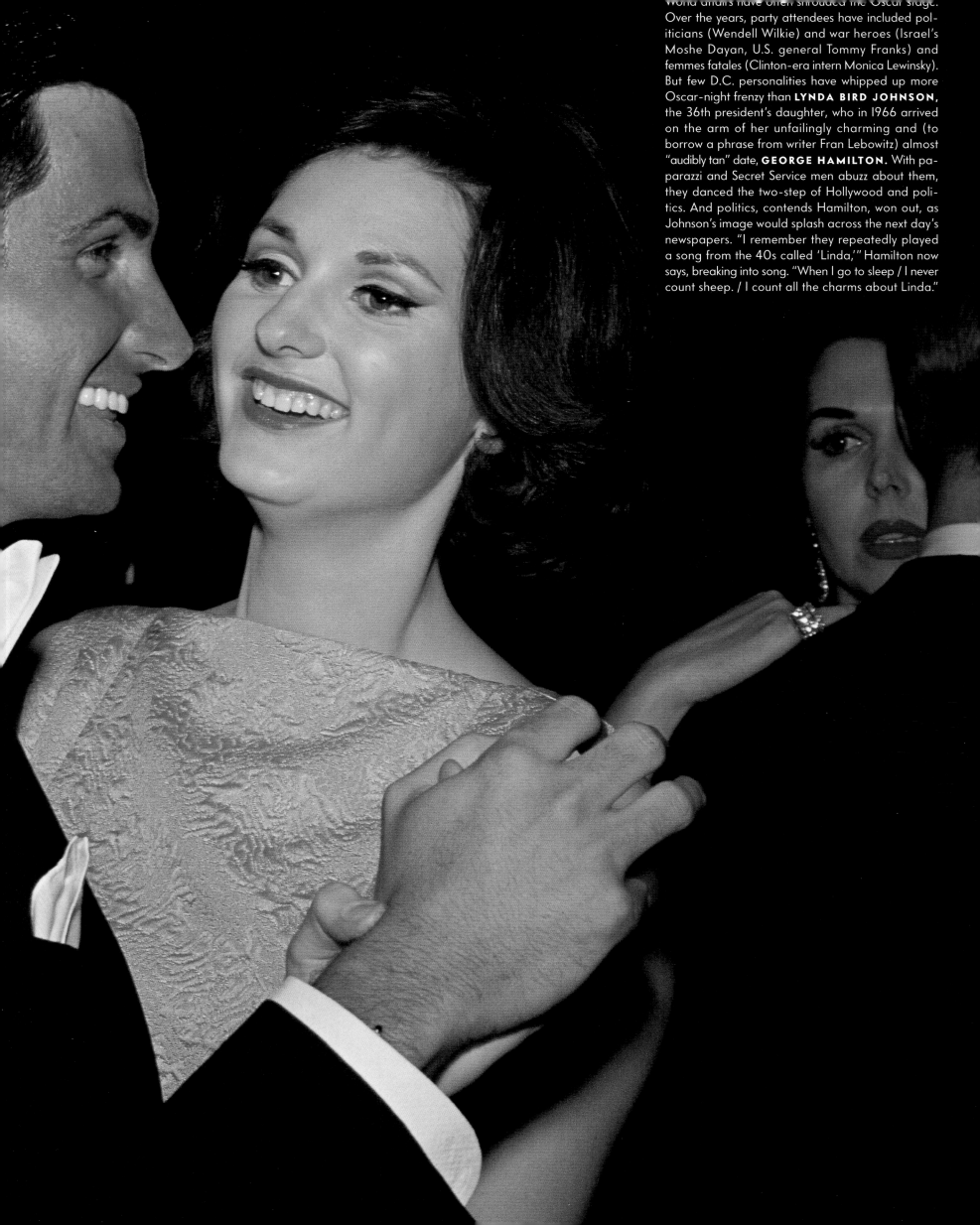

World affairs have often shrouded the Oscar stage. Over the years, party attendees have included politicians (Wendell Wilkie) and war heroes (Israel's Moshe Dayan, U.S. general Tommy Franks) and femmes fatales (Clinton-era intern Monica Lewinsky). But few D.C. personalities have whipped up more Oscar-night frenzy than **LYNDA BIRD JOHNSON,** the 36th president's daughter, who in 1966 arrived on the arm of her unfailingly charming and (to borrow a phrase from writer Fran Lebowitz) almost "audibly tan" date, **GEORGE HAMILTON.** With paparazzi and Secret Service men abuzz about them, they danced the two-step of Hollywood and politics. And politics, contends Hamilton, won out, as Johnson's image would splash across the next day's newspapers. "I remember they repeatedly played a song from the 40s called 'Linda,'" Hamilton now says, breaking into song. "When I go to sleep / I never count sheep. / I count all the charms about Linda."

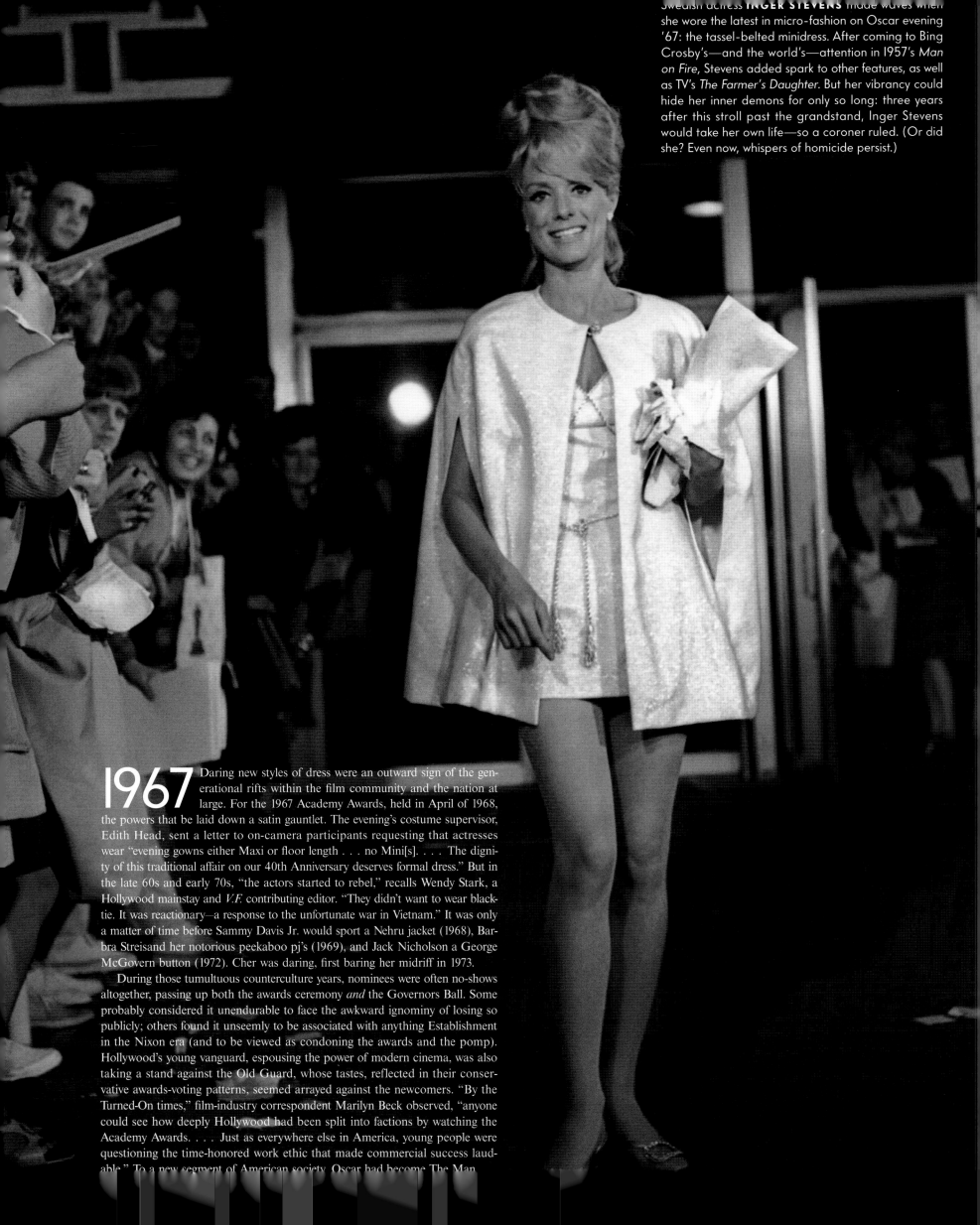

1967

Daring new styles of dress were an outward sign of the generational rifts within the film community and the nation at large. For the 1967 Academy Awards, held in April of 1968, the powers that be laid down a satin gauntlet. The evening's costume supervisor, Edith Head, sent a letter to on-camera participants requesting that actresses wear "evening gowns either Maxi or floor length . . . no Mini[s]. . . . The dignity of this traditional affair on our 40th Anniversary deserves formal dress." But in the late 60s and early 70s, "the actors started to rebel," recalls Wendy Stark, a Hollywood mainstay and *V.F.* contributing editor. "They didn't want to wear black-tie. It was reactionary—a response to the unfortunate war in Vietnam." It was only a matter of time before Sammy Davis Jr. would sport a Nehru jacket (1968), Barbra Streisand her notorious peekaboo pj's (1969), and Jack Nicholson a George McGovern button (1972). Cher was daring, first baring her midriff in 1973.

During those tumultuous counterculture years, nominees were often no-shows altogether, passing up both the awards ceremony *and* the Governors Ball. Some probably considered it unendurable to face the awkward ignominy of losing so publicly; others found it unseemly to be associated with anything Establishment in the Nixon era (and to be viewed as condoning the awards and the pomp). Hollywood's young vanguard, espousing the power of modern cinema, was also taking a stand against the Old Guard, whose tastes, reflected in their conservative awards-voting patterns, seemed arrayed against the newcomers. "By the Turned-On times," film-industry correspondent Marilyn Beck observed, "anyone could see how deeply Hollywood had been split into factions by watching the Academy Awards. . . . Just as everywhere else in America, young people were questioning the time-honored work ethic that made commercial success laudable." To a new segment of American society, Oscar had become The Man.

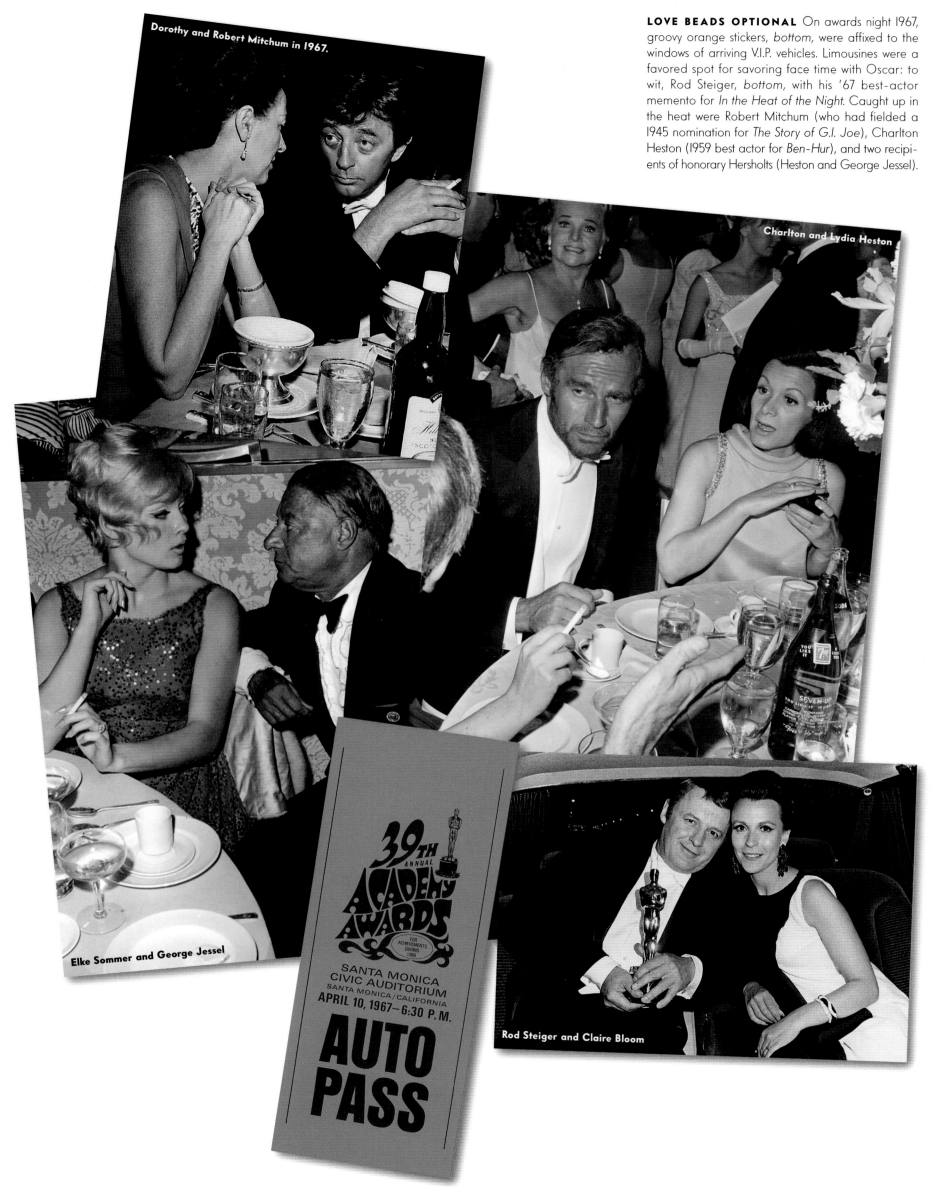

Dorothy and Robert Mitchum in 1967.

Charlton and Lydia Heston

Elke Sommer and George Jessel

Rod Steiger and Claire Bloom

39TH ANNUAL ACADEMY AWARDS

FOR ACHIEVEMENTS DURING 1966

SANTA MONICA CIVIC AUDITORIUM
SANTA MONICA/CALIFORNIA
APRIL 10, 1967—6:30 P.M.

AUTO PASS

LOVE BEADS OPTIONAL On awards night 1967, groovy orange stickers, *bottom*, were affixed to the windows of arriving V.I.P. vehicles. Limousines were a favored spot for savoring face time with Oscar: to wit, Rod Steiger, *bottom*, with his '67 best-actor memento for *In the Heat of the Night*. Caught up in the heat were Robert Mitchum (who had fielded a 1945 nomination for *The Story of G.I. Joe*), Charlton Heston (1959 best actor for *Ben-Hur*), and two recipients of honorary Hersholts (Heston and George Jessel).

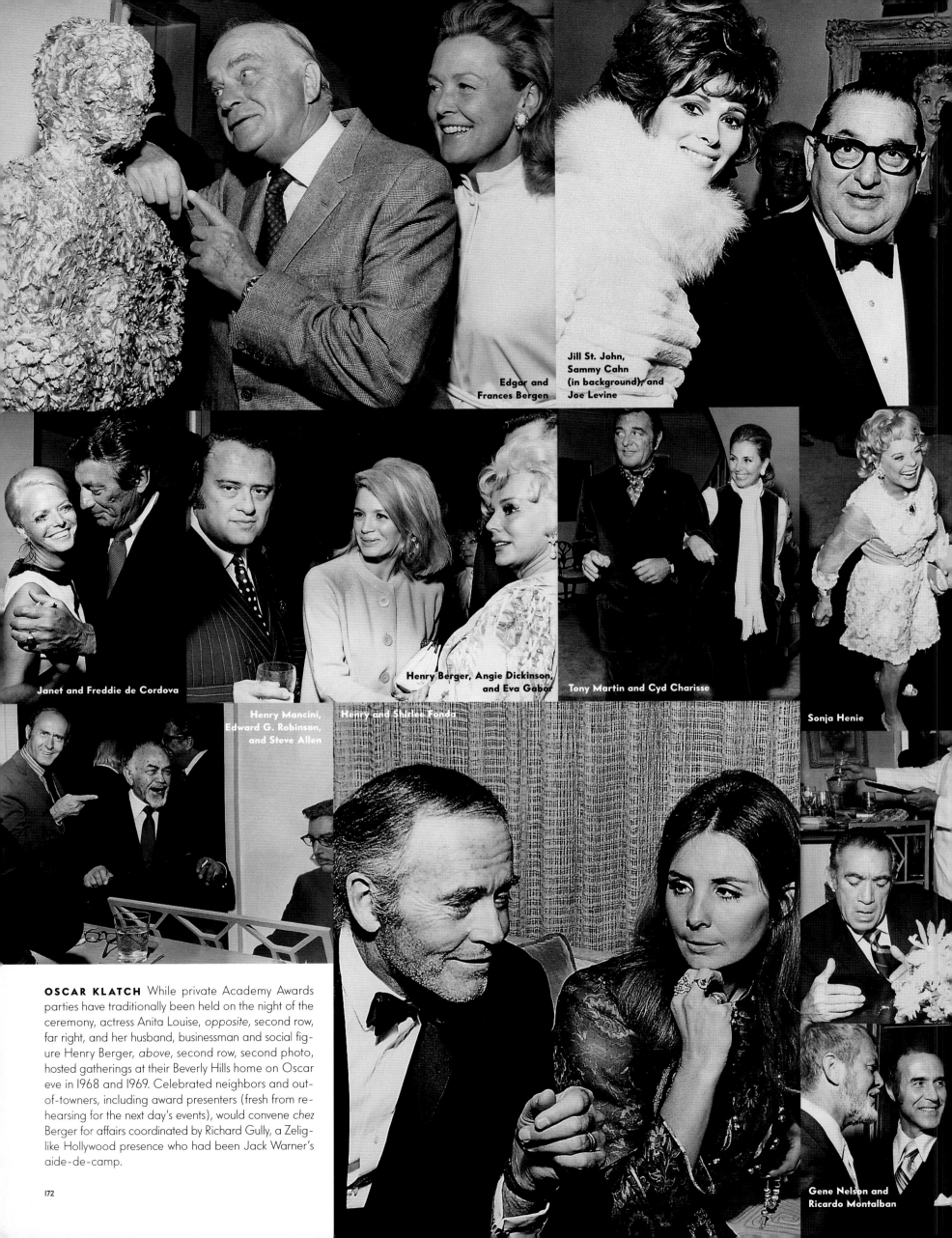

Edgar and
Frances Bergen

Jill St. John,
Sammy Cahn
(in background), and
Joe Levine

Janet and Freddie de Cordova

Henry Berger, Angie Dickinson,
and Eva Gabor

Tony Martin and Cyd Charisse

Sonja Henie

Henry Mancini,
Edward G. Robinson,
and Steve Allen

Henry and Shirley Fonda

OSCAR KLATCH While private Academy Awards parties have traditionally been held on the night of the ceremony, actress Anita Louise, *opposite*, second row, far right, and her husband, businessman and social figure Henry Berger, *above*, second row, second photo, hosted gatherings at their Beverly Hills home on Oscar eve in 1968 and 1969. Celebrated neighbors and out-of-towners, including award presenters (fresh from rehearsing for the next day's events), would convene *chez* Berger for affairs coordinated by Richard Gully, a Zelig-like Hollywood presence who had been Jack Warner's aide-de-camp.

Gene Nelson and
Ricardo Montalban

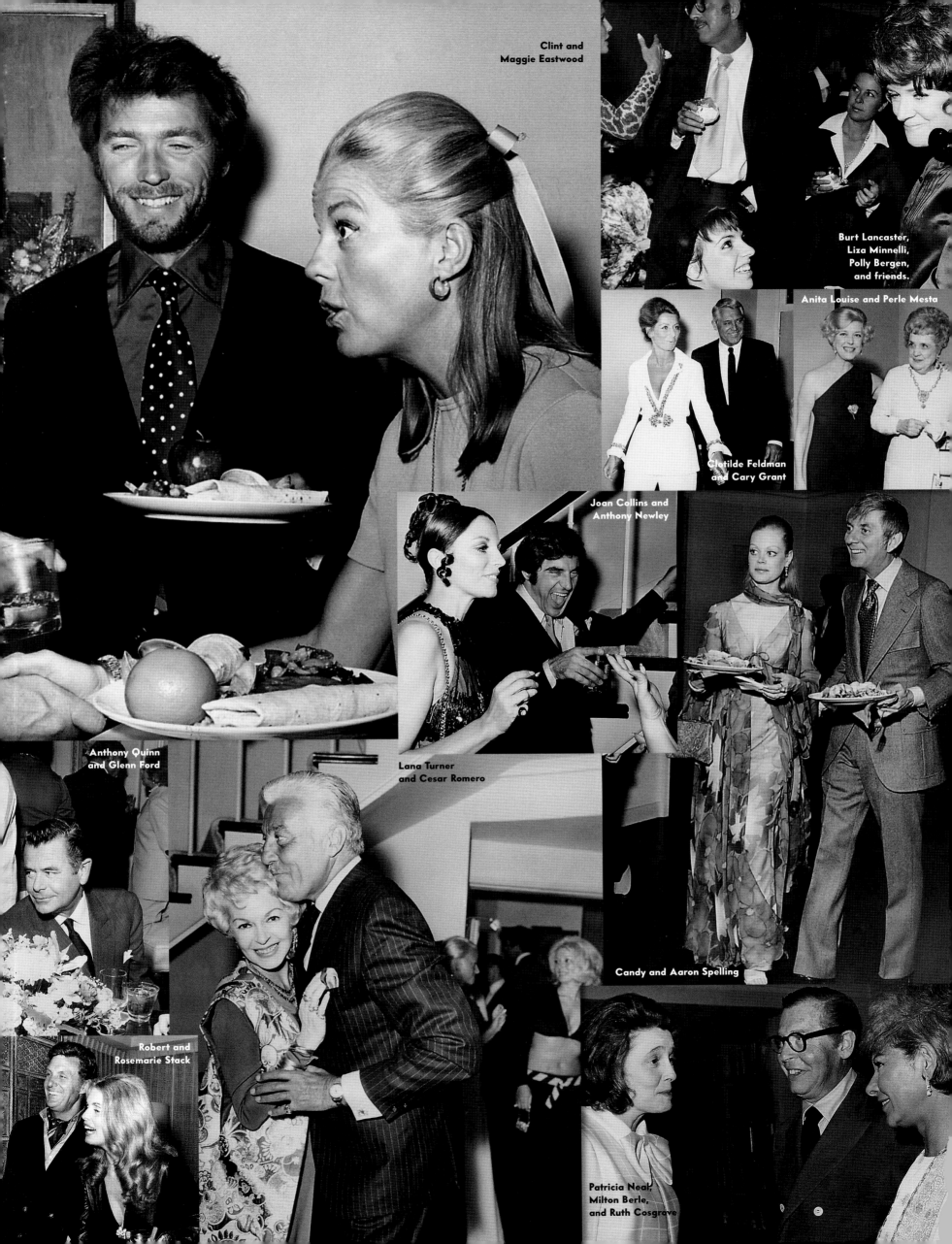

Clint and Maggie Eastwood

Burt Lancaster, Liza Minnelli, Polly Bergen, and friends.

Anita Louise and Perle Mesta

Clotilde Feldman and Cary Grant

Joan Collins and Anthony Newley

Lana Turner and Cesar Romero

Anthony Quinn and Glenn Ford

Candy and Aaron Spelling

Robert and Rosemarie Stack

Patricia Neal, Milton Berle, and Ruth Cosgrove

Among those on hand at the Beverly Hilton **BOARD OF GOVERNORS BALL** in 1969: singer José Feliciano (seated, left, in his trademark shades); Sondra Locke, *The Heart Is a Lonely Hunter*'s best-supporting-actress nominee (center, in profile); an unidentified Oscarbearer, and designer Edith Head (seated, right, in *her* trademark dark frames), who would amass 35 nominations and an astonishing eight Academy Awards.

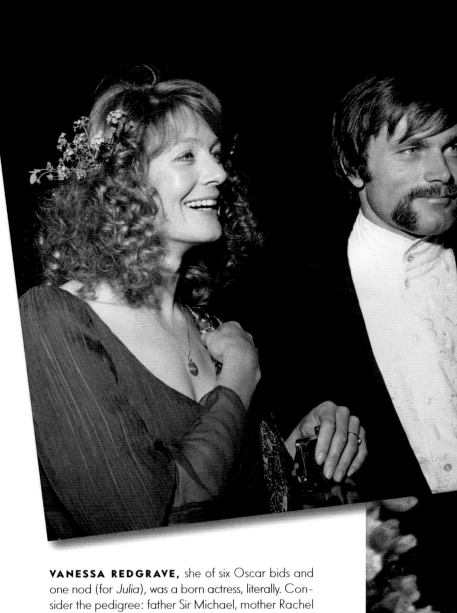

VANESSA REDGRAVE, she of six Oscar bids and one nod (for *Julia*), was a born actress, literally. Consider the pedigree: father Sir Michael, mother Rachel Kempson, sister Lynn. Even her daughters, Joely and Natasha (the latter married to Liam Neeson), were destined for the footlights. In the 1969 awards-night fray, Redgrave, a nominee that evening for *Isadora*, seemed to have an Aquarian air and a touch of nymph as she and her beau, **FRANCO NERO,** arrived. As so often happens in Hollywood, life had imitated celluloid: Redgrave (who had been married to director Tony Richardson) met and started courting her Italian Lancelot while playing Guinevere on the set of *Camelot*.

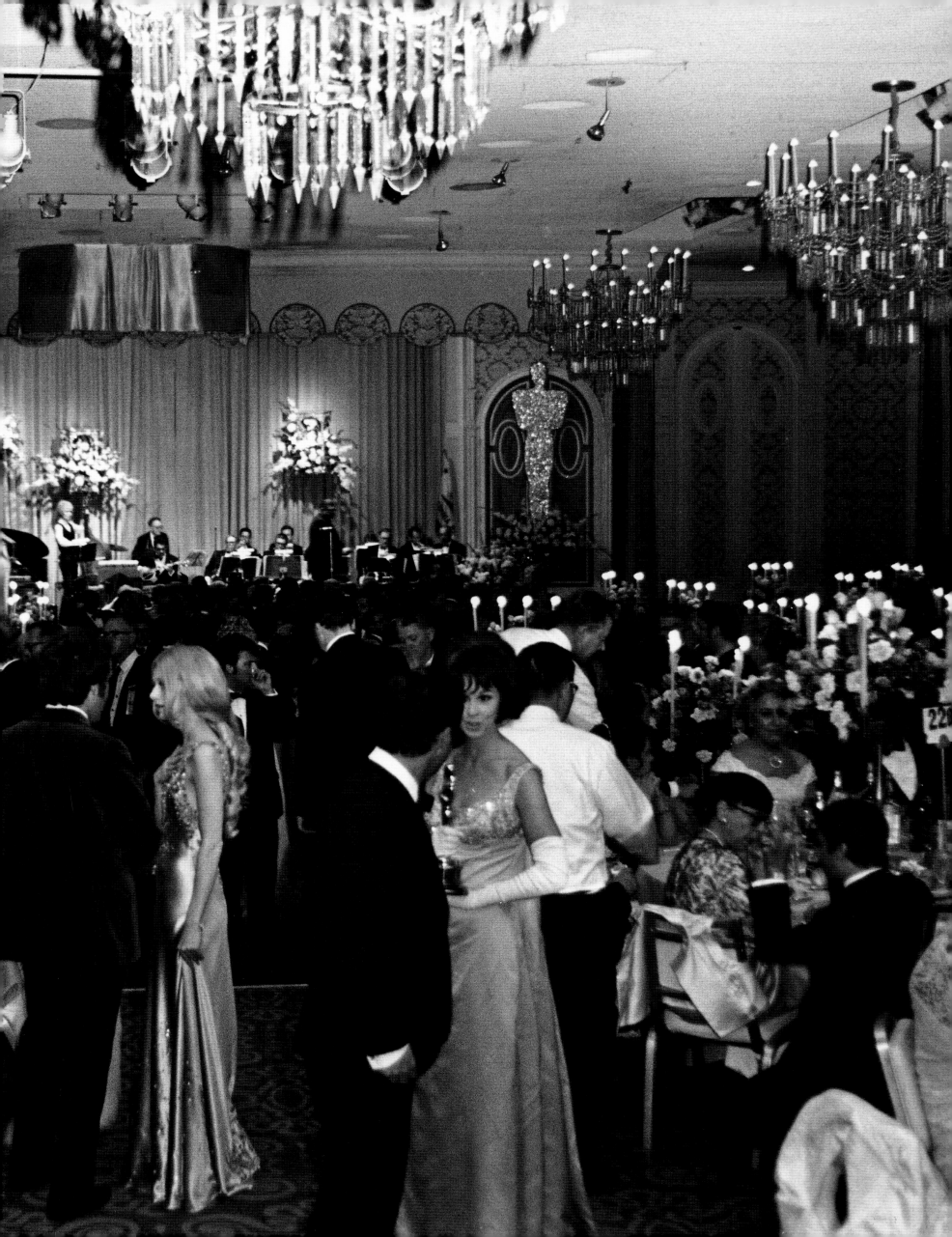

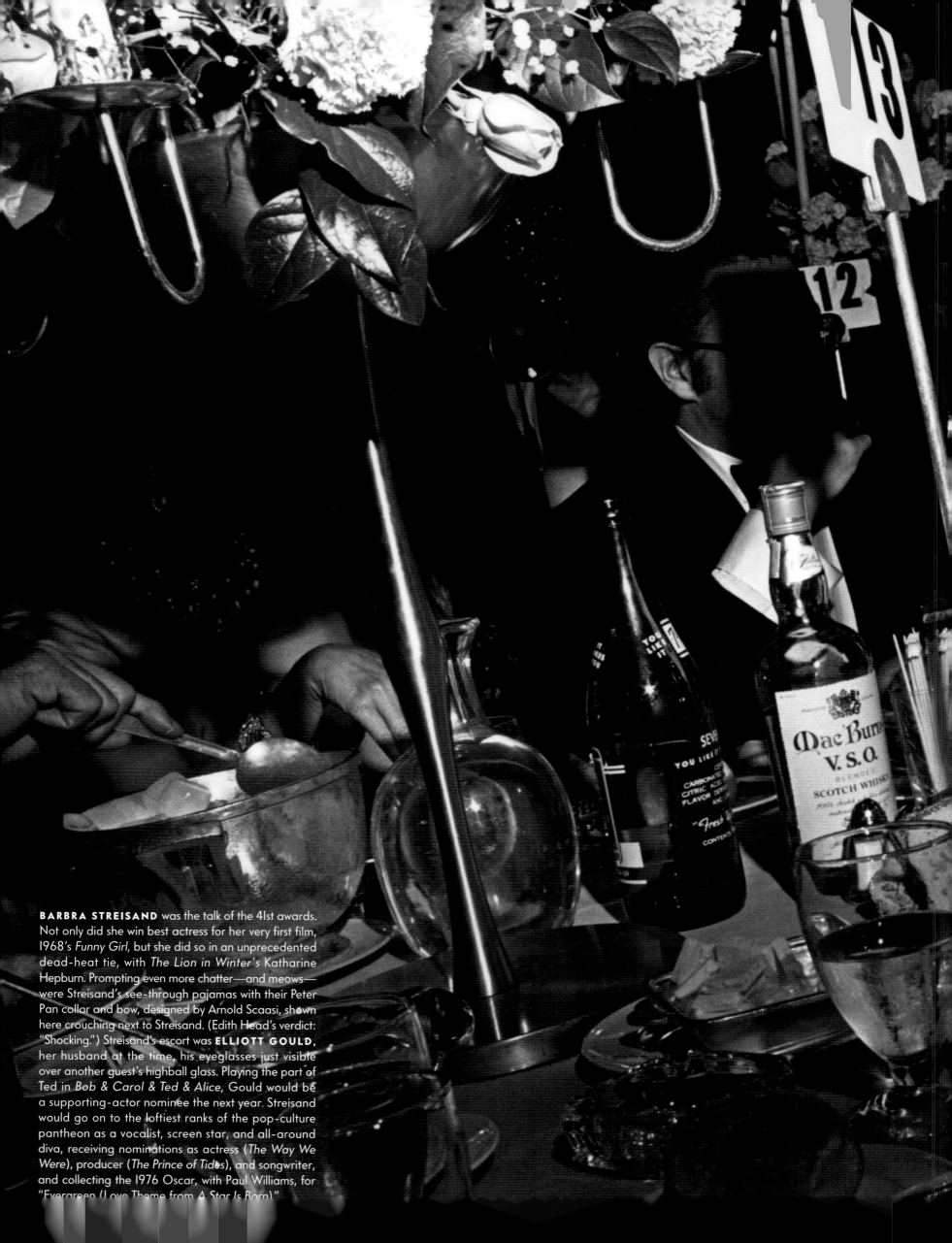

BARBRA STREISAND was the talk of the 41st awards. Not only did she win best actress for her very first film, 1968's *Funny Girl*, but she did so in an unprecedented dead-heat tie, with *The Lion in Winter's* Katharine Hepburn. Prompting even more chatter—and meows—were Streisand's see-through pajamas with their Peter Pan collar and bow, designed by Arnold Scaasi, shown here crouching next to Streisand. (Edith Head's verdict: "Shocking.") Streisand's escort was **ELLIOTT GOULD**, her husband at the time, his eyeglasses just visible over another guest's highball glass. Playing the part of Ted in *Bob & Carol & Ted & Alice*, Gould would be a supporting-actor nominee the next year. Streisand would go on to the loftiest ranks of the pop-culture pantheon as a vocalist, screen star, and all-around diva, receiving nominations as actress (*The Way We Were*), producer (*The Prince of Tides*), and songwriter, and collecting the 1976 Oscar, with Paul Williams, for "Evergreen (Love Theme from *A Star Is Born*)."

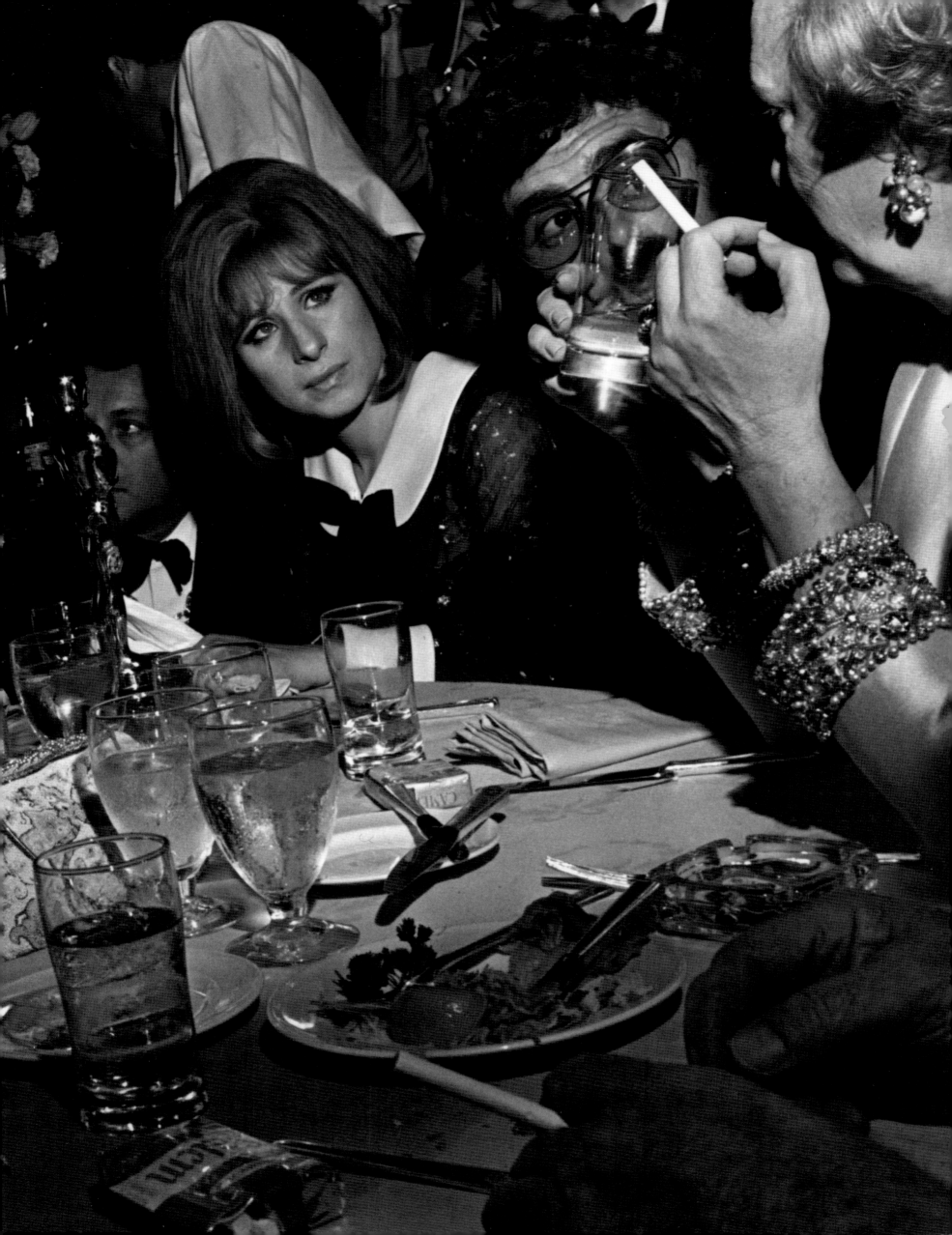

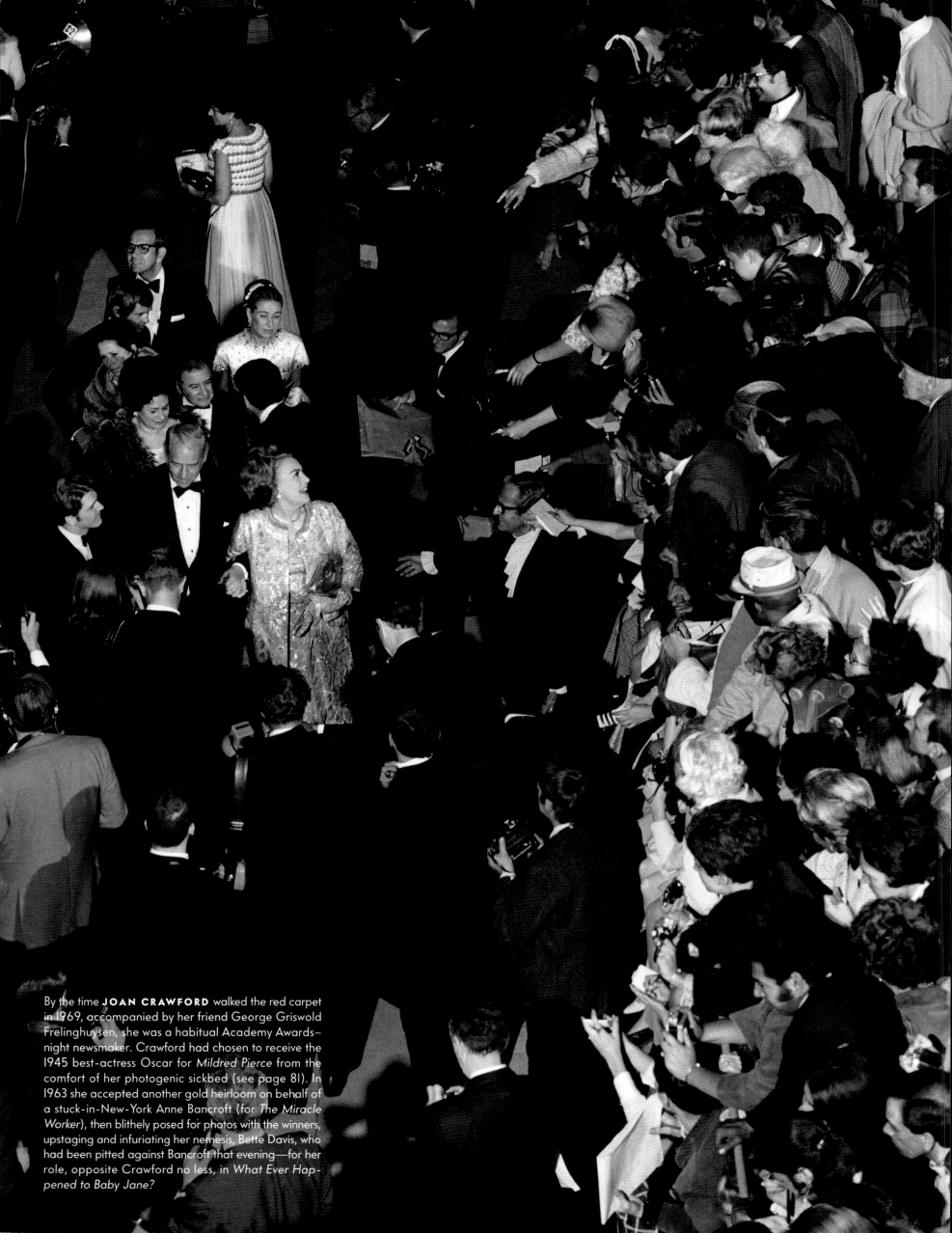

By the time **JOAN CRAWFORD** walked the red carpet in 1969, accompanied by her friend George Griswold Frelinghuysen, she was a habitual Academy Awards—night newsmaker. Crawford had chosen to receive the 1945 best-actress Oscar for *Mildred Pierce* from the comfort of her photogenic sickbed (see page 81). In 1963 she accepted another gold heirloom on behalf of a stuck-in-New-York Anne Bancroft (for *The Miracle Worker*), then blithely posed for photos with the winners, upstaging and infuriating her nemesis, Bette Davis, who had been pitted against Bancroft that evening—for her role, opposite Crawford no less, in *What Ever Happened to Baby Jane?*

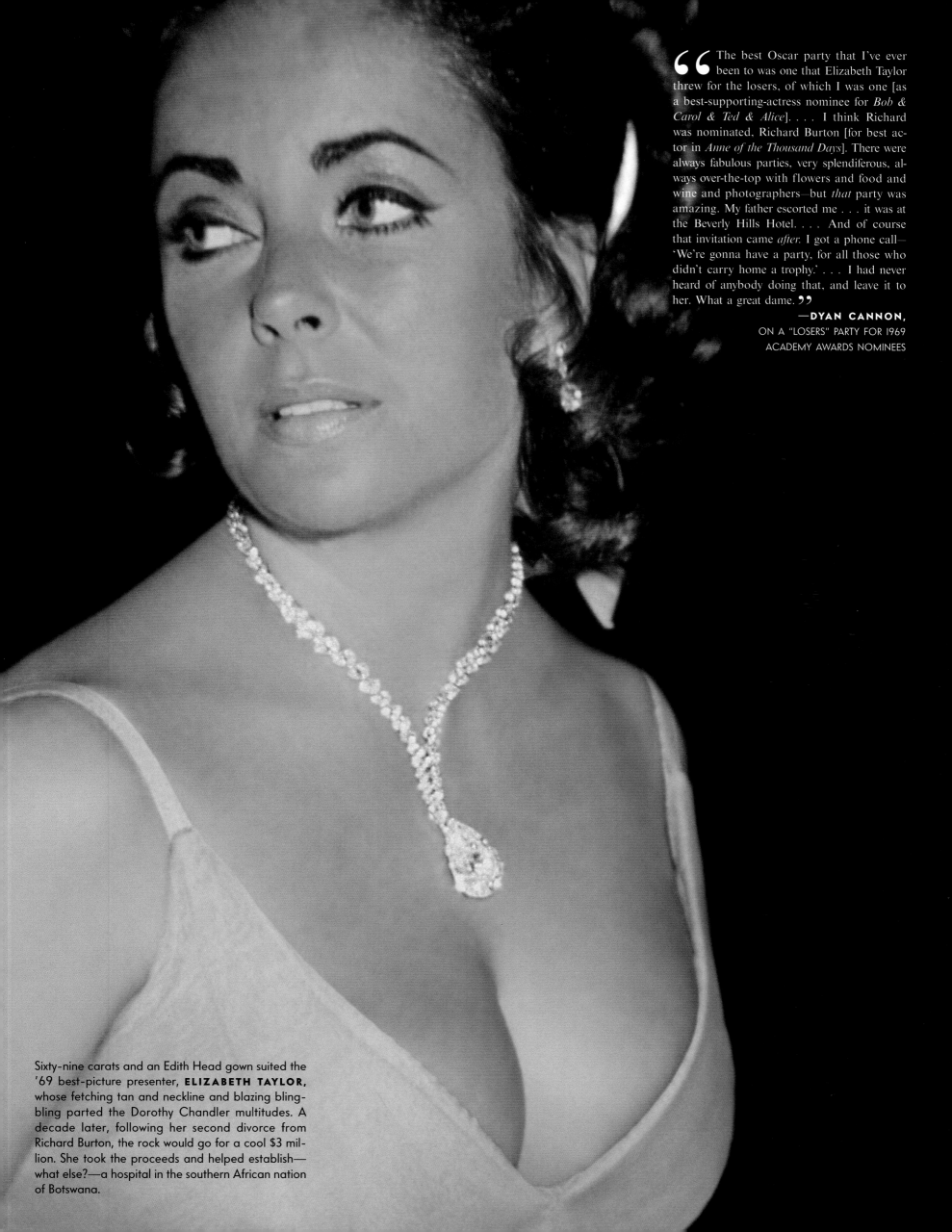

Sixty-nine carats and an Edith Head gown suited the '69 best-picture presenter, **ELIZABETH TAYLOR,** whose fetching tan and neckline and blazing bling-bling parted the Dorothy Chandler multitudes. A decade later, following her second divorce from Richard Burton, the rock would go for a cool $3 million. She took the proceeds and helped establish— what else?—a hospital in the southern African nation of Botswana.

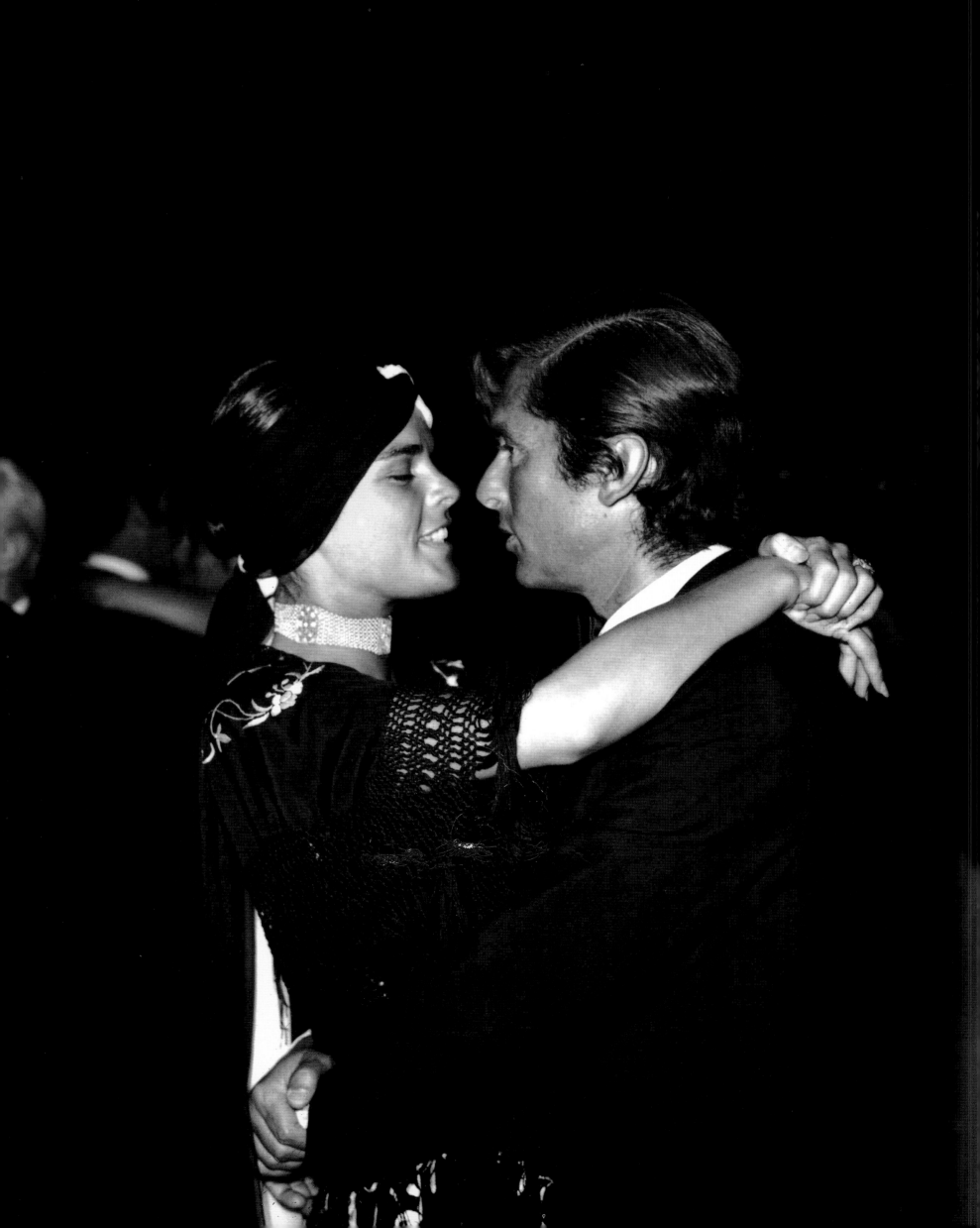

Hollywood's turn-of-the-70s "It couple"—**ALI MacGRAW**, in two-tone headscarf, and her new husband, **ROBERT EVANS** (Paramount's production chief at the time)—slow-danced the night away at the 1970 Governors Ball. "I was the luckiest man in the world," Evans would write in his autobiography, *The Kid Stays in the Picture*. "Few people ever touch Camelot in their lives. Was it a dream?" Paramount enjoyed a big win that evening when John Wayne lassoed his first Oscar, after 40 years in the saddle, for his role in the studio's *True Grit*. But Evans had a genuine coup in store: *Love Story*, starring MacGraw and Ryan O'Neal. Released at Christmas, the tearjerker would land seven Oscar nominations, launch a fad for knit hats, and become one of Hollywood's all-time leading moneymakers. A shame that the dance had to end. In 1972, MacGraw would slip from Evans's grasp, taking up with Steve McQueen, her co-star in *The Getaway*.

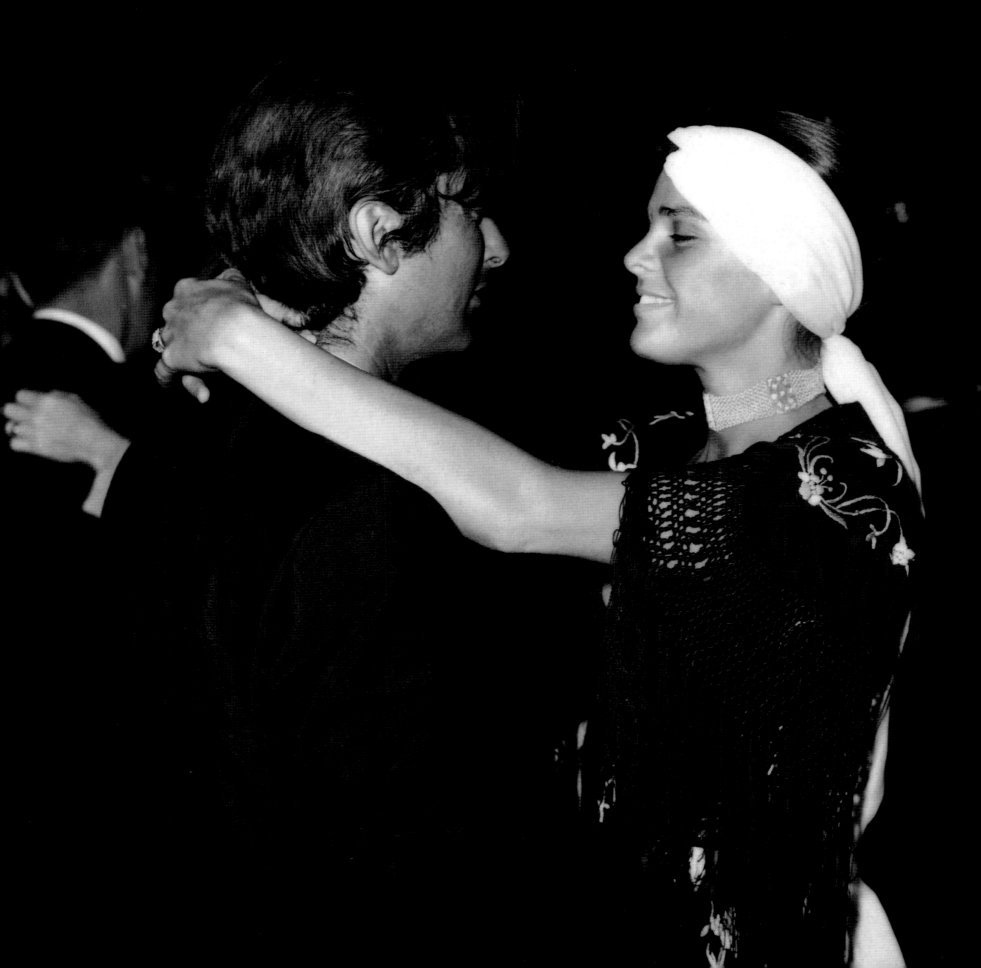

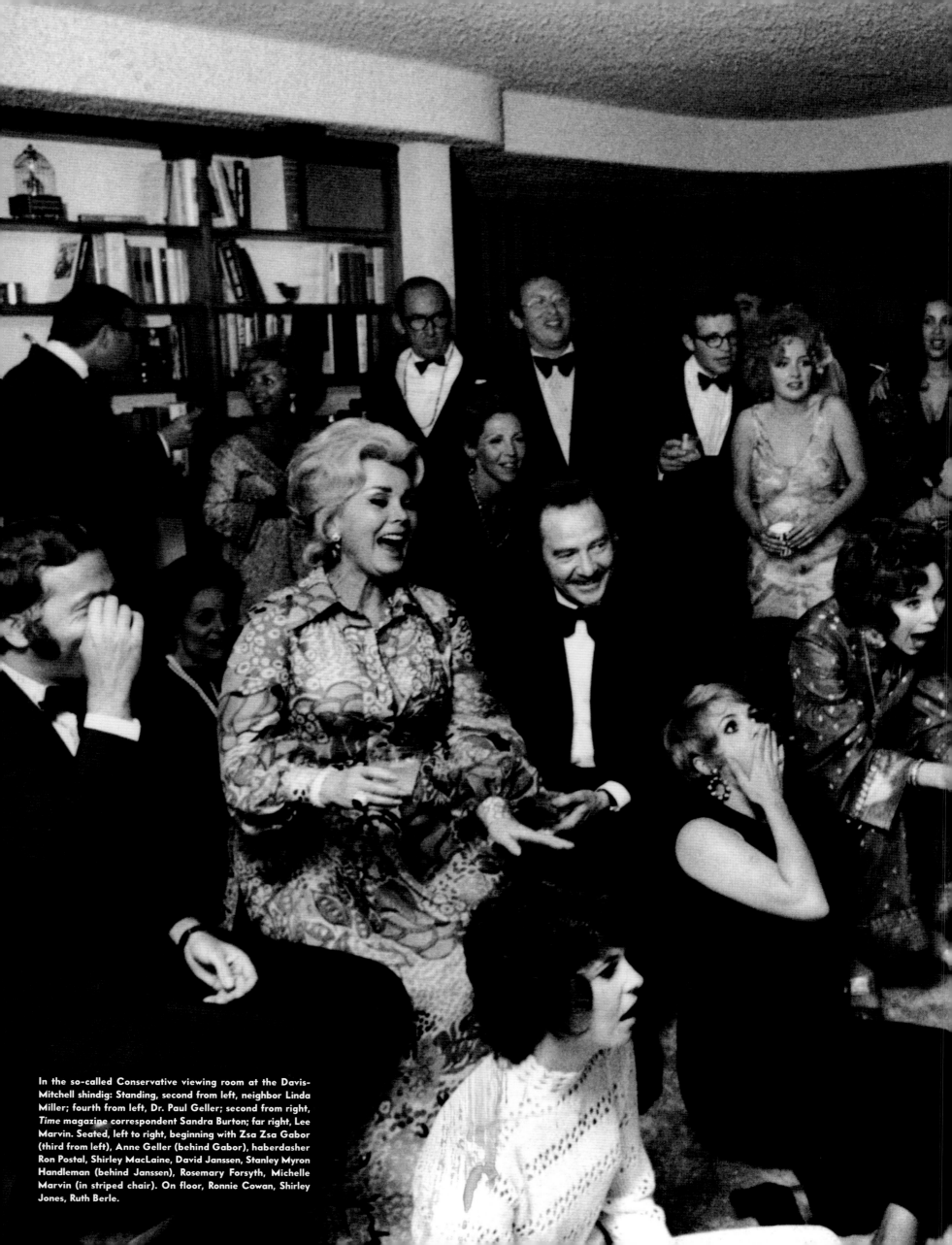

In the so-called Conservative viewing room at the Davis-Mitchell shindig: Standing, second from left, neighbor Linda Miller; fourth from left, Dr. Paul Geller; second from right, *Time* magazine correspondent Sandra Burton; far right, Lee Marvin. Seated, left to right, beginning with Zsa Zsa Gabor (third from left), Anne Geller (behind Gabor), haberdasher Ron Postal, Shirley MacLaine, David Janssen, Stanley Myron Handleman (behind Janssen), Rosemary Forsyth, Michelle Marvin (in striped chair). On floor, Ronnie Cowan, Shirley Jones, Ruth Berle.

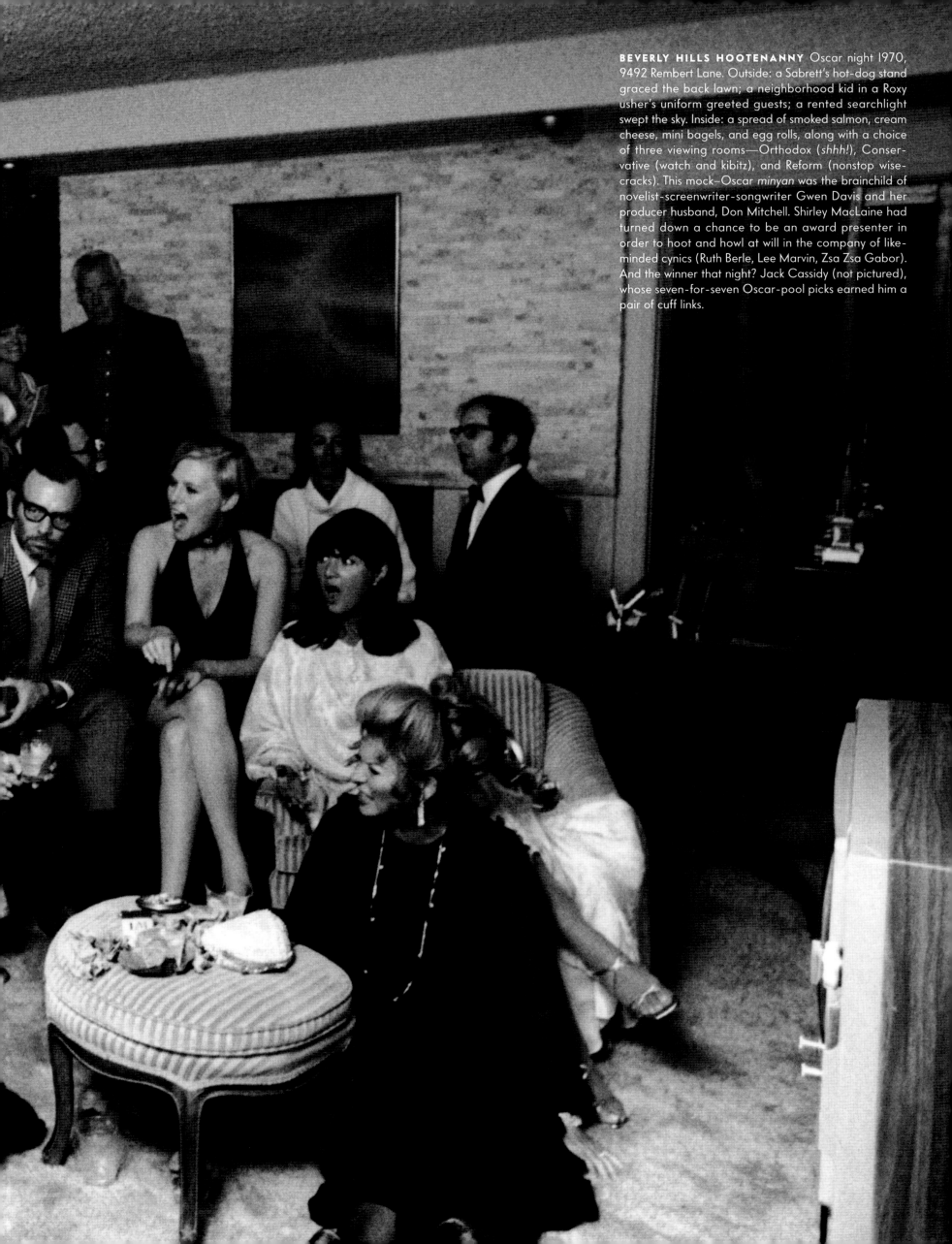

BEVERLY HILLS HOOTENANNY Oscar night 1970, 9492 Rembert Lane. Outside: a Sabrett's hot-dog stand graced the back lawn; a neighborhood kid in a Roxy usher's uniform greeted guests; a rented searchlight swept the sky. Inside: a spread of smoked salmon, cream cheese, mini bagels, and egg rolls, along with a choice of three viewing rooms—Orthodox (*shhh!*), Conservative (watch and kibitz), and Reform (nonstop wisecracks). This mock–Oscar *minyan* was the brainchild of novelist-screenwriter-songwriter Gwen Davis and her producer husband, Don Mitchell. Shirley MacLaine had turned down a chance to be an award presenter in order to hoot and howl at will in the company of likeminded cynics (Ruth Berle, Lee Marvin, Zsa Zsa Gabor). And the winner that night? Jack Cassidy (not pictured), whose seven-for-seven Oscar-pool picks earned him a pair of cuff links.

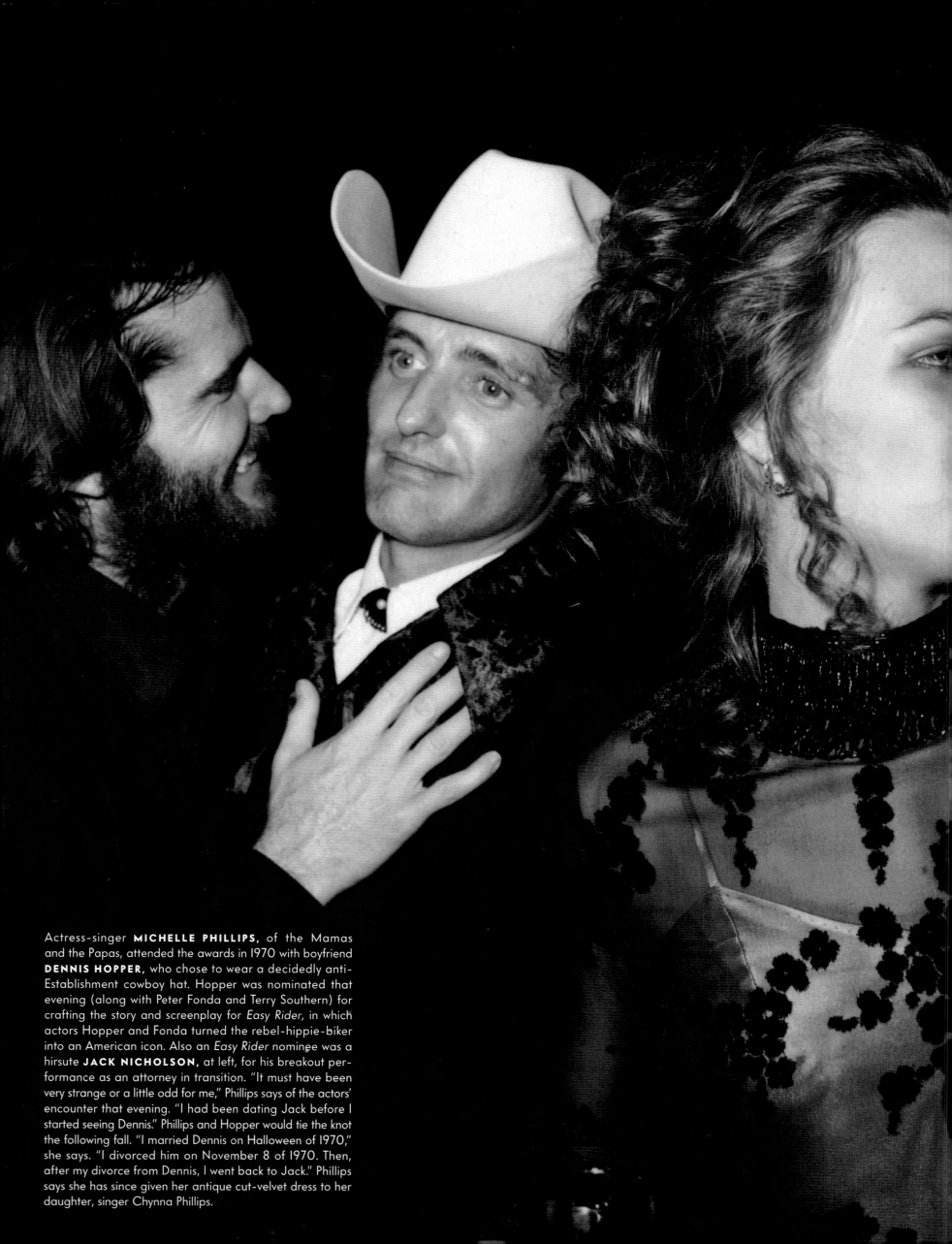

Actress-singer **MICHELLE PHILLIPS,** of the Mamas and the Papas, attended the awards in 1970 with boyfriend **DENNIS HOPPER,** who chose to wear a decidedly anti-Establishment cowboy hat. Hopper was nominated that evening (along with Peter Fonda and Terry Southern) for crafting the story and screenplay for *Easy Rider,* in which actors Hopper and Fonda turned the rebel-hippie-biker into an American icon. Also an *Easy Rider* nominee was a hirsute **JACK NICHOLSON,** at left, for his breakout performance as an attorney in transition. "It must have been very strange or a little odd for me," Phillips says of the actors' encounter that evening. "I had been dating Jack before I started seeing Dennis." Phillips and Hopper would tie the knot the following fall. "I married Dennis on Halloween of 1970," she says. "I divorced him on November 8 of 1970. Then, after my divorce from Dennis, I went back to Jack." Phillips says she has since given her antique cut-velvet dress to her daughter, singer Chynna Phillips.

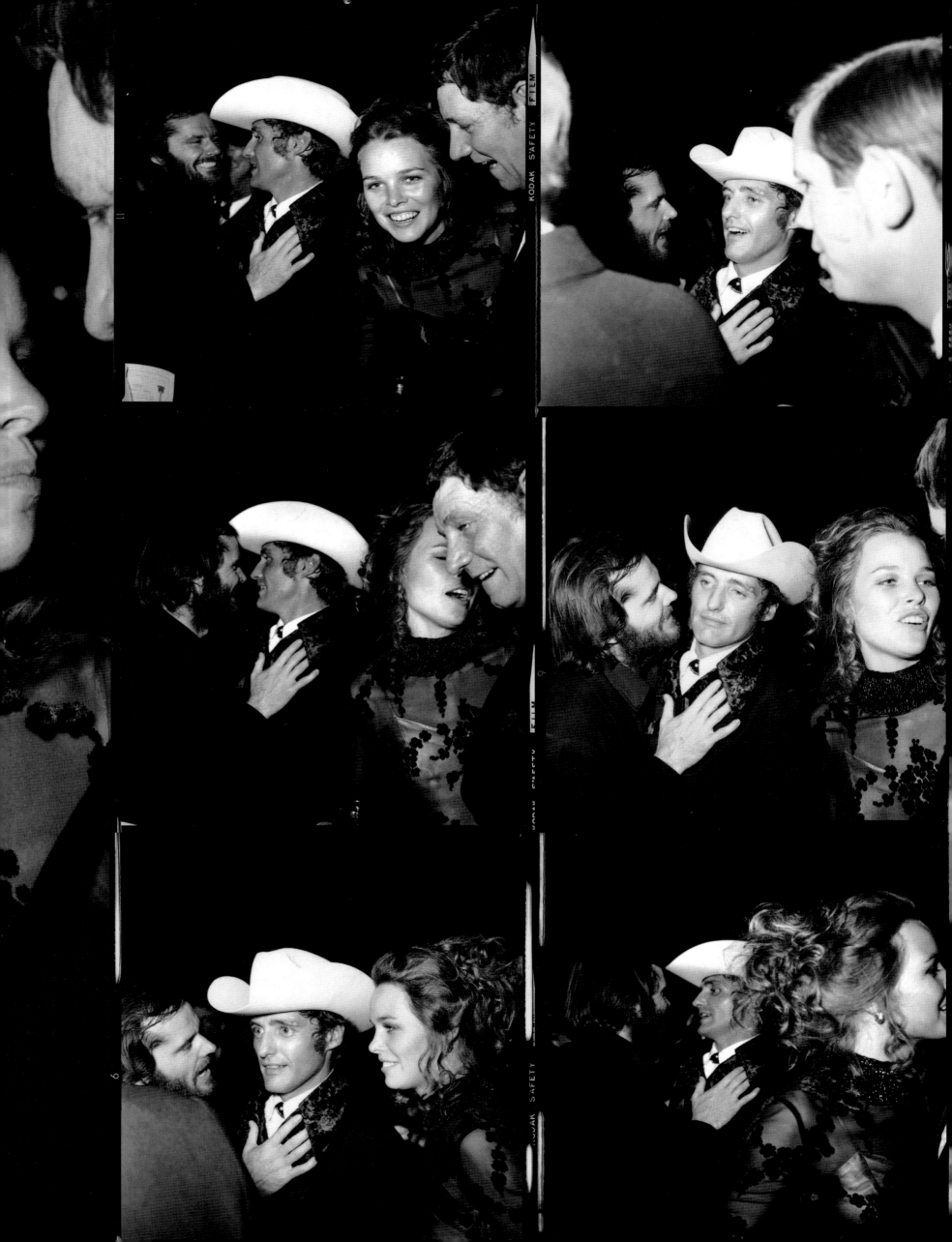

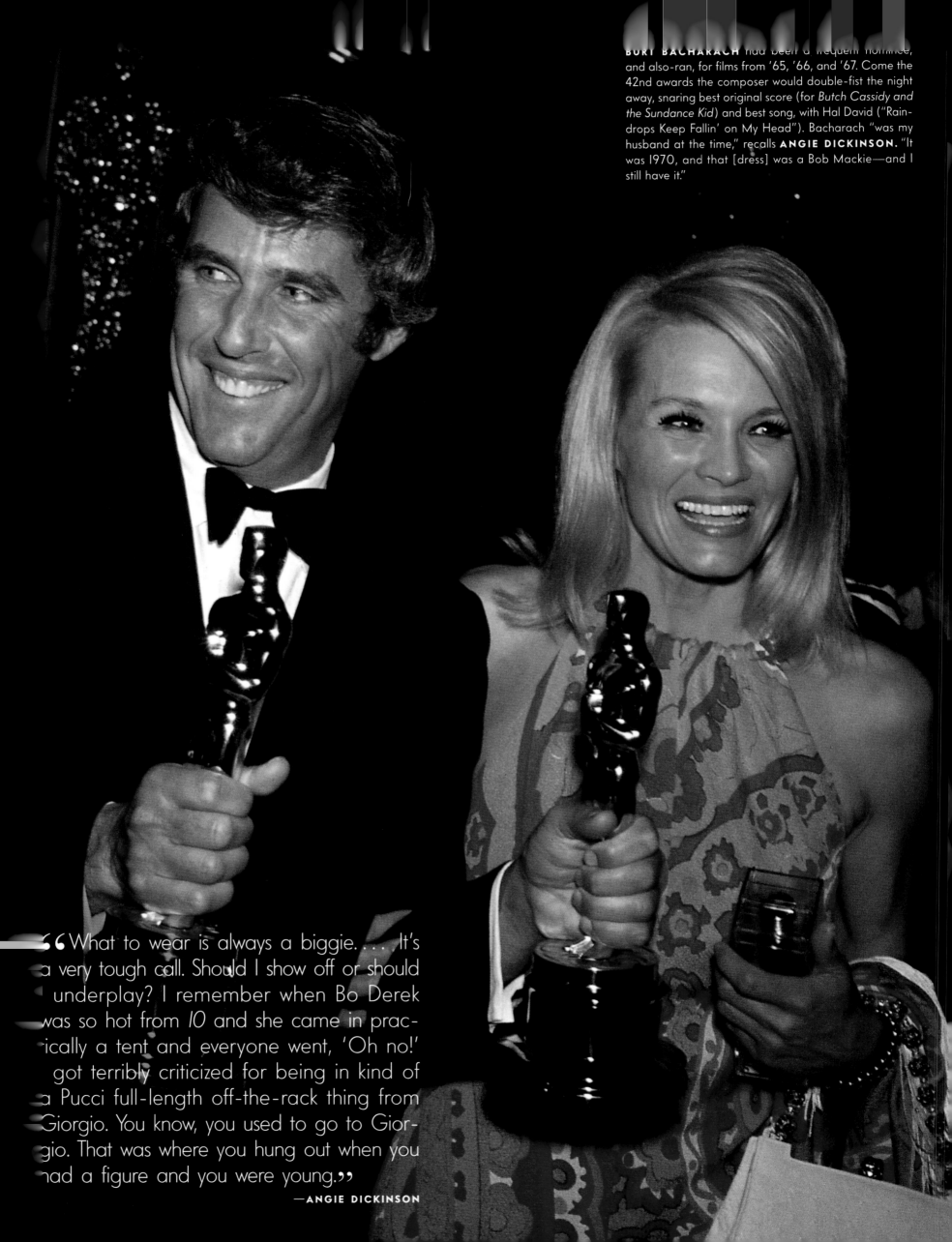

BURT BACHARACH had been a frequent nominee, and also-ran, for films from '65, '66, and '67. Come the 42nd awards the composer would double-fist the night away, snaring best original score (for *Butch Cassidy and the Sundance Kid*) and best song, with Hal David ("Raindrops Keep Fallin' on My Head"). Bacharach "was my husband at the time," recalls **ANGIE DICKINSON.** "It was 1970, and that [dress] was a Bob Mackie—and I still have it."

"What to wear is always a biggie. . . . It's a very tough call. Should I show off or should I underplay? I remember when Bo Derek was so hot from *10* and she came in practically a tent and everyone went, 'Oh no!' I got terribly criticized for being in kind of a Pucci full-length off-the-rack thing from Giorgio. You know, you used to go to Giorgio. That was where you hung out when you had a figure and you were young."
—ANGIE DICKINSON

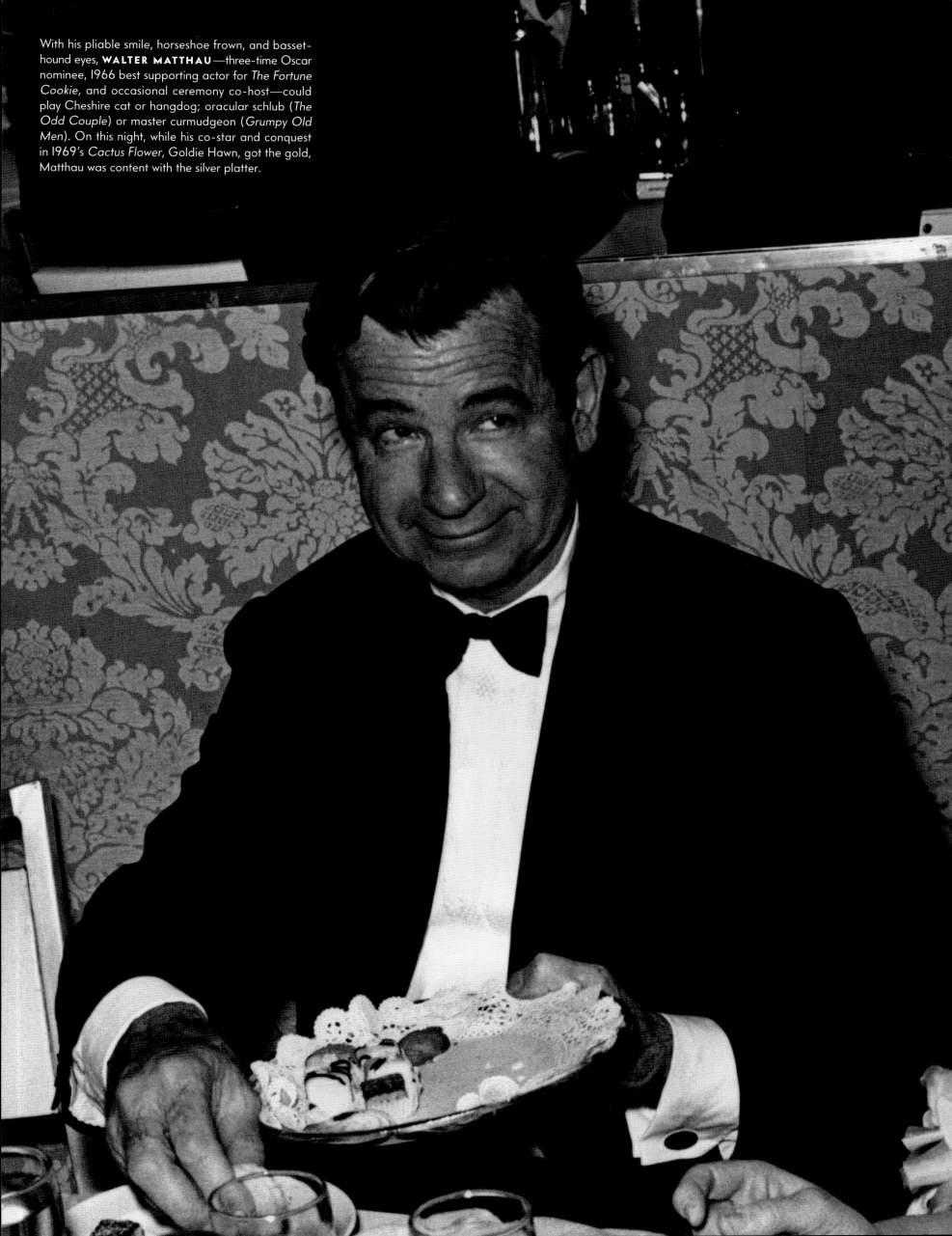

With his pliable smile, horseshoe frown, and basset-hound eyes, **WALTER MATTHAU**—three-time Oscar nominee, 1966 best supporting actor for *The Fortune Cookie*, and occasional ceremony co-host—could play Cheshire cat or hangdog; oracular schlub (*The Odd Couple*) or master curmudgeon (*Grumpy Old Men*). On this night, while his co-star and conquest in 1969's *Cactus Flower*, Goldie Hawn, got the gold, Matthau was content with the silver platter.

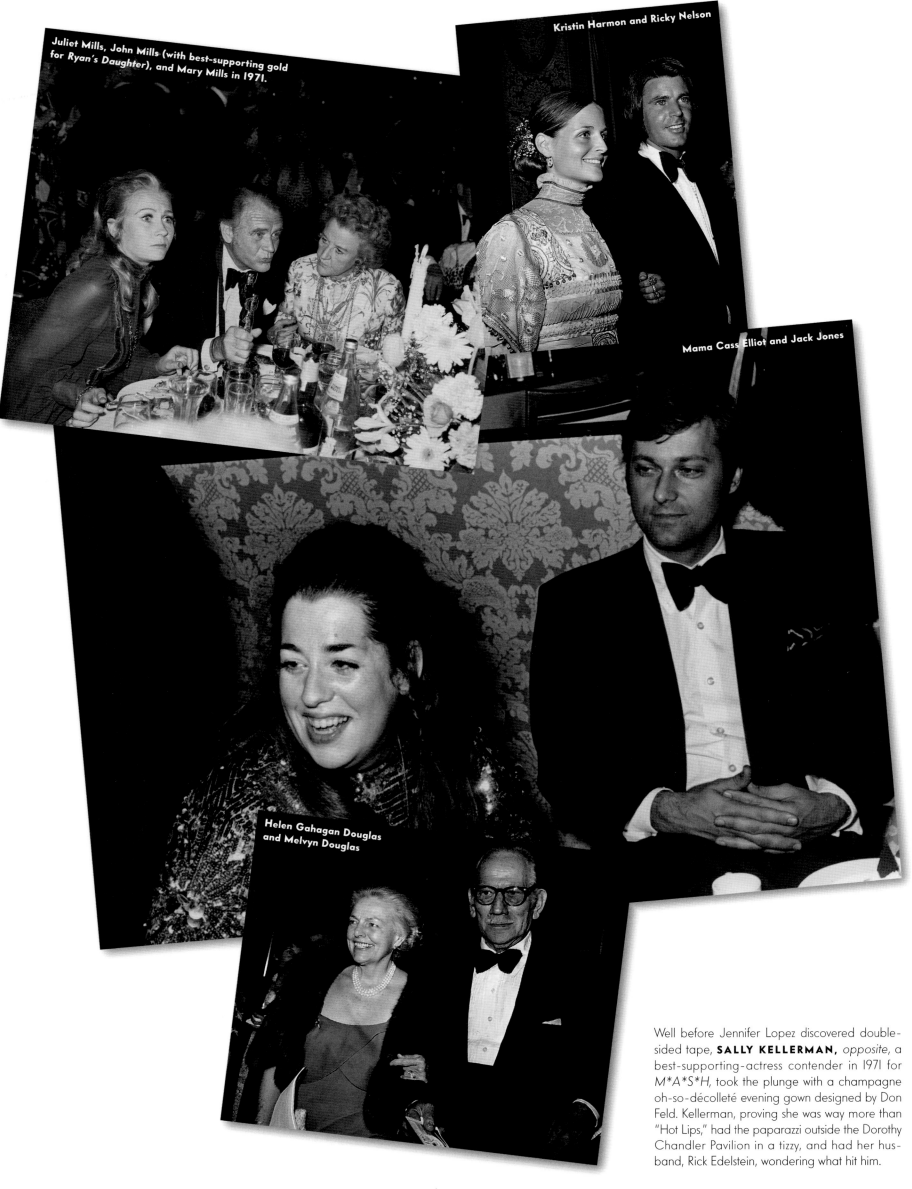

Juliet Mills, John Mills (with best-supporting gold for *Ryan's Daughter*), and Mary Mills in 1971.

Kristin Harmon and Ricky Nelson

Mama Cass Elliot and Jack Jones

Helen Gahagan Douglas and Melvyn Douglas

Well before Jennifer Lopez discovered double-sided tape, **SALLY KELLERMAN,** *opposite,* a best-supporting-actress contender in 1971 for *M*A*S*H,* took the plunge with a champagne oh-so-décolleté evening gown designed by Don Feld. Kellerman, proving she was way more than "Hot Lips," had the paparazzi outside the Dorothy Chandler Pavilion in a tizzy, and had her husband, Rick Edelstein, wondering what hit him.

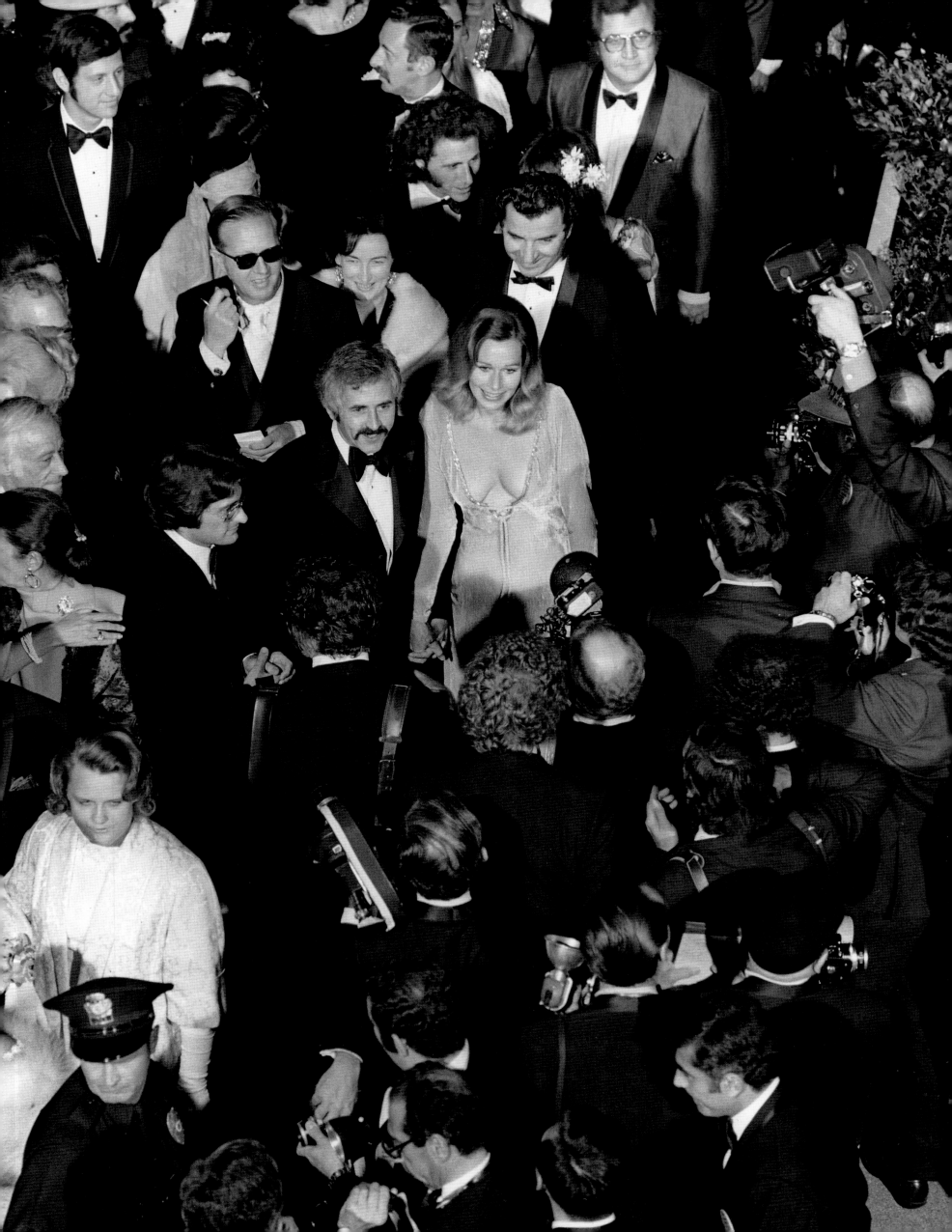

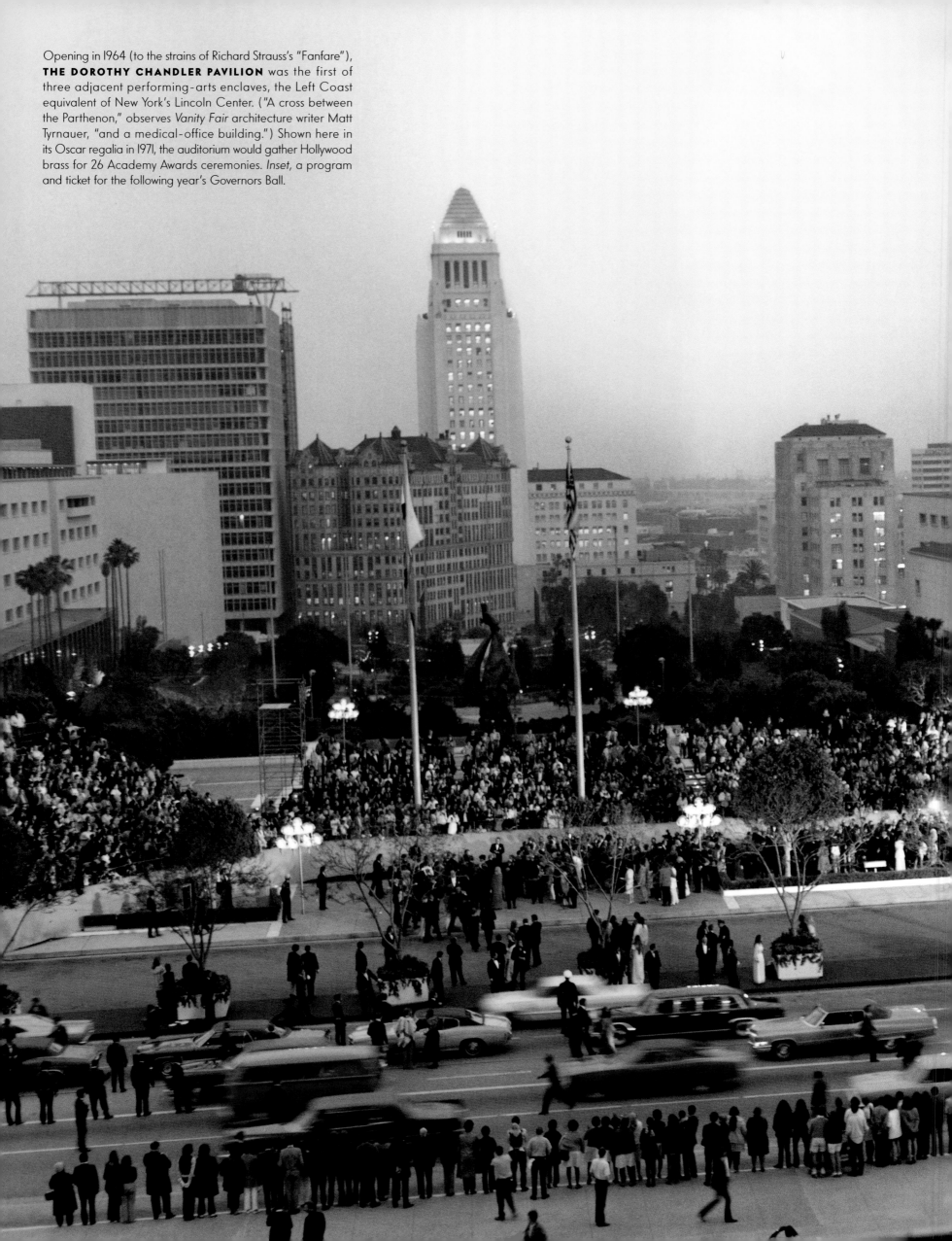

Opening in 1964 (to the strains of Richard Strauss's "Fanfare"), **THE DOROTHY CHANDLER PAVILION** was the first of three adjacent performing-arts enclaves, the Left Coast equivalent of New York's Lincoln Center. ("A cross between the Parthenon," observes *Vanity Fair* architecture writer Matt Tyrnauer, "and a medical-office building.") Shown here in its Oscar regalia in 1971, the auditorium would gather Hollywood brass for 26 Academy Awards ceremonies. *Inset*, a program and ticket for the following year's Governors Ball.

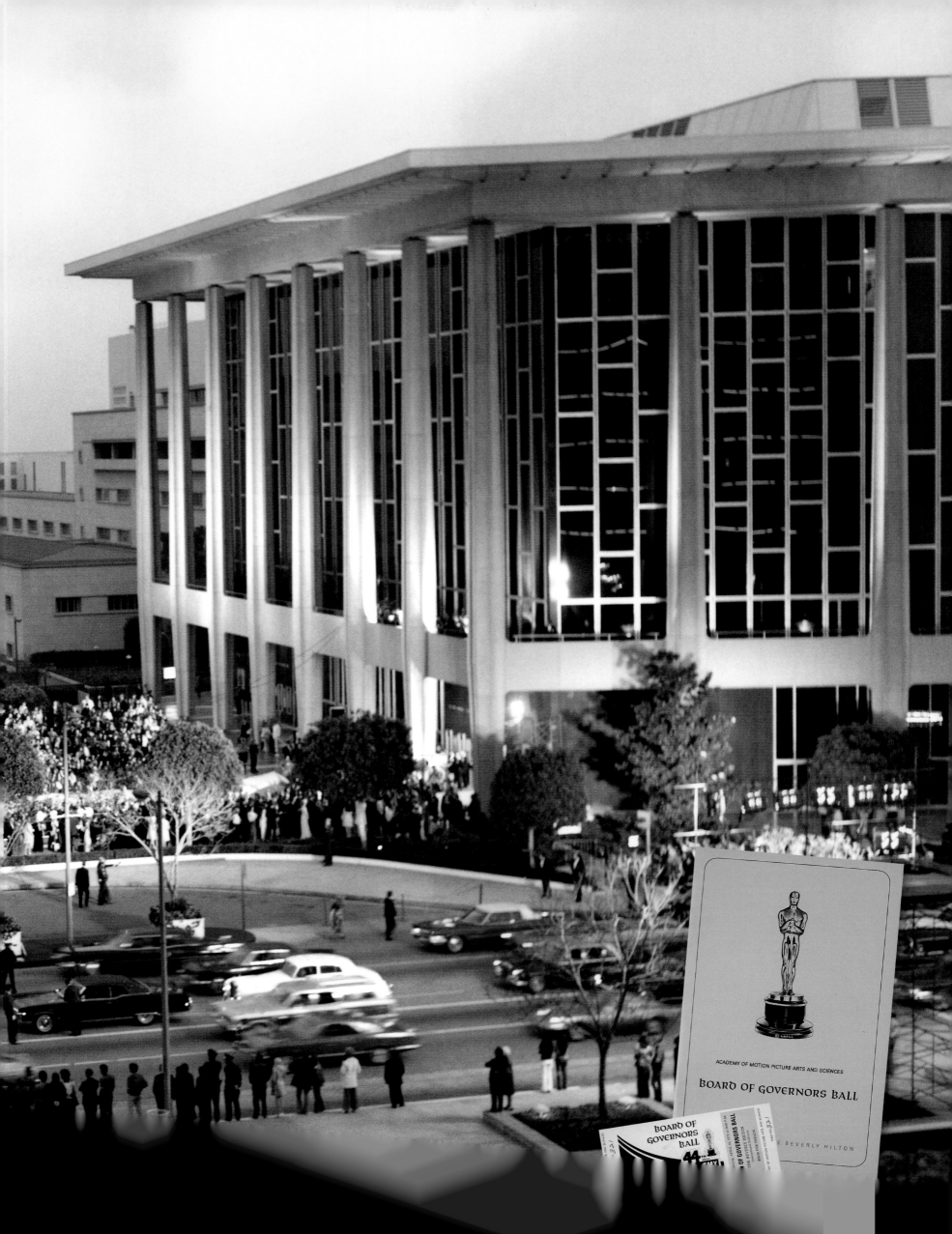

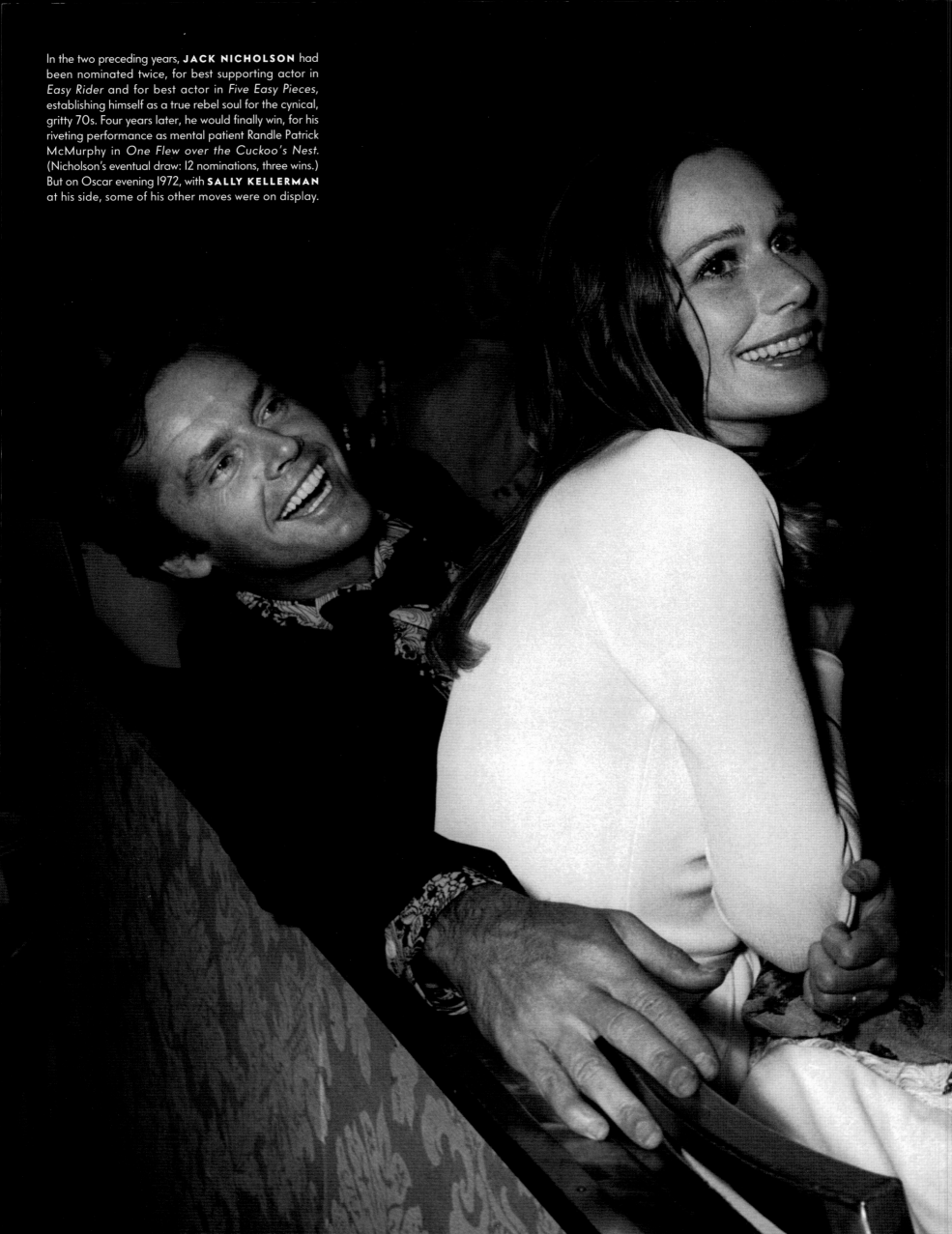

In the two preceding years, **JACK NICHOLSON** had been nominated twice, for best supporting actor in *Easy Rider* and for best actor in *Five Easy Pieces*, establishing himself as a true rebel soul for the cynical, gritty 70s. Four years later, he would finally win, for his riveting performance as mental patient Randle Patrick McMurphy in *One Flew over the Cuckoo's Nest*. (Nicholson's eventual draw: 12 nominations, three wins.) But on Oscar evening 1972, with **SALLY KELLERMAN** at his side, some of his other moves were on display.

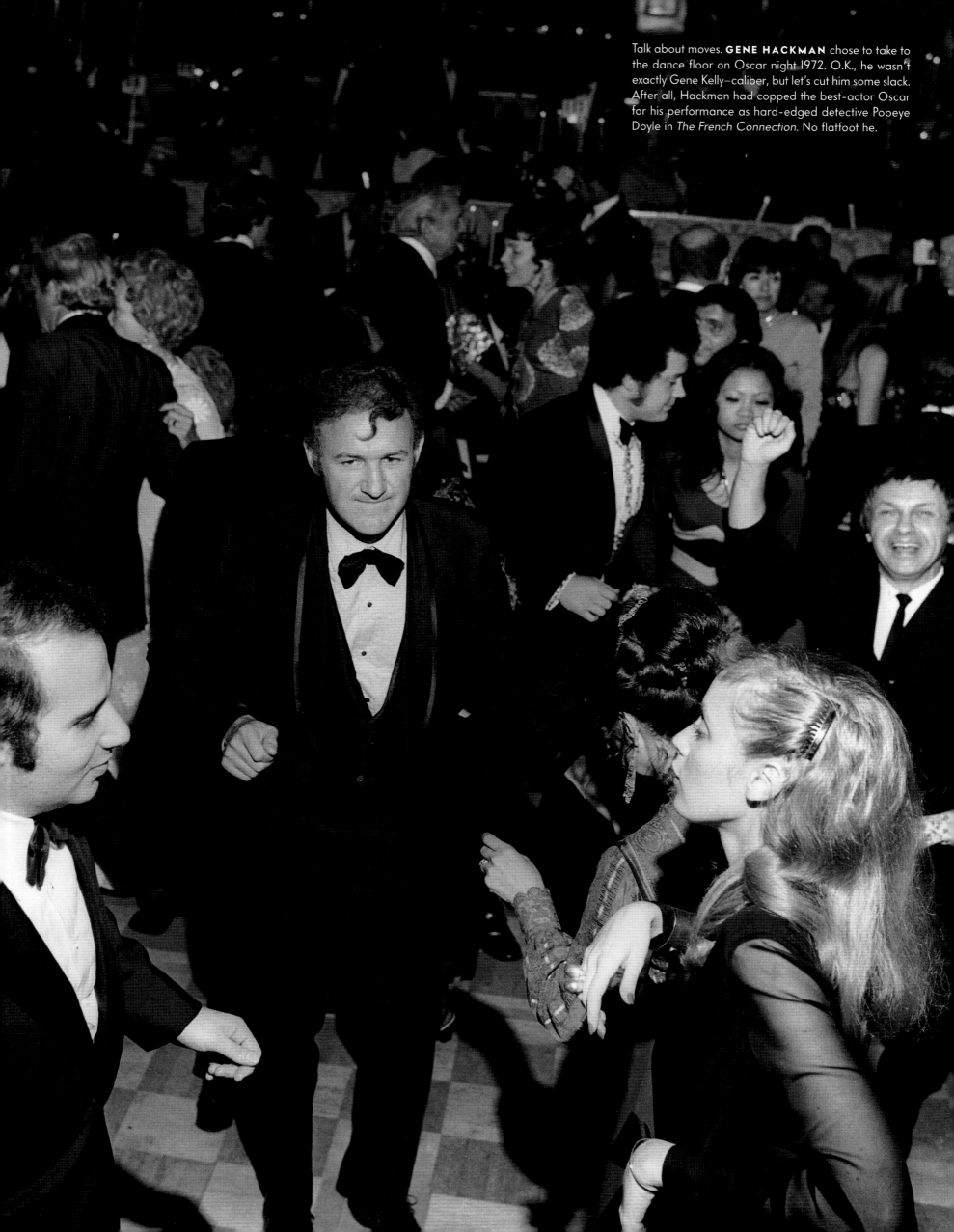

Talk about moves. **GENE HACKMAN** chose to take to the dance floor on Oscar night 1972. O.K., he wasn't exactly Gene Kelly–caliber, but let's cut him some slack. After all, Hackman had copped the best-actor Oscar for his performance as hard-edged detective Popeye Doyle in *The French Connection*. No flatfoot he.

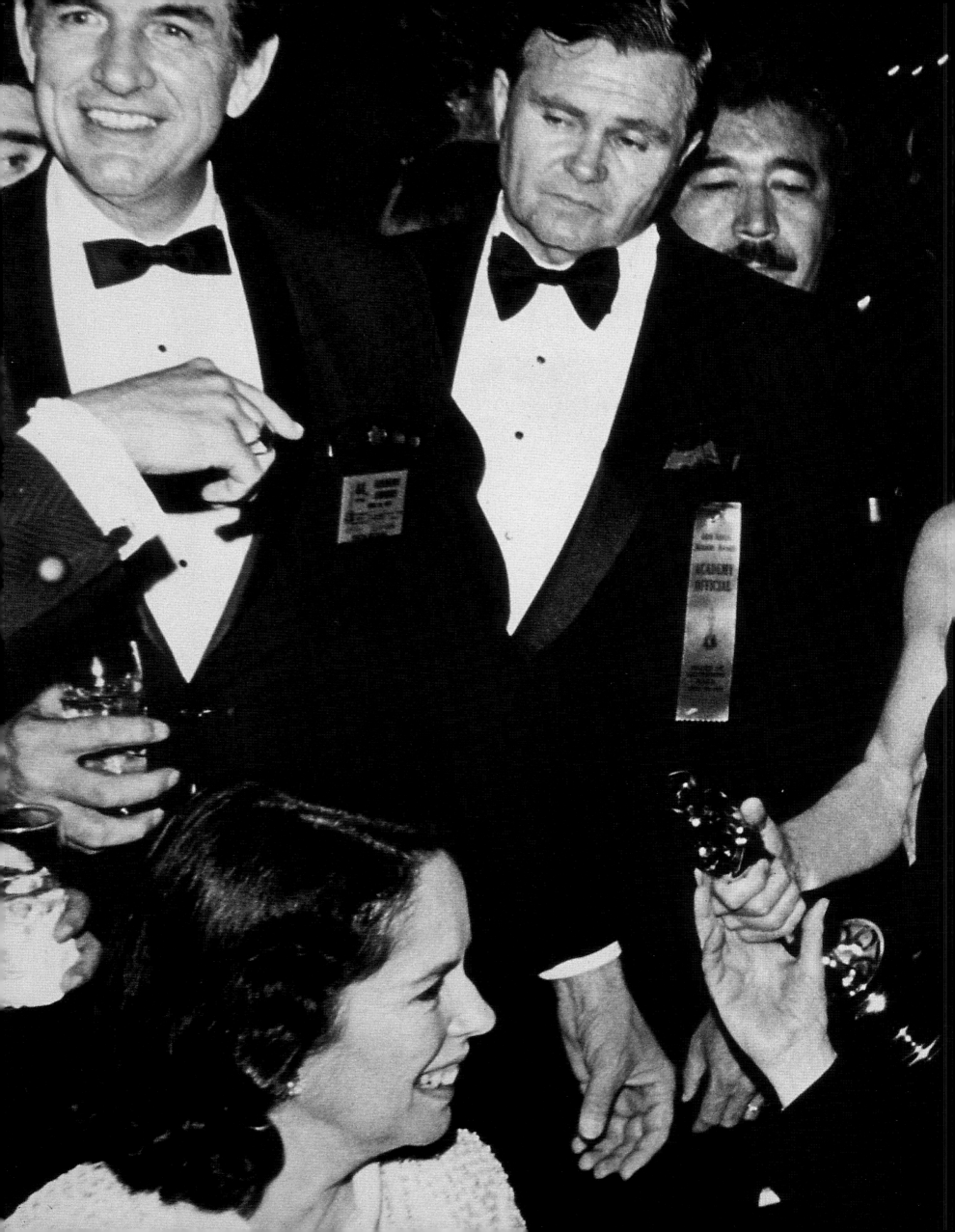

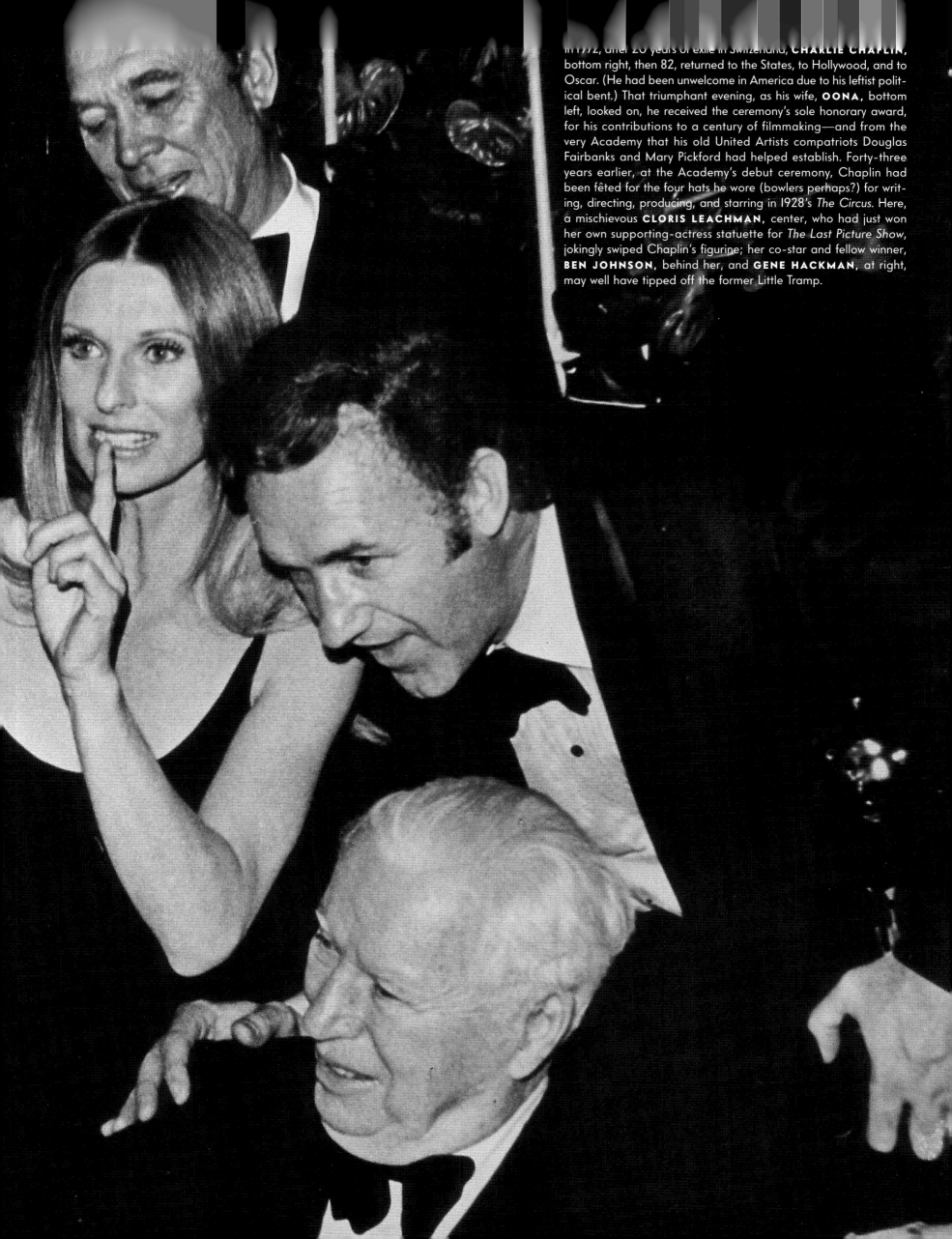

In 1972, after 20 years of exile in Switzerland, **CHARLIE CHAPLIN,** bottom right, then 82, returned to the States, to Hollywood, and to Oscar. (He had been unwelcome in America due to his leftist political bent.) That triumphant evening, as his wife, **OONA,** bottom left, looked on, he received the ceremony's sole honorary award, for his contributions to a century of filmmaking—and from the very Academy that his old United Artists compatriots Douglas Fairbanks and Mary Pickford had helped establish. Forty-three years earlier, at the Academy's debut ceremony, Chaplin had been fêted for the four hats he wore (bowlers perhaps?) for writing, directing, producing, and starring in 1928's *The Circus.* Here, a mischievous **CLORIS LEACHMAN,** center, who had just won her own supporting-actress statuette for *The Last Picture Show,* jokingly swiped Chaplin's figurine; her co-star and fellow winner, **BEN JOHNSON,** behind her, and **GENE HACKMAN,** at right, may well have tipped off the former Little Tramp.

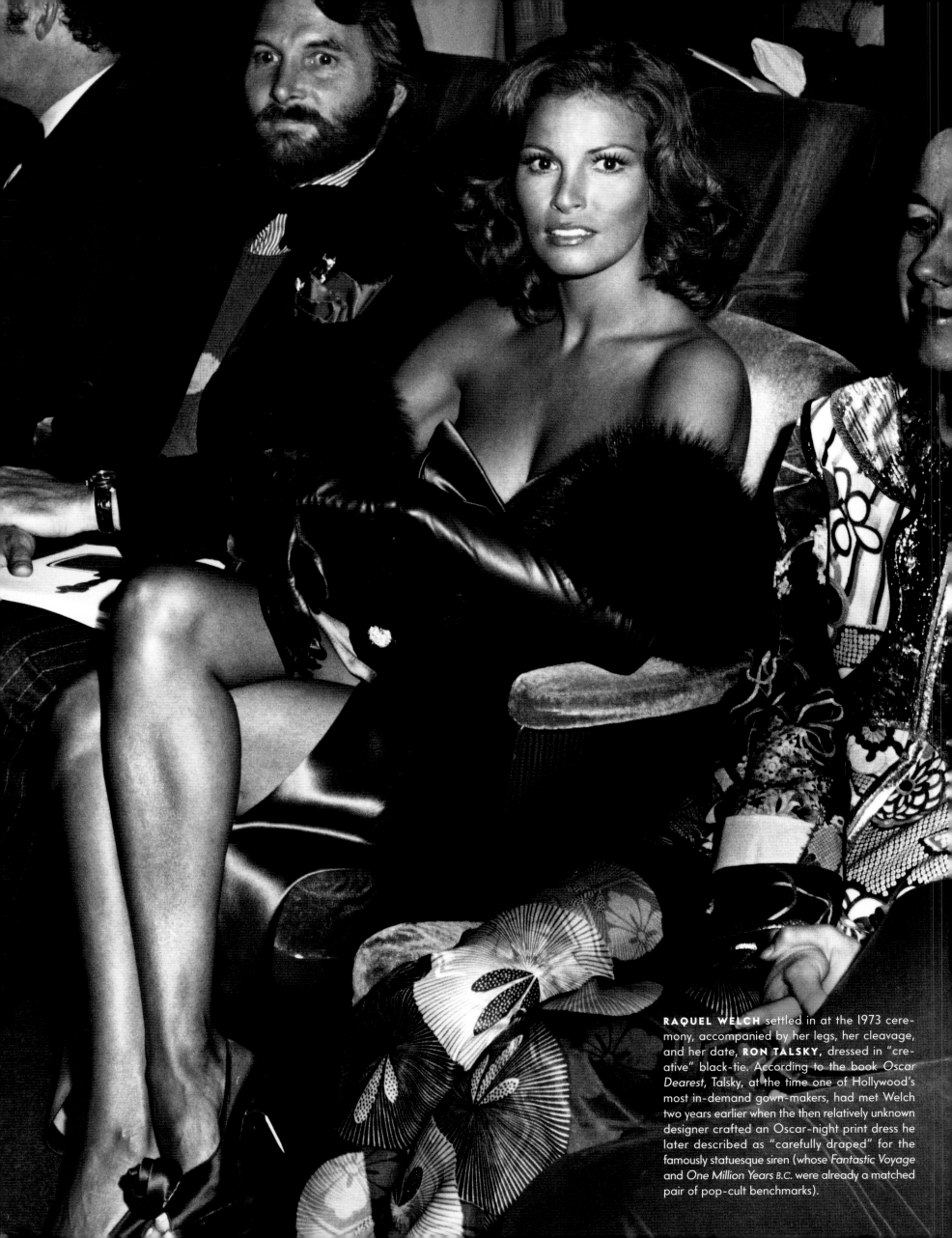

RAQUEL WELCH settled in at the 1973 cere-mony, accompanied by her legs, her cleavage, and her date, RON TALSKY, dressed in "cre-ative" black-tie. According to the book *Oscar Dearest*, Talsky, at the time one of Hollywood's most in-demand gown-makers, had met Welch two years earlier when the then relatively unknown designer crafted an Oscar-night print dress he later described as "carefully draped" for the famously statuesque siren (whose *Fantastic Voyage* and *One Million Years B.C.* were already a matched pair of pop-cult benchmarks).

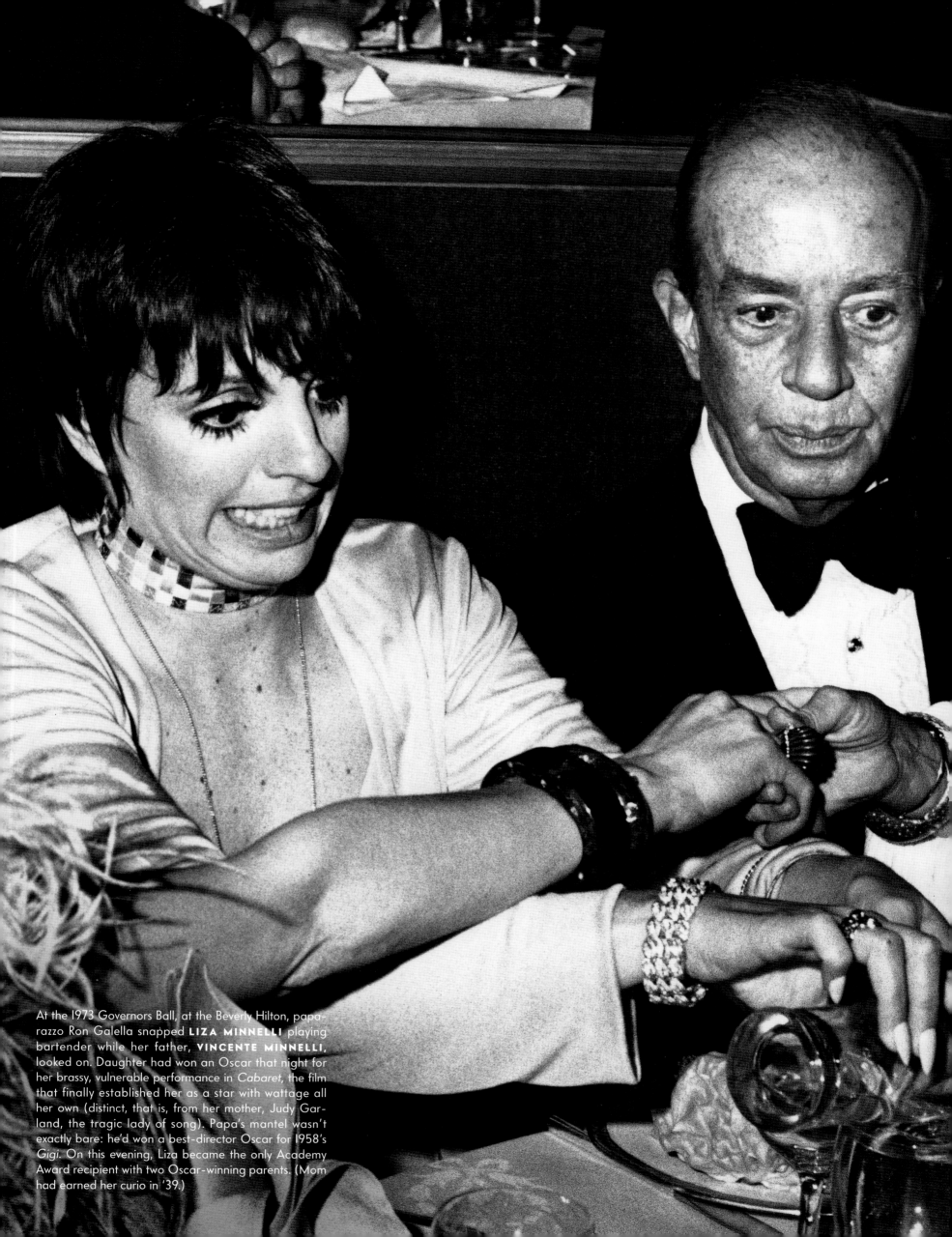

At the 1973 Governors Ball, at the Beverly Hilton, paparazzo Ron Galella snapped **LIZA MINNELLI** playing bartender while her father, **VINCENTE MINNELLI**, looked on. Daughter had won an Oscar that night for her brassy, vulnerable performance in *Cabaret*, the film that finally established her as a star with wattage all her own (distinct, that is, from her mother, Judy Garland, the tragic lady of song). Papa's mantel wasn't exactly bare: he'd won a best-director Oscar for 1958's *Gigi*. On this evening, Liza became the only Academy Award recipient with two Oscar-winning parents. (Mom had earned her curio in '39.)

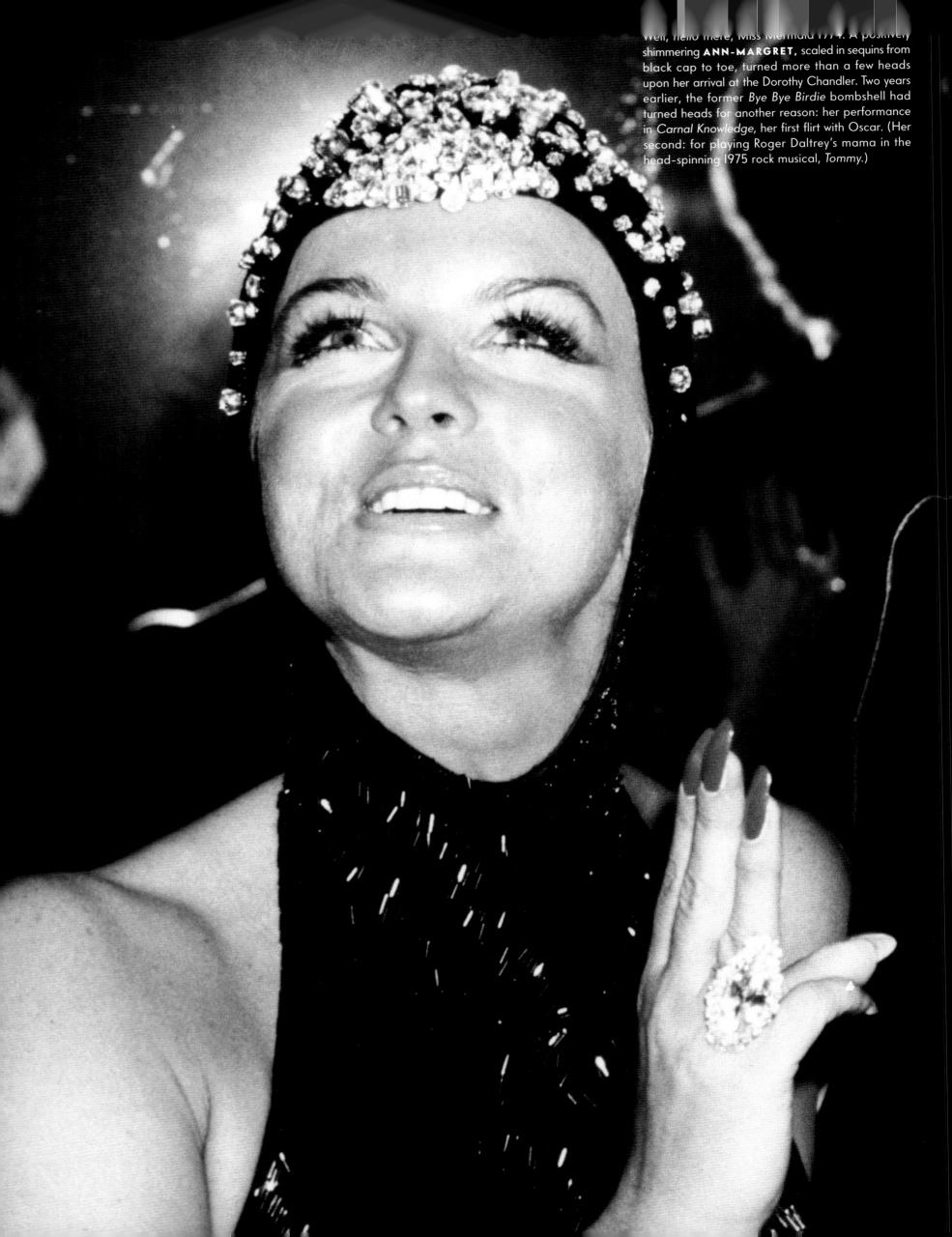

Well, *hello there*, Miss Mermaid 1974. A positively shimmering **ANN-MARGRET,** scaled in sequins from black cap to toe, turned more than a few heads upon her arrival at the Dorothy Chandler. Two years earlier, the former *Bye Bye Birdie* bombshell had turned heads for another reason: her performance in *Carnal Knowledge,* her first flirt with Oscar. (Her second: for playing Roger Daltrey's mama in the head-spinning 1975 rock musical, *Tommy.*)

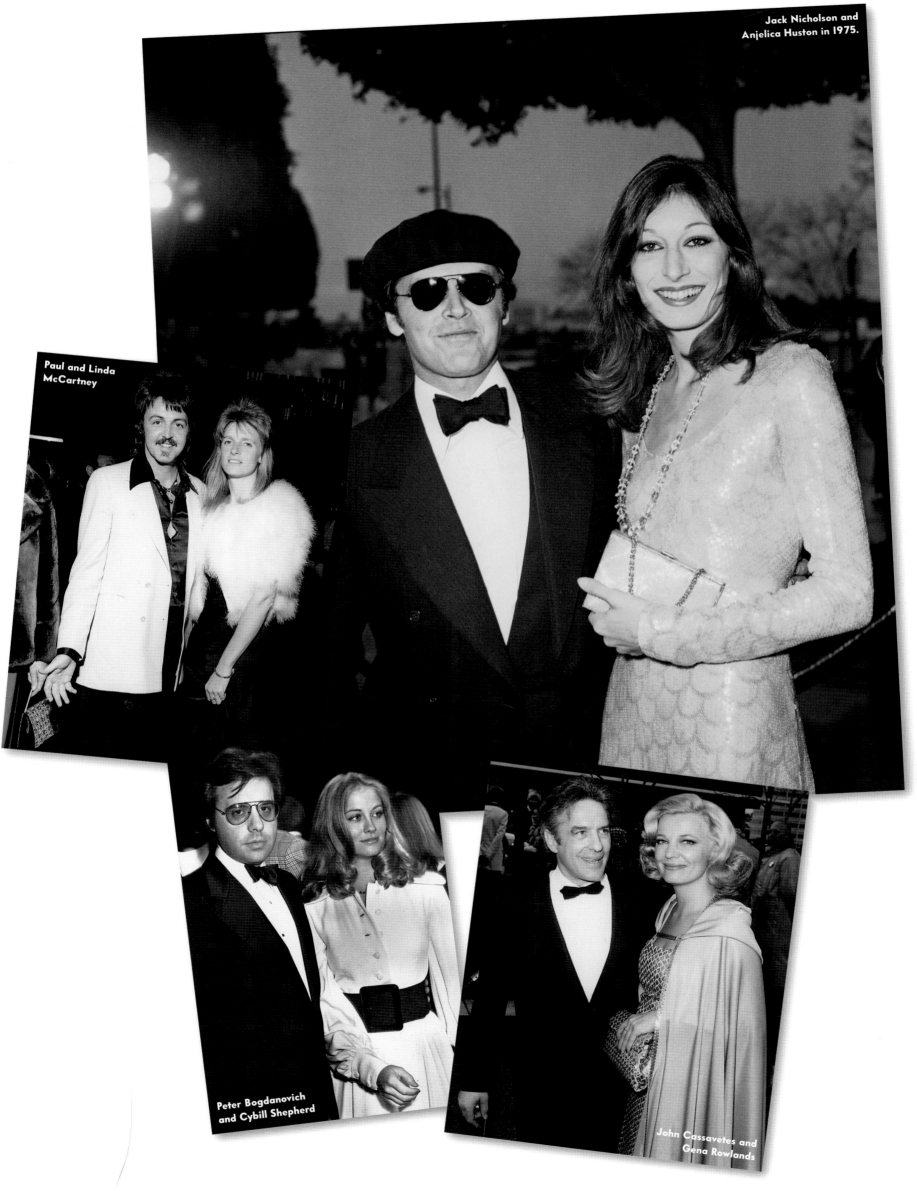

Jack Nicholson and Anjelica Huston in 1975.

Paul and Linda McCartney

Peter Bogdanovich and Cybill Shepherd

John Cassavetes and Gena Rowlands

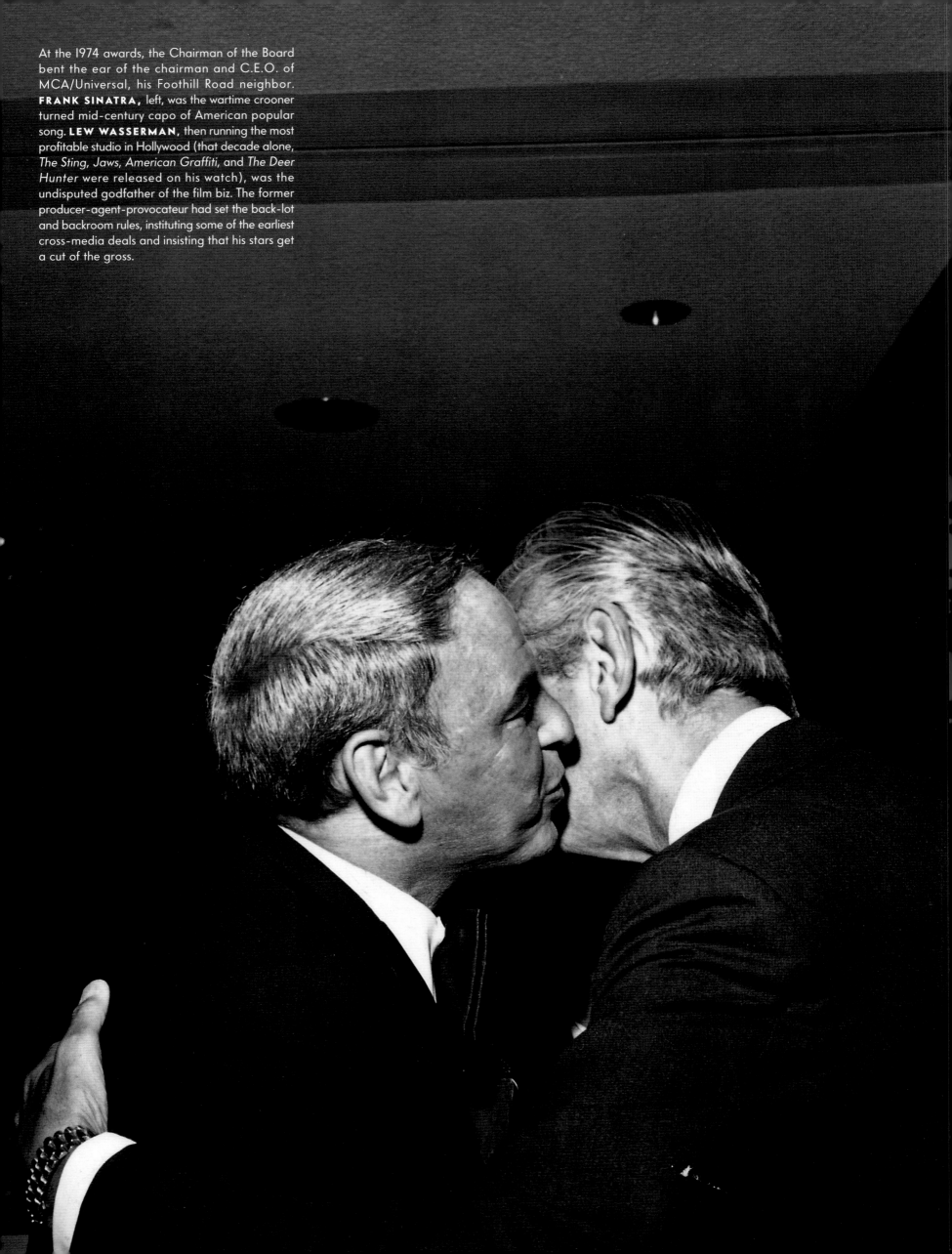

At the 1974 awards, the Chairman of the Board bent the ear of the chairman and C.E.O. of MCA/Universal, his Foothill Road neighbor. **FRANK SINATRA,** left, was the wartime crooner turned mid-century capo of American popular song. **LEW WASSERMAN,** then running the most profitable studio in Hollywood (that decade alone, *The Sting, Jaws, American Graffiti,* and *The Deer Hunter* were released on his watch), was the undisputed godfather of the film biz. The former producer-agent-provocateur had set the back-lot and backroom rules, instituting some of the earliest cross-media deals and insisting that his stars get a cut of the gross.

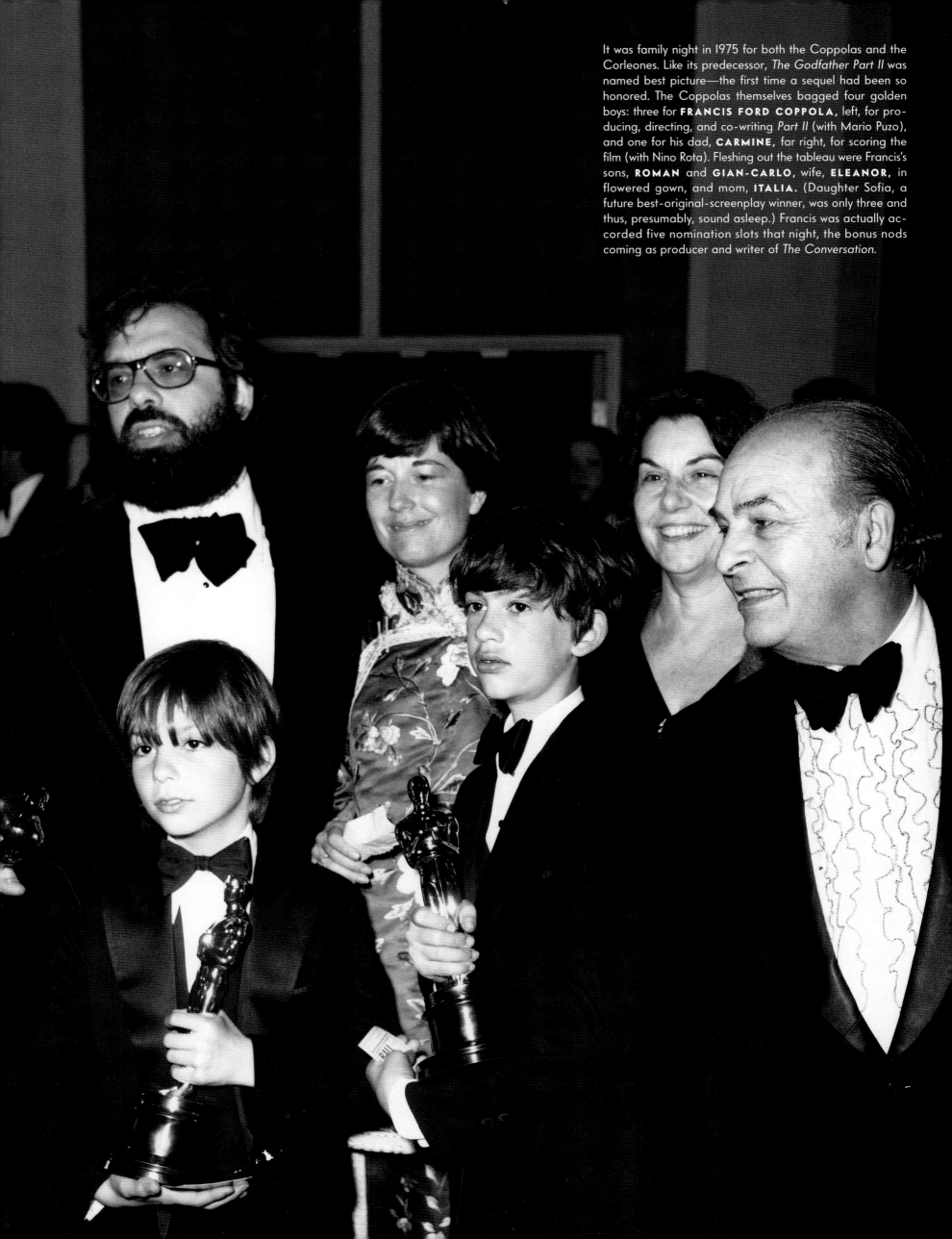

It was family night in 1975 for both the Coppolas and the Corleones. Like its predecessor, *The Godfather Part II* was named best picture—the first time a sequel had been so honored. The Coppolas themselves bagged four golden boys: three for **FRANCIS FORD COPPOLA**, left, for producing, directing, and co-writing *Part II* (with Mario Puzo), and one for his dad, **CARMINE**, far right, for scoring the film (with Nino Rota). Fleshing out the tableau were Francis's sons, **ROMAN** and **GIAN-CARLO**, wife, **ELEANOR**, in flowered gown, and mom, **ITALIA**. (Daughter Sofia, a future best-original-screenplay winner, was only three and thus, presumably, sound asleep.) Francis was actually accorded five nomination slots that night, the bonus nods coming as producer and writer of *The Conversation*.

SWIFTY'S

"I was at the first party at the Bistro," says Janet de Cordova, a Hollywood fixture and the widow of longtime *Tonight Show* producer Freddie de Cordova. She is referring to April 13, 1964, that pivotal night when one of her neighbors, literary agent and social whirligig Swifty Lazar, threw his first Oscar do. The setting was the Bistro restaurant, in Beverly Hills, opened two years before by director Billy Wilder and Kurt Niklas, the former maître d' at Romanoff's. The Bistro was a rather low-key locale when one considered that Swifty's soirée, in time, would become the must-attend affair in Tinseltown. "It wasn't particularly momentous," de Cordova says. "Forty people, upstairs. I remember the folding chairs were kind of arranged like in a movie theater. I can remember George Axelrod—he wrote *The Seven Year Itch*—and his wife. They had [artist] David Hockney with them."

Jimmy Murphy was there, too, that night. "Billy Wilder, the Jack Lemmons, Greg Peck, and two TVs [for watching the awards telecast]," recalls Murphy, then the Bistro's maître d'. "We served beef stew. Then another 30 or 40 people came when the show was over, people nominated or who had won Oscars. And then [Swifty would] order sandwiches from Nate 'n Al, the deli one street over [for the latecomers]. He didn't want to pay the extra that the Bistro would [have] cost him. He never liked to spend very much money. He felt if he brought celebrities he would bring publicity for the restaurant. Why pay?" From such inauspicious and chintzy kindling did Lazar's Oscar party eventually blaze.

If the first Bistro bashes were modest, the mythos surrounding them grew exponentially. In his book, *The Corner Table,* Niklas recalls Lazar bombastically insisting on having 400 that first night. "The crème de la crème," Lazar supposedly said to him. "No riffraff, no amateurs.... I don't want a bunch of wannabes and has-beens.... I want it strictly class—black tie and gowns." Whatever the party's initial pedigree, its guest list became more stellar with the years—an amalgam of moguls and socialites, Lazar's pals and clients, along with Oscar-toting newcomers. Swifty's, in fact, was a movable feast. He switched to the Bistro Garden, put in a cameo at New York's Tavern on the Green in the late 70s, and in 1985 settled at Wolfgang Puck's Spago. Thereafter, Swifty and Spago (with its lox-cream-cheese-and-caviar-laden pizzas) became Hollywood icons in their own right. And every year on Oscar night, flocks of gawkers and paparazzi would make their way to Sunset Boulevard to crane their necks at, and train their lenses on, the stars shooting past.

Amid the colored balloons, five-pointed-star decals, and walls bedecked with film posters, Hollywood's royalty would watch the ceremony on TV screens, holding its collective tongue as Lazar prowled the crowd. "We were there to see and hear the show," recalls Angie Dickinson. Many attendees, however, had come "to be seen," she says. "Irving would go around telling tables to shut up, 'We can't hear, goddammit,' and they would have to, because he was relentless about it." (After a sit-down dinner, two more shifts of invitees would arrive for the revelry: those who had come straight from the awards and those who had attended the Governors Ball.)

"Swifty's party was half high society and half Old Guard Hollywood," says *Vanity Fair*'s Bob Colacello. "Billy and Chessy Rayner. Anne and Kirk Douglas. Jack and Mary Benny. The Erteguns would come from New York. Jimmy and Gloria [Stewart], Gregory and Veronique Peck. It's like any party where it's *the* party to be. Everyone felt special because they'd made the cut. It was very glamorous, but crowded. And the women all wore big jewelry."

Opposite, illustrator Robert Risko's interpretation of Oscar knight **IRVING "SWIFTY" LAZAR.** *Above,* the original **BISTRO,** site of Lazar's first Academy Awards engagement.

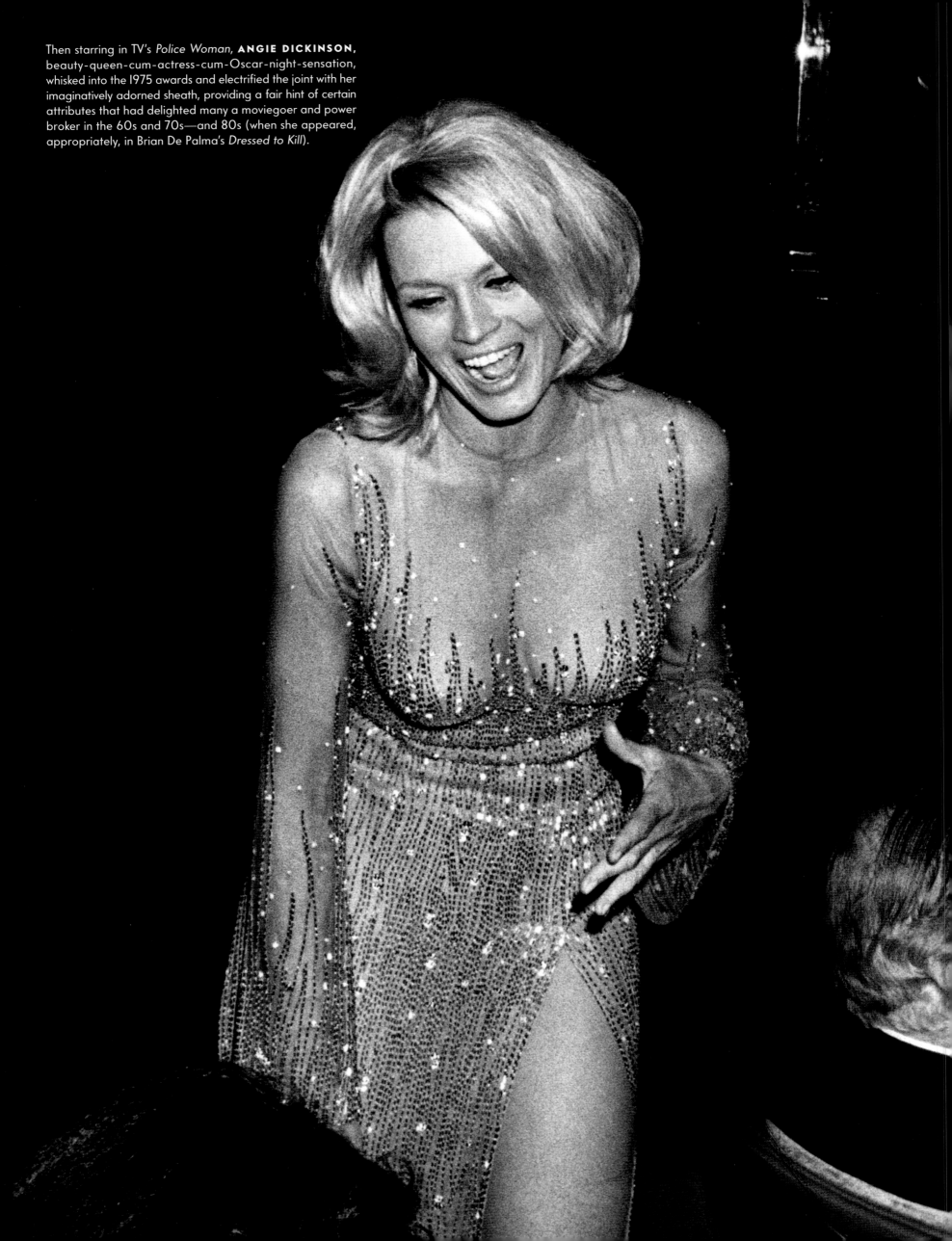

Then starring in TV's *Police Woman*, **ANGIE DICKINSON**, beauty-queen-cum-actress-cum-Oscar-night-sensation, whisked into the 1975 awards and electrified the joint with her imaginatively adorned sheath, providing a fair hint of certain attributes that had delighted many a moviegoer and power broker in the 60s and 70s—and 80s (when she appeared, appropriately, in Brian De Palma's *Dressed to Kill*).

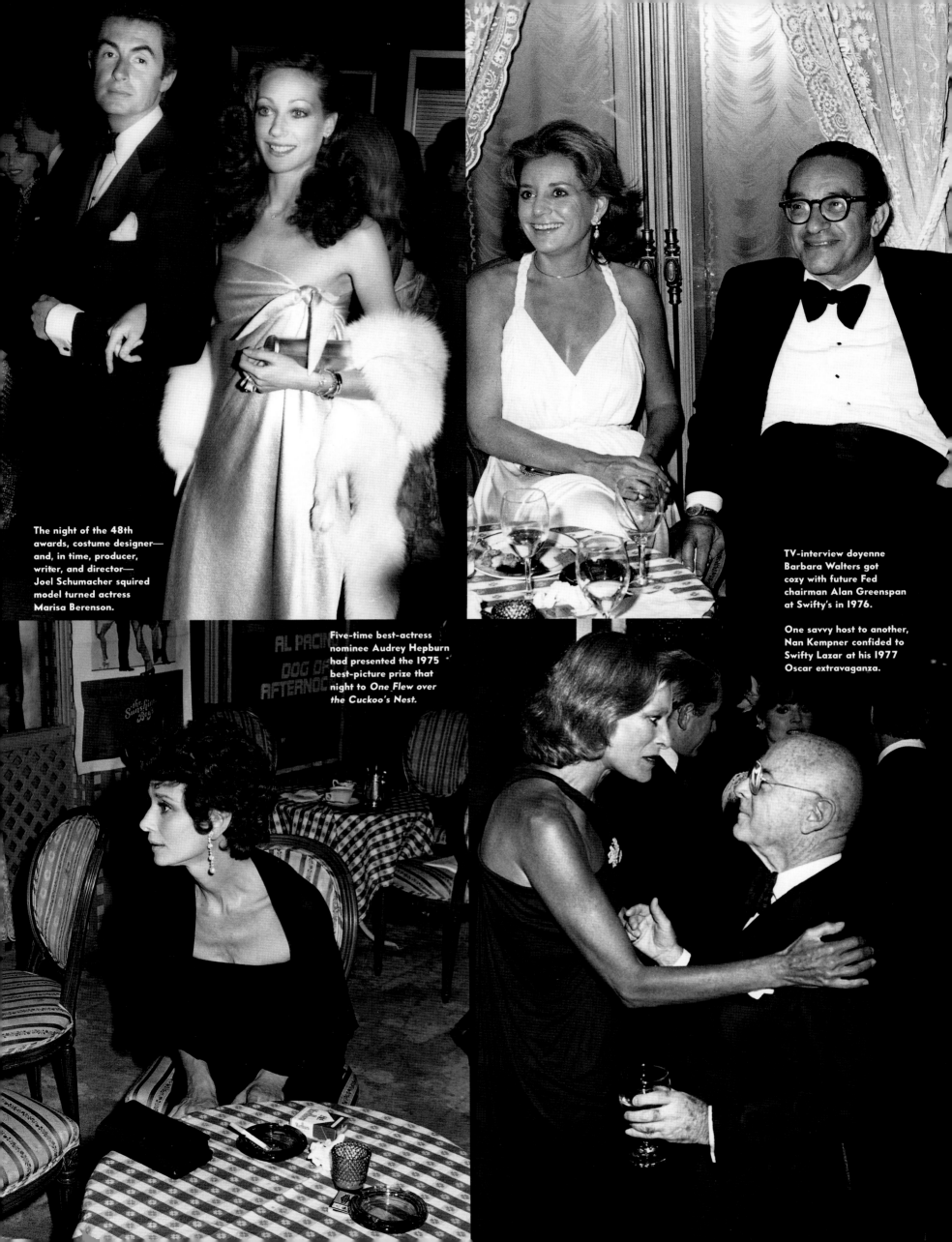

The night of the 48th awards, costume designer—and, in time, producer, writer, and director—Joel Schumacher squired model turned actress Marisa Berenson.

TV-interview doyenne Barbara Walters got cozy with future Fed chairman Alan Greenspan at Swifty's in 1976.

Five-time best-actress nominee Audrey Hepburn had presented the 1975 best-picture prize that night to *One Flew over the Cuckoo's Nest*.

One savvy host to another, Nan Kempner confided to Swifty Lazar at his 1977 Oscar extravaganza.

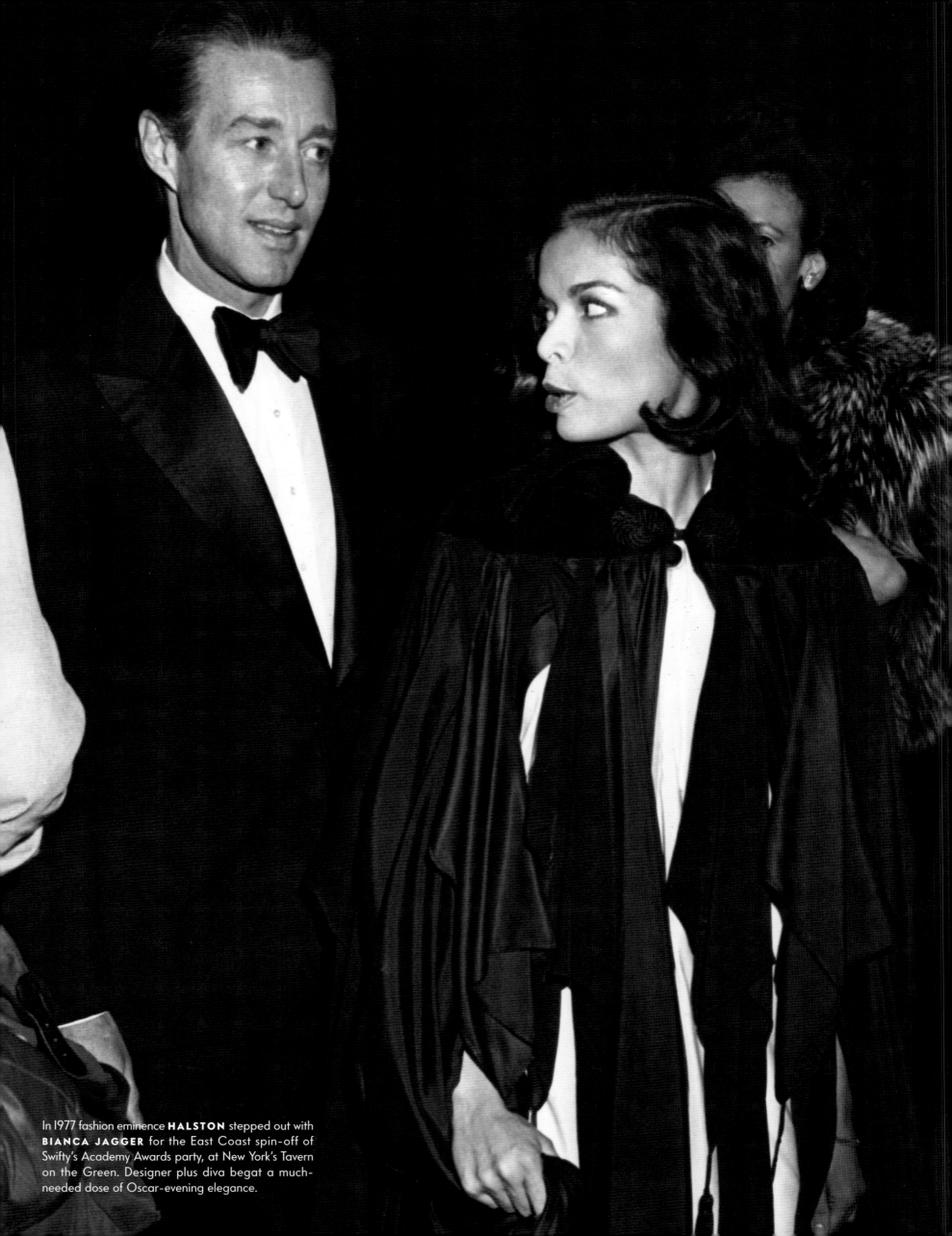

In 1977 fashion eminence **HALSTON** stepped out with **BIANCA JAGGER** for the East Coast spin-off of Swifty's Academy Awards party, at New York's Tavern on the Green. Designer plus diva begat a much-needed dose of Oscar-evening elegance.

"The first year Michael Jackson showed up, he had to hide in the ladies room because so many superstars were bugging him for autographs. Marvin Davis, the billionaire, was miffed when I told him to park his bodyguards outside. Director Michael Cimino insisted that he be served Cristal champagne, so I asked him if that's what he drank at home; when he admitted he didn't, I threw him out.

None of that annoys me as much as the people who think it's their right to come to my Oscar party and won't take no for an answer. One year, Michael Ovitz, who is a friend of mine and always gets invited, called me on behalf of some big-shot producer and asked why I wasn't including him.

'Because he's a bore,' I said. 'And boredom, in my view, must be avoided at all cost. I'm telling you, Mike, boredom is the single greatest threat to my continued existence.' . . .

I much prefer Ovitz's direct and businesslike approach to that of the movers and shakers who just show up uninvited. I remember one who not only crashed but compounded his rudeness by arriving at my black-tie party in an open-necked shirt and no jacket. . . .

'How would you like it if I just appeared at your house and announced, "Hi, I'm here for dinner"?'

'I hadn't thought of it that way.'

'Well, why don't you?' I snapped. 'And while you're at it, why don't you leave?'

What outsiders just don't understand about this party is that I go way back with almost everybody there. Jimmy Stewart, Gene Kelly, Kirk Douglas . . . I've known all of them for decades, and some for half a century. Michael Douglas, Liza Minnelli, Anjelica Huston, Richard Zanuck—I met them when they were kids. Seeing them arrive at Spago with their Oscars, I feel almost like a parent. And I'm reminded of the long sweep of my own life."

—IRVING LAZAR
SWIFTY: MY LIFE AND GOOD TIMES

It was all about the mix then too. **CHESSY RAYNER,** *above* (with husband William Rayner), and **LEE RADZIWILL,** *left* (beside Swifty Lazar and Barry Diller), were both style icons of exceptionally good breeding. They lent further high-society flair to Lazar's 1977 fling.

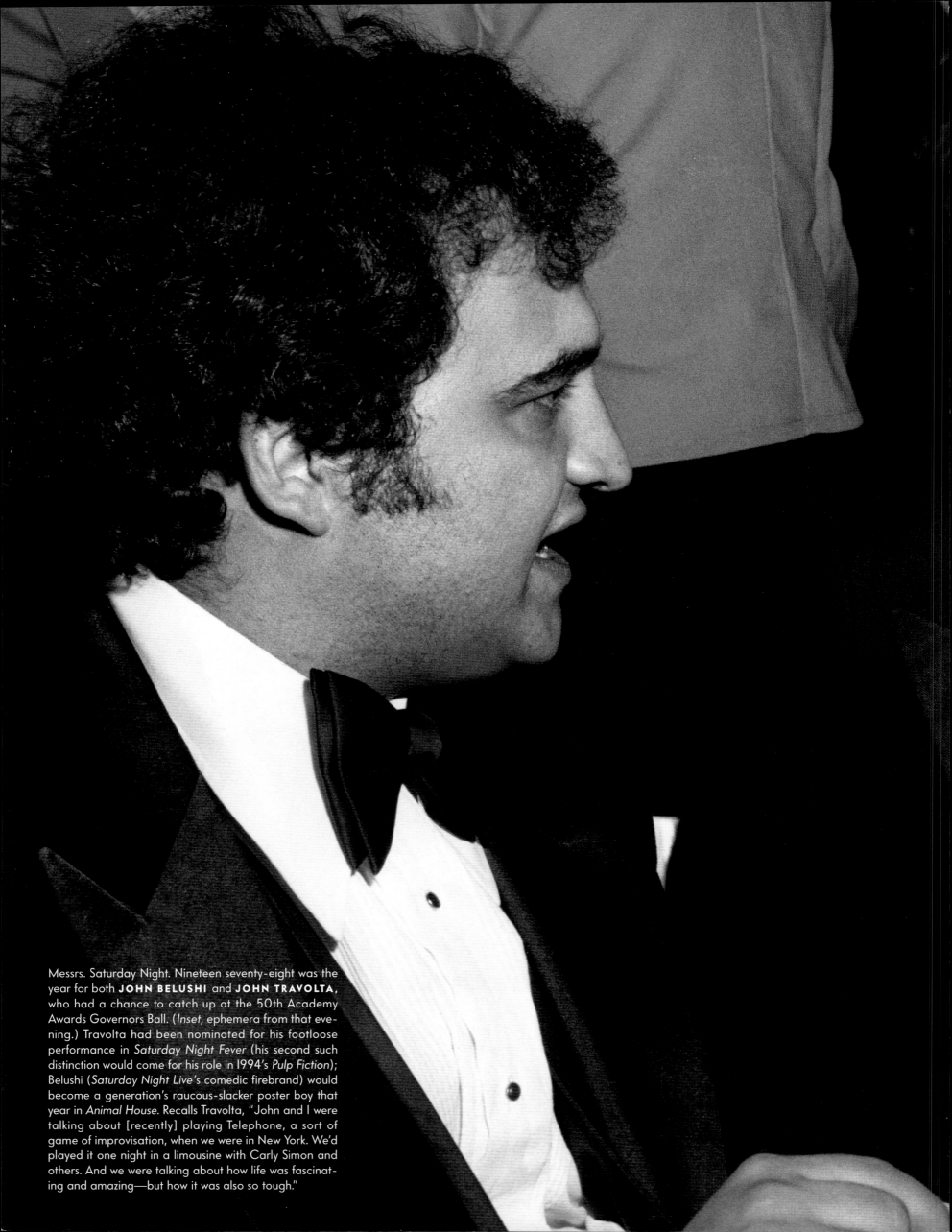

Messrs. Saturday Night. Nineteen seventy-eight was the year for both **JOHN BELUSHI** and **JOHN TRAVOLTA**, who had a chance to catch up at the 50th Academy Awards Governors Ball. (*Inset*, ephemera from that evening.) Travolta had been nominated for his footloose performance in *Saturday Night Fever* (his second such distinction would come for his role in 1994's *Pulp Fiction*); Belushi (*Saturday Night Live*'s comedic firebrand) would become a generation's raucous-slacker poster boy that year in *Animal House*. Recalls Travolta, "John and I were talking about [recently] playing Telephone, a sort of game of improvisation, when we were in New York. We'd played it one night in a limousine with Carly Simon and others. And we were talking about how life was fascinating and amazing—but how it was also so tough."

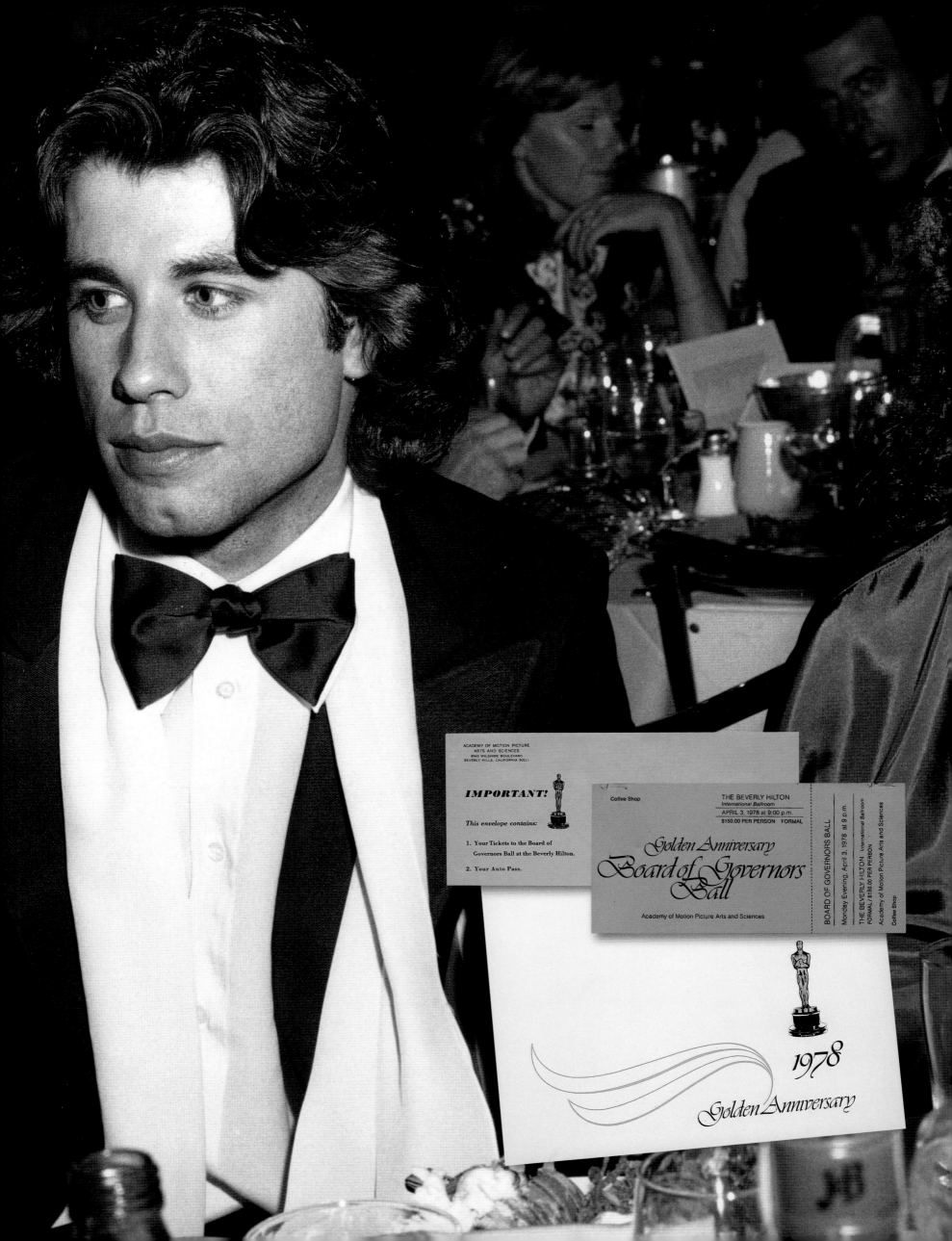

ACADEMY OF MOTION PICTURE
ARTS AND SCIENCES
8949 WILSHIRE BOULEVARD
BEVERLY HILLS, CALIFORNIA 90211

IMPORTANT!

This envelope contains:

1. Your Tickets to the Board of
 Governors Ball at the Beverly Hilton.

2. Your Auto Pass.

Coffee Shop

THE BEVERLY HILTON
International Ballroom
APRIL 3, 1978 at 9:00 p.m.
$150.00 PER PERSON FORMAL

Golden Anniversary
Board of Governors
Ball

Academy of Motion Picture Arts and Sciences

1978

Golden Anniversary

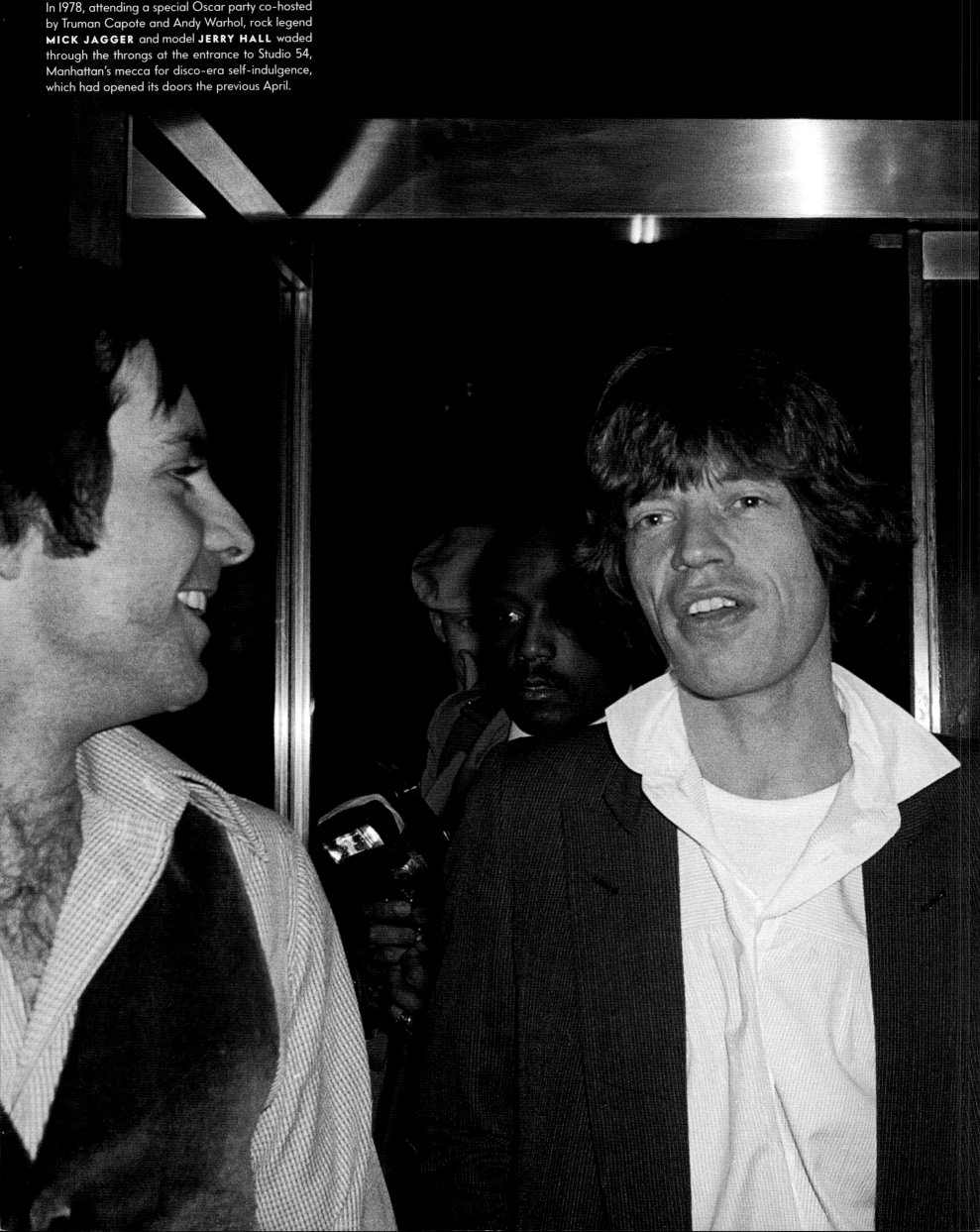

In 1978, attending a special Oscar party co-hosted by Truman Capote and Andy Warhol, rock legend **MICK JAGGER** and model **JERRY HALL** waded through the throngs at the entrance to Studio 54, Manhattan's mecca for disco-era self-indulgence, which had opened its doors the previous April.

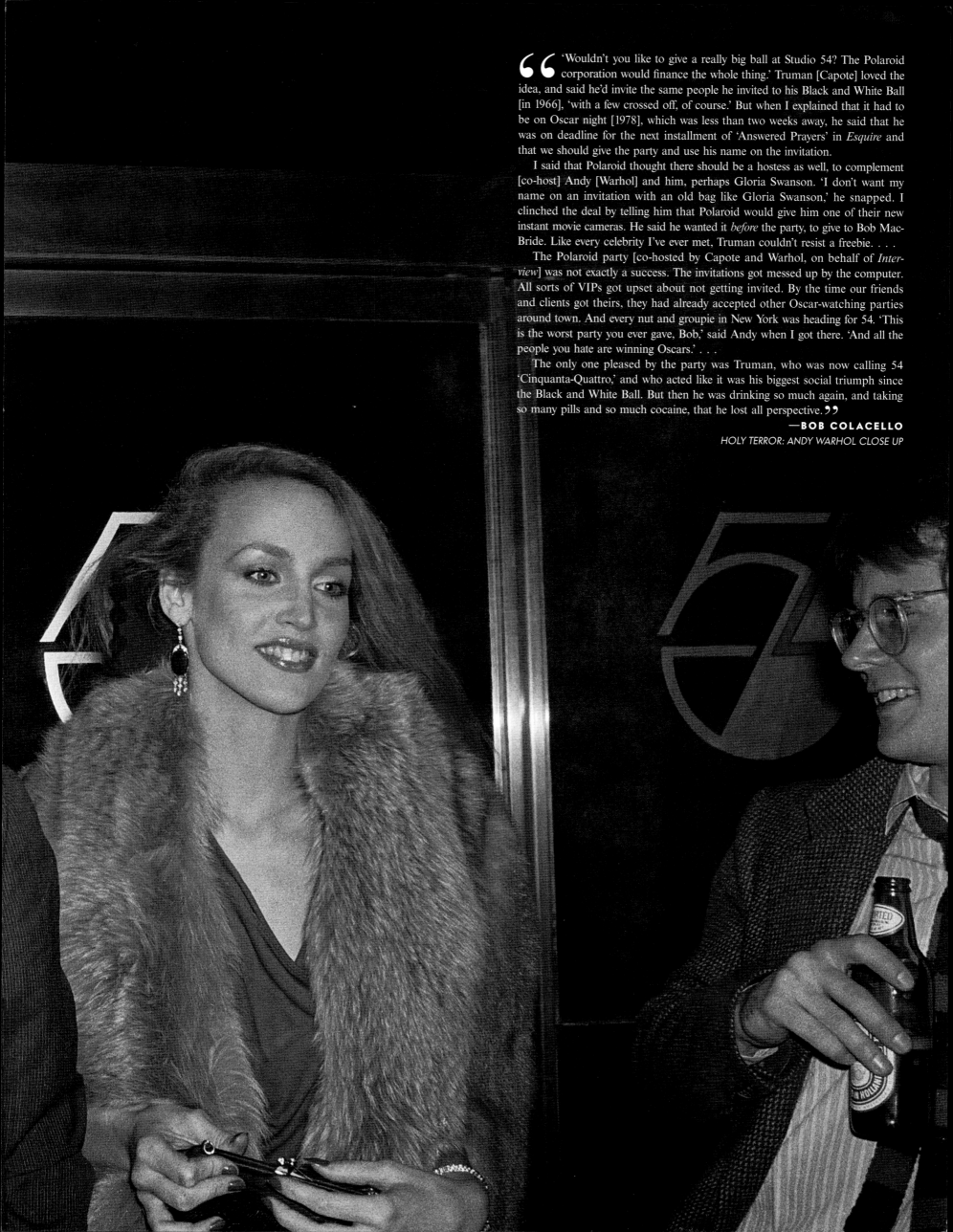

" 'Wouldn't you like to give a really big ball at Studio 54? The Polaroid corporation would finance the whole thing.' Truman [Capote] loved the idea, and said he'd invite the same people he invited to his Black and White Ball [in 1966], 'with a few crossed off, of course.' But when I explained that it had to be on Oscar night [1978], which was less than two weeks away, he said that he was on deadline for the next installment of 'Answered Prayers' in *Esquire* and that we should give the party and use his name on the invitation.

I said that Polaroid thought there should be a hostess as well, to complement [co-host] Andy [Warhol] and him, perhaps Gloria Swanson. 'I don't want my name on an invitation with an old bag like Gloria Swanson,' he snapped. I clinched the deal by telling him that Polaroid would give him one of their new instant movie cameras. He said he wanted it *before* the party, to give to Bob Mac-Bride. Like every celebrity I've ever met, Truman couldn't resist a freebie. . . .

The Polaroid party [co-hosted by Capote and Warhol, on behalf of *Interview*] was not exactly a success. The invitations got messed up by the computer. All sorts of VIPs got upset about not getting invited. By the time our friends and clients got theirs, they had already accepted other Oscar-watching parties around town. And every nut and groupie in New York was heading for 54. 'This is the worst party you ever gave, Bob,' said Andy when I got there. 'And all the people you hate are winning Oscars.' . . .

The only one pleased by the party was Truman, who was now calling 54 'Cinquanta-Quattro,' and who acted like it was his biggest social triumph since the Black and White Ball. But then he was drinking so much again, and taking so many pills and so much cocaine, that he lost all perspective. "

—**BOB COLACELLO**
HOLY TERROR: ANDY WARHOL CLOSE UP

RUMPUS ROOM In 1979, the Oscar telecast brought the New Yorkers at Steve Rubell and Ian Schrager's Studio 54 viewing party to their knees. That night's top honors went to *The Deer Hunter*, for best picture, and to Jon Voight and Jane Fonda, who would take home his-and-her best-acting awards for their performances in *Coming Home*. (Fonda, who had already won the 1971 statue for *Klute*, has since fielded six more nominations.)

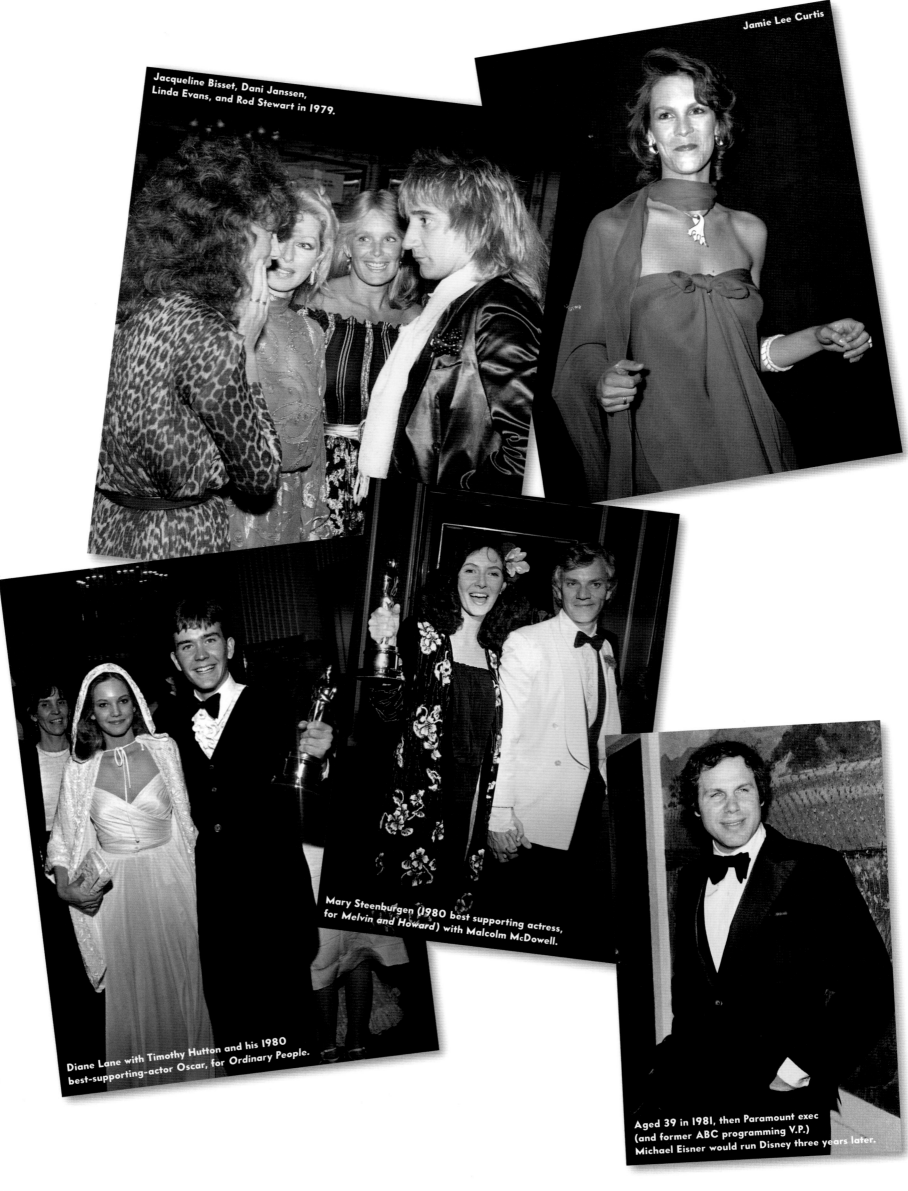

Jacqueline Bisset, Dani Janssen, Linda Evans, and Rod Stewart in 1979.

Jamie Lee Curtis

Mary Steenburgen (1980 best supporting actress, for *Melvin and Howard*) with Malcolm McDowell.

Diane Lane with Timothy Hutton and his 1980 best-supporting-actor Oscar, for *Ordinary People*.

Aged 39 in 1981, then Paramount exec (and former ABC programming V.P.) Michael Eisner would run Disney three years later.

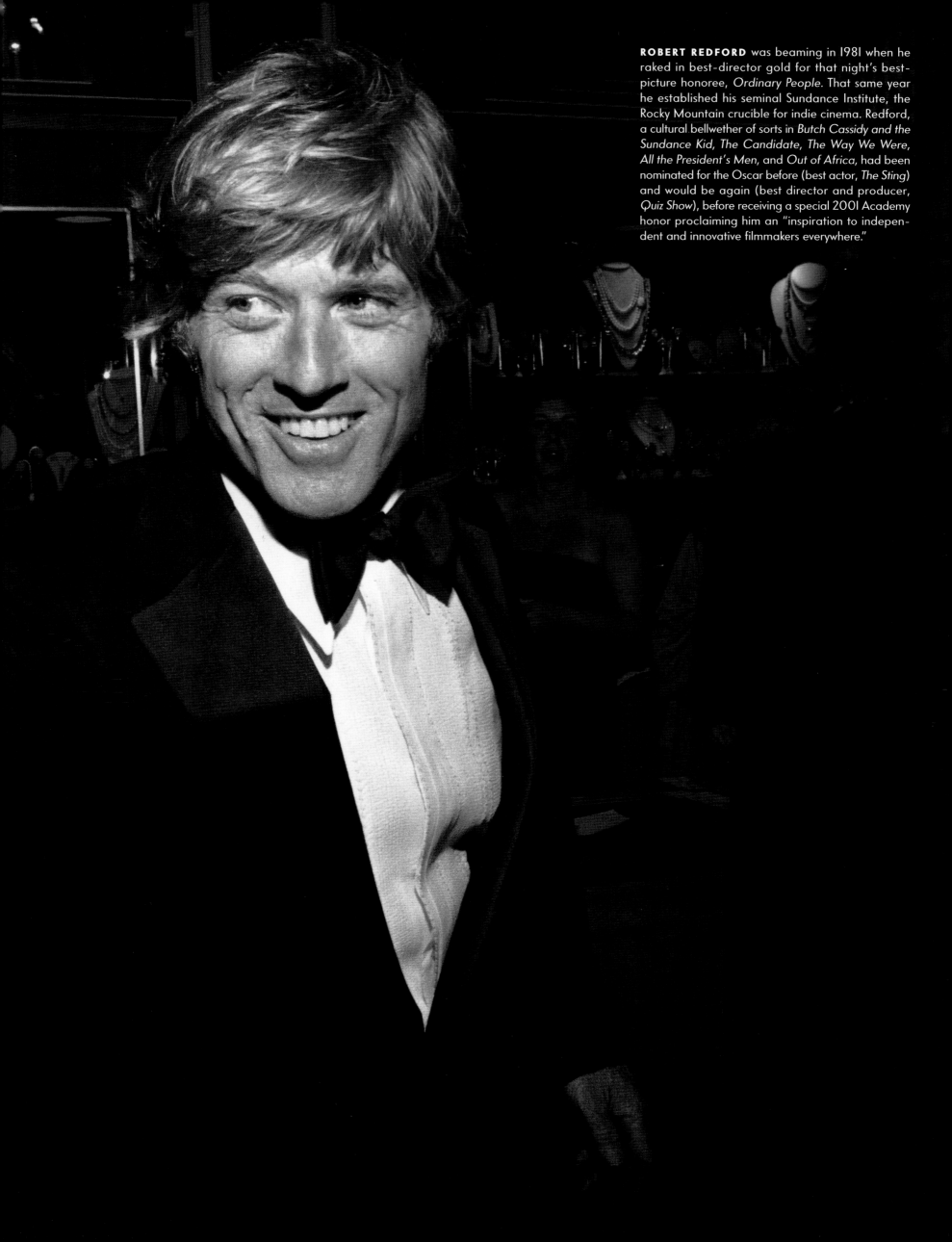

ROBERT REDFORD was beaming in 1981 when he raked in best-director gold for that night's best-picture honoree, *Ordinary People.* That same year he established his seminal Sundance Institute, the Rocky Mountain crucible for indie cinema. Redford, a cultural bellwether of sorts in *Butch Cassidy and the Sundance Kid, The Candidate, The Way We Were, All the President's Men,* and *Out of Africa,* had been nominated for the Oscar before (best actor, *The Sting*) and would be again (best director and producer, *Quiz Show*), before receiving a special 2001 Academy honor proclaiming him an "inspiration to independent and innovative filmmakers everywhere."

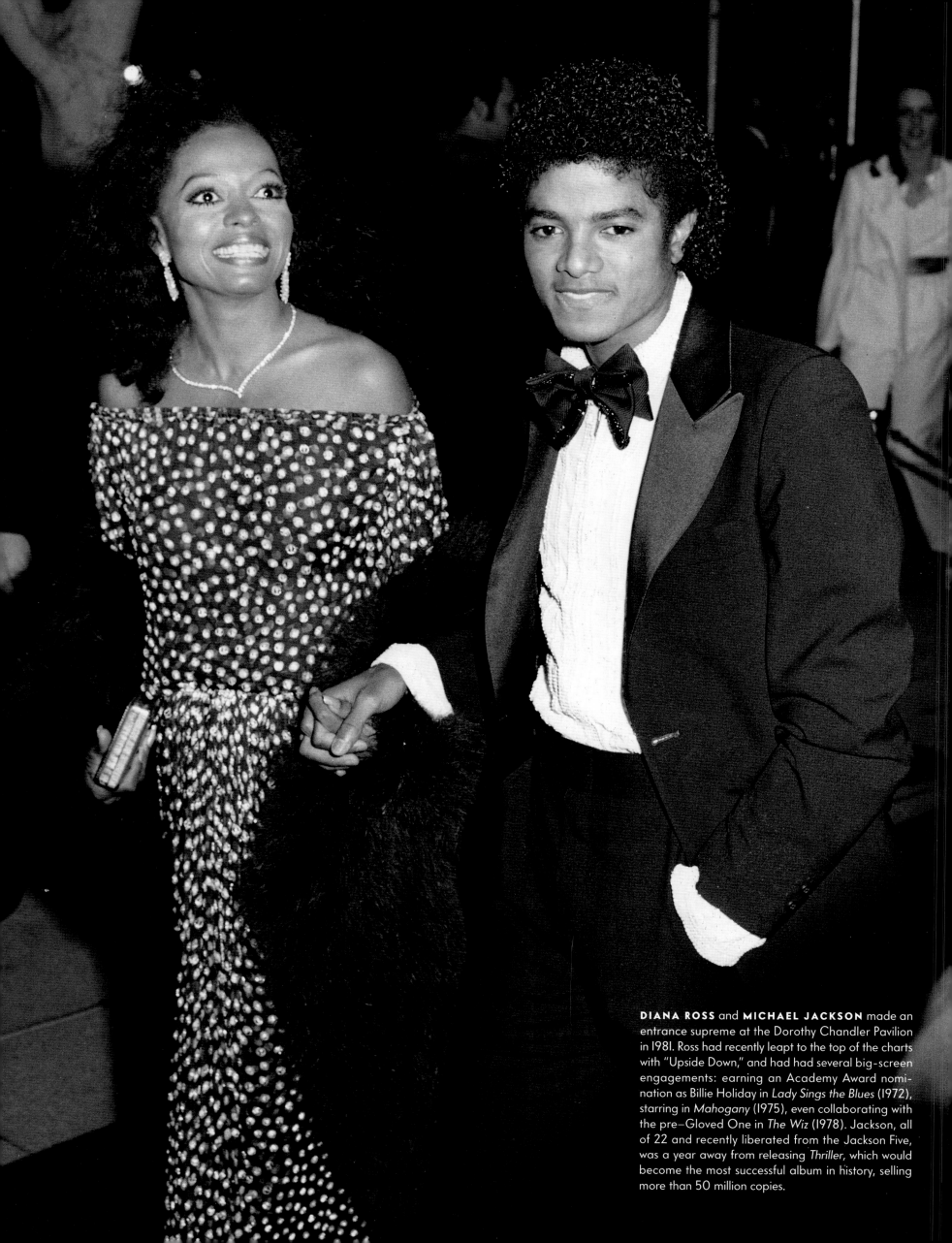

DIANA ROSS and **MICHAEL JACKSON** made an entrance supreme at the Dorothy Chandler Pavilion in 1981. Ross had recently leapt to the top of the charts with "Upside Down," and had had several big-screen engagements: earning an Academy Award nomination as Billie Holiday in *Lady Sings the Blues* (1972), starring in *Mahogany* (1975), even collaborating with the pre–Gloved One in *The Wiz* (1978). Jackson, all of 22 and recently liberated from the Jackson Five, was a year away from releasing *Thriller,* which would become the most successful album in history, selling more than 50 million copies.

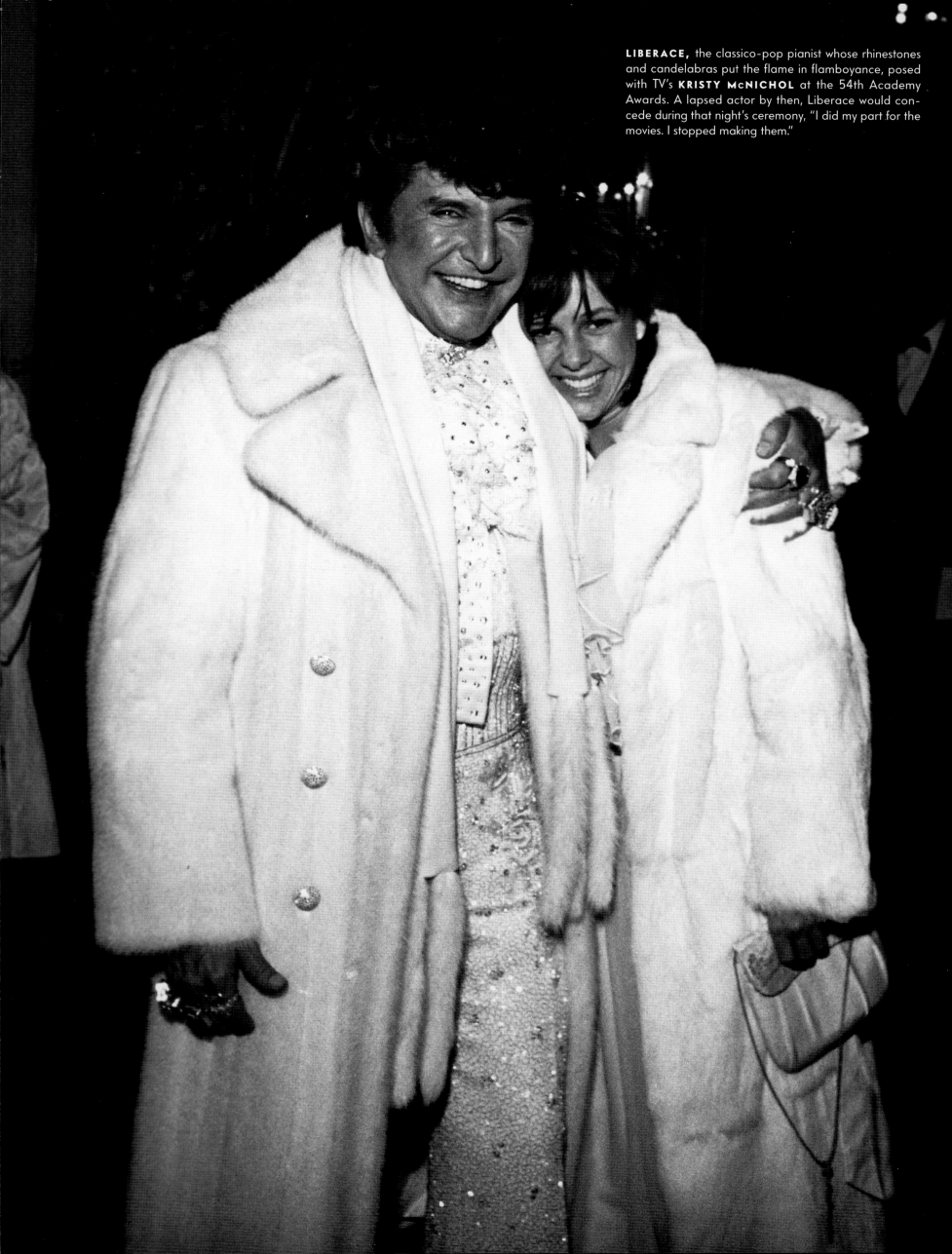

LIBERACE, the classico-pop pianist whose rhinestones and candelabras put the flame in flamboyance, posed with TV's **KRISTY McNICHOL** at the 54th Academy Awards. A lapsed actor by then, Liberace would concede during that night's ceremony, "I did my part for the movies. I stopped making them."

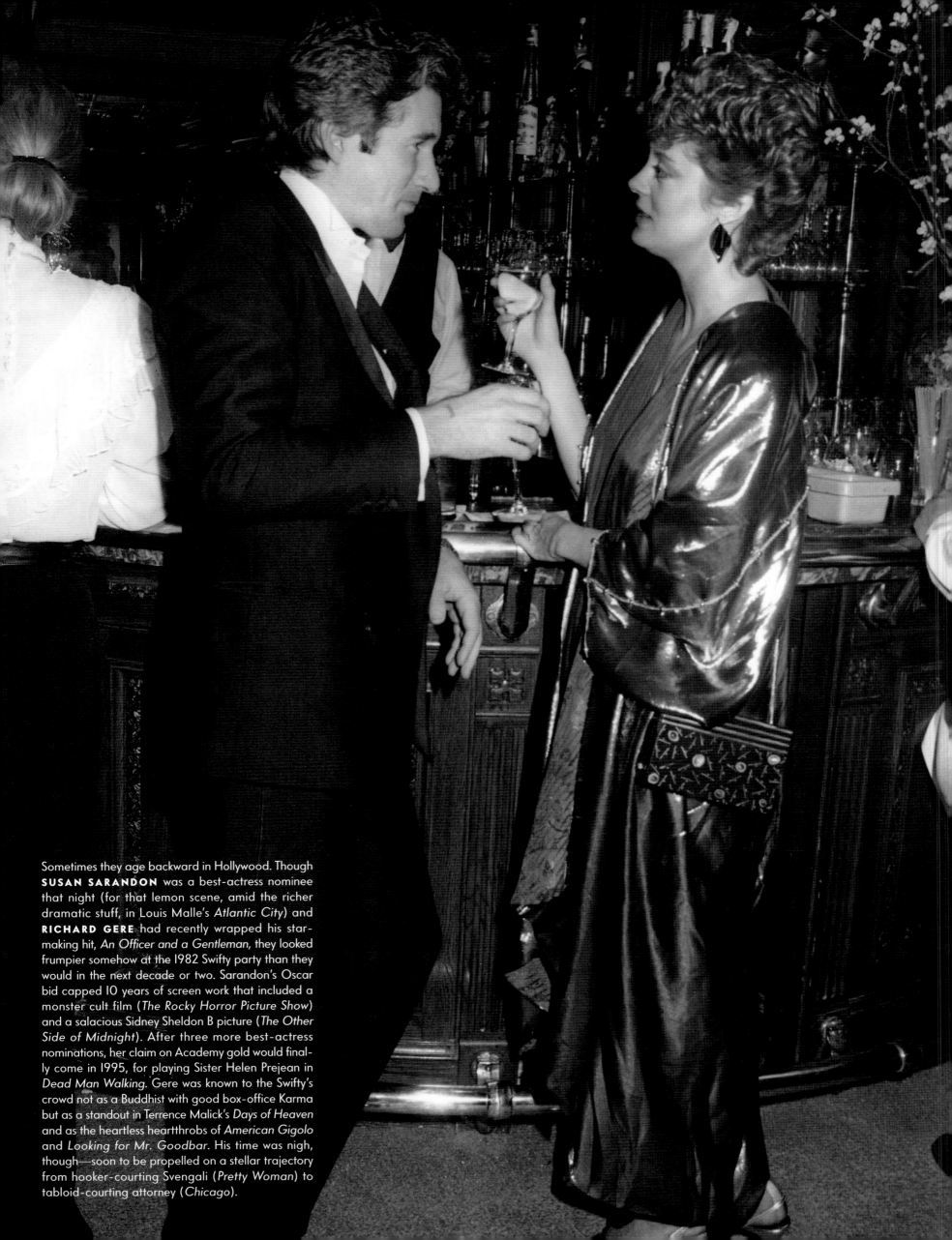

Sometimes they age backward in Hollywood. Though **SUSAN SARANDON** was a best-actress nominee that night (for that lemon scene, amid the richer dramatic stuff, in Louis Malle's *Atlantic City*) and **RICHARD GERE** had recently wrapped his star-making hit, *An Officer and a Gentleman,* they looked frumpier somehow at the 1982 Swifty party than they would in the next decade or two. Sarandon's Oscar bid capped 10 years of screen work that included a monster cult film (*The Rocky Horror Picture Show*) and a salacious Sidney Sheldon B picture (*The Other Side of Midnight*). After three more best-actress nominations, her claim on Academy gold would final-ly come in 1995, for playing Sister Helen Prejean in *Dead Man Walking.* Gere was known to the Swifty's crowd not as a Buddhist with good box-office Karma but as a standout in Terrence Malick's *Days of Heaven* and as the heartless heartthrobs of *American Gigolo* and *Looking for Mr. Goodbar.* His time was nigh, though—soon to be propelled on a stellar trajectory from hooker-courting Svengali (*Pretty Woman*) to tabloid-courting attorney (*Chicago*).

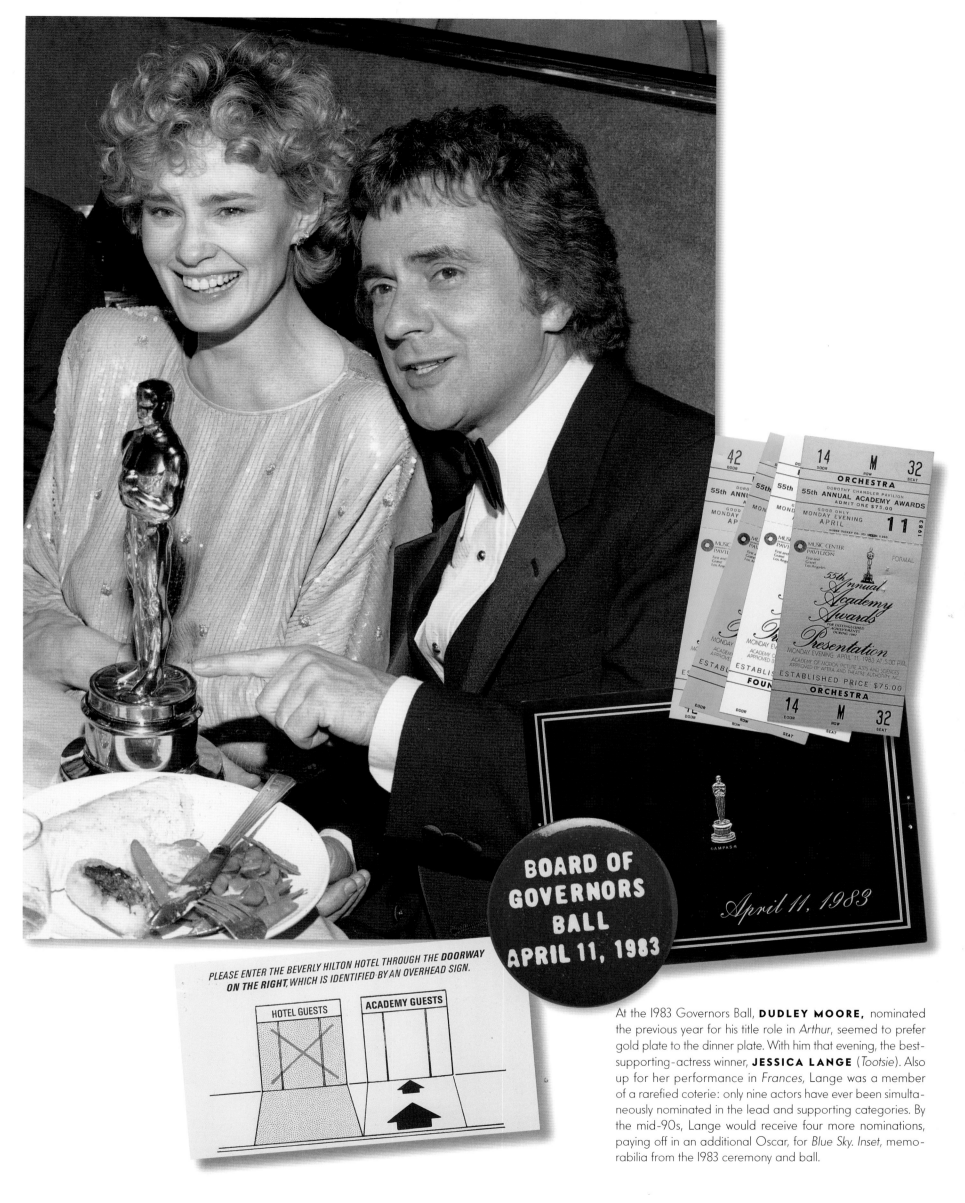

42 DOOR

14 M **32**
DOOR ROW SEAT

ORCHESTRA

DOROTHY CHANDLER PAVILION
55th ANNUAL ACADEMY AWARDS
ADMIT ONE $75.00
GOOD ONLY
MONDAY EVENING
APRIL
11
1983

MUSIC CENTER
PAVILION
First and Grand
Los Angeles

FORMAL

55th Annual
Academy
Awards
FOR DISTINGUISHED ACHIEVEMENT
DURING 1982
Presentation
MONDAY EVENING, APRIL 11, 1983 AT 5:30 P.M.
ACADEMY OF MOTION PICTURE ARTS AND SCIENCES
APPROVED BY AFTRA AND THEATRE AUTHORITY, INC.
ESTABLISHED PRICE $75.00

ORCHESTRA

14 M **32**
DOOR ROW SEAT

April 11, 1983

BOARD OF GOVERNORS BALL APRIL 11, 1983

PLEASE ENTER THE BEVERLY HILTON HOTEL THROUGH THE **DOORWAY ON THE RIGHT,** WHICH IS IDENTIFIED BY AN OVERHEAD SIGN.

HOTEL GUESTS | ACADEMY GUESTS

At the 1983 Governors Ball, **DUDLEY MOORE,** nominated the previous year for his title role in *Arthur*, seemed to prefer gold plate to the dinner plate. With him that evening, the best-supporting-actress winner, **JESSICA LANGE** (*Tootsie*). Also up for her performance in *Frances*, Lange was a member of a rarefied coterie: only nine actors have ever been simultaneously nominated in the lead and supporting categories. By the mid-90s, Lange would receive four more nominations, paying off in an additional Oscar, for *Blue Sky*. *Inset,* memorabilia from the 1983 ceremony and ball.

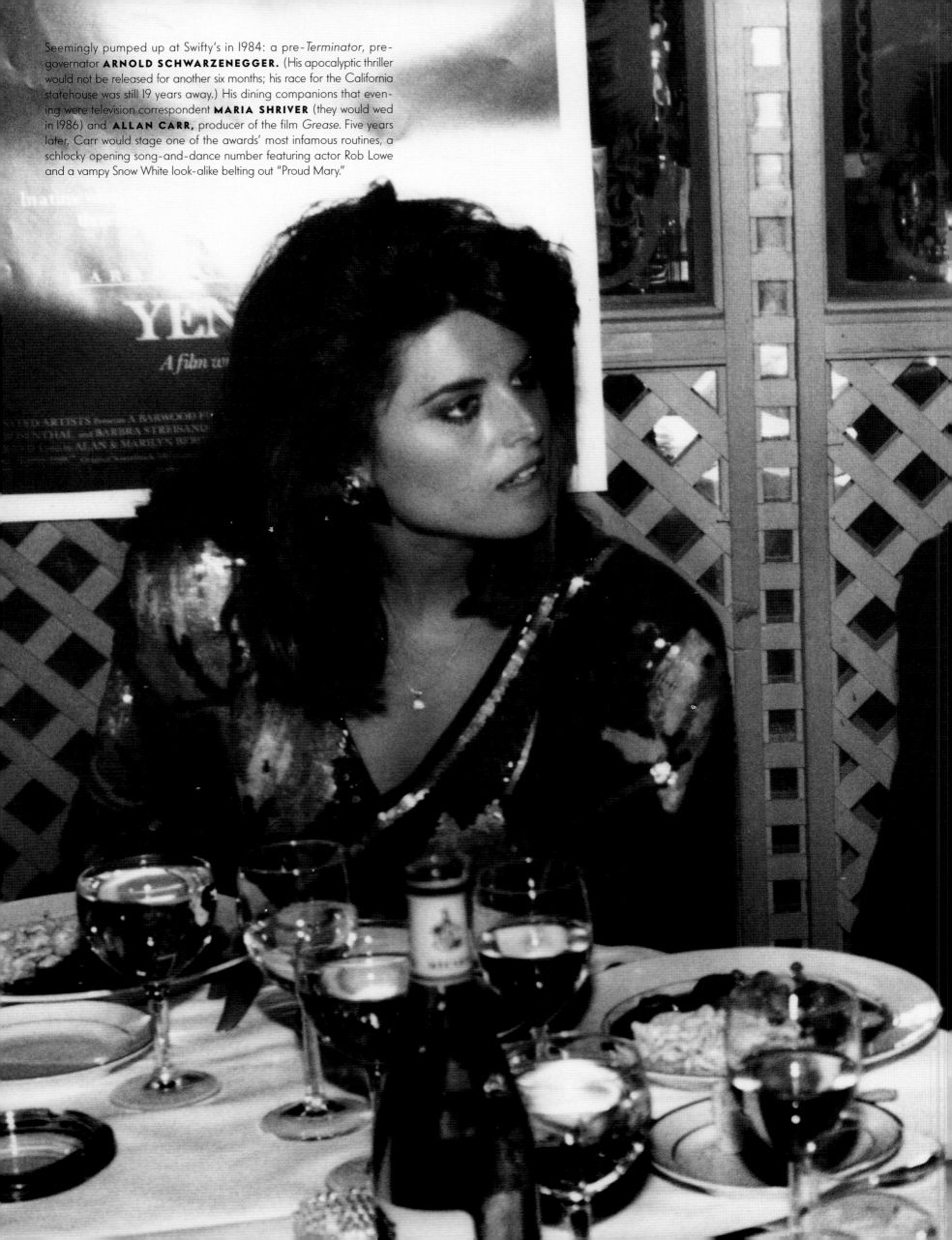

Seemingly pumped up at Swifty's in 1984: a pre-*Terminator*, pre-governator **ARNOLD SCHWARZENEGGER**. (His apocalyptic thriller would not be released for another six months; his race for the California statehouse was still 19 years away.) His dining companions that evening were television correspondent **MARIA SHRIVER** (they would wed in 1986) and **ALLAN CARR,** producer of the film *Grease*. Five years later, Carr would stage one of the awards' most infamous routines, a schlocky opening song-and-dance number featuring actor Rob Lowe and a vampy Snow White look-alike belting out "Proud Mary."

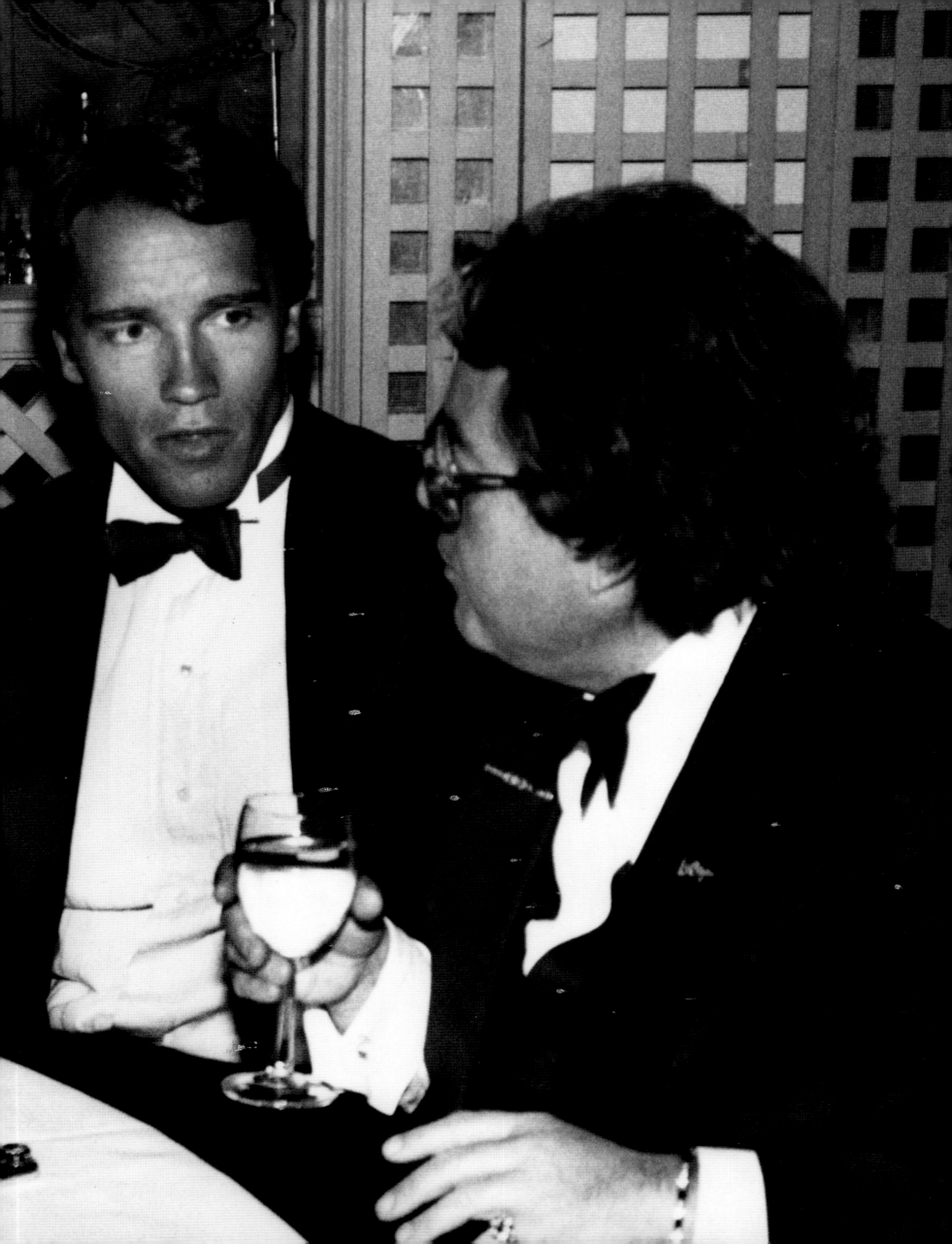

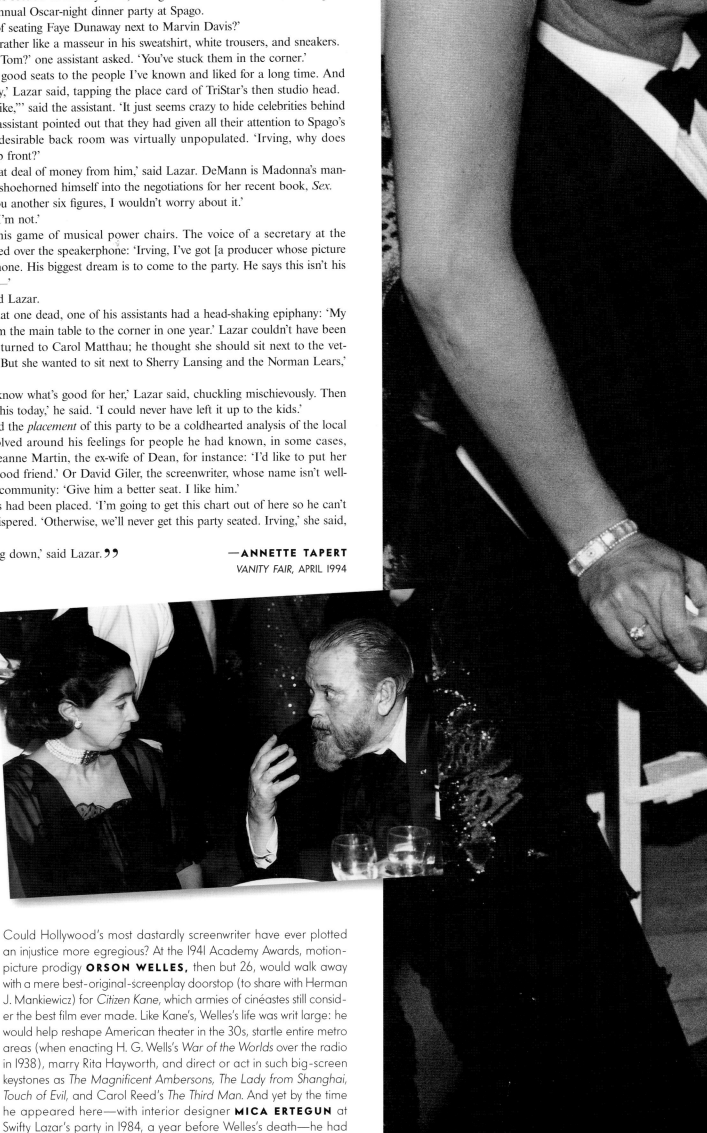

" It was March last year, the week before the Oscars. High above Sunset Boulevard, nestled in the Trousdale Estates section of Beverly Hills, Irving Paul Lazar and two assistants pondered the seating plan for his annual Oscar-night dinner party at Spago.

'Irving, what do you think of seating Faye Dunaway next to Marvin Davis?'

'Great,' said Lazar, looking rather like a masseur in his sweatshirt, white trousers, and sneakers.

'What about Roseanne and Tom?' one assistant asked. 'You've stuck them in the corner.'

'I don't care. I want to give good seats to the people I've known and liked for a long time. And I happen to like Mike Medavoy,' Lazar said, tapping the place card of TriStar's then studio head.

'It has nothing to do with "like,"' said the assistant. 'It just seems crazy to hide celebrities behind a wall.' Eager to move on, the assistant pointed out that they had given all their attention to Spago's front room, and that the less desirable back room was virtually unpopulated. 'Irving, why does Freddy DeMann have to be up front?'

'Because I just earned a great deal of money from him,' said Lazar. DeMann is Madonna's manager, and Lazar had profitably shoehorned himself into the negotiations for her recent book, *Sex*.

'Unless he's going to give you another six figures, I wouldn't worry about it.'

'You're young and fearless. I'm not.'

A phone call interrupted this game of musical power chairs. The voice of a secretary at the Irving Paul Lazar Agency blasted over the speakerphone: 'Irving, I've got [a producer whose picture was up for an Oscar] on the phone. His biggest dream is to come to the party. He says this isn't his first nomination. Ten years ago—'

'Tell him we're full,' snapped Lazar.

As Lazar finished cutting that one dead, one of his assistants had a head-shaking epiphany: 'My God, Dennis Hopper went from the main table to the corner in one year.' Lazar couldn't have been less concerned. His focus had turned to Carol Matthau; he thought she should sit next to the veteran screenwriter Ivan Moffat. 'But she wanted to sit next to Sherry Lansing and the Norman Lears,' the assistant noted gently.

'This is better. She doesn't know what's good for her,' Lazar said, chuckling mischievously. Then he turned to me. 'I had to do this today,' he said. 'I could never have left it up to the kids.'

He was right. I had expected the *placement* of this party to be a coldhearted analysis of the local pecking order; instead, it revolved around his feelings for people he had known, in some cases, for more than four decades. Jeanne Martin, the ex-wife of Dean, for instance: 'I'd like to put her someplace nice. She's been a good friend.' Or David Giler, the screenwriter, whose name isn't well-known outside the Hollywood community: 'Give him a better seat. I like him.'

At last, all 150 dinner guests had been placed. 'I'm going to get this chart out of here so he can't tinker with it,' one assistant whispered. 'Otherwise, we'll never get this party seated. Irving,' she said, 'where are *you* going to sit?'

'I have no intention of sitting down,' said Lazar. "

—**ANNETTE TAPERT**
VANITY FAIR, APRIL 1994

Could Hollywood's most dastardly screenwriter have ever plotted an injustice more egregious? At the 1941 Academy Awards, motion-picture prodigy **ORSON WELLES**, then but 26, would walk away with a mere best-original-screenplay doorstop (to share with Herman J. Mankiewicz) for *Citizen Kane*, which armies of cinéastes still consider the best film ever made. Like Kane's, Welles's life was writ large: he would help reshape American theater in the 30s, startle entire metro areas (when enacting H. G. Wells's *War of the Worlds* over the radio in 1938), marry Rita Hayworth, and direct or act in such big-screen keystones as *The Magnificent Ambersons*, *The Lady from Shanghai*, *Touch of Evil*, and Carol Reed's *The Third Man*. And yet by the time he appeared here—with interior designer **MICA ERTEGUN** at Swifty Lazar's party in 1984, a year before Welles's death—he had already devolved into artiste manqué.

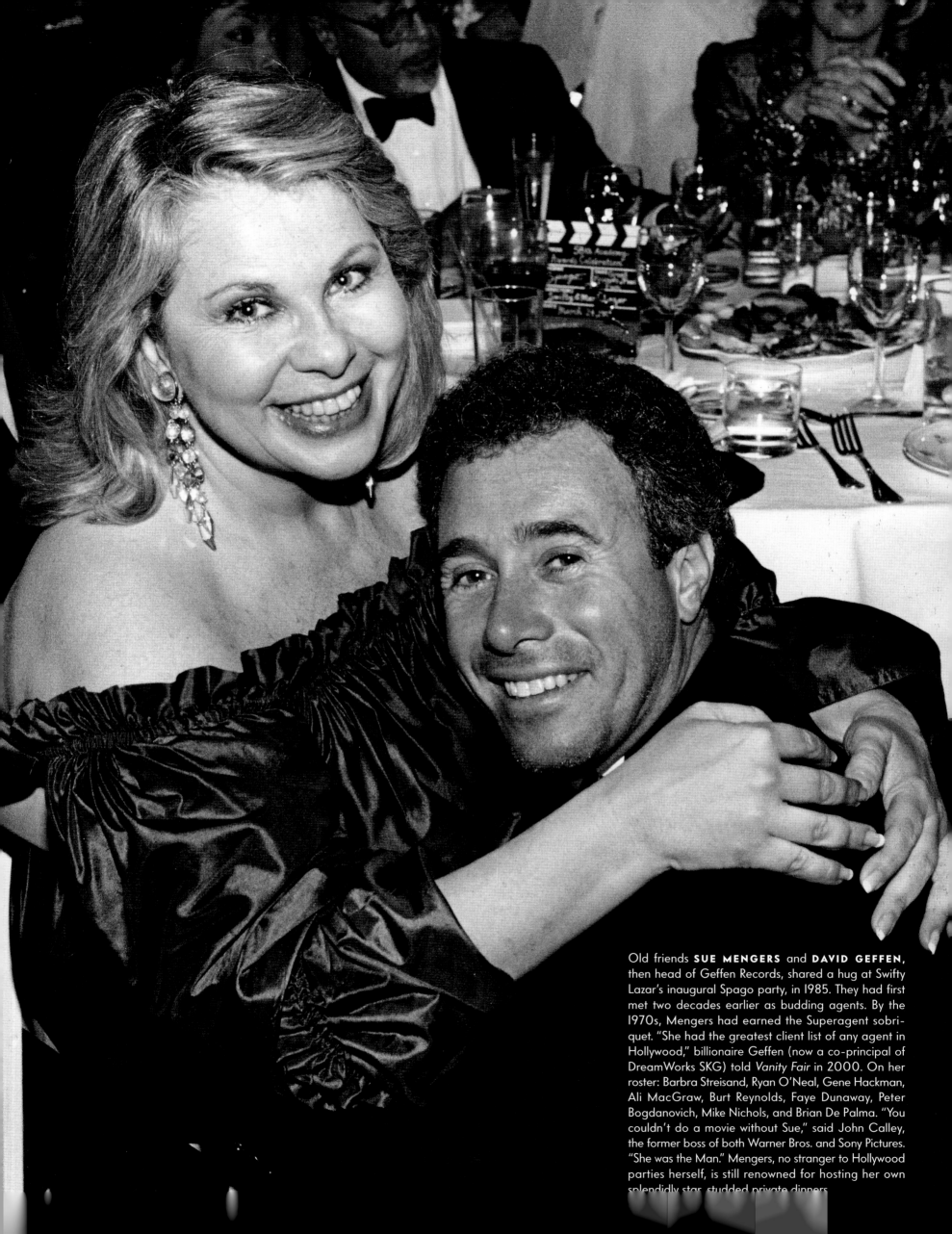

Old friends **SUE MENGERS** and **DAVID GEFFEN**, then head of Geffen Records, shared a hug at Swifty Lazar's inaugural Spago party, in 1985. They had first met two decades earlier as budding agents. By the 1970s, Mengers had earned the Superagent sobriquet. "She had the greatest client list of any agent in Hollywood," billionaire Geffen (now a co-principal of DreamWorks SKG) told *Vanity Fair* in 2000. On her roster: Barbra Streisand, Ryan O'Neal, Gene Hackman, Ali MacGraw, Burt Reynolds, Faye Dunaway, Peter Bogdanovich, Mike Nichols, and Brian De Palma. "You couldn't do a movie without Sue," said John Calley, the former boss of both Warner Bros. and Sony Pictures. "She was the Man." Mengers, no stranger to Hollywood parties herself, is still renowned for hosting her own splendidly star-studded private dinners.

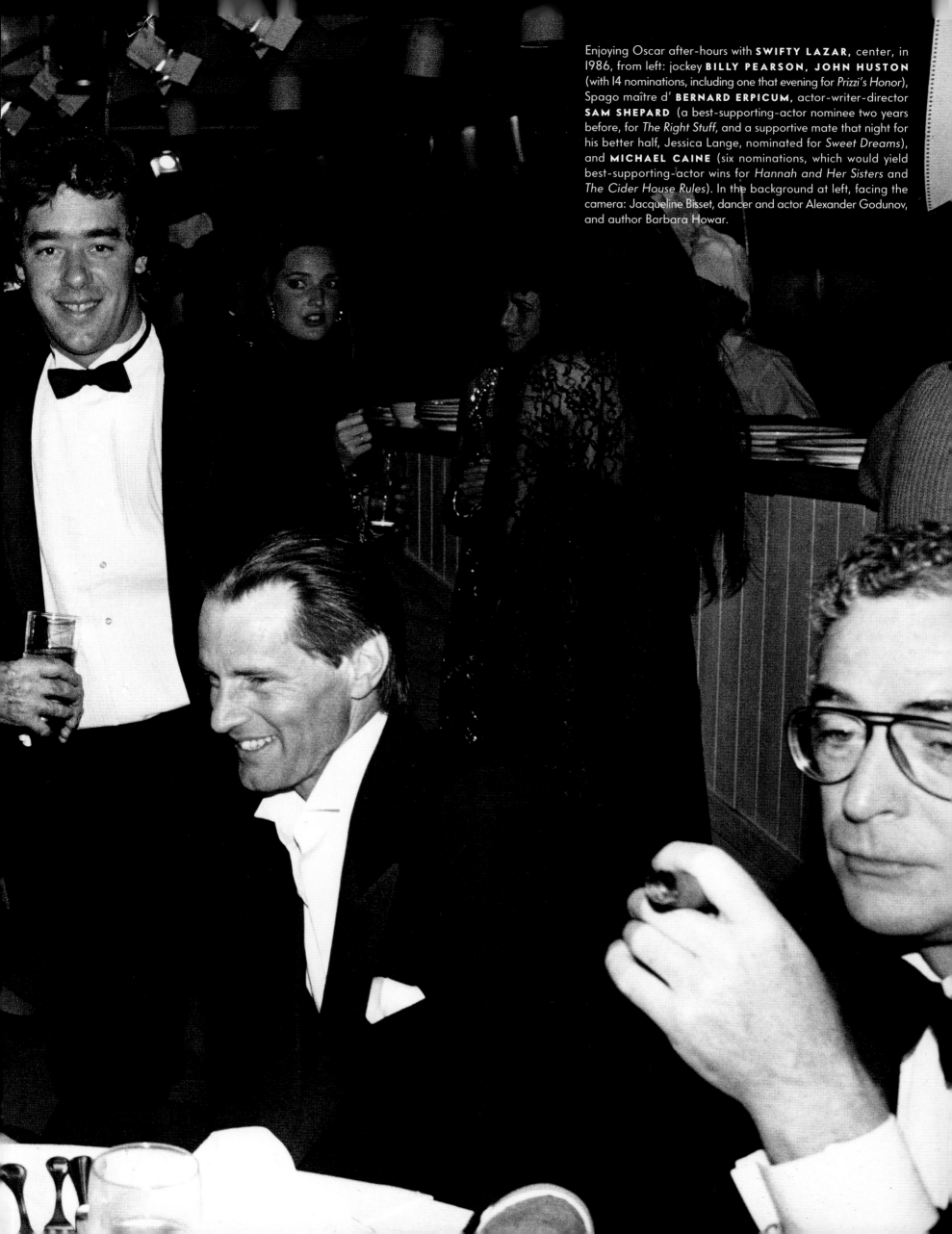

Enjoying Oscar after-hours with **SWIFTY LAZAR**, center, in 1986, from left: jockey **BILLY PEARSON**, **JOHN HUSTON** (with 14 nominations, including one that evening for *Prizzi's Honor*), Spago maître d' **BERNARD ERPICUM**, actor-writer-director **SAM SHEPARD** (a best-supporting-actor nominee two years before, for *The Right Stuff*, and a supportive mate that night for his better half, Jessica Lange, nominated for *Sweet Dreams*), and **MICHAEL CAINE** (six nominations, which would yield best-supporting-actor wins for *Hannah and Her Sisters* and *The Cider House Rules*). In the background at left, facing the camera: Jacqueline Bisset, dancer and actor Alexander Godunov, and author Barbara Howar.

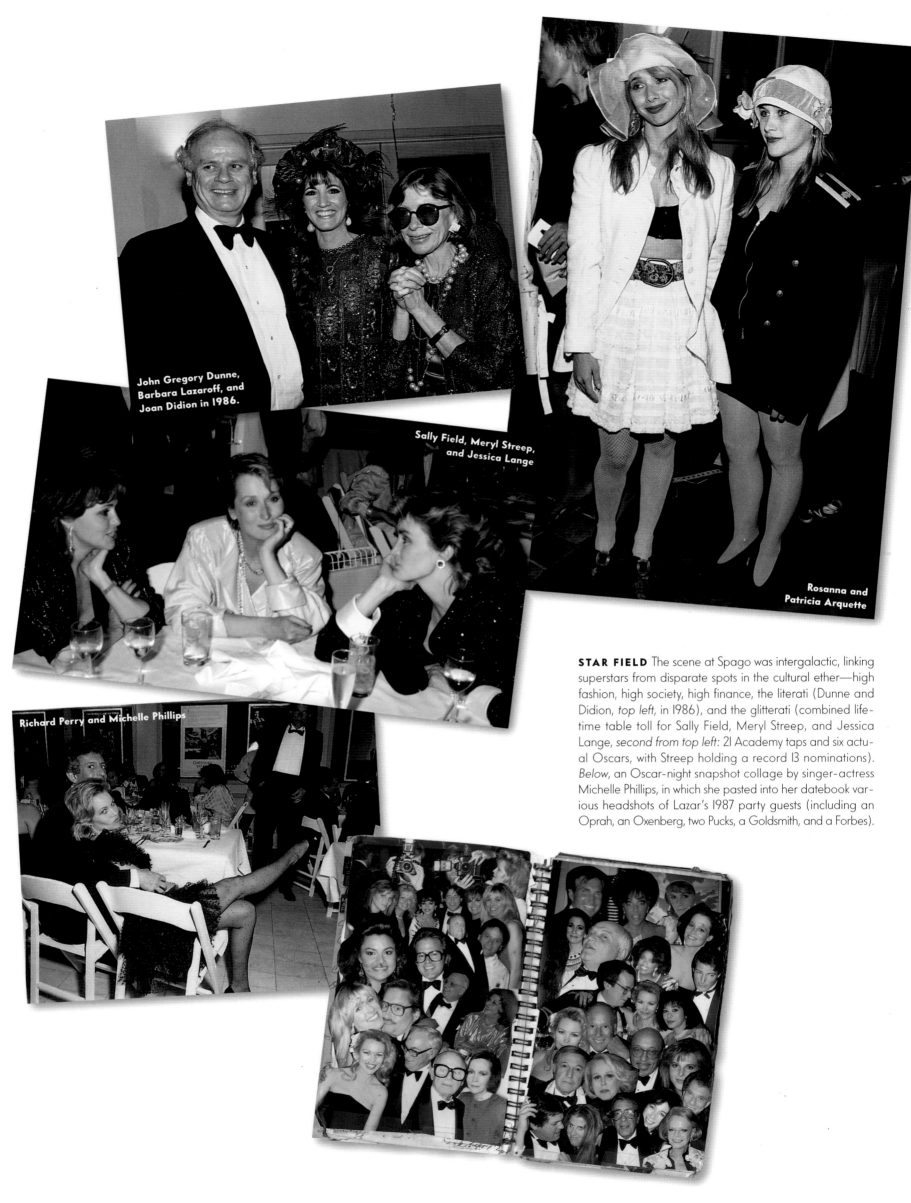

John Gregory Dunne, Barbara Lazaroff, and Joan Didion in 1986.

Sally Field, Meryl Streep, and Jessica Lange

Rosanna and Patricia Arquette

Richard Perry and Michelle Phillips

STAR FIELD The scene at Spago was intergalactic, linking superstars from disparate spots in the cultural ether—high fashion, high society, high finance, the literati (Dunne and Didion, *top left*, in 1986), and the glitterati (combined lifetime table toll for Sally Field, Meryl Streep, and Jessica Lange, *second from top left:* 21 Academy taps and six actual Oscars, with Streep holding a record 13 nominations). *Below,* an Oscar-night snapshot collage by singer-actress Michelle Phillips, in which she pasted into her datebook various headshots of Lazar's 1987 party guests (including an Oprah, an Oxenberg, two Pucks, a Goldsmith, and a Forbes).

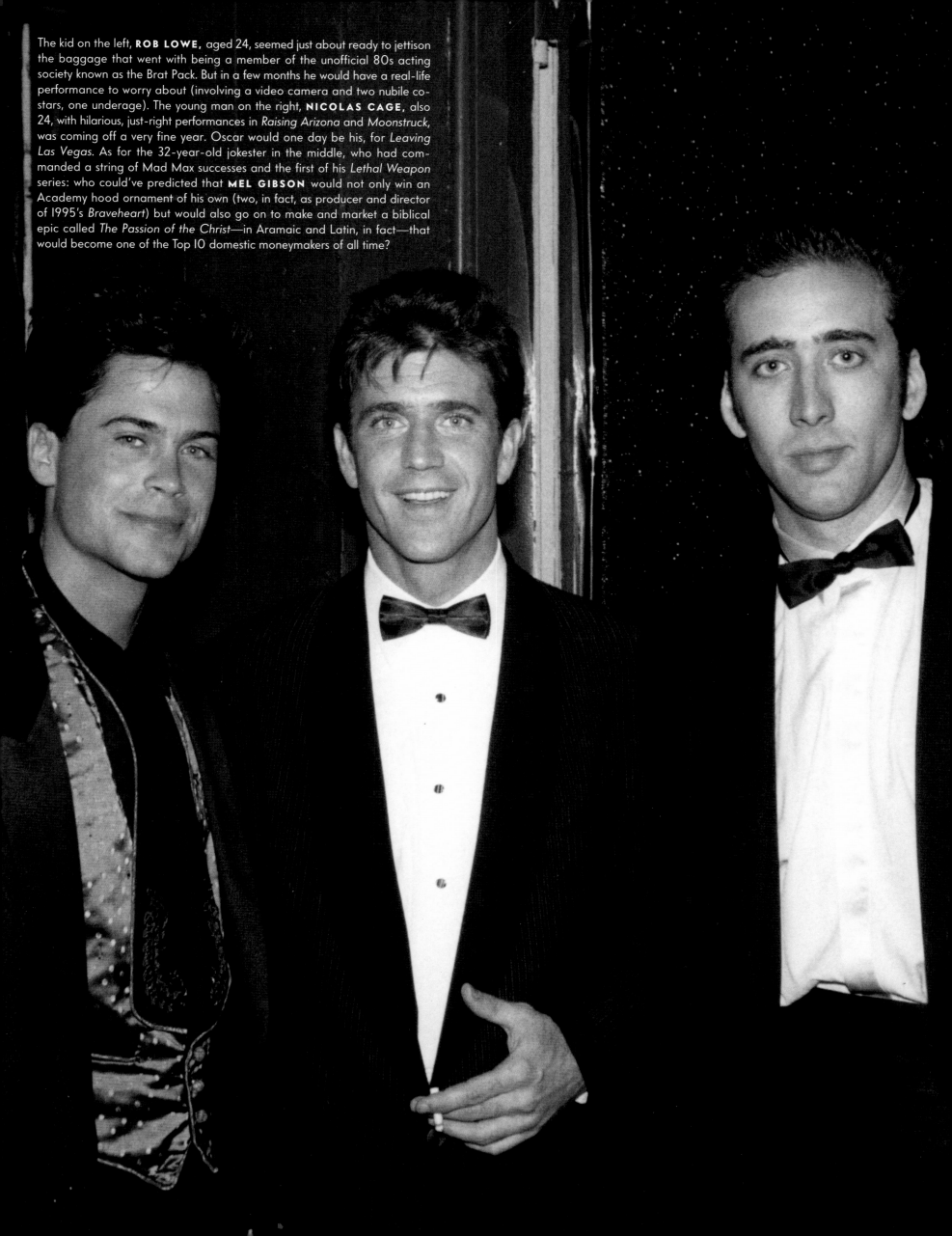

The kid on the left, **ROB LOWE**, aged 24, seemed just about ready to jettison the baggage that went with being a member of the unofficial 80s acting society known as the Brat Pack. But in a few months he would have a real-life performance to worry about (involving a video camera and two nubile co-stars, one underage). The young man on the right, **NICOLAS CAGE**, also 24, with hilarious, just-right performances in *Raising Arizona* and *Moonstruck*, was coming off a very fine year. Oscar would one day be his, for *Leaving Las Vegas*. As for the 32-year-old jokester in the middle, who had commanded a string of Mad Max successes and the first of his *Lethal Weapon* series: who could've predicted that **MEL GIBSON** would not only win an Academy hood ornament of his own (two, in fact, as producer and director of 1995's *Braveheart*) but would also go on to make and market a biblical epic called *The Passion of the Christ*—in Aramaic and Latin, in fact—that would become one of the Top 10 domestic moneymakers of all time?

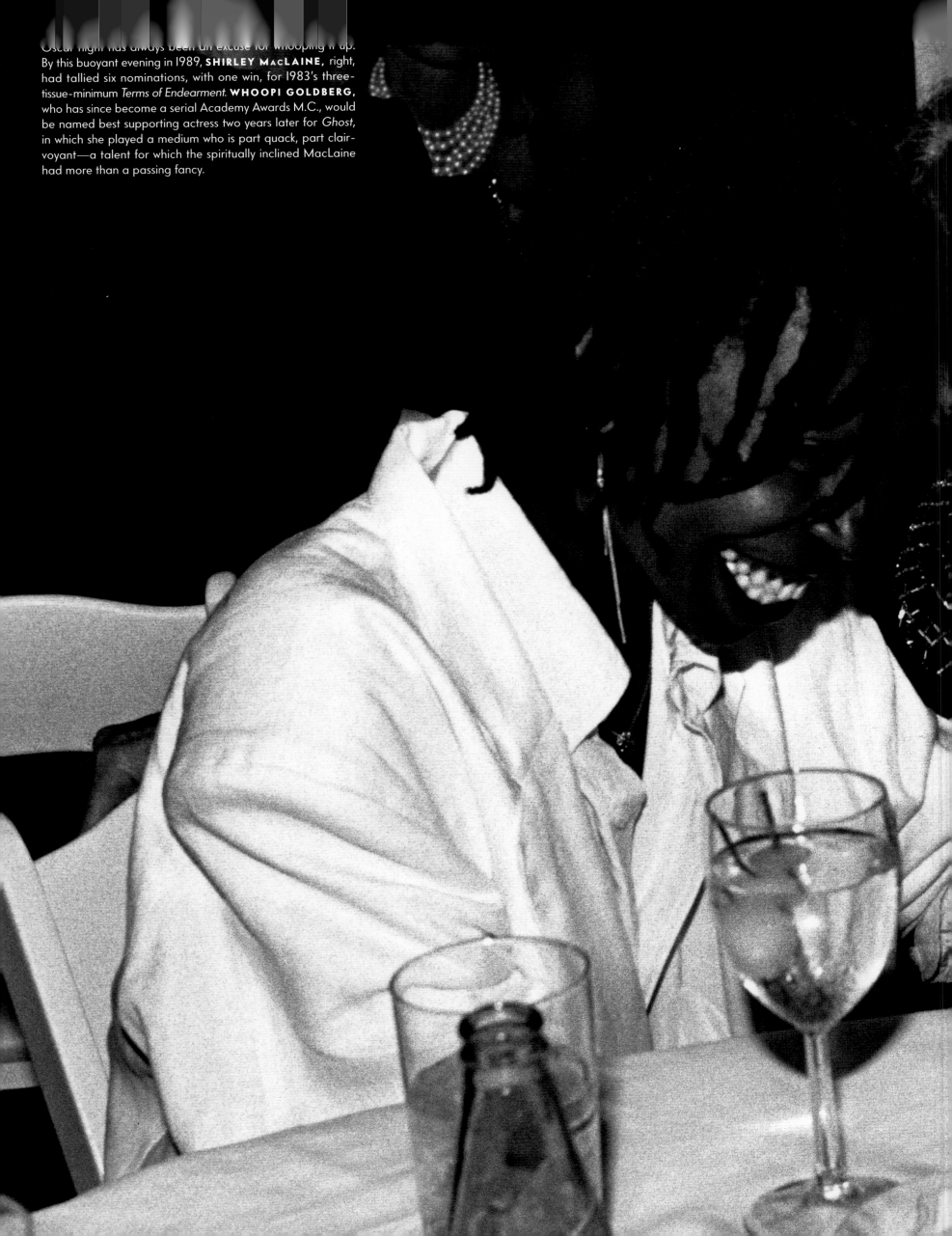

Oscar night has always been an excuse for whooping it up. By this buoyant evening in 1989, **SHIRLEY MacLAINE**, right, had tallied six nominations, with one win, for 1983's three-tissue-minimum *Terms of Endearment.* **WHOOPI GOLDBERG,** who has since become a serial Academy Awards M.C., would be named best supporting actress two years later for *Ghost,* in which she played a medium who is part quack, part clair-voyant—a talent for which the spiritually inclined MacLaine had more than a passing fancy.

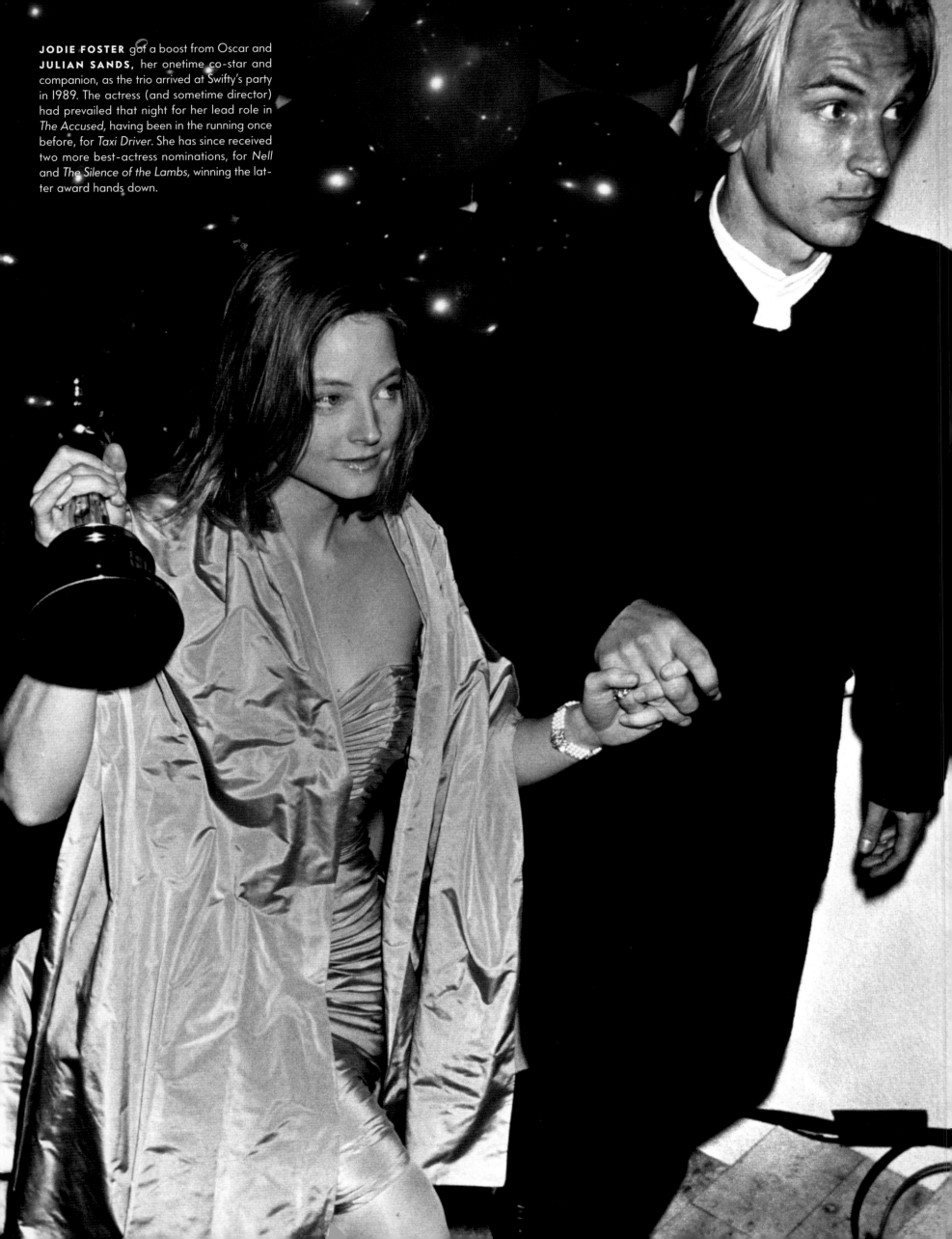

JODIE FOSTER got a boost from Oscar and **JULIAN SANDS,** her onetime co-star and companion, as the trio arrived at Swifty's party in 1989. The actress (and sometime director) had prevailed that night for her lead role in *The Accused,* having been in the running once before, for *Taxi Driver*. She has since received two more best-actress nominations, for *Nell* and *The Silence of the Lambs,* winning the latter award hands down.

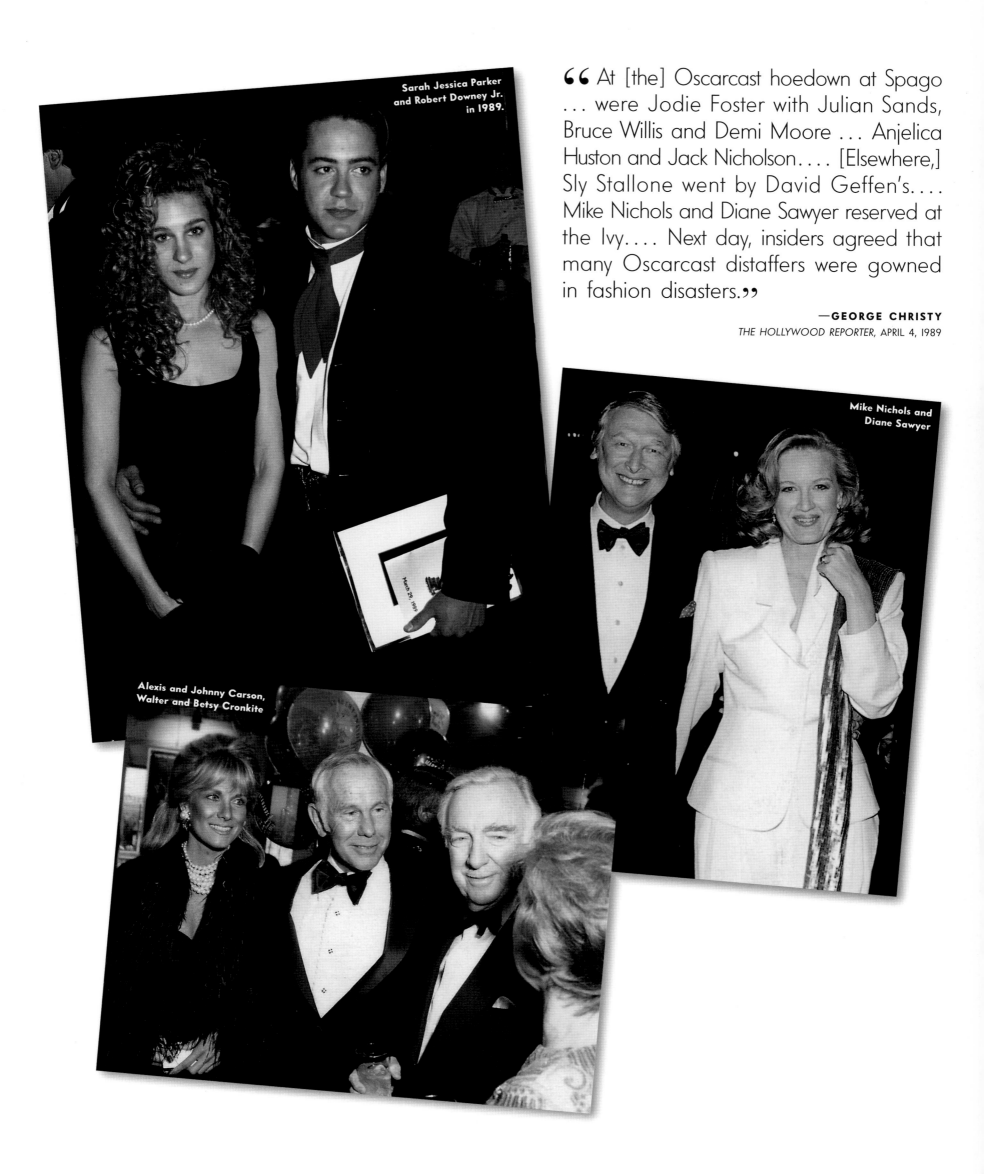

Sarah Jessica Parker
and Robert Downey Jr.
in 1989.

March 29, 1989

Mike Nichols and
Diane Sawyer

Alexis and Johnny Carson,
Walter and Betsy Cronkite

66 At [the] Oscarcast hoedown at Spago
... were Jodie Foster with Julian Sands,
Bruce Willis and Demi Moore ... Anjelica
Huston and Jack Nicholson.... [Elsewhere,]
Sly Stallone went by David Geffen's....
Mike Nichols and Diane Sawyer reserved at
the Ivy.... Next day, insiders agreed that
many Oscarcast distaffers were gowned
in fashion disasters.**99**

—GEORGE CHRISTY
THE HOLLYWOOD REPORTER, APRIL 4, 1989

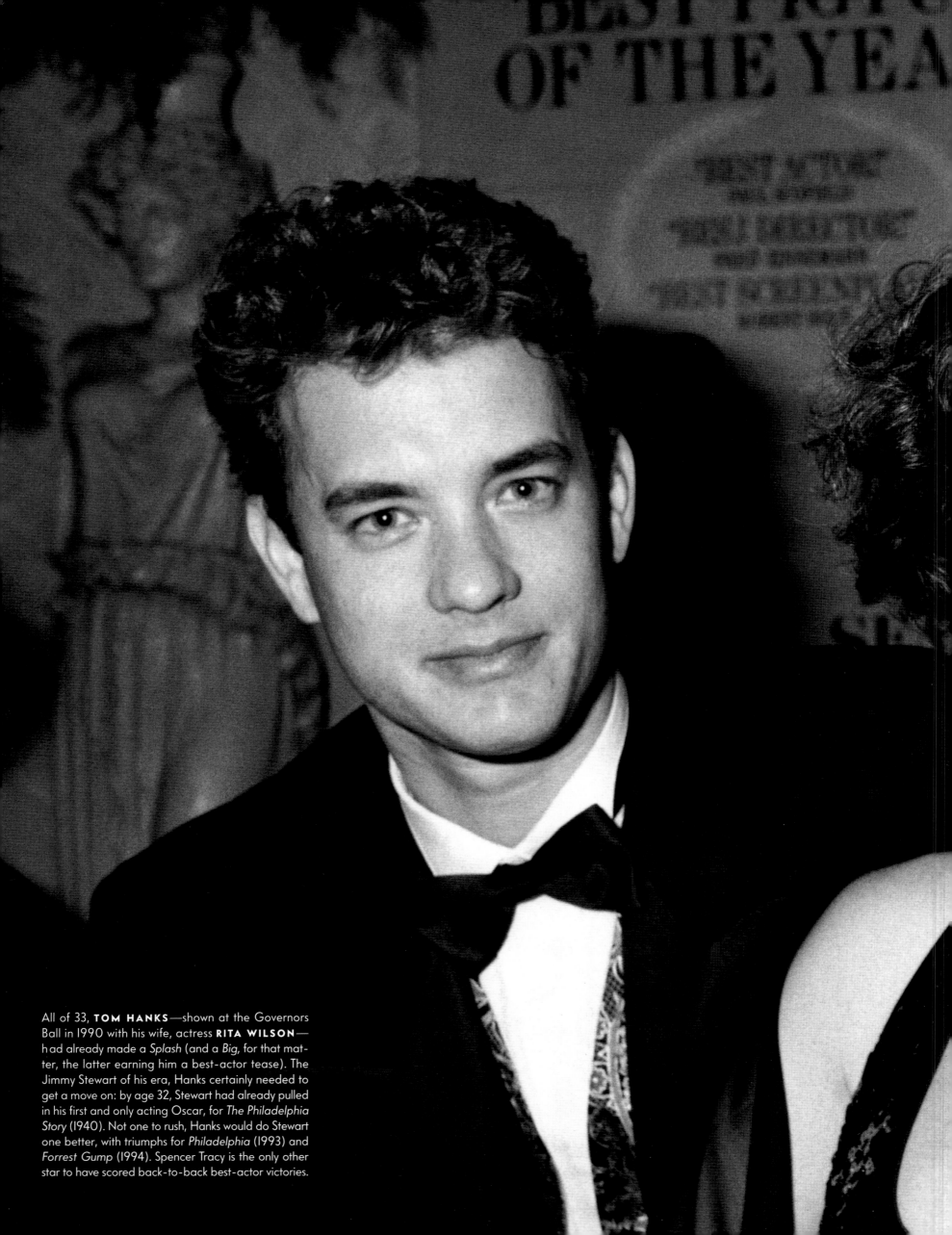

All of 33, **TOM HANKS**—shown at the Governors Ball in 1990 with his wife, actress **RITA WILSON**—had already made a *Splash* (and a *Big*, for that matter, the latter earning him a best-actor tease). The Jimmy Stewart of his era, Hanks certainly needed to get a move on: by age 32, Stewart had already pulled in his first and only acting Oscar, for *The Philadelphia Story* (1940). Not one to rush, Hanks would do Stewart one better, with triumphs for *Philadelphia* (1993) and *Forrest Gump* (1994). Spencer Tracy is the only other star to have scored back-to-back best-actor victories.

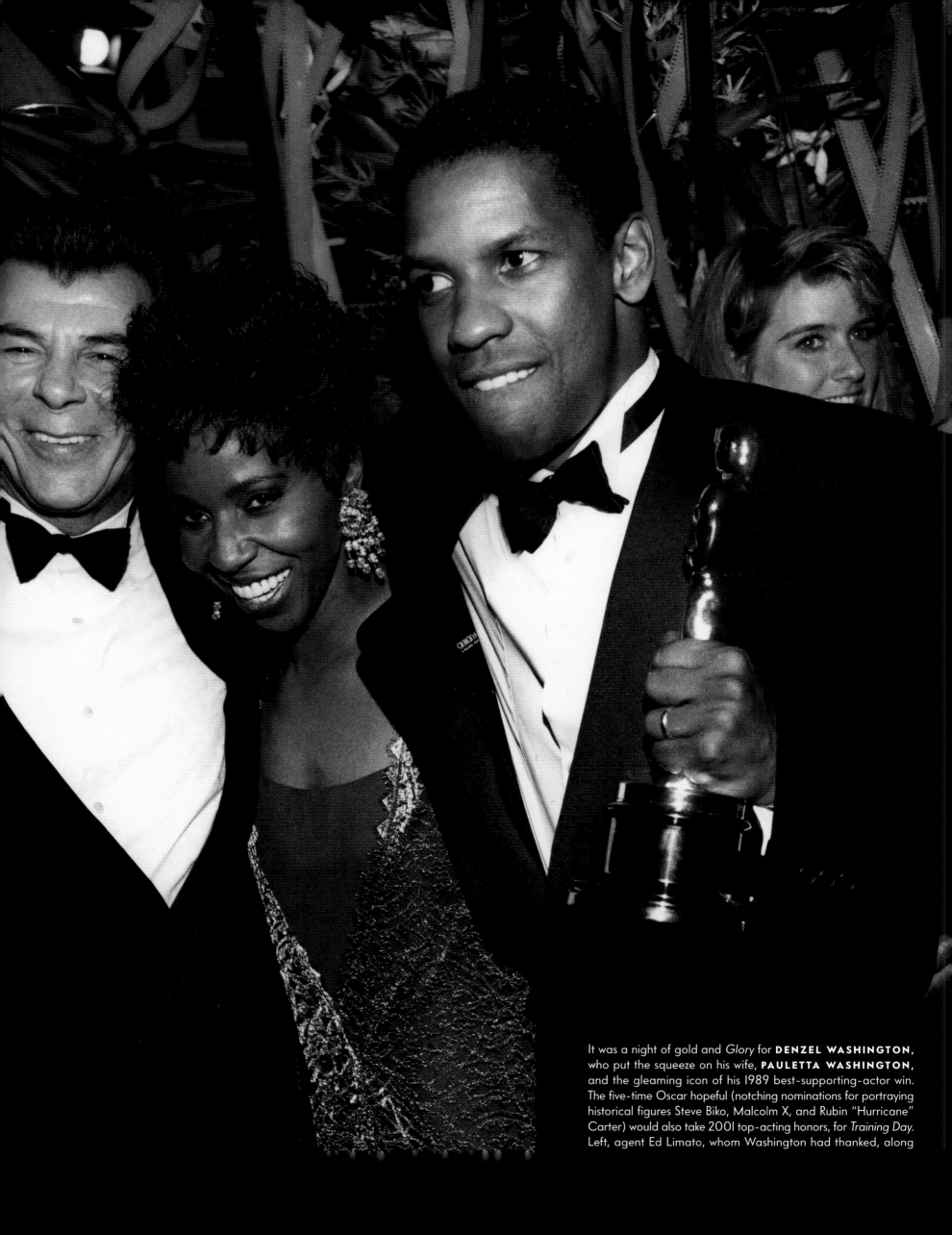

It was a night of gold and *Glory* for **DENZEL WASHINGTON**, who put the squeeze on his wife, **PAULETTA WASHINGTON**, and the gleaming icon of his 1989 best-supporting-actor win. The five-time Oscar hopeful (notching nominations for portraying historical figures Steve Biko, Malcolm X, and Rubin "Hurricane" Carter) would also take 2001 top-acting honors, for *Training Day*. Left, agent Ed Limato, whom Washington had thanked, along

> **"** I turned away the governor of California [Pete Wilson] and his wife and the head of Universal, on Swifty and Mary's instructions. He didn't invite them. They had all this security with them and were calling in and even sent an advance team. *And* they were Republicans. I stood there and I didn't let them in. The Lazars just loved it. **"**
>
> —**ALAN NEVINS,** LITERARY AND TALENT MANAGER, FORMERLY SWIFTY LAZAR'S PARTY COORDINATOR

Beau and Wendy Bridges, Jeff and Susan Bridges, in 1990.

Suzanne Pleshette with Dominick Dunne; right, a Spago centerpiece.

HOLLYWOOD
PRODUCTION *"62ND Academy Award Celebration"*
DIRECTOR *Mary & Irving Lazar*
CAMERA *The Eyes Of The World*

DATE	SCENE	TAKE
March 26 1990	*Spago*	*The Oscar*

Giorgio Armani and niece Silvana Armani.

> **"** Later, the governor was spotted at the [1991] party, with no bodyguards in sight. Madonna, however, had a huge one by her side. **"**
>
> —**JEANNINE STEIN** AND **BILL HIGGINS**
> *LOS ANGELES TIMES,* MARCH 21, 1994

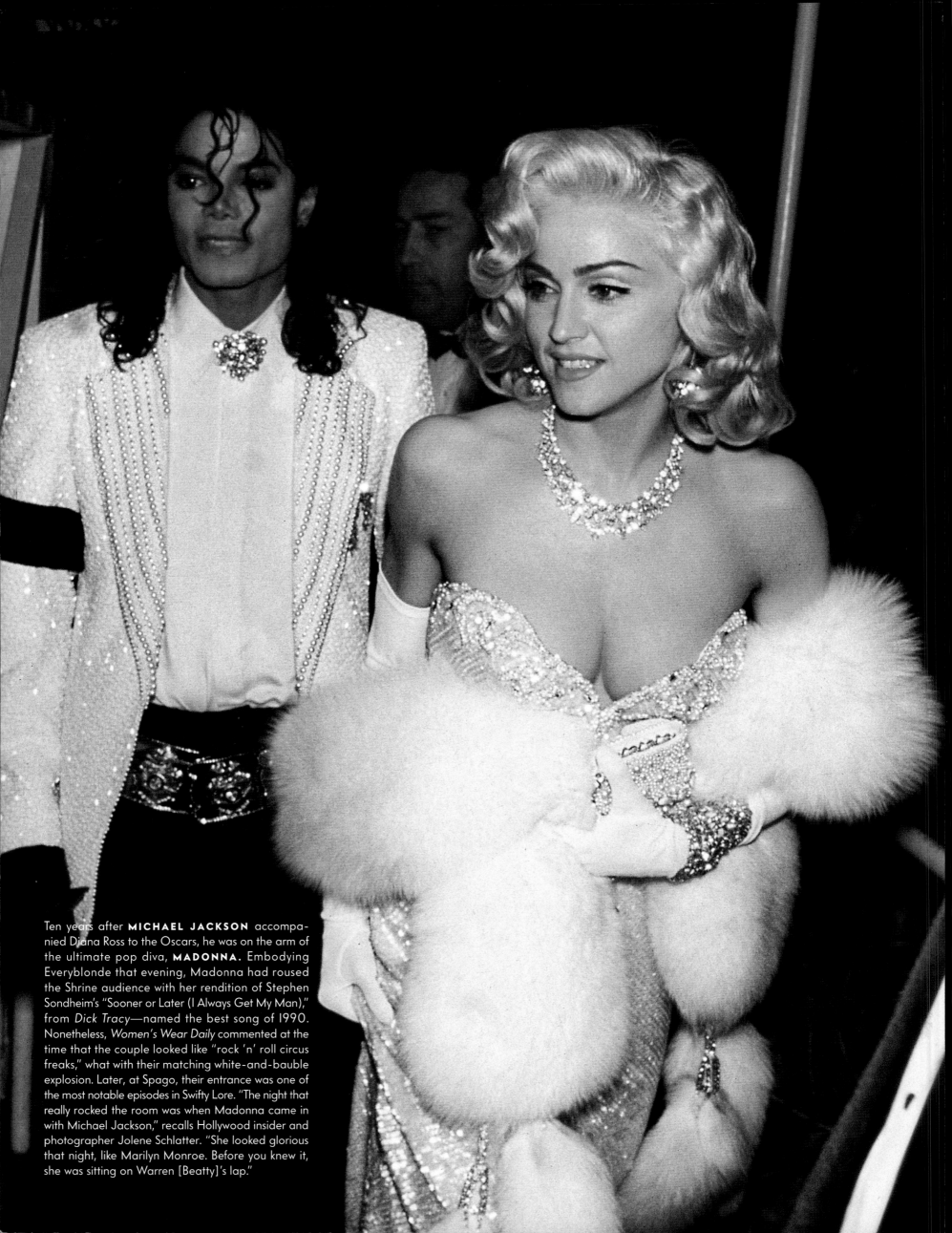

Ten years after **MICHAEL JACKSON** accompanied Diana Ross to the Oscars, he was on the arm of the ultimate pop diva, **MADONNA**. Embodying Everyblonde that evening, Madonna had roused the Shrine audience with her rendition of Stephen Sondheim's "Sooner or Later (I Always Get My Man)," from *Dick Tracy*—named the best song of 1990. Nonetheless, *Women's Wear Daily* commented at the time that the couple looked like "rock 'n' roll circus freaks," what with their matching white-and-bauble explosion. Later, at Spago, their entrance was one of the most notable episodes in Swifty Lore. "The night that really rocked the room was when Madonna came in with Michael Jackson," recalls Hollywood insider and photographer Jolene Schlatter. "She looked glorious that night, like Marilyn Monroe. Before you knew it, she was sitting on Warren [Beatty]'s lap."

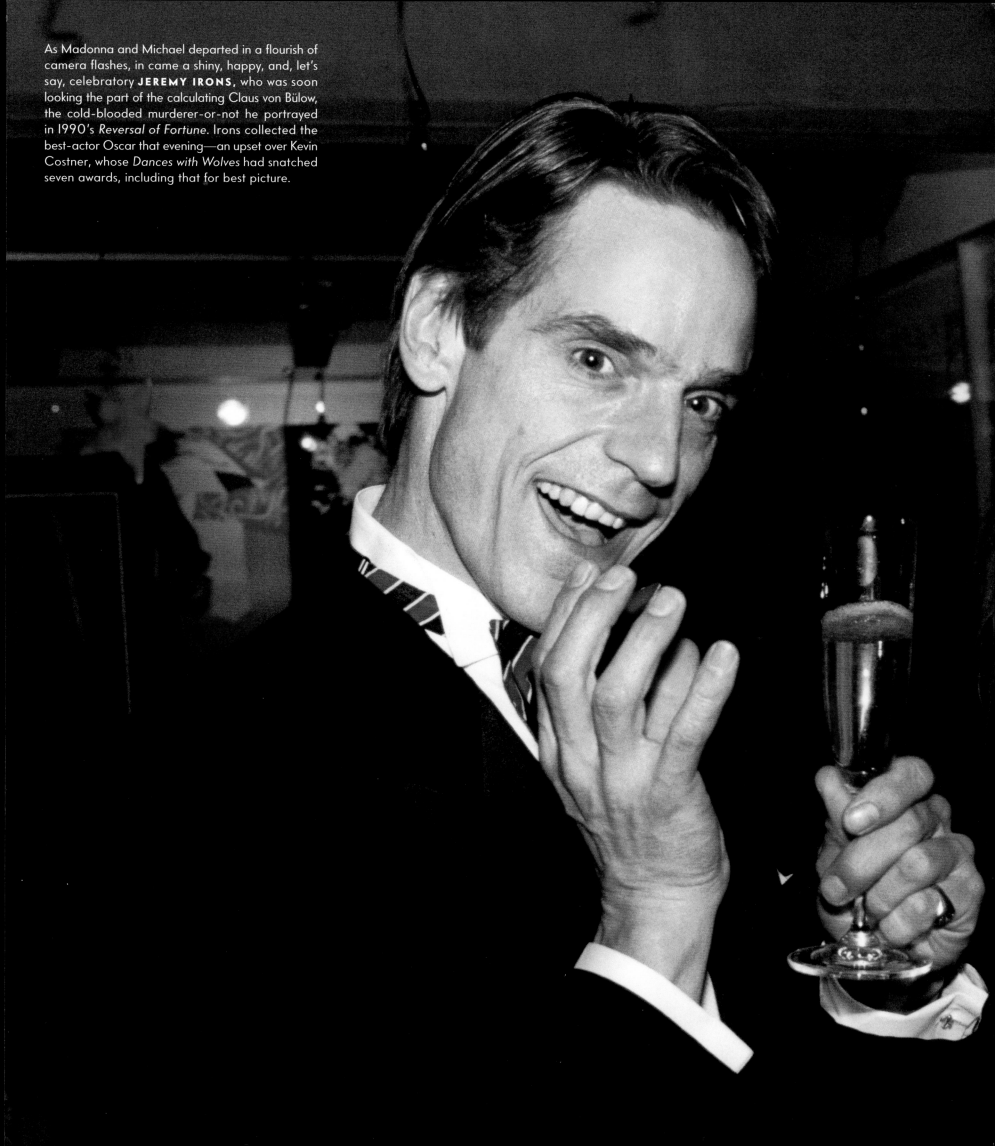

As Madonna and Michael departed in a flourish of camera flashes, in came a shiny, happy, and, let's say, celebratory **JEREMY IRONS**, who was soon looking the part of the calculating Claus von Bülow, the cold-blooded murderer-or-not he portrayed in 1990's *Reversal of Fortune*. Irons collected the best-actor Oscar that evening—an upset over Kevin Costner, whose *Dances with Wolves* had snatched seven awards, including that for best picture.

❝I didn't expect to meet *her*. But then, she didn't expect to meet *me*.**❞**

—WALTER CRONKITE
ON SITTING WITH MADONNA AT SPAGO

" I've been going to the party since Swifty gave it at the old Bistro on Cañon. There's nothing like carrying a little statue around at a party, and hanging on to it for dear life. . . .

Swifty would work the door—he knew everything that was going on. The slightest lapse of behavior and you were out . . . never to be invited again. The first Oscar parties given by Swifty were quite intimate—sort of like a small town. Irving would write a little note, no security was permitted— bodyguards were told to stay outside. Lazar was ruthless in his seating arrangement—you got near the kitchen, like it or not, if your picture bombed. No celebrity . . . no mogul was big enough to intimidate this man. **"**

—**DAVID BROWN,** PRODUCER OF *JAWS* AND *CHOCOLAT,* AMONG OTHER FILMS

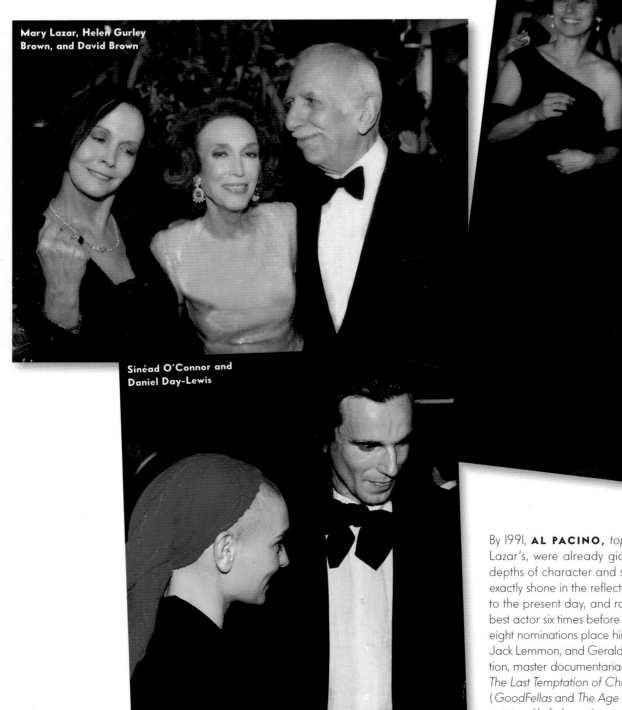

Lyndall Hobbs, Al Pacino, and Barry Levinson in 1991.

Mary Lazar, Helen Gurley Brown, and David Brown

Sinéad O'Connor and Daniel Day-Lewis

Barbara De Fina and Martin Scorsese

By 1991, **AL PACINO,** *top,* and **MARTIN SCORSESE,** *above,* at Swifty Lazar's, were already giants in filmmaking, having probed the darkest depths of character and society in their respective crafts. Yet neither had exactly shone in the reflected light of Oscar, a sad state that has continued to the present day, and rankles in many quarters. Pacino was courted for best actor six times before he finally won, for 1992's *Scent of a Woman.* (His eight nominations place him in the all-time Top 10, tied with Marlon Brando, Jack Lemmon, and Geraldine Page.) Scorsese, a champion of film preservation, master documentarian, and Oscar nominee for directing (*Raging Bull, The Last Temptation of Christ, GoodFellas, Gangs of New York*) and writing (*GoodFellas* and *The Age of Innocence*), has waited an awfully long time for a statue. (*Left,* three-time nominee **DANIEL DAY-LEWIS,** who was named the best actor of 1989 for *My Left Foot.*)

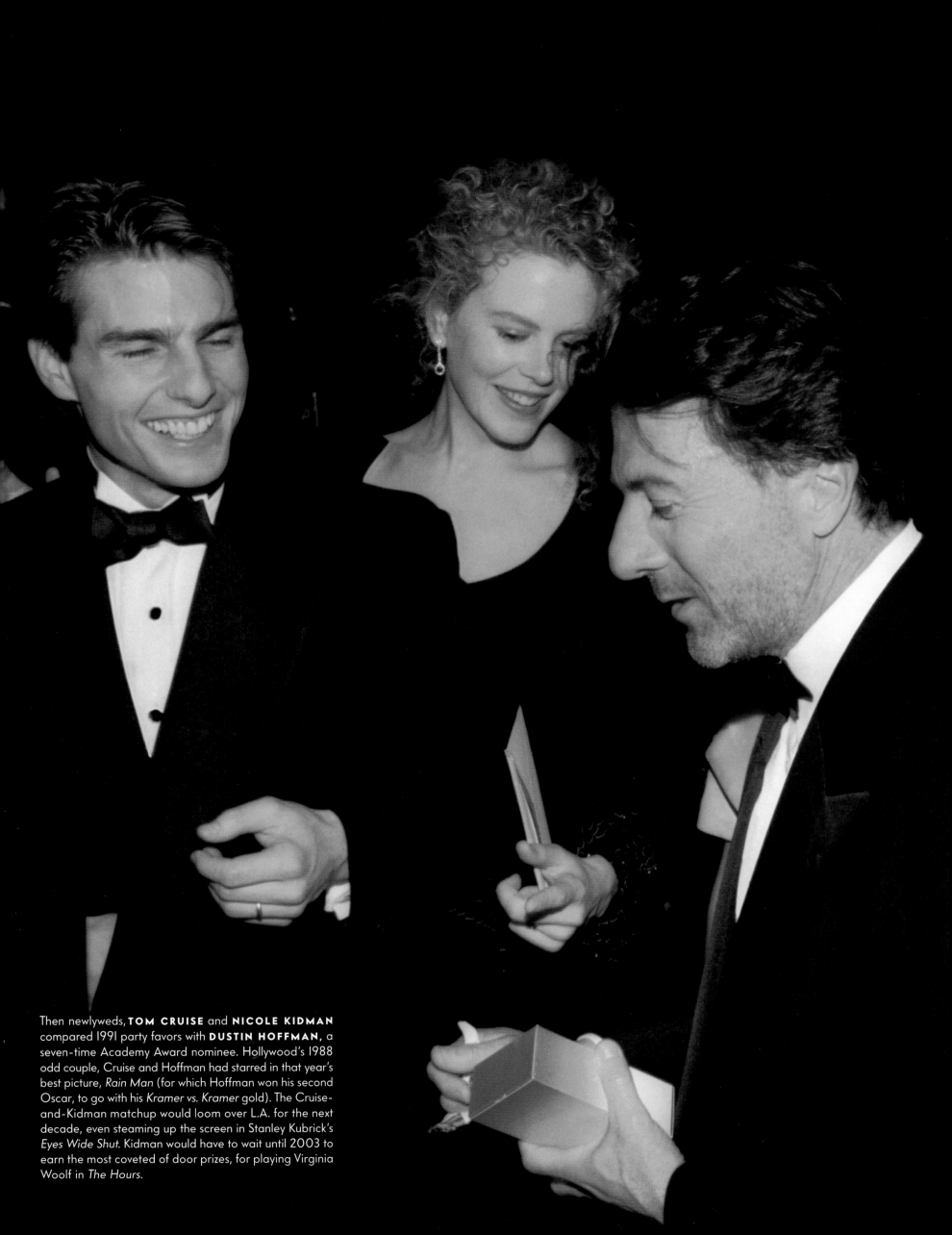

Then newlyweds, **TOM CRUISE** and **NICOLE KIDMAN**
compared 1991 party favors with **DUSTIN HOFFMAN,** a
seven-time Academy Award nominee. Hollywood's 1988
odd couple, Cruise and Hoffman had starred in that year's
best picture, *Rain Man* (for which Hoffman won his second
Oscar, to go with his *Kramer vs. Kramer* gold). The Cruise-
and-Kidman matchup would loom over L.A. for the next
decade, even steaming up the screen in Stanley Kubrick's
Eyes Wide Shut. Kidman would have to wait until 2003 to
earn the most coveted of door prizes, for playing Virginia
Woolf in *The Hours*.

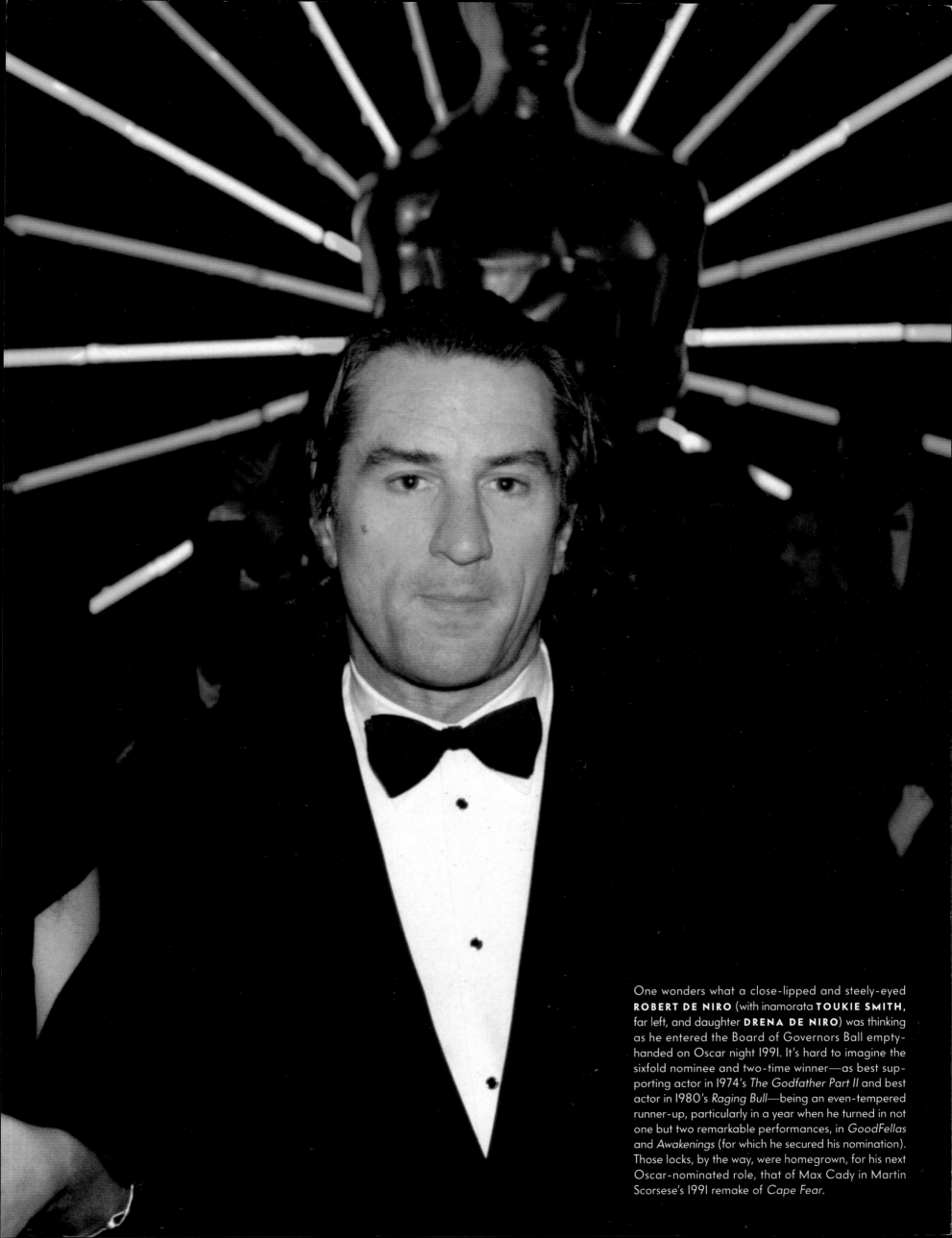

One wonders what a close-lipped and steely-eyed **ROBERT DE NIRO** (with inamorata **TOUKIE SMITH,** far left, and daughter **DRENA DE NIRO**) was thinking as he entered the Board of Governors Ball empty-handed on Oscar night 1991. It's hard to imagine the sixfold nominee and two-time winner—as best supporting actor in 1974's *The Godfather Part II* and best actor in 1980's *Raging Bull*—being an even-tempered runner-up, particularly in a year when he turned in not one but two remarkable performances, in *GoodFellas* and *Awakenings* (for which he secured his nomination). Those locks, by the way, were homegrown, for his next Oscar-nominated role, that of Max Cady in Martin Scorsese's 1991 remake of *Cape Fear.*

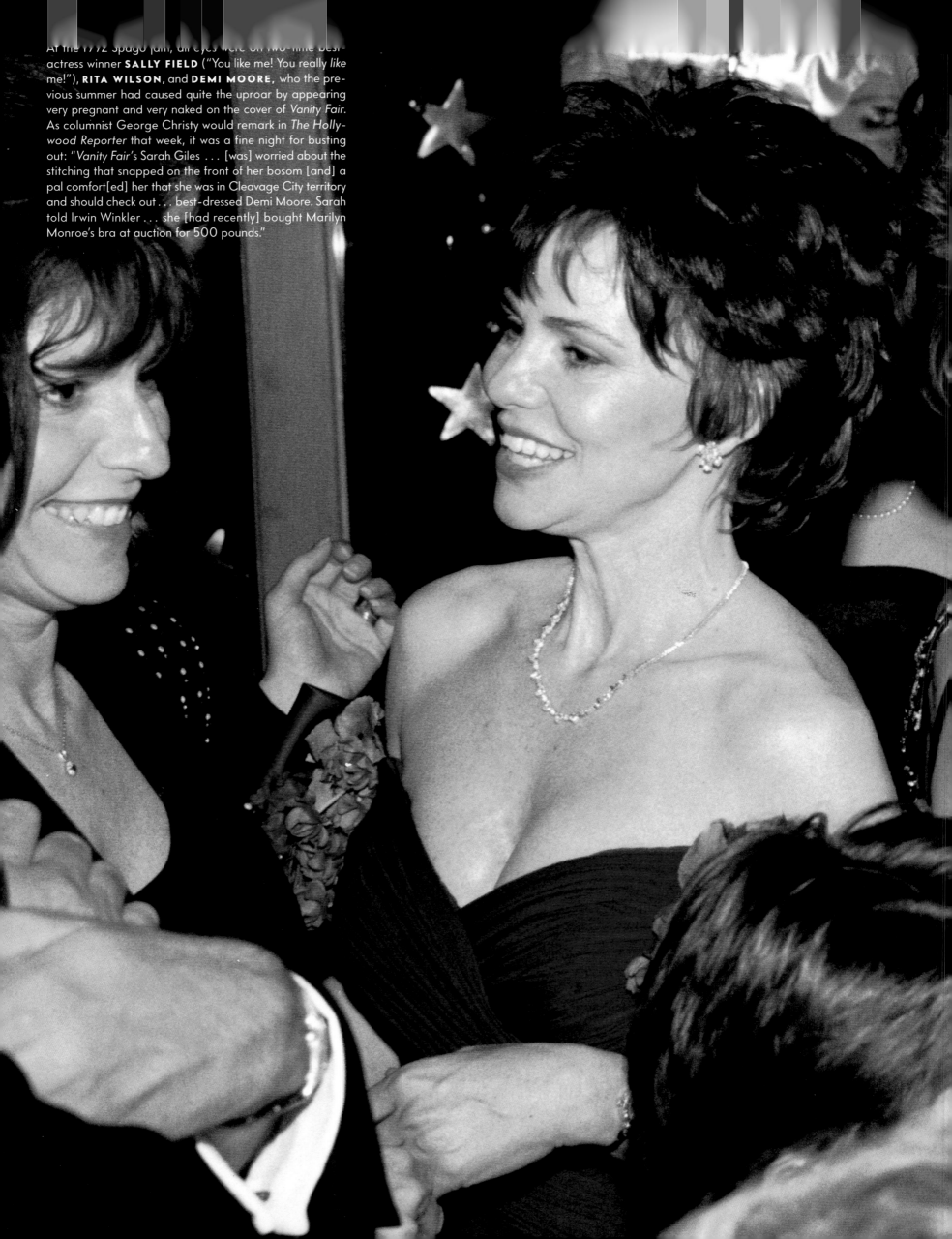

At the 1992 Spago jam, all eyes were on two-time best-actress winner **SALLY FIELD** ("You like me! You really *like* me!"), **RITA WILSON**, and **DEMI MOORE**, who the previous summer had caused quite the uproar by appearing very pregnant and very naked on the cover of *Vanity Fair*. As columnist George Christy would remark in *The Hollywood Reporter* that week, it was a fine night for busting out: "*Vanity Fair*'s Sarah Giles . . . [was] worried about the stitching that snapped on the front of her bosom [and] a pal comfort[ed] her that she was in Cleavage City territory and should check out . . . best-dressed Demi Moore. Sarah told Irwin Winkler . . . she [had recently] bought Marilyn Monroe's bra at auction for 500 pounds."

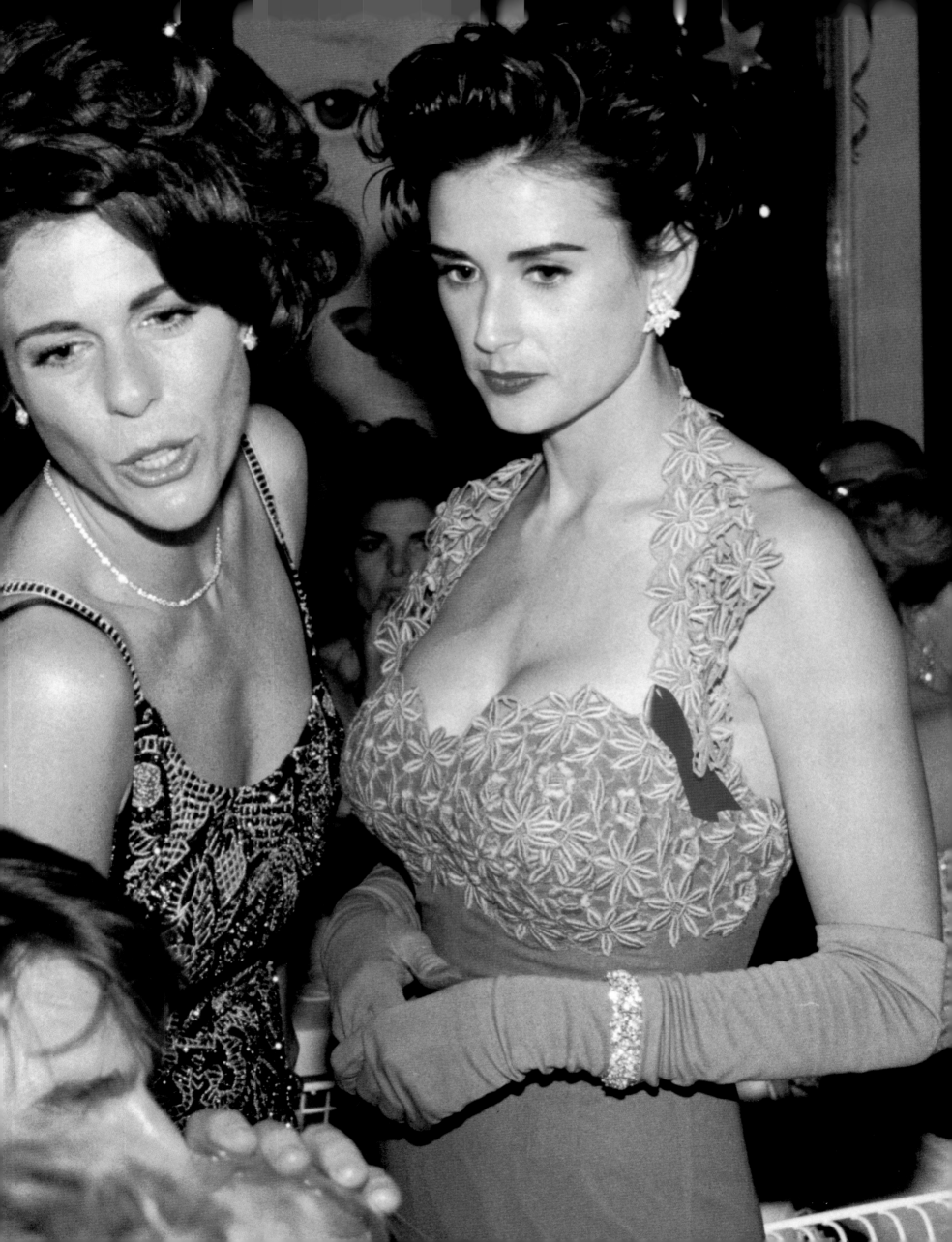

THE FORCE *Below*, directors Spike Lee, left, and John Singleton, right, joined George Lucas, winner of that night's Thalberg Award, at the 1992 Board of Governors Ball. In his acceptance speech, Lucas had thanked the "thousands of men, women, robots, and aliens" who helped make the *Star Wars* and Indiana Jones sagas possible.

Spike Lee, George Lucas, and John Singleton in 1992.

Countess Marina Cicogna, Graydon Carter, Wendy Stark, and Benedetta Gardona

66 Nineteen-ninety-two, at Swifty's, was *the* Oscar party for me. I was hosting, but I had a 103 temperature. They had me on I.V. Everybody was worried. [After the ceremony] I came into Spago and they gave me a standing ovation. Wolfgang [Puck] gave me chicken soup with matzo balls, and Diana Ross arranged this napkin around my neck. 99

—BILLY CRYSTAL
M.C. OF EIGHT ACADEMY AWARDS CEREMONIES

Saturday Night Live cast members **DAVID SPADE, CHRIS ROCK,** and **CHRIS FARLEY** cut loose at the Maple Drive restaurant for Elton John's first annual viewing party, in 1993, a fund-raiser for his eponymous AIDS foundation. Two years later, Sir Elton himself would share an Oscar with Tim Rice for their song "Can You Feel the Love Tonight," from Disney's *The Lion King*.

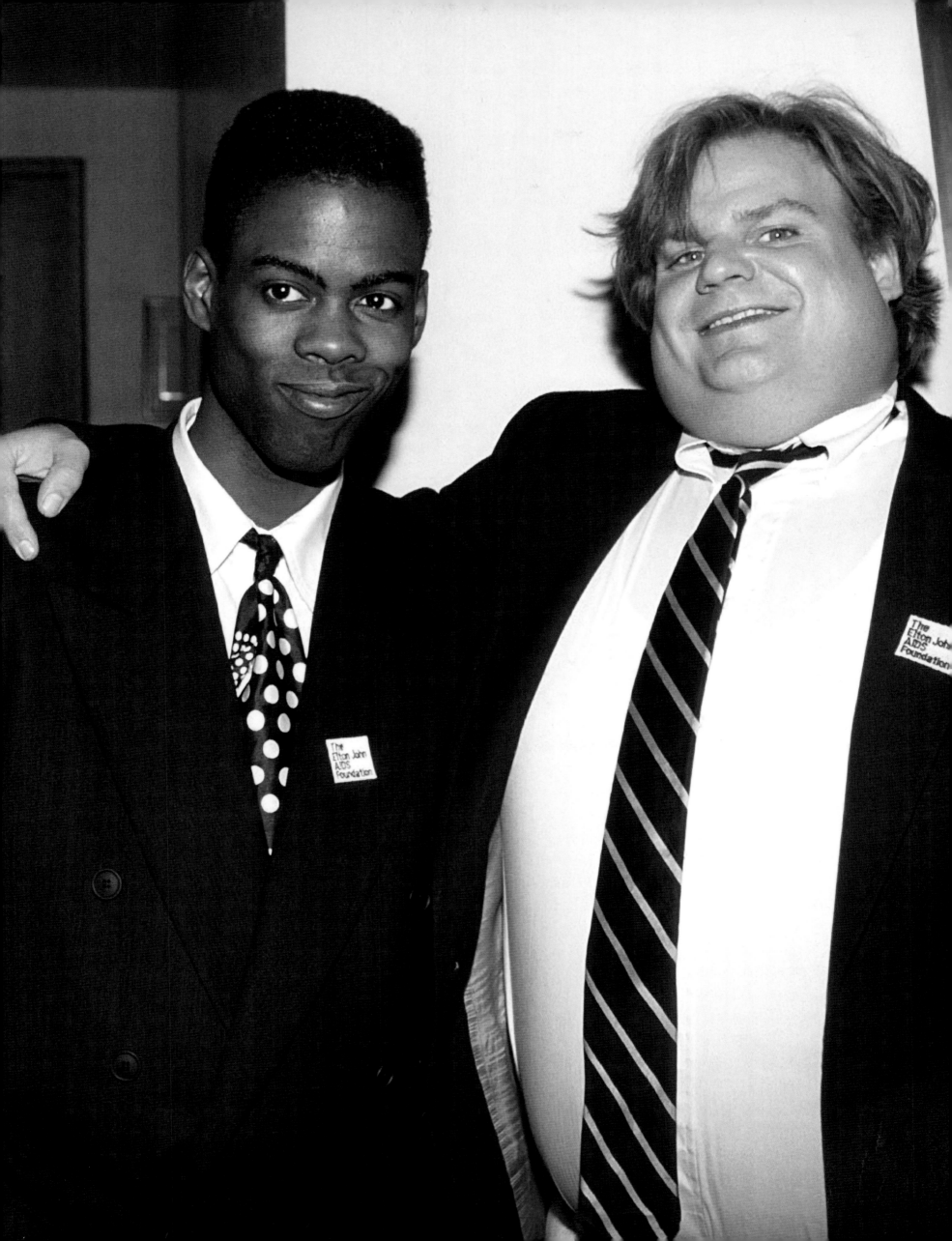

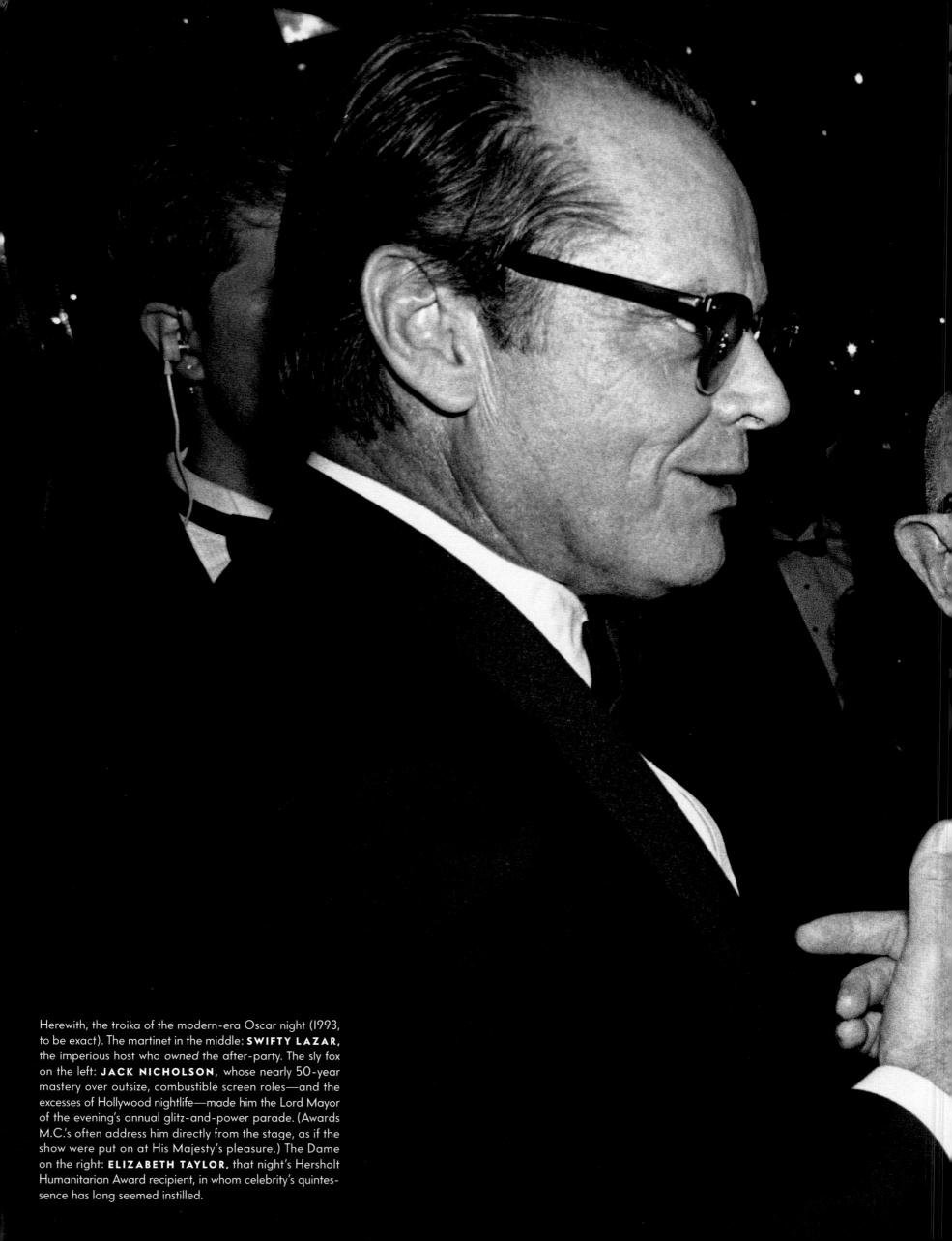

Herewith, the troika of the modern-era Oscar night (1993, to be exact). The martinet in the middle: **SWIFTY LAZAR,** the imperious host who *owned* the after-party. The sly fox on the left: **JACK NICHOLSON,** whose nearly 50-year mastery over outsize, combustible screen roles—and the excesses of Hollywood nightlife—made him the Lord Mayor of the evening's annual glitz-and-power parade. (Awards M.C.'s often address him directly from the stage, as if the show were put on at His Majesty's pleasure.) The Dame on the right: **ELIZABETH TAYLOR,** that night's Hersholt Humanitarian Award recipient, in whom celebrity's quintessence has long seemed instilled.

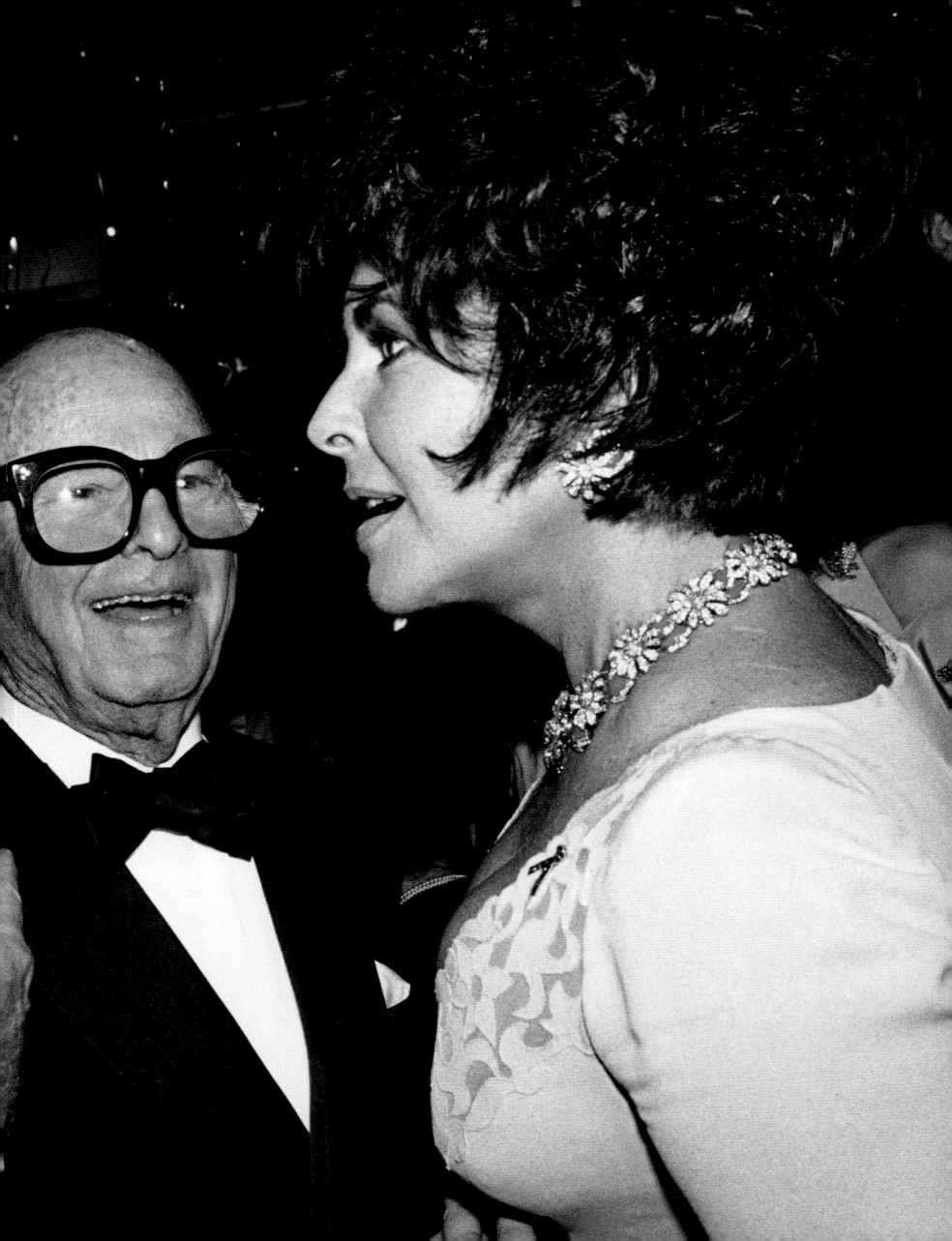

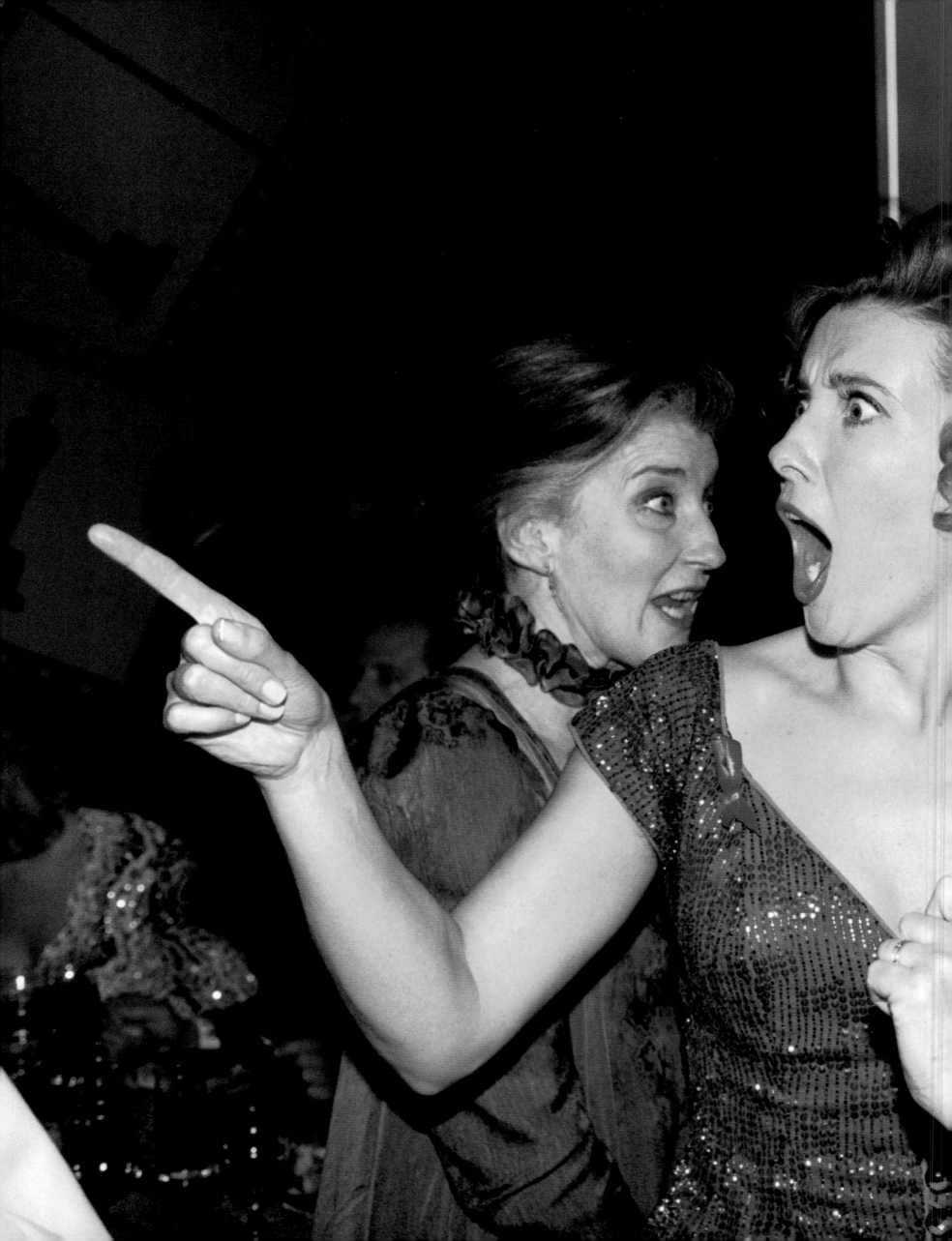

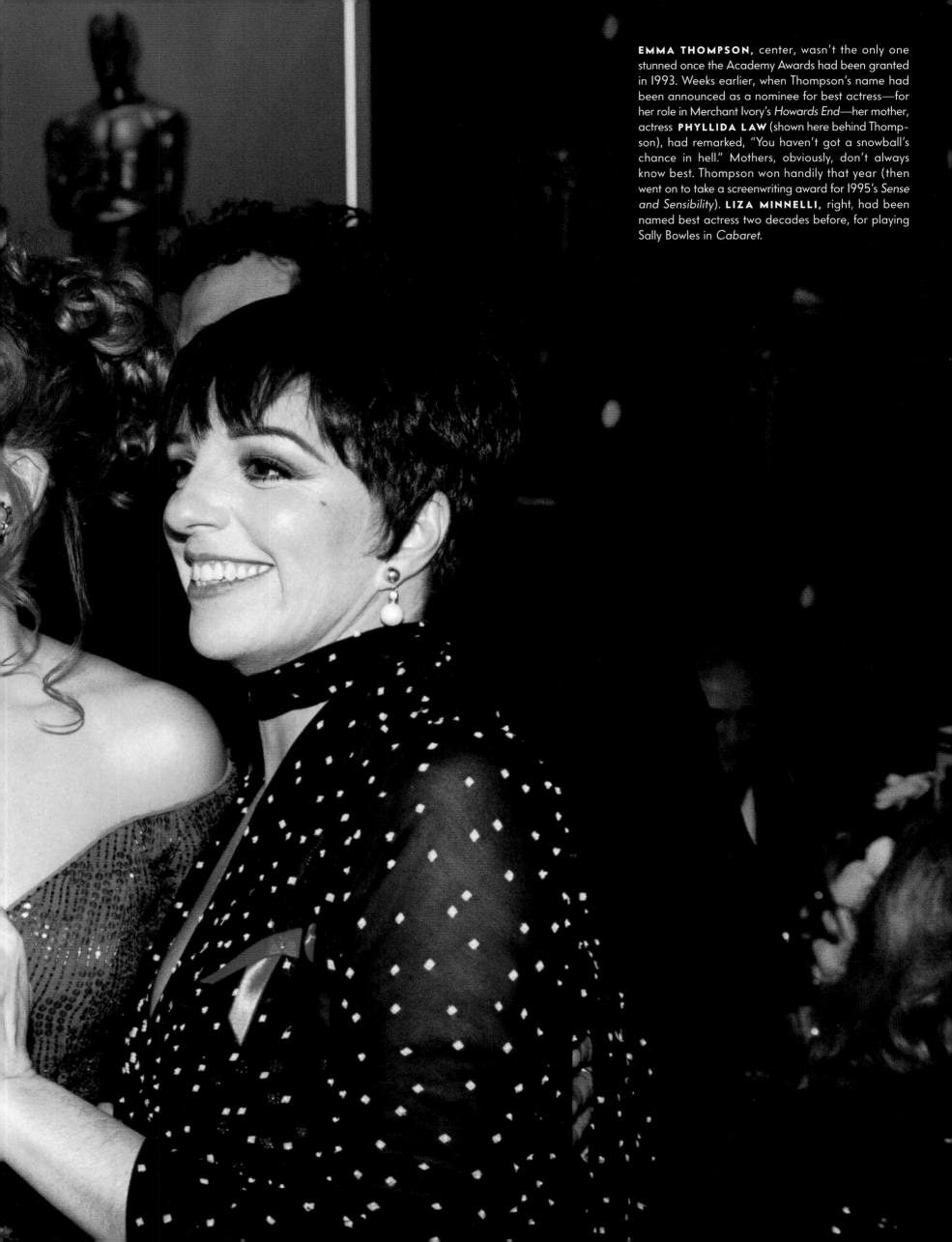

EMMA THOMPSON, center, wasn't the only one stunned once the Academy Awards had been granted in 1993. Weeks earlier, when Thompson's name had been announced as a nominee for best actress—for her role in Merchant Ivory's *Howards End*—her mother, actress **PHYLLIDA LAW** (shown here behind Thompson), had remarked, "You haven't got a snowball's chance in hell." Mothers, obviously, don't always know best. Thompson won handily that year (then went on to take a screenwriting award for 1995's *Sense and Sensibility*). **LIZA MINNELLI,** right, had been named best actress two decades before, for playing Sally Bowles in *Cabaret.*

1994

After Swifty Lazar passed away, in late 1993, the starriest night of the year seemed destined to lose its sparkle. Entering the vacuum, *Vanity Fair* summoned its troops and took over Mortons in West Hollywood for the evening of March 21, 1994, establishing what would emerge as the premier annual gala in American nightlife. The *Vanity Fair* Oscar party, from its inception, was a chic, formal dinner followed by an after-bash that would draw a dizzyingly high-octane guest list of boldfaced names and Oscar nominees, many cradling shiny ingots of newly gotten gold.

That first night, Krista Smith, the magazine's West Coast editor, assumed a perch near the Mortons entrance with photographer Annie Leibovitz, hoping to point out the less familiar celebrities, who might otherwise slip past unrecognized. "She was shooting," Smith recalls, "and literally here comes Goldie Hawn. Here comes Debra Winger, Michael Douglas, Meg Ryan, Sharon Stone. Emma Thompson and Kenneth Branagh, Annette Bening and Warren Beatty. Prince just suddenly showed up. For an hour the stream of people were all household names. It's been that way ever since." Nowadays, invitations to the party are valued like social bullion. One year Sara Marks, *V.F.*'s director of special projects, who coordinates every detail of the affair, was offered $30,000 for a pair of tickets. Then the rumor mill started spinning. "By the time I got to the party," she says, the offer had somehow escalated "to half a million."

The gathering, says Smith, "always has a requisite number of billionaires and young, single, beautiful actors and actresses; a requisite 25 percent studio heads and friends of the magazine; and everyone who is nominated in all the major categories. Then, if you've got the gold statue, come on in! Most of the people who were included in [that year's *Vanity Fair*] Hollywood Issue are invited; it brings the pages of the magazine to life." Mix in an array of society and literary figures, power brokers, and scads of musicians, then suffuse the space with perfect ambience—and the air itself seems laced with stardust. Kismet, too. Ellen DeGeneres famously met Anne Heche at the party one year; cosmetics baron Ronald Perelman met Ellen Barkin; Ashley Judd met Bobby Shriver. Remarked one attendee on Oscar night 1999: "At dinner we had two men who had both slept with Ava Gardner and Lana Turner."

Today, Oscar week is a social marathon, with events hosted by fashion and media companies, talent agencies, and studios (Miramax's party has typically included a satirical play put on by the stars), or by Beverly Hills royalty (Barry Diller and Diane von Furstenberg set out lounging pillows and Persian carpets for their Saturday picnic). And there are other venerable fetes come the big night, such as the Elton John AIDS Foundation benefit and the Board of Governors Ball (which fields a culinary staff of 150—and 22,000 flowers—for a choice 1,600 guests). And yet the *Vanity Fair* soirée is something else again. "Now that Swifty doesn't do his parties at Spago anymore," Tom Hanks once remarked at the *V.F.* party, "everyone comes here. . . . Vanity Fair has become sort of a show business bible." Mortons, on Oscar night, hums with the sweet harmonics of perpetual celebrity, endlessly replenished. The result is the ultimate Hollywood high—especially if you happen to have an Oscar in tow.

HOLLYWOOD'S GREEN GIANT Dominating the Mortons-restaurant promenade at the first *Vanity Fair* Academy Awards–night party, in 1994: a Bunyanesque shrub sculpted to look suspiciously like Mr. O.

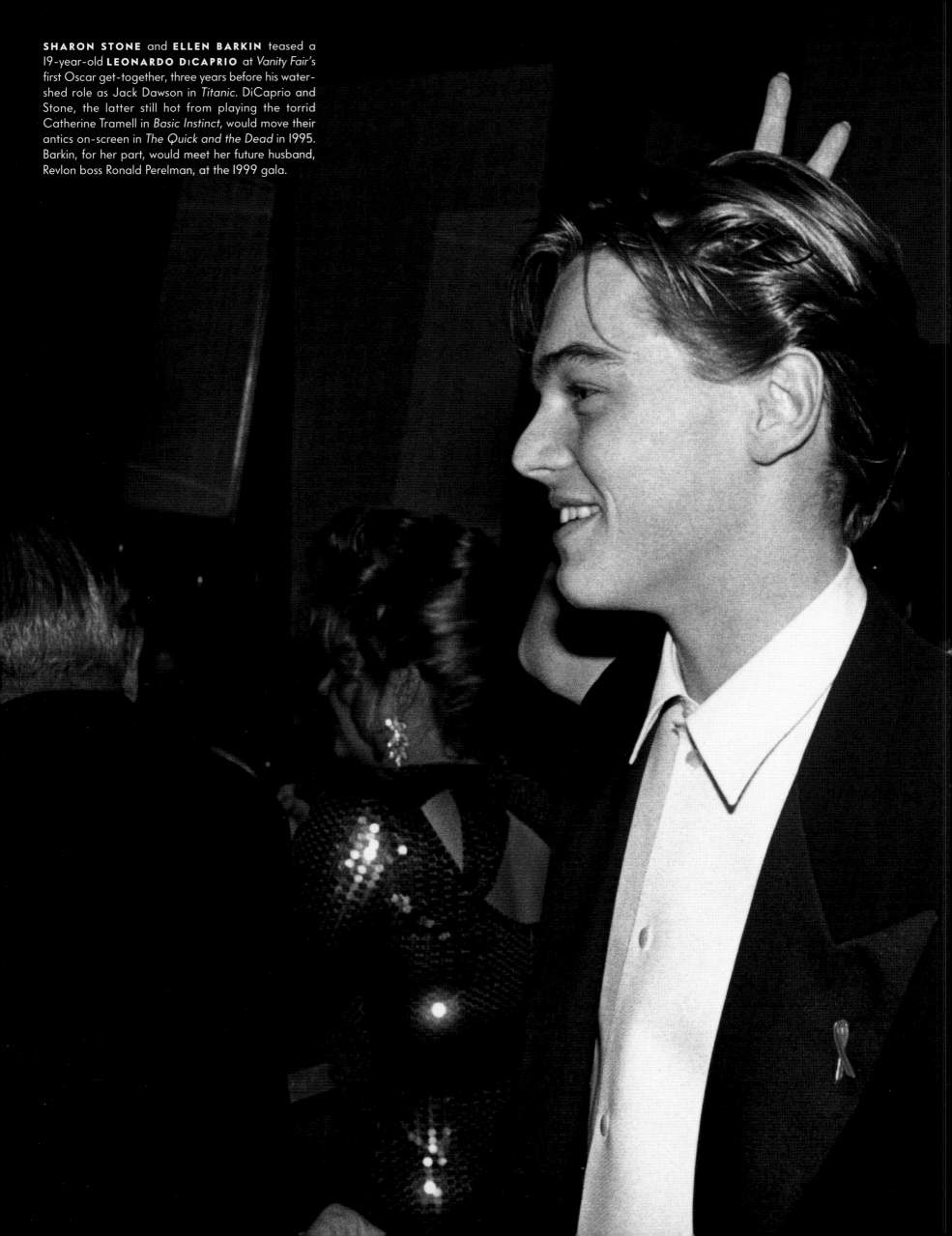

SHARON STONE and **ELLEN BARKIN** teased a 19-year-old **LEONARDO DiCAPRIO** at *Vanity Fair*'s first Oscar get-together, three years before his watershed role as Jack Dawson in *Titanic*. DiCaprio and Stone, the latter still hot from playing the torrid Catherine Tramell in *Basic Instinct*, would move their antics on-screen in *The Quick and the Dead* in 1995. Barkin, for her part, would meet her future husband, Revlon boss Ronald Perelman, at the 1999 gala.

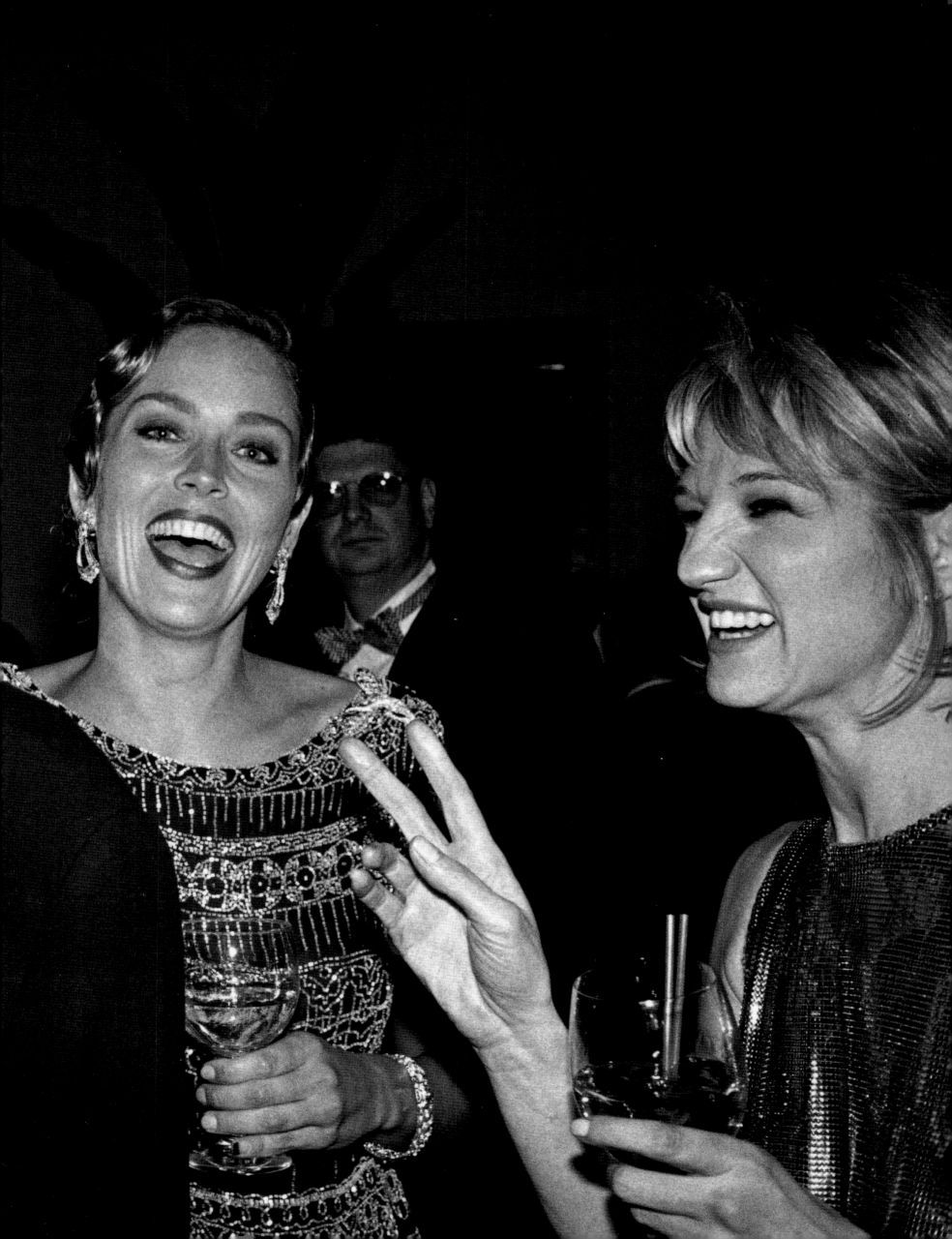

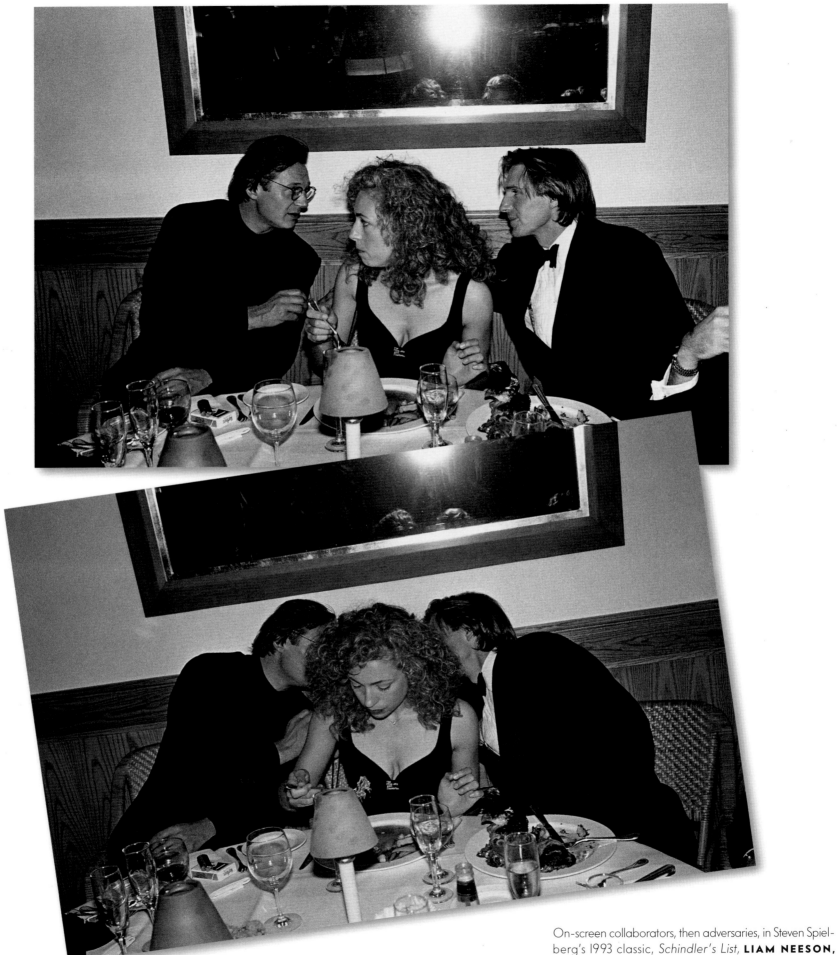

66 Prince, flanked by two bodyguards, stood against a wall sucking on a lollipop. Goldie Hawn kissed Republican campaign strategist Ed Rollins and later gave a big hug to ice princess Nancy Kerrigan. Kirk Douglas greeted Robert De Niro like a long-lost son. 99 —RICHARD JOHNSON WITH KIMBERLEY RYAN
"PAGE SIX," *NEW YORK POST,* MARCH 23, 1994

On-screen collaborators, then adversaries, in Steven Spielberg's 1993 classic, *Schindler's List,* **LIAM NEESON,** left, and **RALPH FIENNES** had received tandem nominations that evening (as lead and supporting actor, respectively). Though neither won, their mesmerizing Holocaust saga was named best picture. Later that night, the Mortons tablemates had an animated tête-à-tête. In the breach: Fiennes's wife at the time, and a future *ER* mainstay, **ALEX KINGSTON.**

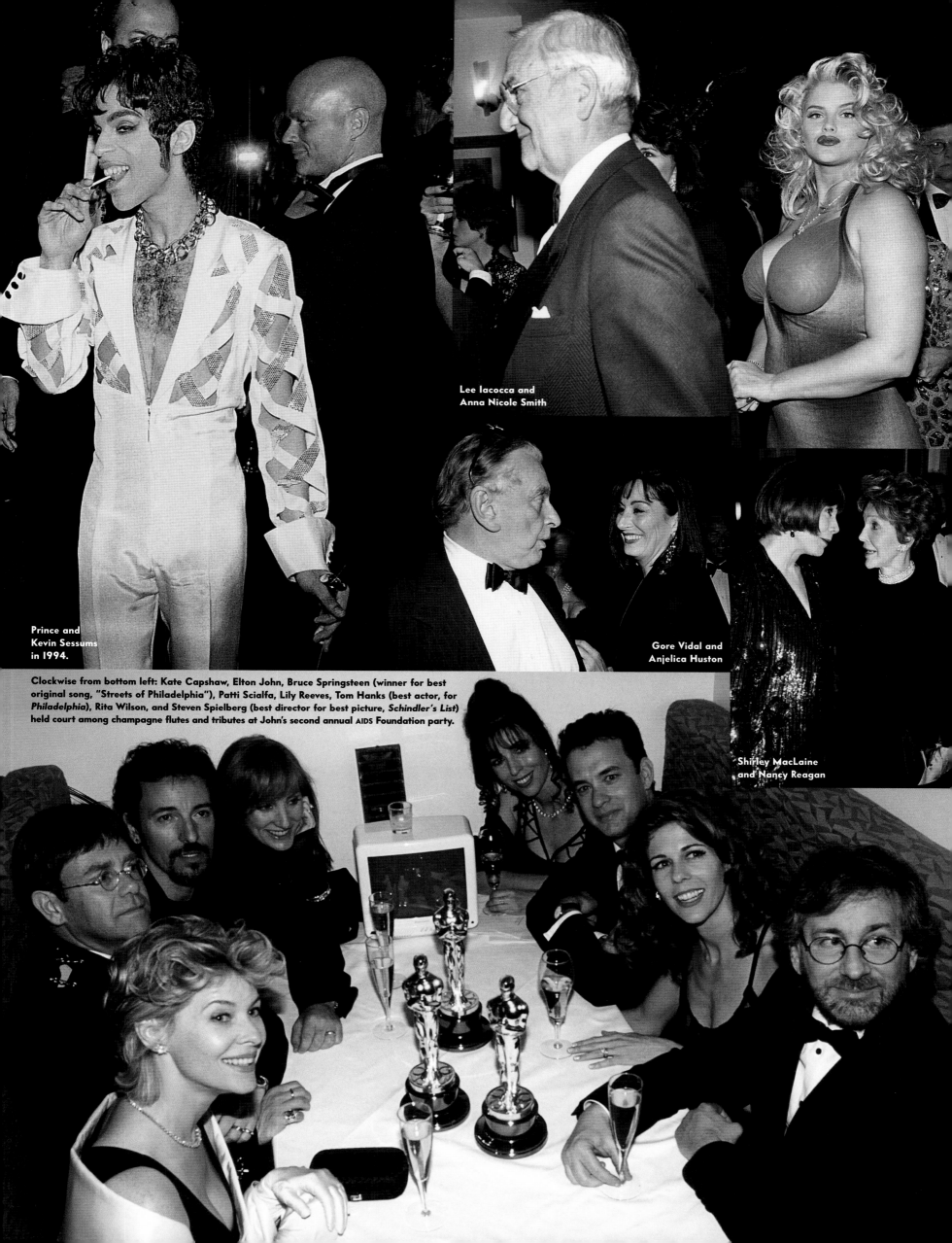

Lee Iacocca and
Anna Nicole Smith

Prince and
Kevin Sessums
in 1994.

Gore Vidal and
Anjelica Huston

Shirley MacLaine
and Nancy Reagan

Clockwise from bottom left: Kate Capshaw, Elton John, Bruce Springsteen (winner for best
original song, "Streets of Philadelphia"), Patti Scialfa, Lily Reeves, Tom Hanks (best actor, for
Philadelphia), Rita Wilson, and Steven Spielberg (best director for best picture, *Schindler's List*)
held court among champagne flutes and tributes at John's second annual AIDS Foundation party.

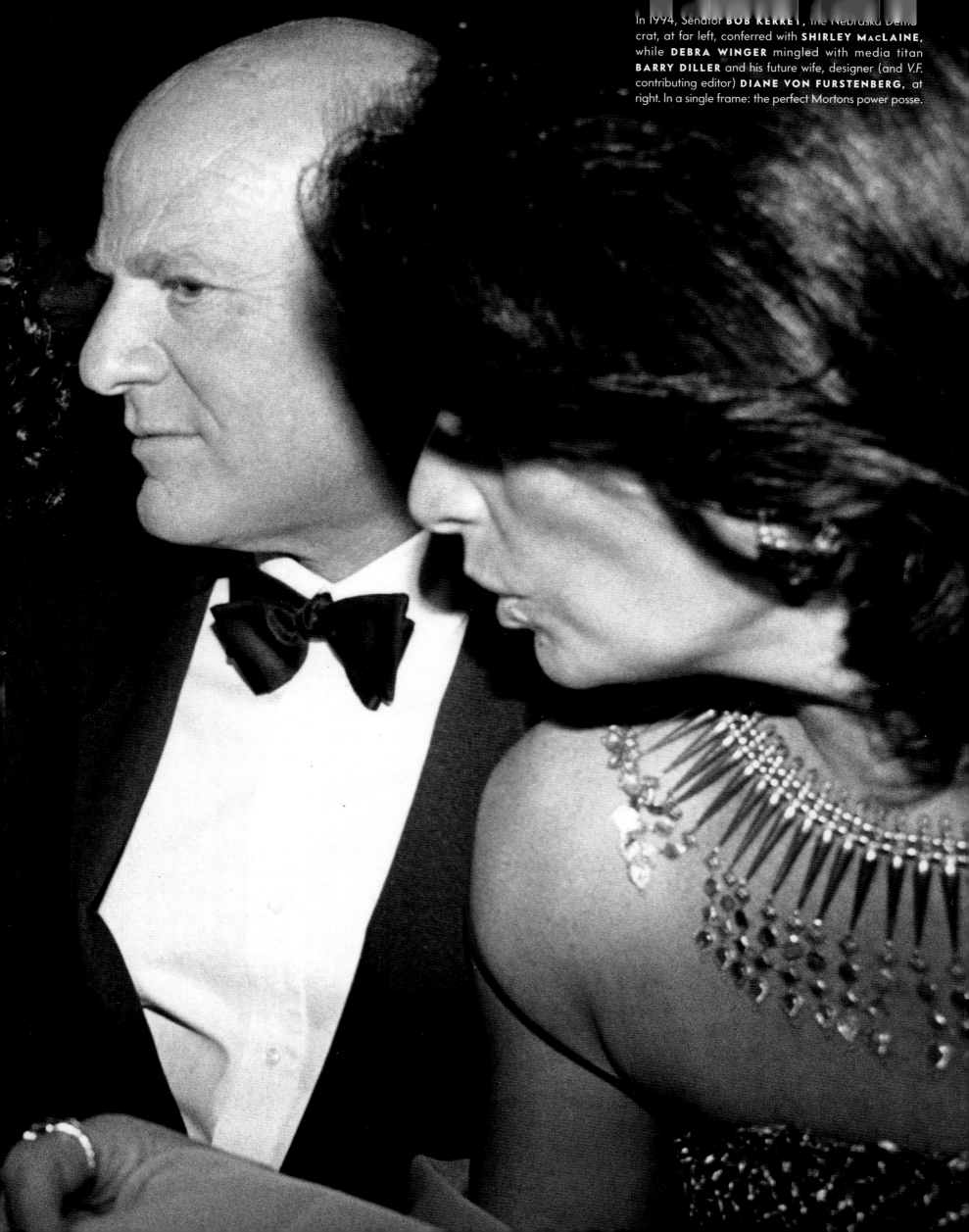

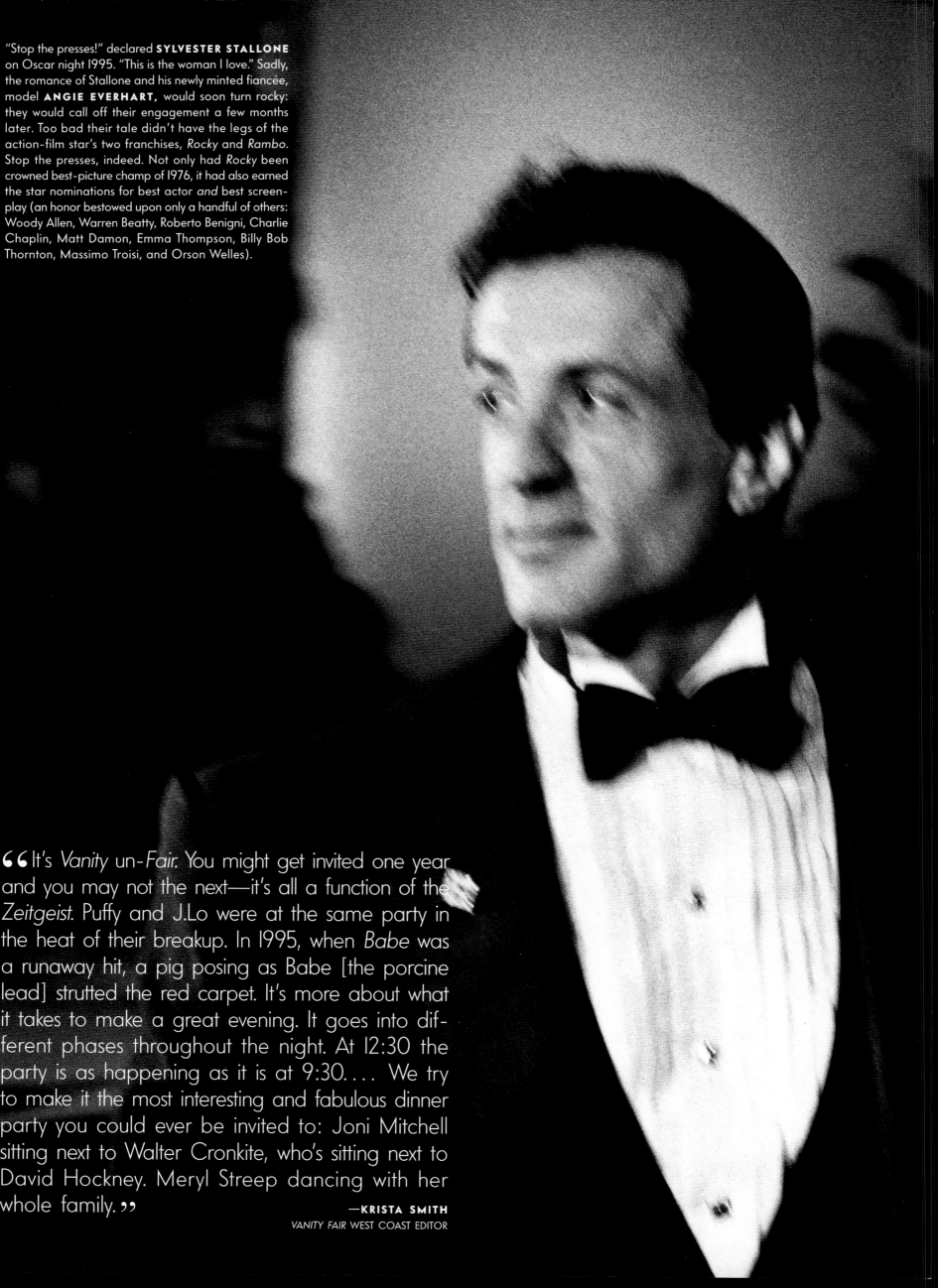

"Stop the presses!" declared **SYLVESTER STALLONE** on Oscar night 1995. "This is the woman I love." Sadly, the romance of Stallone and his newly minted fiancée, model **ANGIE EVERHART,** would soon turn rocky: they would call off their engagement a few months later. Too bad their tale didn't have the legs of the action-film star's two franchises, *Rocky* and *Rambo*. Stop the presses, indeed. Not only had *Rocky* been crowned best-picture champ of 1976, it had also earned the star nominations for best actor *and* best screenplay (an honor bestowed upon only a handful of others: Woody Allen, Warren Beatty, Roberto Benigni, Charlie Chaplin, Matt Damon, Emma Thompson, Billy Bob Thornton, Massimo Troisi, and Orson Welles).

66 It's *Vanity* un-*Fair*. You might get invited one year and you may not the next—it's all a function of the *Zeitgeist*. Puffy and J.Lo were at the same party in the heat of their breakup. In 1995, when *Babe* was a runaway hit, a pig posing as Babe [the porcine lead] strutted the red carpet. It's more about what it takes to make a great evening. It goes into different phases throughout the night. At 12:30 the party is as happening as it is at 9:30.... We try to make it the most interesting and fabulous dinner party you could ever be invited to: Joni Mitchell sitting next to Walter Cronkite, who's sitting next to David Hockney. Meryl Streep dancing with her whole family. 99

—**KRISTA SMITH**
VANITY FAIR WEST COAST EDITOR

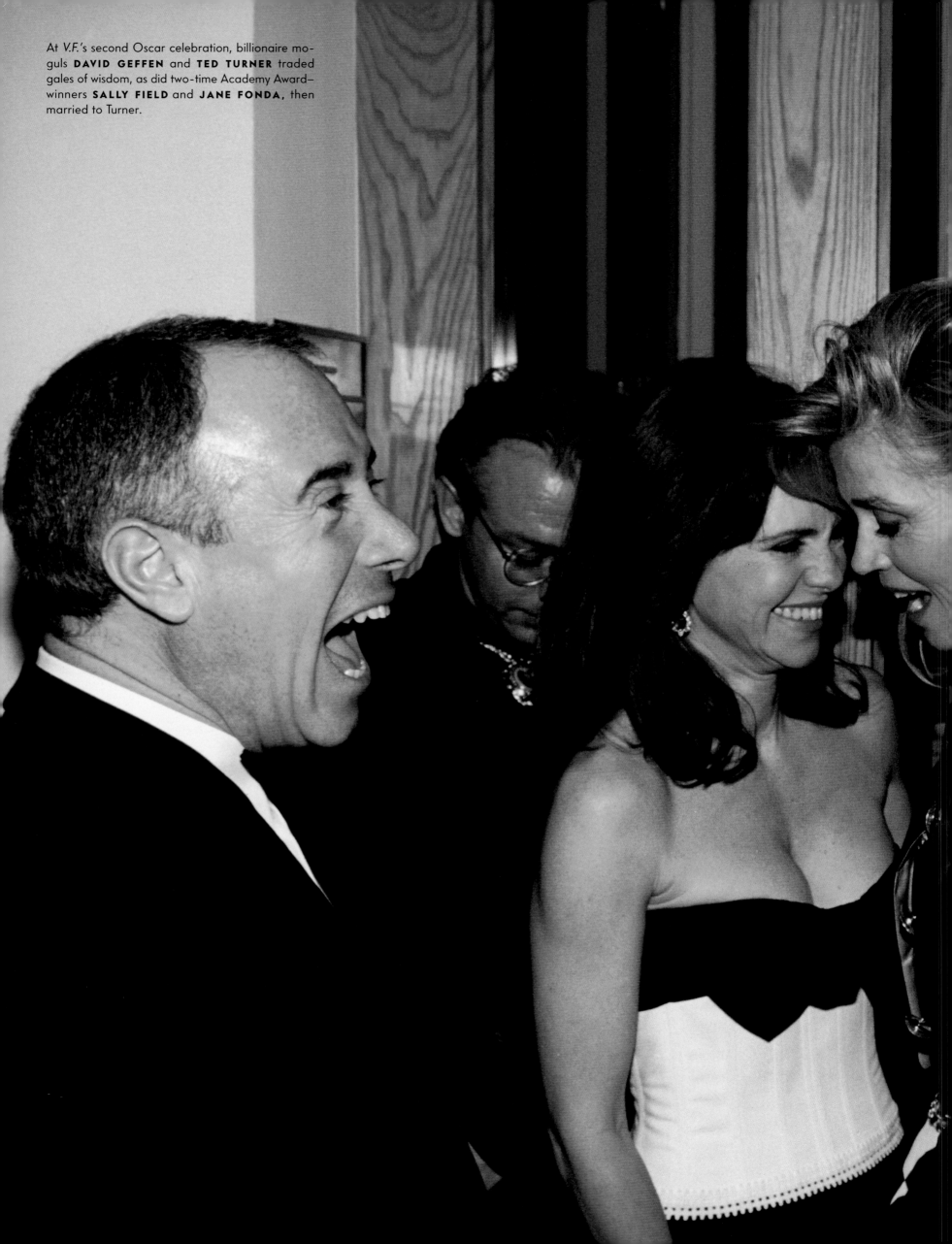

At V.F.'s second Oscar celebration, billionaire moguls **DAVID GEFFEN** and **TED TURNER** traded gales of wisdom, as did two-time Academy Award–winners **SALLY FIELD** and **JANE FONDA**, then married to Turner.

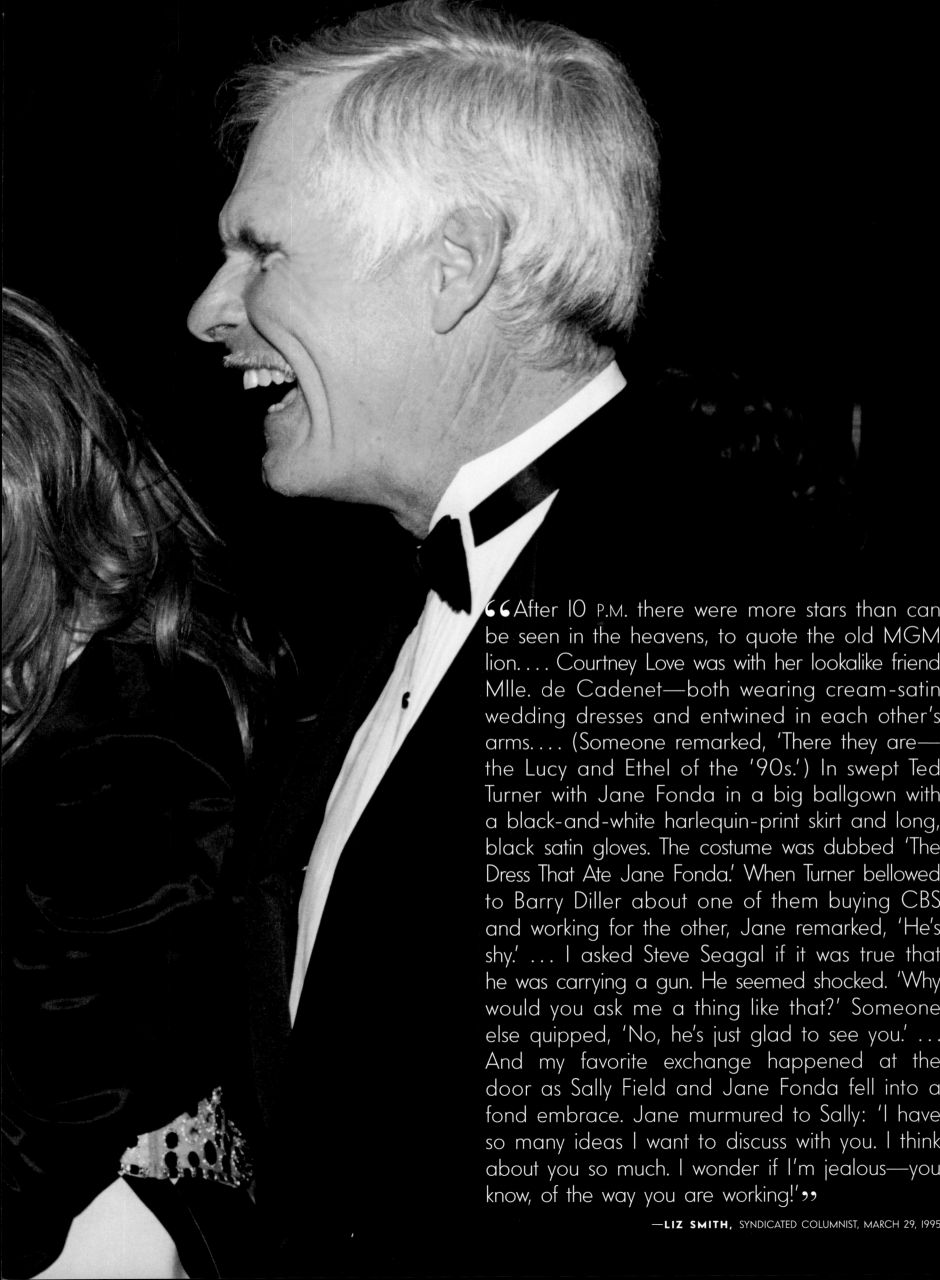

❝After 10 P.M. there were more stars than can be seen in the heavens, to quote the old MGM lion.... Courtney Love was with her lookalike friend Mlle. de Cadenet—both wearing cream-satin wedding dresses and entwined in each other's arms.... (Someone remarked, 'There they are— the Lucy and Ethel of the '90s.') In swept Ted Turner with Jane Fonda in a big ballgown with a black-and-white harlequin-print skirt and long, black satin gloves. The costume was dubbed 'The Dress That Ate Jane Fonda.' When Turner bellowed to Barry Diller about one of them buying CBS and working for the other, Jane remarked, 'He's shy.' ... I asked Steve Seagal if it was true that he was carrying a gun. He seemed shocked. 'Why would you ask me a thing like that?' Someone else quipped, 'No, he's just glad to see you.' ... And my favorite exchange happened at the door as Sally Field and Jane Fonda fell into a fond embrace. Jane murmured to Sally: 'I have so many ideas I want to discuss with you. I think about you so much. I wonder if I'm jealous—you know, of the way you are working!'❞

—LIZ SMITH, SYNDICATED COLUMNIST, MARCH 29, 1995

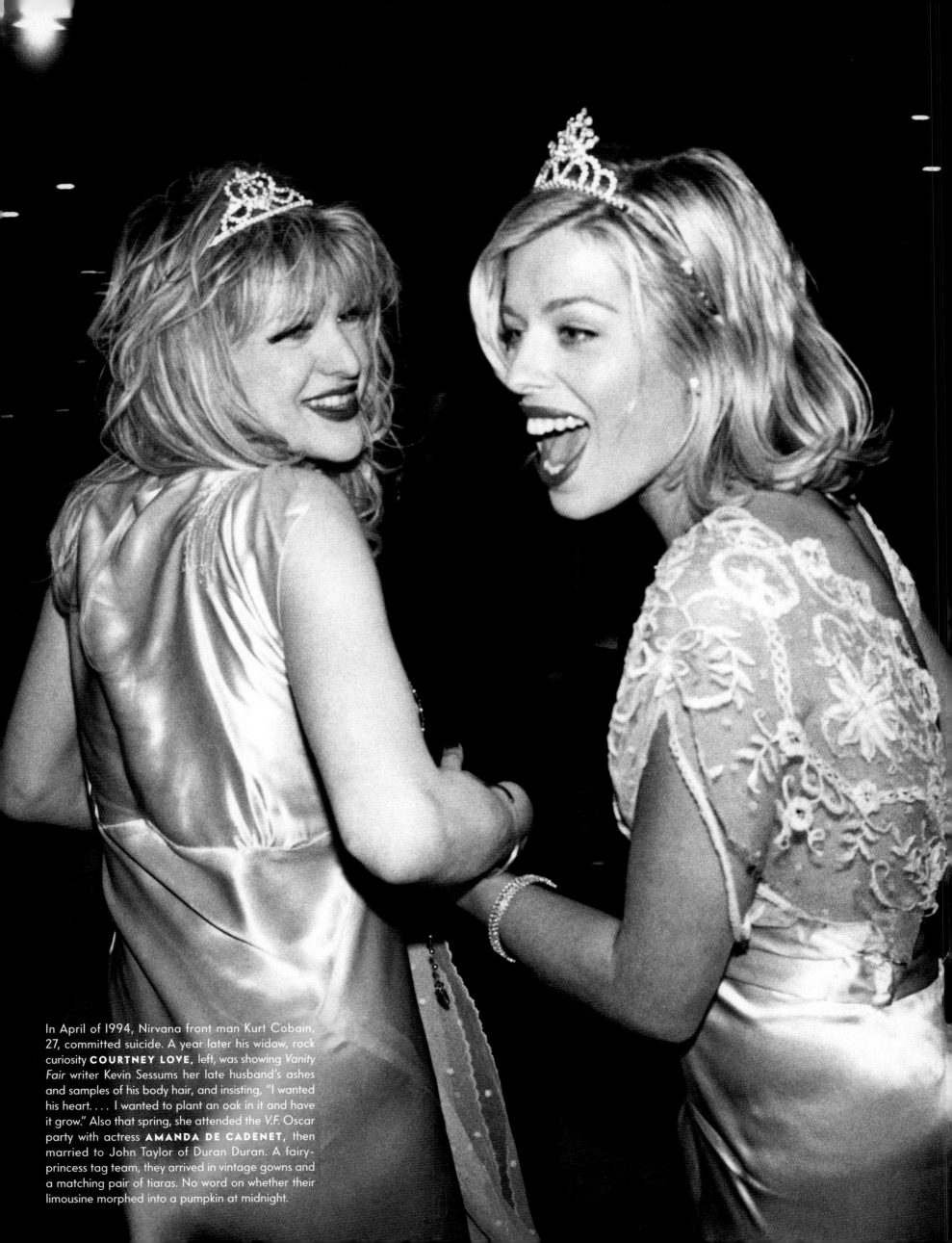

In April of 1994, Nirvana front man Kurt Cobain, 27, committed suicide. A year later his widow, rock curiosity **COURTNEY LOVE**, left, was showing *Vanity Fair* writer Kevin Sessums her late husband's ashes and samples of his body hair, and insisting, "I wanted his heart. . . . I wanted to plant an oak in it and have it grow." Also that spring, she attended the V.F. Oscar party with actress **AMANDA DE CADENET**, then married to John Taylor of Duran Duran. A fairy-princess tag team, they arrived in vintage gowns and a matching pair of tiaras. No word on whether their limousine morphed into a pumpkin at midnight.

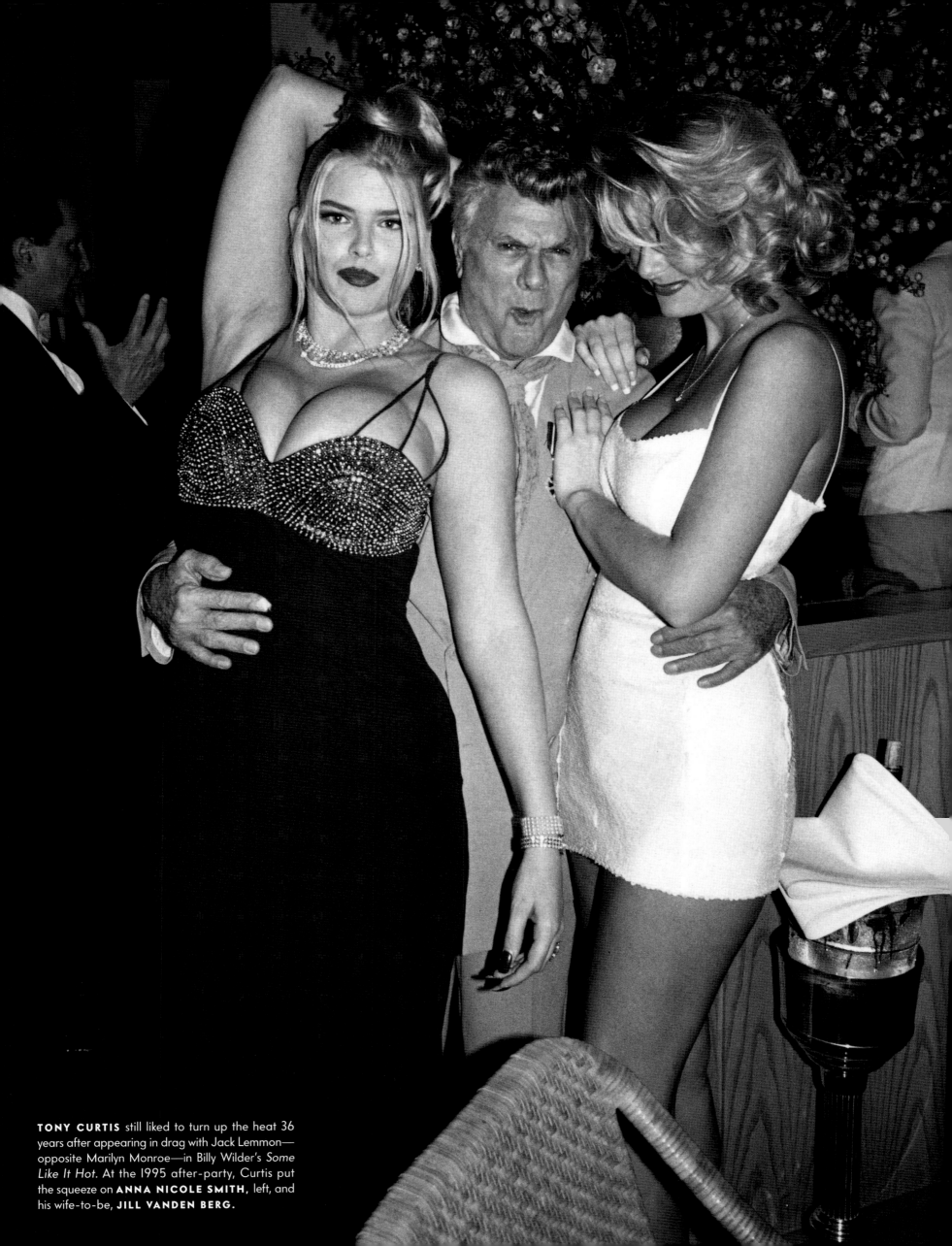

TONY CURTIS still liked to turn up the heat 36 years after appearing in drag with Jack Lemmon—opposite Marilyn Monroe—in Billy Wilder's *Some Like It Hot*. At the 1995 after-party, Curtis put the squeeze on ANNA NICOLE SMITH, left, and his wife-to-be, JILL VANDEN BERG.

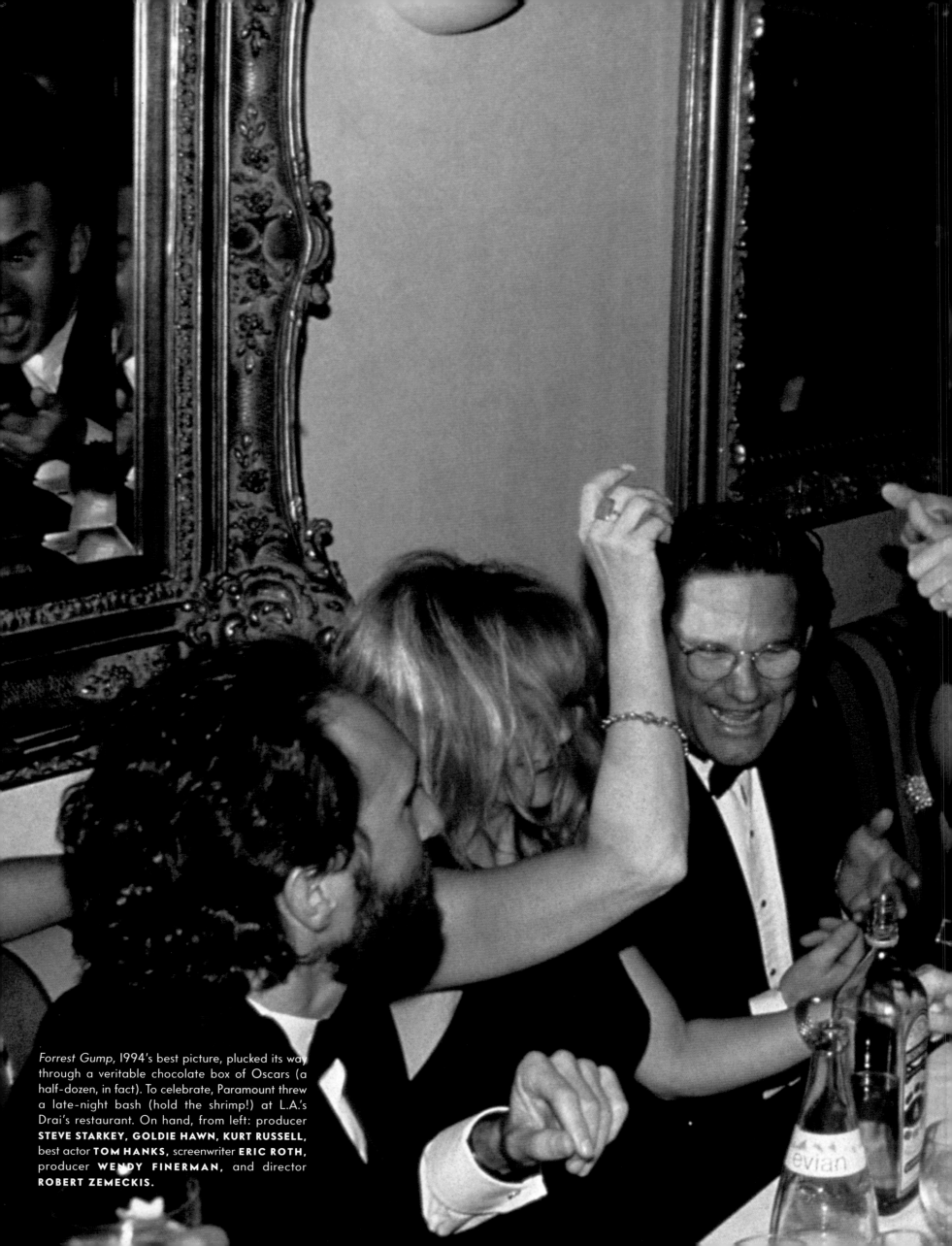

Forrest Gump, 1994's best picture, plucked its way through a veritable chocolate box of Oscars (a half-dozen, in fact). To celebrate, Paramount threw a late-night bash (hold the shrimp!) at L.A.'s Drai's restaurant. On hand, from left: producer **STEVE STARKEY, GOLDIE HAWN, KURT RUSSELL,** best actor **TOM HANKS,** screenwriter **ERIC ROTH,** producer **WENDY FINERMAN,** and director **ROBERT ZEMECKIS.**

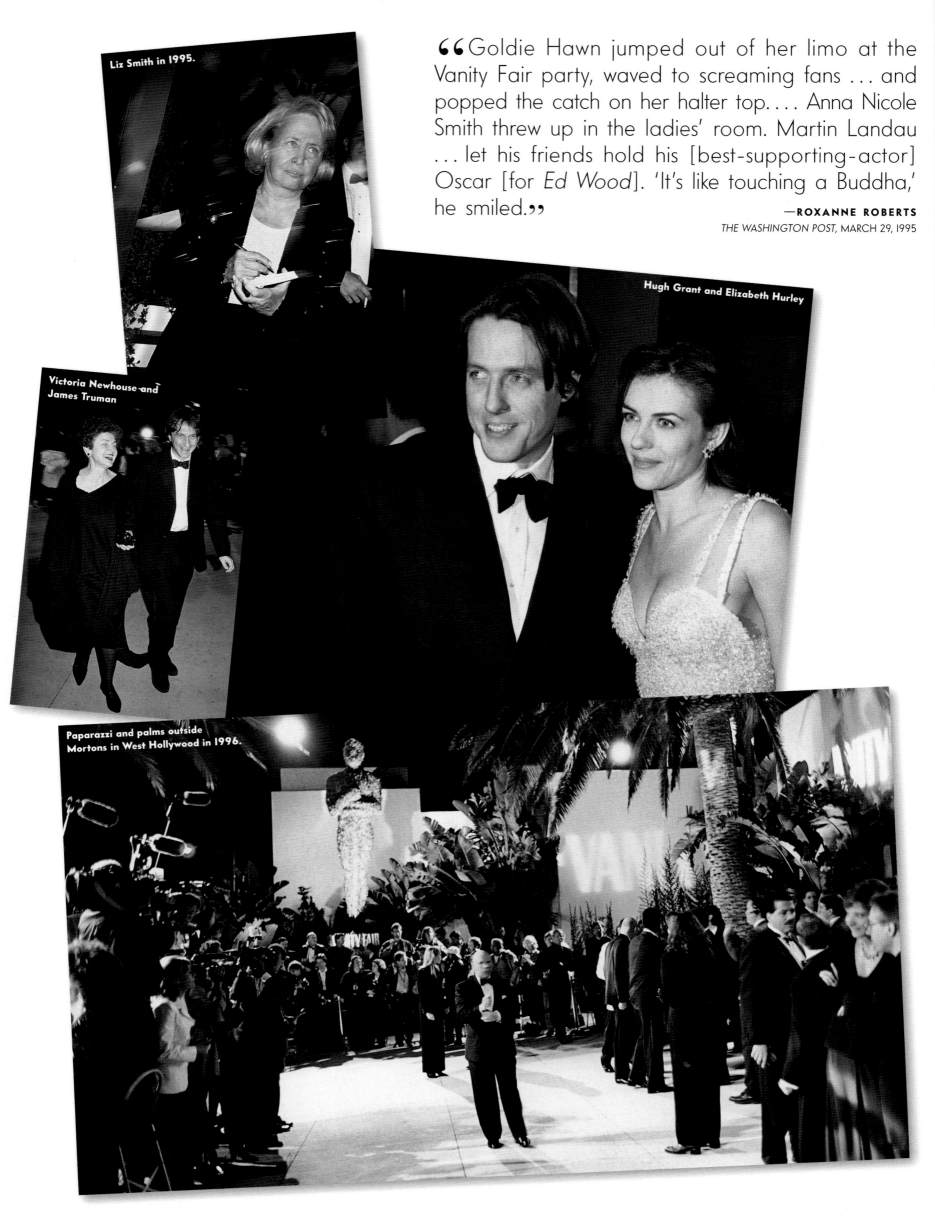

Liz Smith in 1995.

"Goldie Hawn jumped out of her limo at the Vanity Fair party, waved to screaming fans ... and popped the catch on her halter top.... Anna Nicole Smith threw up in the ladies' room. Martin Landau ... let his friends hold his [best-supporting-actor] Oscar [for *Ed Wood*]. 'It's like touching a Buddha,' he smiled."

—ROXANNE ROBERTS
THE WASHINGTON POST, MARCH 29, 1995

Hugh Grant and Elizabeth Hurley

Victoria Newhouse and James Truman

Paparazzi and palms outside Mortons in West Hollywood in 1996.

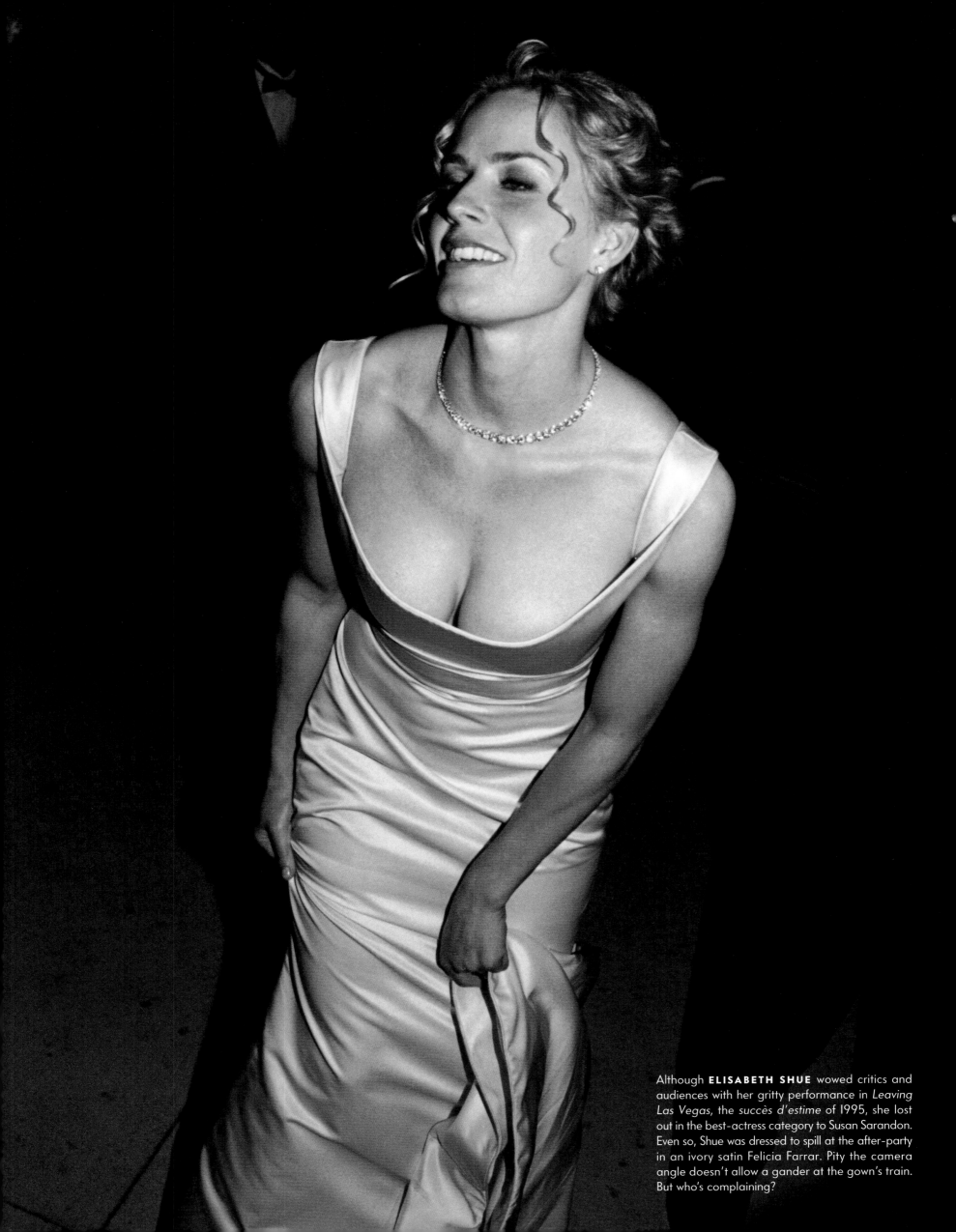

Although **ELISABETH SHUE** wowed critics and audiences with her gritty performance in *Leaving Las Vegas*, the *succès d'estime* of 1995, she lost out in the best-actress category to Susan Sarandon. Even so, Shue was dressed to spill at the after-party in an ivory satin Felicia Farrar. Pity the camera angle doesn't allow a gander at the gown's train. But who's complaining?

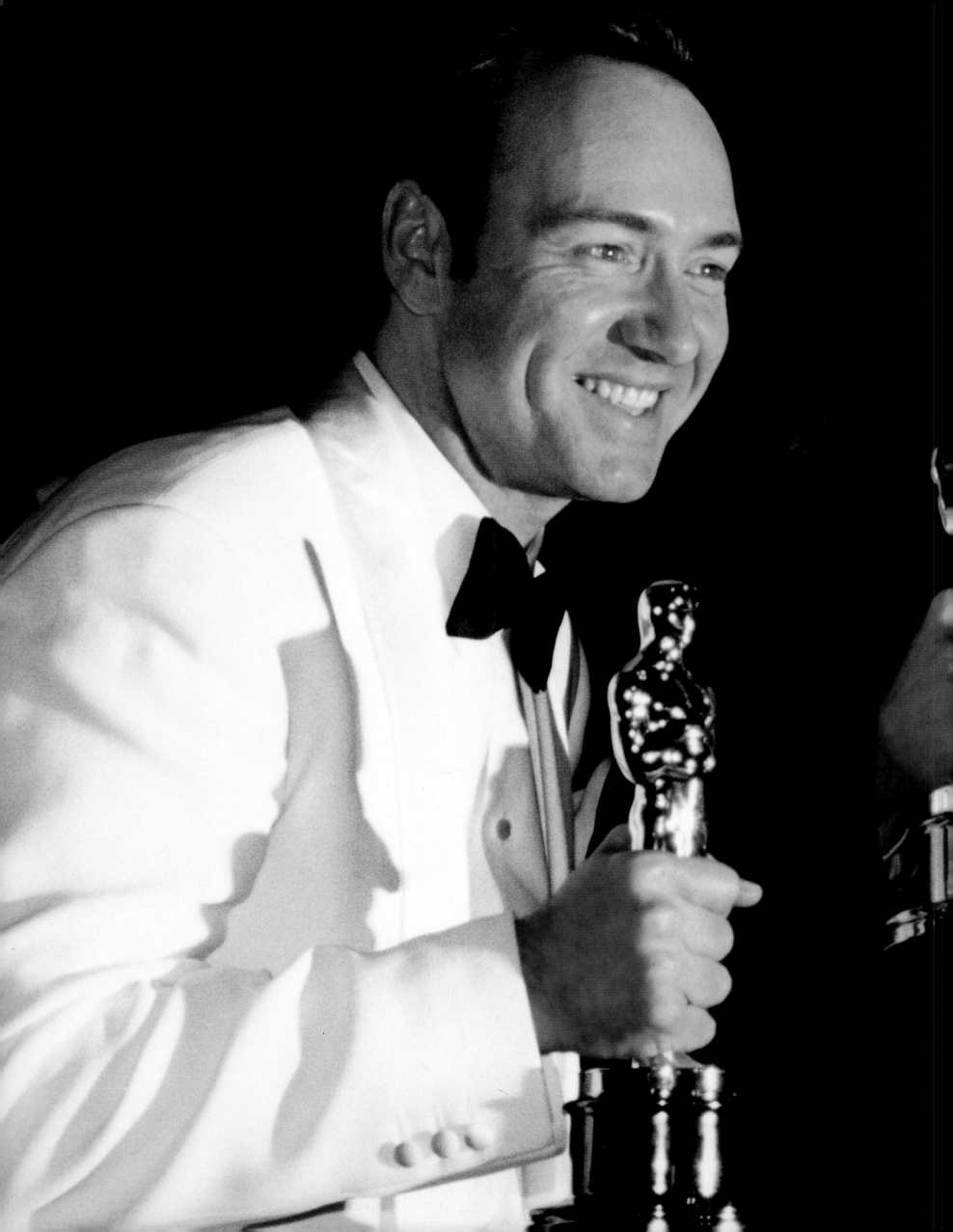

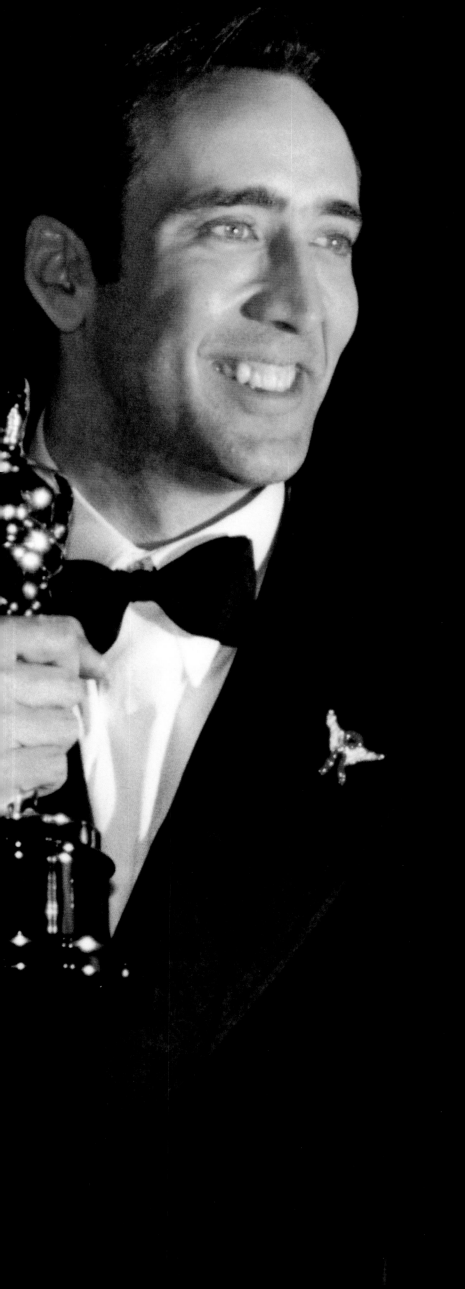

First-time Oscarlings **KEVIN SPACEY,** left, who won the 1995 best-supporting runoff for his part in *The Usual Suspects,* and **NICOLAS CAGE,** who took that night's best-actor trophy for *Leaving Las Vegas,* became the hub of the after-party hubbub, showing off their pearly whites and their Oscars' gleam. At right, Cage's then wife, **PATRICIA ARQUETTE.**

❝The road to glamour *Vanity Fair*–style came after successfully passing the police barricade on Robertson Boulevard. It was here that privileged guest was separated from ordinary, inconvenienced motorist. Fifty yards further, one of the 25 parking attendants was opening car doors and there was a chance to take in the scene: the pair of 30-foot Oscar-shaped topiaries that looked like behemoth Chia plants, the 40 film crews yelling in a babel of foreign accents, dozens of security guards talking frantically into their sleeves, the rock concert–style lighting system that bathed Mortons restaurant in purples, yellows and pinks.... Who could blame the crowd for talking? How often does Diana Ross get to dine with Prince Dimitri of Yugoslavia and Tim Allen?... 'I interviewed this whole room,' Larry King said as he surveyed the mob.❞

—BILL HIGGINS
LOS ANGELES TIMES, MARCH 27, 1996

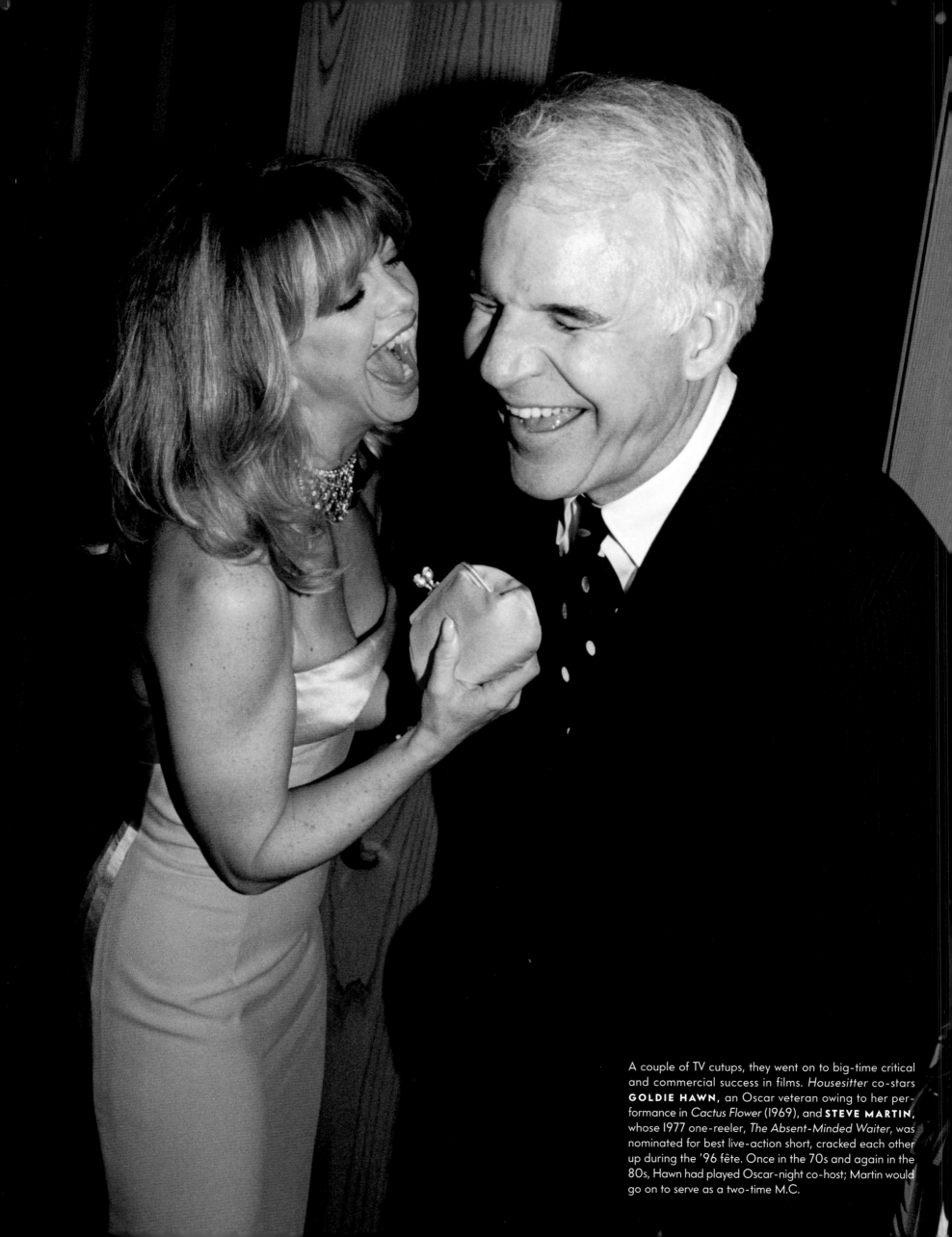

A couple of TV cutups, they went on to big-time critical and commercial success in films. *Housesitter* co-stars **GOLDIE HAWN,** an Oscar veteran owing to her performance in *Cactus Flower* (1969), and **STEVE MARTIN,** whose 1977 one-reeler, *The Absent-Minded Waiter,* was nominated for best live-action short, cracked each other up during the '96 fête. Once in the 70s and again in the 80s, Hawn had played Oscar-night co-host; Martin would go on to serve as a two-time M.C.

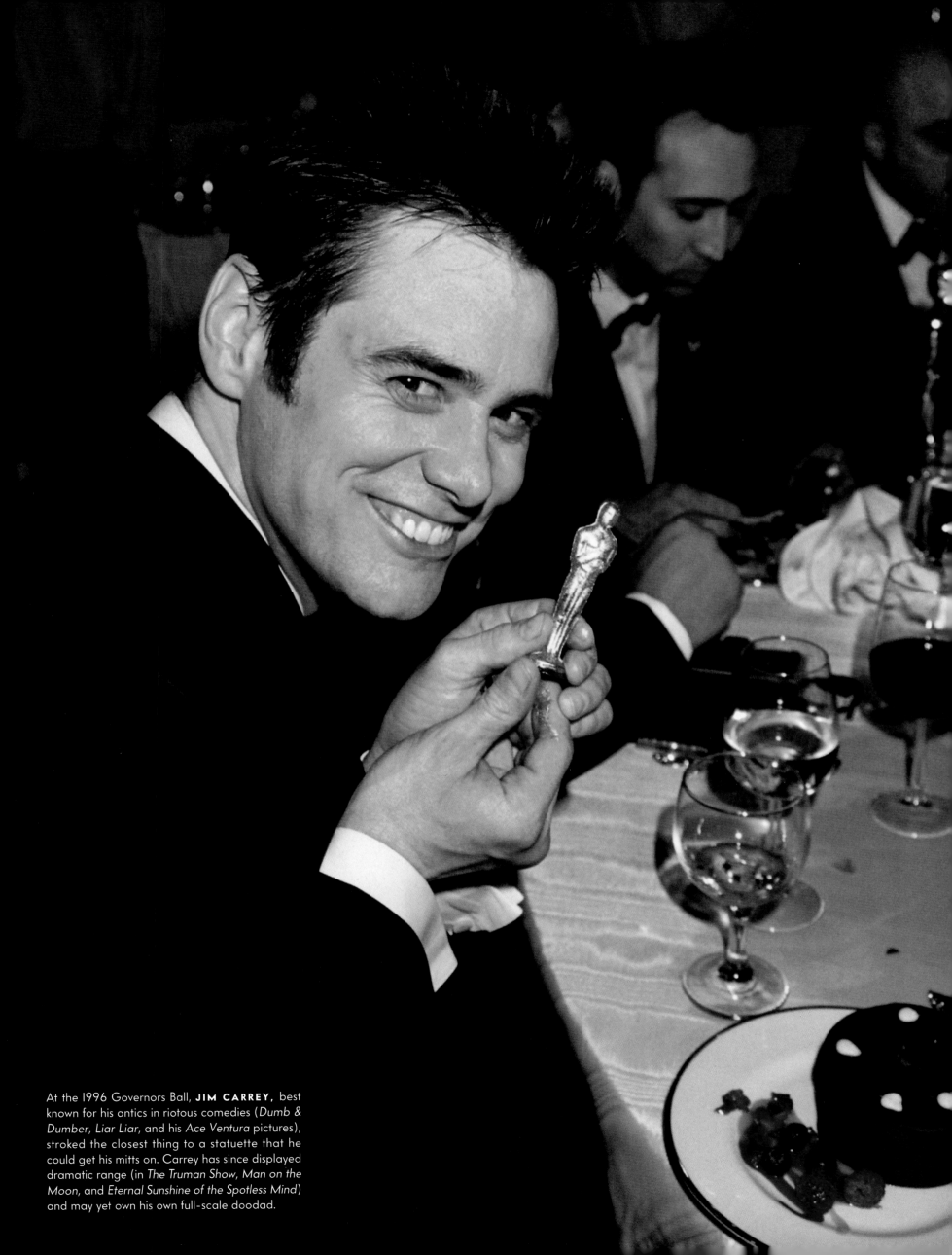

At the 1996 Governors Ball, **JIM CARREY,** best known for his antics in riotous comedies (*Dumb & Dumber, Liar Liar,* and his *Ace Ventura* pictures), stroked the closest thing to a statuette that he could get his mitts on. Carrey has since displayed dramatic range (in *The Truman Show, Man on the Moon,* and *Eternal Sunshine of the Spotless Mind*) and may yet own his own full-scale doodad.

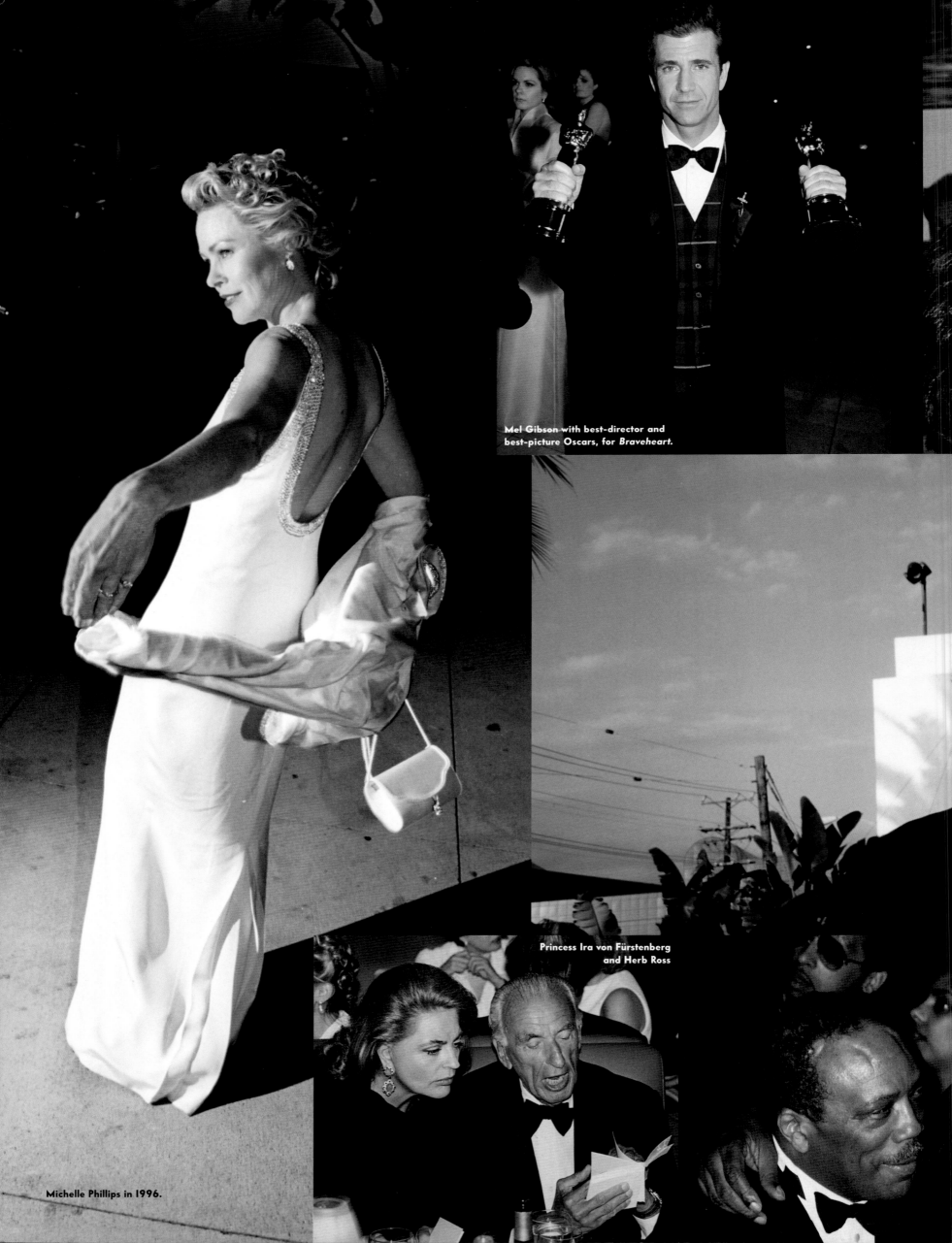

Mel Gibson with best-director and best-picture Oscars, for *Braveheart*.

Princess Ira von Fürstenberg and Herb Ross

Michelle Phillips in 1996.

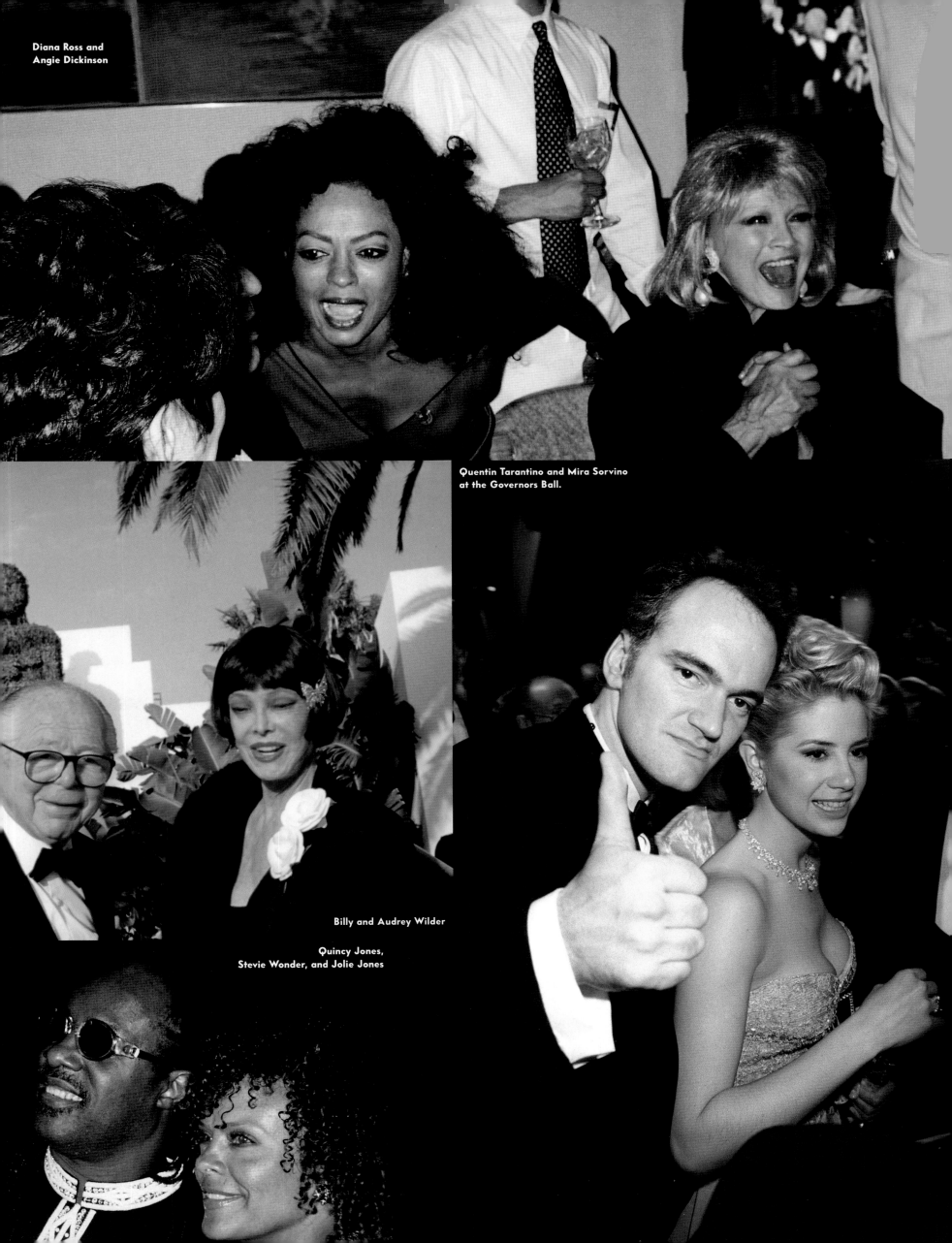

Diana Ross and
Angie Dickinson

Quentin Tarantino and Mira Sorvino
at the Governors Ball.

Billy and Audrey Wilder

Quincy Jones,
Stevie Wonder, and Jolie Jones

❝ [*Vanity Fair's*] entree into the Oscar-party void left by the death of the inimitable agent Irving (Swifty) Lazar was initially greeted on the Left Coast with the kind of skepticism reserved for all carpetbaggers who attempt to muscle their way into Hollywood's company town. But this year's soiree left no doubt that the ghost of Swifty has been buried once and for all.... Standing in the center of Mortons was like treading water in a celebrity wave pool. ❞ —FRANK DiGIACOMO

THE NEW YORK OBSERVER, MARCH 31, 1997

Hands behind her, the rest all smile and sizzle, **KELLY LYNCH,** in 1997, seemed the apotheosis of the Hollywood actress, tripping motor drives with abandon.

Photographer Dafydd Jones was nimble enough to move in and catch this sequence as **TOM CRUISE** high-fived his *Jerry Maguire* co-star **CUBA GOODING JR.**, while **JIM CARREY** and **LAUREN HOLLY**, standing, and **KEVIN SESSUMS** and **PAULA WAGNER**, seated, watched their victory dance. Earlier that evening, Gooding had earned the night's runaway-rapture prize by hefting up his 1996 best-supporting-actor O and doing a hallelujah number ("Everybody involved with the movie! I love you! . . . I love you!") to a standing O. Even compared with Roberto Benigni (who accepted his 1998 best-actor bijou after a traipse atop the theater-seat armrests), no Academy Award recipient had ever seemed more ebullient. Show me the Oscar!

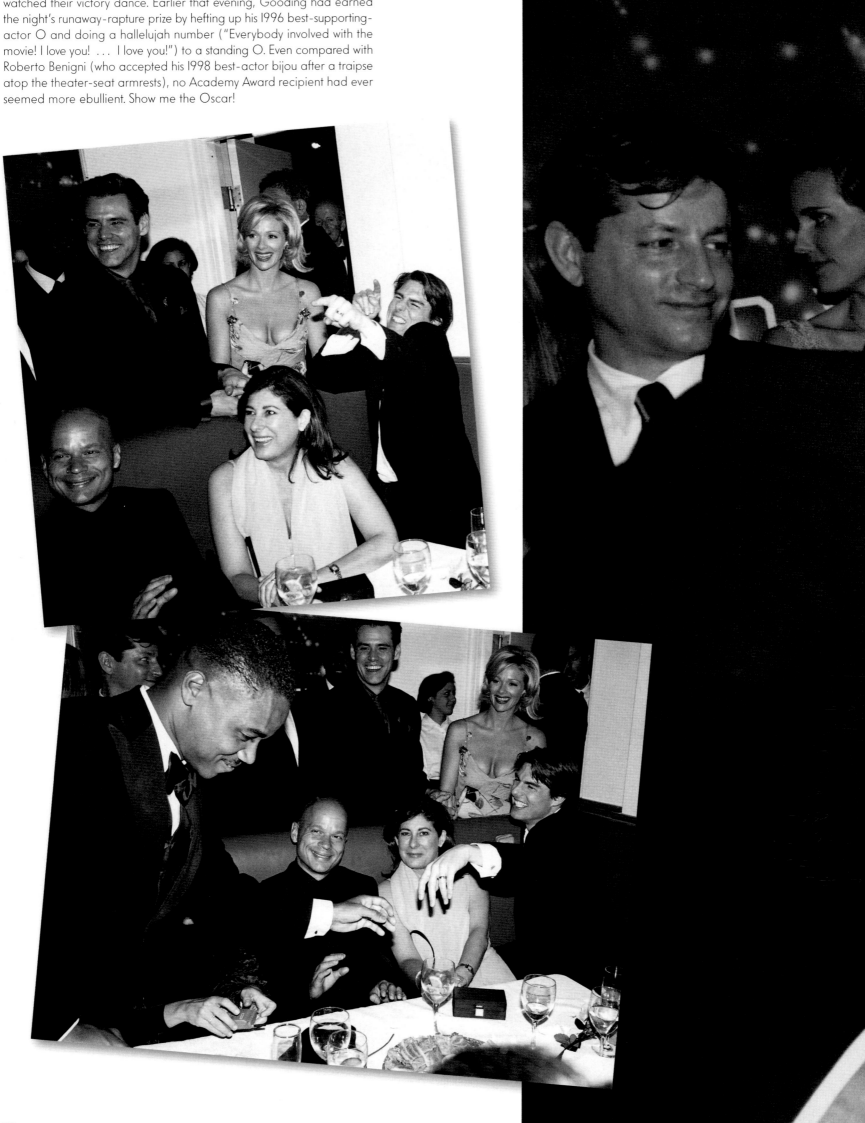

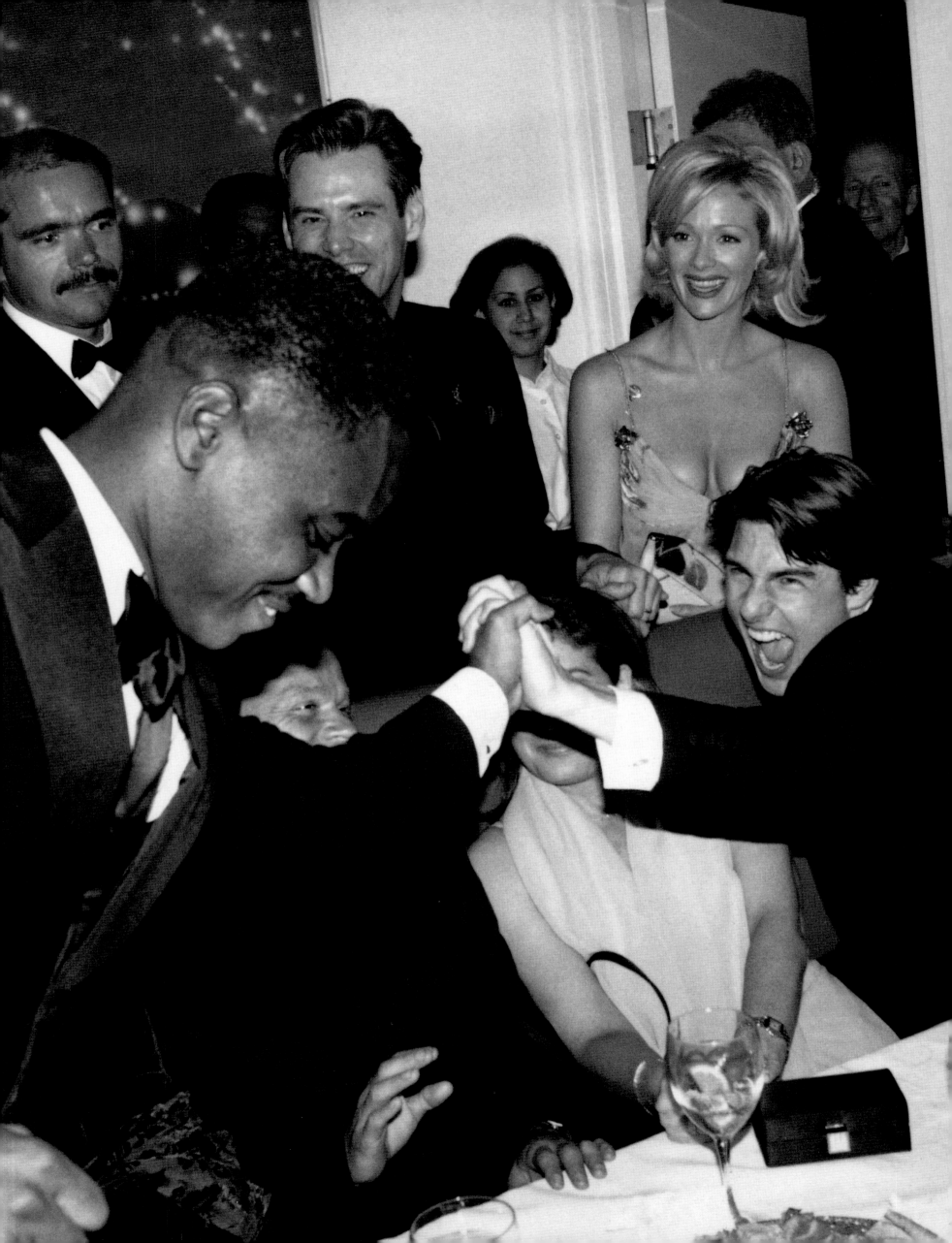

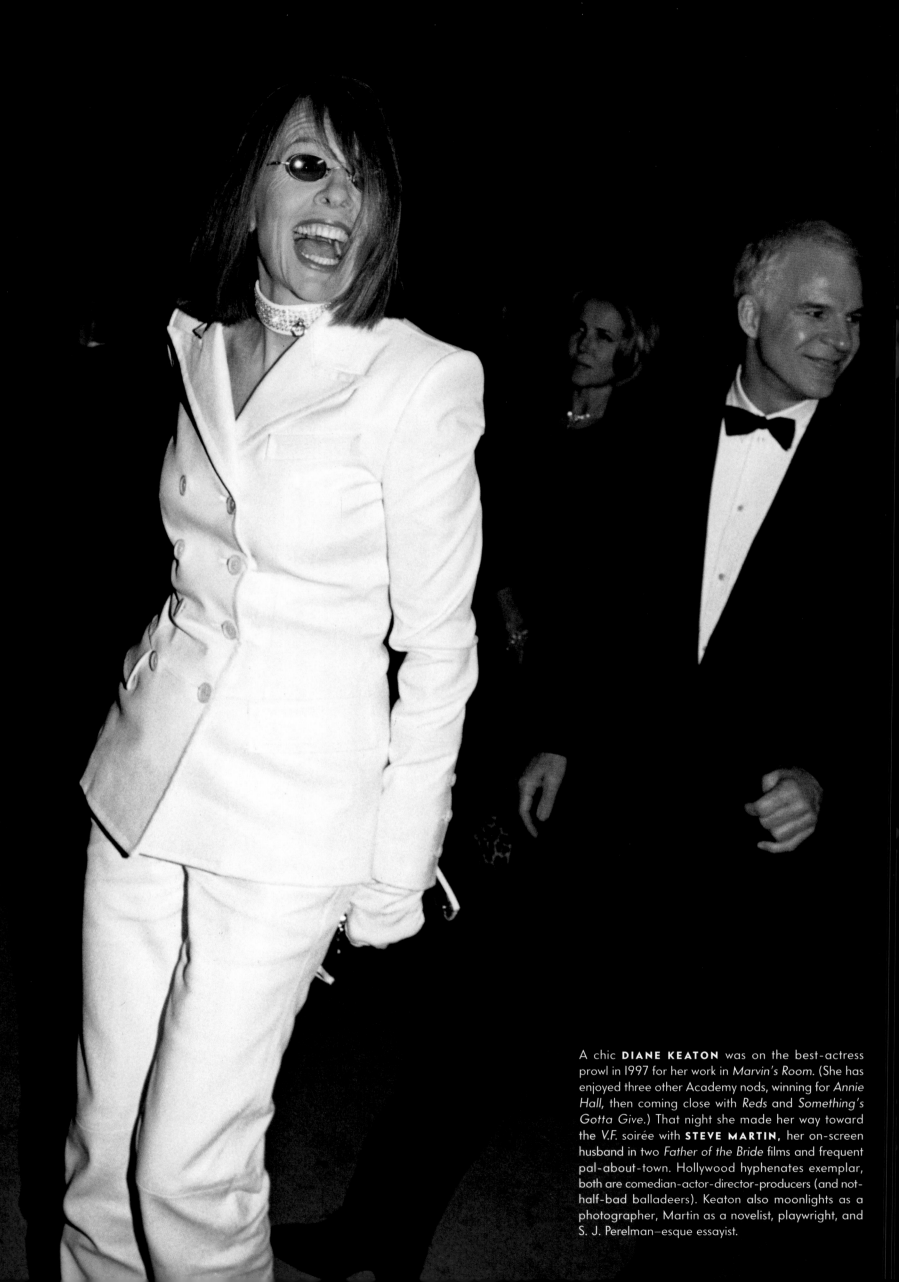

A chic **DIANE KEATON** was on the best-actress prowl in 1997 for her work in *Marvin's Room*. (She has enjoyed three other Academy nods, winning for *Annie Hall*, then coming close with *Reds* and *Something's Gotta Give*.) That night she made her way toward the V.F. soirée with **STEVE MARTIN,** her on-screen husband in two *Father of the Bride* films and frequent pal-about-town. Hollywood hyphenates exemplar, both are comedian-actor-director-producers (and not-half-bad balladeers). Keaton also moonlights as a photographer, Martin as a novelist, playwright, and S. J. Perelman–esque essayist.

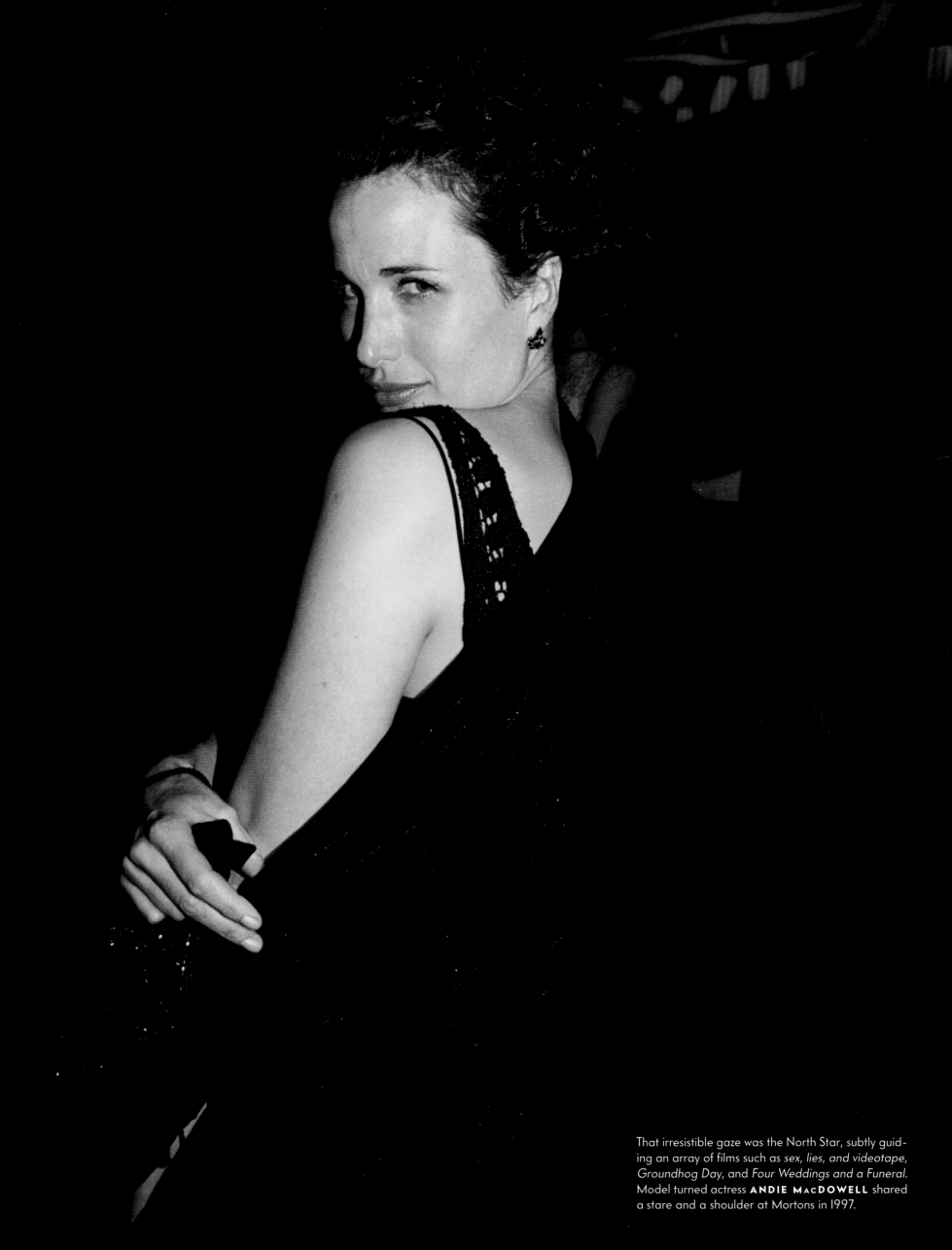

That irresistible gaze was the North Star, subtly guiding an array of films such as *sex, lies, and videotape*, *Groundhog Day*, and *Four Weddings and a Funeral*. Model turned actress **ANDIE MACDOWELL** shared a stare and a shoulder at Mortons in 1997.

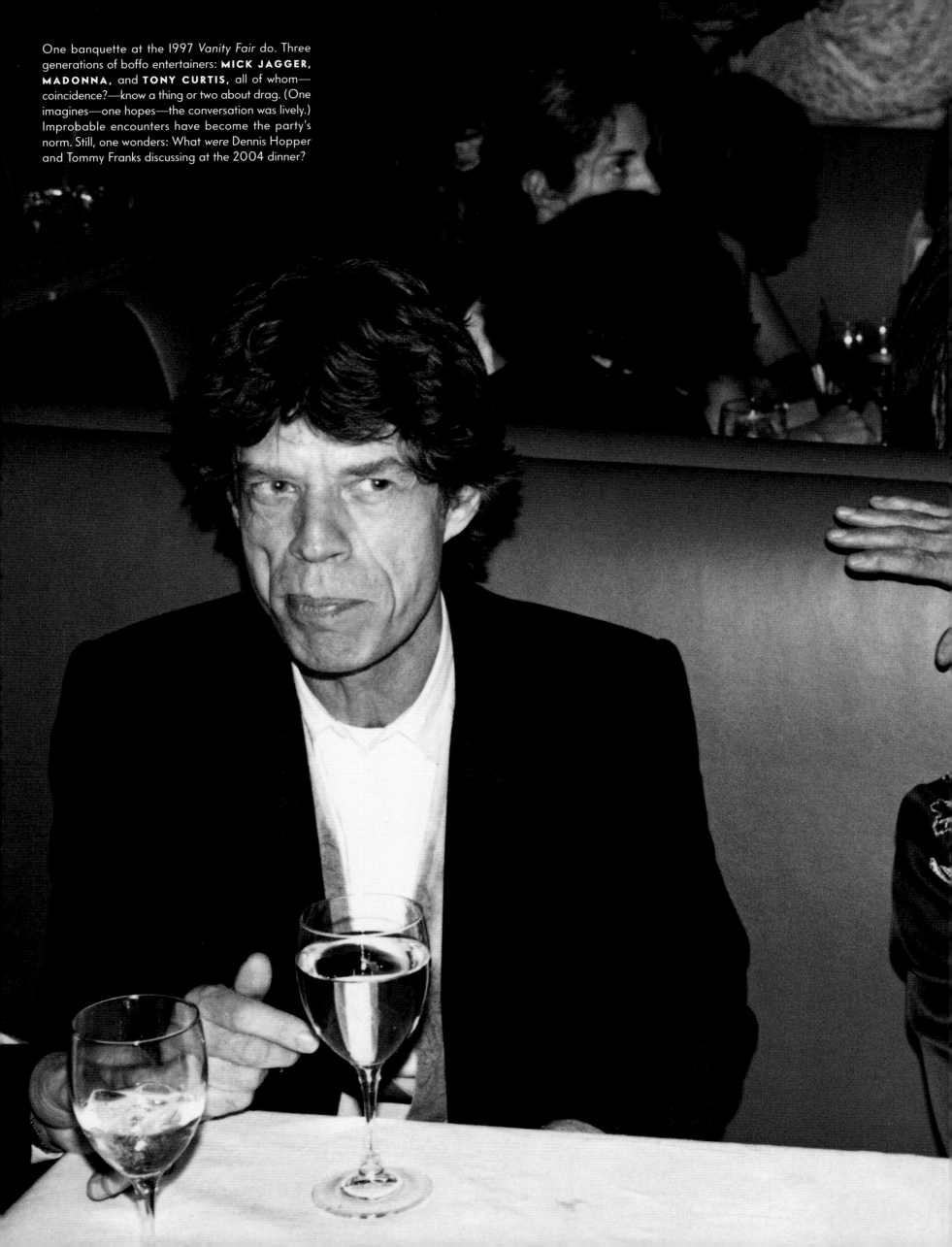

One banquette at the 1997 *Vanity Fair* do. Three generations of boffo entertainers: **MICK JAGGER, MADONNA,** and **TONY CURTIS,** all of whom—coincidence?—know a thing or two about drag. (One imagines—one hopes—the conversation was lively.) Improbable encounters have become the party's norm. Still, one wonders: What *were* Dennis Hopper and Tommy Franks discussing at the 2004 dinner?

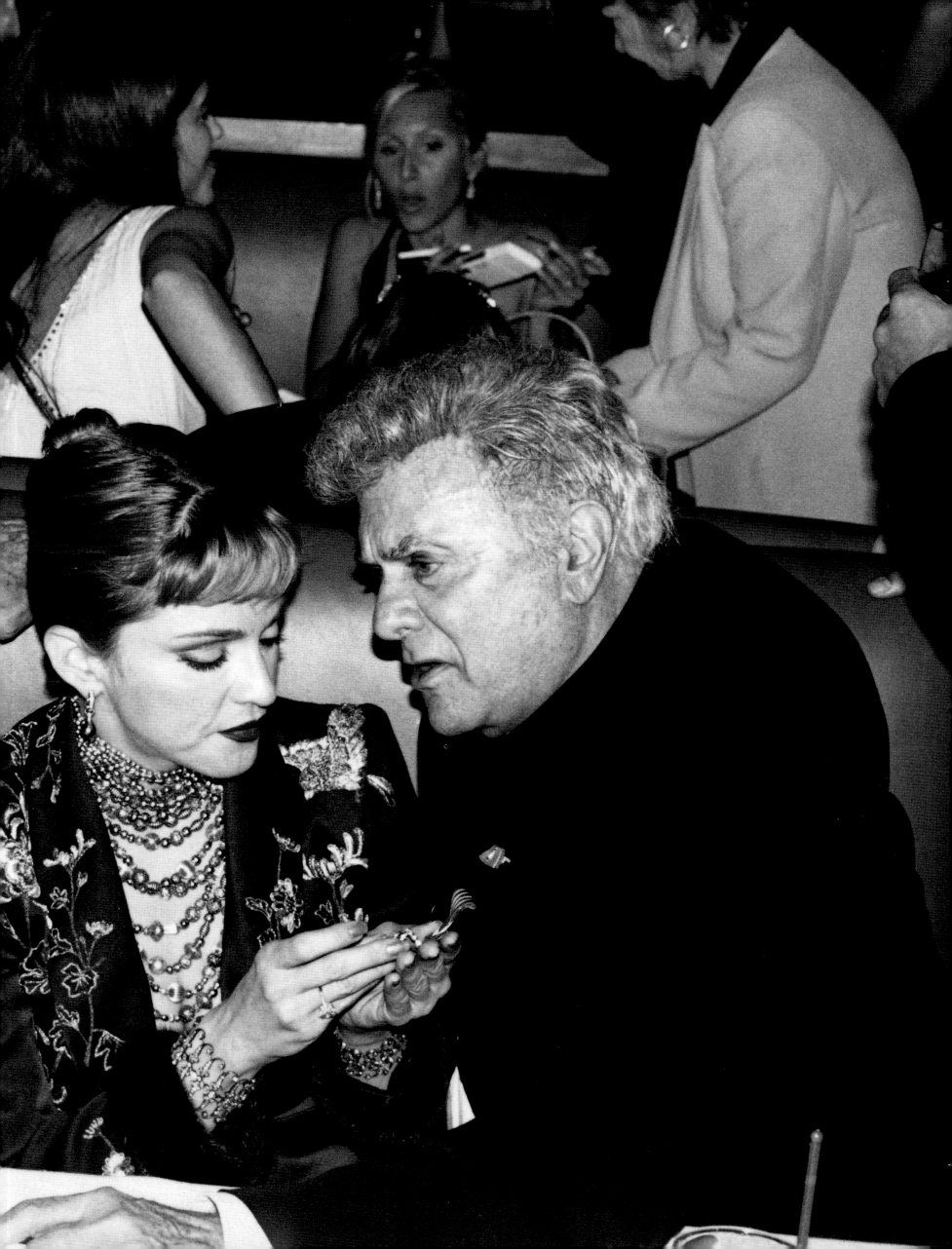

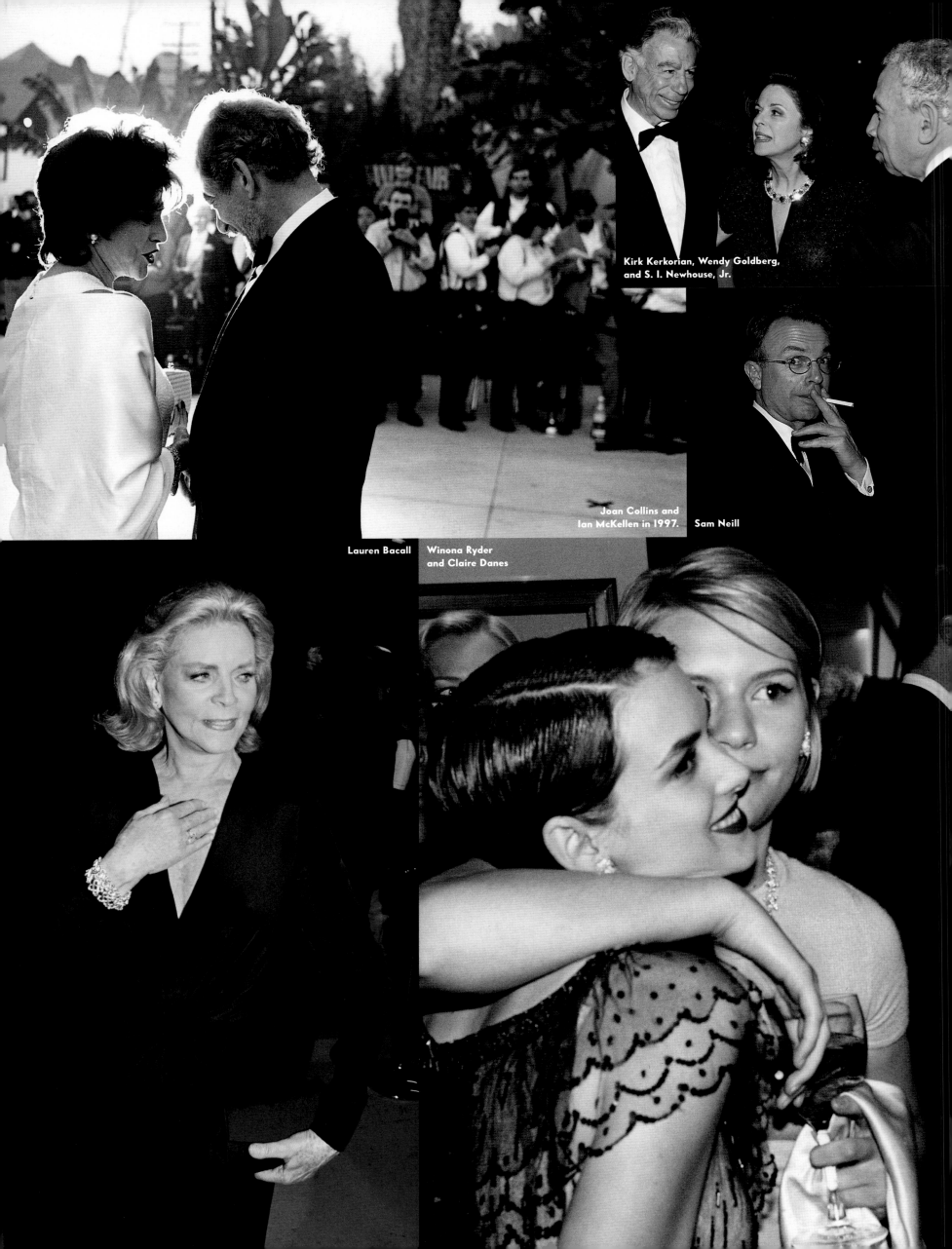

Kirk Kerkorian, Wendy Goldberg, and S. I. Newhouse, Jr.

Joan Collins and Ian McKellen in 1997.

Sam Neill

Lauren Bacall

Winona Ryder and Claire Danes

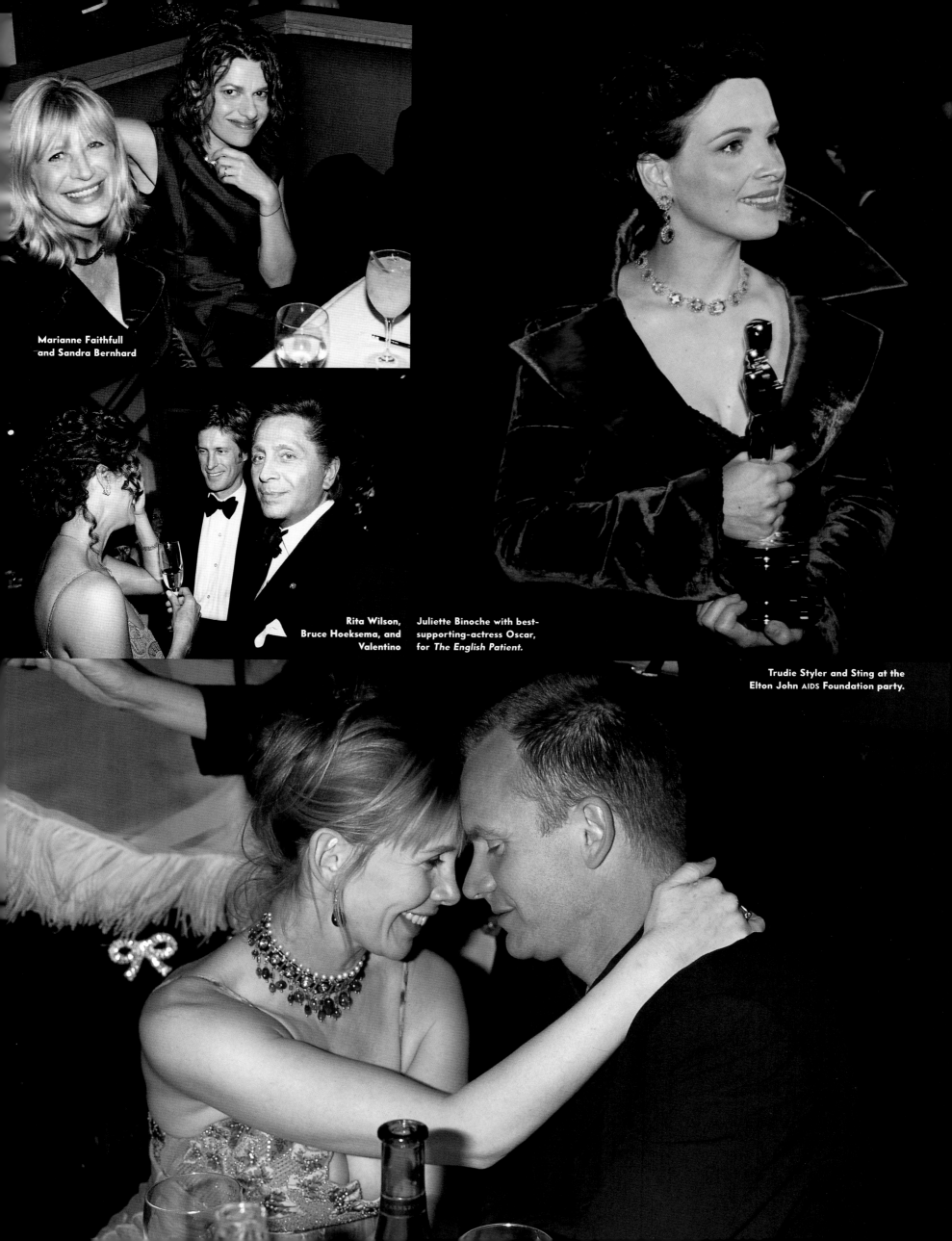

Marianne Faithfull and Sandra Bernhard

Rita Wilson, Bruce Hoeksema, and Valentino

Juliette Binoche with best-supporting-actress Oscar, for *The English Patient*.

Trudie Styler and Sting at the Elton John AIDS Foundation party.

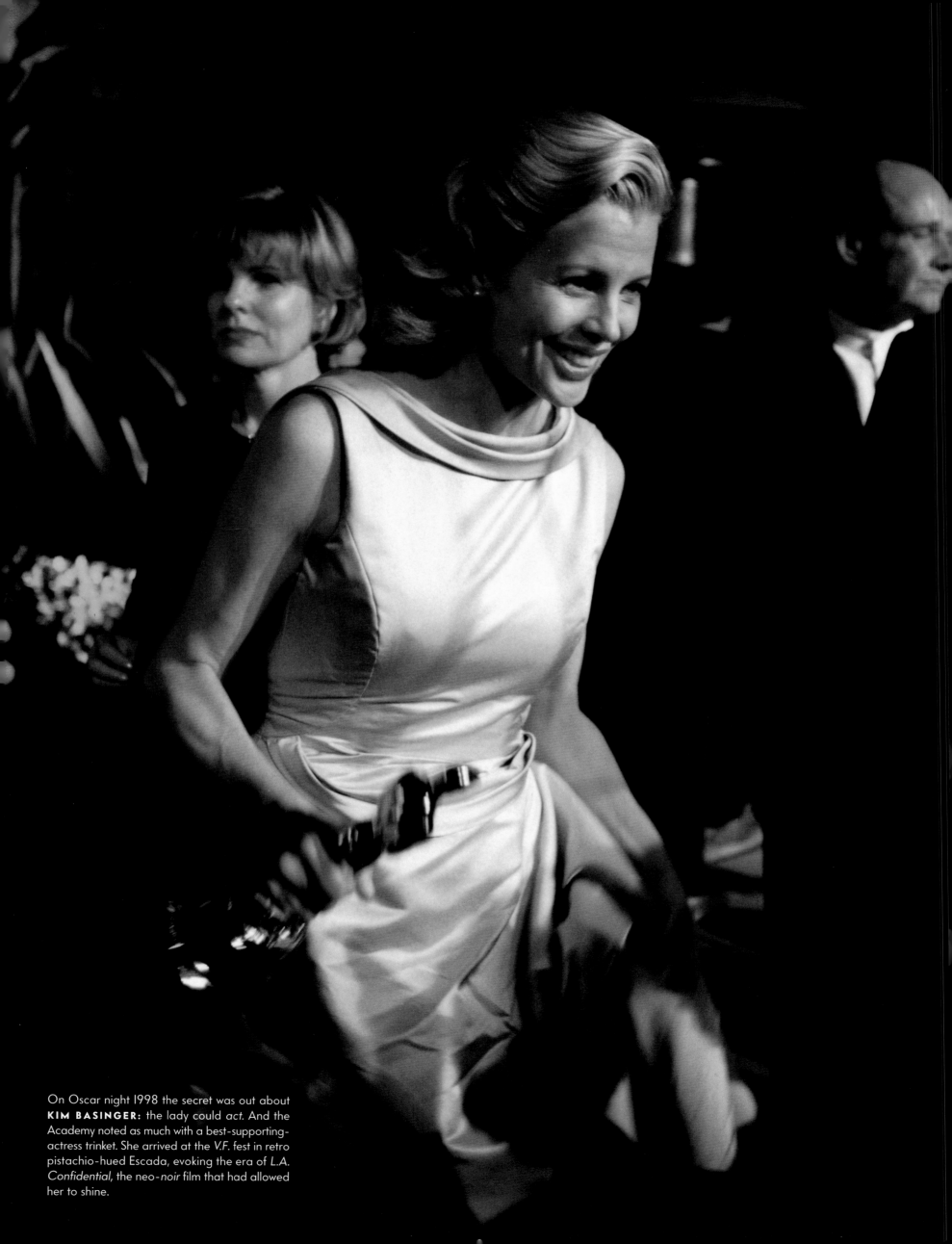

On Oscar night 1998 the secret was out about **KIM BASINGER:** the lady could *act*. And the Academy noted as much with a best-supporting-actress trinket. She arrived at the *V.F.* fest in retro pistachio-hued Escada, evoking the era of *L.A. Confidential,* the neo-*noir* film that had allowed her to shine.

"It's like the school proms. Everybody looks great for the first part of the evening, and toward the end of the evening the make-up's all over the place and their hair gets disheveled, and they're just running around, but it's fun. It really is fun.... I remember [one] party and all these young ladies of another generation dancing, and they just pulled me onto the dance floor."

—JON VOIGHT

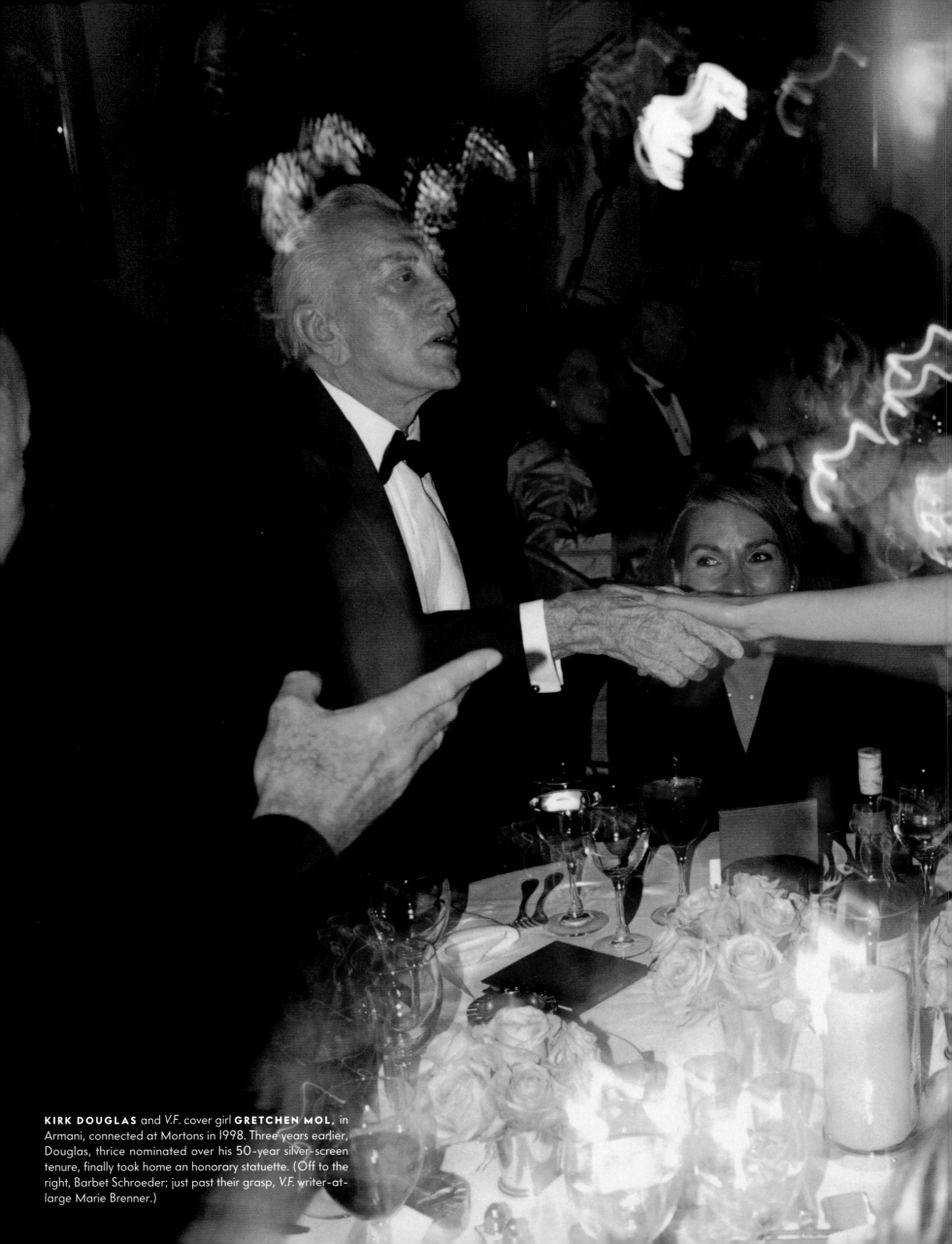

KIRK DOUGLAS and *V.F.* cover girl **GRETCHEN MOL**, in Armani, connected at Mortons in 1998. Three years earlier, Douglas, thrice nominated over his 50-year silver-screen tenure, finally took home an honorary statuette. (Off to the right, Barbet Schroeder; just past their grasp, *V.F.* writer-at-large Marie Brenner.)

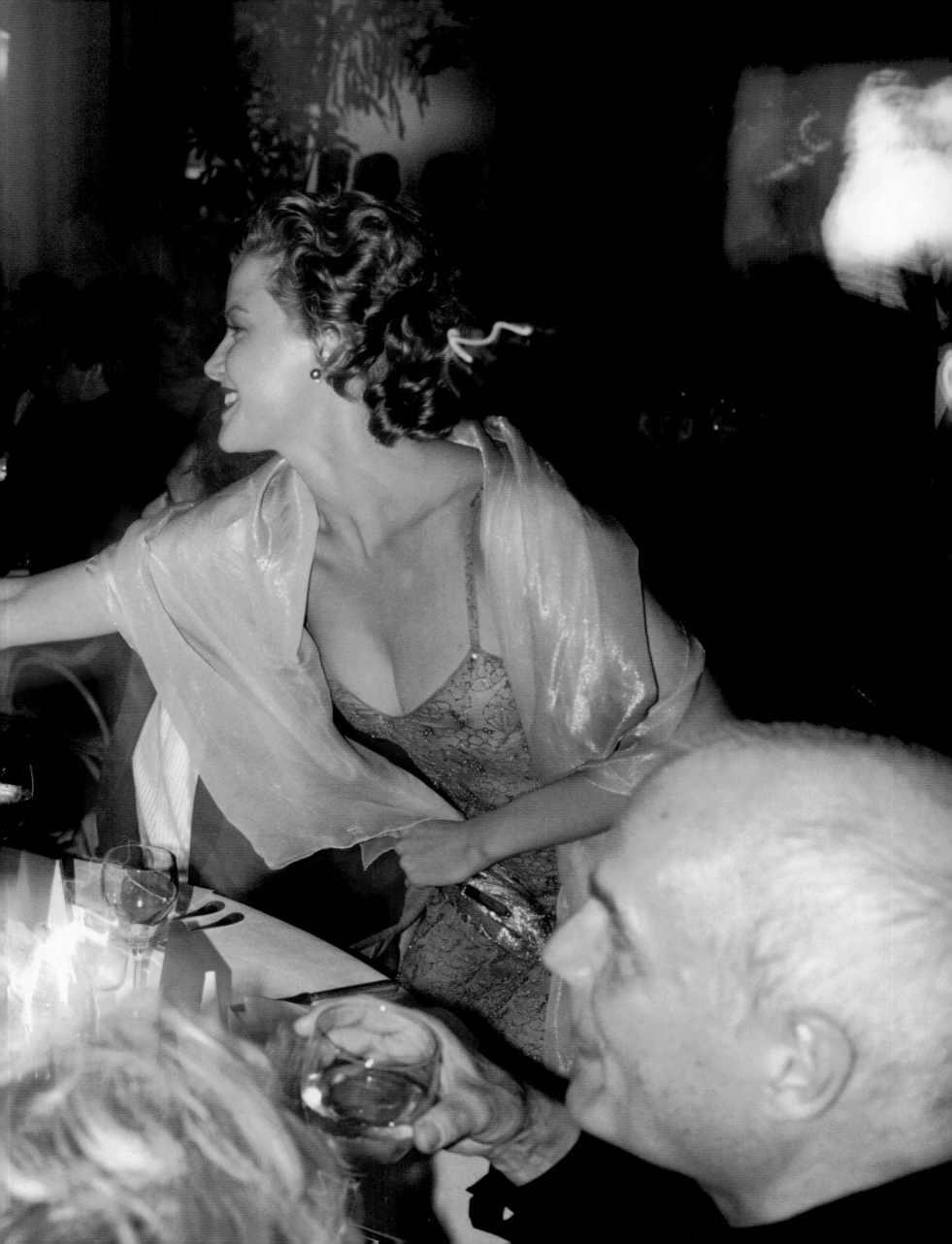

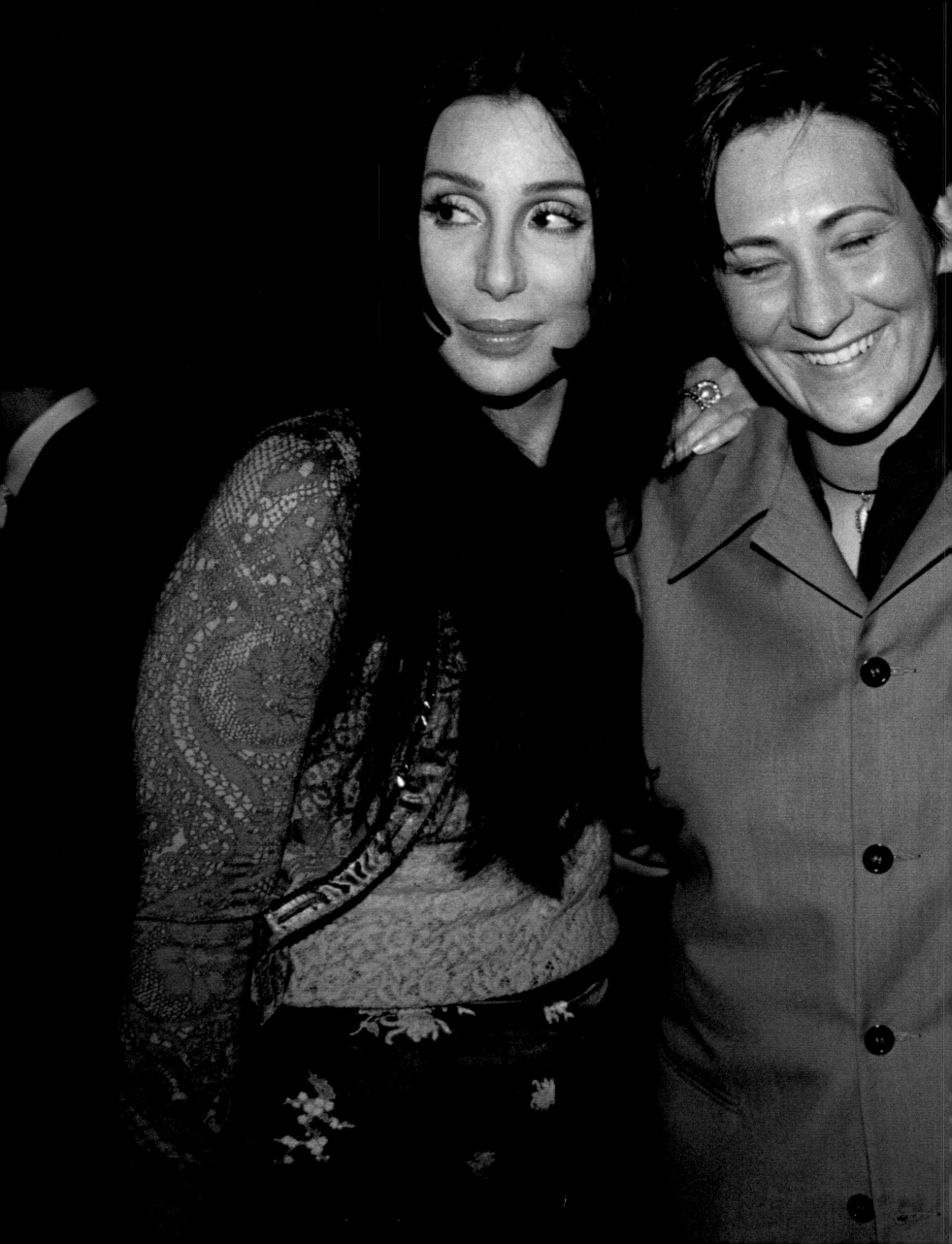

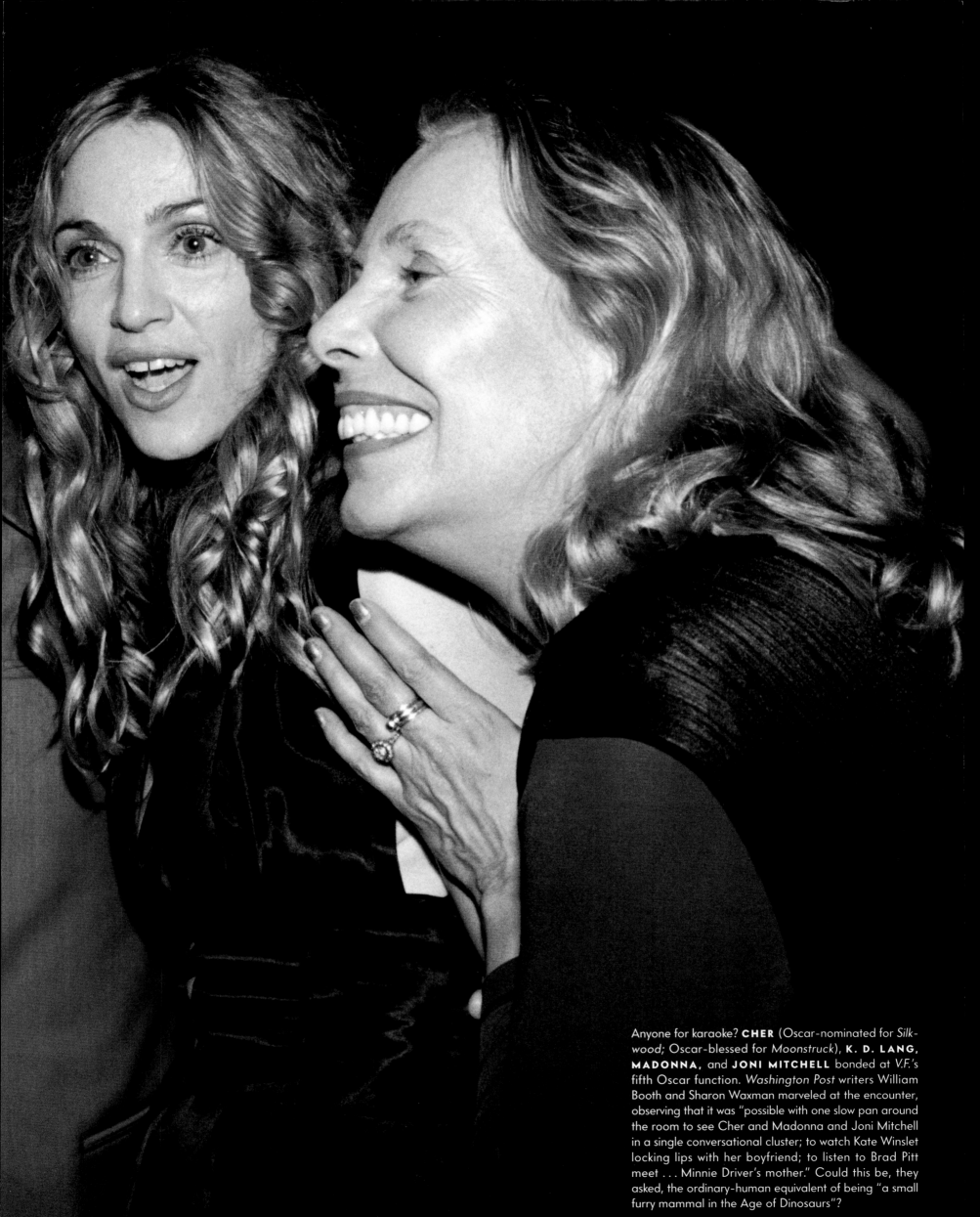

Anyone for karaoke? **CHER** (Oscar-nominated for *Silkwood*; Oscar-blessed for *Moonstruck*), **K. D. LANG**, **MADONNA**, and **JONI MITCHELL** bonded at *V.F.*'s fifth Oscar function. *Washington Post* writers William Booth and Sharon Waxman marveled at the encounter, observing that it was "possible with one slow pan around the room to see Cher and Madonna and Joni Mitchell in a single conversational cluster; to watch Kate Winslet locking lips with her boyfriend; to listen to Brad Pitt meet . . . Minnie Driver's mother." Could this be, they asked, the ordinary-human equivalent of being "a small furry mammal in the Age of Dinosaurs"?

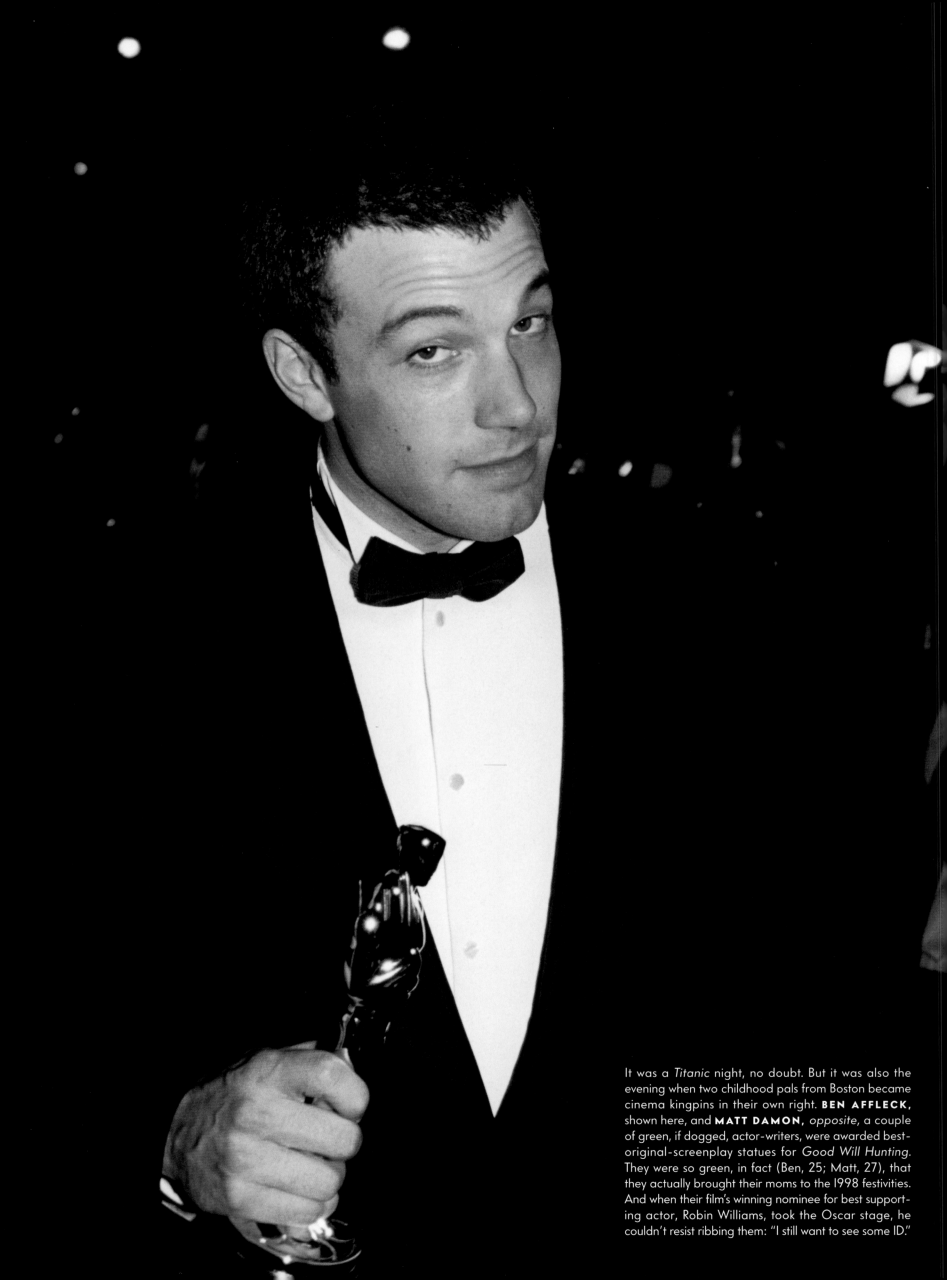

It was a *Titanic* night, no doubt. But it was also the evening when two childhood pals from Boston became cinema kingpins in their own right. **BEN AFFLECK,** shown here, and **MATT DAMON,** *opposite,* a couple of green, if dogged, actor-writers, were awarded best-original-screenplay statues for *Good Will Hunting.* They were so green, in fact (Ben, 25; Matt, 27), that they actually brought their moms to the 1998 festivities. And when their film's winning nominee for best supporting actor, Robin Williams, took the Oscar stage, he couldn't resist ribbing them: "I still want to see some ID."

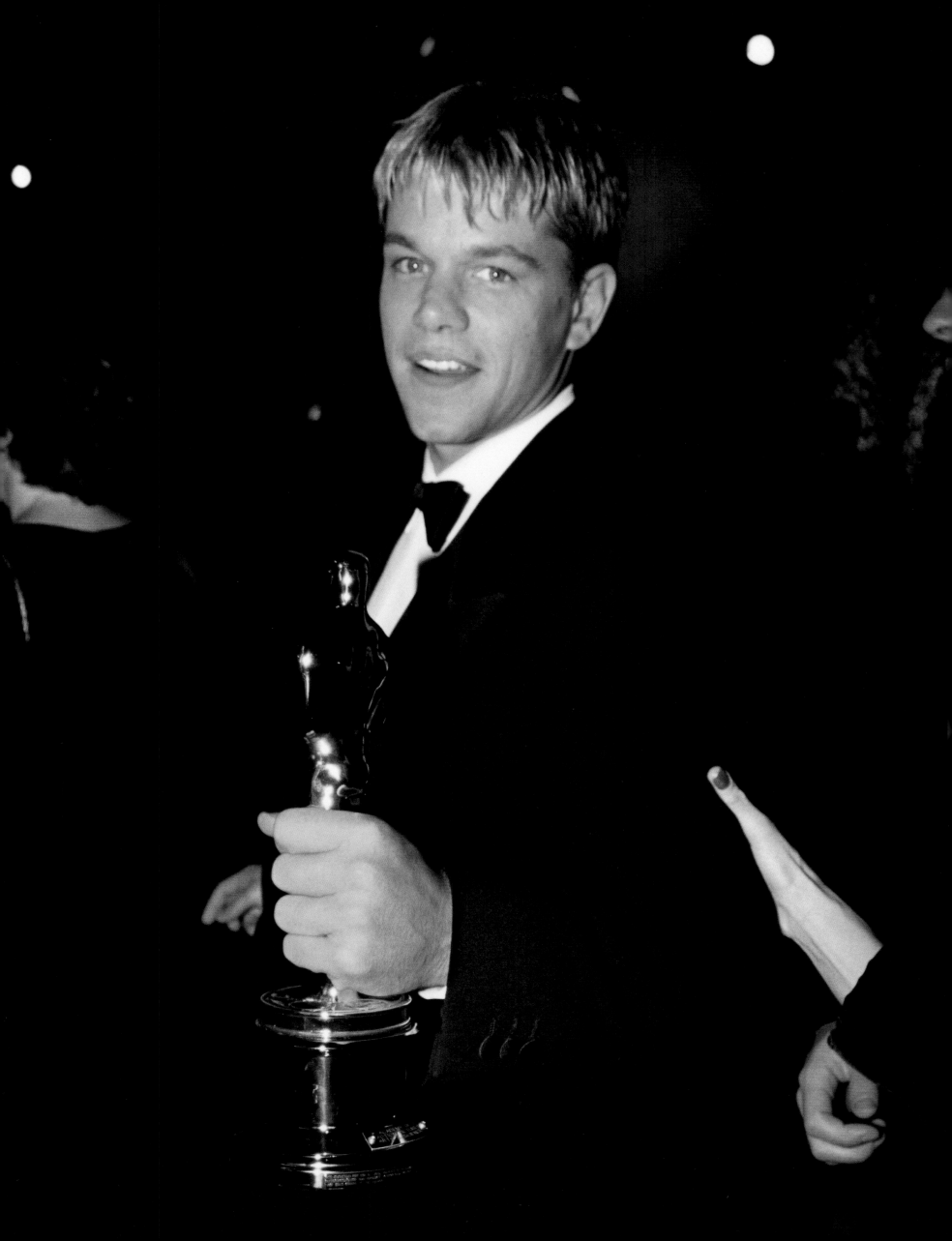

The 70th annual Academy Awards also represented the one-year mark for **ELLEN DeGENERES,** left, and **ANNE HECHE,** who had met at the 1997 *Vanity Fair* party. On their anniversary night the two were still going strong and, when not chatting with the likes of thrice-nominated **SIGOURNEY WEAVER,** were either draped on each other or sharing major face time.

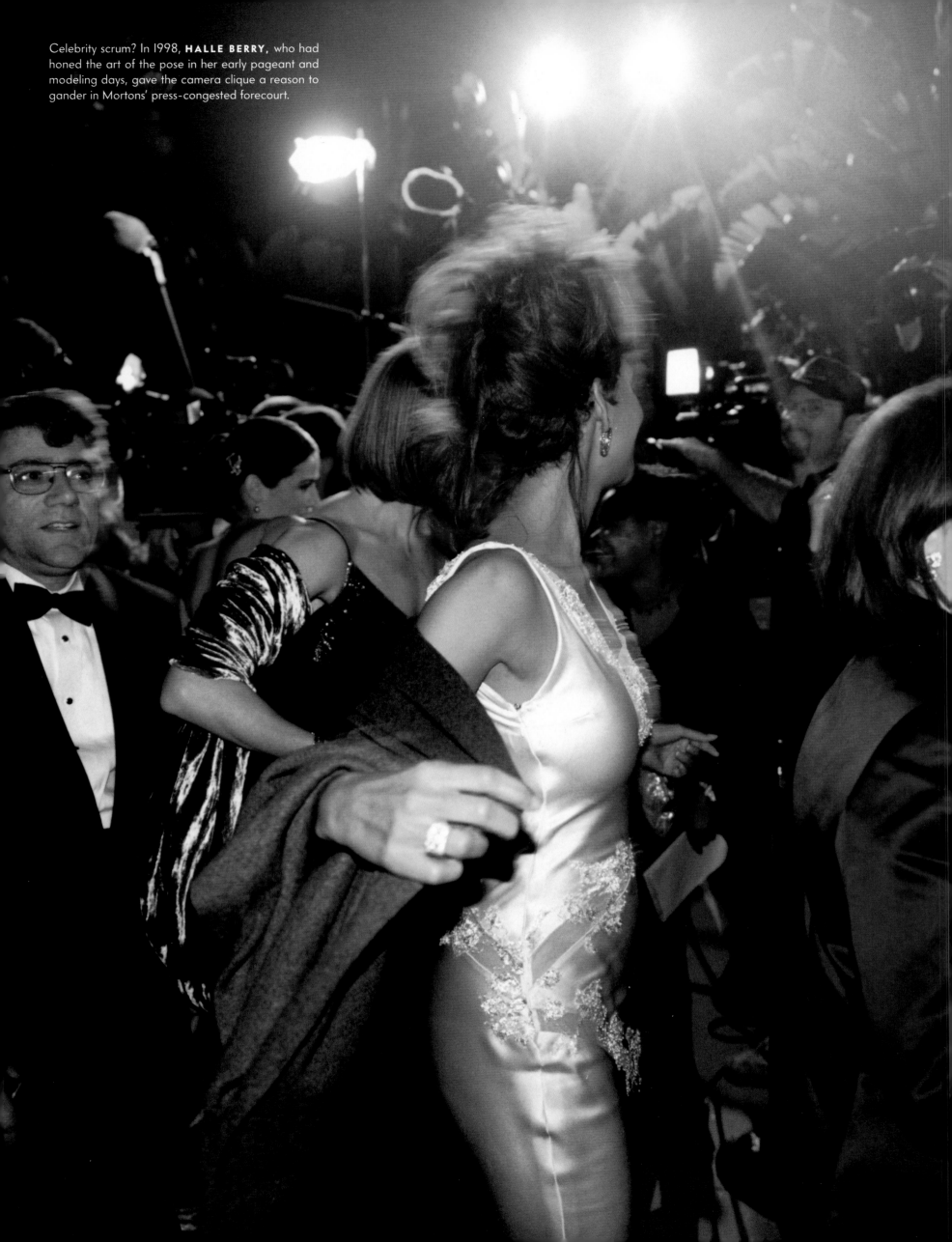

Celebrity scrum? In 1998, **HALLE BERRY,** who had honed the art of the pose in her early pageant and modeling days, gave the camera clique a reason to gander in Mortons' press-congested forecourt.

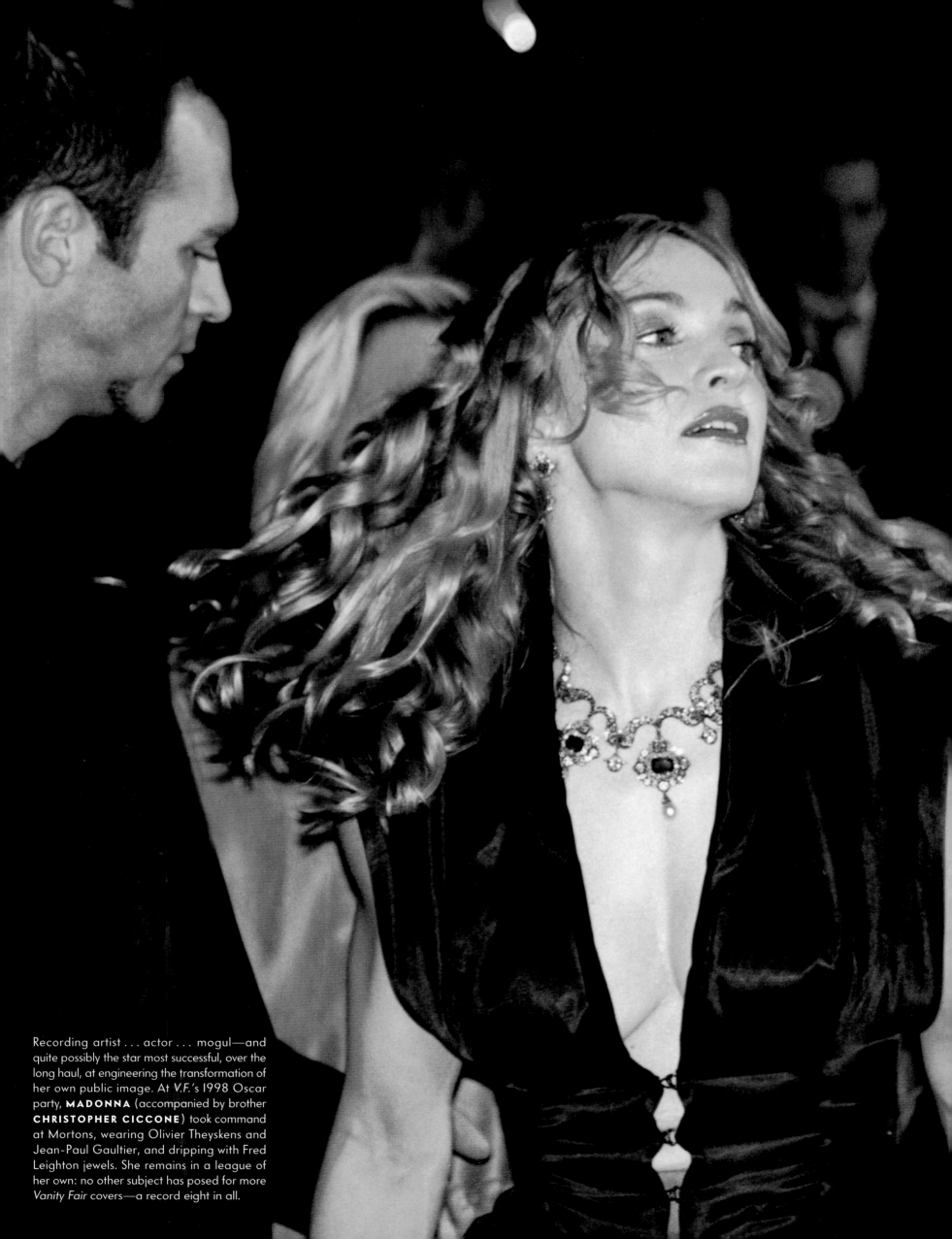

Recording artist . . . actor . . . mogul—and quite possibly the star most successful, over the long haul, at engineering the transformation of her own public image. At *V.F.*'s 1998 Oscar party, **MADONNA** (accompanied by brother **CHRISTOPHER CICCONE**) took command at Mortons, wearing Olivier Theyskens and Jean-Paul Gaultier, and dripping with Fred Leighton jewels. She remains in a league of her own: no other subject has posed for more *Vanity Fair* covers—a record eight in all.

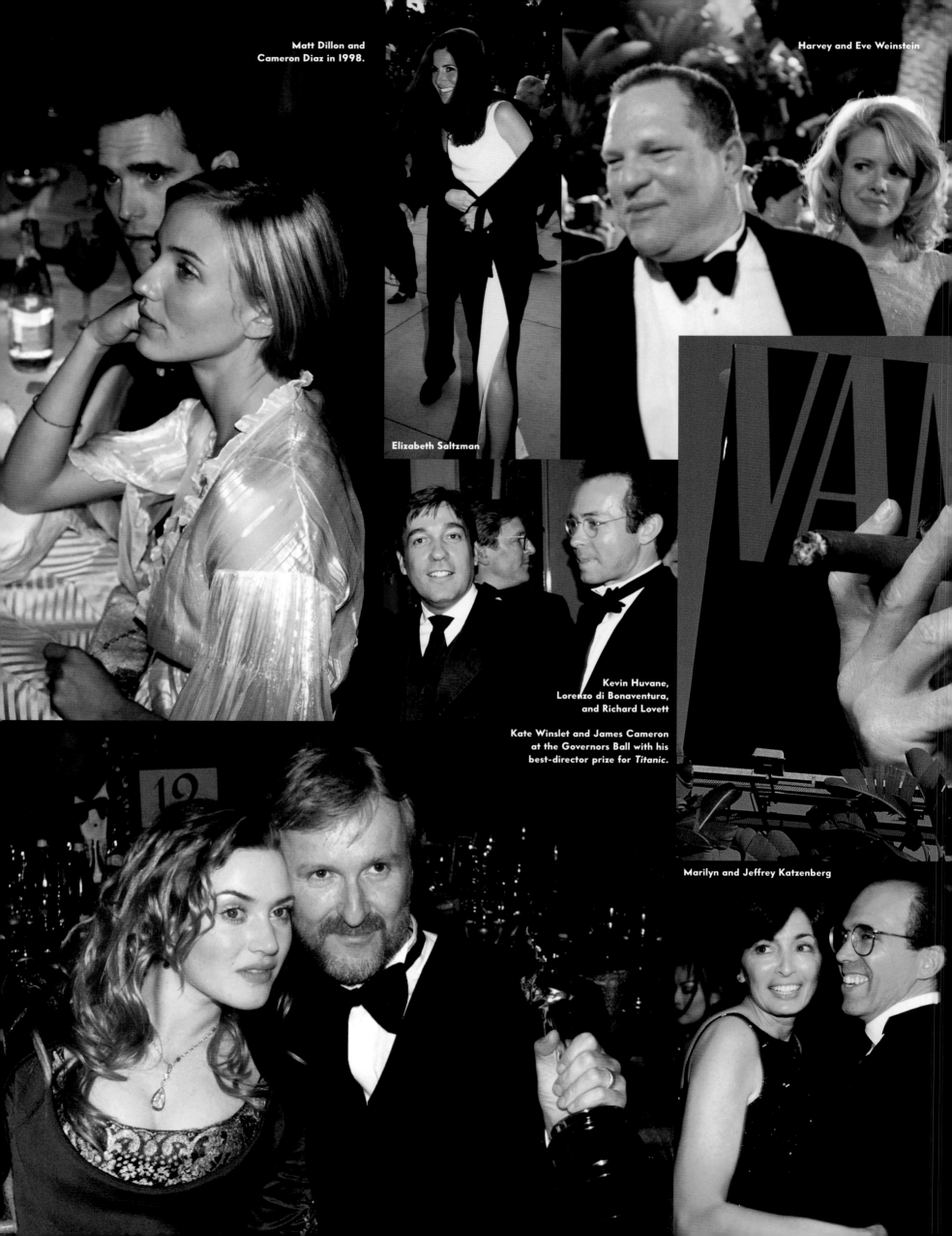

Matt Dillon and
Cameron Diaz in 1998.

Harvey and Eve Weinstein

Elizabeth Saltzman

Kevin Huvane,
Lorenzo di Bonaventura,
and Richard Lovett

Kate Winslet and James Cameron
at the Governors Ball with his
best-director prize for *Titanic*.

Marilyn and Jeffrey Katzenberg

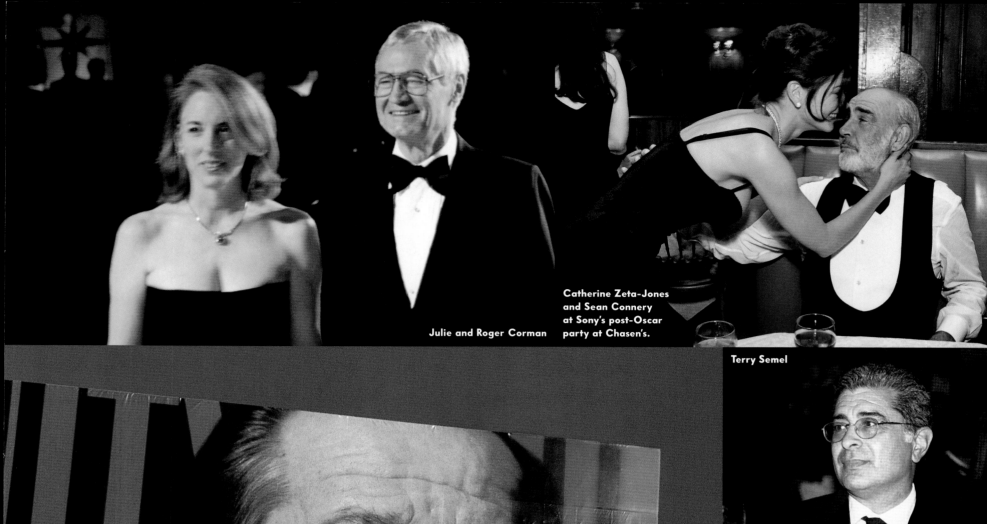

Julie and Roger Corman

Catherine Zeta-Jones and Sean Connery at Sony's post-Oscar party at Chasen's.

Terry Semel

Tom and Kathy Freston

Sean (P. Diddy) Combs and Oliver Stone

Jack Nicholson billboard on Sunset Boulevard.

Alana Stewart and George Hamilton

The HOLLYWOOD Issue

Proving she can curl those lips every bit as sassily as Daddy, **LISA MARIE PRESLEY** either (a) tells photographer Dafydd Jones to "kiss off" or (b) opts for the blowfish rather than Mortons' popular sea bass at the 1999 *Vanity Fair* party. Three years removed from her marriage to Michael Jackson (they said it would *last*), Presley was hardly the most gossip-plagued young woman on the premises. That honor belonged to Forever Former White House Intern Monica Lewinsky.

"Maybe you get a night like this at a party in Washington, New York, or Paris, but when the main event is the Academy Awards and the whole world is watching, you feel the power behind the history of Hollywood and the story lines of all the movies you've ever lost yourself in all come alive in a single room. It's like comets colliding—stars exploding—creating little stars, and you are watching this in a virtual movie in which you are a character."

—**JANE SARKIN**
VANITY FAIR FEATURES EDITOR

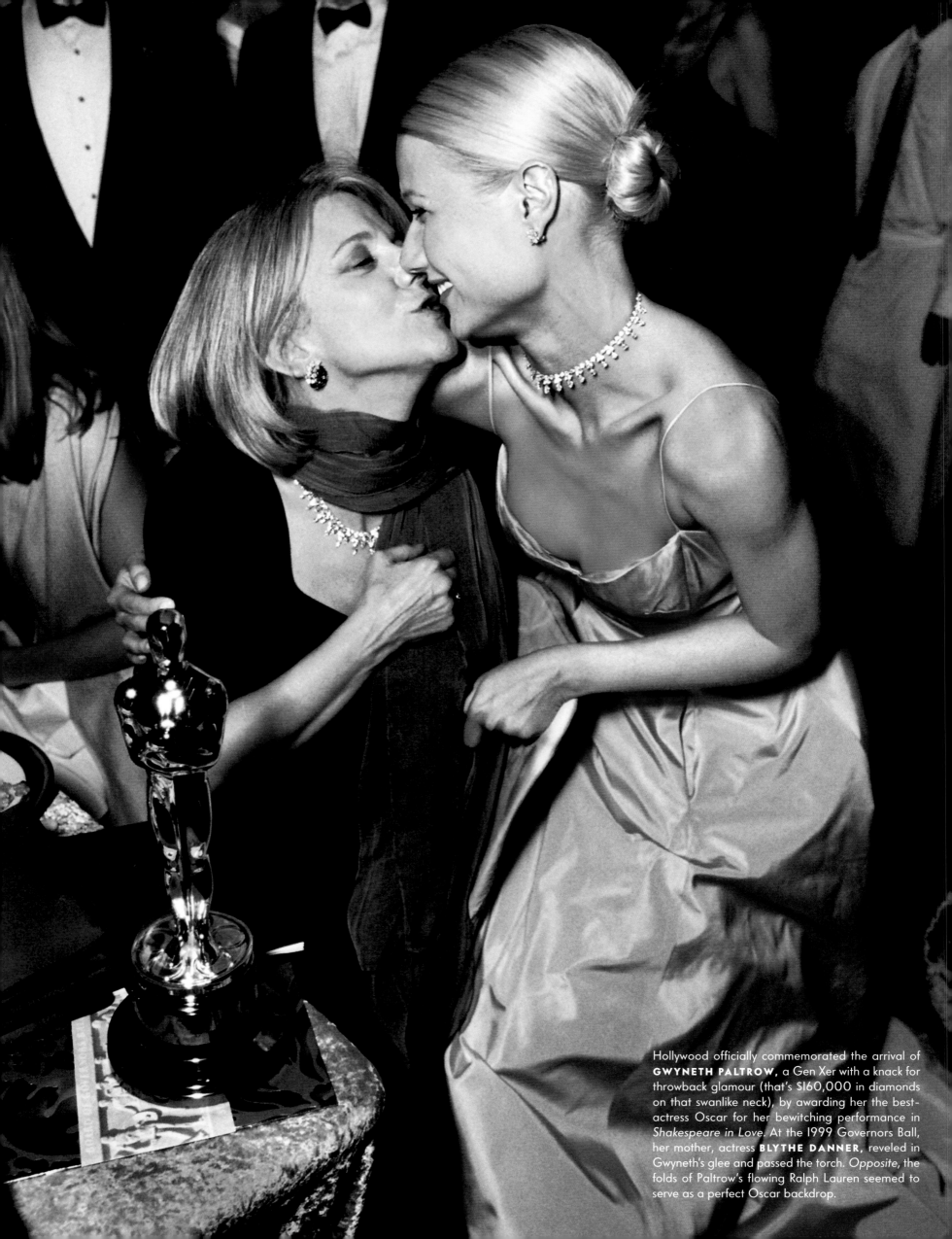

Hollywood officially commemorated the arrival of **GWYNETH PALTROW**, a Gen Xer with a knack for throwback glamour (that's $160,000 in diamonds on that swanlike neck), by awarding her the best-actress Oscar for her bewitching performance in *Shakespeare in Love*. At the 1999 Governors Ball, her mother, actress **BLYTHE DANNER**, reveled in Gwyneth's glee and passed the torch. *Opposite*, the folds of Paltrow's flowing Ralph Lauren seemed to serve as a perfect Oscar backdrop.

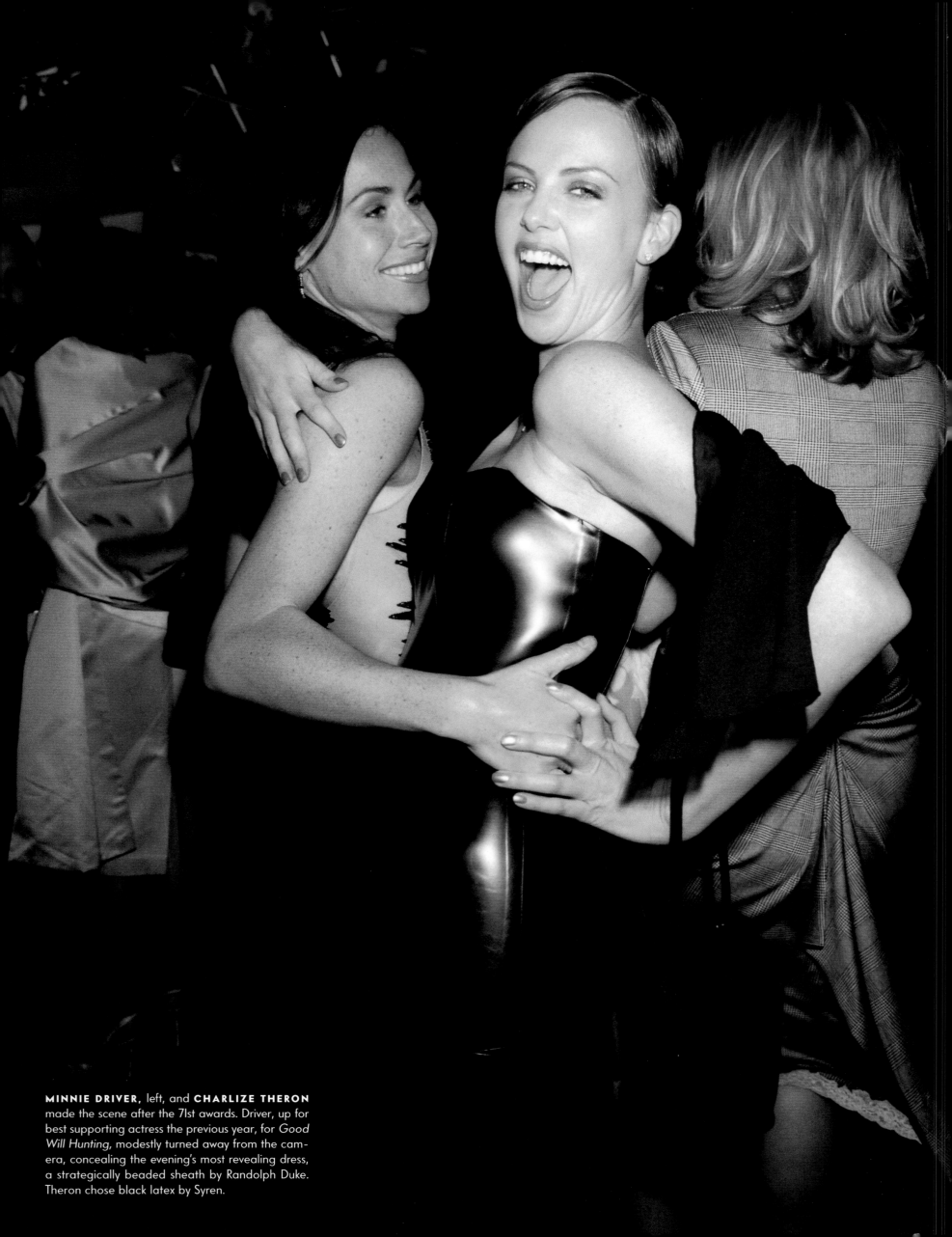

MINNIE DRIVER, left, and **CHARLIZE THERON** made the scene after the 71st awards. Driver, up for best supporting actress the previous year, for *Good Will Hunting*, modestly turned away from the camera, concealing the evening's most revealing dress, a strategically beaded sheath by Randolph Duke. Theron chose black latex by Syren.

Though he was overlooked by the best-actor nominators for his roles in 1998's forgettable *Mercury Rising* and forgotten *Thick as Thieves*, dapper **ALEC BALDWIN** looked every bit the best man as he was flanked by security men outside Mortons on Academy Awards night 1999. Five years later, Baldwin would be in the hunt with his first Oscar nomination, for *The Cooler*.

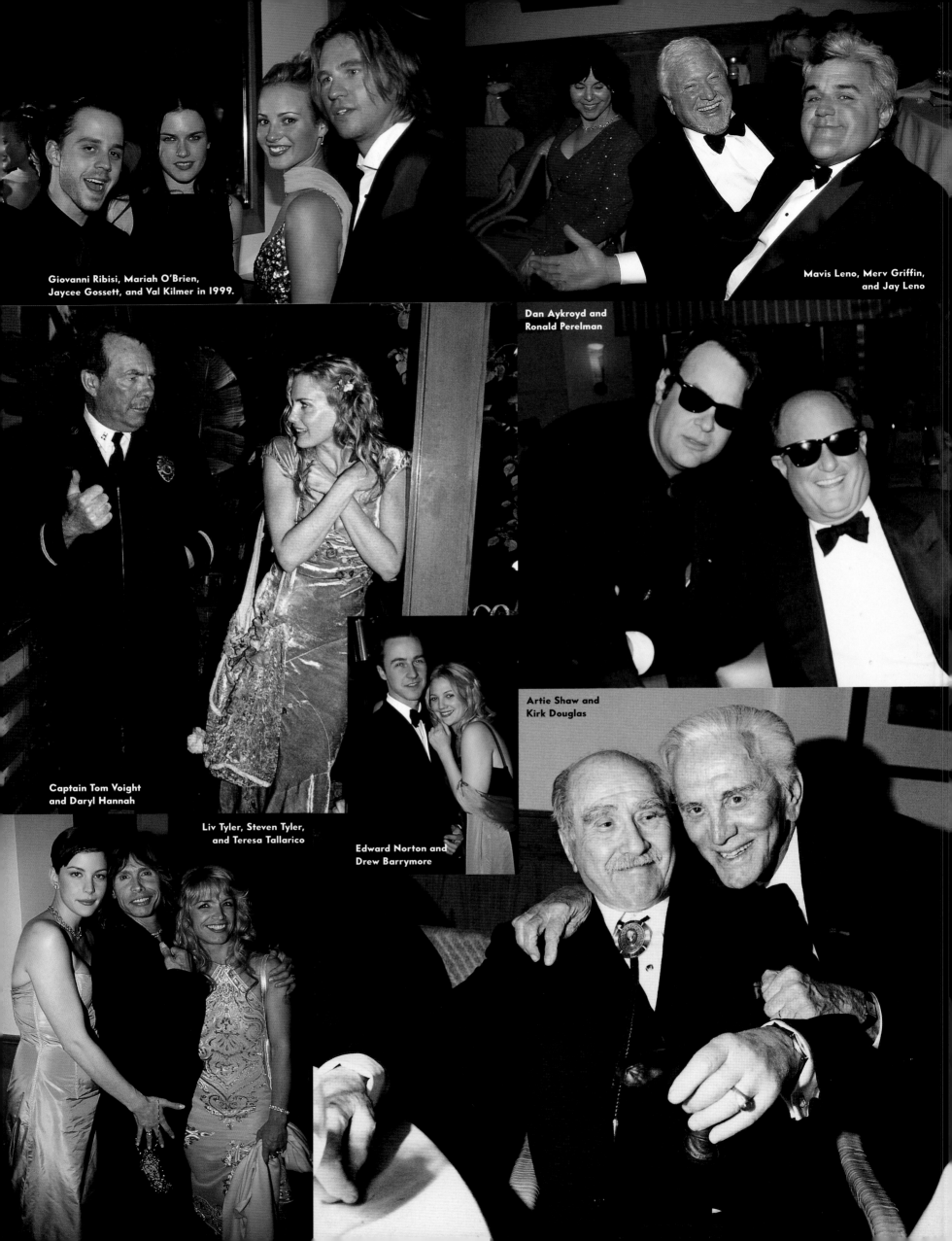

Giovanni Ribisi, Mariah O'Brien, Jaycee Gossett, and Val Kilmer in 1999.

Mavis Leno, Merv Griffin, and Jay Leno

Dan Aykroyd and Ronald Perelman

Captain Tom Voight and Daryl Hannah

Artie Shaw and Kirk Douglas

Liv Tyler, Steven Tyler, and Teresa Tallarico

Edward Norton and Drew Barrymore

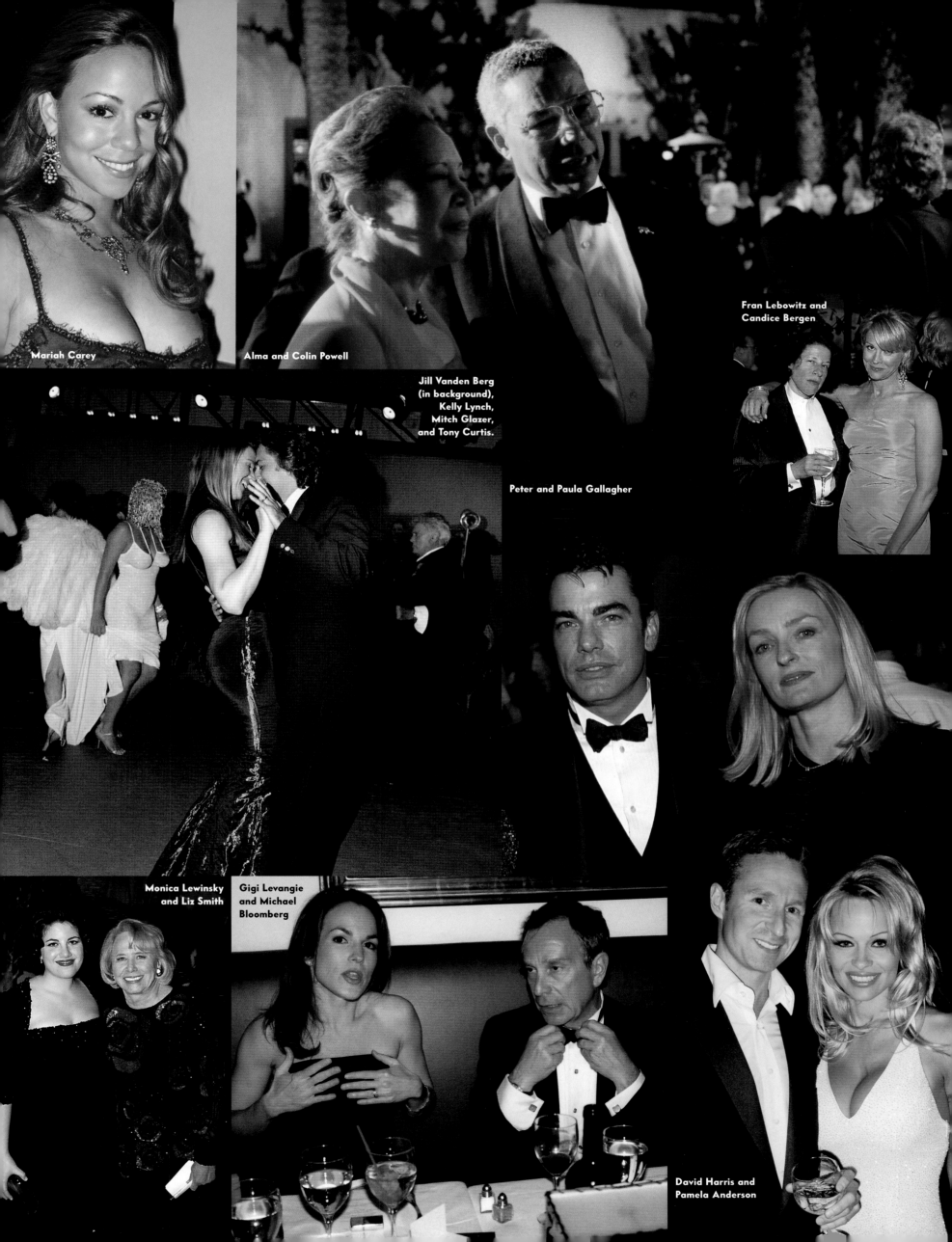

Mariah Carey

Alma and Colin Powell

Fran Lebowitz and
Candice Bergen

Jill Vanden Berg
(in background),
Kelly Lynch,
Mitch Glazer,
and Tony Curtis.

Peter and Paula Gallagher

Monica Lewinsky
and Liz Smith

Gigi Levangie
and Michael
Bloomberg

David Harris and
Pamela Anderson

‟The *Vanity Fair* party...has become the Royal enclosure of Oscar night.... Where else could you find Walter Cronkite dancing with Madonna and Jon Bon Jovi or Mick Jagger with Barbra Streisand? Or see Steve Martin sharing a joke with Jim Carrey, Brad Pitt and Tiger Woods or even Billy Wilder sharing wisdom with Steven Spielberg, Tom Hanks and Sam Mendes?„

—SIMON DAVIS
LONDON *DAILY TELEGRAPH*, MARCH 25, 2000

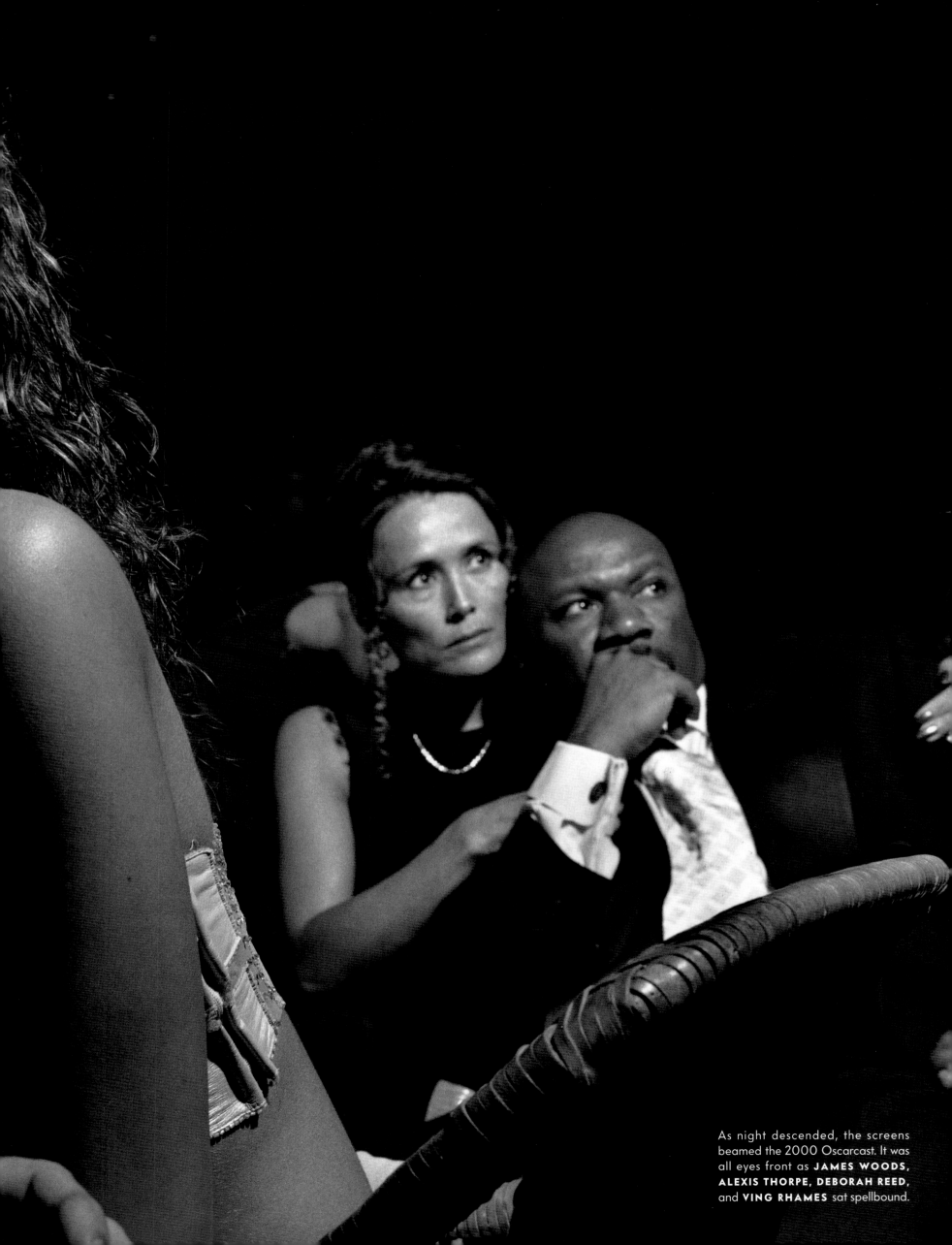

As night descended, the screens beamed the 2000 Oscarcast. It was all eyes front as **JAMES WOODS**, **ALEXIS THORPE**, **DEBORAH REED**, and **VING RHAMES** sat spellbound.

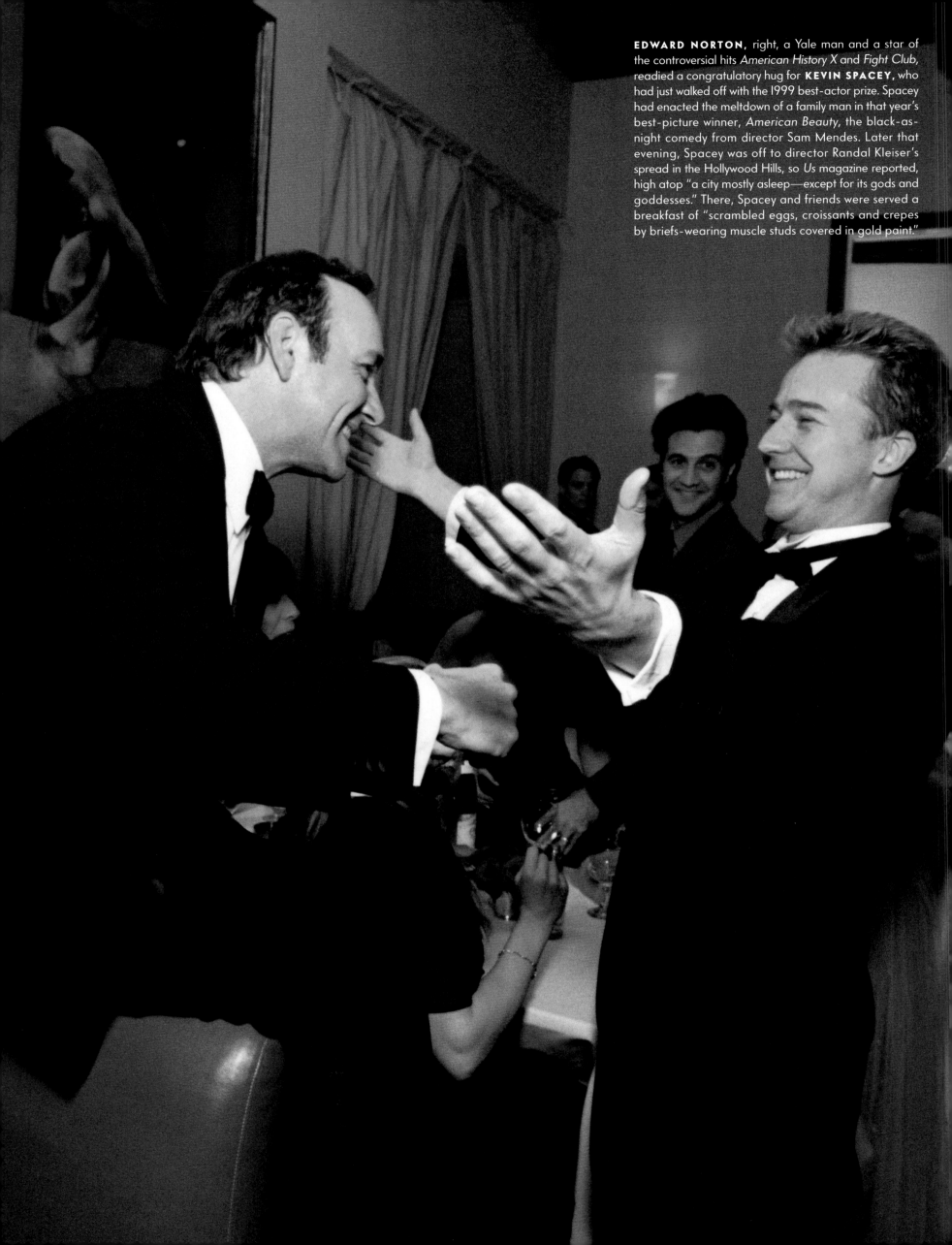

EDWARD NORTON, right, a Yale man and a star of the controversial hits *American History X* and *Fight Club*, readied a congratulatory hug for KEVIN SPACEY, who had just walked off with the 1999 best-actor prize. Spacey had enacted the meltdown of a family man in that year's best-picture winner, *American Beauty*, the black-as-night comedy from director Sam Mendes. Later that evening, Spacey was off to director Randal Kleiser's spread in the Hollywood Hills, so *Us* magazine reported, high atop "a city mostly asleep—except for its gods and goddesses." There, Spacey and friends were served a breakfast of "scrambled eggs, croissants and crepes by briefs-wearing muscle studs covered in gold paint."

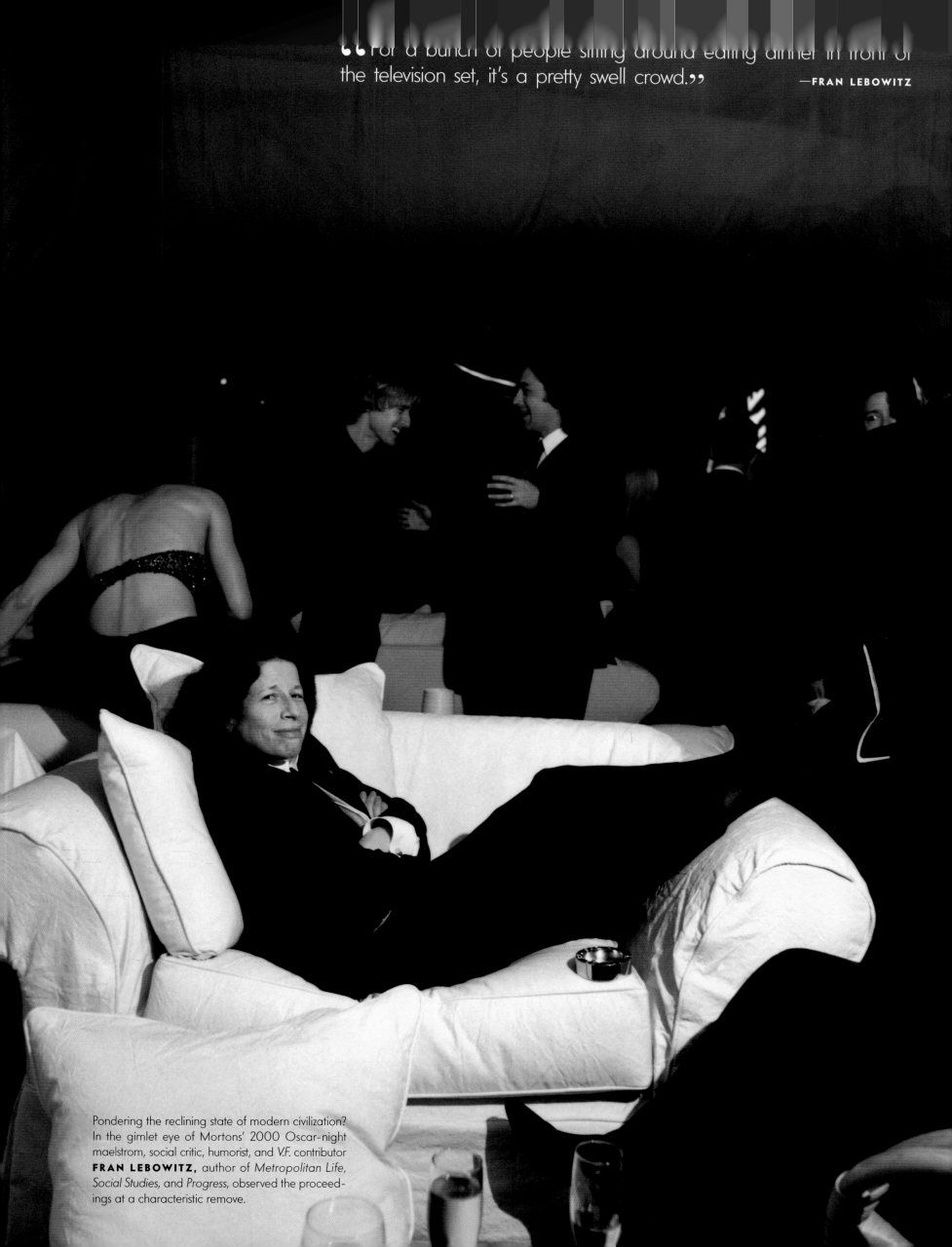

"For a bunch of people sitting around eating dinner in front of the television set, it's a pretty swell crowd." —FRAN LEBOWITZ

Pondering the reclining state of modern civilization? In the gimlet eye of Mortons' 2000 Oscar-night maelstrom, social critic, humorist, and *V.F.* contributor **FRAN LEBOWITZ**, author of *Metropolitan Life*, *Social Studies*, and *Progress*, observed the proceedings at a characteristic remove.

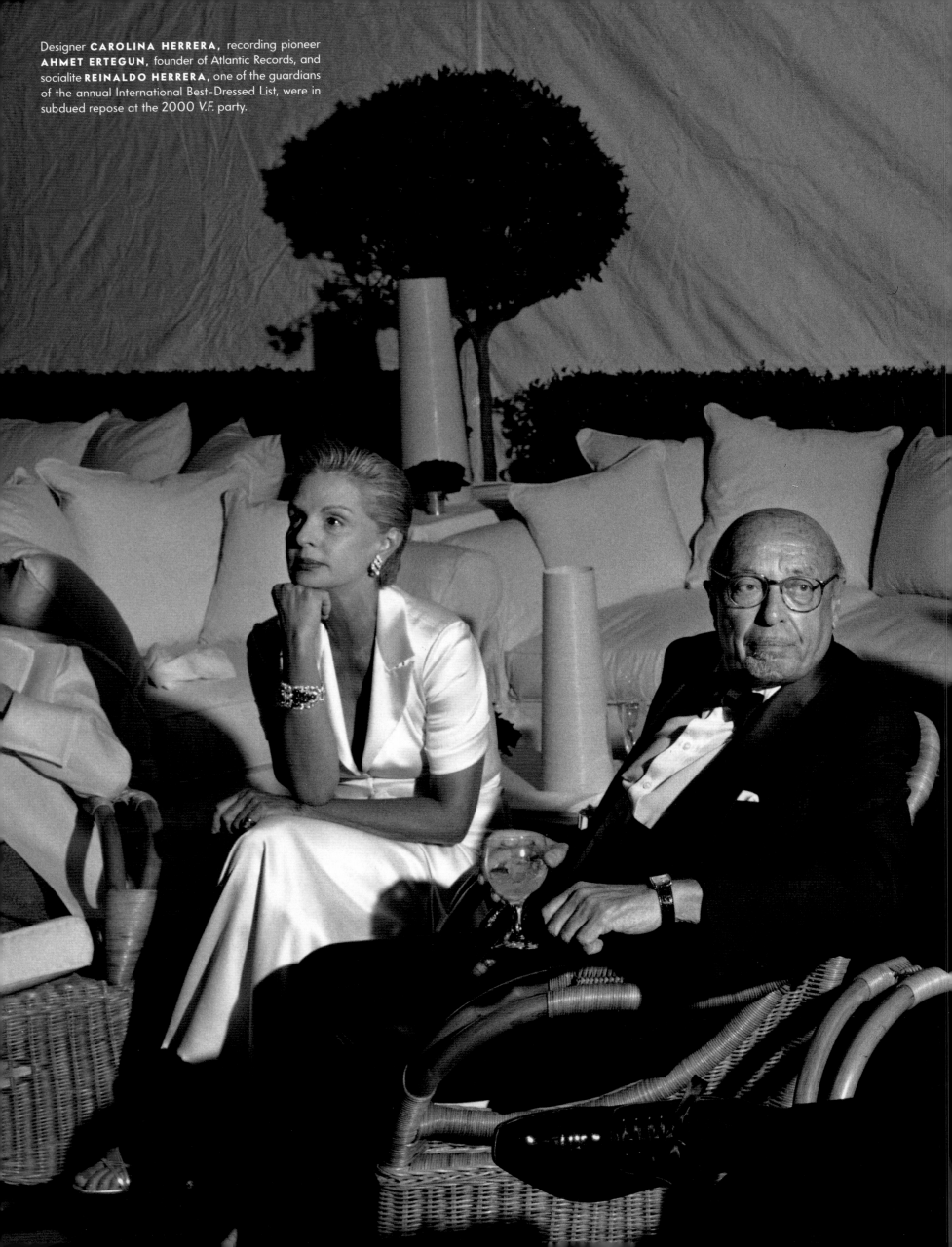

Designer **CAROLINA HERRERA**, recording pioneer **AHMET ERTEGUN**, founder of Atlantic Records, and socialite **REINALDO HERRERA**, one of the guardians of the annual International Best-Dressed List, were in subdued repose at the 2000 V.F. party.

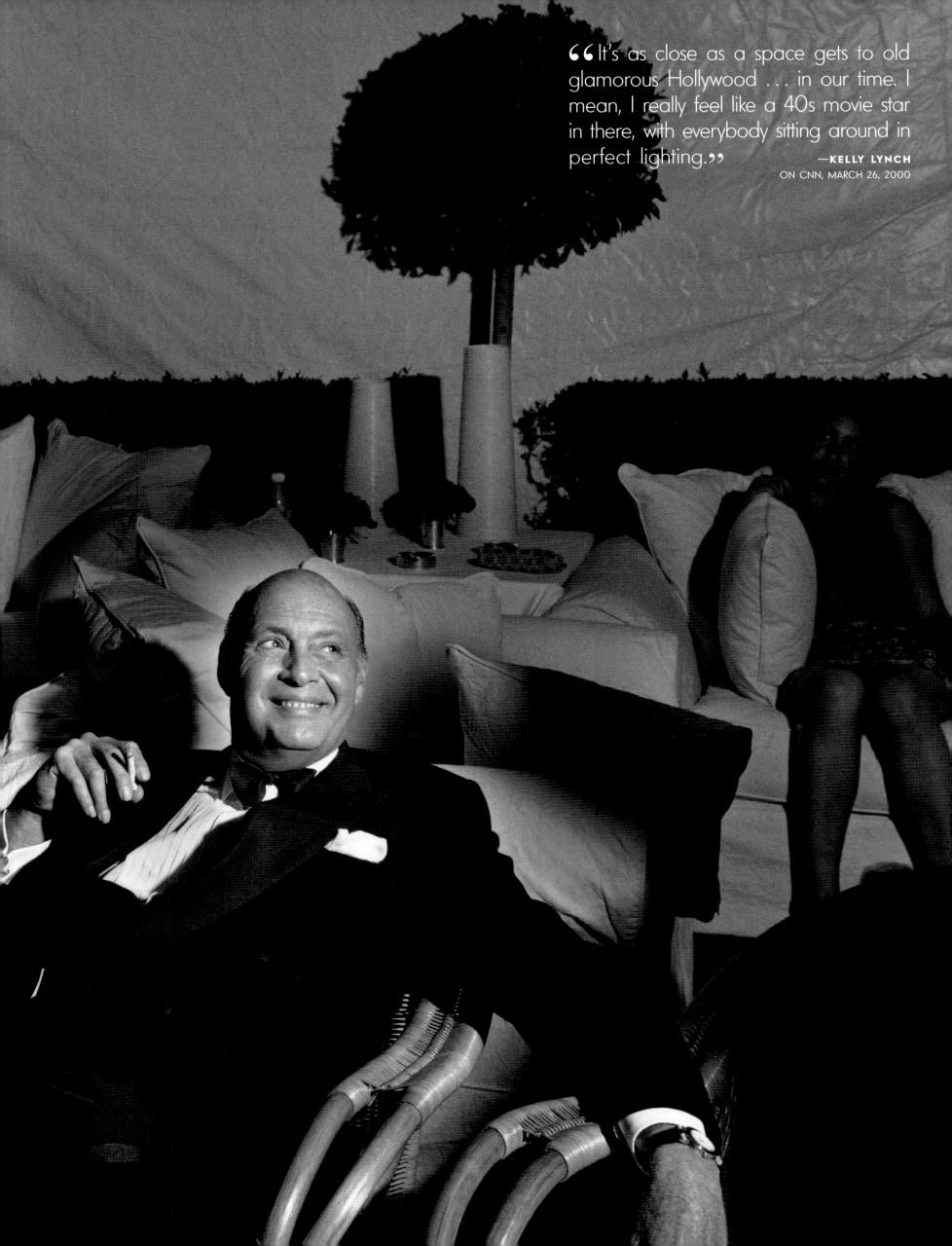

" It's as close as a space gets to old glamorous Hollywood . . . in our time. I mean, I really feel like a 40s movie star in there, with everybody sitting around in perfect lighting. **"**

—KELLY LYNCH
ON CNN, MARCH 26, 2000

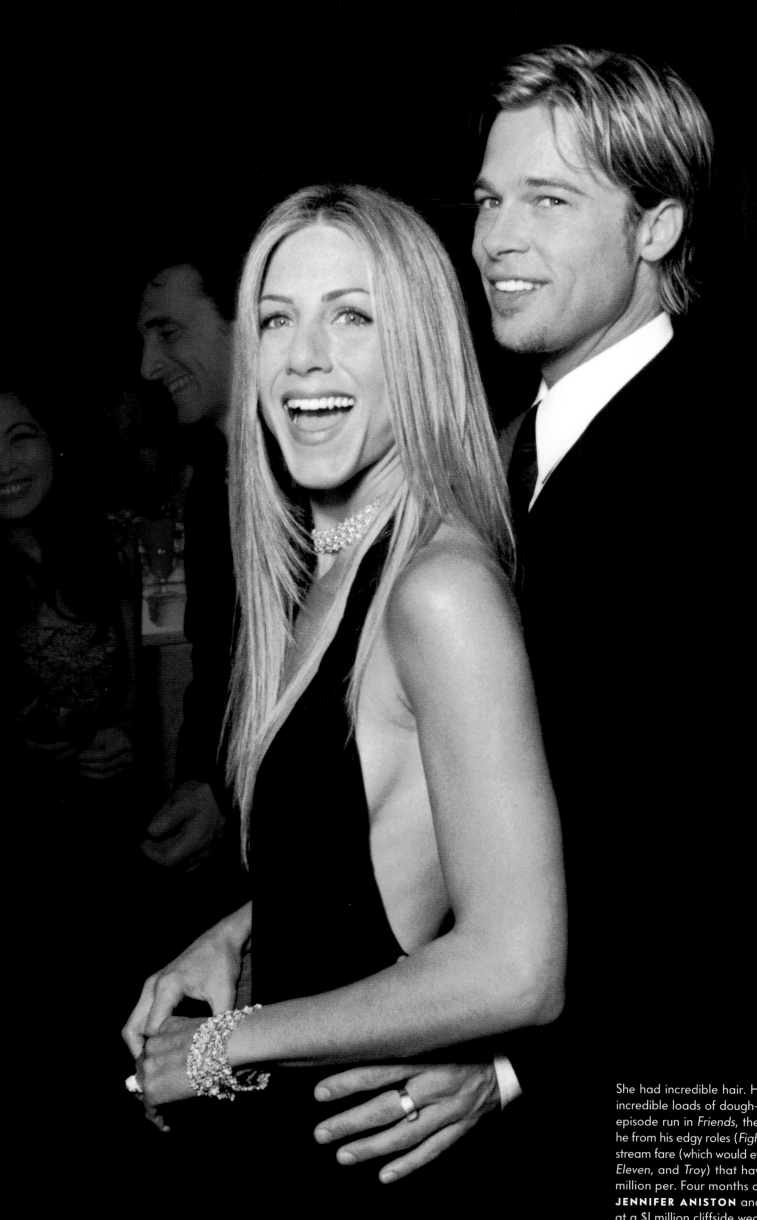

She had incredible hair. He had incredible lips. Each had incredible loads of dough—she from her cool-million-an-episode run in *Friends*, the top-rated TV sitcom of its era; he from his edgy roles (*Fight Club*, *Snatch*) and more mainstream fare (which would eventually include *Se7en*, *Ocean's Eleven*, and *Troy*) that have earned him as much as $20 million per. Four months after this Oscar 2000 portrait, **JENNIFER ANISTON** and **BRAD PITT** would tie the knot at a $1 million cliffside wedding in Malibu.

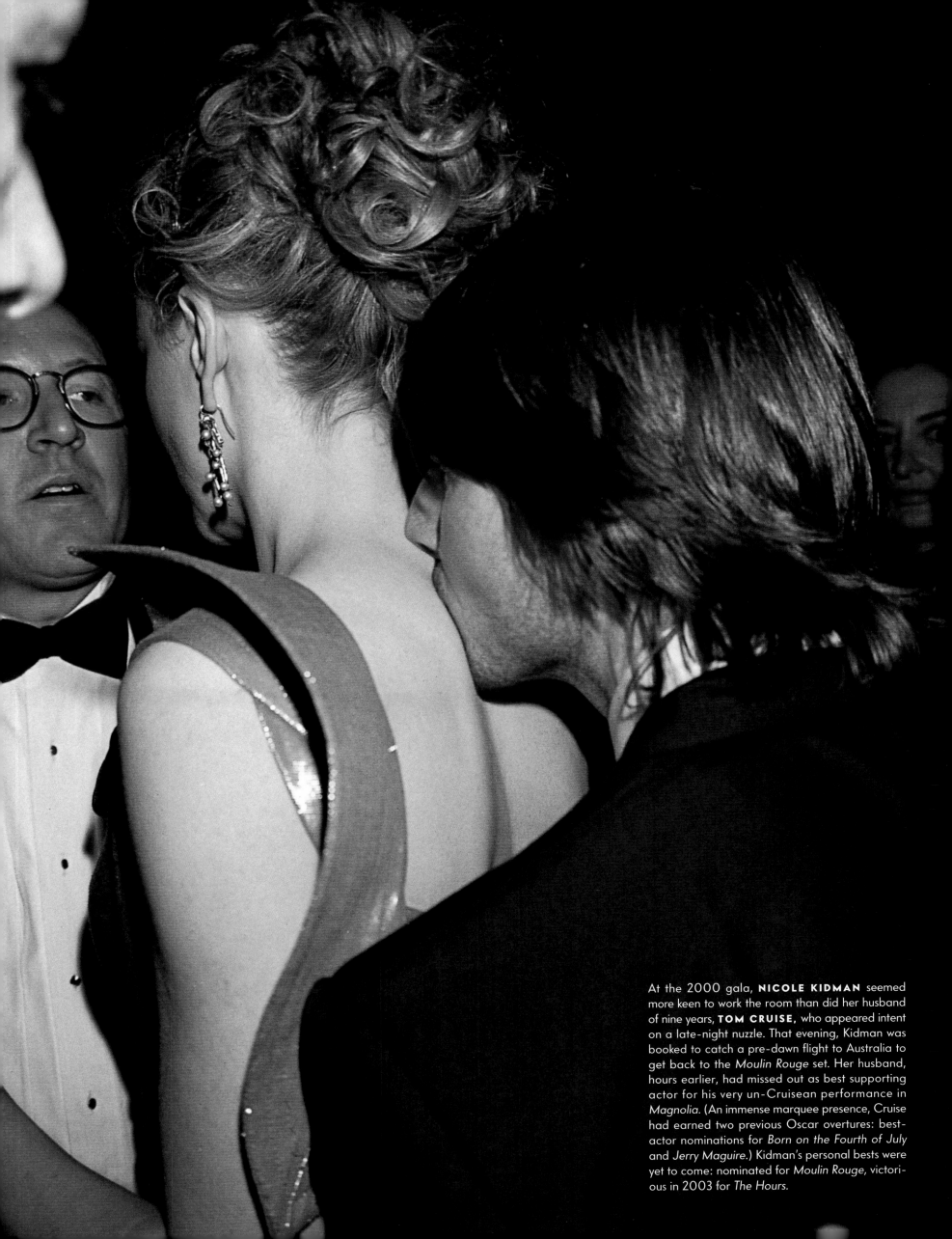

At the 2000 gala, **NICOLE KIDMAN** seemed more keen to work the room than did her husband of nine years, **TOM CRUISE,** who appeared intent on a late-night nuzzle. That evening, Kidman was booked to catch a pre-dawn flight to Australia to get back to the *Moulin Rouge* set. Her husband, hours earlier, had missed out as best supporting actor for his very un-Cruisean performance in *Magnolia.* (An immense marquee presence, Cruise had earned two previous Oscar overtures: best-actor nominations for *Born on the Fourth of July* and *Jerry Maguire.*) Kidman's personal bests were yet to come: nominated for *Moulin Rouge,* victorious in 2003 for *The Hours.*

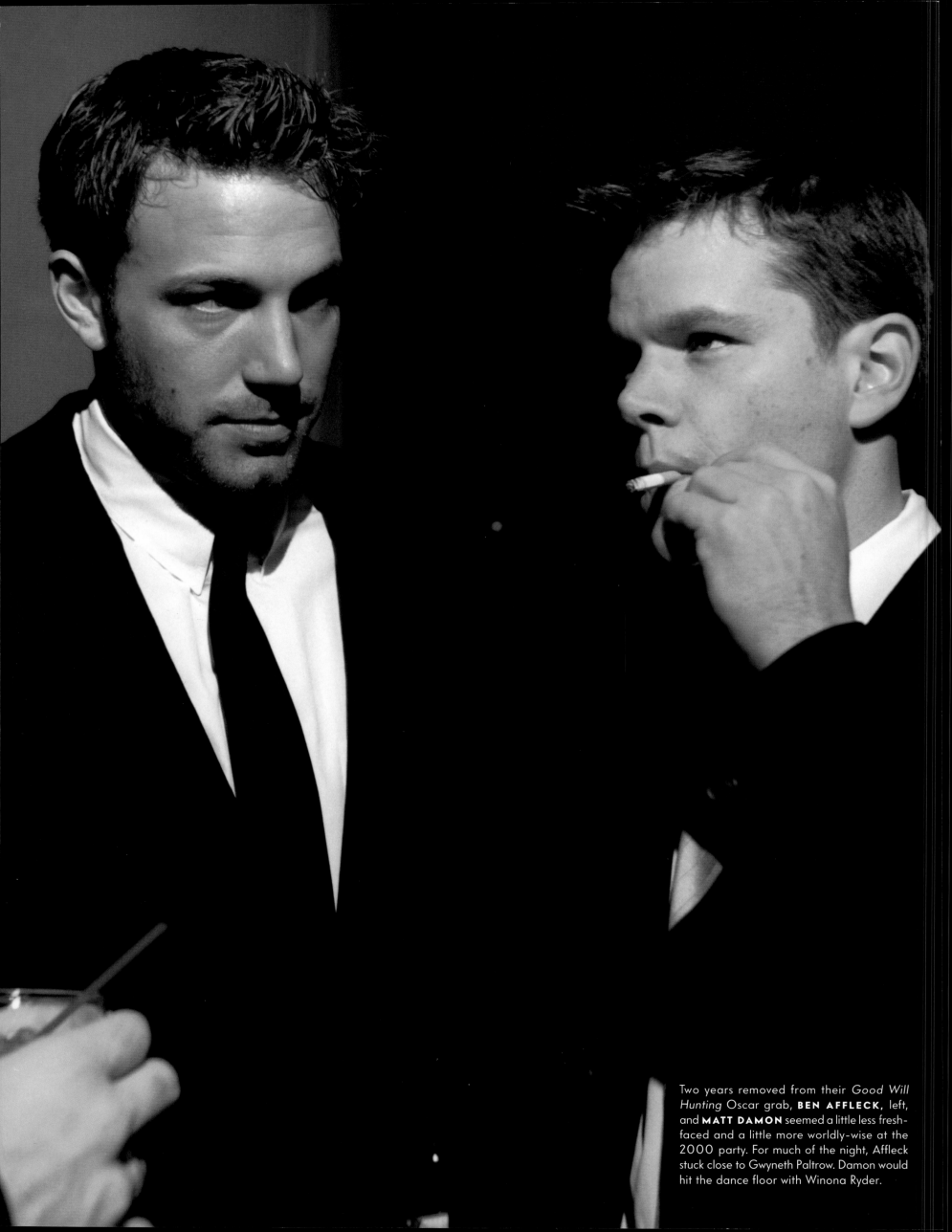

Two years removed from their *Good Will Hunting* Oscar grab, **BEN AFFLECK,** left, and **MATT DAMON** seemed a little less fresh-faced and a little more worldly-wise at the 2000 party. For much of the night, Affleck stuck close to Gwyneth Paltrow. Damon would hit the dance floor with Winona Ryder.

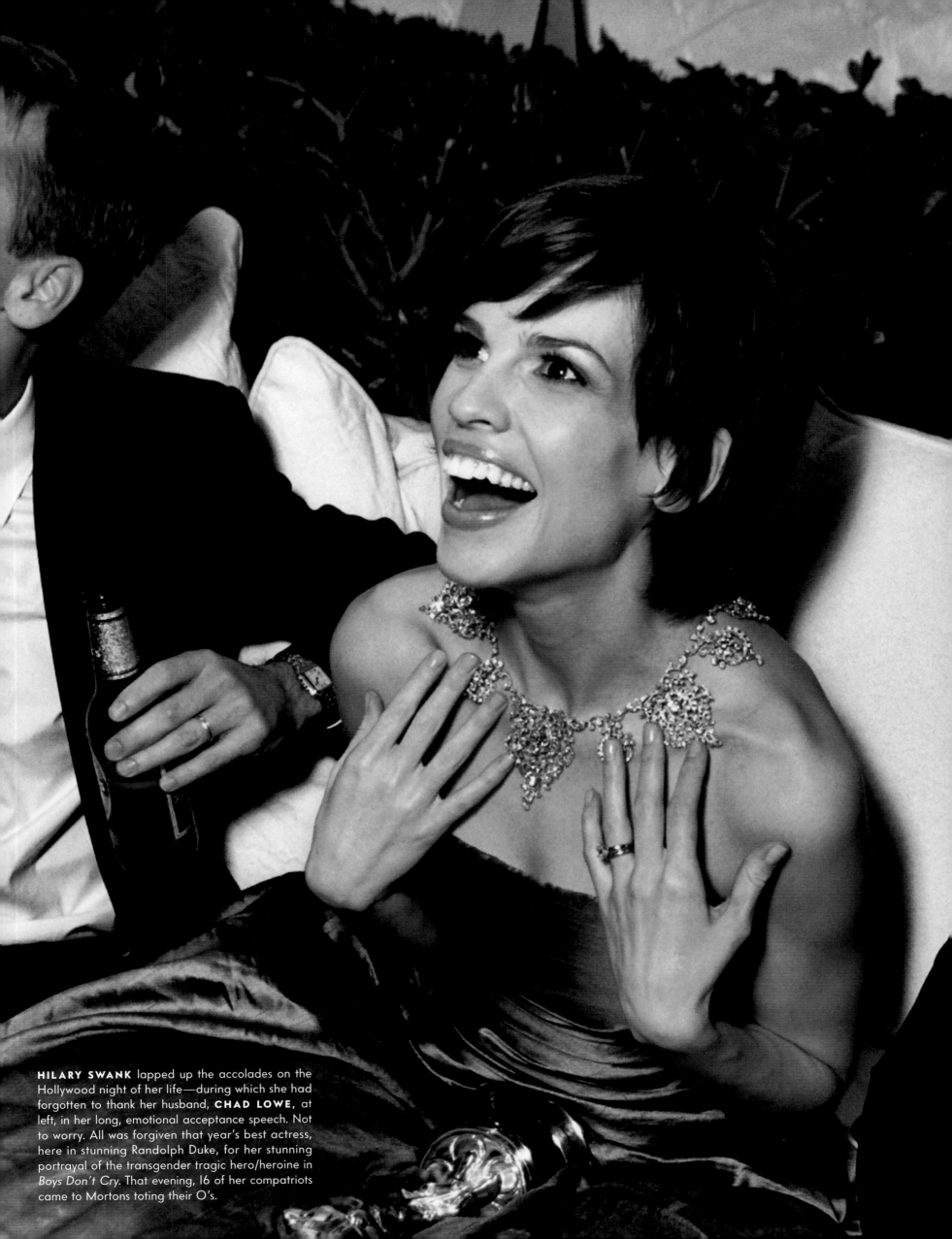

HILARY SWANK lapped up the accolades on the Hollywood night of her life—during which she had forgotten to thank her husband, **CHAD LOWE,** at left, in her long, emotional acceptance speech. Not to worry. All was forgiven that year's best actress, here in stunning Randolph Duke, for her stunning portrayal of the transgender tragic hero/heroine in *Boys Don't Cry.* That evening, 16 of her compatriots came to Mortons toting their O's.

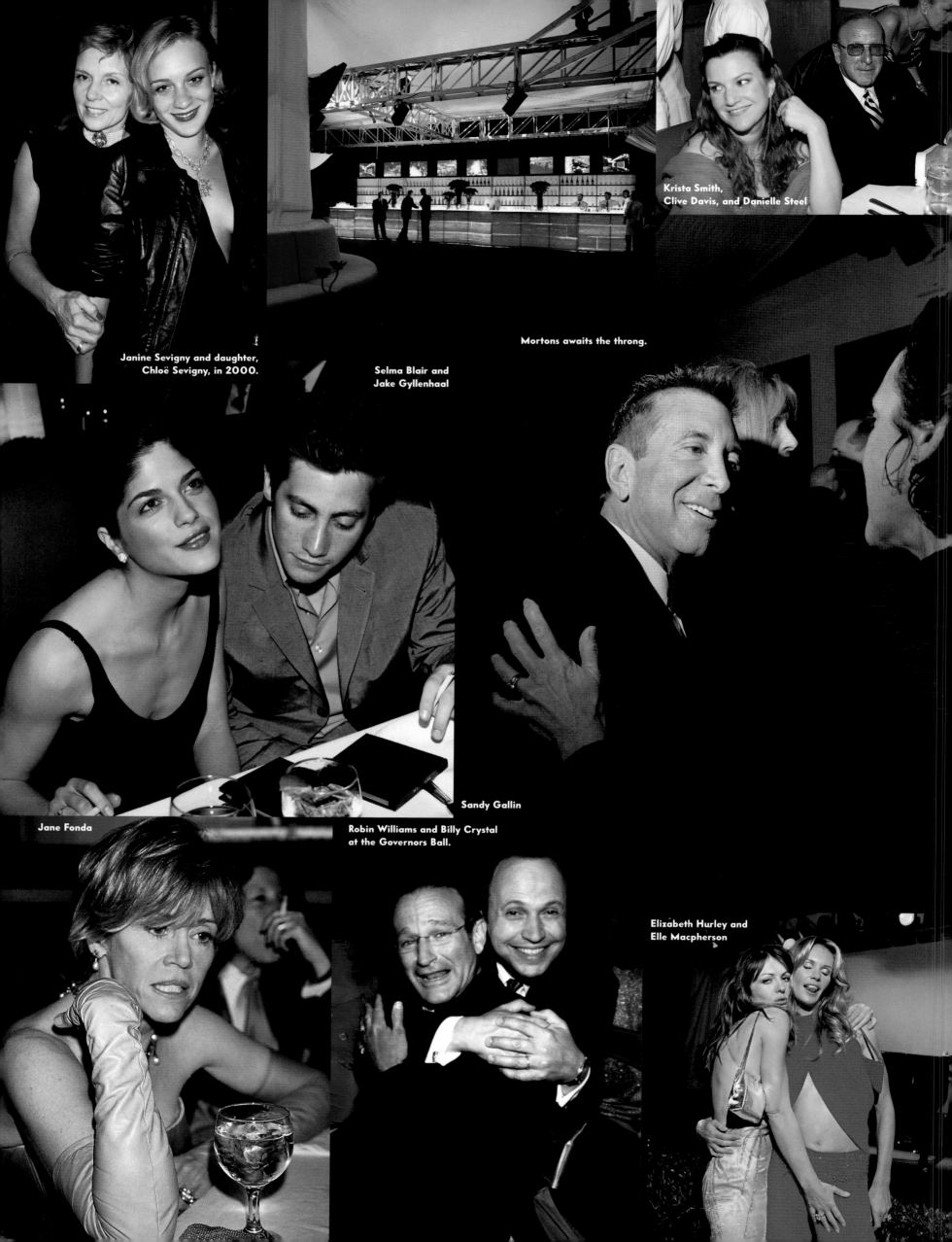

Janine Sevigny and daughter, Chloë Sevigny, in 2000.

Krista Smith, Clive Davis, and Danielle Steel

Mortons awaits the throng.

Selma Blair and Jake Gyllenhaal

Sandy Gallin

Jane Fonda

Robin Williams and Billy Crystal at the Governors Ball.

Elizabeth Hurley and Elle Macpherson

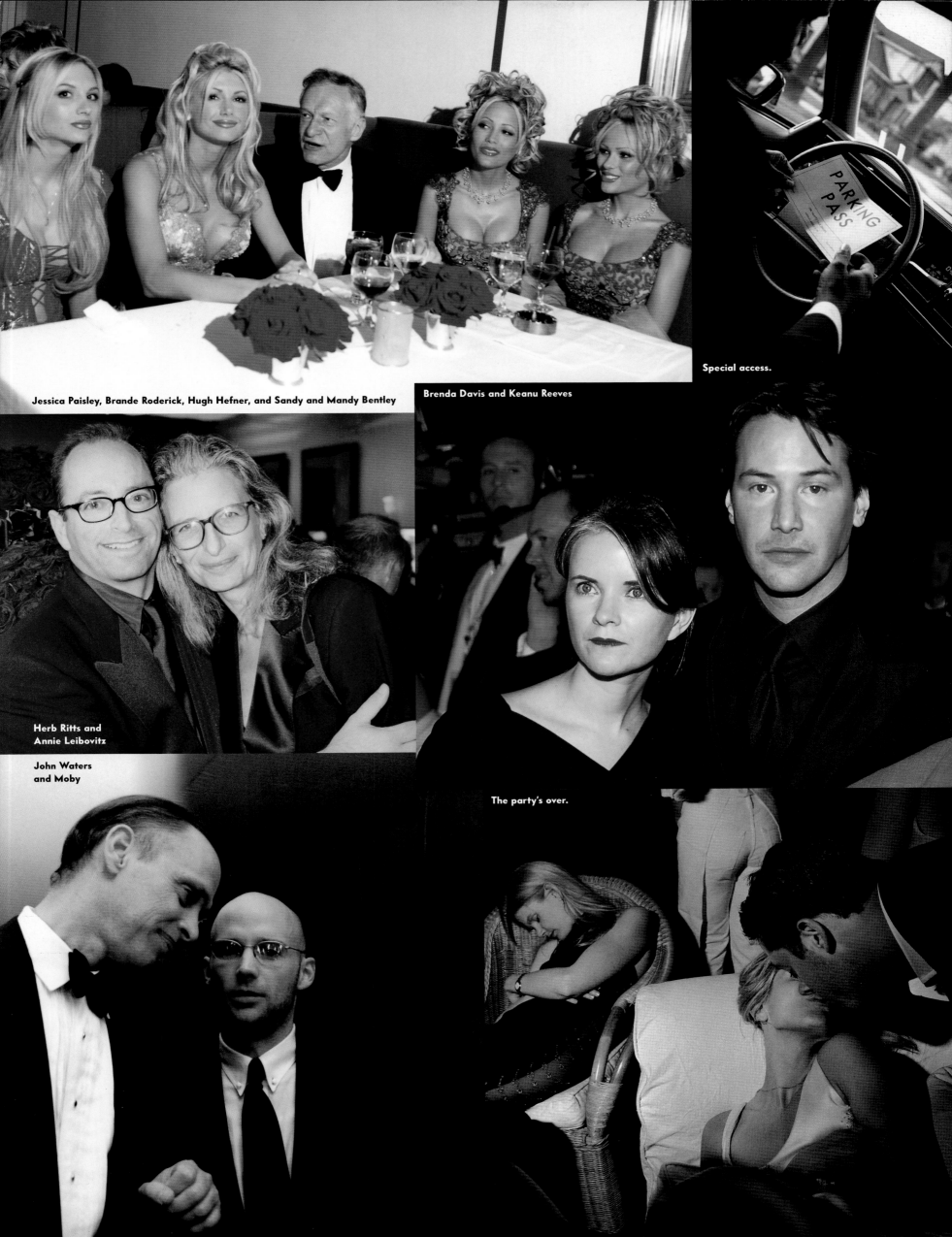

Jessica Paisley, Brande Roderick, Hugh Hefner, and Sandy and Mandy Bentley

Special access.

Brenda Davis and Keanu Reeves

Herb Ritts and
Annie Leibovitz

John Waters
and Moby

The party's over.

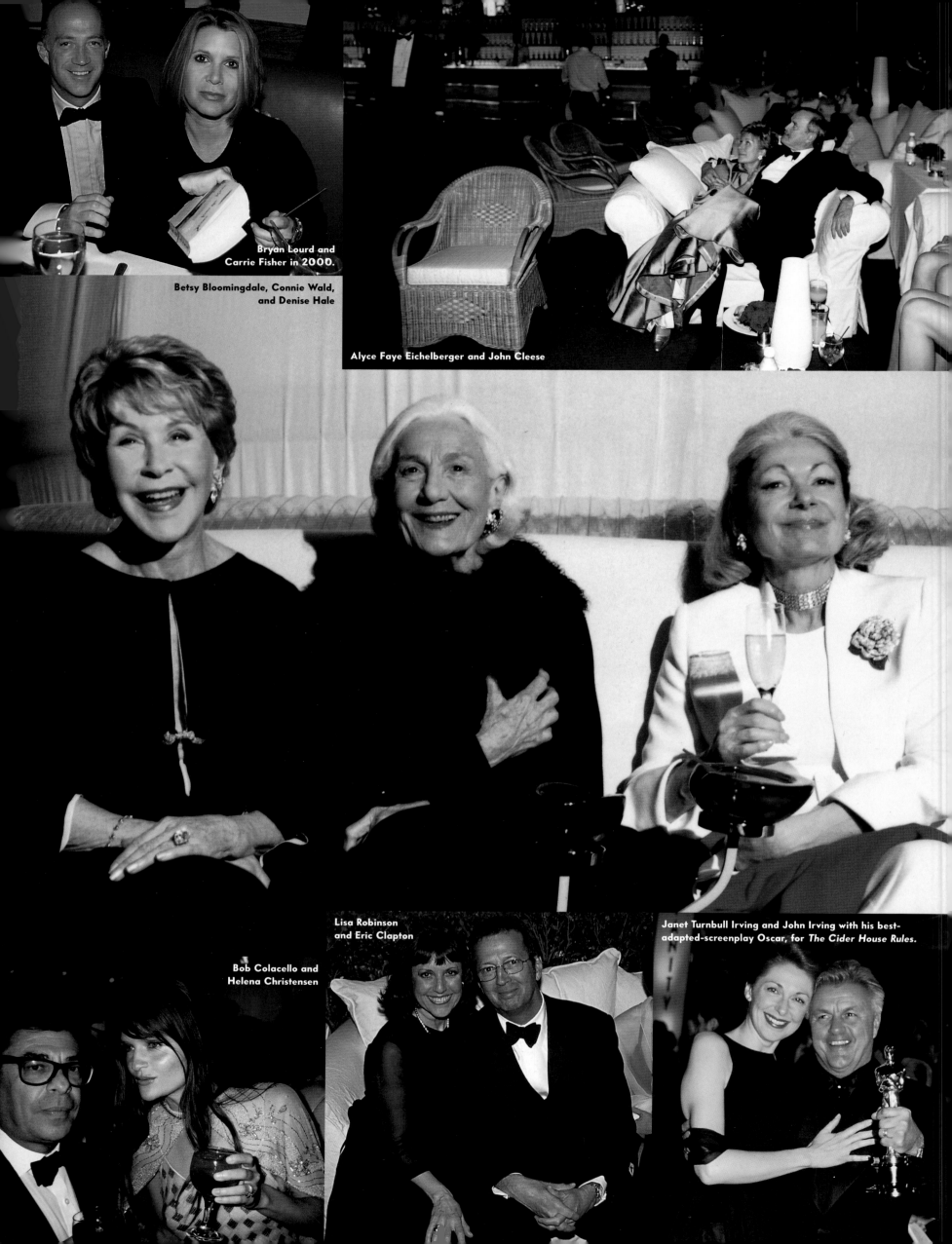

Bryan Lourd and
Carrie Fisher in 2000.

Betsy Bloomingdale, Connie Wald,
and Denise Hale

Alyce Faye Eichelberger and John Cleese

Bob Colacello and
Helena Christensen

Lisa Robinson
and Eric Clapton

Janet Turnbull Irving and John Irving with his best-
adapted-screenplay Oscar, for *The Cider House Rules*.

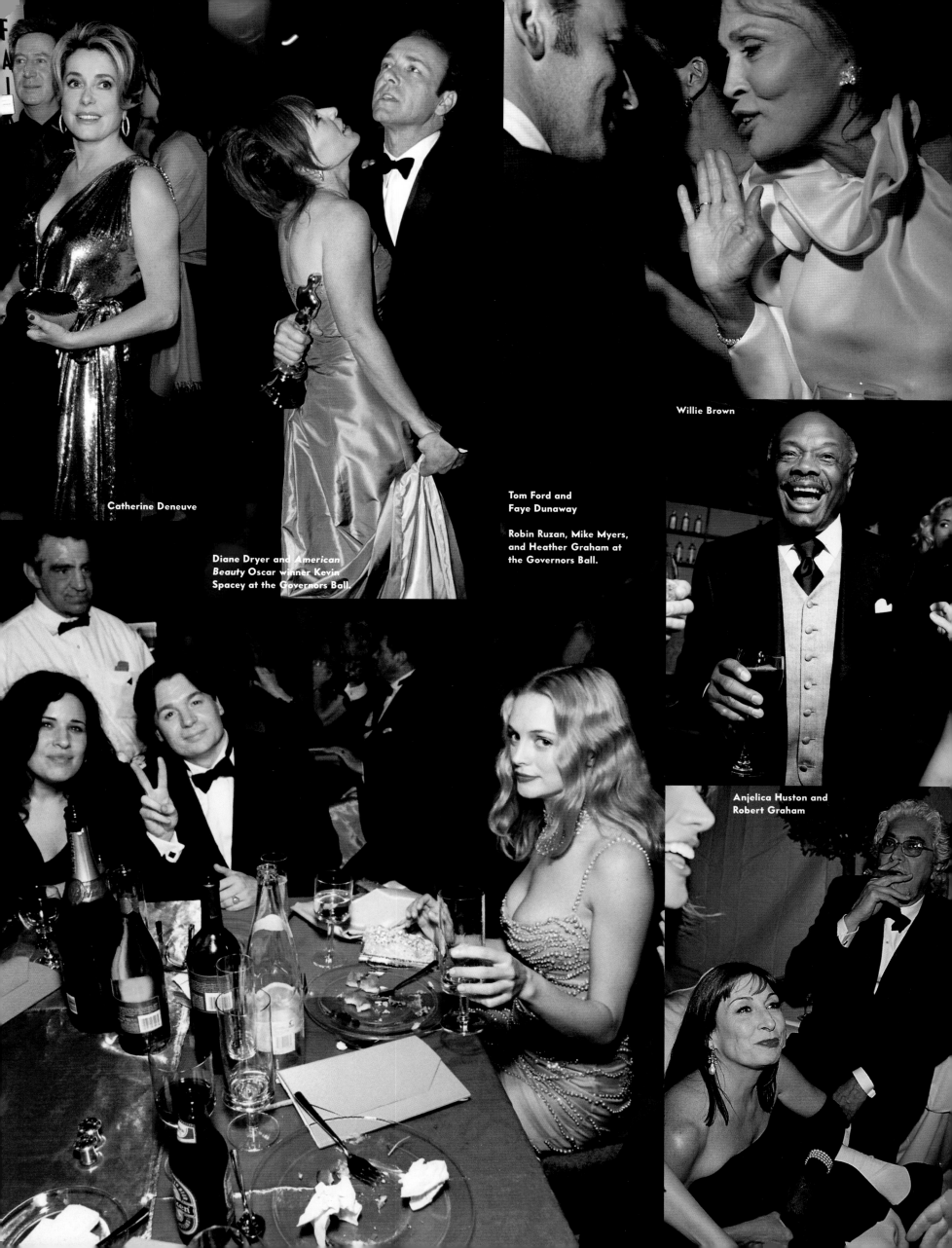

Catherine Deneuve

Diane Dryer and *American Beauty* Oscar winner Kevin Spacey at the Governors Ball.

Tom Ford and Faye Dunaway

Robin Ruzan, Mike Myers, and Heather Graham at the Governors Ball.

Willie Brown

Anjelica Huston and Robert Graham

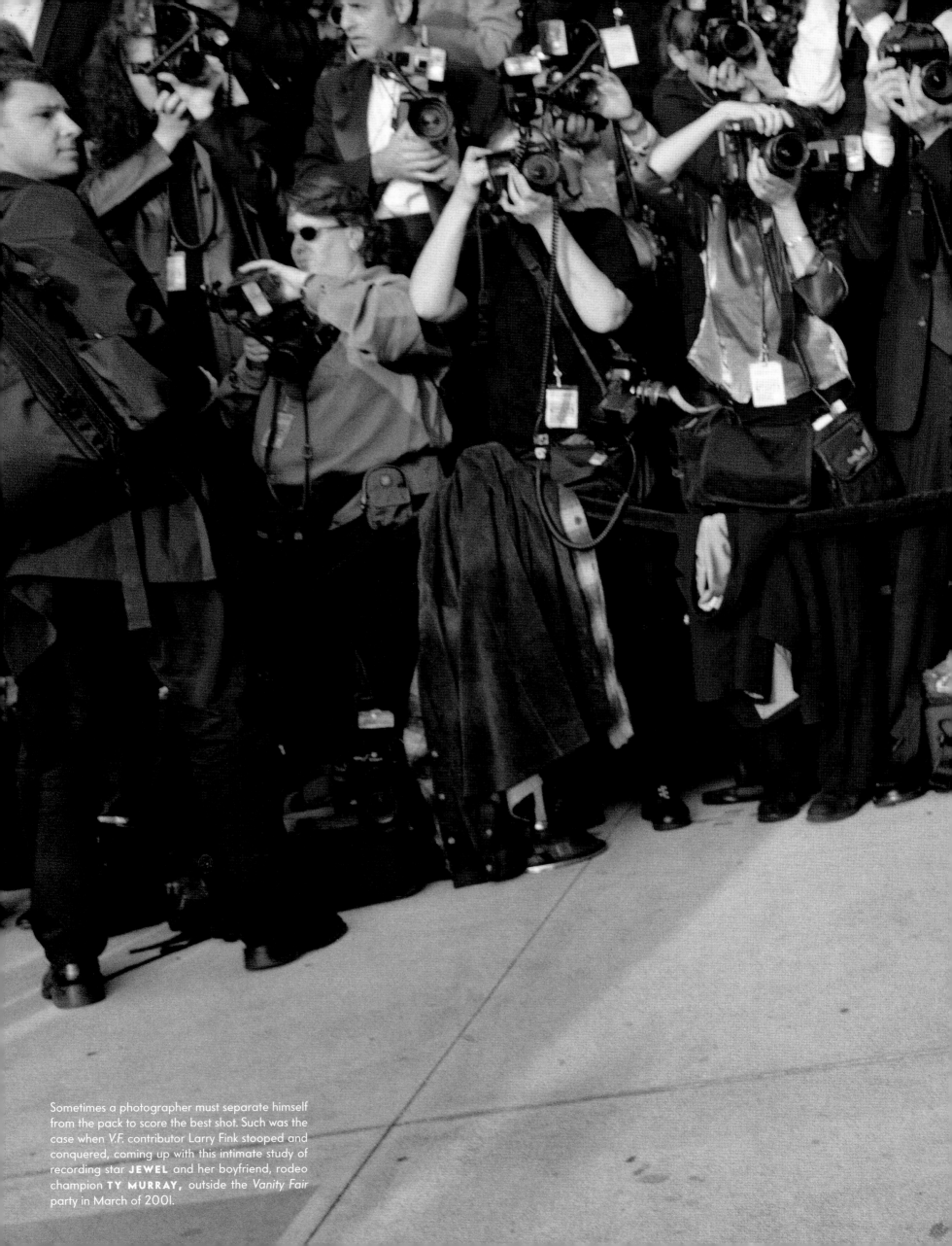

Sometimes a photographer must separate himself from the pack to score the best shot. Such was the case when V.F. contributor Larry Fink stooped and conquered, coming up with this intimate study of recording star **JEWEL** and her boyfriend, rodeo champion **TY MURRAY**, outside the *Vanity Fair* party in March of 2001.

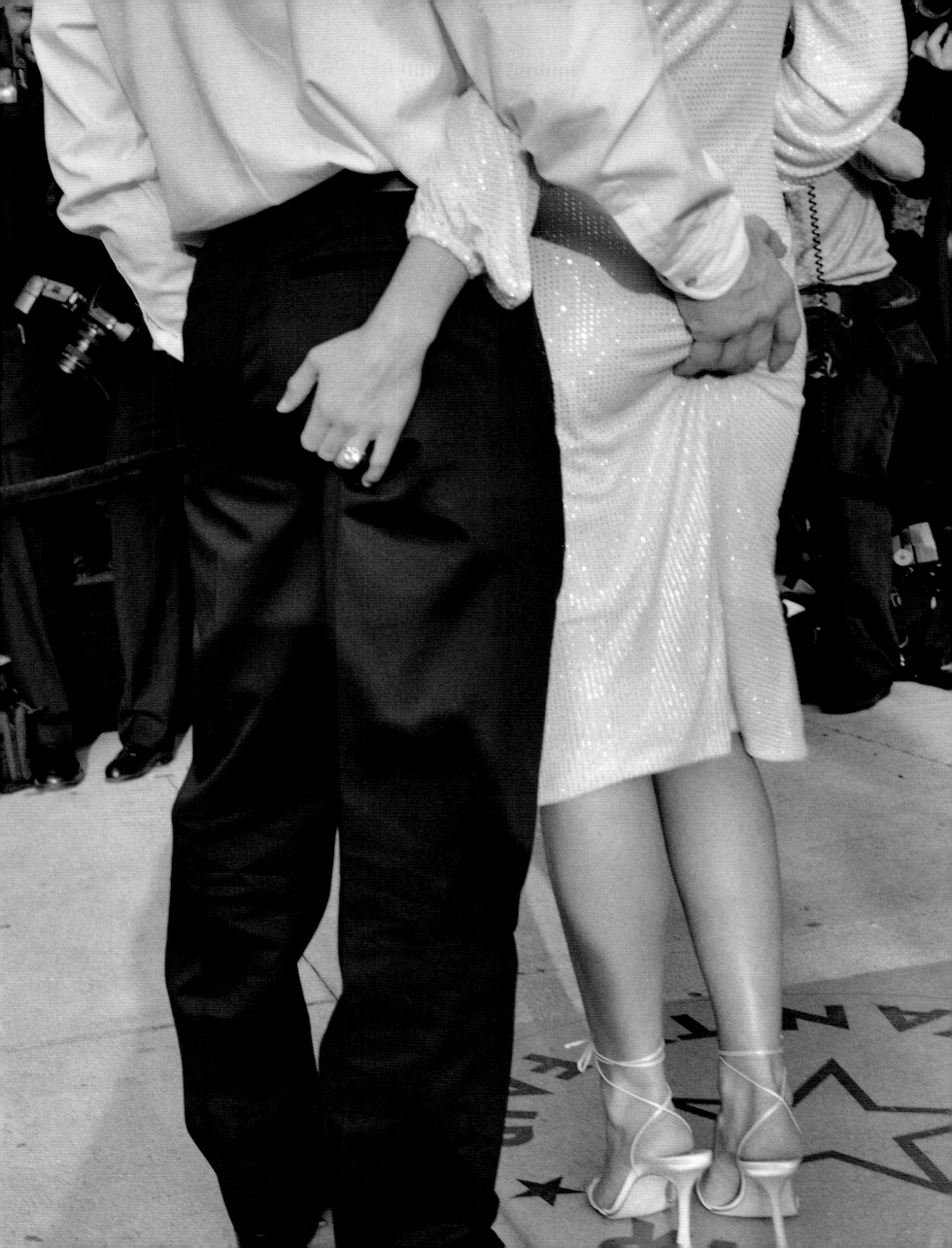

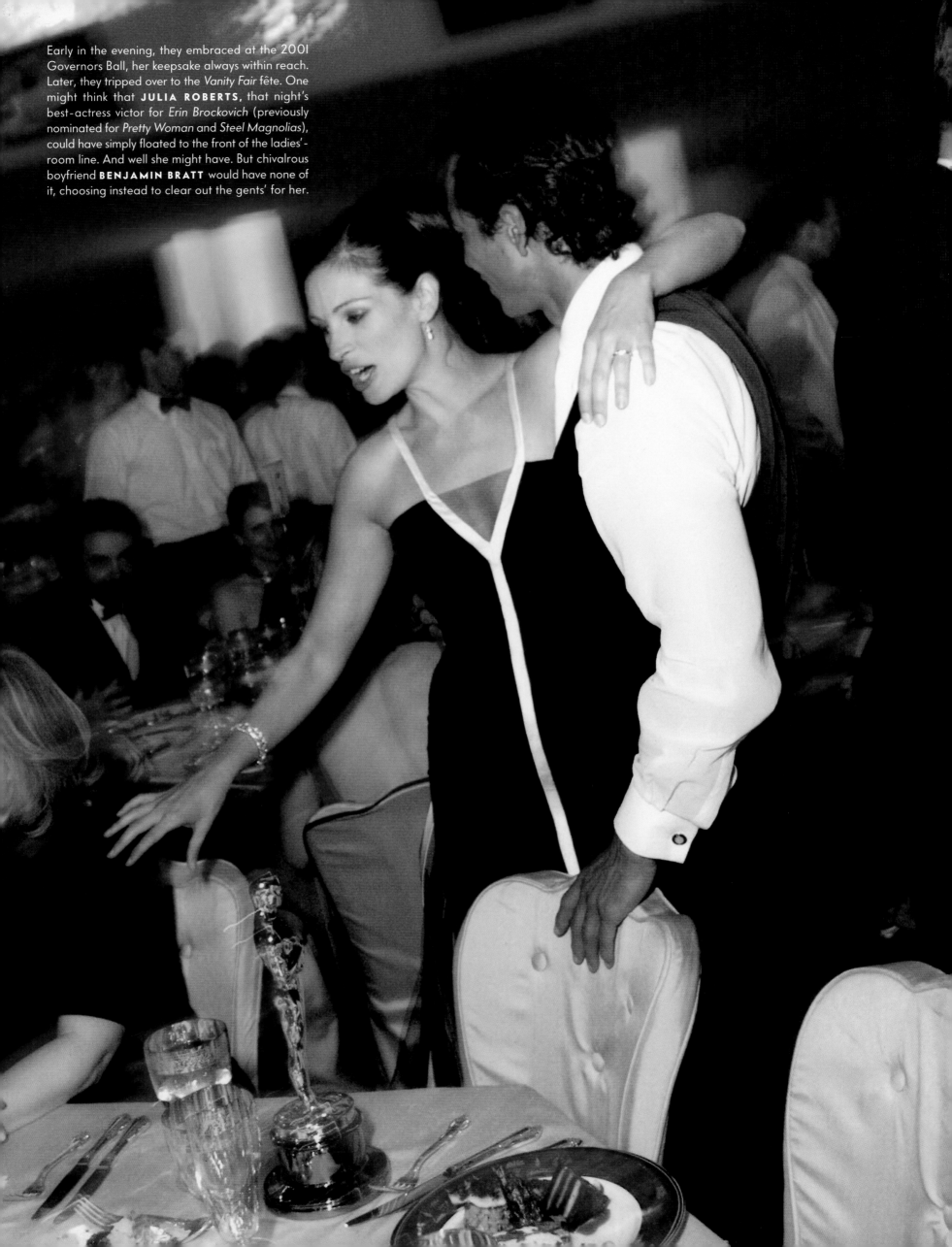

Early in the evening, they embraced at the 2001 Governors Ball, her keepsake always within reach. Later, they tripped over to the *Vanity Fair* fête. One might think that **JULIA ROBERTS,** that night's best-actress victor for *Erin Brockovich* (previously nominated for *Pretty Woman* and *Steel Magnolias*), could have simply floated to the front of the ladies'-room line. And well she might have. But chivalrous boyfriend **BENJAMIN BRATT** would have none of it, choosing instead to clear out the gents' for her.

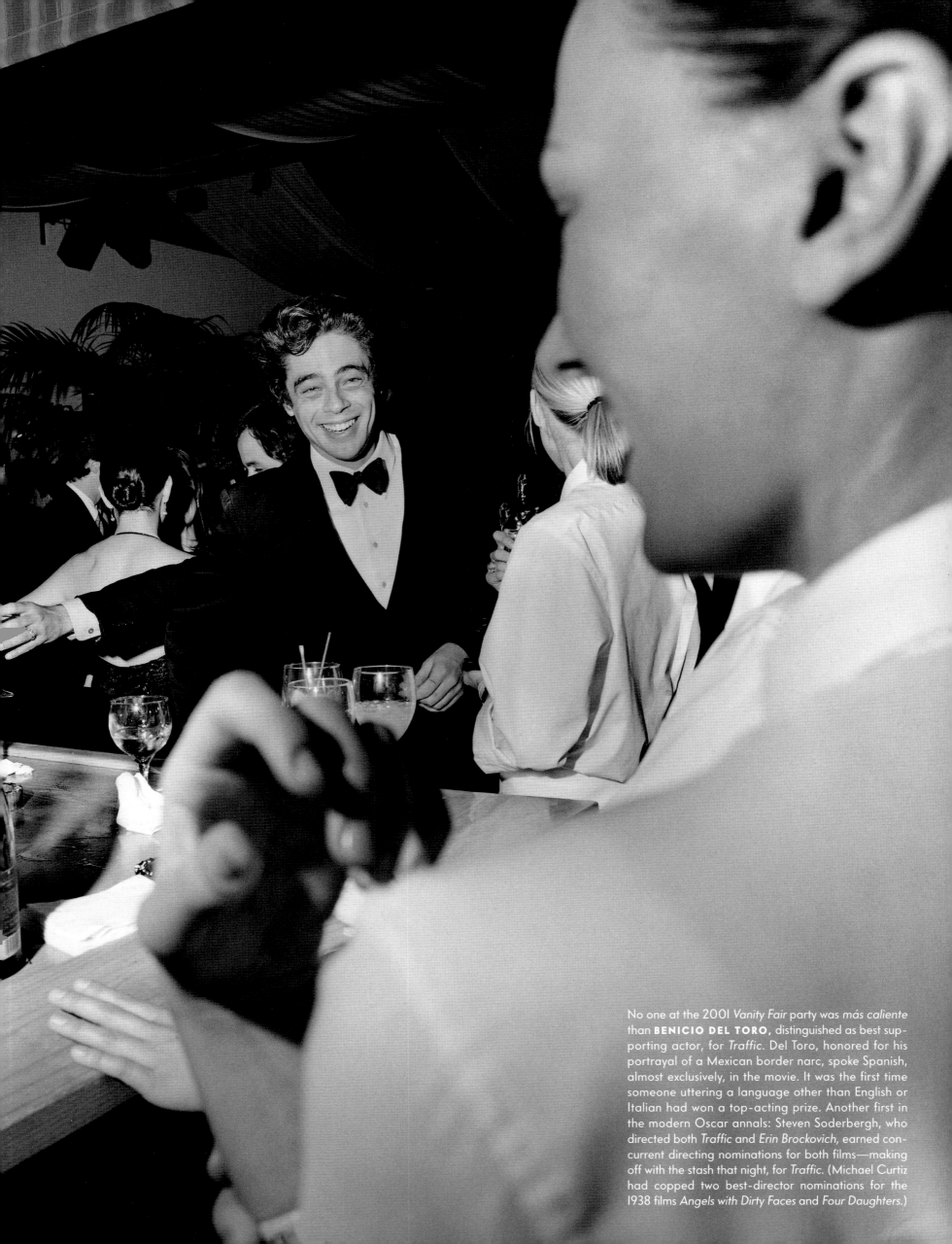

No one at the 2001 *Vanity Fair* party was *más caliente* than **BENICIO DEL TORO**, distinguished as best supporting actor, for *Traffic*. Del Toro, honored for his portrayal of a Mexican border narc, spoke Spanish, almost exclusively, in the movie. It was the first time someone uttering a language other than English or Italian had won a top-acting prize. Another first in the modern Oscar annals: Steven Soderbergh, who directed both *Traffic* and *Erin Brockovich*, earned concurrent directing nominations for both films—making off with the stash that night, for *Traffic*. (Michael Curtiz had copped two best-director nominations for the 1938 films *Angels with Dirty Faces* and *Four Daughters*.)

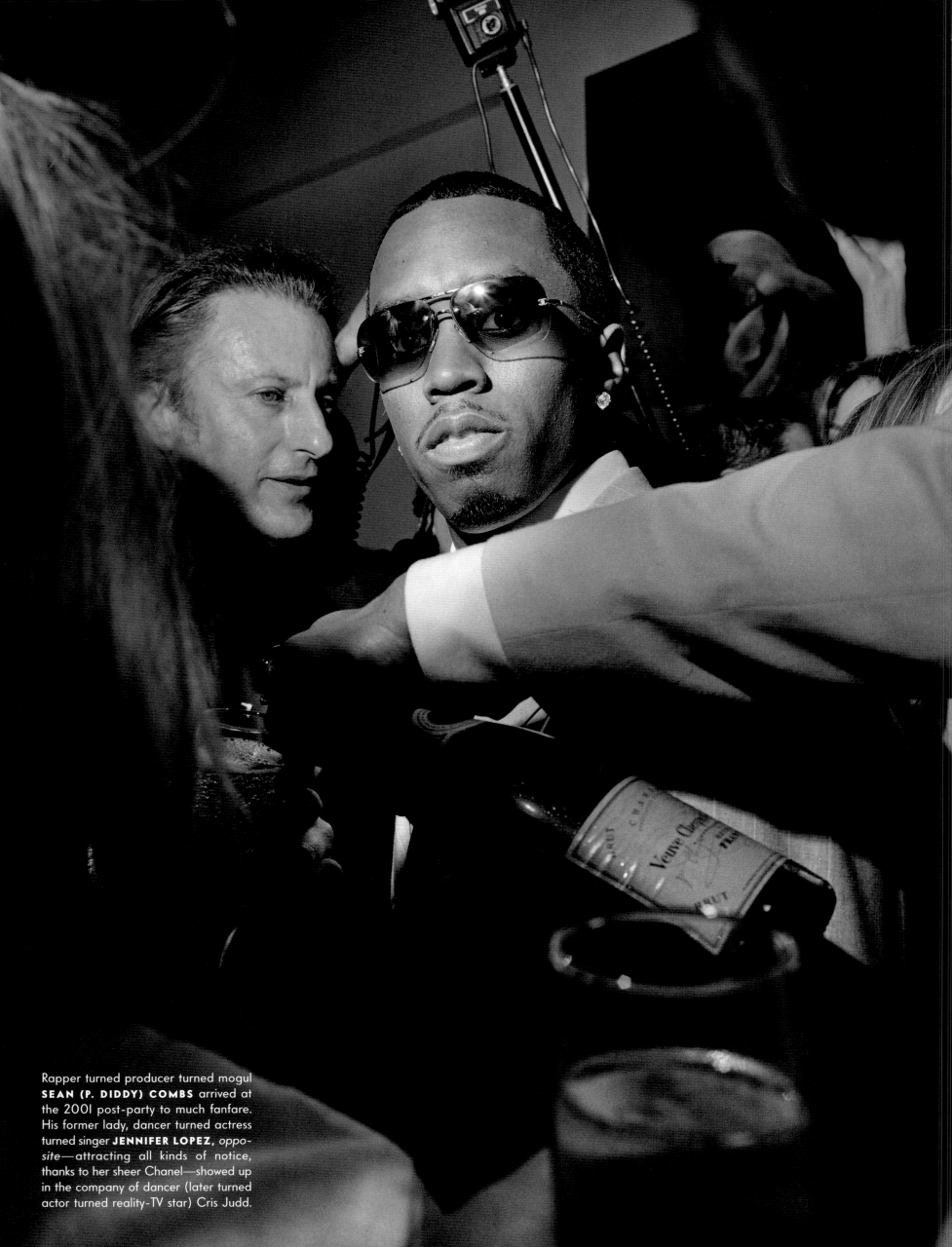

Rapper turned producer turned mogul **SEAN (P. DIDDY) COMBS** arrived at the 2001 post-party to much fanfare. His former lady, dancer turned actress turned singer **JENNIFER LOPEZ,** *opposite*—attracting all kinds of notice, thanks to her sheer Chanel—showed up in the company of dancer (later turned actor turned reality-TV star) Cris Judd.

““ Even a roomful of movie stars on Oscar night was riveted by the latest episode of 'Puffy and J.Lo.' The scene was the *Vanity Fair* party at Mortons. Combs—who some believe is still carrying a torch for Lopez—was the first to arrive. After checking his posse at the door, the rap mogul floated through the party in a cream-colored three-piece suit. One after another, guests congratulated him on his recent acquittal on weapons and bribery charges. . . . And yet you had to figure that somewhere in the back of his mind he was wondering, 'Will Jennifer show up?'

It was close to midnight when Lopez and her entourage arrived from the Shrine Auditorium. She [was] wearing that dress—the Chanel number that would have won any wet T-shirt contest. At her side was Cris Judd, the stocky dancer who has become her boyfriend.

Someone told them Puffy was about. Looking around, they waded through the crowd, holding tightly to one another's hands. For a while, it seemed as though Combs may have left. Then, there he was, striding toward them. People watched as he kissed his ex on the cheek. They shared a hug. . . . After a couple of minutes of conversation, Puff took his leave. 'I just wanted to be a gentleman and clear the air,' he said afterward, sipping a glass of Veuve Clicquot. ””

—GEORGE RUSH AND **JOANNA MOLLOY**
NEW YORK *DAILY NEWS*, MARCH 27, 2001

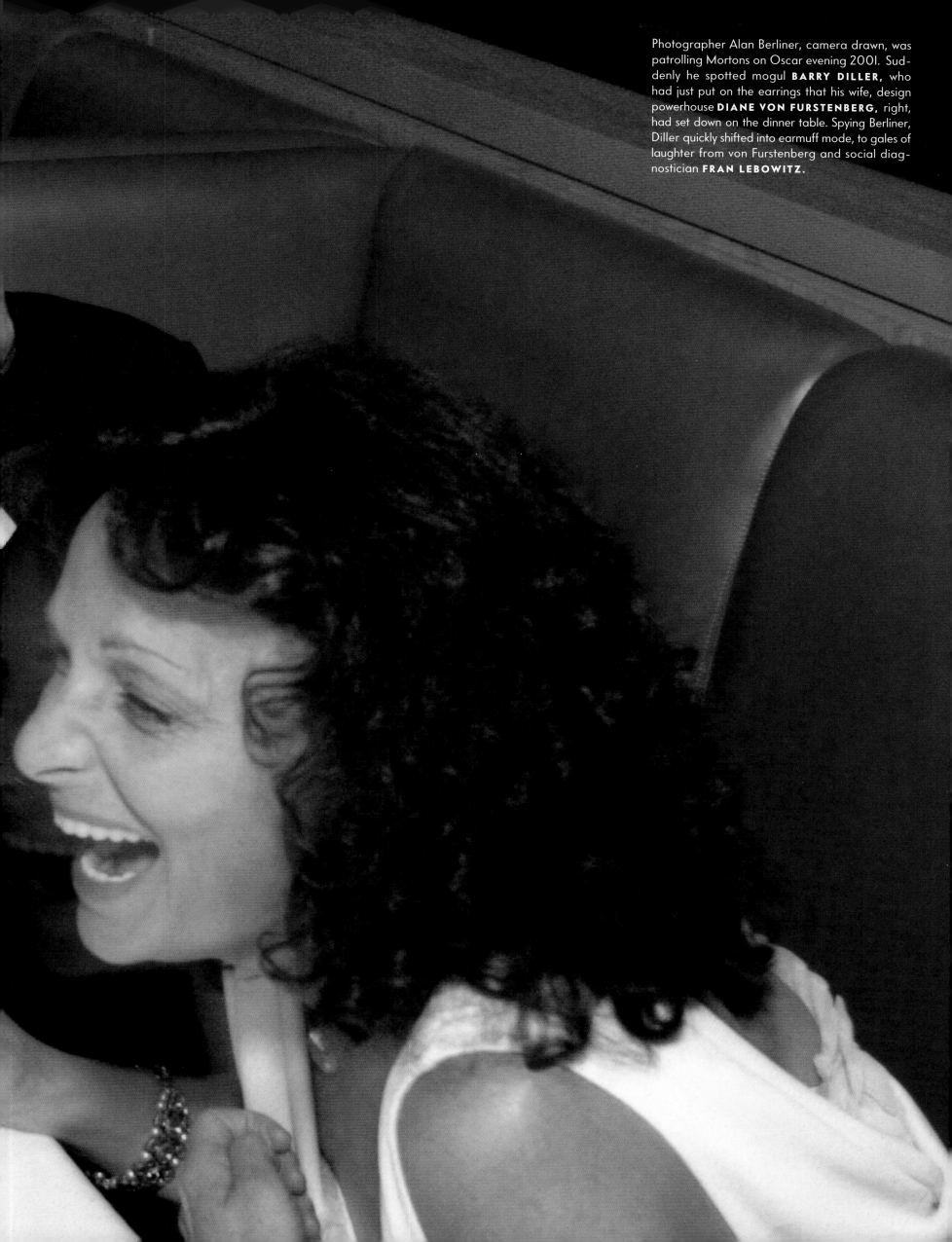

Photographer Alan Berliner, camera drawn, was patrolling Mortons on Oscar evening 2001. Suddenly he spotted mogul **BARRY DILLER,** who had just put on the earrings that his wife, design powerhouse **DIANE VON FURSTENBERG,** right, had set down on the dinner table. Spying Berliner, Diller quickly shifted into earmuff mode, to gales of laughter from von Furstenberg and social diagnostician **FRAN LEBOWITZ.**

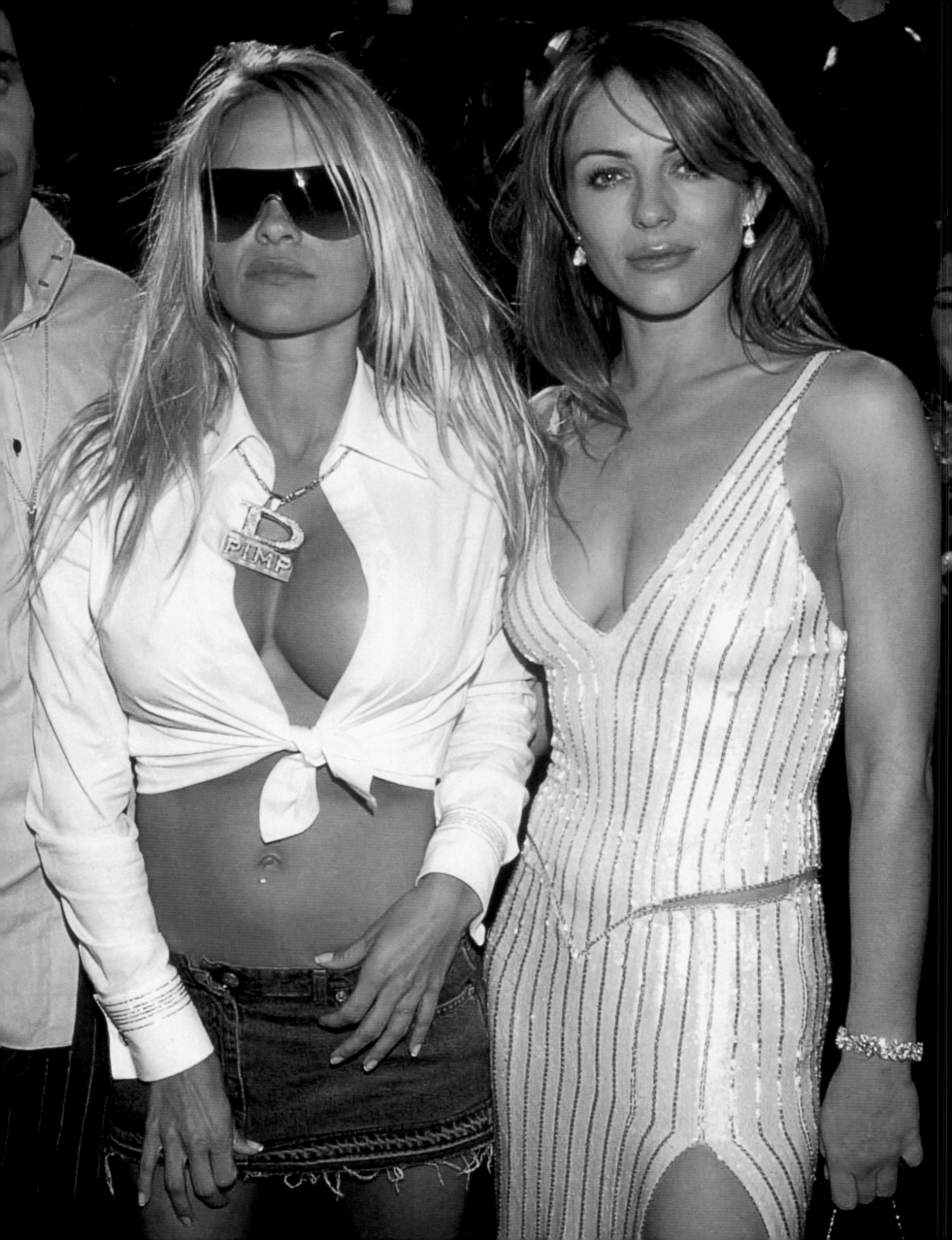

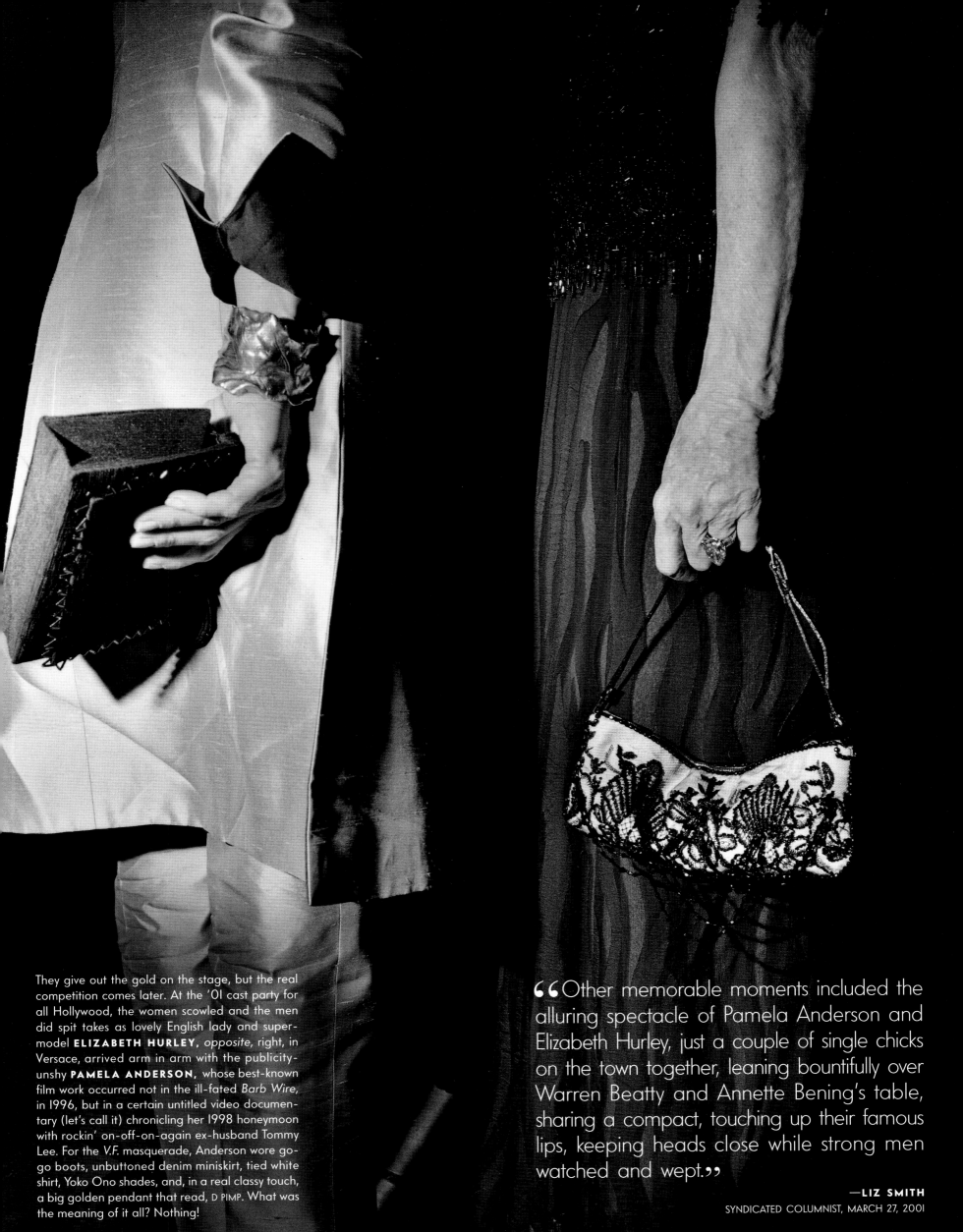

They give out the gold on the stage, but the real competition comes later. At the '01 cast party for all Hollywood, the women scowled and the men did spit takes as lovely English lady and supermodel **ELIZABETH HURLEY**, *opposite*, right, in Versace, arrived arm in arm with the publicity-unshy **PAMELA ANDERSON**, whose best-known film work occurred not in the ill-fated *Barb Wire*, in 1996, but in a certain untitled video documentary (let's call it) chronicling her 1998 honeymoon with rockin' on-off-on-again ex-husband Tommy Lee. For the *V.F.* masquerade, Anderson wore go-go boots, unbuttoned denim miniskirt, tied white shirt, Yoko Ono shades, and, in a real classy touch, a big golden pendant that read, D PIMP. What was the meaning of it all? Nothing!

❝Other memorable moments included the alluring spectacle of Pamela Anderson and Elizabeth Hurley, just a couple of single chicks on the town together, leaning bountifully over Warren Beatty and Annette Bening's table, sharing a compact, touching up their famous lips, keeping heads close while strong men watched and wept.❞

—LIZ SMITH
SYNDICATED COLUMNIST, MARCH 27, 2001

BAUBLES, LOGOS, AND BLING In 2001, a buoyant design, courtesy of Basil Walter Architects, adorned a precipice outside Mortons restaurant on the night of the 73rd Academy Awards. Inside, Elizabeth Hurley was adorned in Harry Winston (a $750,000 bracelet somehow escaped her for an unsettling spell), tables were adorned with Hermitage Dutch Tulips and Coppola private reserve (Chardonnay and Cabernet Sauvignon), and many late arrivals were adorned with little golden escorts.

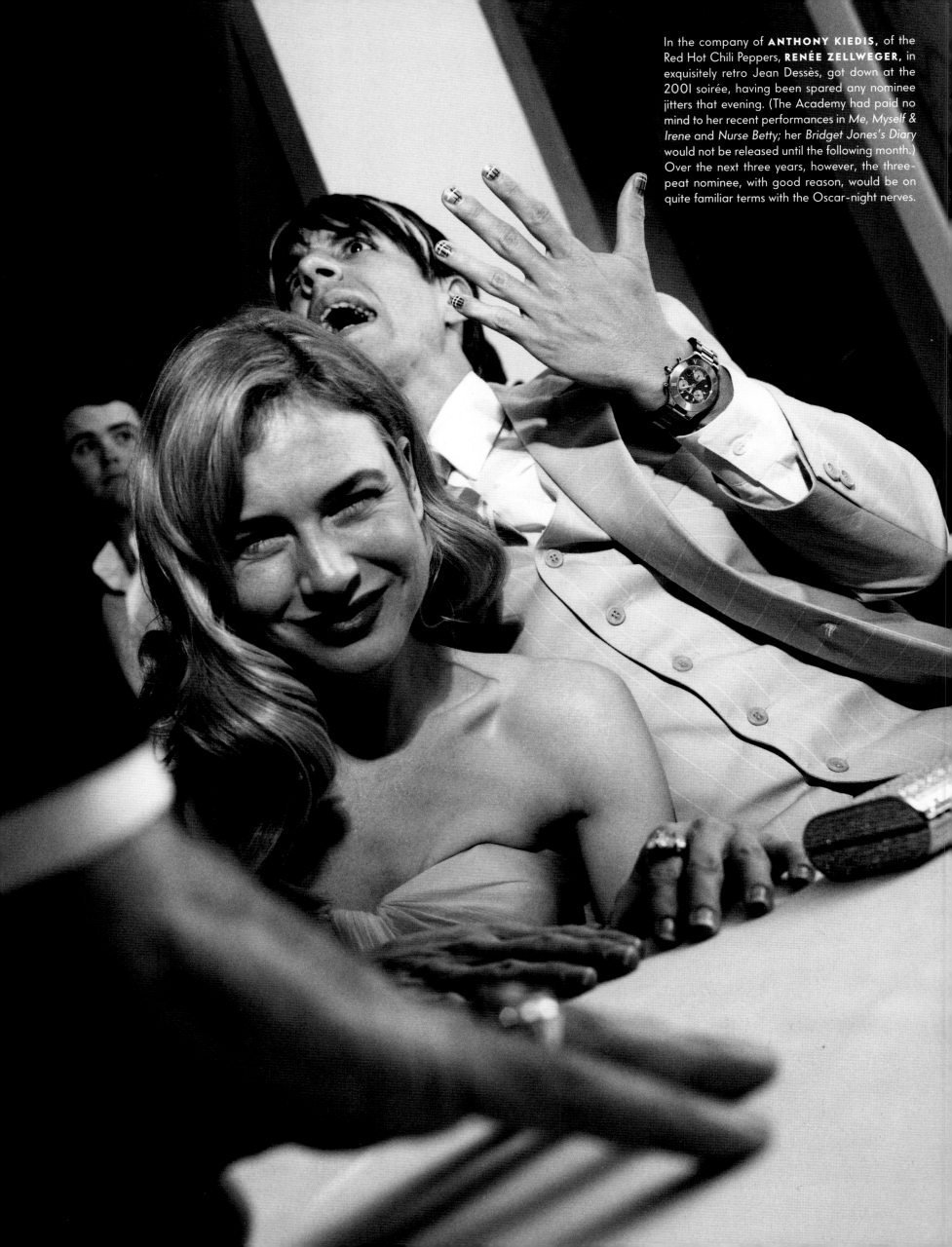

In the company of **ANTHONY KIEDIS**, of the Red Hot Chili Peppers, **RENÉE ZELLWEGER**, in exquisitely retro Jean Dessès, got down at the 2001 soirée, having been spared any nominee jitters that evening. (The Academy had paid no mind to her recent performances in *Me, Myself & Irene* and *Nurse Betty*; her *Bridget Jones's Diary* would not be released until the following month.) Over the next three years, however, the three-peat nominee, with good reason, would be on quite familiar terms with the Oscar-night nerves.

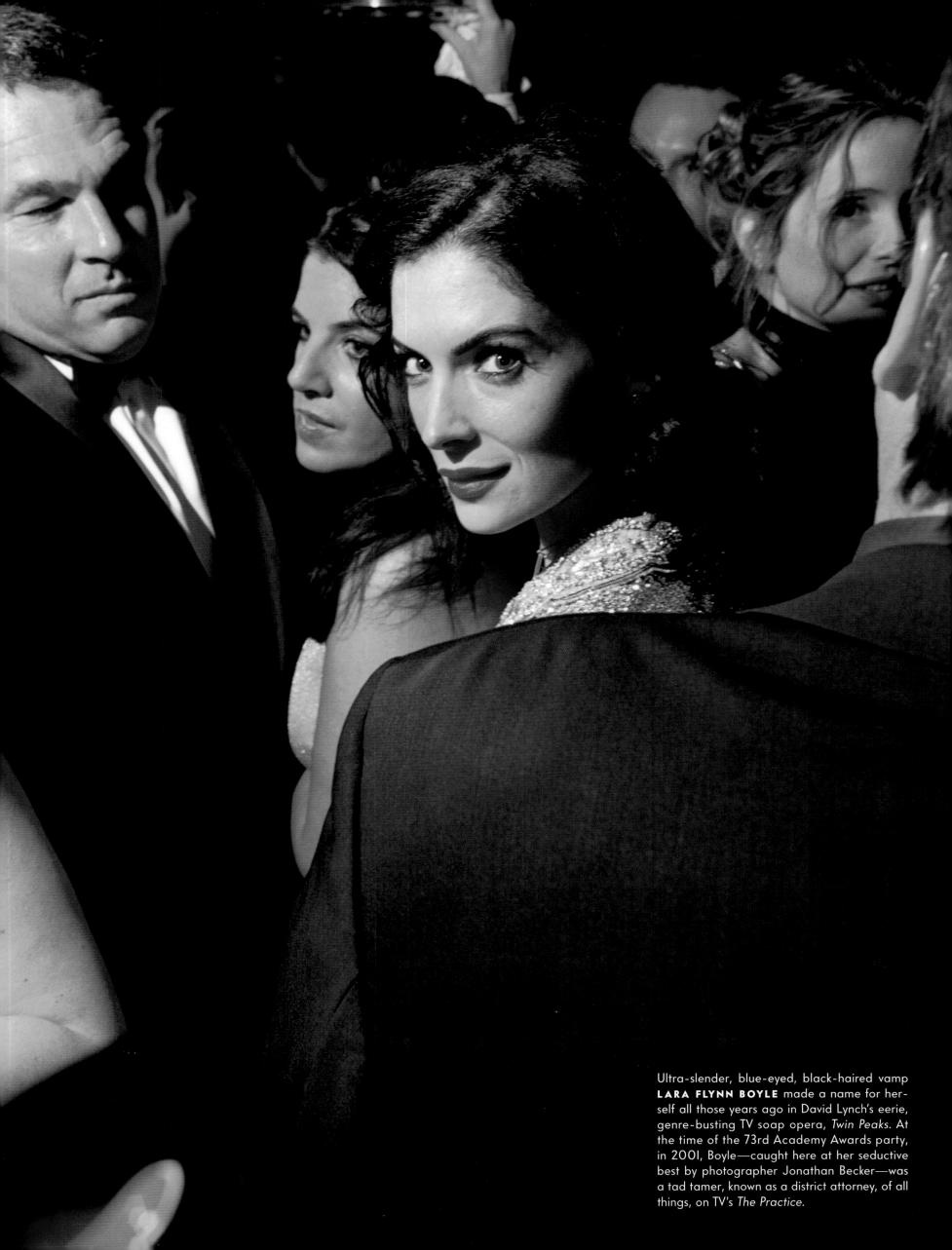

Ultra-slender, blue-eyed, black-haired vamp
LARA FLYNN BOYLE made a name for her-
self all those years ago in David Lynch's eerie,
genre-busting TV soap opera, *Twin Peaks*. At
the time of the 73rd Academy Awards party,
in 2001, Boyle—caught here at her seductive
best by photographer Jonathan Becker—was
a tad tamer, known as a district attorney, of all
things, on TV's *The Practice*.

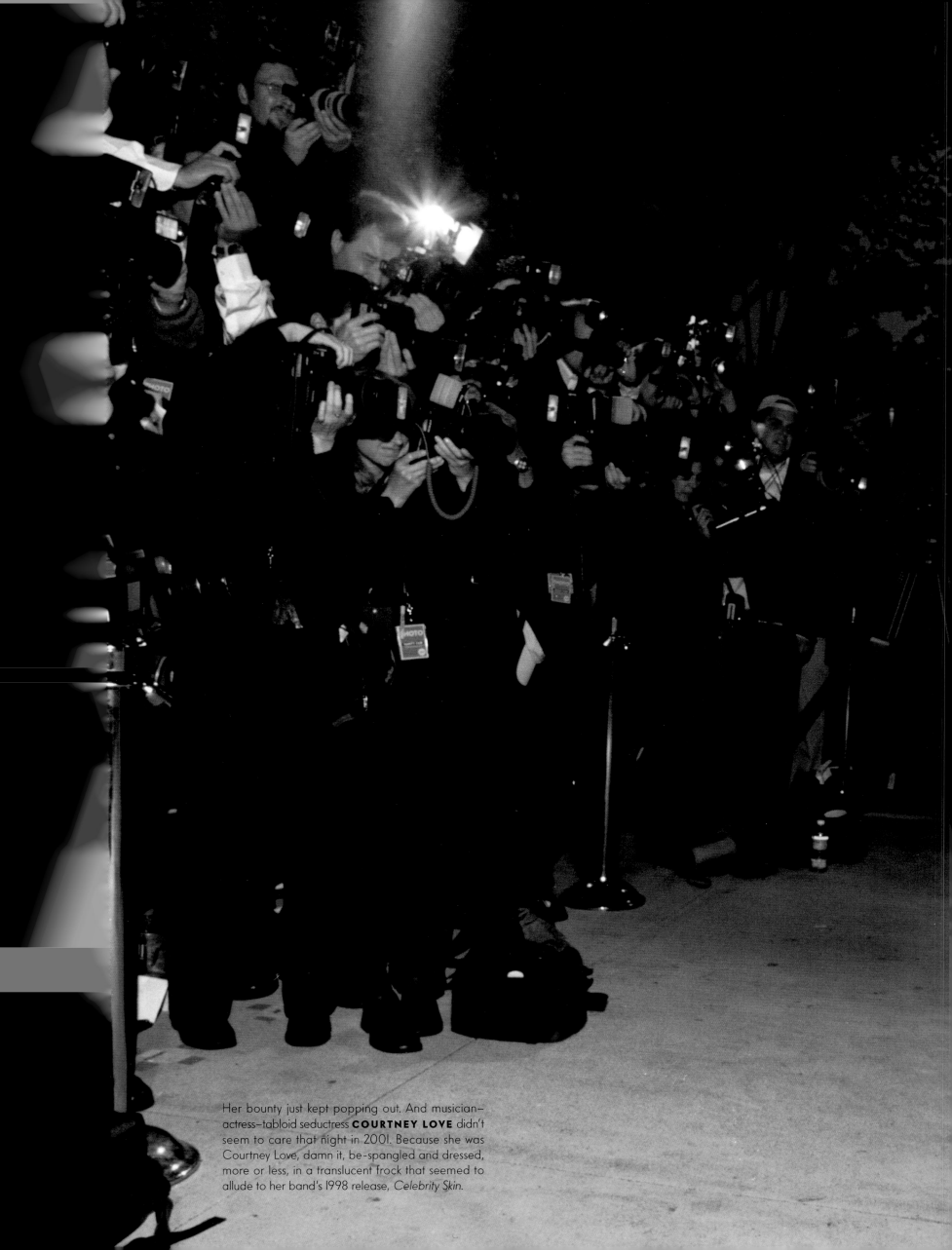

Her bounty just kept popping out. And musician–
actress–tabloid seductress **COURTNEY LOVE** didn't
seem to care that night in 2001. Because she was
Courtney Love, damn it, be-spangled and dressed,
more or less, in a translucent frock that seemed to
allude to her band's 1998 release, *Celebrity Skin*.

Paul Reubens and Bud Cort in 2001.

Julian Schnabel

Ernest Lehman with his honorary Oscar.

Jon Voight and daughter Angelina Jolie.

The night is young.

Eugene Levy and Catherine O'Hara

E. Elias Merhige, Willem Dafoe, and Eddie Izzard

Cameron Crowe with his best-original-screenplay Oscar, for *Almost Famous.*

Samuel L. Jackson

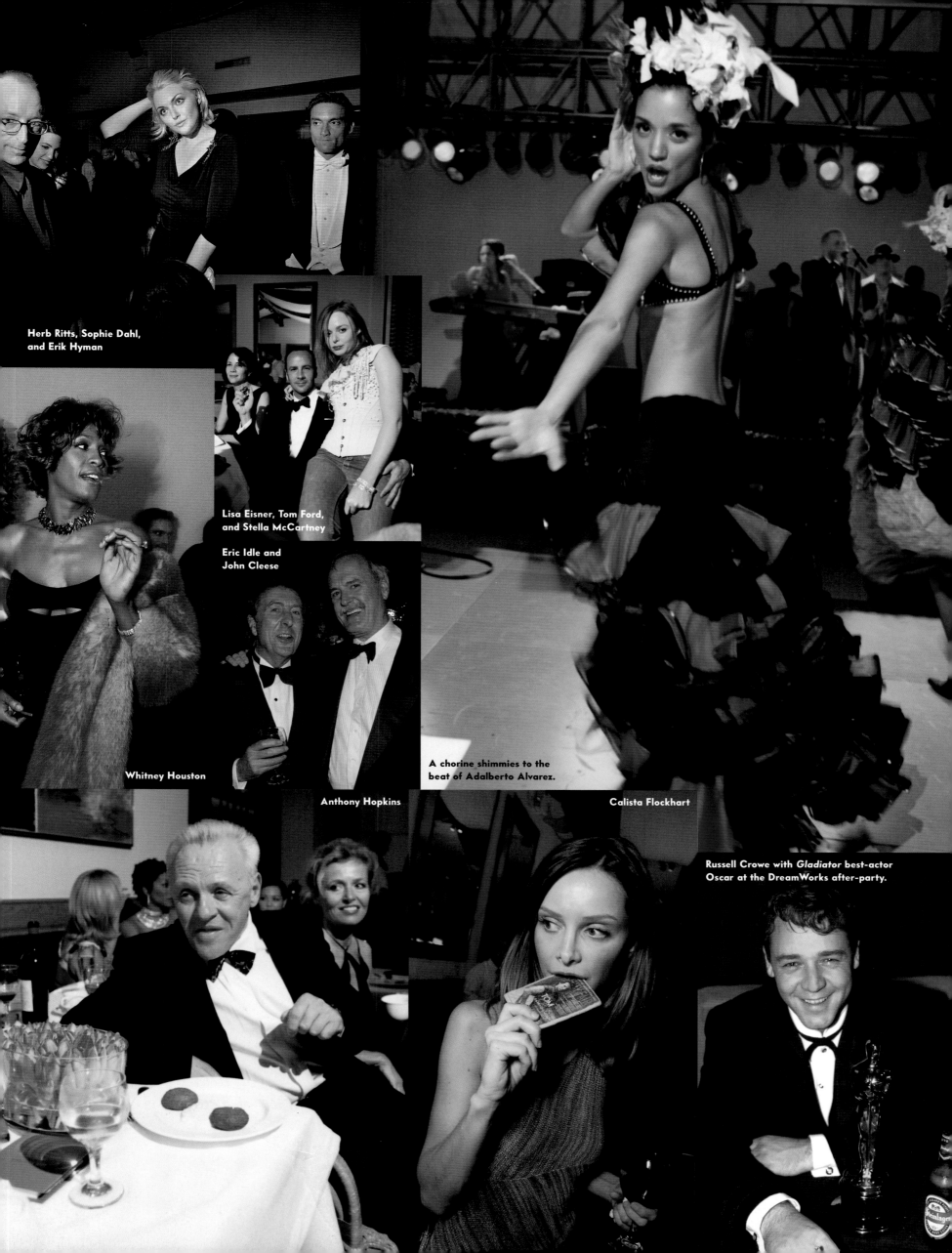

Herb Ritts, Sophie Dahl, and Erik Hyman

Lisa Eisner, Tom Ford, and Stella McCartney

Eric Idle and John Cleese

Whitney Houston

A chorine shimmies to the beat of Adalberto Alvarez.

Anthony Hopkins

Calista Flockhart

Russell Crowe with *Gladiator* best-actor Oscar at the DreamWorks after-party.

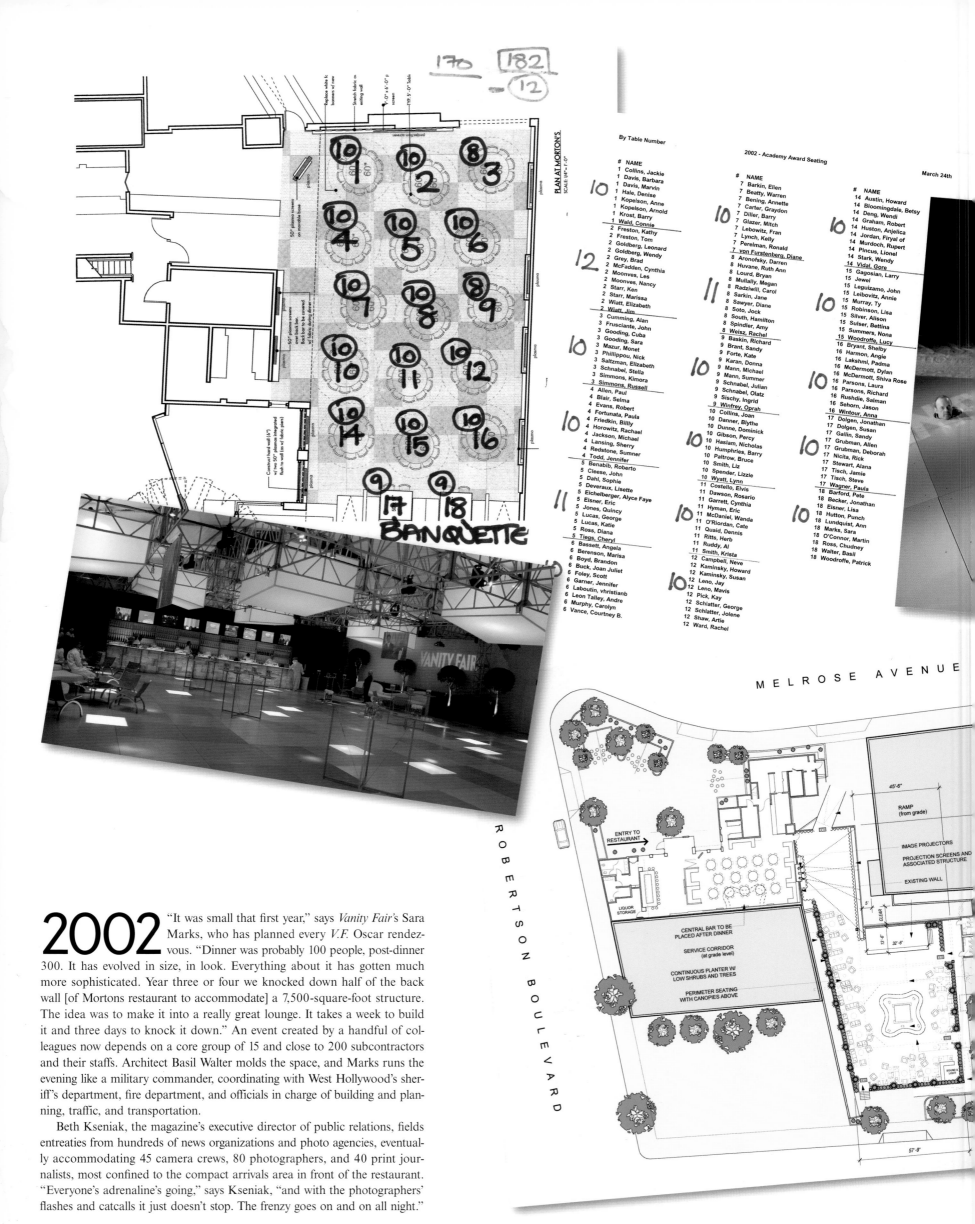

By Table Number

2002 - Academy Award Seating

March 24th

#	NAME		#	NAME		#	NAME
1	Collins, Jackie		7	Barkin, Ellen		14	Austin, Howard
1	Davis, Barbara		7	Beatty, Warren		14	Bloomingdale, Betsy
1	Davis, Marvin		7	Bening, Annette		14	Deng, Wendi
1	Hale, Denise		7	Carter, Graydon		14	Graham, Robert
1	Kopelson, Anne		7	Diller, Barry		14	Huston, Anjelica
1	Kopelson, Arnold		7	Glazer, Mitch		14	Jordan, Firyal of
1	Krost, Barry		7	Lebowitz, Fran		14	Murdoch, Rupert
1	Wald, Connie		7	Lynch, Kelly		14	Pincus, Lionel
2	Freston, Kathy		7	Perelman, Ronald		14	Stark, Wendy
2	Freston, Tom		7	von Furstenberg, Diane		14	Vidal, Gore
2	Goldberg, Leonard		8	Aronofsky, Darren		15	Gagosian, Larry
2	Goldberg, Wendy		8	Huvane, Ruth Ann		15	Jewel
2	Grey, Brad		8	Lourd, Bryan		15	Leguizamo, John
2	McFadden, Cynthia		8	Mullally, Megan		15	Leibovitz, Annie
2	Moonves, Les		8	Radziwill, Carol		15	Murray, Ty
2	Moonves, Nancy		8	Sarkin, Jane		15	Robinson, Lisa
2	Starr, Ken		8	Sawyer, Diane		15	Silver, Alison
2	Starr, Marissa		8	Soto, Jock		15	Sulser, Bettina
2	Wiatt, Elizabeth		8	South, Hamilton		15	Summers, Nona
2	Wiatt, Jim		8	Spindler, Amy		15	Woodroffe, Lucy
3	Cumming, Alan		8	Weisz, Rachel		16	Bryant, Shelby
3	Frusciante, John		9	Baskin, Richard		16	Harmon, Angie
3	Gooding, Cuba		9	Brant, Sandy		16	Lakshmi, Padma
3	Gooding, Sara		9	Forte, Kate		16	McDermott, Dylan
3	Mazur, Monet		9	Karan, Donna		16	McDermott, Shiva Rose
3	Phillippou, Nick		9	Mann, Michael		16	Parsons, Laura
3	Saltzman, Elizabeth		9	Mann, Summer		16	Parsons, Richard
3	Schnabel, Stella		9	Schnabel, Julian		16	Rushdie, Salman
3	Simmons, Kimora		9	Schnabel, Olatz		16	Sehorn, Jason
3	Simmons, Russell		9	Sischy, Ingrid		16	Wintour, Anna
4	Allen, Paul		9	Winfrey, Oprah		17	Dolgen, Jonathan
4	Blair, Selma		10	Collins, Joan		17	Dolgen, Susan
4	Evans, Robert		10	Danner, Blythe		17	Gallin, Sandy
4	Fortunata, Paula		10	Dunne, Dominick		17	Grubman, Allen
4	Friedkin, Billy		10	Gibson, Percy		17	Grubman, Deborah
4	Horowitz, Rachael		10	Haslam, Nicholas		17	Nicita, Rick
4	Jackson, Michael		10	Humphries, Barry		17	Stewart, Alana
4	Lansing, Sherry		10	Paltrow, Bruce		17	Tisch, Jamie
4	Redstone, Sumner		10	Smith, Liz		17	Tisch, Steve
4	Todd, Jennifer		10	Spender, Lizzie		17	Wagner, Paula
5	Benabib, Roberto		10	Wyatt, Lynn		18	Barford, Pete
5	Cleese, John		11	Costello, Elvis		18	Becker, Jonathan
5	Dahl, Sophie		11	Dawson, Rosario		18	Eisner, Lisa
5	Deveraux, Lisette		11	Garrett, Cynthia		18	Hutton, Punch
5	Eichelberger, Alyce Faye		11	Hyman, Eric		18	Lundquist, Ann
5	Eisner, Eric		11	McDaniel, Wanda		18	Marks, Sara
5	Jones, Quincy		11	O'Riordan, Cate		18	O'Connor, Martin
5	Lucas, George		11	Quaid, Dennis		18	Ross, Chuey
5	Lucas, Katie		11	Ritts, Herb		18	Walter, Basil
5	Ross, Diana		11	Ruddy, Al		18	Woodroffe, Patrick
5	Tiegs, Cheryl		11	Smith, Krista			
6	Bassett, Angela		12	Campbell, Neve			
6	Berenson, Marisa		12	Kaminsky, Howard			
6	Boyd, Brandon		12	Kaminsky, Susan			
6	Buck, Joan Juliet		12	Leno, Jay			
6	Foley, Scott		12	Leno, Mavis			
6	Garner, Jennifer		12	Pick, Kay			
6	Laboutin, vhristianb		12	Schlatter, George			
6	Leon Talley, Andre		12	Schlatter, Jolene			
6	Murphy, Carolyn		12	Shaw, Artie			
6	Vance, Courtney B.		12	Ward, Rachel			

PLAN AT MORTON'S
SCALE 1/4" = 1'-0"

MELROSE AVENUE

ROBERTSON BOULEVARD

RAMP (from grade)

IMAGE PROJECTORS

PROJECTION SCREENS AND ASSOCIATED STRUCTURE

EXISTING WALL

ENTRY TO RESTAURANT

LIQUOR STORAGE

CENTRAL BAR TO BE PLACED AFTER DINNER

SERVICE CORRIDOR (at grade level)

CONTINUOUS PLANTER W/ LOW SHRUBS AND TREES

PERIMETER SEATING WITH CANOPIES ABOVE

2002

"It was small that first year," says *Vanity Fair*'s Sara Marks, who has planned every *V.F.* Oscar rendezvous. "Dinner was probably 100 people, post-dinner 300. It has evolved in size, in look. Everything about it has gotten much more sophisticated. Year three or four we knocked down half of the back wall [of Mortons restaurant to accommodate] a 7,500-square-foot structure. The idea was to make it into a really great lounge. It takes a week to build it and three days to knock it down." An event created by a handful of colleagues now depends on a core group of 15 and close to 200 subcontractors and their staffs. Architect Basil Walter molds the space, and Marks runs the evening like a military commander, coordinating with West Hollywood's sheriff's department, fire department, and officials in charge of building and planning, traffic, and transportation.

Beth Kseniak, the magazine's executive director of public relations, fields entreaties from hundreds of news organizations and photo agencies, eventually accommodating 45 camera crews, 80 photographers, and 40 print journalists, most confined to the compact arrivals area in front of the restaurant. "Everyone's adrenaline's going," says Kseniak, "and with the photographers' flashes and catcalls it just doesn't stop. The frenzy goes on and on all night."

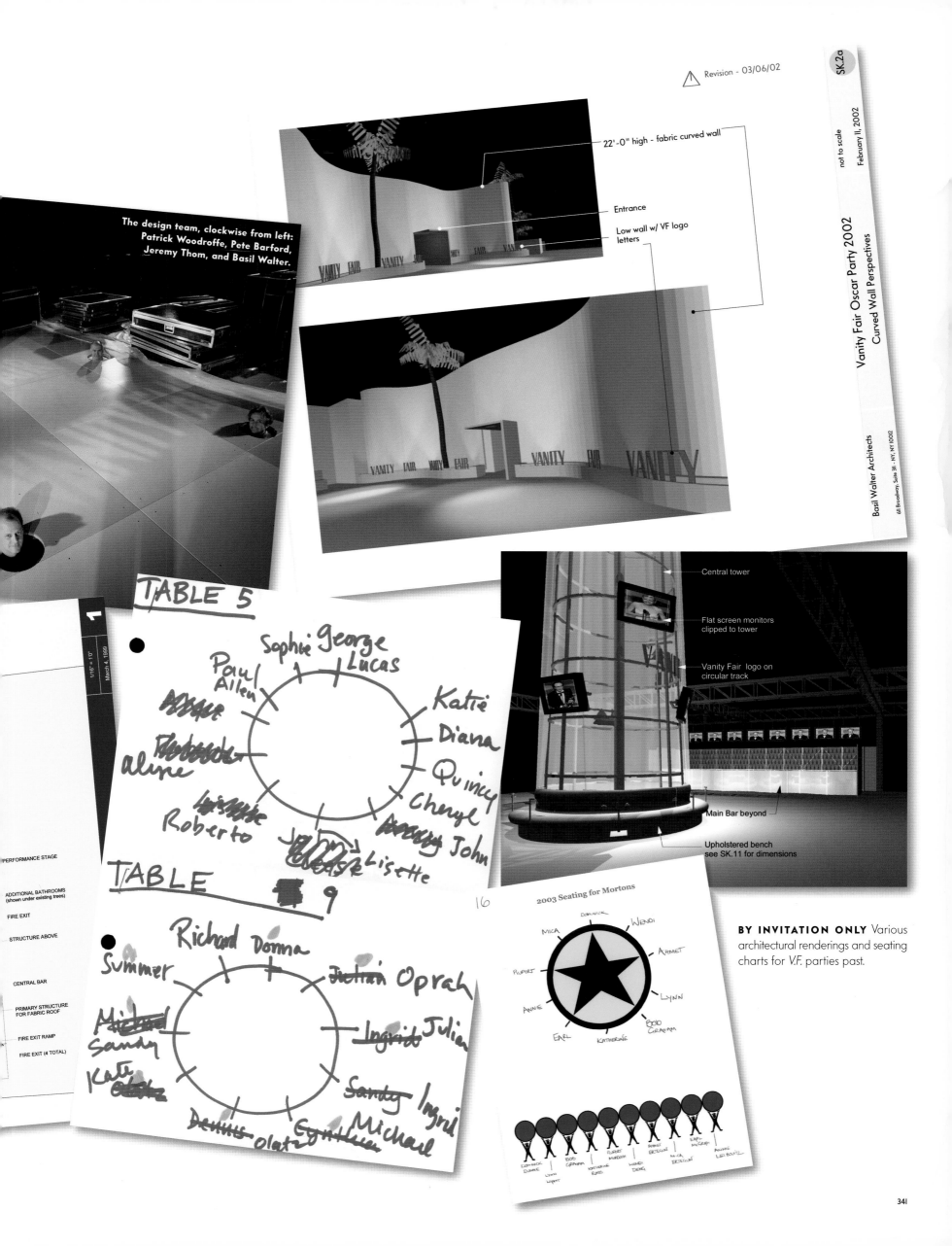

The design team, clockwise from left: Patrick Woodroffe, Pete Barford, Jeremy Thom, and Basil Walter.

Revision - 03/06/02

SK.2a

not to scale
February 11, 2002

Vanity Fair Oscar Party 2002
Curved Wall Perspectives

Basil Walter Architects
68 Broadway, Suite 3H - NY, NY 10012

22'-0" high - fabric curved wall

Entrance

Low wall w/ VF logo letters

VANITY FAIR VANITY FAIR

VANITY FAIR VANITY

Central tower

Flat screen monitors clipped to tower

Vanity Fair logo on circular track

Main Bar beyond

Upholstered bench see SK.11 for dimensions

1
1/16" = 1'0"
March 4, 1999

PERFORMANCE STAGE

ADDITIONAL BATHROOMS (shown under existing trees)

FIRE EXIT

STRUCTURE ABOVE

CENTRAL BAR

PRIMARY STRUCTURE FOR FABRIC ROOF

FIRE EXIT RAMP

FIRE EXIT (4 TOTAL)

TABLE 5

Sophie George Lucas
Paul Allen
Katie
Diana
Quincy
Cheryl
John
Roberto
Lisette
Aline

TABLE 9

Richard Donna
Summer
Julian Oprah
Ingrid Julian
Michael Sandy
Sandy Ingrid
Kate
Olatz Michael

16

2003 Seating for Mortons

MICA DOMINICK WENDI
RUPERT AHMET
ANNIE LYNN
EARL BOB GRAHAM
KATHERINE

DOMINICK DUNNE / LYNN WYATT / BOB GRAHAM / KATHERINE ROSS / RUPERT MURDOCH / WENDI DENG / AHMET ERTEGUN / MICA ERTEGUN / EARL MCGRATH / ANNIE LEIBOVITZ

BY INVITATION ONLY Various architectural renderings and seating charts for V.F. parties past.

341

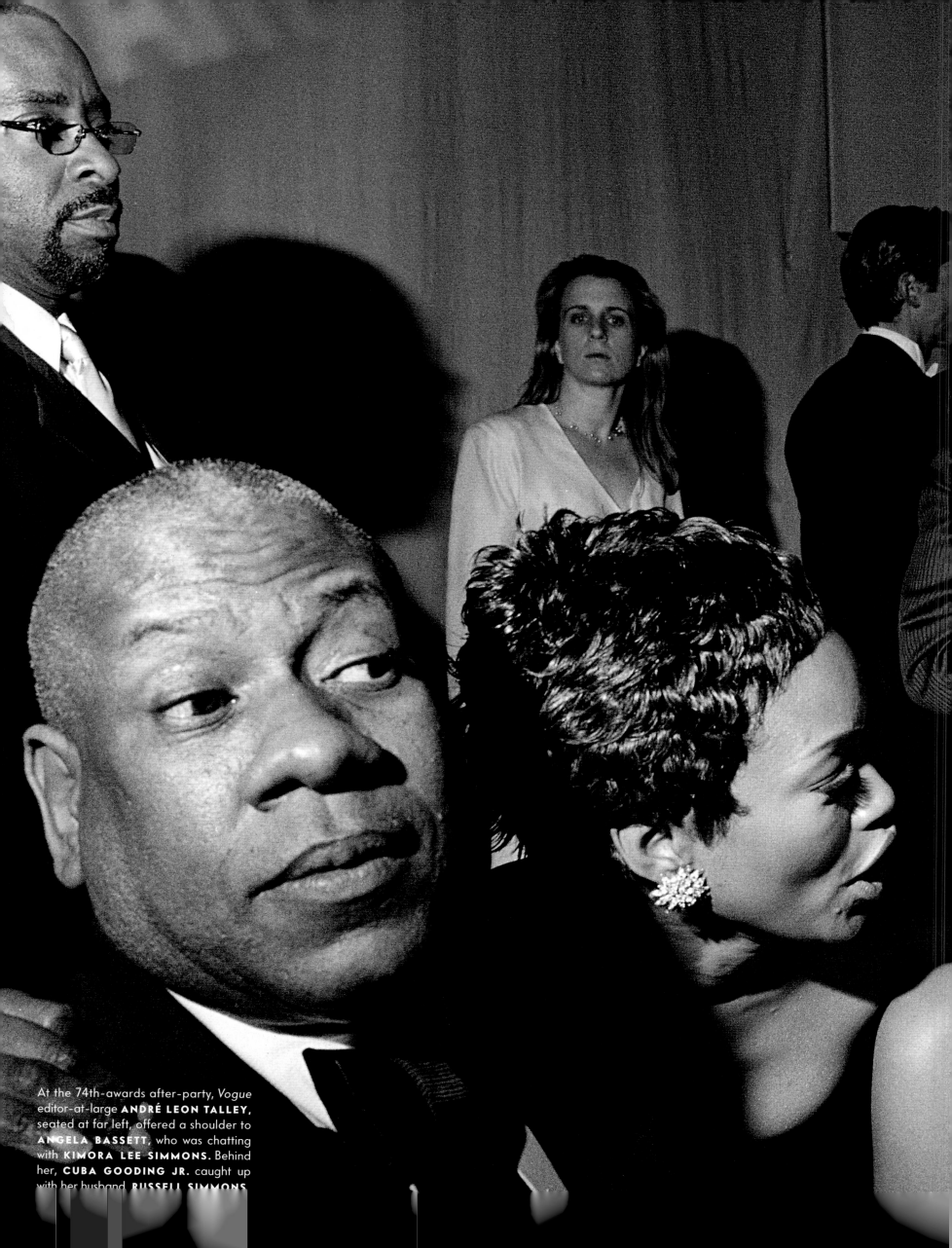

At the 74th-awards after-party, *Vogue* editor-at-large **ANDRÉ LEON TALLEY**, seated at far left, offered a shoulder to **ANGELA BASSETT**, who was chatting with **KIMORA LEE SIMMONS**. Behind her, **CUBA GOODING JR.** caught up with her husband, **RUSSELL SIMMONS**

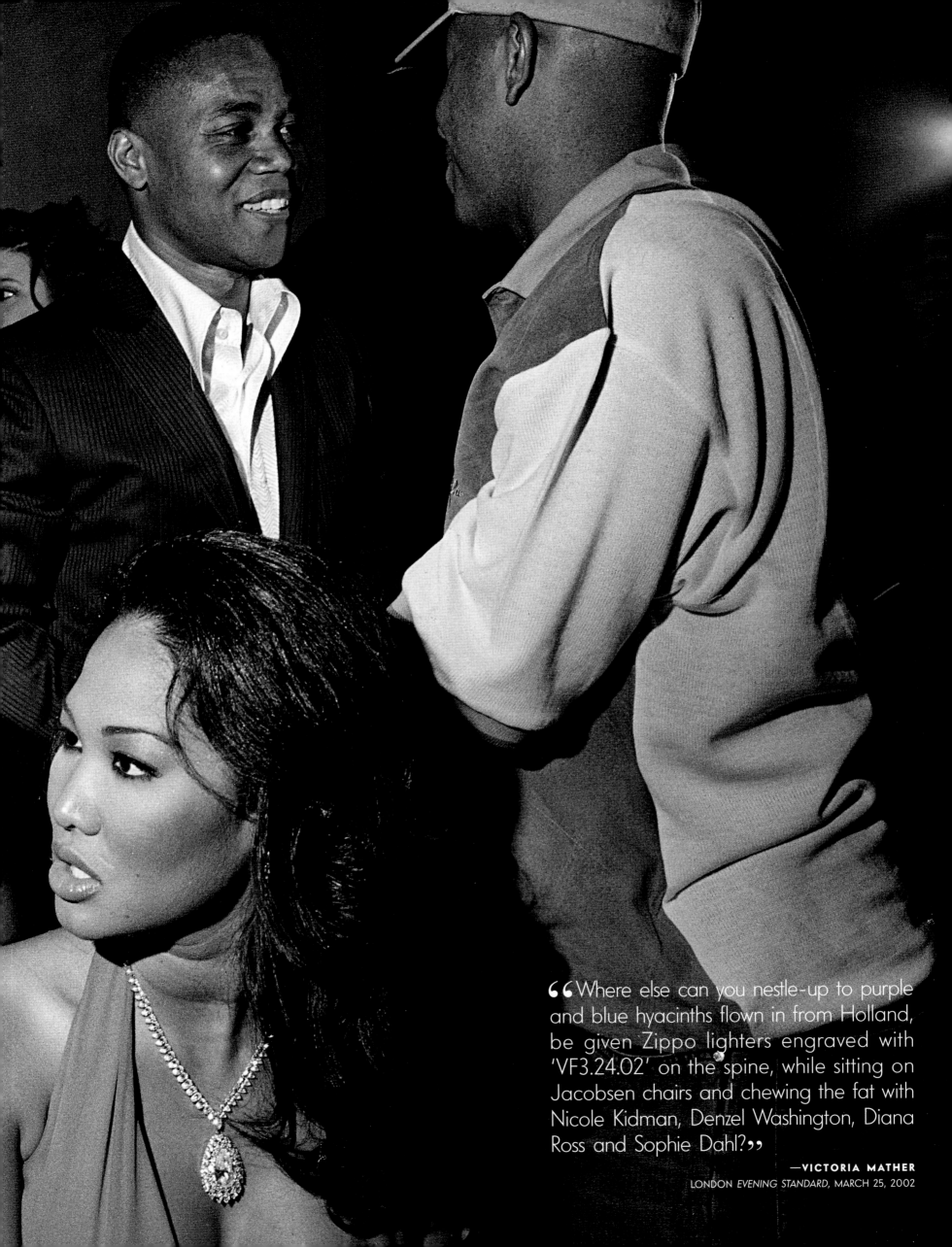

"Where else can you nestle-up to purple and blue hyacinths flown in from Holland, be given Zippo lighters engraved with 'VF3.24.02' on the spine, while sitting on Jacobsen chairs and chewing the fat with Nicole Kidman, Denzel Washington, Diana Ross and Sophie Dahl?"

—VICTORIA MATHER
LONDON *EVENING STANDARD*, MARCH 25, 2002

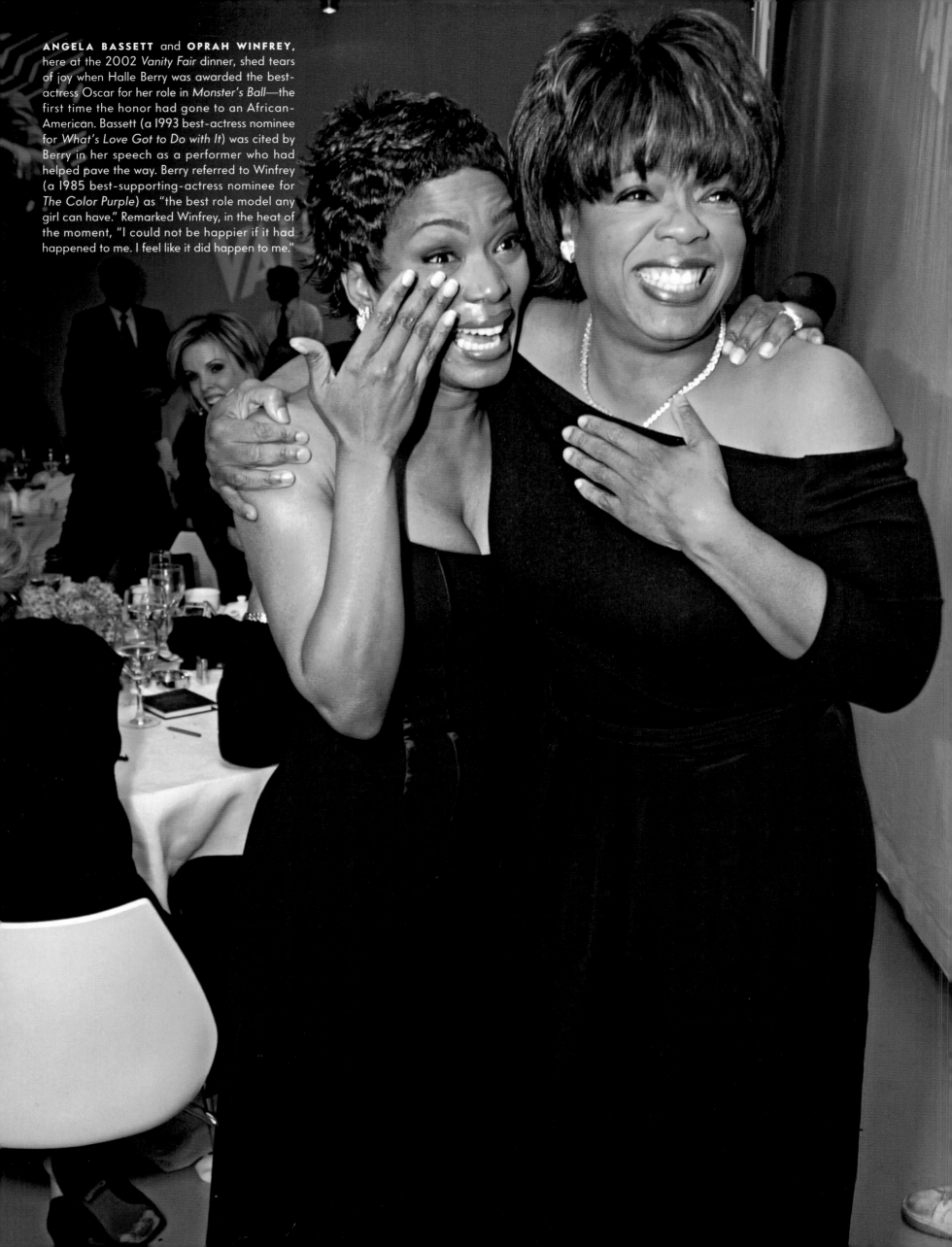

ANGELA BASSETT and **OPRAH WINFREY,** here at the 2002 *Vanity Fair* dinner, shed tears of joy when Halle Berry was awarded the best-actress Oscar for her role in *Monster's Ball*—the first time the honor had gone to an African-American. Bassett (a 1993 best-actress nominee for *What's Love Got to Do with It*) was cited by Berry in her speech as a performer who had helped pave the way. Berry referred to Winfrey (a 1985 best-supporting-actress nominee for *The Color Purple*) as "the best role model any girl can have." Remarked Winfrey, in the heat of the moment, "I could not be happier if it had happened to me. I feel like it did happen to me."

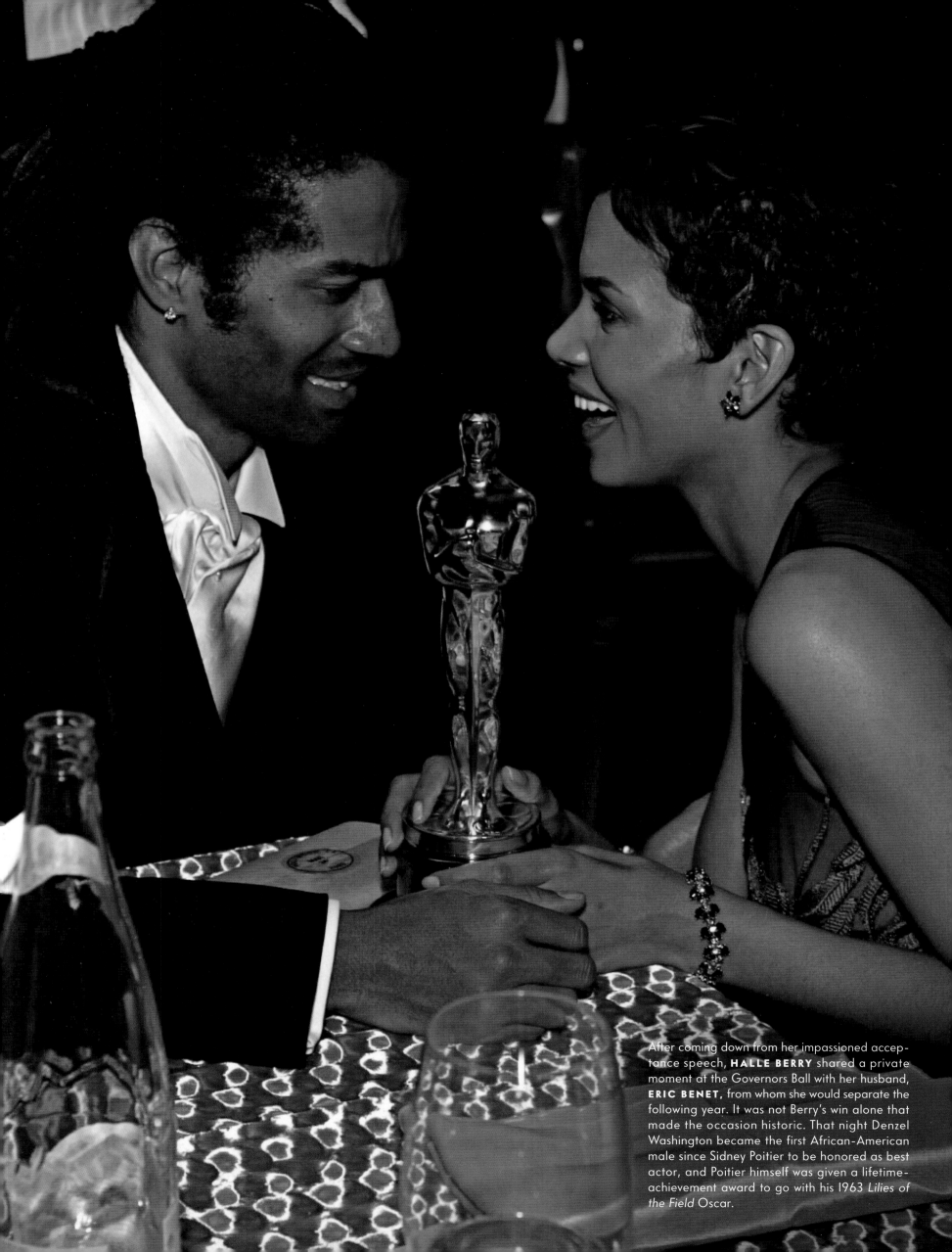

After coming down from her impassioned acceptance speech, **HALLE BERRY** shared a private moment at the Governors Ball with her husband, **ERIC BENET,** from whom she would separate the following year. It was not Berry's win alone that made the occasion historic. That night Denzel Washington became the first African-American male since Sidney Poitier to be honored as best actor, and Poitier himself was given a lifetime-achievement award to go with his 1963 *Lilies of the Field* Oscar.

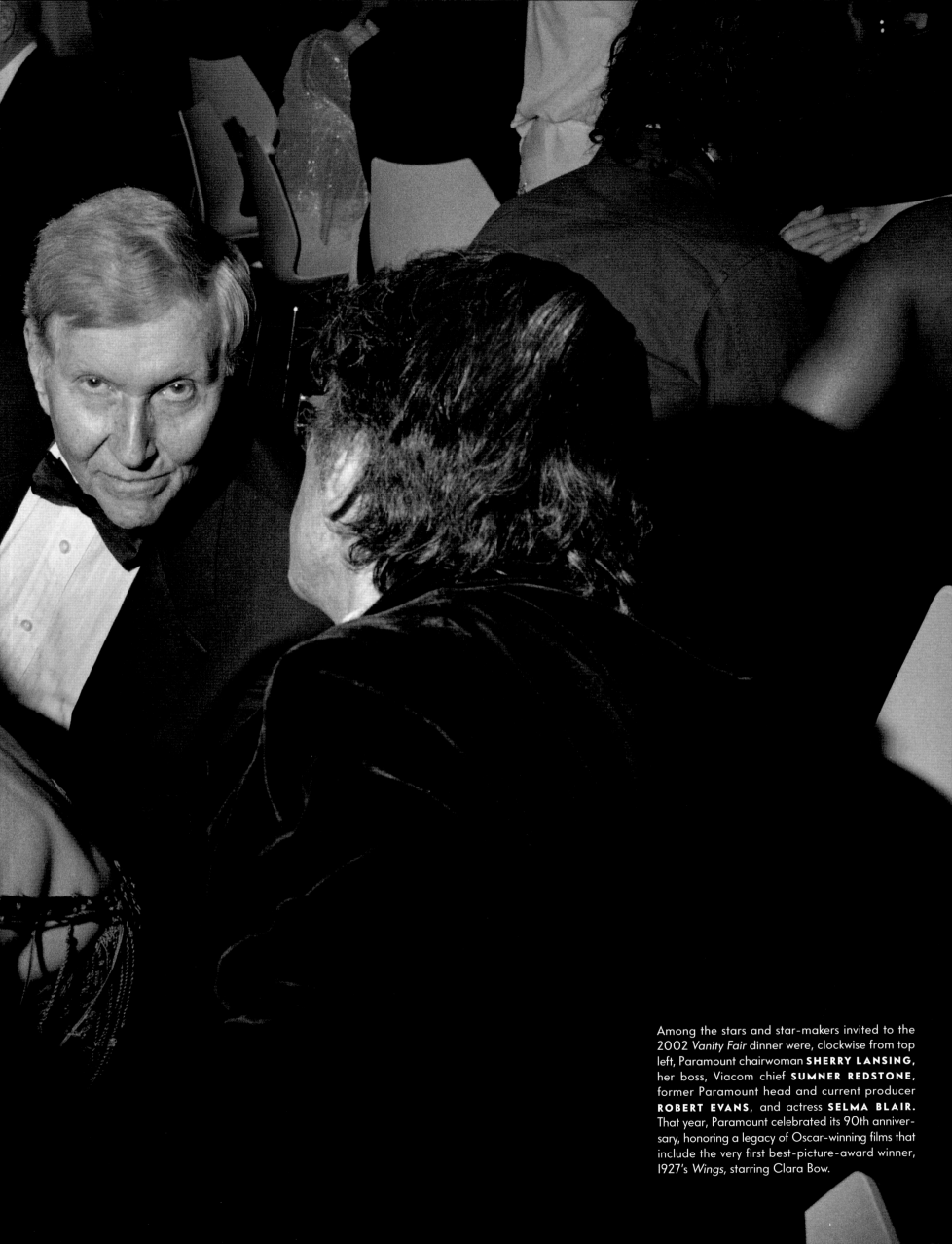

Among the stars and star-makers invited to the 2002 *Vanity Fair* dinner were, clockwise from top left, Paramount chairwoman **SHERRY LANSING,** her boss, Viacom chief **SUMNER REDSTONE,** former Paramount head and current producer **ROBERT EVANS,** and actress **SELMA BLAIR.** That year, Paramount celebrated its 90th anniversary, honoring a legacy of Oscar-winning films that include the very first best-picture-award winner, 1927's *Wings,* starring Clara Bow.

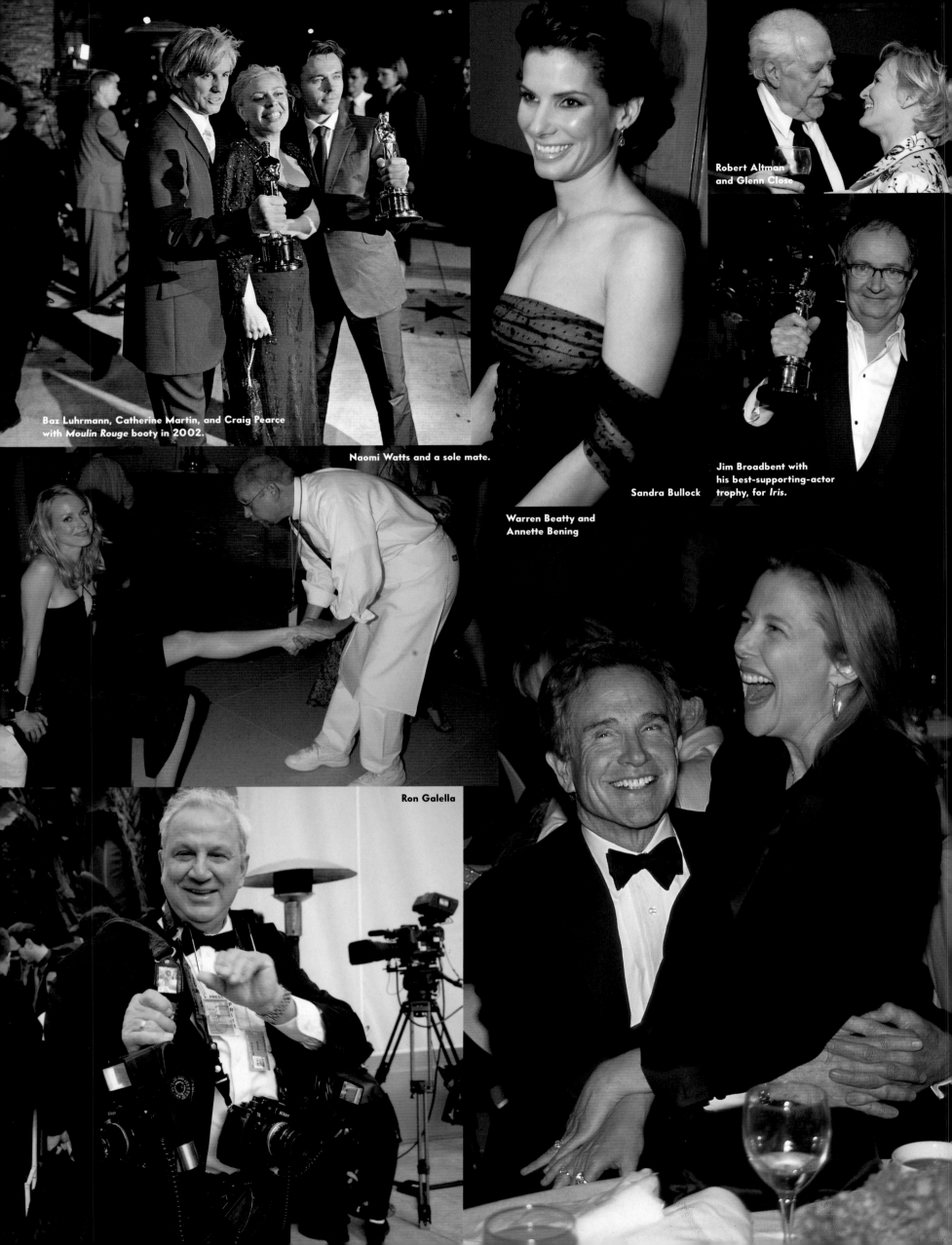

Baz Luhrmann, Catherine Martin, and Craig Pearce with *Moulin Rouge* booty in 2002.

Robert Altman and Glenn Close

Naomi Watts and a sole mate.

Sandra Bullock

Jim Broadbent with his best-supporting-actor trophy, for *Iris*.

Warren Beatty and Annette Bening

Ron Galella

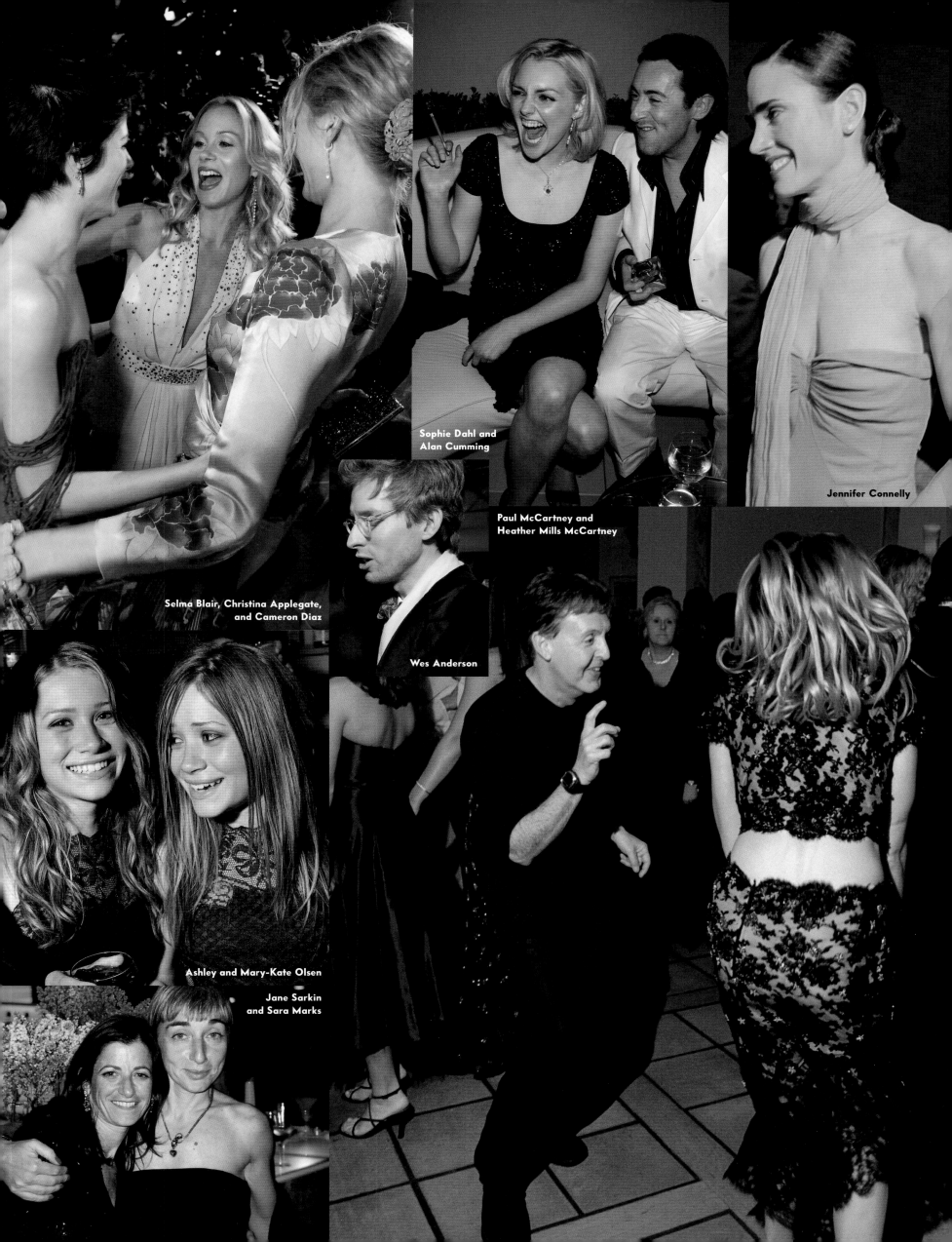

Sophie Dahl and
Alan Cumming

Jennifer Connelly

Paul McCartney and
Heather Mills McCartney

Selma Blair, Christina Applegate,
and Cameron Diaz

Wes Anderson

Ashley and Mary-Kate Olsen

Jane Sarkin
and Sara Marks

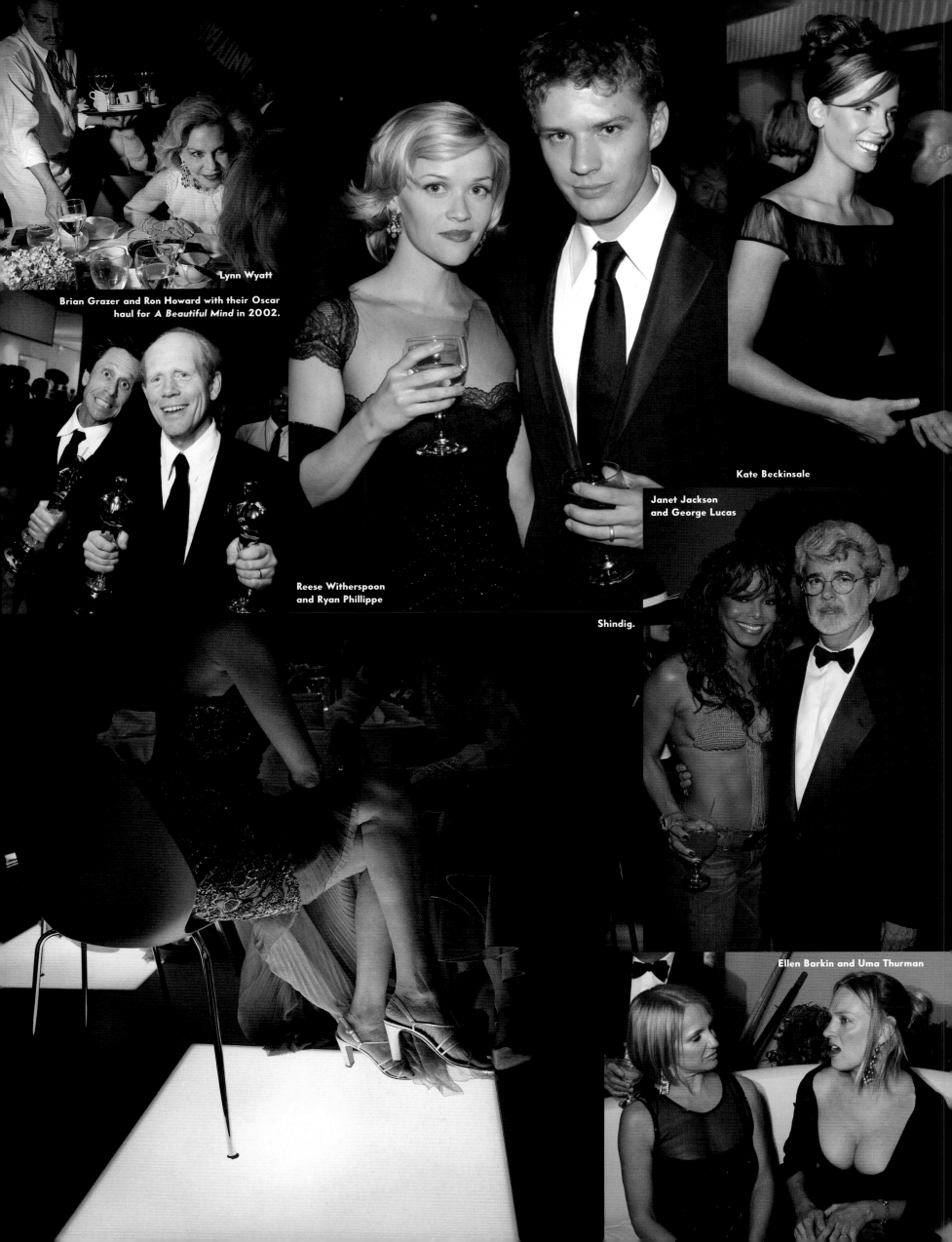

Lynn Wyatt

Brian Grazer and Ron Howard with their Oscar haul for *A Beautiful Mind* in 2002.

Reese Witherspoon and Ryan Phillippe

Kate Beckinsale

Janet Jackson and George Lucas

Shindig.

Ellen Barkin and Uma Thurman

VANITY FAIR

THE SEVENTY-FOURTH
ACADEMY AWARDS®
LOS ANGELES

MARCH 24, 2002

Graydon Carter

VANITY FAIR
ACADEMY AWARDS PARTY 2002
MORTONS RESTAURANT

ROASTED BEET SALAD
Belgian Endive, Avocado & Lemon Thyme Vinaigrette

DRY AGED NEW YORK STEAK
French Fries & Haricot Verts
or
PAN SEARED STRIPED BASS
Italian Cous Cous, Cipolini Onions & Baby Spinach
or
MACARONI & AGED CHEDDAR CHEESE
Tempura French Beans

FROZEN CHEESECAKE PARFAIT
Seasonal Berries & Raspberry Sauce

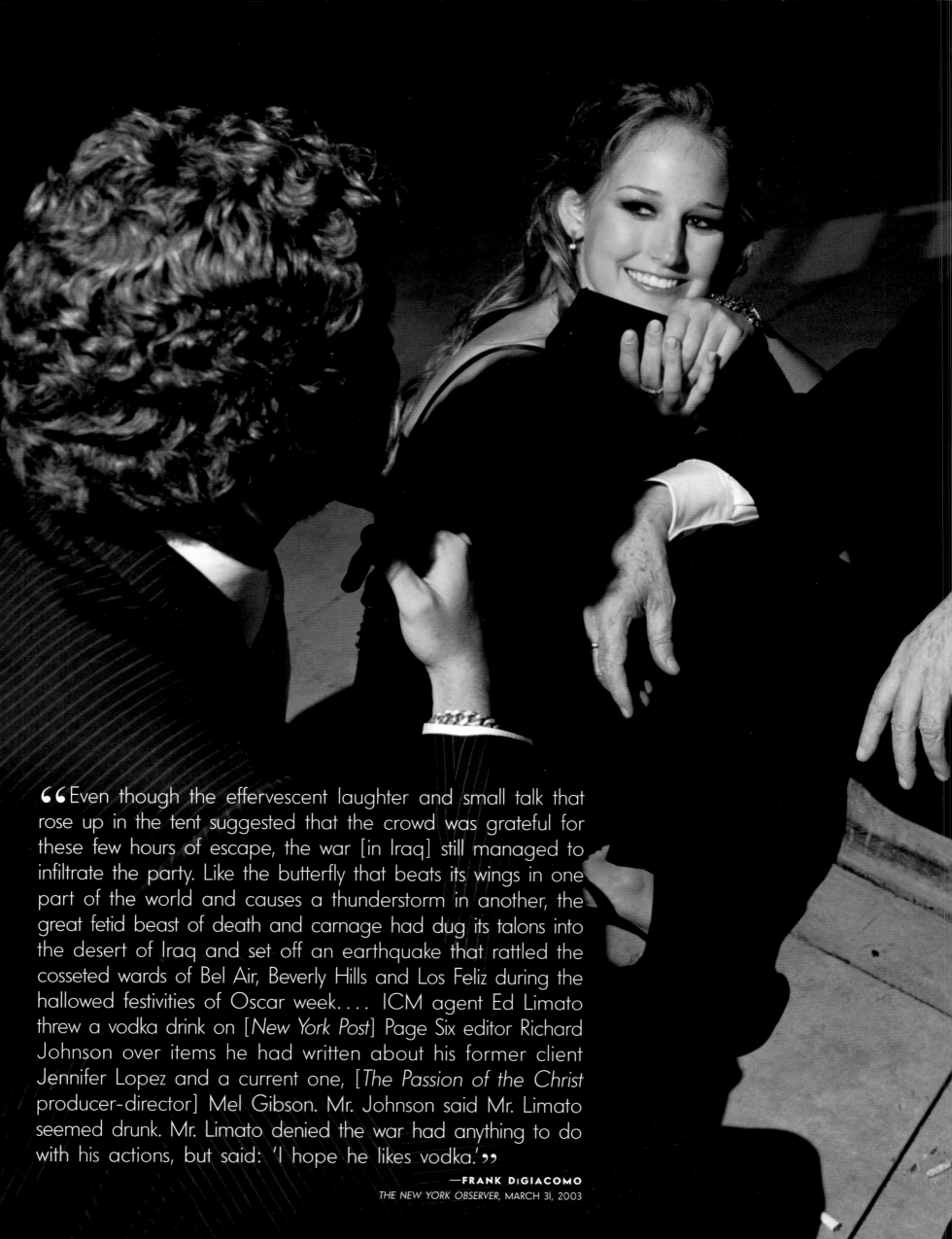

"Even though the effervescent laughter and small talk that rose up in the tent suggested that the crowd was grateful for these few hours of escape, the war [in Iraq] still managed to infiltrate the party. Like the butterfly that beats its wings in one part of the world and causes a thunderstorm in another, the great fetid beast of death and carnage had dug its talons into the desert of Iraq and set off an earthquake that rattled the cosseted wards of Bel Air, Beverly Hills and Los Feliz during the hallowed festivities of Oscar week.... ICM agent Ed Limato threw a vodka drink on [*New York Post*] Page Six editor Richard Johnson over items he had written about his former client Jennifer Lopez and a current one, [*The Passion of the Christ* producer-director] Mel Gibson. Mr. Johnson said Mr. Limato seemed drunk. Mr. Limato denied the war had anything to do with his actions, but said: 'I hope he likes vodka.'"

—FRANK DiGIACOMO
THE NEW YORK OBSERVER, MARCH 31, 2003

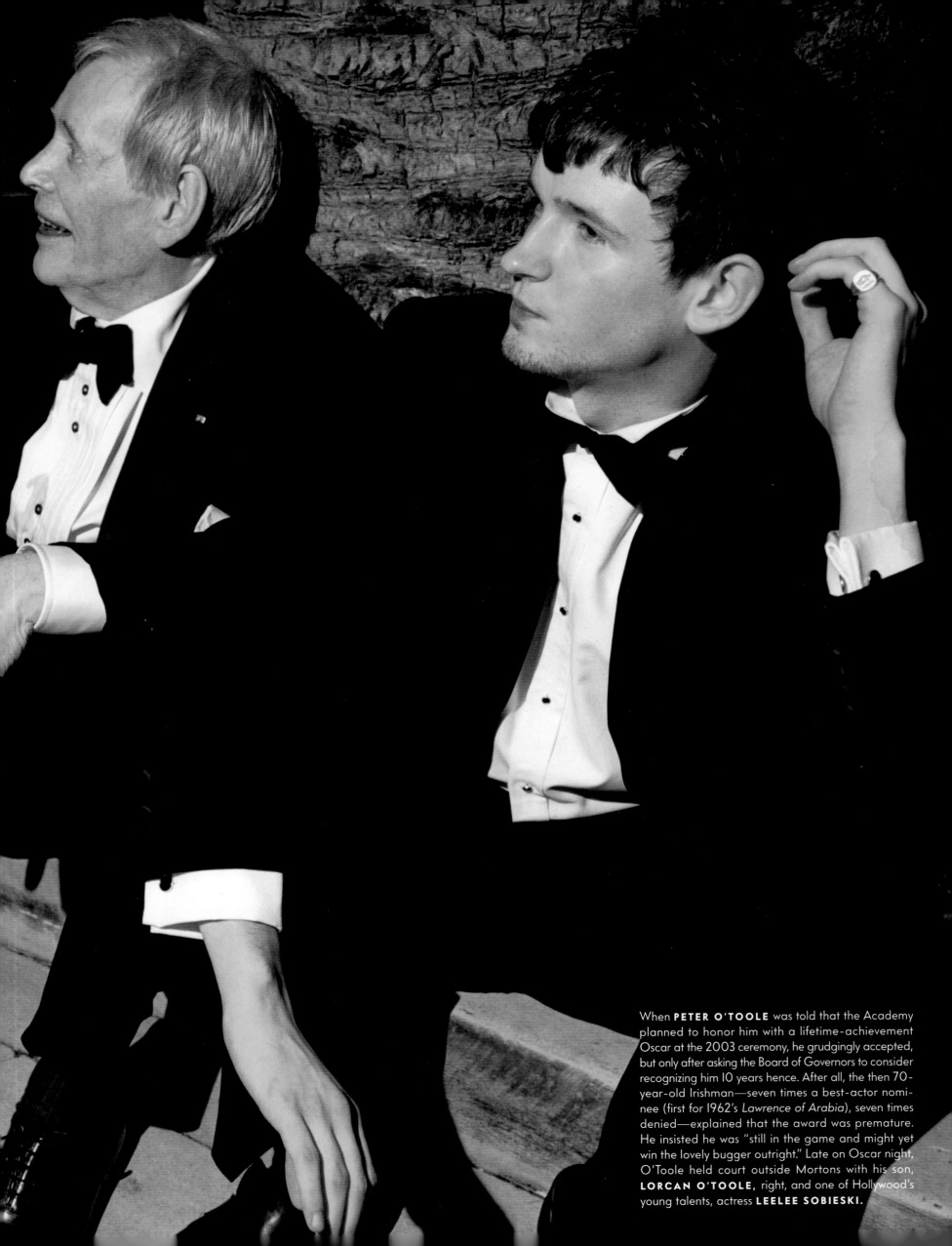

When **PETER O'TOOLE** was told that the Academy planned to honor him with a lifetime-achievement Oscar at the 2003 ceremony, he grudgingly accepted, but only after asking the Board of Governors to consider recognizing him 10 years hence. After all, the then 70-year-old Irishman—seven times a best-actor nominee (first for 1962's *Lawrence of Arabia*), seven times denied—explained that the award was premature. He insisted he was "still in the game and might yet win the lovely bugger outright." Late on Oscar night, O'Toole held court outside Mortons with his son, **LORCAN O'TOOLE**, right, and one of Hollywood's young talents, actress **LEELEE SOBIESKI**.

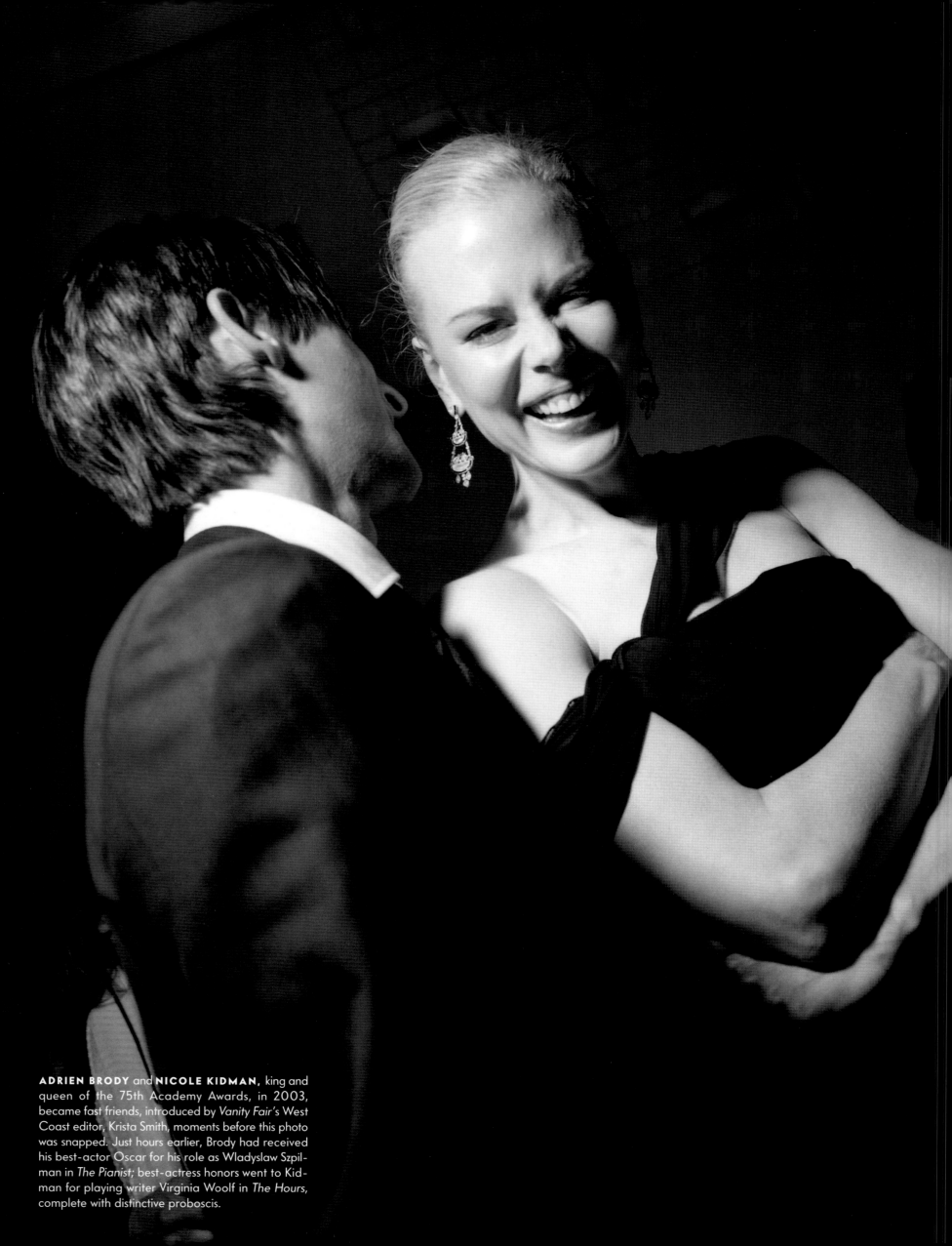

ADRIEN BRODY and **NICOLE KIDMAN,** king and queen of the 75th Academy Awards, in 2003, became fast friends, introduced by *Vanity Fair*'s West Coast editor, Krista Smith, moments before this photo was snapped. Just hours earlier, Brody had received his best-actor Oscar for his role as Wladyslaw Szpilman in *The Pianist;* best-actress honors went to Kidman for playing writer Virginia Woolf in *The Hours,* complete with distinctive proboscis.

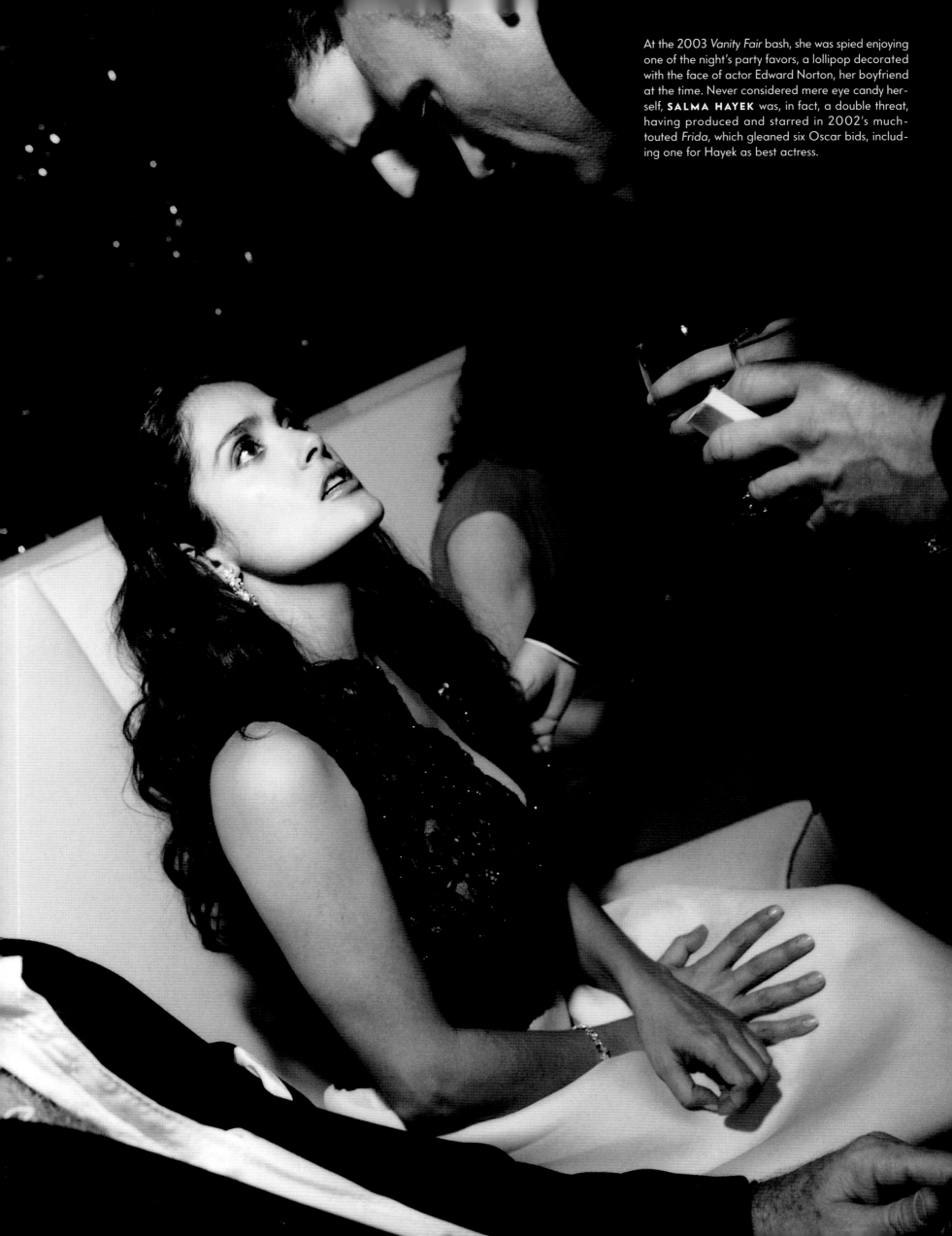

At the 2003 *Vanity Fair* bash, she was spied enjoying one of the night's party favors, a lollipop decorated with the face of actor Edward Norton, her boyfriend at the time. Never considered mere eye candy herself, **SALMA HAYEK** was, in fact, a double threat, having produced and starred in 2002's much-touted *Frida*, which gleaned six Oscar bids, including one for Hayek as best actress.

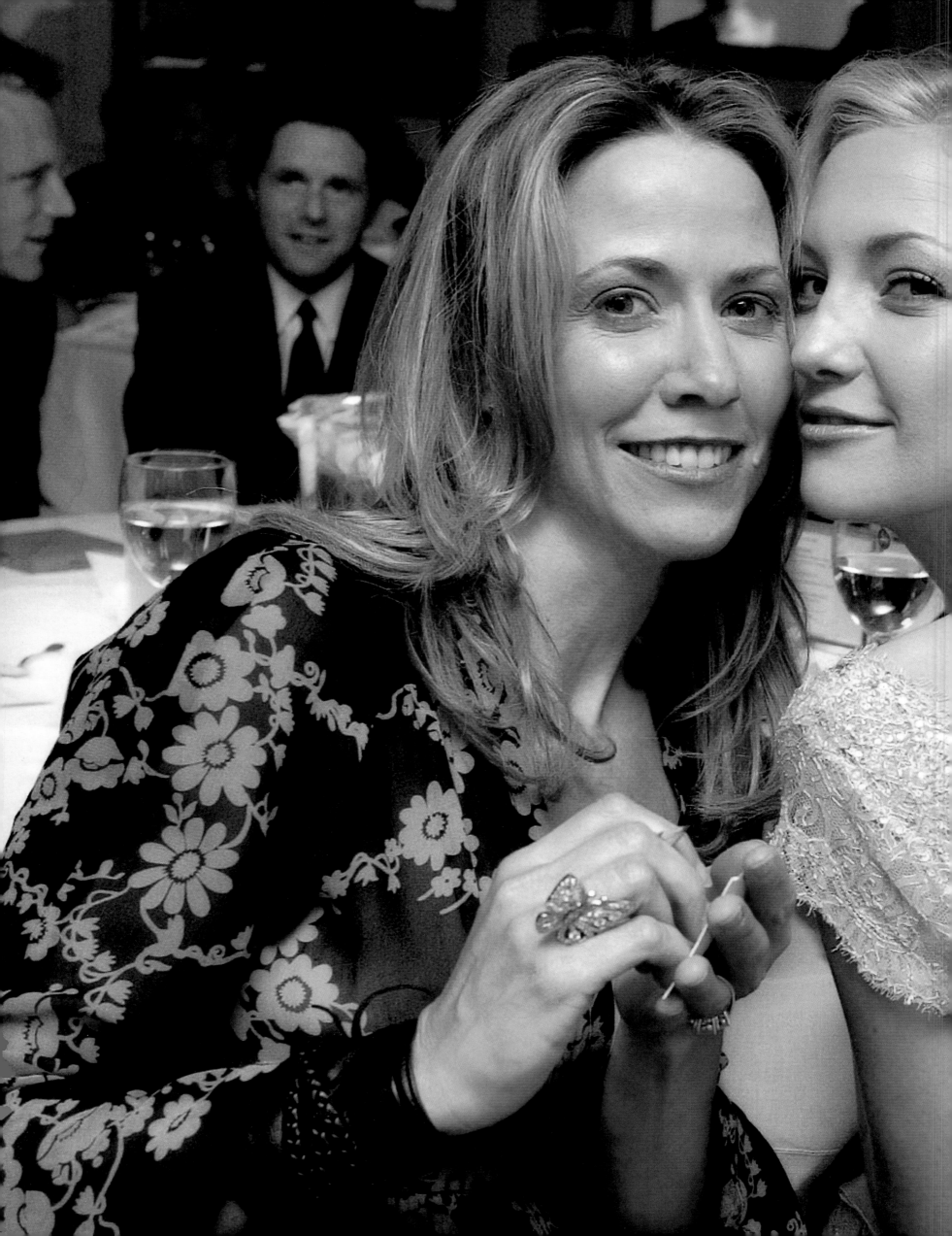

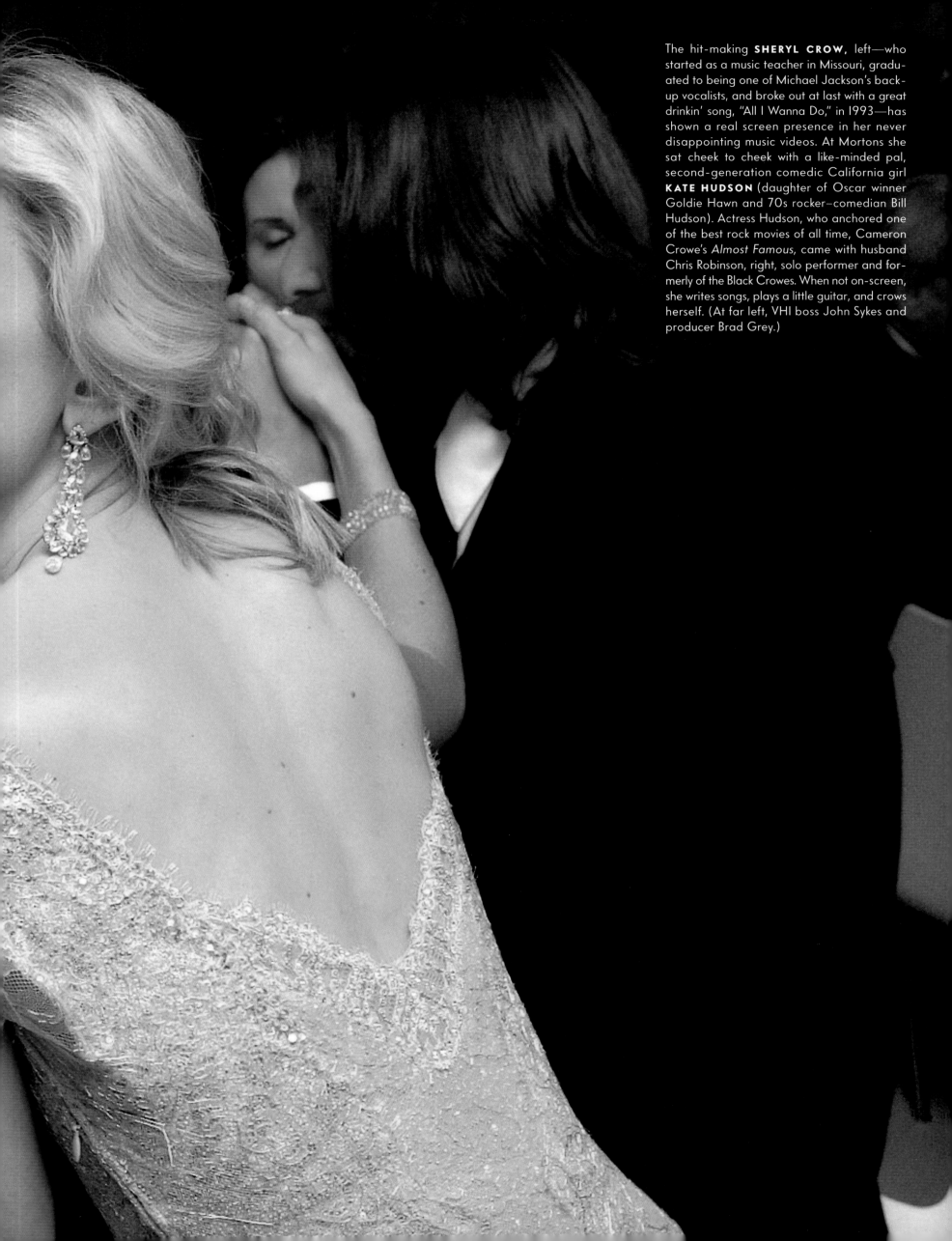

The hit-making **SHERYL CROW**, left—who started as a music teacher in Missouri, graduated to being one of Michael Jackson's back-up vocalists, and broke out at last with a great drinkin' song, "All I Wanna Do," in 1993—has shown a real screen presence in her never disappointing music videos. At Mortons she sat cheek to cheek with a like-minded pal, second-generation comedic California girl **KATE HUDSON** (daughter of Oscar winner Goldie Hawn and 70s rocker–comedian Bill Hudson). Actress Hudson, who anchored one of the best rock movies of all time, Cameron Crowe's *Almost Famous*, came with husband Chris Robinson, right, solo performer and formerly of the Black Crowes. When not on-screen, she writes songs, plays a little guitar, and crows herself. (At far left, VH1 boss John Sykes and producer Brad Grey.)

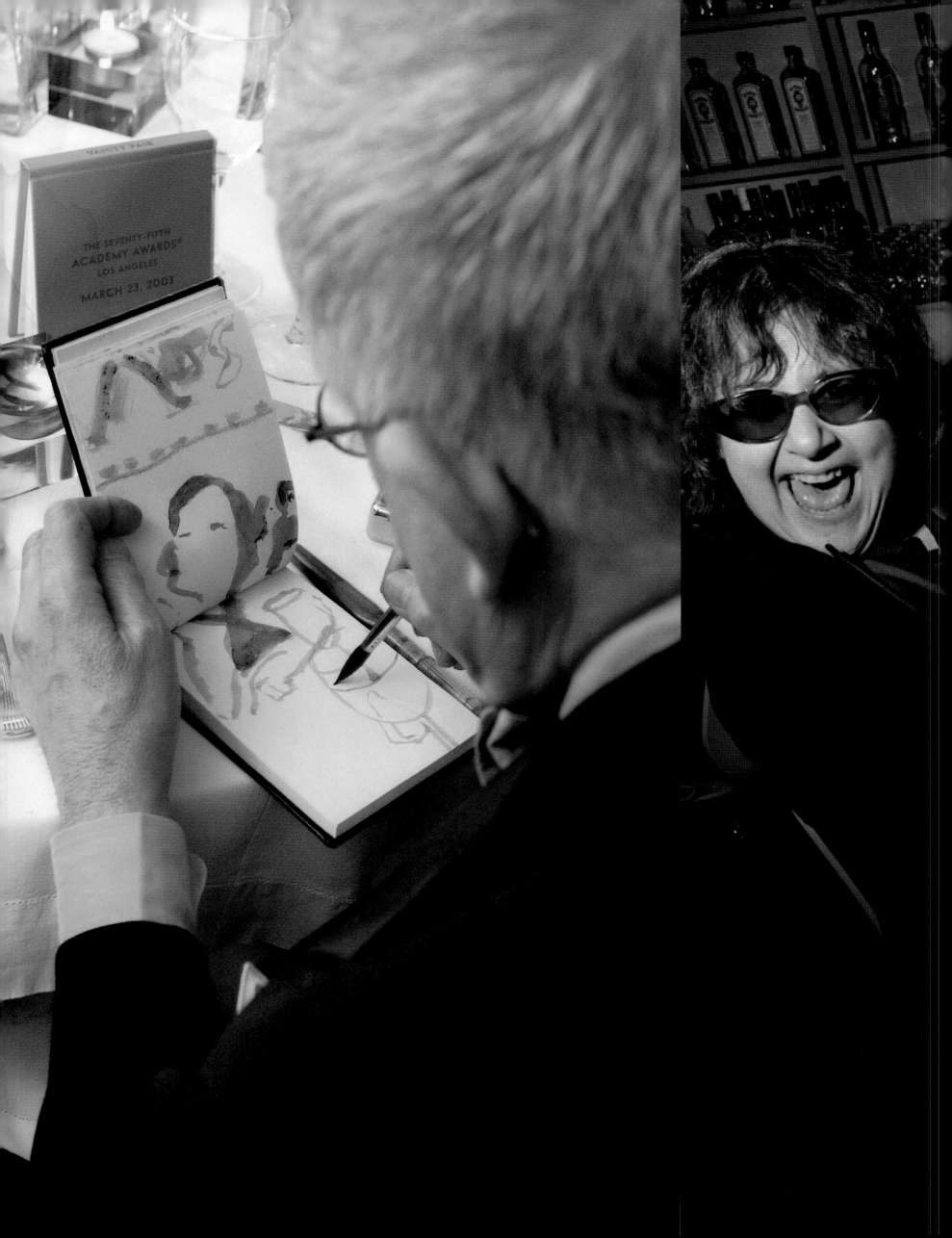

THE SEVENTY-FIFTH
ACADEMY AWARDS®
LOS ANGELES

MARCH 23, 2003

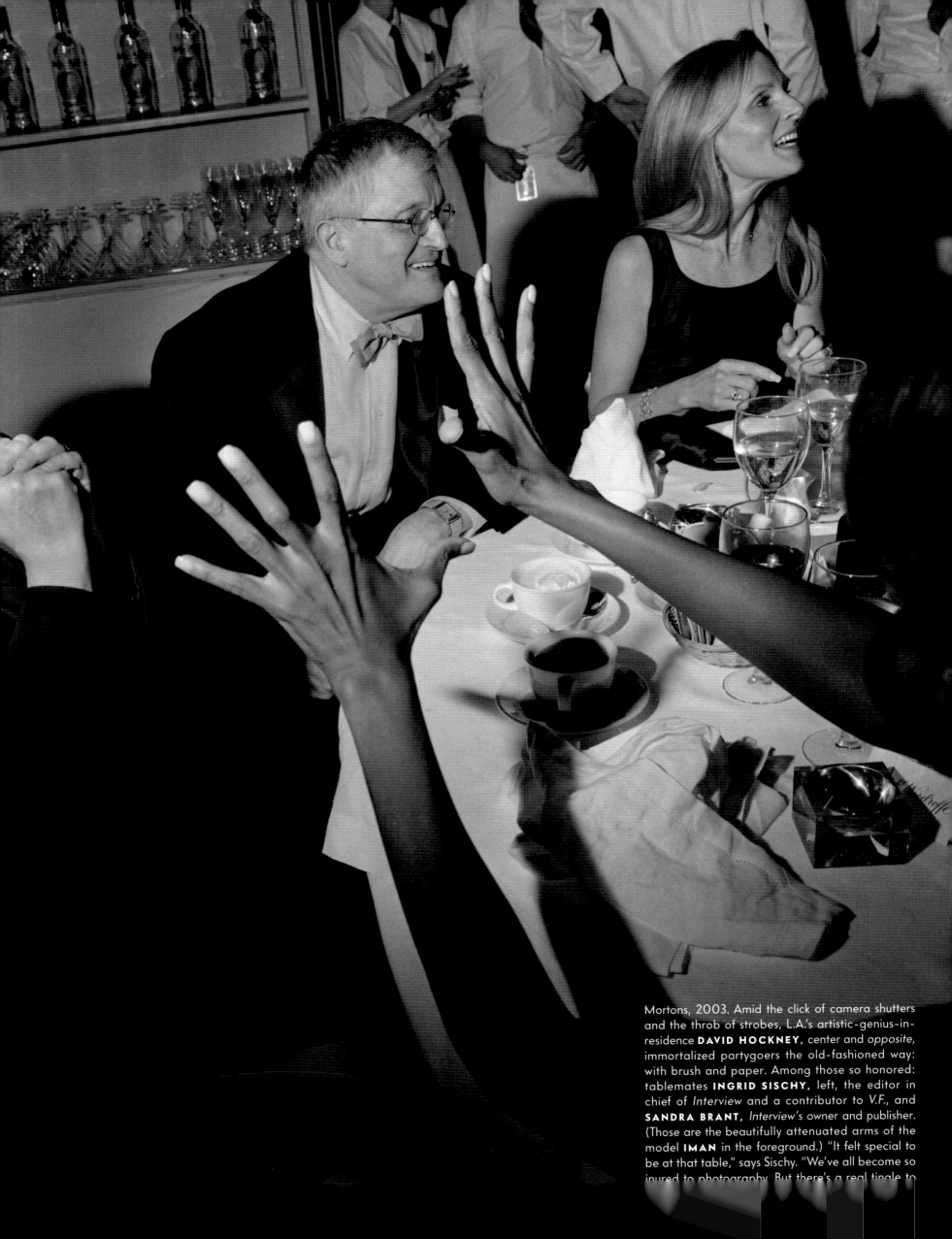

Mortons, 2003. Amid the click of camera shutters and the throb of strobes, L.A.'s artistic-genius-in-residence **DAVID HOCKNEY,** center and *opposite,* immortalized partygoers the old-fashioned way: with brush and paper. Among those so honored: tablemates **INGRID SISCHY,** left, the editor in chief of *Interview* and a contributor to *V.F.,* and **SANDRA BRANT,** *Interview*'s owner and publisher. (Those are the beautifully attenuated arms of the model **IMAN** in the foreground.) "It felt special to be at that table," says Sischy. "We've all become so inured to photography. But there's a real tingle to

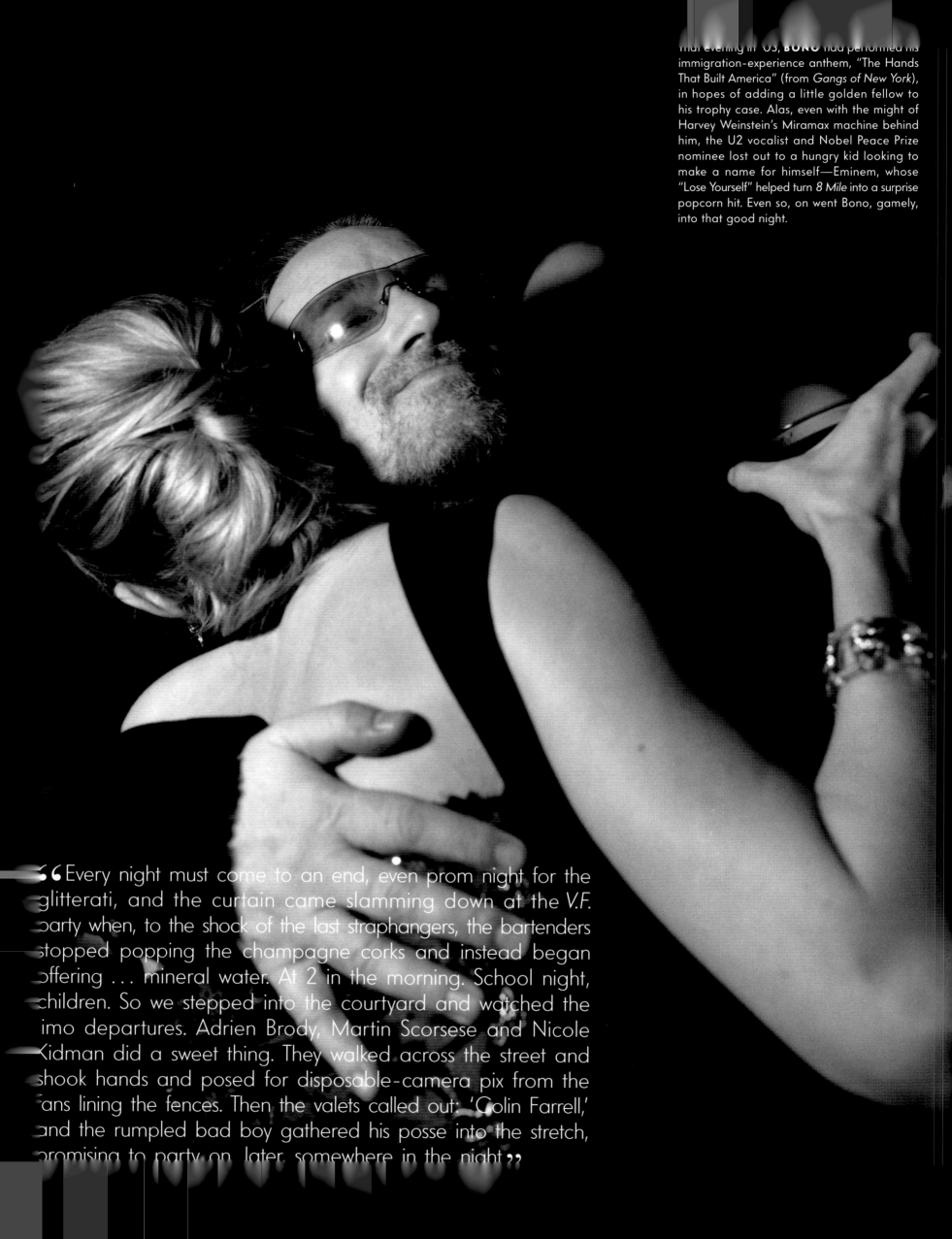

That evening in '03, **BONO** had performed his immigration-experience anthem, "The Hands That Built America" (from *Gangs of New York*), in hopes of adding a little golden fellow to his trophy case. Alas, even with the might of Harvey Weinstein's Miramax machine behind him, the U2 vocalist and Nobel Peace Prize nominee lost out to a hungry kid looking to make a name for himself—Eminem, whose "Lose Yourself" helped turn *8 Mile* into a surprise popcorn hit. Even so, on went Bono, gamely, into that good night.

"Every night must come to an end, even prom night for the glitterati, and the curtain came slamming down at the *V.F.* party when, to the shock of the last straphangers, the bartenders stopped popping the champagne corks and instead began offering … mineral water. At 2 in the morning. School night, children. So we stepped into the courtyard and watched the limo departures. Adrien Brody, Martin Scorsese and Nicole Kidman did a sweet thing. They walked across the street and shook hands and posed for disposable-camera pix from the fans lining the fences. Then the valets called out: 'Colin Farrell,' and the rumpled bad boy gathered his posse into the stretch, promising to party on, later, somewhere in the night"

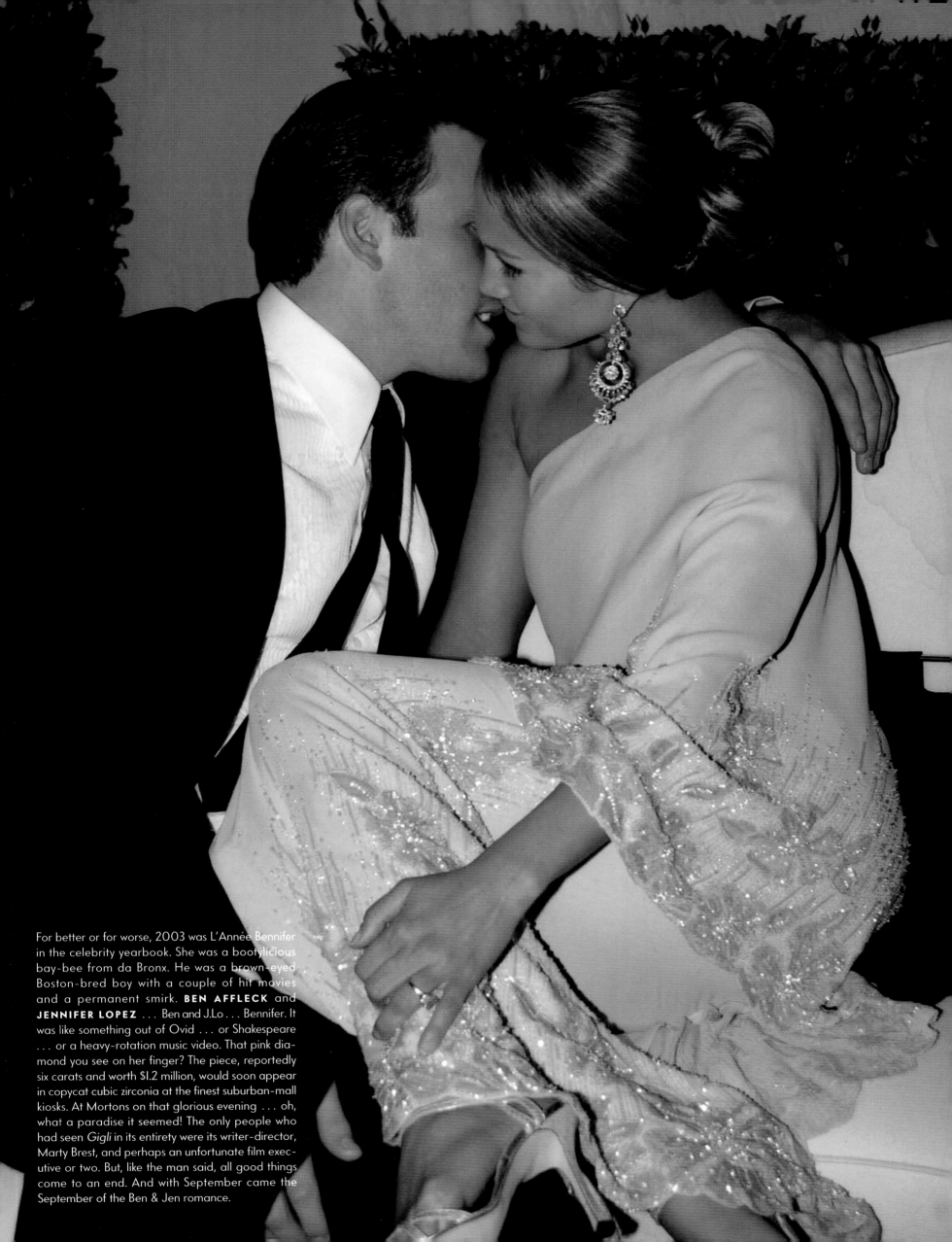

For better or for worse, 2003 was L'Année Bennifer in the celebrity yearbook. She was a bootylicious bay-bee from da Bronx. He was a brown-eyed Boston-bred boy with a couple of hit movies and a permanent smirk. **BEN AFFLECK** and **JENNIFER LOPEZ** . . . Ben and J.Lo . . . Bennifer. It was like something out of Ovid . . . or Shakespeare . . . or a heavy-rotation music video. That pink diamond you see on her finger? The piece, reportedly six carats and worth $1.2 million, would soon appear in copycat cubic zirconia at the finest suburban-mall kiosks. At Mortons on that glorious evening . . . oh, what a paradise it seemed! The only people who had seen *Gigli* in its entirety were its writer-director, Marty Brest, and perhaps an unfortunate film executive or two. But, like the man said, all good things come to an end. And with September came the September of the Ben & Jen romance.

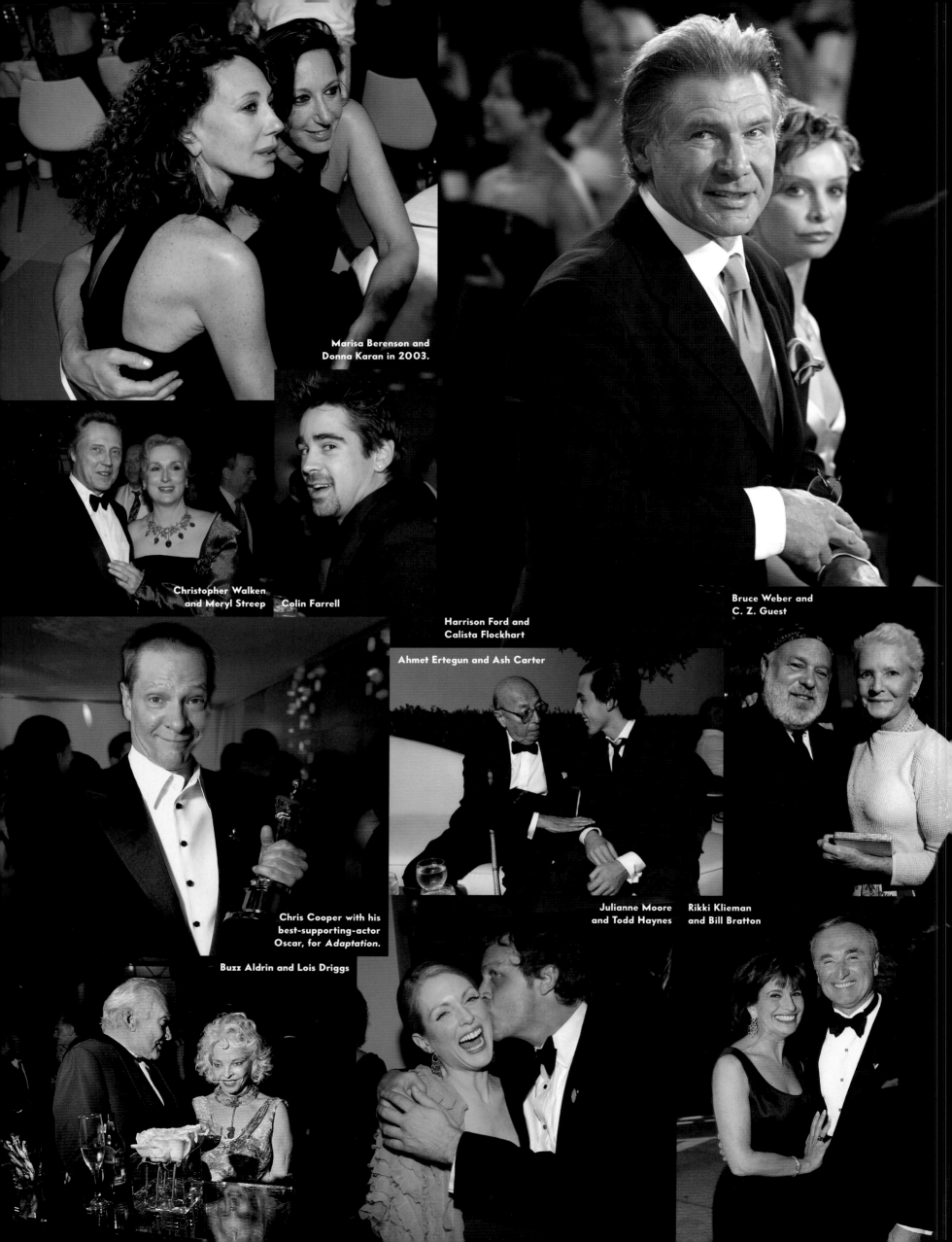

Marisa Berenson and
Donna Karan in 2003.

Christopher Walken
and Meryl Streep Colin Farrell

Bruce Weber and
C. Z. Guest

Harrison Ford and
Calista Flockhart

Ahmet Ertegun and Ash Carter

Chris Cooper with his
best-supporting-actor
Oscar, for *Adaptation*.

Julianne Moore Rikki Klieman
and Todd Haynes and Bill Bratton

Buzz Aldrin and Lois Driggs

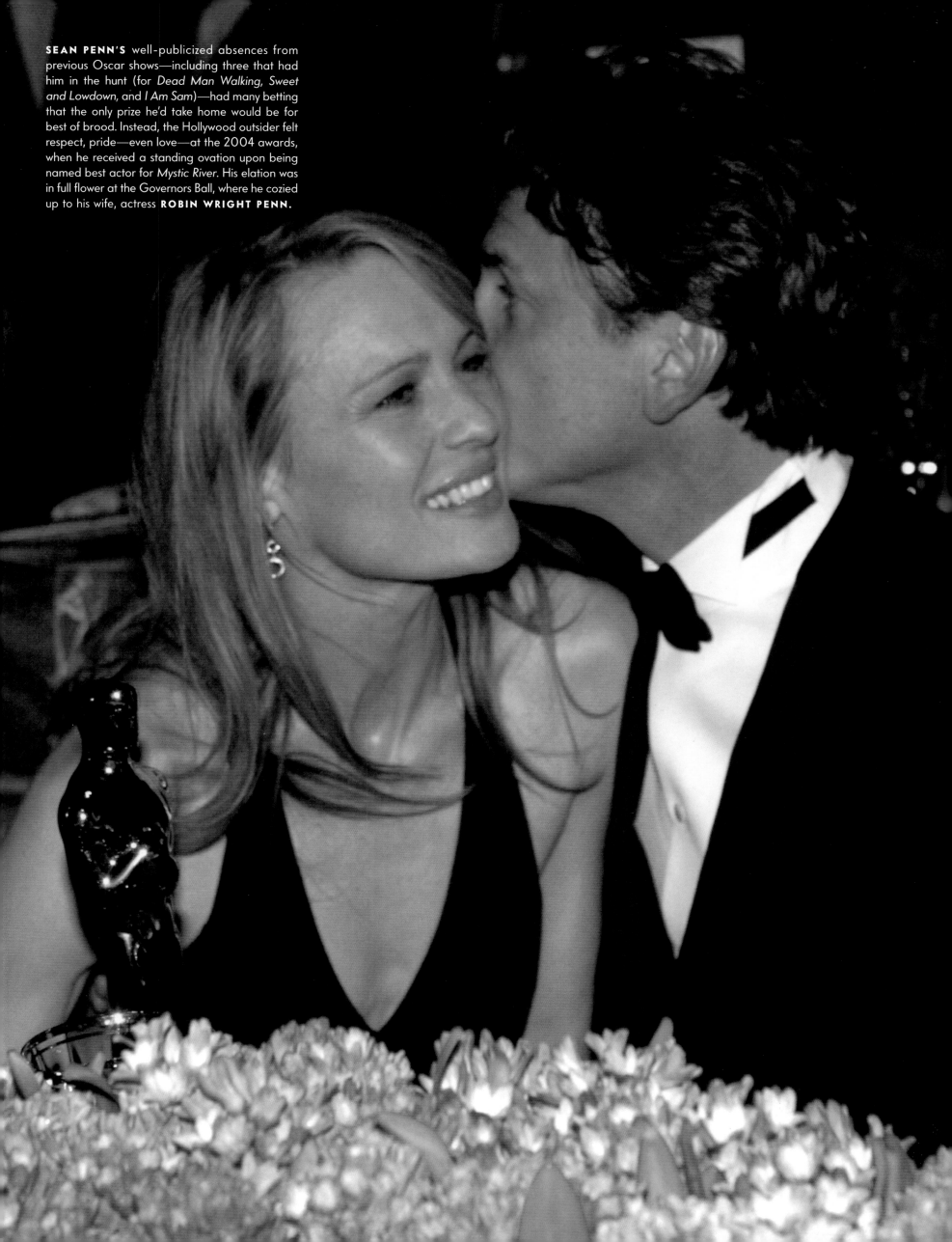

SEAN PENN'S well-publicized absences from previous Oscar shows—including three that had him in the hunt (for *Dead Man Walking, Sweet and Lowdown,* and *I Am Sam*)—had many betting that the only prize he'd take home would be for best of brood. Instead, the Hollywood outsider felt respect, pride—even love—at the 2004 awards, when he received a standing ovation upon being named best actor for *Mystic River.* His elation was in full flower at the Governors Ball, where he cozied up to his wife, actress **ROBIN WRIGHT PENN.**

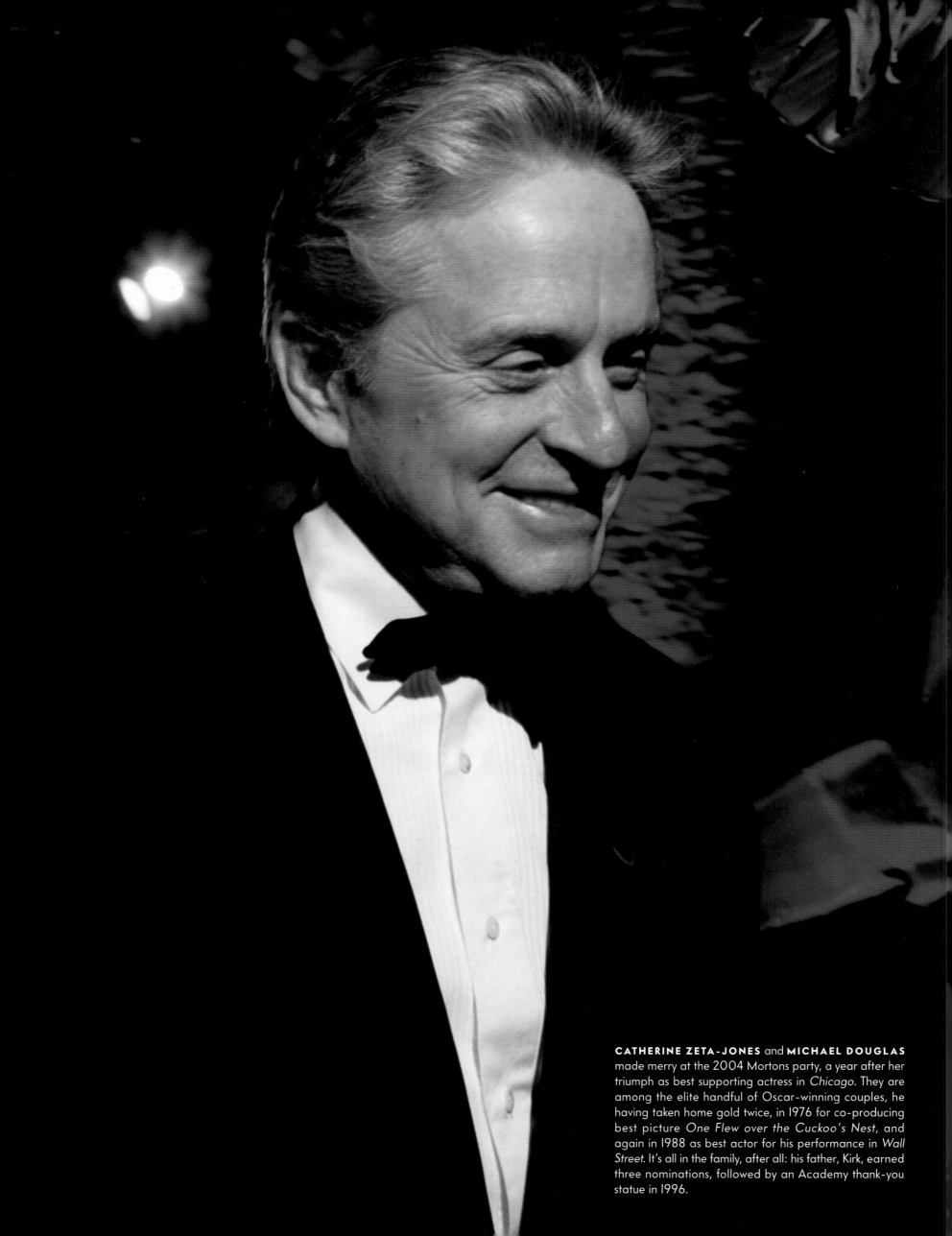

CATHERINE ZETA-JONES and **MICHAEL DOUGLAS** made merry at the 2004 Mortons party, a year after her triumph as best supporting actress in *Chicago*. They are among the elite handful of Oscar-winning couples, he having taken home gold twice, in 1976 for co-producing best picture *One Flew over the Cuckoo's Nest*, and again in 1988 as best actor for his performance in *Wall Street*. It's all in the family, after all: his father, Kirk, earned three nominations, followed by an Academy thank-you statue in 1996.

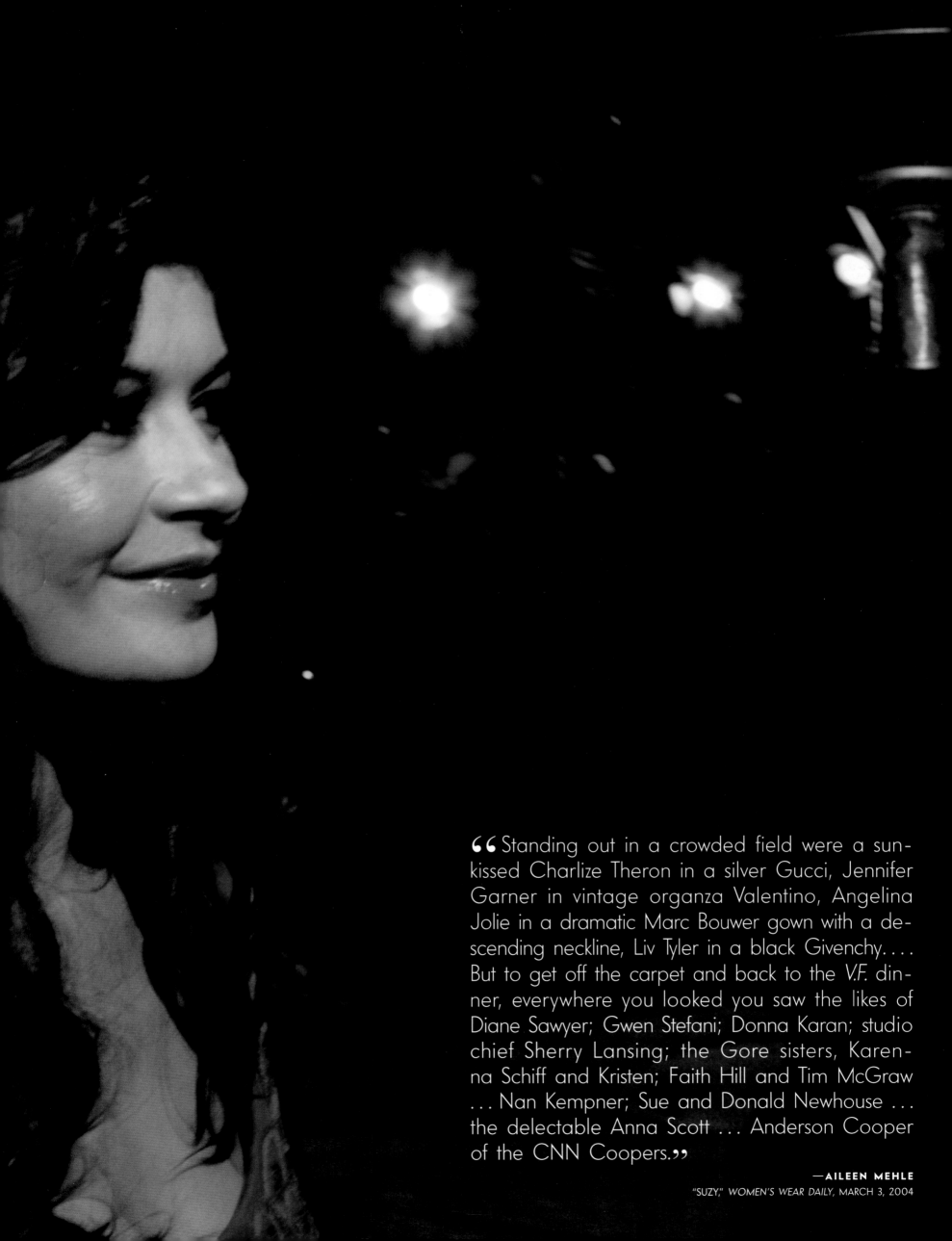

66 Standing out in a crowded field were a sun-kissed Charlize Theron in a silver Gucci, Jennifer Garner in vintage organza Valentino, Angelina Jolie in a dramatic Marc Bouwer gown with a descending neckline, Liv Tyler in a black Givenchy. . . . But to get off the carpet and back to the V.F. dinner, everywhere you looked you saw the likes of Diane Sawyer; Gwen Stefani; Donna Karan; studio chief Sherry Lansing; the Gore sisters, Karenna Schiff and Kristen; Faith Hill and Tim McGraw . . . Nan Kempner; Sue and Donald Newhouse . . . the delectable Anna Scott . . . Anderson Cooper of the CNN Coopers. 99

—AILEEN MEHLE
"SUZY," WOMEN'S WEAR DAILY, MARCH 3, 2004

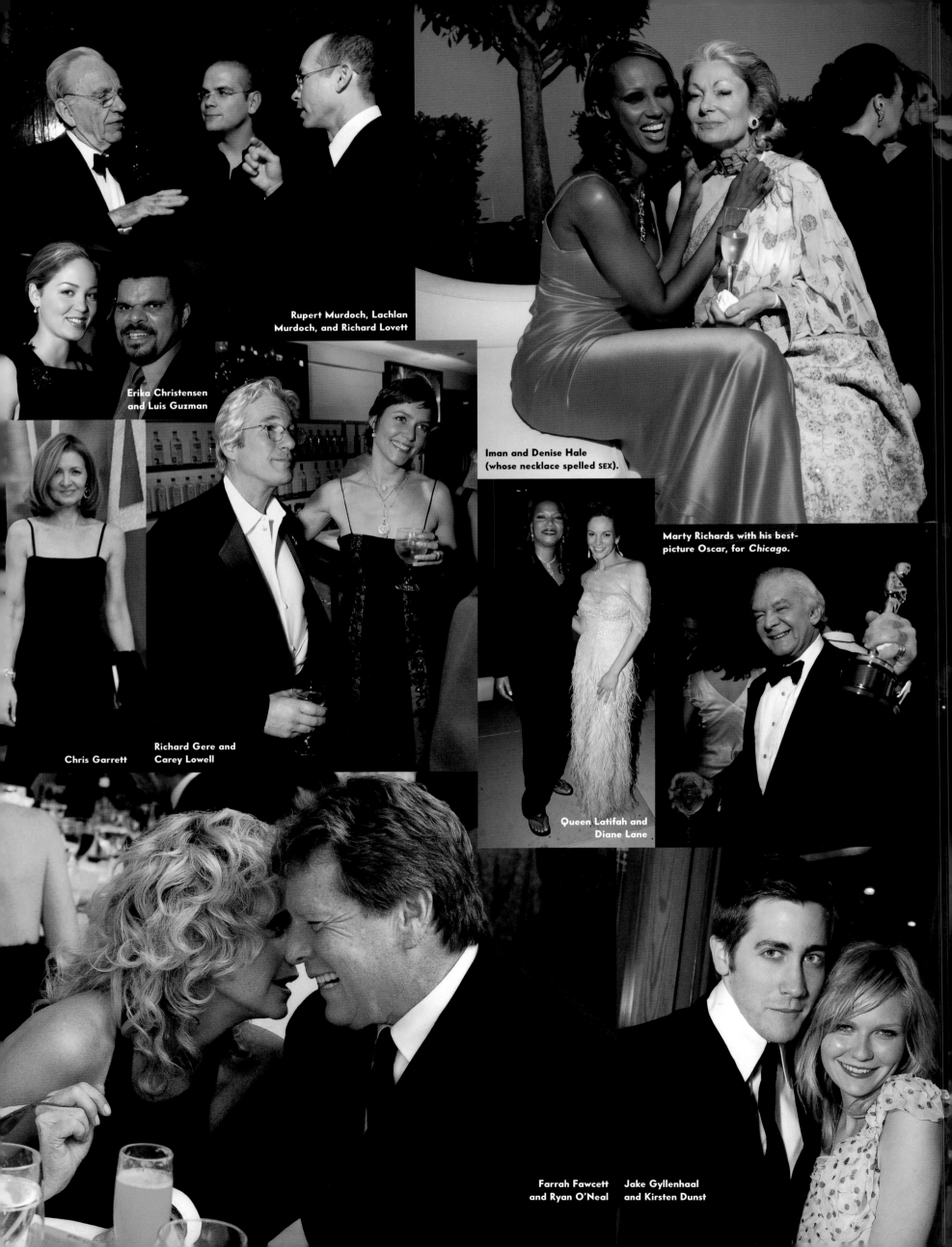

Rupert Murdoch, Lachlan
Murdoch, and Richard Lovett

Erika Christensen
and Luis Guzman

Iman and Denise Hale
(whose necklace spelled SEX).

Marty Richards with his best-
picture Oscar, for *Chicago*.

Chris Garrett

Richard Gere and
Carey Lowell

Queen Latifah and
Diane Lane

Farrah Fawcett Jake Gyllenhaal
and Ryan O'Neal and Kirsten Dunst

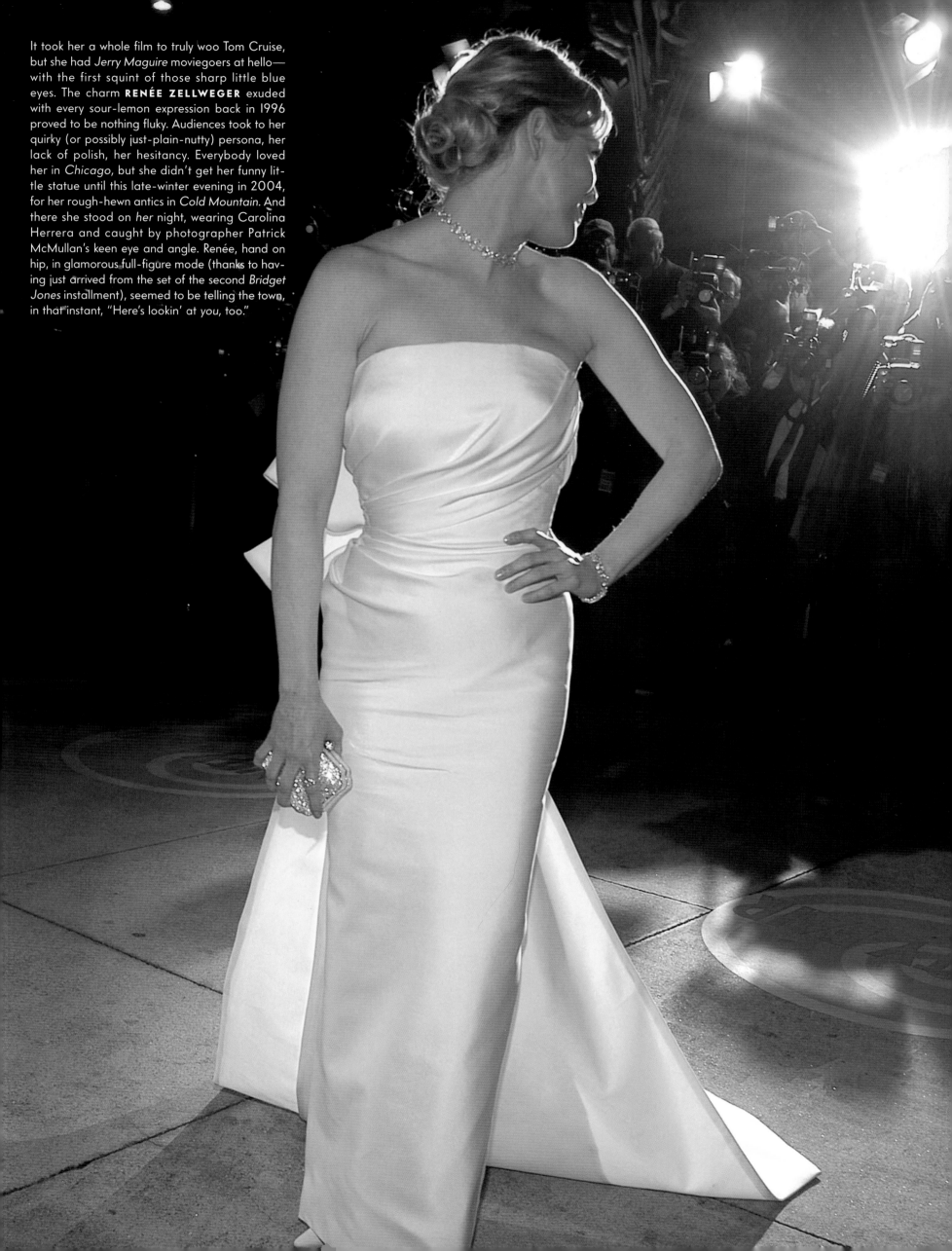

It took her a whole film to truly woo Tom Cruise, but she had *Jerry Maguire* moviegoers at hello—with the first squint of those sharp little blue eyes. The charm **RENÉE ZELLWEGER** exuded with every sour-lemon expression back in 1996 proved to be nothing fluky. Audiences took to her quirky (or possibly just-plain-nutty) persona, her lack of polish, her hesitancy. Everybody loved her in *Chicago*, but she didn't get her funny little statue until this late-winter evening in 2004, for her rough-hewn antics in *Cold Mountain*. And there she stood on *her* night, wearing Carolina Herrera and caught by photographer Patrick McMullan's keen eye and angle. Renée, hand on hip, in glamorous full-figure mode (thanks to having just arrived from the set of the second *Bridget Jones* installment), seemed to be telling the town, in that instant, "Here's lookin' at you, too."

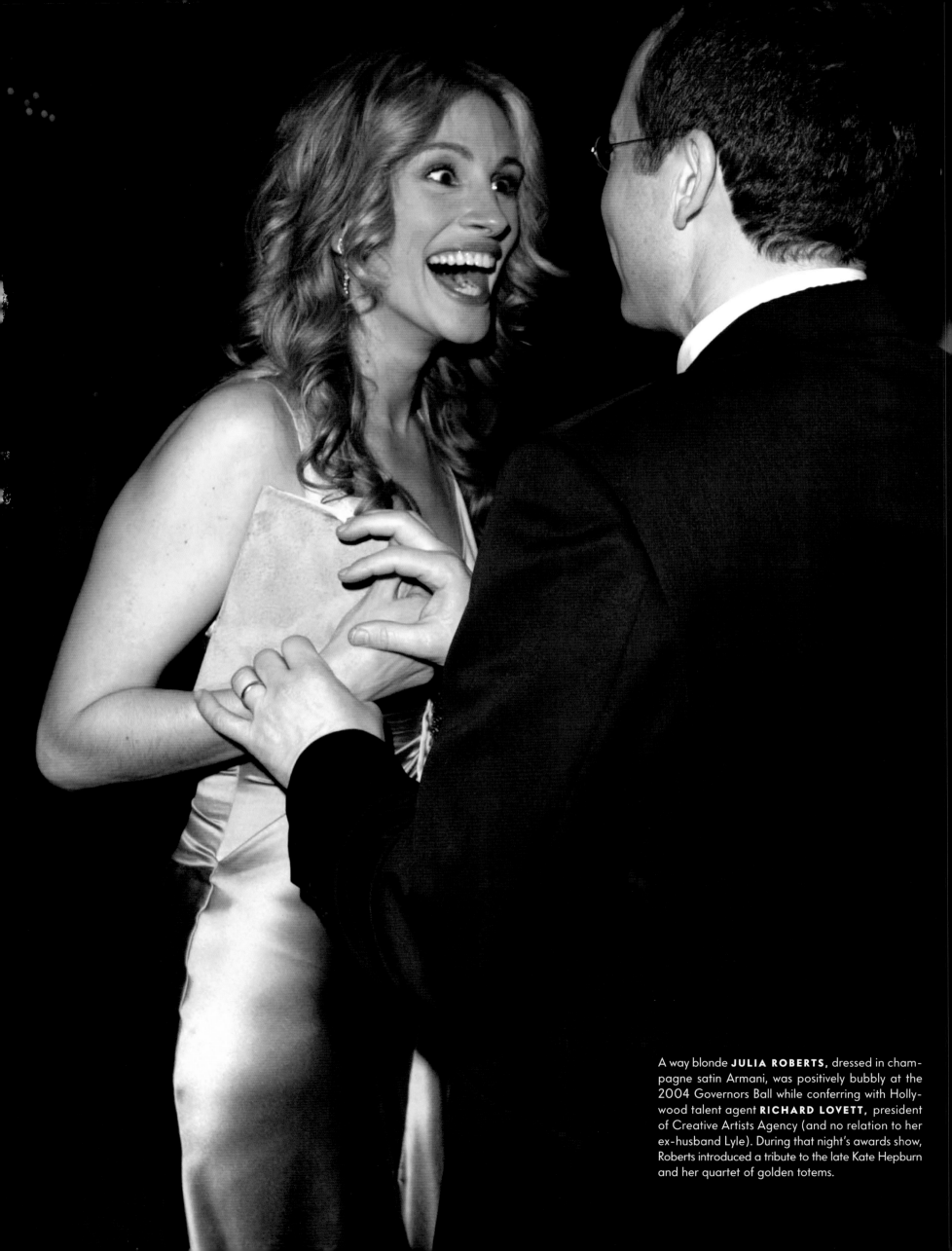

A way blonde **JULIA ROBERTS,** dressed in champagne satin Armani, was positively bubbly at the 2004 Governors Ball while conferring with Hollywood talent agent **RICHARD LOVETT,** president of Creative Artists Agency (and no relation to her ex-husband Lyle). During that night's awards show, Roberts introduced a tribute to the late Kate Hepburn and her quartet of golden totems.

LOST AND FOUND It took 76 years for a best-director nomination to be bestowed upon an American woman. And although she did not claim that prize for her film *Lost in Translation*, Sofia Coppola—photographed at the 2004 Governors Ball with her father, five-time Oscar champ Francis Ford Coppola—did whittle a victory for best original screenplay. The Coppolas (Carmine, Francis, and Sofia—not to mention Sofia's cousin Nicolas Cage) joined the fabled Hustons (Walter, John, and Anjelica) as the only families to claim three generations of Oscar winners. At the *Vanity Fair* party: *top inset,* *Lost in Translation*'s pivotal player, Bill Murray, a best-actor nominee; *bottom inset,* his co-star, Scarlett Johansson (with Michael Keaton).

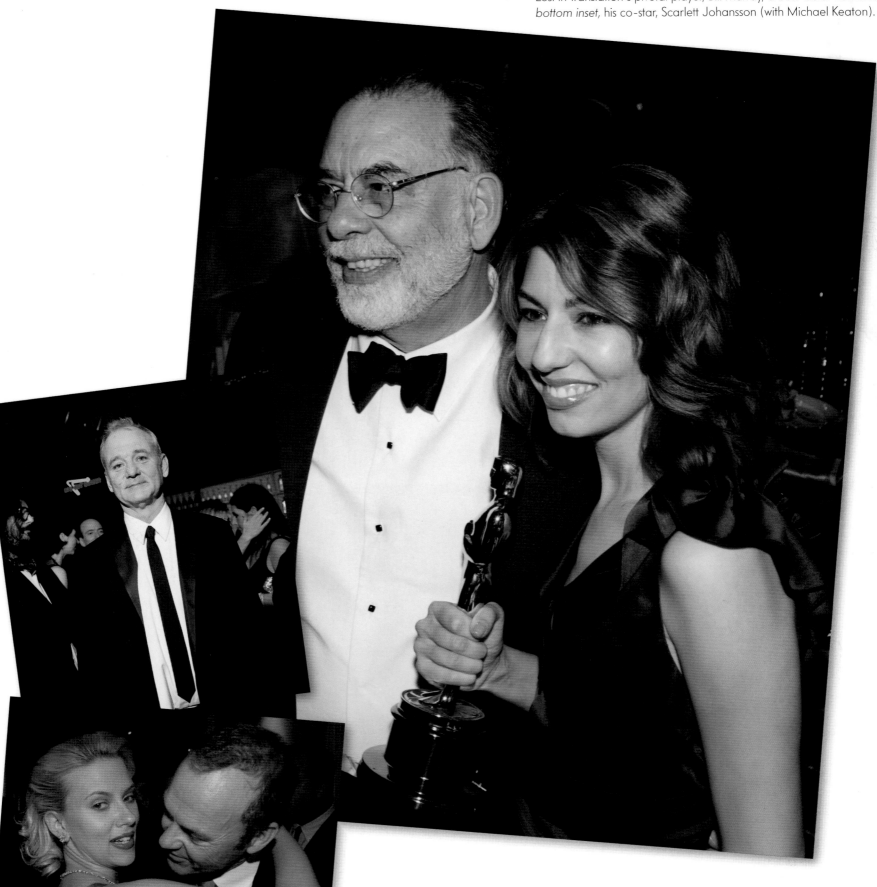

66 I only had eyes for Scarlett Johansson, busy licking a lollipop of her own face. She handed me one, this time with Gwyneth Paltrow on it, and cheekily asked: 'How'd you like to lick that?' 99

—**BAZ BAMIGBOYE**
LONDON *DAILY MAIL*, MARCH 5, 2004

369

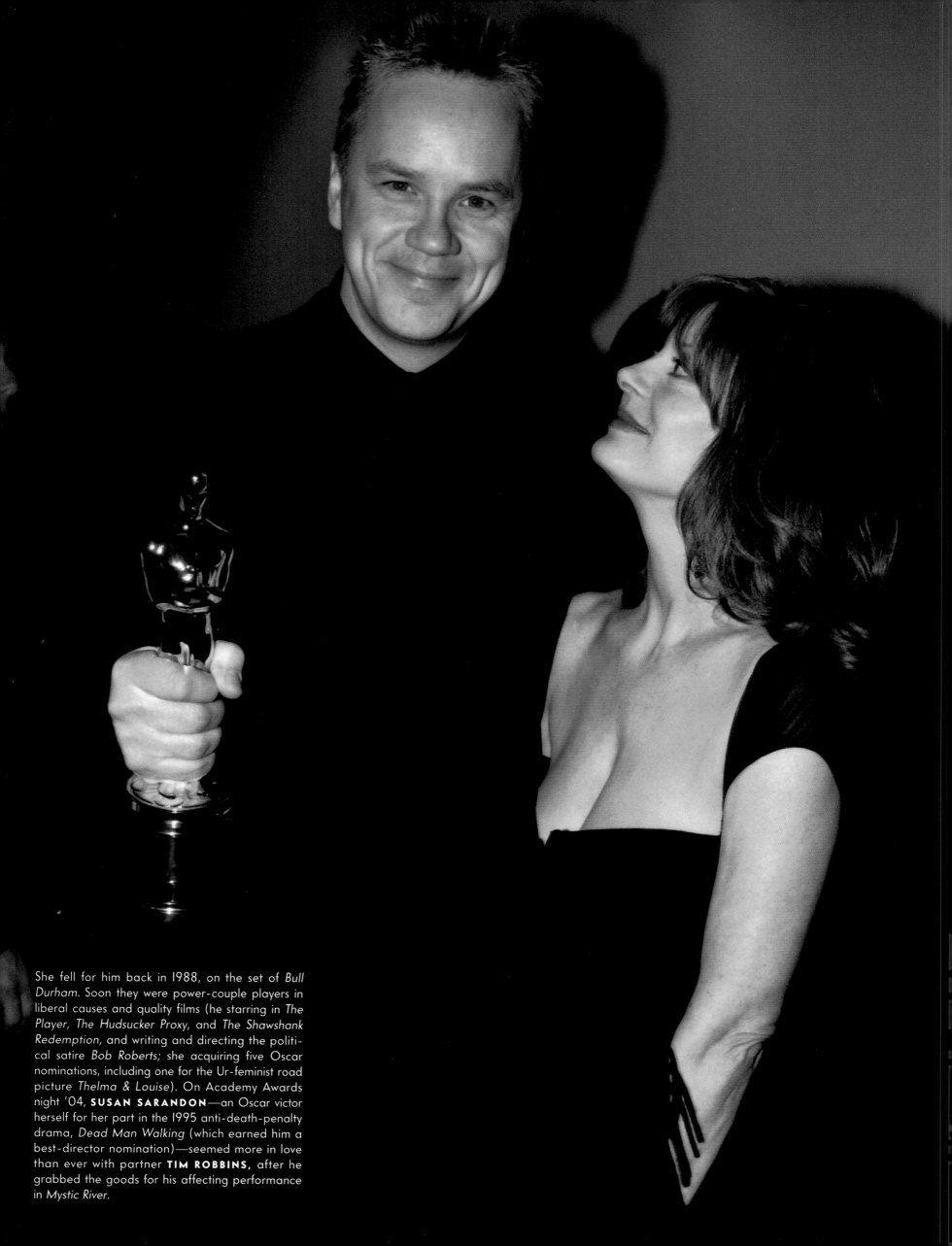

She fell for him back in 1988, on the set of *Bull Durham*. Soon they were power-couple players in liberal causes and quality films (he starring in *The Player*, *The Hudsucker Proxy*, and *The Shawshank Redemption*, and writing and directing the political satire *Bob Roberts*; she acquiring five Oscar nominations, including one for the Ur-feminist road picture *Thelma & Louise*). On Academy Awards night '04, **SUSAN SARANDON**—an Oscar victor herself for her part in the 1995 anti-death-penalty drama, *Dead Man Walking* (which earned him a best-director nomination)—seemed more in love than ever with partner **TIM ROBBINS,** after he grabbed the goods for his affecting performance in *Mystic River.*

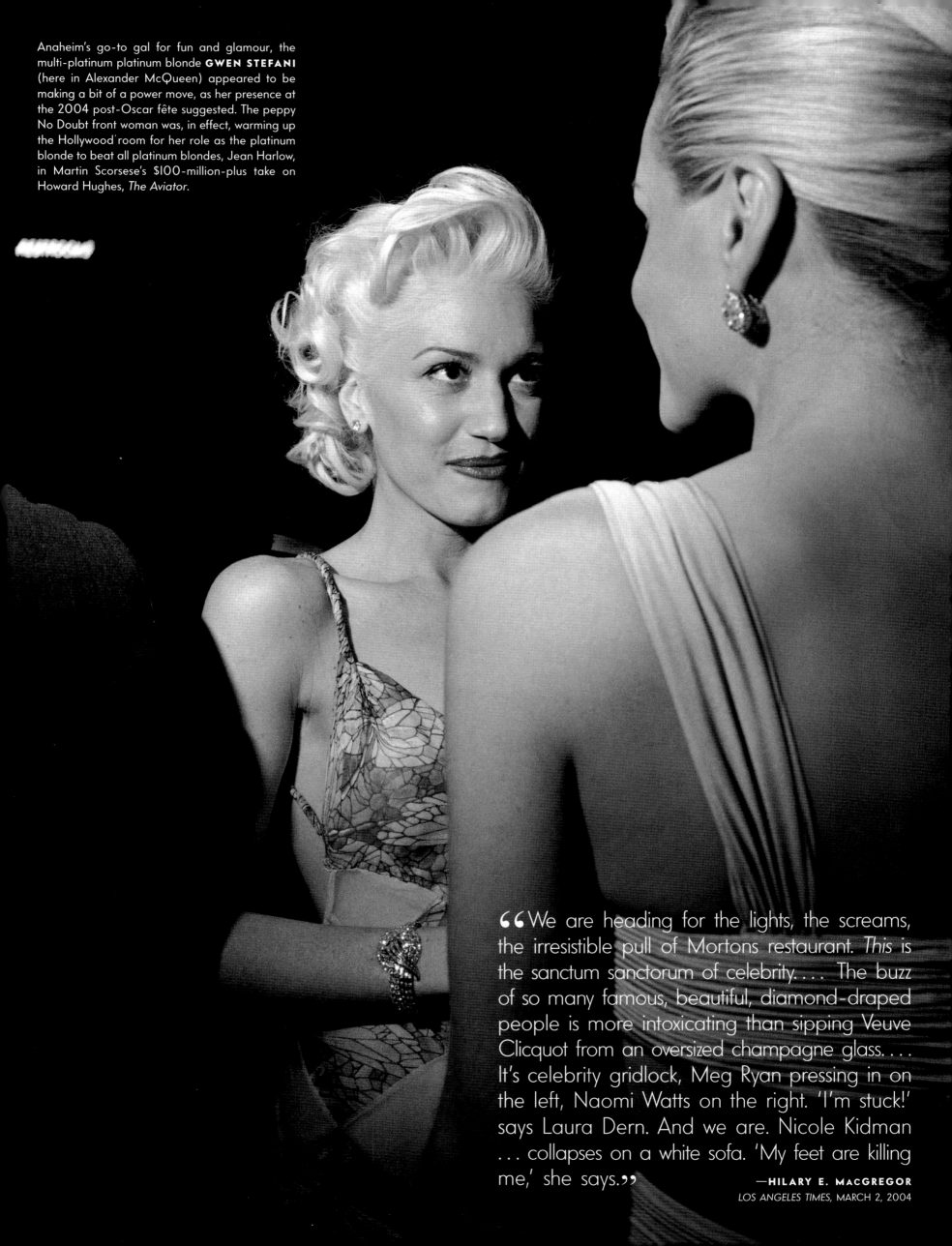

Anaheim's go-to gal for fun and glamour, the multi-platinum platinum blonde **GWEN STEFANI** (here in Alexander McQueen) appeared to be making a bit of a power move, as her presence at the 2004 post-Oscar fête suggested. The peppy No Doubt front woman was, in effect, warming up the Hollywood room for her role as the platinum blonde to beat all platinum blondes, Jean Harlow, in Martin Scorsese's $100-million-plus take on Howard Hughes, *The Aviator*.

❝We are heading for the lights, the screams, the irresistible pull of Mortons restaurant. *This* is the sanctum sanctorum of celebrity. . . . The buzz of so many famous, beautiful, diamond-draped people is more intoxicating than sipping Veuve Clicquot from an oversized champagne glass. . . . It's celebrity gridlock, Meg Ryan pressing in on the left, Naomi Watts on the right. 'I'm stuck!' says Laura Dern. And we are. Nicole Kidman . . . collapses on a white sofa. 'My feet are killing me,' she says.❞

—HILARY E. MACGREGOR
LOS ANGELES TIMES, MARCH 2, 2004

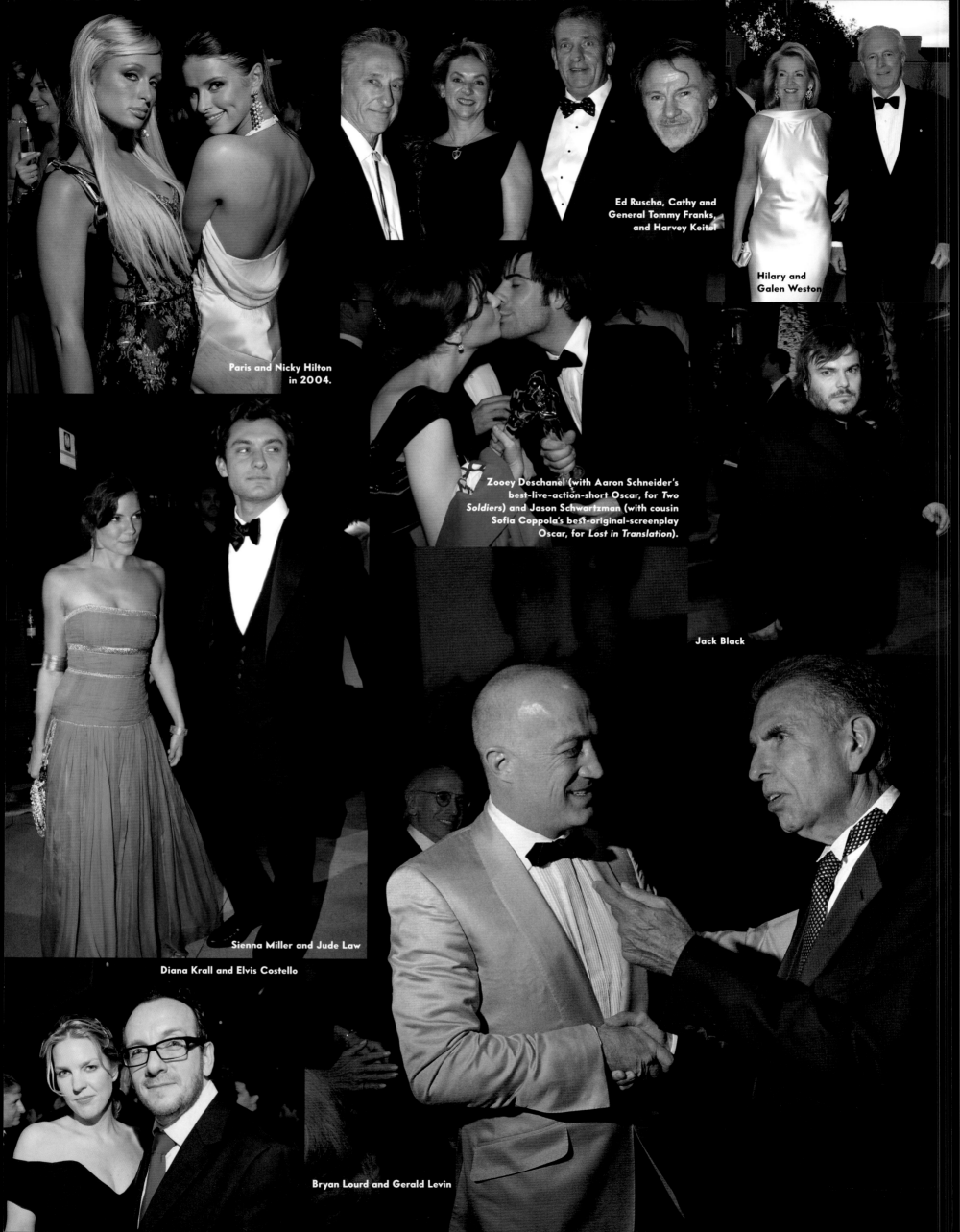

Paris and Nicky Hilton
in 2004.

Ed Ruscha, Cathy and
General Tommy Franks,
and Harvey Keitel

Hilary and
Galen Weston

Zooey Deschanel (with Aaron Schneider's
best-live-action-short Oscar, for *Two
Soldiers*) and Jason Schwartzman (with cousin
Sofia Coppola's best-original-screenplay
Oscar, for *Lost in Translation*).

Jack Black

Sienna Miller and Jude Law

Diana Krall and Elvis Costello

Bryan Lourd and Gerald Levin

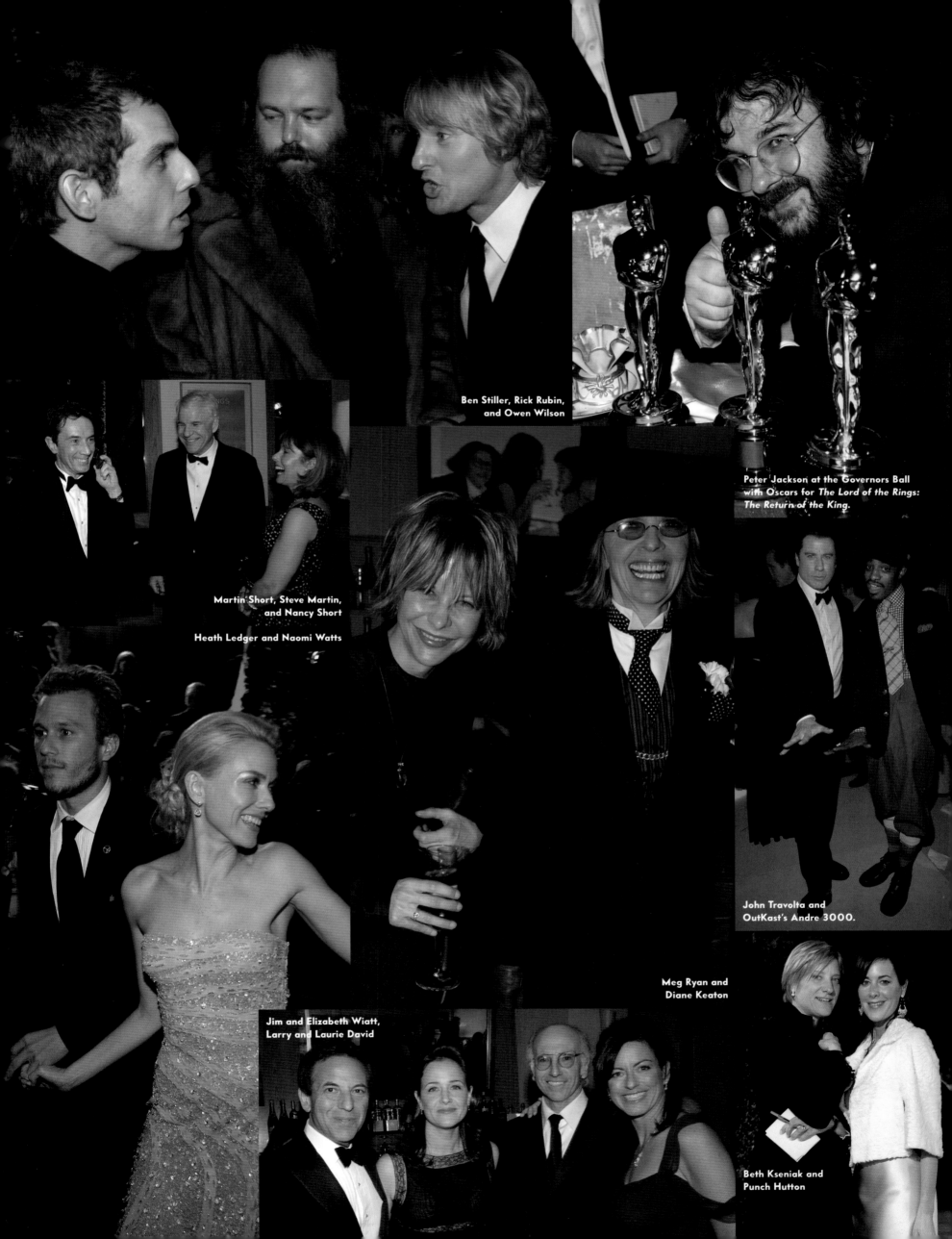

Ben Stiller, Rick Rubin,
and Owen Wilson

Peter Jackson at the Governors Ball
with Oscars for *The Lord of the Rings:
The Return of the King.*

Martin Short, Steve Martin,
and Nancy Short

Heath Ledger and Naomi Watts

John Travolta and
OutKast's Andre 3000.

Meg Ryan and
Diane Keaton

Jim and Elizabeth Wiatt,
Larry and Laurie David

Beth Kseniak and
Punch Hutton

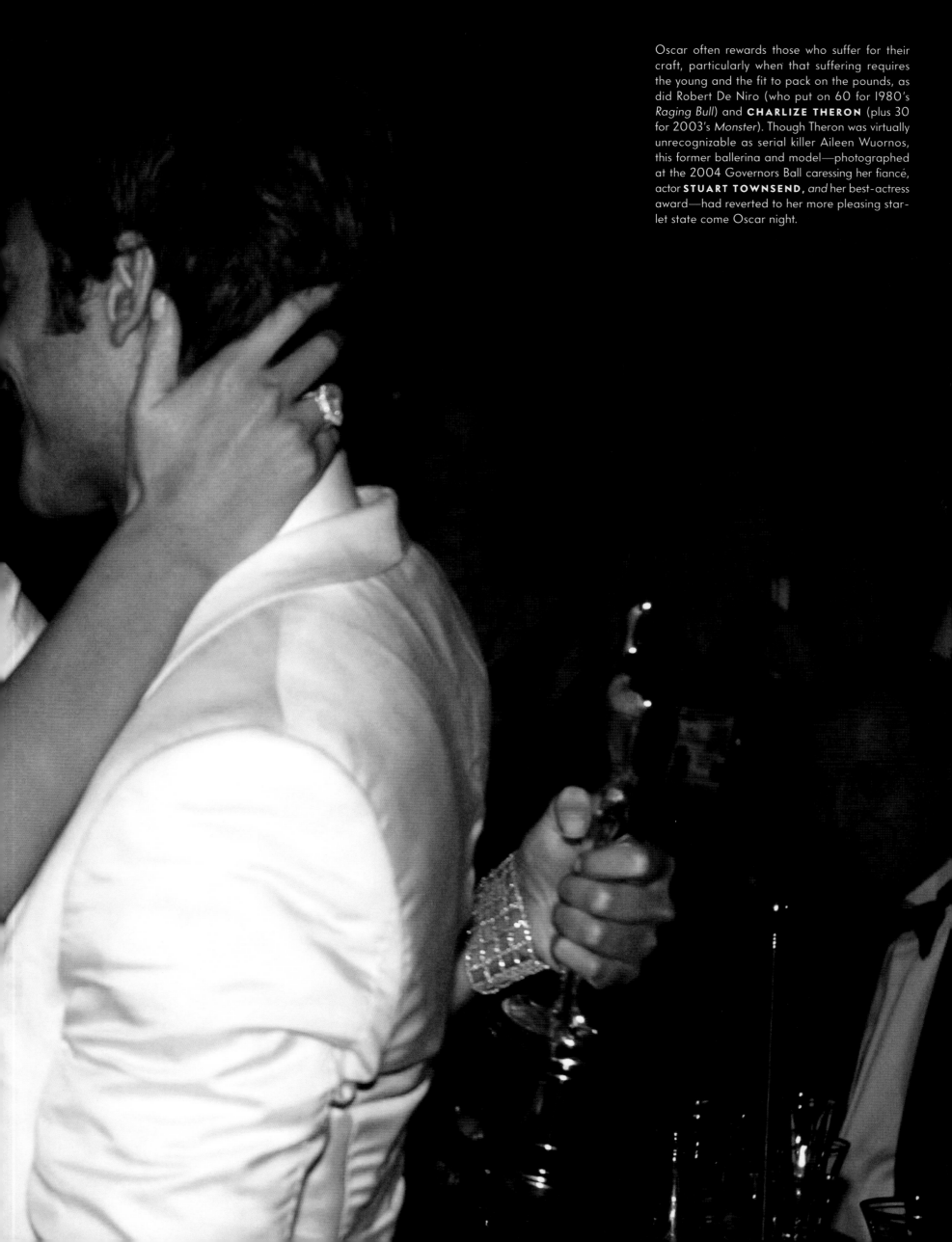

Oscar often rewards those who suffer for their craft, particularly when that suffering requires the young and the fit to pack on the pounds, as did Robert De Niro (who put on 60 for 1980's *Raging Bull*) and **CHARLIZE THERON** (plus 30 for 2003's *Monster*). Though Theron was virtually unrecognizable as serial killer Aileen Wuornos, this former ballerina and model—photographed at the 2004 Governors Ball caressing her fiancé, actor **STUART TOWNSEND,** *and* her best-actress award—had reverted to her more pleasing starlet state come Oscar night.

ACADEMY AWARDS®, YEAR BY YEAR (MAJOR CATEGORIES)

Joan Fontaine admires her 1941 best-actress Oscar, for *Suspicion*.

	FILM YEAR	CEREMONY AND PARTY	PICTURE	ACTOR	ACTRESS	SUPPORTING ACTOR	SUPPORTING ACTRESS	DIRECTOR
1st	1927–1928	1929	*Wings*	Emil Jannings *The Last Command; The Way of All Flesh*	Janet Gaynor *7th Heaven; Street Angel; Sunrise*			Lewis Milestone *Two Arabian Knights;* Frank Borzage *7th Heaven*
2nd	1928–1929	Spring 1930	*The Broadway Melody*	Warner Baxter *In Old Arizona*	Mary Pickford *Coquette*			Frank Lloyd *The Divine Lady*
3rd	1929–1930	Fall 1930	*All Quiet on the Western Front*	George Arliss *Disraeli*	Norma Shearer *The Divorcee*			Lewis Milestone *All Quiet on the Western Front*
4th	1930–1931	1931	*Cimarron*	Lionel Barrymore *A Free Soul*	Marie Dressler *Min and Bill*			Norman Taurog *Skippy*
5th	1931–1932	1932	*Grand Hotel*	Wallace Beery *The Champ;* Fredric March *Dr. Jekyll and Mr. Hyde*	Helen Hayes *The Sin of Madelon Claudet*			Frank Borzage *Bad Girl*
6th	1932–1933	1934	*Cavalcade*	Charles Laughton *The Private Life of Henry VIII*	Katharine Hepburn *Morning Glory*			Frank Lloyd *Cavalcade*
7th	1934	1935	*It Happened One Night*	Clark Gable *It Happened One Night*	Claudette Colbert *It Happened One Night*			Frank Capra *It Happened One Night*
8th	1935	1936	*Mutiny on the Bounty*	Victor McLaglen *The Informer*	Bette Davis *Dangerous*			John Ford *The Informer*
9th	1936	1937	*The Great Ziegfeld*	Paul Muni *The Story of Louis Pasteur*	Luise Rainer *The Great Ziegfeld*	Walter Brennan *Come and Get It*	Gale Sondergaard *Anthony Adverse*	Frank Capra *Mr. Deeds Goes to Town*
10th	1937	1938	*The Life of Emile Zola*	Spencer Tracy *Captains Courageous*	Luise Rainer *The Good Earth*	Joseph Schildkraut *The Life of Emile Zola*	Alice Brady *In Old Chicago*	Leo McCarey *The Awful Truth*
11th	1938	1939	*You Can't Take It with You*	Spencer Tracy *Boys Town*	Bette Davis *Jezebel*	Walter Brennan *Kentucky*	Fay Bainter *Jezebel*	Frank Capra *You Can't Take It with You*
12th	1939	1940	*Gone with the Wind*	Robert Donat *Goodbye, Mr. Chips*	Vivien Leigh *Gone with the Wind*	Thomas Mitchell *Stagecoach*	Hattie McDaniel *Gone with the Wind*	Victor Fleming *Gone with the Wind*
13th	1940	1941	*Rebecca*	James Stewart *The Philadelphia Story*	Ginger Rogers *Kitty Foyle*	Walter Brennan *The Westerner*	Jane Darwell *The Grapes of Wrath*	John Ford *The Grapes of Wrath*
14th	1941	1942	*How Green Was My Valley*	Gary Cooper *Sergeant York*	Joan Fontaine *Suspicion*	Donald Crisp *How Green Was My Valley*	Mary Astor *The Great Lie*	John Ford *How Green Was My Valley*
15th	1942	1943	*Mrs. Miniver*	James Cagney *Yankee Doodle Dandy*	Greer Garson *Mrs. Miniver*	Van Heflin *Johnny Eager*	Teresa Wright *Mrs. Miniver*	William Wyler *Mrs. Miniver*
16th	1943	1944	*Casablanca*	Paul Lukas *Watch on the Rhine*	Jennifer Jones *The Song of Bernadette*	Charles Coburn *The More the Merrier*	Katina Paxinou *For Whom the Bell Tolls*	Michael Curtiz *Casablanca*
17th	1944	1945	*Going My Way*	Bing Crosby *Going My Way*	Ingrid Bergman *Gaslight*	Barry Fitzgerald *Going My Way*	Ethel Barrymore *None but the Lonely Heart*	Leo McCarey *Going My Way*
18th	1945	1946	*The Lost Weekend*	Ray Milland *The Lost Weekend*	Joan Crawford *Mildred Pierce*	James Dunn *A Tree Grows in Brooklyn*	Anne Revere *National Velvet*	Billy Wilder *The Lost Weekend*
19th	1946	1947	*The Best Years of Our Lives*	Fredric March *The Best Years of Our Lives*	Olivia De Havilland *To Each His Own*	Harold Russell *The Best Years of Our Lives*	Anne Baxter *The Razor's Edge*	William Wyler *The Best Years of Our Lives*
20th	1947	1948	*Gentleman's Agreement*	Ronald Colman *A Double Life*	Loretta Young *The Farmer's Daughter*	Edmund Gwenn *Miracle on 34th Street*	Celeste Holm *Gentleman's Agreement*	Elia Kazan *Gentleman's Agreement*
21st	1948	1949	*Hamlet*	Laurence Olivier *Hamlet*	Jane Wyman *Johnny Belinda*	Walter Huston *The Treasure of the Sierra Madre*	Claire Trevor *Key Largo*	John Huston *The Treasure of the Sierra Madre*
22nd	1949	1950	*All the King's Men*	Broderick Crawford *All the King's Men*	Olivia De Havilland *The Heiress*	Dean Jagger *Twelve O'Clock High*	Mercedes McCambridge *All the King's Men*	Joseph L. Mankiewicz *A Letter to Three Wives*
23rd	1950	1951	*All About Eve*	José Ferrer *Cyrano de Bergerac*	Judy Holliday *Born Yesterday*	George Sanders *All About Eve*	Josephine Hull *Harvey*	Joseph L. Mankiewicz *All About Eve*
24th	1951	1952	*An American in Paris*	Humphrey Bogart *The African Queen*	Vivien Leigh *A Streetcar Named Desire*	Karl Malden *A Streetcar Named Desire*	Kim Hunter *A Streetcar Named Desire*	George Stevens *A Place in the Sun*
25th	1952	1953	*The Greatest Show on Earth*	Gary Cooper *High Noon*	Shirley Booth *Come Back, Little Sheba*	Anthony Quinn *Viva Zapata!*	Gloria Grahame *The Bad and the Beautiful*	John Ford *The Quiet Man*
26th	1953	1954	*From Here to Eternity*	William Holden *Stalag 17*	Audrey Hepburn *Roman Holiday*	Frank Sinatra *From Here to Eternity*	Donna Reed *From Here to Eternity*	Fred Zinnemann *From Here to Eternity*
27th	1954	1955	*On the Waterfront*	Marlon Brando *On the Waterfront*	Grace Kelly *The Country Girl*	Edmond O'Brien *The Barefoot Contessa*	Eva Marie Saint *On the Waterfront*	Elia Kazan *On the Waterfront*
28th	1955	1956	*Marty*	Ernest Borgnine *Marty*	Anna Magnani *The Rose Tattoo*	Jack Lemmon *Mister Roberts*	Jo Van Fleet *East of Eden*	Delbert Mann *Marty*
29th	1956	1957	*Around the World in 80 Days*	Yul Brynner *The King and I*	Ingrid Bergman *Anastasia*	Anthony Quinn *Lust for Life*	Dorothy Malone *Written on the Wind*	George Stevens *Giant*
30th	1957	1958	*The Bridge on the River Kwai*	Alec Guinness *The Bridge on the River Kwai*	Joanne Woodward *The Three Faces of Eve*	Red Buttons *Sayonara*	Miyoshi Umeki *Sayonara*	David Lean *The Bridge on the River Kwai*
31st	1958	1959	*Gigi*	David Niven *Separate Tables*	Susan Hayward *I Want to Live!*	Burl Ives *The Big Country*	Wendy Hiller *Separate Tables*	Vincente Minnelli *Gigi*
32nd	1959	1960	*Ben-Hur*	Charlton Heston *Ben-Hur*	Simone Signoret *Room at the Top*	Hugh Griffith *Ben-Hur*	Shelley Winters *The Diary of Anne Frank*	William Wyler *Ben-Hur*
33rd	1960	1961	*The Apartment*	Burt Lancaster *Elmer Gantry*	Elizabeth Taylor *Butterfield 8*	Peter Ustinov *Spartacus*	Shirley Jones *Elmer Gantry*	Billy Wilder *The Apartment*
34th	1961	1962	*West Side Story*	Maximilian Schell *Judgment at Nuremberg*	Sophia Loren *Two Women*	George Chakiris *West Side Story*	Rita Moreno *West Side Story*	Robert Wise, Jerome Robbins *West Side Story*
35th	1962	1963	*Lawrence of Arabia*	Gregory Peck *To Kill a Mockingbird*	Anne Bancroft *The Miracle Worker*	Ed Begley *Sweet Bird of Youth*	Patty Duke *The Miracle Worker*	David Lean *Lawrence of Arabia*
36th	1963	1964	*Tom Jones*	Sidney Poitier *Lilies of the Field*	Patricia Neal *Hud*	Melvyn Douglas *Hud*	Margaret Rutherford *The V.I.P.s*	Tony Richardson *Tom Jones*
37th	1964	1965	*My Fair Lady*	Rex Harrison *My Fair Lady*	Julie Andrews *Mary Poppins*	Peter Ustinov *Topkapi*	Lila Kedrova *Zorba the Greek*	George Cukor *My Fair Lady*

FILM YEAR	CEREMONY AND PARTY	PICTURE	ACTOR	ACTRESS	SUPPORTING ACTOR	SUPPORTING ACTRESS	DIRECTOR
38th 1965	1966	*The Sound of Music*	Lee Marvin *Cat Ballou*	Julie Christie *Darling*	Martin Balsam *A Thousand Clowns*	Shelley Winters *A Patch of Blue*	Robert Wise *The Sound of Music*
39th 1966	1967	*A Man for All Seasons*	Paul Scofield *A Man for All Seasons*	Elizabeth Taylor *Who's Afraid of Virginia Woolf?*	Walter Matthau *The Fortune Cookie*	Sandy Dennis *Who's Afraid of Virginia Woolf?*	Fred Zinnemann *A Man for All Seasons*
40th 1967	1968 (no party)	*In the Heat of the Night*	Rod Steiger *In the Heat of the Night*	Katharine Hepburn *Guess Who's Coming to Dinner*	George Kennedy *Cool Hand Luke*	Estelle Parsons *Bonnie and Clyde*	Mike Nichols *The Graduate*
41st 1968	1969	*Oliver!*	Cliff Robertson *Charly*	Katharine Hepburn *The Lion in Winter;* Barbra Streisand *Funny Girl*	Jack Albertson *The Subject Was Roses*	Ruth Gordon *Rosemary's Baby*	Carol Reed *Oliver!*
42nd 1969	1970	*Midnight Cowboy*	John Wayne *True Grit*	Maggie Smith *The Prime of Miss Jean Brodie*	Gig Young *They Shoot Horses, Don't They?*	Goldie Hawn *Cactus Flower*	John Schlesinger *Midnight Cowboy*
43rd 1970	1971	*Patton*	George C. Scott *Patton*	Glenda Jackson *Women in Love*	John Mills *Ryan's Daughter*	Helen Hayes *Airport*	Franklin J. Schaffner *Patton*
44th 1971	1972	*The French Connection*	Gene Hackman *The French Connection*	Jane Fonda *Klute*	Ben Johnson *The Last Picture Show*	Cloris Leachman *The Last Picture Show*	William Friedkin *The French Connection*
45th 1972	1973	*The Godfather*	Marlon Brando *The Godfather*	Liza Minnelli *Cabaret*	Joel Grey *Cabaret*	Eileen Heckart *Butterflies Are Free*	Bob Fosse *Cabaret*
46th 1973	1974	*The Sting*	Jack Lemmon *Save the Tiger*	Glenda Jackson *A Touch of Class*	John Houseman *The Paper Chase*	Tatum O'Neal *Paper Moon*	George Roy Hill *The Sting*
47th 1974	1975	*The Godfather Part II*	Art Carney *Harry and Tonto*	Ellen Burstyn *Alice Doesn't Live Here Anymore*	Robert De Niro *The Godfather Part II*	Ingrid Bergman *Murder on the Orient Express*	Francis Ford Coppola *The Godfather Part II*
48th 1975	1976	*One Flew over the Cuckoo's Nest*	Jack Nicholson *One Flew over the Cuckoo's Nest*	Louise Fletcher *One Flew over the Cuckoo's Nest*	George Burns *The Sunshine Boys*	Lee Grant *Shampoo*	Miloš Forman *One Flew over the Cuckoo's Nest*
49th 1976	1977	*Rocky*	Peter Finch *Network*	Faye Dunaway *Network*	Jason Robards *All the President's Men*	Beatrice Straight *Network*	John G. Avildsen *Rocky*
50th 1977	1978	*Annie Hall*	Richard Dreyfuss *The Goodbye Girl*	Diane Keaton *Annie Hall*	Jason Robards *Julia*	Vanessa Redgrave *Julia*	Woody Allen *Annie Hall*
51st 1978	1979	*The Deer Hunter*	Jon Voight *Coming Home*	Jane Fonda *Coming Home*	Christopher Walken *The Deer Hunter*	Maggie Smith *California Suite*	Michael Cimino *The Deer Hunter*
52nd 1979	1980	*Kramer vs. Kramer*	Dustin Hoffman *Kramer vs. Kramer*	Sally Field *Norma Rae*	Melvyn Douglas *Being There*	Meryl Streep *Kramer vs. Kramer*	Robert Benton *Kramer vs. Kramer*
53rd 1980	1981	*Ordinary People*	Robert De Niro *Raging Bull*	Sissy Spacek *Coal Miner's Daughter*	Timothy Hutton *Ordinary People*	Mary Steenburgen *Melvin and Howard*	Robert Redford *Ordinary People*
54th 1981	1982	*Chariots of Fire*	Henry Fonda *On Golden Pond*	Katharine Hepburn *On Golden Pond*	John Gielgud *Arthur*	Maureen Stapleton *Reds*	Warren Beatty *Reds*
55th 1982	1983	*Gandhi*	Ben Kingsley *Gandhi*	Meryl Streep *Sophie's Choice*	Louis Gossett Jr. *An Officer and a Gentleman*	Jessica Lange *Tootsie*	Richard Attenborough *Gandhi*
56th 1983	1984	*Terms of Endearment*	Robert Duvall *Tender Mercies*	Shirley MacLaine *Terms of Endearment*	Jack Nicholson *Terms of Endearment*	Linda Hunt *The Year of Living Dangerously*	James L. Brooks *Terms of Endearment*
57th 1984	1985	*Amadeus*	F. Murray Abraham *Amadeus*	Sally Field *Places in the Heart*	Haing S. Ngor *The Killing Fields*	Peggy Ashcroft *A Passage to India*	Miloš Forman *Amadeus*
58th 1985	1986	*Out of Africa*	William Hurt *Kiss of the Spider Woman*	Geraldine Page *The Trip to Bountiful*	Don Ameche *Cocoon*	Anjelica Huston *Prizzi's Honor*	Sydney Pollack *Out of Africa*
59th 1986	1987	*Platoon*	Paul Newman *The Color of Money*	Marlee Matlin *Children of a Lesser God*	Michael Caine *Hannah and Her Sisters*	Dianne Wiest *Hannah and Her Sisters*	Oliver Stone *Platoon*
60th 1987	1988	*The Last Emperor*	Michael Douglas *Wall Street*	Cher *Moonstruck*	Sean Connery *The Untouchables*	Olympia Dukakis *Moonstruck*	Bernardo Bertolucci *The Last Emperor*
61st 1988	1989	*Rain Man*	Dustin Hoffman *Rain Man*	Jodie Foster *The Accused*	Kevin Kline *A Fish Called Wanda*	Geena Davis *The Accidental Tourist*	Barry Levinson *Rain Man*
62nd 1989	1990	*Driving Miss Daisy*	Daniel Day-Lewis *My Left Foot*	Jessica Tandy *Driving Miss Daisy*	Denzel Washington *Glory*	Brenda Fricker *My Left Foot*	Oliver Stone *Born on the Fourth of July*
63rd 1990	1991	*Dances with Wolves*	Jeremy Irons *Reversal of Fortune*	Kathy Bates *Misery*	Joe Pesci *GoodFellas*	Whoopi Goldberg *Ghost*	Kevin Costner *Dances with Wolves*
64th 1991	1992	*The Silence of the Lambs*	Anthony Hopkins *The Silence of the Lambs*	Jodie Foster *The Silence of the Lambs*	Jack Palance *City Slickers*	Mercedes Ruehl *The Fisher King*	Jonathan Demme *The Silence of the Lambs*
65th 1992	1993	*Unforgiven*	Al Pacino *Scent of a Woman*	Emma Thompson *Howards End*	Gene Hackman *Unforgiven*	Marisa Tomei *My Cousin Vinny*	Clint Eastwood *Unforgiven*
66th 1993	1994	*Schindler's List*	Tom Hanks *Philadelphia*	Holly Hunter *The Piano*	Tommy Lee Jones *The Fugitive*	Anna Paquin *The Piano*	Steven Spielberg *Schindler's List*
67th 1994	1995	*Forrest Gump*	Tom Hanks *Forrest Gump*	Jessica Lange *Blue Sky*	Martin Landau *Ed Wood*	Dianne Wiest *Bullets over Broadway*	Robert Zemeckis *Forrest Gump*
68th 1995	1996	*Braveheart*	Nicolas Cage *Leaving Las Vegas*	Susan Sarandon *Dead Man Walking*	Kevin Spacey *The Usual Suspects*	Mira Sorvino *Mighty Aphrodite*	Mel Gibson *Braveheart*
69th 1996	1997	*The English Patient*	Geoffrey Rush *Shine*	Frances McDormand *Fargo*	Cuba Gooding Jr. *Jerry Maguire*	Juliette Binoche *The English Patient*	Anthony Minghella *The English Patient*
70th 1997	1998	*Titanic*	Jack Nicholson *As Good As It Gets*	Helen Hunt *As Good As It Gets*	Robin Williams *Good Will Hunting*	Kim Basinger *L.A. Confidential*	James Cameron *Titanic*
71st 1998	1999	*Shakespeare in Love*	Roberto Benigni *Life Is Beautiful*	Gwyneth Paltrow *Shakespeare in Love*	James Coburn *Affliction*	Judi Dench *Shakespeare in Love*	Steven Spielberg *Saving Private Ryan*
72nd 1999	2000	*American Beauty*	Kevin Spacey *American Beauty*	Hilary Swank *Boys Don't Cry*	Michael Caine *The Cider House Rules*	Angelina Jolie *Girl, Interrupted*	Sam Mendes *American Beauty*
73rd 2000	2001	*Gladiator*	Russell Crowe *Gladiator*	Julia Roberts *Erin Brockovich*	Benicio Del Toro *Traffic*	Marcia Gay Harden *Pollock*	Steven Soderbergh *Traffic*
74th 2001	2002	*A Beautiful Mind*	Denzel Washington *Training Day*	Halle Berry *Monster's Ball*	Jim Broadbent *Iris*	Jennifer Connelly *A Beautiful Mind*	Ron Howard *A Beautiful Mind*
75th 2002	2003	*Chicago*	Adrien Brody *The Pianist*	Nicole Kidman *The Hours*	Chris Cooper *Adaptation*	Catherine Zeta-Jones *Chicago*	Roman Polanski *The Pianist*
76th 2003	2004	*The Lord of the Rings: The Return of the King*	Sean Penn *Mystic River*	Charlize Theron *Monster*	Tim Robbins *Mystic River*	Renée Zellweger *Cold Mountain*	Peter Jackson *The Lord of the Rings: The Return of the King*

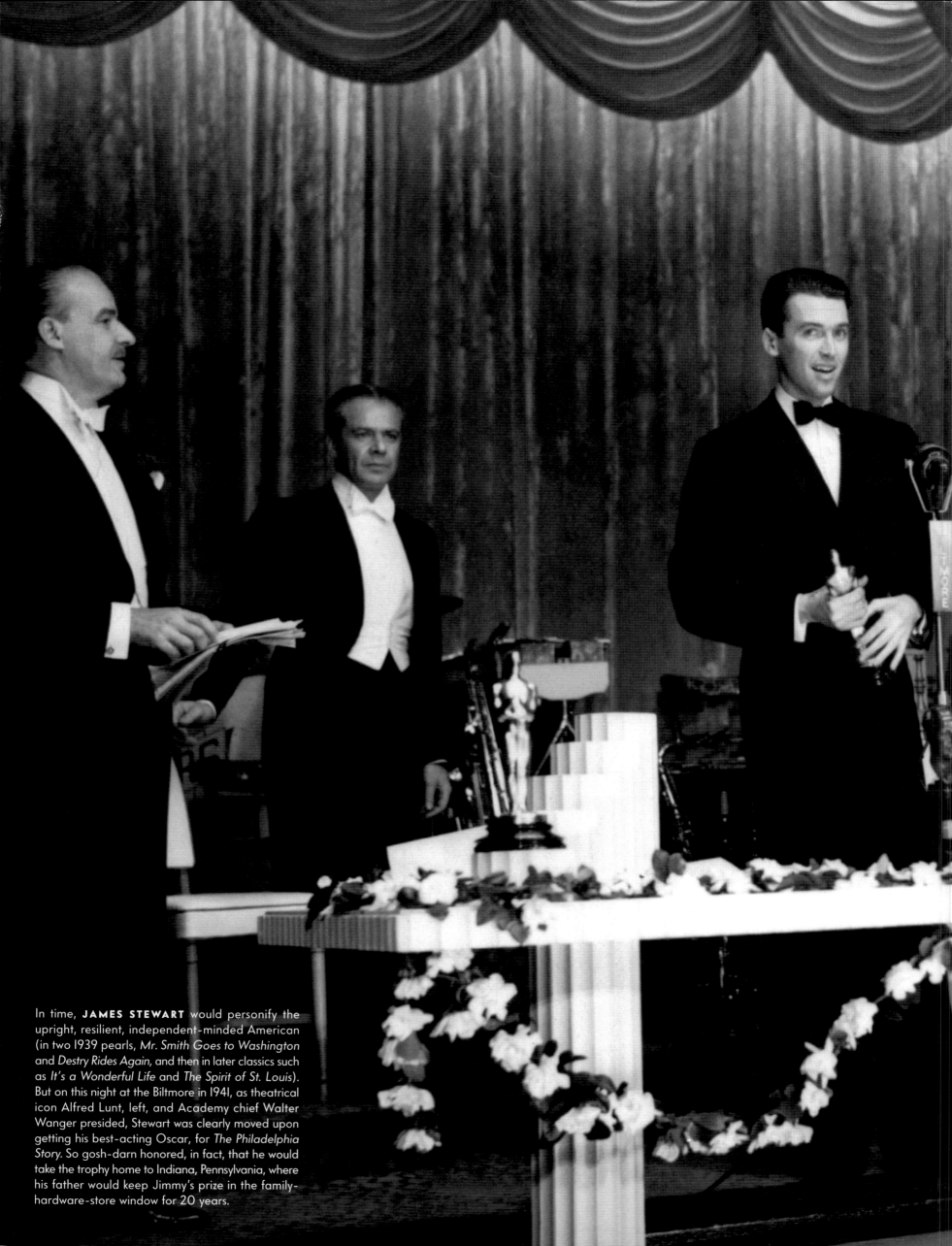

In time, **JAMES STEWART** would personify the upright, resilient, independent-minded American (in two 1939 pearls, *Mr. Smith Goes to Washington* and *Destry Rides Again*, and then in later classics such as *It's a Wonderful Life* and *The Spirit of St. Louis*). But on this night at the Biltmore in 1941, as theatrical icon Alfred Lunt, left, and Academy chief Walter Wanger presided, Stewart was clearly moved upon getting his best-acting Oscar, for *The Philadelphia Story*. So gosh-darn honored, in fact, that he would take the trophy home to Indiana, Pennsylvania, where his father would keep Jimmy's prize in the family-hardware-store window for 20 years.

BIBLIOGRAPHY

SELECTED BIBLIOGRAPHY

Brown, Peter H., and Jim Pinkston. Oscar Dearest: Six Decades of Scandal, Politics and Greed Behind Hollywood's Academy Awards, 1927–1986. New York: Perennial Library, 1987.

Carter, Graydon, and David Friend, ed. Vanity Fair's Hollywood. New York: Viking Studio, 2000.

Chace, Reeve. The Complete Book of Oscar Fashion: Variety's 75 Years of Glamour on the Red Carpet. New York: Reed, 2003.

Fox, Patty. Star Style at the Academy Awards: A Century of Glamour. Santa Monica: Angel City, 2000.

Katz, Ephraim. The Film Encyclopedia. New York: Harper & Row, 1990.

Monaco, James, and the editors of Baseline. The Encyclopedia of Film. New York: Perigee, 1991.

Niklas, Kurt. The Corner Table: From Cabbages to Caviar, Sixty Years in the Celebrity Restaurant Trade. Los Angeles: Tuxedo, 2000.

Osborne, Robert. 75 Years of the Oscar: The Official History of the Academy Awards. New York: Abbeville, 2003.

———. Academy Awards Illustrated: A Complete History of Hollywood's Academy Awards in Words and Pictures. La Habra, Calif.: Ernest E. Schwork, 1977.

Thomson, David. A Biographical Dictionary of Film. New York: Knopf, 1994.

Wiley, Mason, and Damien Bona. Inside Oscar: The Unofficial History of the Academy Awards. New York: Ballantine, 1996.

Zeman, Ned. "Oscar Invasion!" Vanity Fair, Apr. 2000, supplement.

The Internet Movie Database (IMDb). Internet Movie Database Inc. 1990–2004. http://www.imdb.com.
LexisNexis. Reed Elsevier Inc. 2004. http://www.nexis.com/research.
The Official Academy Awards® Database. Academy of Motion Picture Arts and Sciences, 2003. http://www.oscars.org/awardsdatabase/index.html.

ADDITIONAL SOURCES

BOOKS AND CATALOGUES

Anger, Kenneth. Hollywood Babylon. New York: Dell, 1981.

Arce, Hector. The Secret Life of Tyrone Power. New York: Morrow, 1979.

Arthur, Zinn. Shooting Superstars: "Me, My Camera, and the Showbiz Legends." Chicago: Artique/Cloverline, 1990.

Beck, Marilyn. Marilyn Beck's Hollywood. New York: Hawthorn, 1973.

Bergman, Ingrid, and Alan Burgess. Ingrid Bergman: My Story. New York: Delacorte, 1980.

Bernstein, Matthew. Walter Wanger, Hollywood Independent. Minneapolis: University of Minnesota Press, 2000.

Billips, Connie J. Janet Gaynor: A Bio-Bibliography. New York: Greenwood, 1992.

Blackwell, Earl. Earl Blackwell's Celebrity Regilster. Towson, Md.: Times Publishing Group, 1986.

Bona, Damien. Inside Oscar 2. New York: Ballantine, 2002.

Brown, Gene. Movie Time: A Chronology of Hollywood and the Movie Industry from Its Beginnings to the Present. New York: Macmillan, 1995.

Cagney, James. Cagney by Cagney. New York: Doubleday, 1976.

Carpozi, George. The Gary Cooper Story. New Rochelle, N.Y.: Arlington House, 1970.

Chierichetti, David. Edith Head: The Life and Times of Hollywood's Celebrated Costume Designer. New York: HarperCollins, 2003.

Considine, Shaun. Bette & Joan: The Divine Feud. New York: Dutton, 1989.

Crampton, Luke, and Dafydd Rees. Rock & Roll Year by Year. New York: Dorling Kindersley, 2003.

Crawford, Christina. Mommie Dearest. New York: Morrow, 1978.

Crowe, Cameron. Conversations with Wilder. New York: Knopf, 2001.

Davis Jr., Sammy, and Jane and Burt Boyar. Yes I Can: The Story of Sammy Davis, Jr. New York: Farrar, Straus and Giroux, 1965.

Dewey, Donald. James Stewart: A Biography. Atlanta: Turner, 1996.

Douglas, Kirk. Climbing the Mountain: My Search for Meaning. New York: Simon & Schuster, 1997.

Eells, George. Hedda and Louella. New York: Putnam, 1972.

Evans, Robert. The Kid Stays in the Picture. Los Angeles: NewStar, 1995.

Flamini, Roland. Thalberg: The Last Tycoon and the World of M-G-M. New York: Crown, 1994.

Fontaine, Joan. No Bed of Roses. New York: Morrow, 1978.

Fowles, Jib. Starstruck: Celebrity Performers and the American Public. Washington, D.C.: Smithsonian Institution Press, 1992.

Friedrich, Otto. City of Nets: A Portrait of Hollywood in the 1940's. Berkeley: University of California Press, 1997.

Gabler, Neal. An Empire of Their Own: How the Jews Invented Hollywood. New York: Anchor, 1989.

Galella, Ron. The Photographs of Ron Galella, 1965–1989. Los Angeles: Greybull, 2002.

Gehman, Richard. The Tall American: The Story of Gary Cooper. New York: Hawthorn, 1963.

Giddins, Gary. Bing Crosby: A Pocketful of Dreams. Boston: Little, Brown, 2001.

Grobel, Lawrence. The Hustons. New York: Scribner, 1989.

Gottfried, Martin. George Burns and the Hundred-Year Dash. New York: Simon & Schuster, 1996.

Graham, Sheilah. Hollywood Revisited: A Fiftieth Anniversary Celebration. New York: St. Martin's, 1985.

Guiles, Fred Lawrence. Tyrone Power: The Last Idol. Garden City, N.Y.: Doubleday, 1979.

Hamilton, George. Life's Little Pleasures. Santa Monica: General Publishing Group, 1998.

Harkness, John, ed. The Academy Awards Handbook. New York: Kensington, 1996.

Harris, Warren G. Lucy & Desi: The Legendary Love Story of Television's Most Famous Couple. New York: Simon & Schuster, 1991.

Huston, John. An Open Book. New York: Ballantine Books, 1981.

Hyams, Joe. Bogart & Bacall: A Love Story. New York: David McKay, 1975.

Jacobson, Laurie. Dishing Hollywood: The Real Scoop on Tinseltown's Most Notorious Scandals. Nashville: Cumberland House, 2003.

———. Hollywood Heartbreak: The Tragic and Mysterious Deaths of Hollywood's Most Remarkable Legends. New York: Simon & Schuster, 1984.

Janis, Maria Cooper. Gary Cooper Off Camera: A Daughter Remembers. New York: Abrams, 1999.

Kinn, Gail, and Jim Piazza. The Academy Awards: The Complete History of Oscar. New York: Black Dog & Leventhal, 2002.

Konigsberg, Ira. The Complete Film Dictionary. New York: Penguin Reference, 1997.

Koszarski, Richard. "An Evening's Entertainment: The Age of the Silent Feature Picture, 1915–1928." History of the American Cinema. Ed. Charles Harpole. New York: Scribner, 1990.

Lacey, Robert. Grace. New York: Putnam, 1994.

Leamer, Laurence. As Time Goes By: The Life of Ingrid Bergman. New York: Harper & Row, 1986.

Levy, Emanuel. All About Oscar: The History and Politics of the Academy Awards. New York: Continuum, 2003.

Levy, Shawn. King of Comedy: The Life and Art of Jerry Lewis. New York: St. Martin's, 1996.

LIFE Goes to the Movies. New York: Time-Life Books, 1975.

Lissauer, Robert. Lissauer's Encyclopedia of Popular Music in America: 1888 to the Present. New York: Paragon House, 1991.

Loengard, John. Life Photographers: What They Saw. Boston: Little, Brown, 1998.

Louvish, Simon. Stan and Ollie: The Roots of Comedy: The Double Life of Laurel and Hardy. New York: Thomas Dunne, 2004.

Maltin, Leonard, ed. Leonard Maltin's 2004 Movie & Video Guide. New York: Signet, 2003.

———. Leonard Maltin's Movie Encyclopedia. New York: Plume, 1995.

McDougal, Dennis. The Last Mogul: Lew Wasserman, MCA and the Hidden History of Hollywood. New York: Crown, 1998.

McNeil, Alex. Total Television: The Comprehensive Guide to Programming from 1948 to the Present. New York: Penguin, 1996.

Nickson, Chris. Matt Damon: An Unauthorized Biography. Los Angeles: Renaissance, 1999.

Paris, Barry. Audrey Hepburn. New York: Putnam, 1996.

Parker, John. Warren Beatty: The Last Great Lover of Hollywood. New York: Carroll & Graf, 1994.

Pendergast, Tom, and Sara Pendergast, eds. International Dictionary of Film and Filmmakers ,Vol. 3. Detroit: St. James, 2000.

Poitier, Sidney. This Life. New York: Knopf, 1980.

Quirk, Lawrence J. The Films of Fredric March. New York: Citadel, 1971.

Redgrave, Vanessa. Vanessa Redgrave: An Autobiography. New York: Random House, 1994.

Riva, Maria. Marlene Dietrich. New York: Knopf, 1993.

Rogers, Henry C. Walking the Tightrope: The Private Confessions of a Public Relations Man. New York: Morrow, 1980.

Royce, Brenda Scott. Donna Reed: A Bio-Bibliography. New York: Greenwood, 1990.

Sands, Pierre Norman. Historical Study of the Academy of Motion Picture Arts and Sciences, 1927–1947. New York: Arno, 1973.

Schwartz, Nancy Lynn, and Sheila Schwartz. The Hollywood Writers' Wars. New York: Knopf, 1982.

Schott, Ben. Schott's Original Miscellany. New York: Bloomsbury, 2003.

Shale, Richard, ed. Academy Awards: An Ungar Reference Index. New York: Ungar, 1982.

———. The Academy Awards Index: The Complete Categorical and Chronological Record. Westport, Conn.: Greenwood, 1993.

Sharp, Kathleen. Mr. and Mrs. Hollywood: Edie and Lew Wasserman and Their Entertainment Empire. New York: Carroll & Graf, 2003.

Sikov, Ed. On Sunset Boulevard: The Life and Times of Billy Wilder. New York: Hyperion, 1998.

Sperber, A. M., and Eric Lax. Bogart. New York: Morrow, 1997.

Thomas, Bob. Golden Boy: The Untold Story of William Holden. New York: St. Martin's, 1983.

The Thomas Guide: Los Angeles County Street Guide and Directory. Irvine, Calif.: Thomas Bros. Maps, 1995.

Thomson, David. Showman: The Life of David O. Selznick. New York: Knopf, 1992.

Toffel, Neile McQueen. My Husband, My Friend. New York: Atheneum, 1986.

Troyan, Michael. A Rose for Mrs. Miniver: The Life of Greer Garson. Lexington: University Press of Kentucky, 1999.

Unforgettable: Fashion of the Oscars (catalogue). New York: Christie's, 18 Mar. 1999.

Walker, Alexander. Elizabeth: The Life of Elizabeth Taylor. New York: Grove, 2001.

Welch, Julie, and Louise Brody. Leading Men. New York: Crescent, 1987.

Windeler, Robert. Julie Andrews: A Life on Stage and Screen. New York: Birch Lane, 1997.

MAGAZINES AND NEWSPAPERS

Allis, Tim. "A Night's Tale." In Style Mar. 2004: 455-64.

Allman, Kevin. "First Stop on the Post-Awards Tour: the Governor's Ball." Los Angeles Times 27 Mar. 1991.

"Angelenos Share Their Ambassador Hotel Memories." Los Angeles Conservancy News Sept./Oct. 2003.

Archerd, Army. "Goldberg Eyes Second Round." Variety 23 Mar. 1994.

"Audrey Waits for Academy Decision." Life 5 Apr. 1954: 137–39.

"Awards Are Bestowed at Academy Dinner." The Hollywood Reporter 6 Nov. 1930: 3.

"Awards Given at Academy Banquet." Filmograph 18 May 1929.

Babette. "Gorgeous Gowns Vie with Oscars for Attention." The Los Angeles Examiner 5 Apr. 1960: sec. 2, p. 2.

"Bedeck Milday at Acad. Fete." Daily Variety 6 Mar. 1936.

Bamigboye, Baz. Column. London Daily Mail 5 Mar. 2004.

Biskind, Peter. "When Sue Was Queen." Vanity Fair Apr. 2000: 400–405, 432–42.

Booth, William, and Sharon Waxman. "After the Oscars, a Total Implosion of Stars." The Washington Post 25 Mar. 1998.

"A Boston Ingenue." Vanity Fair Nov. 1932: 50.

Bosworth, Patricia. "The Gangster and the Goddess." Vanity Fair Apr. 1999: 244–71.

Brantley, Darryl. "Oscar Wild!" Vanity Fair June 2000: 102–8.

Brenner, Marie. "The Last Goddess." Vanity Fair Apr. 1998: 358–63, 394–401.

Burton, Sandra. "Mocking the Mockery." Time 20 Apr. 1970: 72.

Carroll, Harrison. Column. The Los Angeles Herald Examiner 5 Apr. 1964.

Chapman, John. "Hollywood: Diary of a Movie Correspondent." New York News 2 Mar. 1942.

Chavez, Paul. "Historic L.A. Hotel May Be Demolished." Canada National Post 23 Sept. 2003: A14.

Christy, George. "The Great Life" (Column). The Hollywood Reporter 4 Apr. 1989: 96.

———. "The Great Life" (Column). The Hollywood Reporter 2 Apr. 1992: 26.

———. "The Great Life" (Column). The Hollywood Reporter, Weekly. 2 Feb–27 Mar 2001: 124.

Collins, Amy Fine. "Vanity Fair, The Early Years: 1914-1936." Vanity Fair Mar. 1999: 146.

Collins, Keith. "Oscar's Diary, 1927–1999." Daily Variety 19 Mar. 1999: 16.

Connolly, Mike. "Rambling Reporter." The Hollywood Reporter. 18 Apr. 1961.

Dretzka, Gary. "A Star Is Reborn." Chicago Tribune 12 June 1995: C1.

Dunne, Dominick. "Beverly Hills Coup." Vanity Fair Feb. 1986: 71–73, 117.

———. "Lazarama." Vanity Fair June 1986: 26.

———. "The Little Prince." Vanity Fair Apr. 1999: 392–405.

Durant, Alta. "Gab" (Column). Daily Variety 1 Mar. 1940.

Edwards, Owen. "Think Pink." In Style Oct. 1995: 94.

"Fashion Parade of Stars Dazzles Crowds at Annual Academy Awards Presentation." Hollywood Citizen-News 14 Mar. 1947: 13.

"Film Academy Gives Awards." Hollywood News 17 May 1929.

Frye, William. "The Devil in Miss Davis." Vanity Fair Apr. 2001: 222–57.

"Gary Cooper." Vanity Fair Feb. 1930: 53.

Gold, Todd. "After the Party." Us Weekly 10 Apr. 2000: 80.

"'Gone,' Selznick, Donat, Leigh and Fleming." Daily Variety 1 Mar. 1940.

Handy, Bruce. "Top of the Evening." Vanity Fair June 2003: 132–38.

Harris, Radie. "Broadway Ballyhoo." The Hollywood Reporter 26 Mar. 1952.

Harvey, Steve. "Only in L.A." Los Angeles Times. 17 Jan. 1996: B4.

Higgins, Bill. "Oscar's Night Out; Lazar at Spago: It's 2 Parties in One." Los Angeles Times 27 Mar. 1991.

——— and Jeannine Stein. "Lights Out at the Best Party in Town . . ." Los Angeles Times 21 Mar. 1994.

Hodgman, George. "Oscar Bravo." Vanity Fair June 1995: 102–103.

"Hollywood Inside." Daily Variety 3 Mar. 1944.

"The Hollywood Portfolio." Vanity Fair Apr. 2001: 349–402.

Hopper, Hedda. Column. Los Angeles Times 15 Mar. 1938.

———. Column. Los Angeles Times 6 Mar. 1944.

———. Column. Los Angeles Times 5 Mar. 1946.

———. Column. Los Angeles Times 11 Mar. 1946.

———. Column. Los Angeles Times 17 Mar. 1947.

———. Column. Los Angeles Times 27 Mar. 1950.

Horyn, Cathy. "Oscar Style: All Polished, Pretty and Banal." *The New York Times* 28 Mar. 2000: B8.

Hume, Christopher. "But Is It Art?" *Toronto Star* 21 Mar. 1986: D1.

Hutchings, David. "Oh, What a Night!" *People* 7 Apr. 2003: 104–18.

Johnson, Richard, and Kimberley Ryan. "Page Six: Making the Scene on Oscar Night." *New York Post* 23 Mar. 1994: 6.

Kamp, David. "When Liz Met Dick." *Vanity Fair* Apr. 1998: 366–94.

Kashner, Sam. "Natalie Wood's Fatal Voyage." *Vanity Fair* Mar. 2000: 214–33.

Kearns, Audrey. "Governors' Ball Tops Oscar Night." *Hollywood Citizen-News* 27 Mar. 1958.

Kiley, Sam. "When the Winners Are Still Looking Up to the Stars." The London *Sunday Times* 31 Mar. 1991.

King, Susan. "The Oscars." *Los Angeles Times* 29 Mar. 2003: B1.

————. "Reunion for a Gold Man Group." *Los Angeles Times.* 28 Jan. 2003: E2.

Kuczynski, Alex. "Good Times and Bum Times, but She's Here." *The New York Times* 29 Sept. 2002: sec. 9, p. 1.

"LIFE in Hollywood," *Life* (Special Edition) 10 Mar. 2003: 72, 83–87, 90–97.

Mather, Victoria. "Only If You're Rich, Famous, Hip, Starry . . . or Monica." London *Evening Standard* 22 Mar. 1999: 5.

————. "Pamper Me, I'm a Star." London *Evening Standard* 24 Mar. 2000: 30.

————. "Inside Hollywood's Hottest Oscar Party." London *Evening Standard* 25 Mar. 2002.

McGrory, Brian. "The Famed Beverly Hills Hotel Has Reopened . . ." *The Boston Globe* 14 Jan 1996: B1.

McNamara, Mary. "A Night on the Strip." *Los Angeles Times* 15 Dec. 1996: 35.

McQuaid, Peter. "The Standard-Bearers." *The New York Times* 25 May 2003: sec. 6, p. 47.

Melton, Mary. "Oscar Style Through the Years: The Glamour of Hollywood's Biggest Fashion Blast." *Los Angeles Times* 21 Mar. 1999: 36.

Muir, Florabel. "Wearing of the Green: Not Unlucky to Loretta; Film Gals Gaily Decked." *Variety* 22 Mar 1948.

"A Night to Remember." *Vanity Fair* June 1998: 106–17.

"Norma Shearer—Royalty to the Fore." *Vanity Fair* Nov. 1933: 46.

O'Neill, Ann. "City of Angles." *Los Angeles Times* 27 Mar. 2001.

"Oscar Jewels: Where Are They Now?" *People* 15 Mar. 2004: 87–92.

"Oscar Night 2003: Record-Setting Moments." *People* 7 Apr. 2003: 121–28.

"Oscar on TV." *Life* 30 Mar. 1953.

"Oscar Revels." *Vanity Fair* June 1997: 91–98.

"Oscar Style." *People* (Special Edition). New York: People Books, 2003.

"Oscarlights." *The Hollywood Reporter* 3 Mar. 1944.

"Oscars for Jose and Judy." *Life* 9 Apr. 1951.

Parsons, Louella O. "Film Folk Organize Good Will Academy." *The Los Angeles Examiner* 12 May 1927.

————. Column. *The Los Angeles Examiner* 4 Apr. 1930.

————. Column. *The Los Angeles Examiner* 7 Apr. 1930.

————. Column. *The Los Angeles Examiner* 5 Mar. 1937.

————. Column. *The Los Angeles Examiner* 12 Mar. 1938.

————. Column. *The Los Angeles Examiner* 15 Mar. 1945.

————. Column. *The Los Angeles Examiner* 17 Mar. 1947.

————. Column. *The Los Angeles Examiner* 26 Mar. 1949.

————. Column. *The Los Angeles Examiner* 29 Mar. 1954.

————. Column. *The Los Angeles Examiner* 1 Apr. 1955.

————. Column. *The Los Angeles Examiner* 30 Mar. 1957.

————. Column. *The Los Angeles Examiner* 1 Apr. 1957.

————. Column. *The Los Angeles Examiner* 28 Mar. 1958.

————. Column. *The Los Angeles Examiner* 5 Apr. 1960.

————. Column. *The Los Angeles Examiner* 6 Apr. 1960.

Peretz, Evgenia. "Some Dramatic Evening." *Vanity Fair* June 2001: 122–28.

"Perspectives: Overheard." *Newsweek* 13 Apr. 1992: 19.

Piccalo, Gina, and Louise Roug. "The Oscars." *Los Angeles Times* 26 Mar. 2002: part 5, p. 1.

Reginato, James. "Dani Girl." *W* Jan. 1998: 34.

Roberts, Roxanne. "The Politics of Hollywood's Starriest Night." *The Washington Post* 29 Mar. 1995: B1.

Rush, George, and Joanna Molloy. "Oprah Talks Up Halle, Denzel Oscars." (New York) *Daily News* 26 Mar. 2002: 34.

Schulberg, Budd. "Builders & Titans: Louis B. Mayer." *Time* 7 Dec. 1998: 66.

"Screen Academy Pays Tribute to Film Folk on Second Anniversary." *Hollywood Citizen* 16 May 1929.

Sessums, Kevin. "Love Child." *Vanity Fair* June 1995: 106–15, 169–71.

"Simone's Moment of Suspense." *Life* 18 Apr. 1960.

Smith, Krista. "A Little Night Magic." *Vanity Fair* June 2002: 136–42.

————. "An Irresistible Force." *Vanity Fair* Feb. 2003: 70–75, 128–30.

————. "Dazzling Till Dawn." *Vanity Fair* May 2003: 156–66.

"Star Crossed." *W* Feb. 2002: 56.

"Starry Night." *Vanity Fair* June 1994: 94–95.

Smith, Liz. Column. *New York Post* 27 Mar. 2001.

Stein, Jeannine. "Oscar: An Overnight Sensation." *Los Angeles Times* 31 Mar. 1989: sec. IV, p. 1.

————. "Where the Stars Come Out to Shine After Oscars Show." *Los Angeles Times* 29 Mar. 1999: sec. IV, p. 1.

Tapert, Annette. "Swifty's A-List Life." *Vanity Fair* Apr. 1994: 152–60, 181–84.

Taylor, Elizabeth, and Brad Darrach. "An Extraordinary Life." *Life* Apr. 1997: 78–88.

"Tension and Triumph for a Young Actress." *Life* 7 Apr. 1958.

"They're Tough to Be Famous." *Vanity Fair* Sept. 1932: 38.

Tosches, Nick. "The Death, and Life, of the Rat Pack." *The New York Times* 7 Jan. 1996: sec. 2, p. 34.

Tyrnauer, Matt. "Oscar Invasion." *Vanity Fair* June 1999: 112–21.

Williams, Jeannie. "'Fair' Game for an After-Oscar Party." *USA Today* 28 Mar. 2000: 2D.

Wolcott, James. "The Real McQueen." *Vanity Fair* Sept. 2000: 346–49, 378.

Wolk, Josh. "Act 4: The Parties." *Entertainment Weekly* 16 Apr. 2001: 66–74.

Young, Paul. "It's Oscar Time." *WWD: The Oscars* Spring 2003: 64–66.

"100 Years of Hollywood." *People* (*People Weekly* Extra) Spring 1987: 96.

"The 1939 Classics." *Life* (Special Issue: Hollywood, 1939–1989), Spring 1989: 25–49.

"4,000 Actors for 600 Jobs on Coast, Told at Academy's Award Meeting." *Daily Variety* 22 May 1929: 4.

WEB SITES

Bartleby.com: Great Books Online. 2004. http://www.bartleby.com.

Biography Resource Center. President and Fellows of Harvard College. 2004. http://lib.harvard.edu/e-resources.

Current Biography. The HW Wilson Company. 2003.
http://www.currentbiography.com.

Fashion Planet. Digital Fashion, Inc. 1993–2004.
http://www.fashionplanet.com/.

Massoni, Jennifer. "A Decade of Vanity Fair Parties." *Style.com.* Condé Net Inc. 2004. http://www.style.com/peopleparties/vanityfair.

Merriam-Webster OnLine. Merriam-Webster, Inc. 2004.
http://www.m-w.com/.

Motion Picture & Television Photo Archive. Sid Avery and Associates, Inc. 2004. http://www.mptv.net.

CREDITS

PERMISSION ACKNOWLEDGMENTS

Grateful acknowledgment is made to the following for permission to reprint previously published material.

Bonnie Churchill: Excerpt from "A Journalist's Tales from Backstage at the Oscars," by Bonnie Churchill, from *The Christian Science Monitor* (March 24, 2000). Reprinted by permission of the author.

The Daily Telegraph: Excerpt from "Where the Stars Meet Their Heroes," by Simon Davis, from *The Daily Telegraph* (March 25, 2000). Copyright © 2000 by Telegraph Group Limited. Reprinted by permission of *The Daily Telegraph.*

Daily Variety: Excerpt from an article on the Oscars by Army Archerd, from *Daily Variety* (March 18, 1958). Reprinted by permission of *Daily Variety.*

Fairchild Publications: Excerpt from "Suzy" (Oscar article), by Aileen Mehle, from *Women's Wear Daily* (March 3, 2004). Reprinted by permission of Fairchild Publications.

Bill Higgins: Excerpt from "The Oscar Parties," by Bill Higgins, from the *Los Angeles Times* (March 27, 1996). Reprinted by permission of the author.

The Hollywood Reporter: Excerpts from "That Alka-Seltzer Fizzing All Over Town Yesterday . . . ," by Mike Connolly, from *The Hollywood Reporter* (March 23, 1956), and from "The Many Parties in the Grove Last Night . . . ," from *The Hollywood Reporter* (March 1, 1940). Copyright © 2004 by VNU Business Media, Inc. Reprinted by permission of *The Hollywood Reporter.*

Janklow & Nesbit Associates: Excerpt from *Holy Terror: Andy Warhol Close Up,* by Bob Colacello. Copyright © 1990 by Bob Colacello. Reprinted by permission of the author.

Los Angeles Times: Excerpt from an article by Hedda Hopper on the Oscars, from the *Los Angeles Times* (March 15, 1938), and an excerpt from "The Oscars 76th Annual Academy Awards," by Hilary E. MacGregor, from the *Los Angeles Times* (March 2, 2004). Reprinted by permission of the *Los Angeles Times.*

New York Daily News, L.P.: Excerpt from "When Puffy Met J. Lo, the Sequel," by George Rush and Joanna Molloy, from the *Daily News* (March 27, 2001). Copyright © New York *Daily News,* L.P. Reprinted by permission of the New York *Daily News,* L.P.

The New York Observer, L.P.: Excerpt from an article on the Oscars by Frank DiGiacomo, from *The New York Observer* (March 26, 1997), and an excerpt from "Oscars at War," by Frank DiGiacomo, from *The New York Observer* (March 31, 2003). Copyright © by *The New York Observer.* Reprinted by permission of *The New York Observer.*

Princeton University Library and **Harold Ober Associates Incorporated:** Excerpt from "The Big Academy Dinner," by F. Scott Fitzgerald (March 10, 1938). Copyright © 1981 by Scottie Fitzgerald Smith. From the F. Scott Fitzgerald Papers, Manuscript Division, Department of Rare Books and Special Collections, Princeton University Library. Reprinted by permission of the Princeton University Library and Harold Ober Associates Incorporated.

The Roosevelt Hotel: Excerpt from *The Roosevelt* newsletter (May 1929). Reprinted by permission of the Roosevelt Hotel in Hollywood.

Simon & Schuster: Excerpt from *Swifty: My Life and Good Times,* by Irving Lazar with Annette Tapert. Copyright © 1995 by Martin Singer, Trustee, Survivors Trust under the Irving Paul and Mary M. Lazar 1981 Trust. Reprinted by permission of Simon & Schuster Adult Publishing Group.

Liz Smith: Excerpts from Liz Smith's article on the Oscars from her syndicated column (March 29, 1995). Reprinted by permission of the author.

Annette Tapert: Excerpt from "Swifty's A-List Life," by Annette Tapert, from *Vanity Fair* (April 1994). Reprinted by permission of the author.

Time, Inc.: Excerpt from "Sad News of Cooper," from *Life* (April 28, 1961). Copyright © 1961 by Time, Inc. Reprinted by permission of Time, Inc.

The Washington Post: Excerpt from "Hollywood Partyers, Soldiering On," by William Booth and Sharon Waxman, from *The Washington Post* (March 25, 2003). Copyright © 2003 by *The Washington Post.* Reprinted by permission of *The Washington Post.*

Sheila Weller: Excerpt from "Life Begins at 8:30," by Sheila Weller, from *Vanity Fair* (April 1998). Reprinted by permission of the author.

William Morris Agency: Excerpt from *The Name Above the Title,* by Frank Capra. Copyright © 1971 by Frank Capra. Reprinted by permission of the William Morris Agency on behalf of the Estate of Frank Capra.

PHOTOGRAPHY CREDITS

Copyright © Academy of Motion Picture Arts and Sciences/ Courtesy of the Academy of Motion Picture Arts and Sciences: pages 6–7, 18–19, 24, 26 (Shearer and Thalberg; Herrick; Kern, Berman, and Rogers), 28–33, 38, 39 (McCarthy and Bergen), 40–42, 44–45, 47, 49, 56, 60–63, 66–69, 72–75, 78–79, 98–99, 118–21, 125–29, 134–35, 146 (Lancaster; Brynner), 154, 157, 160, 162–63, 171 (Hestons; Sommer and Jessel), 189, 193, 199 (McCartneys; Cassavetes and Rowlands), 208–9, 216, 219, 227, 231 (Nichols and Sawyer), 238 (O'Connor and Day-Lewis), and 248–49.

Pages 2–3: Ed Clark/Time Life Pictures/Getty Images.

Page 5: Phil Stern/CPi.

Pages 10–11: Jonathan Becker.

Page 14: Bison Archives.

Pages 20–21: Bison Archives (Cocoanut Grove).

Page 21: Everett Collection (Hayes).

Pages 22–23: Everett Collection.

Page 25: Everett Collection.

Page 26: Cliff Wesselman Collection, courtesy of Gregory Williams/ Print courtesy of the Academy of Motion Picture Arts and Sciences (photographers).

Page 27: Cliff Wesselman Collection, courtesy of Gregory Williams/ Print courtesy of the Academy of Motion Picture Arts and Sciences.

Pages 34–35: Rex Hardy Jr./Time Life Pictures/Getty Images.

Pages 36–37: Corbis.

Page 39: Photofest (Tracy), **John Swope**/Time Life Pictures/ Getty Images (Fields and Sennett).

Page 43: Culver Pictures.

Page 46: Photofest.

Page 48: Corbis.

Page 51: Bison Archives (McDaniel), **Peter Stackpole**/Time Life Pictures/Getty Images (Leigh).

Pages 52–53: Bison Archives.

Pages 54–55: Peter Stackpole/Time Life Pictures/Getty Images.

Page 57: Culver Pictures.

Pages 58–59: Cliff Wesselman Collection, courtesy of Gregory Williams/Print courtesy of the Academy of Motion Picture Arts and Sciences.

Pages 64–65: Lester Glassner Collection/Neal Peters.

Pages 70–71: AP/Wide World Photos.

Page 77: © **Ewing Galloway** (Grauman's Chinese Theatre), Photofest (Crisp, Jones, and Coburn; Crosby and Bergman).

Page 80: AP/Wide World Photos.

Page 81: Photofest.

Page 82: © **Ernest A. Bachrach**/RKO, courtesy of the Rathvon family; copy photo by **Joe McCary**/Photo Response.

Page 83: AP/Wide World Photos.

Page 84: Bison Archives.

Page 85: Globe Photos.

Pages 86–87: Ed Clark/Time Life Pictures/Getty Images.

Pages 88–89: MPTV.net.

Pages 90–91: AP/Wide World Photos.

Page 92: George Zeno Collection.

Page 93: Top and bottom, George Zeno Collection; center, **Bob Beerman**/George Zeno Collection.

Pages 94–95: Loomis Dean/Time Life Pictures/Getty Images.

Pages 96–97: NBC/Globe Photos.

Pages 100–101: Ed Clark/Time Life Pictures/Getty Images.

Page 102: John Peodincuk/New York *Daily News.*

Page 103: Everett Collection.

Pages 104–5: Ed Clark/Time Life Pictures/Getty Images.

Pages 106–7: George Silk/Time Life Pictures/Getty Images.

Pages 108–9: Phil Stern/CPi.

Pages 110–11: George Silk/Time Life Pictures/Getty Images.

Pages 112–13: Courtesy of Linda LeRoy Janklow.

Pages 114–15: Bison Archives (Beverly Hills Hotel).

Page 115: Hulton Archive/Getty Images (Borgnine and Kerins).
Pages 116–17: MPTV.net.
Pages 122–23: Hulton Archive/Getty Images.
Page 124: J. R. Eyerman/Time Life Pictures/Getty Images.
Pages 130–31: Bernie Abramson/MPTV.net.
Pages 132–33: Allan Grant/Time Life Pictures/Getty Images.
Pages 136–37: Dennis Stock/Magnum Photos.
Pages 138–40: David Sutton/MPTV.net.
Page 141: Bernie Abramson/MPTV.net.
Pages 142–43: Dennis Stock/Magnum Photos.
Page 144: Bernie Abramson/MPTV.net.
Page 145: David Sutton/MPTV.net.
Page 146: Photofest (Ustinov).
Page 147: Jack Albin/Getty Images.
Pages 148–49: Globe Photos.
Pages 150–51: © 1963 by Lawrence Schiller.
Page 152: Jack Albin/Getty Images (Passani and Peck; Sharif and Barton), Hulton Archive/Getty Images (Farr and Lemmon).
Page 153: Photofest.
Page 155: MPTV.net.
Page 156: Gene Lester/Getty Images.
Pages 158–59: Bud Gray/MPTV.net.
Page 161: Bud Gray/MPTV.net (Coburn), Hulton Archive/Getty Images (Marvin), Photofest (Warner, Cooper, and Harrison).
Pages 164–67: Bud Gray/MPTV.net.
Pages 168–69: Bernie Abramson/MPTV.net.
Page 170: Gunther/MPTV.net.
Page 171: Globe Photos (Mitchums), David Sutton/MPTV.net (Steiger and Bloom).
Pages 172–73: Courtesy of Mr. and Mrs. Henry Berger; copy photos by Jim McHugh.
Pages 174–77: Globe Photos (Redgrave and Nero), Bud Gray/MPTV.net (overview of room; Streisand and Gould).
Page 178: Photofest.
Page 179: Frank Edwards/Fotos International/Archive Photos/Getty Images.
Pages 180–81: Jack Albin/Getty Images.
Pages 182–83: Gunther/MPTV.net.
Pages 184–85: Max Miller/Fotos International/Getty Images.
Pages 186–87: Gunther/MPTV.net.
Page 188: Nate Cutler/Globe Photos (Douglases; Harmon and Nelson), Gunther/MPTV.net (Elliot and Jones), Max Miller/Fotos International/Getty Images (Millses).
Pages 190–91: Sheedy & Long/Photofest.
Page 192: Sheedy & Long/MPTV.net.
Pages 194–95: Bud Gray/MPTV.net.
Pages 196–98: Ron Galella.
Page 199: Fotos International/Getty Images (Nicholson and Huston), IPOL/Globe Photos (Bogdanovich and Shepherd).
Page 200: Globe Photos.
Page 201: Photofest.
Page 202: Bison Archives.
Page 204: Ron Galella.
Page 205: Alan Berliner and Ken Abbinante/Women's Wear Daily (Walters and Greenspan; Hepburn), Harry Morrison/Women's Wear Daily (Kempner and Lazar), Women's Wear Daily (Schumacher and Berenson).
Pages 206–7: Harry Morrison/Women's Wear Daily.
Pages 210–11: Corbis.
Pages 212–13: Dustin Pittman/Women's Wear Daily.
Page 214: Alan Berliner/Women's Wear Daily (Eisner; Bisset, Janssen, Evans, and Stewart), Nate Cutler/Globe Photos (Curtis), Ralph Dominguez/Globe Photos (Steenburgen and McDowell; Lane and Hutton).
Pages 215 and 217: Ralph Dominguez/Globe Photos.
Page 218: Roman Salicki/Women's Wear Daily.
Pages 220–21: Marissa Roth/Women's Wear Daily.
Pages 222–23: © 1985 Michael Jacobs/MJP (Mengers and Geffen), Marissa Roth/Women's Wear Daily (Ertegun and Welles).
Pages 224–25: © 1985 Michael Jacobs/MJP.
Page 226: DMI/Time Life Pictures/Getty Images (Field, Streep, and Lange), Aloma Ichinose/Women's Wear Daily (Arquettes); © 1986 Michael Jacobs/MJP (Dunne, Lazaroff, and Didion); Bill Nation/Corbis, print courtesy of Annette Tapert (Perry and Phillips).
Pages 228–29: © 1989 by Michael Jacobs/MJP.
Page 230: Ron Galella.
Page 231: Alex Berliner © Berliner Studio/BEImages (Parker and Downey), Bill Nation/Corbis, print courtesy of Annette Tapert (Carsons and Cronkites).
Pages 232–33: © Berliner Studio/BEImages.
Page 234: Pierre-Gilles Vidoli/Women's Wear Daily.
Page 235: © Berliner Studio/BEImages/Print courtesy of the Academy of Motion Picture Arts and Sciences (Bridgeses), Scott Downie/CelebrityPhoto.com (Armanis); © 1986 Michael Jacobs/MJP (Pleshette and Dunne).
Page 236: David McGough/Time Life Pictures/Getty Images.
Page 237: © 1991 Michael Jacobs/MJP.
Page 238: Pierre-Gilles Vidoli/Women's Wear Daily (Hobbs, Pacino, and Levinson; De Fina and Scorsese; Lazar and Browns).

Pages 239–41: © Berliner Studio/BEImages.
Pages 242–43: © 1992 Michael Jacobs/MJP.
Pages 244–45: © Berliner Studio/BEImages/Print courtesy of the Academy of Motion Picture Arts and Sciences (Lee, Lucas, and Singleton), Dafydd Jones (Cicogna, Carter, Stark, and Gardona), Kevin Mazur/WireImage.com (Spade, Rock, and Farley).
Pages 246–47 and 250–54: Dafydd Jones.
Page 255: Dafydd Jones (Prince and Sessums; Iacocca and Smith; Vidal and Huston; MacLaine and Reagan), Kevin Mazur/WireImage.com (Capshaw et al.).
Pages 256–59: Dafydd Jones.
Pages 260–61: Alan Berliner © Berliner Studio/BEImages.
Pages 262–63: Dafydd Jones.
Pages 264–65: Alan Berliner © Berliner Studio/BEImages.
Page 266: Dafydd Jones (Newhouse and Truman; Grant and Hurley; paparazzi), Michael Toth (Smith).
Pages 267–69: Alan Berliner © Berliner Studio/BEImages.
Pages 270–71: Dafydd Jones.
Page 272: © Berliner Studio/BEImages.
Page 273: Alex Berliner © Berliner Studio/BEImages.
Pages 274–75: Alan Berliner © Berliner Studio/BEImages (Gibson), © Berliner Studio/BEImages (Phillips; Tarantino and Sorvino), Peter Beard (Ross and Dickinson; Wilders; Joneses and Wonder), Dafydd Jones (von Fürstenberg and Ross).
Pages 276–77: Peter Beard.
Pages 278–79: Dafydd Jones.
Pages 280–81: Alan Berliner © Berliner Studio/BEImages.
Pages 282–83: Dafydd Jones.
Pages 284–85: © Berliner Studio/BEImages (Kerkorian, Goldberg, and Newhouse; Bacall), Dana Brown (Neill), Dafydd Jones (Collins and McKellen; Ryder and Danes; Faithfull and Bernhard; Wilson, Hoeksema, and Valentino; Binoche), Kevin Mazur/WireImage.com (Styler and Sting).
Page 286: Dafydd Jones.
Page 287: Peter Beard.
Pages 288–89: Jonathan Becker.
Pages 290–93: © Berliner Studio/BEImages.
Pages 294–95: Dafydd Jones.
Page 296: Jonathan Becker.
Page 297: Peter Beard.
Pages 298–99: Peter Beard (Cormans), Jonathan Becker (Dillon and Diaz; Huvane, di Bonaventura, and Lovett; Katzenbergs), Alan Berliner © Berliner Studio/BEImages (Zeta-Jones and Connery), Michael Caulfield/AP/Wide World Photos (Winslet and Cameron), Dana Brown (Semel), Dominick Dunne (Stewart and Hamilton), Dafydd Jones (Saltzman; Weinsteins; Combs and Stone), Sam Jones (Nicholson), Patrick McMullan (Frestons).
Pages 300–301: Dafydd Jones.
Page 302: Alex Berliner © Berliner Studio/BEImages.
Page 303: Jonathan Becker.
Pages 304–5: Dafydd Jones.
Pages 306–7: Jonathan Becker (Aykroyd and Perelman; Shaw and Douglas; Vanden Berg, Lynch, Glazer, and Curtis), Dafydd Jones (Voight and Hannah; Powells; Levangie and Bloomberg), Patrick McMullan (Ribisi, O'Brien, Gossett, and Kilmer; Lenos and Griffin; Norton and Barrymore; Tylers and Tallarico; Lebowitz and Bergen; Gallaghers; Lewinsky and Smith), Herb Ritts Foundation (Carey; Harris and Anderson).
Pages 308–9: Larry Fink.
Page 310: Eric Charbonneau © Berliner Studio/BEImages.
Page 311: Jonathan Becker.
Pages 312–13: Larry Fink.
Page 314: Eric Charbonneau © Berliner Studio/BEImages.
Page 315: Richard Young/Rex USA.
Page 316: Jonathan Becker.
Page 317: Eric Charbonneau © Berliner Studio/BEImages.
Pages 318–19: Jonathan Becker (Mortons; Smith, Davis, and Steel; Paisley, Roderick, Hefner, and Bentleys; Blair and Gyllenhaal; Hurley and Macpherson; Waters and Moby), Todd Eberle (Sevignys), Larry Fink (Gallin; "the party's over"), Erik Hyman (Ritts and Leibovitz), Kevin Mazur/WireImage.com (Williams and Crystal), Patrick McMullan (Davis and Reeves), Michael Toth ("special access"), Richard Young/Rex USA (Fonda).
Pages 320–21: Evan Agostini © Berliner Studio/BEImages (Deneuve), Jonathan Becker (Bloomingdale, Wald, and Hale; Eichelberger and Cleese; Brown), © Berliner Studio/BEImages (Ruzan, Myers, and Graham), Larry Fink (Ford and Dunaway), Patrick McMullan (Lourd and Fisher; Robinson and Clapton; Irvings), Long Photography/Photofest (Dryer and Spacey), Mario Testino (Colacello and Christensen), Richard Young/Rex USA (Huston and Graham).
Pages 322–23: Larry Fink.
Page 324: © Berliner Studio/BEImages.
Pages 325–26: Larry Fink.
Page 327: Jonathan Becker.
Pages 328–29: Alan Berliner © Berliner Studio/BEImages.
Page 330: Richard Young.
Page 331: Larry Fink.
Pages 332–33: Jonathan Becker.
Page 334: Sophie Olmsted.
Pages 335–37: Jonathan Becker.
Pages 338–39: Jonathan Becker (Merhige, Dafoe, and Izzard; "the night is young"; Hopkins; Ford and McCartney; chorine), Alan

Berliner © Berliner Studio/BEImages (Houston; Flockhart), © Berliner Studio/BEImages (Reubens and Cort; C. Crowe), Eric Charbonneau © Berliner Studio/BEImages (Voight and Jolie), Todd Eberle (Lehman), Larry Fink (Ritts, Dahl, and Hyman), David Harris (Levy and O'Hara), Jeff Kravitz/FilmMagic.com (R. Crowe), Sophie Olmsted (Schnabel; Jackson), Richard Young (Idle and Cleese).
Page 341: Jonathan Becker (Woodroffe, Barford, Thom, and Walter).
Pages 342–43: Larry Fink.
Page 344: Eric Charbonneau © Berliner Studio/BEImages.
Page 345: © Berliner Studio/BEImages.
Pages 346–47: Larry Fink.
Pages 348–49: Jonathan Becker (Galella; Altman and Close; McCartneys), Eric Charbonneau © Berliner Studio/BEImages (Bullock; Blair, Applegate, and Diaz; Anderson), Todd Eberle (Sarkin and Marks), Larry Fink (Luhrmann, Martin, and Pearce; Olsens), Patrick McMullan (Beatty and Bening), Richard Young (Watts; Broadbent; Dahl and Cumming).
Page 350: Eric Charbonneau © Berliner Studio/BEImages (Grazer and Howard; Beckinsale; Barkin and Thurman), Larry Fink (Wyatt; "shindig"), Richard Young (Witherspoon and Phillippe; Jackson and Lucas).
Page 351: Eric Charbonneau © Berliner Studio/BEImages.
Pages 352–53: Jonathan Becker.
Pages 354–55: Sophie Olmsted.
Pages 356–57: Eric Charbonneau © Berliner Studio/BEImages.
Pages 358–59: Eric Charbonneau © Berliner Studio/BEImages (Hockney), Larry Fink (Sischy, Brant, and Iman).
Page 360: Sophie Olmsted.
Page 361: Richard Young.
Pages 362–63: Jonathan Becker (Berenson and Karan; Ertegun and Carter; Weber and Guest; Murdochs and Lovett; Garrett; Iman and Hale; Richards), Eric Charbonneau © Berliner Studio/BEImages (Cooper; Klieman and Bratton; Christensen and Guzman; Gere and Lowell; Fawcett and O'Neal; Gyllenhaal and Dunst), Larry Fink (Aldrin and Driggs), Patrick McMullan (Walken and Streep; Farrell; Moore and Haynes; Latifah and Lane), Kevin Winter/Getty Images (Ford and Flockhart).
Pages 364–65: Jonathan Becker.
Page 366: Kevork Djansezian/AP/Wide World Photos.
Page 367: Patrick McMullan.
Page 368: Jeff Vespa/WireImage.com.
Page 369: Jonathan Becker (Murray), Patrick McMullan (Johansson and Keaton), Kevin Winter/Getty Images (Coppolas).
Page 370: Richard Young.
Page 371: Larry Fink.
Pages 372–73: Jonathan Becker (Hiltons; Krall and Costello; Kseniak and Hutton), Larry Fink (Lourd and Levin), Patrick McMullan (Deschanel and Schwartzman; Black; Stiller, Rubin, and Wilson; Shorts and Martin; Ledger and Watts; Wiatts and Davids; Travolta and Andre 3000), Jeff Vespa/WireImage.com (Jackson), Richard Young (Miller and Law; Ruscha, Frankses, and Keitel; Westons; Ryan and Keaton).
Pages 374–75: Kevin Winter/Getty Images.
Page 376: Peter Stackpole/Time Life Pictures/Getty Images.
Page 378: Wisconsin Center for Film and Theater Research.
Pages 382–83: Terry O'Neill/Corbis.

Digital colorization by Nucleus Imaging Inc., N.Y.C.: pages 24, 43, 61, 72, 81, 88–89, 98–99, 104–5, 129, 156, and 190–91.

ILLUSTRATION AND EPHEMERA CREDITS

Copyright © Academy of Motion Picture Arts and Sciences/Courtesy of the Academy of Motion Picture Arts and Sciences; photos by Jim McHugh: pages 15–17, 21, 26, 30 (response card), 34, 51, 56–57 (inset), 76, 94 (guest list and seating charts), 128, 130, 157, 171, 191, 209, and 219.

Page 8: Vanity Fair Archive, calligraphy by Sandy McDonnell/SJM Design.
Page 30: Courtesy of Variety, courtesy of the Academy of Motion Picture Arts and Sciences; photo by Jim McHugh (Daily Variety).
Pages 46–47: Courtesy of Arnold Schwartzman (inset).
Page 50: Reprinted with permission from Paul Politi and Suzanne Politi Bischof, courtesy of the Academy of Motion Picture Arts and Sciences; photo by Jim McHugh.
Page 73: Reprinted with permission from the Wyler family, courtesy of the Academy of Motion Picture Arts and Sciences; photo by Jim McHugh.
Page 80: Courtesy of Sheila Weller.
Page 94: Courtesy of Gloria Romanoff; photo by Four Legs Photography (matchbook).
Page 203: Risko.
Page 226: Courtesy of Michelle Phillips (snapshot collage).
Page 235: Courtesy of Mrs. Jolene Schlatter; photo by Jim McHugh (clapboard).
Pages 340–41: Vanity Fair Archive (seating charts); Basil Walter Architects (architectural renderings).

Captions accompanying the photographs in this book were set in VF Sans, a typeface drawn exclusively for Vanity Fair by James Montalbano of Terminal Design, Inc. A geometric sans serif, it was inspired by early-20th-century typefaces such as Futura, Kabel, and Johnston Underground. Other text elements were set in Times Roman.

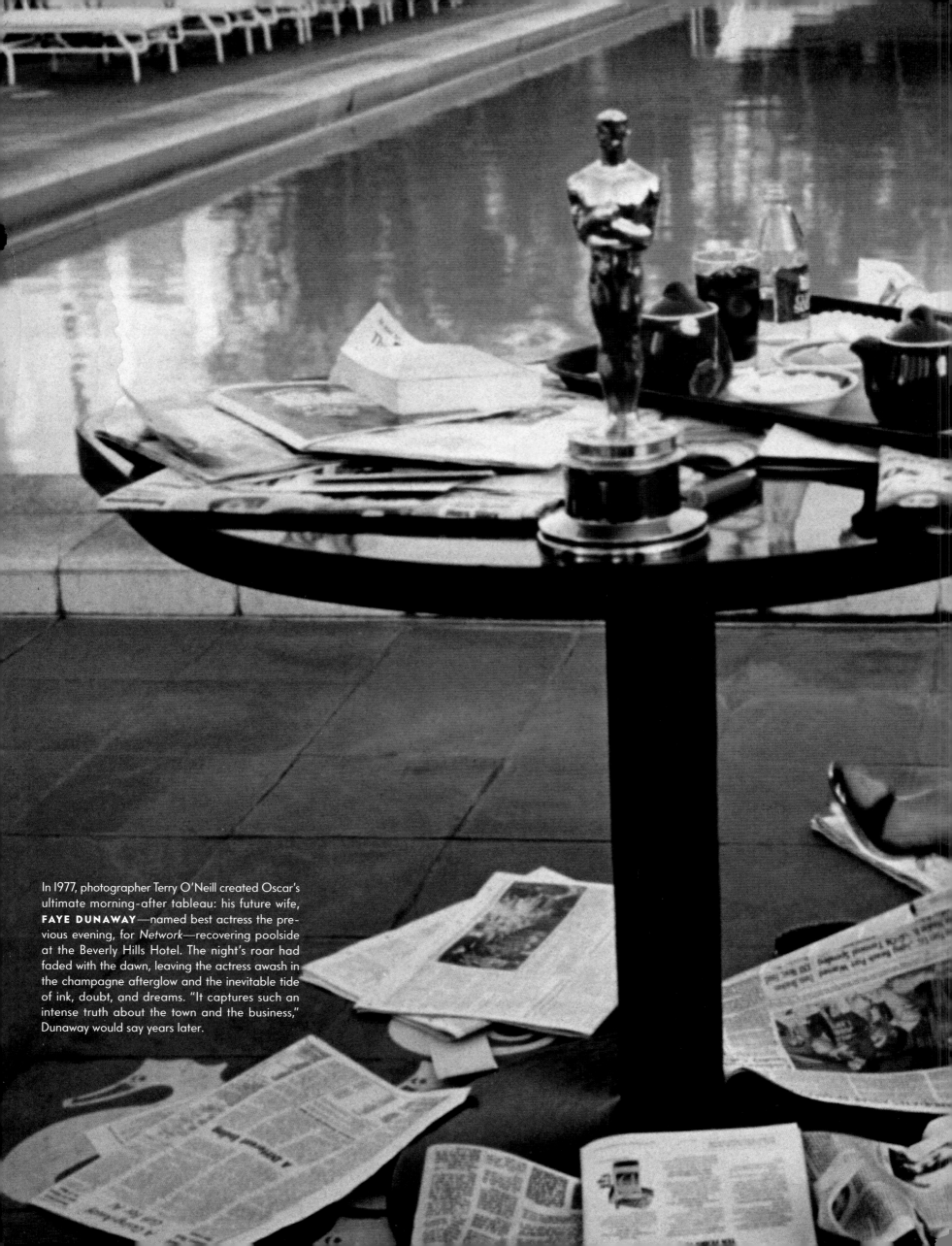

In 1977, photographer Terry O'Neill created Oscar's ultimate morning-after tableau: his future wife, **FAYE DUNAWAY**—named best actress the previous evening, for *Network*—recovering poolside at the Beverly Hills Hotel. The night's roar had faded with the dawn, leaving the actress awash in the champagne afterglow and the inevitable tide of ink, doubt, and dreams. "It captures such an intense truth about the town and the business," Dunaway would say years later.

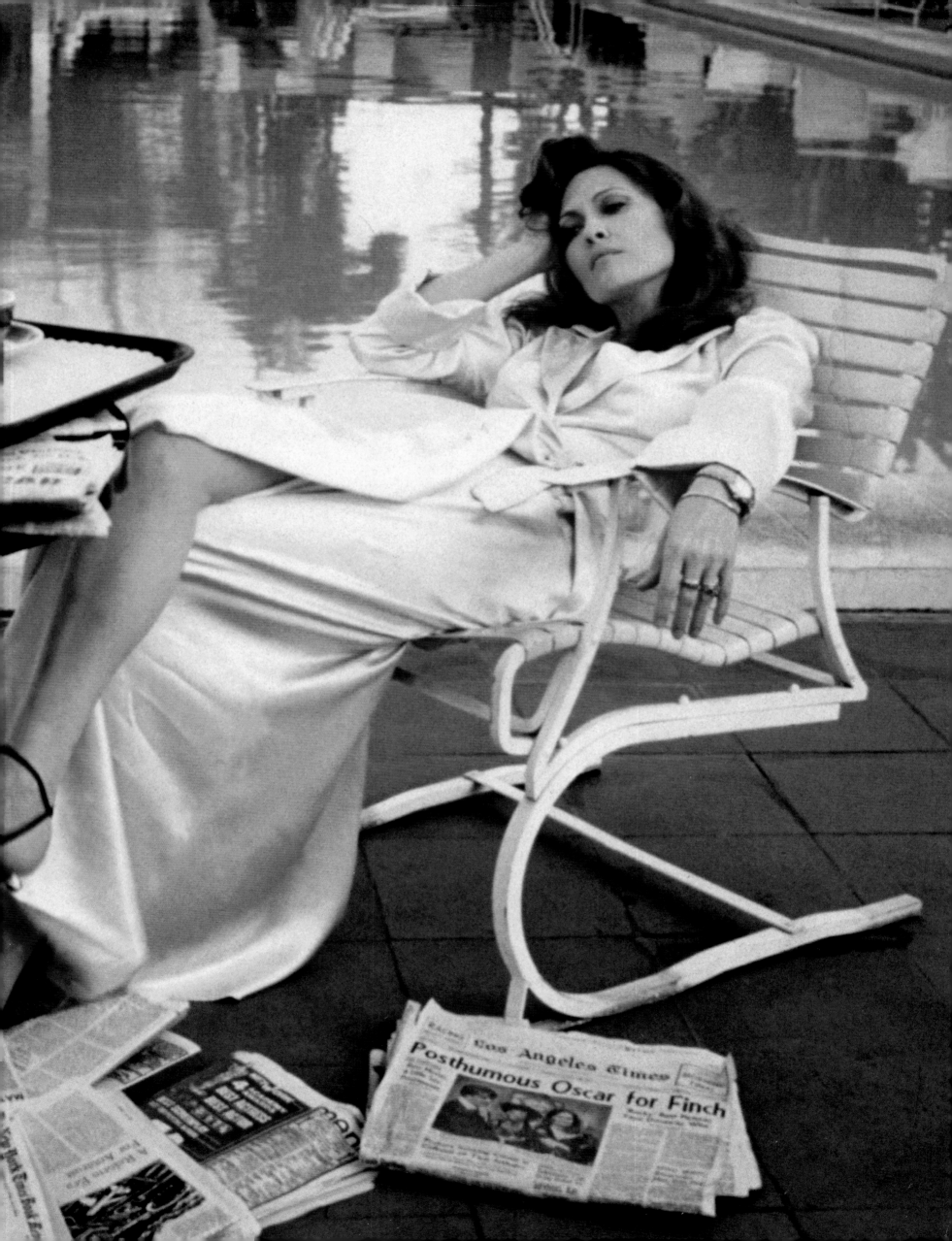

By Dominick Dunne

Noël Coward, the ultimate sophisticate, said it best in the opening lyric of his campy song—"I've been to a marvelous party." He didn't mean the Oscar party, but that is exactly what people say, and have been saying for 75 years, on the morning after the Academy Awards. Oscar night is *the* party night in Hollywood—New Year's Eve and the Fourth of July rolled into one—and since 1994 the *Vanity Fair* party has been the one to be seen at. It's also the hardest to get into, which makes it all the more desirable. Such glamour, such swank, such high fashion, and, above all, such star power. The crowd outside cheers the famous descending from their limousines, and the journalists, lined up behind velvet ropes, scream the stars' names, take flash photos, and hold out microphones. You enter on a high at five in the afternoon, and the high lasts until three or four o'clock in the morning. For someone like me, who loves to mingle with movie stars, it's Nirvana. *Hi, Nicole. Hi, Sean. Hi, Renée. Hi, Anjelica. Oh, my God, there's Charlize Theron, carrying her Oscar! Introduce me.*

I attended my first Oscar party, at Romanoff's in 1955, two years before I moved to Hollywood. The Governors Ball, which is given on Oscar night by the Academy of Motion Picture Arts and Sciences, didn't begin until three years later, in 1958. Grace Kelly won the best-actress award in 1955, for her performance in *The Country Girl,* opposite Bing Crosby. Grace, whom I had known when she was starting out as an actress in New York and I was a television stage manager, was one of the greatest beauties in the history of the movies. She looked ravishing that night, in a beautiful ice-blue evening gown by Paramount costume designer Edith Head. Grace walked through the throng of actors, directors, and producers at Romanoff's, kissing friends and never imagining that she was about to end her spectacular career. A month later she would meet Prince Rainier of Monaco at the Cannes Film Festival. After completing *The Swan* and *High Society,* she would leave Hollywood forever to reign with him as Princess Grace.

Gossip columnists have always played a big part in Hollywood, and at one time they wielded a great deal of power. For six or seven years in the 60s, Joyce Haber of the *Los Angeles Times* was the acknowledged successor to the great gossip rivals Louella Parsons and Hedda Hopper, both of whom I knew. Hedda and Louella were so powerful they could create or destroy careers. Joyce Haber had power, too. She could be extremely difficult, and very mean on occasion, especially when she created the A- and B-lists of Hollywood society, but everyone in the industry read her every morning. She was married to Douglas Cramer, who was not yet the rich and famous TV producer he would become after their divorce, when he partnered with Aaron Spelling on such wildly successful series as *Dynasty* and *The Love Boat.* Joyce and Doug lived in the Beverly Hills house that had been the residence of Clifton Webb, the urbane star who was in such great Twentieth Century Fox films as *Laura* and *The Razor's Edge.* Joyce always said that Clifton's ghost haunted the place. In the projection room she hung a portrait of him, painted by his friend Cecil Beaton, which she had bought at a yard sale of his furniture. After being badly seated at an Academy Awards ceremony, Joyce never went back, and in 1975 she gave her own party at home, with an A-list of guests. Robert Evans, the head of Paramount Studios at the time, was up for best picture for *Chinatown* and was the odds-on favorite to win. Joyce was determined that her friend Bob would get the award. Evans was expected at her house after his acceptance speech and a quick, obligatory appearance at the Governors Ball. Alas, Evans didn't win. Francis Ford Coppola won, for *The Godfather Part II.* There were cries of disappointment and anger at the house, for the whole purpose of Joyce's party was ruined, and at that very moment—I swear to God—Clifton Webb's portrait fell off the wall. Joyce said Clifton was showing his disapproval that Bob didn't win. I recently called Evans to ask him about that night. His disappointment was still vivid after all these years. He said, "Warren Beatty was giving out the award for best picture that night, and when he opened the envelope he looked at me in the audience, and I knew then, before he announced the winner, that I didn't win, that Francis won."

Humphrey Bogart gave Irving Paul Lazar, the literary agent, the nickname Swifty, which stuck for the rest of his life. Swifty always wanted to be famous, a goal rarely reached by literary agents. He hung out with the crème de la crème of Hollywood society—the Samuel Goldwyns, the William Goetzes, the Billy Wilders, the Bogarts—but he was never quite of the same rank, and it rankled him. Tiny, funny-looking, with enormous black-rimmed glasses that covered most of his face, Swifty always had a tall, great-looking girl on his arm, which made him the butt of jokes among his swell friends. But he got even. He married a comely beauty from Chicago named Mary Van Nuys, who was popular, fun, and exactly the right person for him. He had his Beverly Hills house re-done by a New York society decorator, and he took an apartment on Fifth Avenue. He started buying Impressionist paintings. Soon he became successful enough to create his own Oscar-night party, and it brought him the superstar status he had always craved.

Swifty didn't have time for anyone who wasn't important. He took pleasure in telling off people who tried to get invited to his party, even studio heads. He would say, "This is not an industry function. This is a party for my friends. I never see you all year long." And then he would hang up. He would walk around the party like a ringmaster, changing place cards right up to the last minute. He bawled out people who talked during the televised ceremony, but a beatific expression would come over his face as each new star arrived, having bolted the Governors Ball for his party.

For years Swifty's party was at the Bistro, on North Cañon Drive in Beverly Hills, and I attended it there several times. But then I went through a long flop period and ceased to be invited. I wasn't reinstated until six years later, after I'd written my first best-seller. Hooker that I am, I went right back and greeted the Lazars as if they were my best friends. I was not going to miss that party, which in 1985 had shifted from the Bistro to Spago, on Sunset Boulevard. It had grown so much that more space was needed, and the up-and-coming restaurateur Wolfgang Puck had made a deal with Swifty that was irresistible. Spago became one of the most famous restaurants in the world.

One year I was at a table with Elizabeth Taylor and Audrey Hepburn. I knew them both, but I was always stunned by their magnificence. Just watching those two legends cry out each other's name and lean across the table to kiss-kiss made the evening an event. Audrey was one of the best-dressed women in the world, the height of understated style, and that night she had on a black evening dress by Givenchy. Elizabeth was bedecked in a huge diamond necklace and a huge diamond ring. "Kenny Lane?" asked Audrey, pointing at the necklace. "No, Mike Todd," answered Elizabeth, mentioning her third husband. "Kenny Lane?" asked Audrey, indicating the ring. "No, Richard Burton," replied Elizabeth, mentioning her fifth and sixth husband. With that the two stars screamed with laughter and kissed again.

The most fascinating couple another year at Swifty's party was the young Madonna, in a white rhinestone-encrusted gown with white fox and diamonds, and the young Michael Jackson, in one of his military-type costumes. Great stars, including James Stewart, stood on chairs to get a better look at them. Young though they were, they were both completely aware of the stir they were causing. In short, Swifty always had the most "in" party of the year. He re-discovered what Cole Porter and Elsa Maxwell had figured out back in the 30s: showbiz people like to look at social people just as much as social people like to look at showbiz people.

I was in Turkey with Swifty and Mary when he became ill. At his memorial service, in 1994, I heard people around me whisper to one another, "What do you think will happen to the Academy Awards party?" That's when *Vanity Fair* stepped into the picture, and since then its Oscar party has been the hot social event of the year in Hollywood. Instead of emulating Swifty's party, Graydon Carter decided to create something totally new. It was his idea to go to Mortons, and he put together a team of such creative force that each year the excitement mounts and the crowd is more amazing. Last year someone whispered in my ear, "Have you noticed Mrs. Rupert Murdoch's emerald necklace?" The beat goes on. □